art since 1900

To Nikos Stangos (1936–2004), in memoriam

With love, admiration, and grief, we dedicate this book to
Nikos Stangos, great editor, poet, and friend, whose belief
in this project both instigated and sustained it through the
course of its development.

We would like to thank Thomas Neurath and Peter Warner for
their patient support, and Nikos Stangos and Andrew Brown
for their editorial expertise. The book would not have been
begun without Nikos; it would not have been completed
without Andrew.

hal foster
rosalind krauss
yve-alain bois
benjamin h. d. buchloh
david joselit

third edition

volume 1
1900–1944

393 illustrations,
262 in color

art since 1900

modernism antimodernism postmodernism

Thames & Hudson

The publishers would like to thank
Amy Dempsey for her assistance in
the preparation of this book.

First published in 2004 in the United States
of America by Thames & Hudson Inc.,
500 Fifth Avenue, New York, NY 10110

thamesandhudsonusa.com

Second edition 2011
Third edition 2016

Library of Congress Catalog Control Number
(volume 1): 2016933436
Library of Congress Catalog Control Number
(volume 2): 2016933436

ISBN (volume 1): 978-0-500-29271-6
ISBN (volume 2): 978-0-500-29272-3

Printed and bound in China by
C&C Offset Printing Co. Ltd

Contents

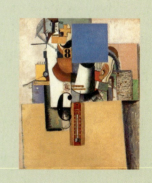
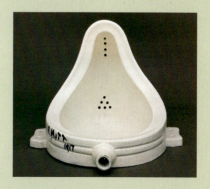

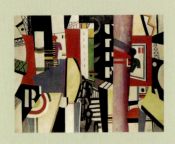

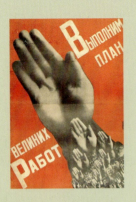

1970–1979

1980–1989

798 2007c As Damien Hirst exhibits *For the Love of God*, a platinum cast of a human skull studded with diamonds costing £14 million and for sale for £50 million, some art is explicitly positioned as a media sensation and a market investment.

804 2009a Tania Bruguera presents *Generic Capitalism* at the multimedia conference "Our Literal Speed," a performance that visualizes the assumed bonds and networks of trust and likemindedness among its art-world audience by transgressing those very bonds.

810 2009b Jutta Koether shows "Lux Interior" at Reena Spaulings Gallery in New York, an exhibition that introduces performance and installation into the heart of painting's meaning: the impact of networks on even the most traditional of aesthetic mediums—painting—is widespread among artists in Europe and the United States.

818 2009c Harun Farocki exhibits a range of works on the subject of war and vision at the Ludwig Museum in Cologne and Raven Row in London that demonstrate the relationship between popular forms of new-media entertainment such as video games and the conduct of modern war.

824 2010a Ai Weiwei's large-scale installation *Sunflower Seeds* opens in the Turbine Hall of London's Tate Modern: Chinese artists respond to China's rapid modernization and economic growth with works that both engage with the country's abundant labor market and morph into social and mass-employment projects in their own right.

830 2010b French artist Claire Fontaine, whose "operation" by two human assistants is itself an explicit division of labor, dramatizes the economies of art in a major retrospective at the Museum of Contemporary Art in North Miami, Florida: the show marks the emergence of the avatar as a new form of artistic subjecthood.

836 2015 As Tate Modern, the Museum of Modern Art, and the Metropolitan Museum of Art plan further expansions, the Whitney Museum of American Art opens its new building, capping a period of international growth in exhibition space for modern and contemporary art including performance and dance.

842 Roundtable | The predicament of contemporary art

How to use this book

Art Since 1900 has been designed to make it straightforward for you to follow the development of art through the twentieth century and up to the present day. Here are the features that will help you find your way through the book.

Each entry centers on a key moment in the history of twentieth- and twenty-first-century art, indicated by the title at the head of the entry. It might be the creation of a groundbreaking work, the publication of a seminal text, the opening of a crucial exhibition, or another significant event. Where two or more entries appear in any one year, they are identified as 1900a, 1900b, and so on.

Picture references in the text direct you clearly to the illustration under discussion.

Symbols in the margin indicate that other related entries may be of interest. The corresponding cross-references at the foot of the page direct you to the relevant entries. These allow you to follow your own course through the book, to trace, for example, the history of photography or sculpture or the development of abstraction in its different forms.

2009b

Jutta Koether shows "Lux Interior" at Reena Spaulings Gallery in New York, an exhibition that introduces performance and installation into the heart of painting's meaning: the impact of networks on even the most traditional of aesthetic mediums—painting—is widespread among artists in Europe and the United States.

With a characteristic flourish of perversity linking painting to pasta, the German artist Martin Kippenberger (1953–97) identified in an interview from 1990–1 the most important painterly problem to arise since Warhol's silkscreens of the sixties: "Simply to hang a painting on the wall and say that it's art is dreadful. The whole network is important! Even spaghettini…. When you say art, then everything possible belongs to it. In a gallery that is also the floor, the architecture, the color of the walls." In Kippenberger's work, which included painting and sculpture as well as many hybrid practices in between, the limits of an individual object were consistently challenged. Already in his first painting project of 1976–7, *One of You, a German in Florence* [1], Kippenberger displaced attention from singular works by rapidly executing one hundred canvases in grisaille all the same size, that reproduced snapshots or newspaper clippings. His intention was to make enough paintings so that when piled up they would be as tall as him. Here painting enters several types of network at once: each individual canvas belonged to a "family grouping"; all were assimilated to the fluid economy of photographic information, referencing the personal snapshot or the journalistic document; and the scale of the series was indexed to the physical characteristics of the artist—namely, his height—as well as his everyday activities, as marked by the choice of motifs that might be recorded by any avid, though eccentric, German resident in Florence.

If we take Kippenberger at his word, then, a significant question arises: How can painting incorporate the multiple networks that frame it? This late-twentieth-century problem, whose relevance has only increased with the turn of the twenty-first century and the growing ubiquity of digital networks, joins a sequence of modernist challenges to painting. Early in the last century, Cubism pushed the limits of what a coherent painterly mark could be by demonstrating the minimum requirements for visual coherence. Mid-twentieth-century gestural abstraction, epitomized by Abstract Expressionism, raised the issue of how representation may approach the status of pure matter—consisting of nothing but raw paint applied to canvas. And finally, during the sixties a whole range of photomechanical procedures pioneered by Pop and

1 • Martin Kippenberger, *Untitled* (from the series *One of You, a German in Florence*), 1976–7
Oil on canvas, each 50 × 60 (19¹¹⁄₁₆ × 23⅝)

▲ 1911, 1913, 1921a ● 1947b, 1949, 1951 ■ 1960c, 1964b, 1967c

2000–2015

Boxes throughout provide background information on key personalities, important concepts, and some of the issues surrounding the art of the day. Further elaboration of terms is available in the glossary at the back of the book.

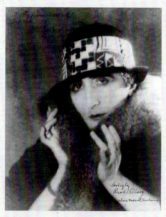

Rrose Sélavy

One of the sketches Duchamp drew for the *Large Glass* and published in the *Green Box* shows the double field of the work with the upper area labeled "MAR" (short for *mariée* [bride]) and the lower one "CEL" (short for *célibataires* [bachelors]). With this personal identification with the protagonists of the *Glass*, (MAR + CEL = Marcel) Duchamp thought about assuming a feminine persona. As he told his interviewer, Pierre Cabanne:

Cabanne: *Rrose Sélavy was born in 1920, I think.*
Duchamp: *In effect, I wanted to change my identity, and the*

first idea that came to me was to take a Jewish name …
I didn't find a Jewish name that I especially liked, or that
tempted me, and suddenly I had an idea: why not change
sex? It was much simpler. So the name Rrose Sélavy came
from that …
Cabanne: *You went so far in your sex change as to have
yourself photographed dressed a a woman.*
Duchamp: *It was Man Ray who did the photograph …*

Having stopped work on the *Glass* in 1923, Duchamp transferred his artistic enterprise to this new character and had business cards printed up giving his name and profession as "Rrose Sélavy, Precision Oculist." The works he went on to make as "oculist" were machines with turning optical disks—the *Rotary Demisphere* and the *Rotoreliefs*—as well as films, such as *Anemic Cinema.*

There is a way to understand Rrose Sélavy's enterprise as the undermining of the Kantian aesthetic system in which the work of art opens onto a collective visual space acknowledging, in effect, the simultaneity of points of view of all the spectators who are gathered to see it, a multiplicity whose appreciation for the work speaks with, as Kant would say, the universal voice. On the contrary, Duchamp's "precision optics" were, like the holes in the door of his installation *Etant données*, available to only one viewer at a time. Organized as optical illusions, they were clearly the solitary visual projection of the viewer placed in the right vector to experience them. As the *Rotoreliefs*—a set of printed cards—revolved like visual records on a phonograph turntable, their designs of slightly skewed concentric circles spiral to burgeon outward like a balloon inflating and then to reverse themselves into an inward, sucking movement. Some appeared like eyes or breasts, trembling in a phantom space; another sported a goldfish that seemed to be swimming in a basin whose plug had been pulled, so that the fish was being sucked down the drain. In this sense, Duchamp's switch to Rrose and her activities marks a turn from an interest in the mechanical (the Bachelor Machine, the Chocolate Grinder) to a concern for the optical.

The decade is indicated at the side of each page.

1910–1919

Perspective had specifically located this viewer in its plotting of a ▲ precise vantage point. But both Cubism and Fauvism, by finding other means to unify the pictorial space, also address themselves to a unified human subject: the viewer/interpreter of the work.

The final implication of Duchamp's removal of his field of operations from the iconic to the indexical sign becomes clear in this context. For beyond its marking a break with "picturing" and a rejection of "skill," beyond its displacement of meaning from repeatable code to unique event, the index's aspect as shifter has implications for the status of the subject, of the one who says "I," in this case Duchamp "himself." For as the subject of the vast self-portrait assembled by *Tu m'*, Duchamp declares himself a disjunctive, fractured subject, split axially into the two facing poles of pronominal space, even as he would split himself sexually into the two opposite poles of gender in the many photographic self-

portraits he would make while in drag and sign "Rrose Sélavy" [**5**]. Taking up Rimbaud's "je est un autre" ("I is an other"), Duchamp's shattering of subjectivity was perhaps his most radical act. RK

Further reading lists at the end of each entry enable you to continue your study by directing you to some of the key books and articles on the subject, including primary and secondary historical documents and recently published texts. A general bibliography and a list of useful websites at the back of the book provide additional resources for research.

FURTHER READING
Roland Barthes, "The Photographic Message" and "The Rhetoric of the Image," *Image/Music/Text* (New York: Hill and Wang, 1977)
Marcel Duchamp, *Salt Seller: The Writings of Marcel Duchamp (Marchand du Sel)*, eds Michel Sanouillet and Elmer Peterson (New York: Oxford University Press, 1973)
Thierry de Duve, *Pictorial Nominalism: On Duchamp's Passage from Painting to the Readymade*, trans. Dana Polan (Minneapolis: University of Minnesota Press, 1991)
Thierry de Duve (ed.), *The Definitively Unfinished Marcel Duchamp* (Cambridge, Mass.: MIT Press, 1991)
Rosalind Krauss, "Notes on the Index," *The Originality of the Avant-Garde and Other Modernist Myths* (Cambridge, Mass.: MIT Press, 1985)
Robert Lebel, *Marcel Duchamp* (New York: Grove Press, 1959)
Francis M. Naumann and Hector Obalk (eds), *Affect t l Marcel : The Selected Correspondence of Marcel Duchamp* (London: Thames & Hudson, 2000)

The entry's date and name appears at the foot of each page.

▲ 1906, 1907, 1911, 1912, 1921a

Preface: a reader's guide

This book is organized as a succession of important events, each keyed to an appropriate date, and can thus be read as a chronological account of twentieth- and twenty-first-century art. But, like the pieces of a large puzzle that can be transformed into a great variety of images, its 130 entries can also be arranged in different ways to suit the particular needs of individual readers.

First, some narratives might be constructed along national lines. For example, within the prewar period alone, the story of French art unfolds via studies of figurative sculpture, Fauvist painting, Cubist collage, and Surrealist objects, while German practice is traced in terms of Expressionist painting, Dada photomontage, Bauhaus design, and Neue Sachlichkeit (New Objectivity) painting and photography. The Russian avant-garde is followed from its early experiments with new forms and materials, through its direct involvement in political transformation, to its eventual suppression under Stalin. Meanwhile, British and American artists are tracked in their ambivalent oscillation between the demands of national idioms and the attractions of international styles.

As an alternative to such national narratives, the reader might trace transnational developments. For example, again in the prewar period, one might focus on the fascination with tribal objects, the emergence of abstract painting, or the spread of a Constructivist language of forms. The different incarnations of Dada from Zurich to New York, or the various engagements of modernist artists with design, might be compared. More generally, one might cluster entries that treat the great experiment that is modernism as such, or that discuss the virulent reactions against this idea, especially in totalitarian regimes. Mini-histories might be produced not only of the traditional forms of painting and sculpture, but also of new modes distinctive to twentieth- and twenty-first-century art, such as collaged and montaged images, found and readymade

objects, film and video, and digital technologies. For the first time in any survey, a discussion of photography—both in terms of its own development and as a force that radically transforms other media—is woven into the text.

A third approach might be to group entries according to thematic concerns, within the prewar or the postwar periods, or in ways that span both. For example, the impact of the mass media on modern art might be gauged from the first Futurist manifesto, published in a major newspaper, *Le Figaro*, in 1909, through the Situationist critique of consumer culture in France after World War II, to the rise of the artist as celebrity in our own time and the use of the avatar as an artistic strategy. Similarly, the institutions that shaped twentieth-century art might also be explored, either in close focus or in broad overview. For instance, one can review the signal school of modernist design, the Bauhaus, from its interwar incarnations in Germany to its postwar afterlife in the United States. Or one can follow the history of the art exhibition, from the Paris Salons before World War I, through the propagandistic displays of 1937 (including the "Degenerate 'Art'" ["Entartete 'Kunst'"] show staged by the Nazis), to the postwar forms of blockbuster exhibition and international survey (such as Documenta 5 in 1972 in Germany). The complicated relationship between art and politics in the twentieth and twenty-first centuries can be studied through any number of entries. One might also define an approach through readings in such topics as the relationships between prewar and postwar avant-gardes, or between modernist and postmodernist models of art.

Along with narratives of form and theme, other subtexts in the history of twentieth- and twenty-first-century art can be foregrounded. Especially important to the authors are the theoretical methods that have framed the manifold practices of this art. One such approach is psychoanalytic criticism, which focuses on the subjective effects of the work of art. Another method is the social history of art, which attends to

social, political, and economic contexts. A third seeks to clarify the intrinsic structure of the work—not only how it is *made* (in the formalist version of this approach) but also how it *means* (in its structuralist version). Lastly, poststructuralism is deployed in order to critique structuralism's description of communication as the neutral transmission of a message. For poststructuralists, such transmission (whether in a university or an art gallery) is never neutral, always doing the work of establishing the person with the "right" to speak. Many entries present test cases of these four methods, especially when their own development is related to that of the art at issue. For each mode of criticism, an introduction sketching its history and defining its terms is provided, while a fifth considers the impact of globalization on the practice of both art and art history.

As might be expected, these methods often clash: the subjective focus of psychoanalytic criticism, the contextual emphasis of the social history of art, the intrinsic concerns of formalist and structuralist accounts, and the poststructuralist attention to the artist's "right to speak" cannot easily be reconciled. In this book, these tensions are not masked by an unbroken story unified by a single voice; rather, they are dramatized by the five authors, each of whom has a different allegiance to these methods. In this regard, *Art Since 1900* is "dialogical," in the sense given to the term by Russian theorist Mikhail Bakhtin: each speech act is structured by the positions that it confronts, as a response to other speakers whom it moves to oppose or attempts to persuade. The marks of such dialogue are multiple in this book. They appear in the different types of perspective that one author might privilege, or in the different ways that a single subject—abstraction, say— might be treated by the various voices. This conversation is also carried on through the cross-references that act as signposts to the intersections between the entries. This "intertext" not only allows two different positions to coexist but also, perhaps in relation to the third perspective provided by the reader, dialectically binds them.

Of course, with new orientations come new omissions. Certain artists and movements, addressed in previous textbooks, are scanted here, and every reader will see grievous exclusions—this is the case for each of the authors as well. But we also have the conviction that the richness of the conversation, as it illuminates different facets of the debates, struggles, breakthroughs, and setbacks of twentieth- and twenty-first-century art, compensates a little for the parts of the story that are left in ellipsis. Our use of the headline to introduce each entry acknowledges both the strengths and the weaknesses of our overall approach, for this telegraphic form can be seen either as a mere signal of a complex event—from which it is then severed—or as an emblematic marker of the very complexity of the history of which it is the evocative precipitate.

The authors wish to acknowledge the precedence of the pedagogical structure developed in Denis Hollier's *A New History of French Literature* and its importance for this text. It is now common practice—in publishing, in teaching, and in curating—to break the art of the twentieth century into two halves separated by World War II. We acknowledge this tendency with the option of the two-volume format; at the same time we believe that a crucial subject for any history of this art is the complex dialogue between prewar and postwar avant-gardes. To tell this story it is necessary to produce the full sweep of the twentieth century at once. But then such a panorama is also essential for the many other stories to which the five of us have lent our voices here.

Hal Foster
Rosalind Krauss
Yve-Alain Bois
Benjamin H. D. Buchloh
David Joselit

Introductions

In these five introductions, the authors of *Art Since 1900* set out some of the theoretical methods of framing the art of the twentieth and twenty-first centuries. Each describes the historical development of a particular methodology or set of ideas and explains its relevance to the production and reception of the art of the period.

The last hundred years or so have witnessed several major shifts in both private and public debates about art, its nature, and its functions. These shifts need to be considered in terms of other histories, too: with the emergence of new academic disciplines, new ways of thinking and speaking about cultural production coexist with new modes of expression.

We have written the following methodological introductions in order to identify and analyze the different conventions, approaches, and intellectual projects that underpin our project as a whole. Our intention has been to present the diverse theoretical frameworks that can be found in the book and to explain their relationship to the works and practices discussed in the individual entries. For that reason, each introduction begins with an overview of the mode of criticism, setting it firmly in its historical and intellectual context, before proceeding to a brief discussion of its relevance to the production and interpretation of art. Whether these five introductions are read as stand-alone essays or in conjunction with other texts dealing with the individual modes of criticism, they will inform and enhance understanding in ways that allow each reader to develop an individual approach to the book and to the art of the period.

1 Psychoanalysis in modernism and as method

1 • Hannah Höch, *The Sweet One,*
***From an Ethnographic Museum*, c. 1926**
Photomontage with watercolor, 30 × 15.5 (11¹³⁄₁₆ × 6⅛)

In this collage—one of a series that combines found
photographs of tribal sculpture and modern women—
Höch plays on associations at work in psychoanalytic
theory and modernist art: ideas of "the primitive"
and the sexual, of racial others and unconscious desires.
She exploits these associations to suggest the power
of "the New Woman," but she also seems to mock them,
literally cutting up the images, deconstructing and
reconstructing them, exposing them as constructions.

Psychoanalysis was developed by Sigmund Freud (1856–1939)
and his followers as a "science of the unconscious" in the
early years of the twentieth century, at the same time that
modernist art came into its own. As with the other interpretative
methods presented in these introductions, psychoanalysis thus
shares its historical ground with modernist art and intersects with it
in various ways throughout the twentieth century. First, artists have
drawn directly on psychoanalysis—sometimes to explore its ideas
visually, as often in Surrealism in the twenties and thirties, and
sometimes to critique them theoretically and politically, as often in
▲ feminism in the seventies and eighties. Second, psychoanalysis and
modernist art share several interests—a fascination with origins,
with dreams and fantasies, with "the primitive," the child, and the
insane, and, more recently, with the workings of subjectivity and
● sexuality, to name only a few [1]. Third, many psychoanalytic terms
have entered the basic vocabulary of twentieth- and twenty-first-
century art and criticism (e.g., repression, sublimation, fetishism,
the gaze). Here I will focus on historical connections and method-
ological applications, and, when appropriate, I will key them, along
with critical terms, to entries in which they are discussed.

Historical connections with art

Psychoanalysis emerged in the Vienna of artists such as Gustav
■ Klimt, Egon Schiele, and Oskar Kokoschka, during the decline of
the Austro-Hungarian Empire. With the secession of such artists
from the Art Academy, this was a time of Oedipal revolt in
advanced art, with subjective experiments in pictorial expression
that drew on regressive dreams and erotic fantasies. Bourgeois
Vienna did not usually tolerate these experiments, for they
suggested a crisis in the stability of the ego and its social institu-
tions—a crisis that Freud was prompted to analyze as well.

This crisis was hardly specific to Vienna; in terms of its rele-
vance to psychoanalysis, it was perhaps most evident in the
attraction to things "primitive" on the part of modernists in
France and Germany. For some artists this "primitivism" involved
◆ a "going-native" of the sort play-acted by Paul Gauguin in the
South Seas. For others it was focused on formal revisions of
Western conventions of representation, as undertaken with the

▲ 1924, 1930b, 1931a, 1942b, 1975a ● 1903, 1907, 1922, 1977b, 1987, 1994a ■ 1900a ◆ 1903

2 • Meret Oppenheim, *Object* (also called *Fur-Lined Teacup* and *Déjeuner en fourrure*), 1936
Fur-covered teacup, saucer, and spoon, height 7.3 (2⅞)

To make this work, Meret Oppenheim simply lined a teacup, saucer, and spoon bought in Paris with the fur of a Chinese gazelle. Mixing attraction and repulsion, this dis / agreeable work is quintessentially Surrealist, for it adapts the device of the found thing to explore the idea of "the fetish," which psychoanalysis understands as an unlikely object invested with a powerful desire diverted from its proper aim. Here art appreciation is no longer a matter of disinterested teatime propriety: it is boldly interrupted through a smutty allusion to female genitalia that forces us to think about the relation between aesthetics and erotics.

3 • André Masson, *Figure*, 1927
Oil and sand, 46 × 33 (18⅛ × 13)

In the Surrealist practice of "automatic writing," the author, released from rational control, "took dictation" from his or her unconscious. André Masson's use of strange materials and gestural marks, sometimes almost dissolving the distinction between the figure and the ground, suggested one method to pursue "psychic automatism," opening up painting to new explorations not only of the unconscious but also of form and its opposite.

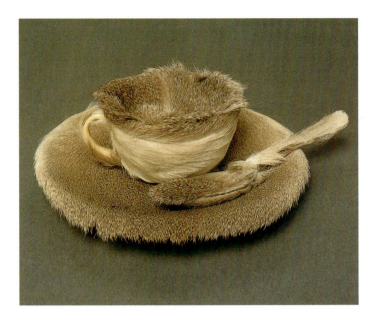

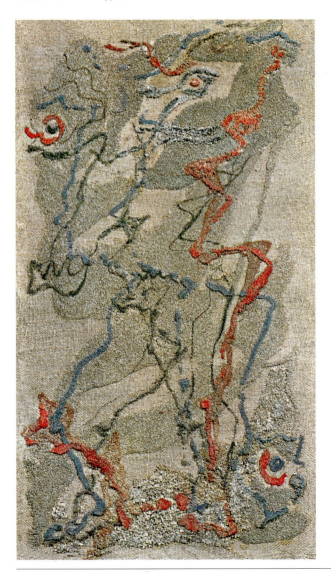

aid of African objects, by Pablo Picasso and Henri Matisse in Paris. Yet almost all modernists projected onto tribal peoples a purity of artistic vision that was associated with the simplicity of instinctual life. This projection is the primitivist fantasy *par excellence* and psychoanalysis participated in it then even as it provides ways to question it now. (For example, Freud saw tribal peoples as somehow fixed in pre-Oedipal or infantile stages.)

Strange though it may seem today, for some modernists an interest in tribal objects shaded into involvement with the art of children and of the insane. In this regard, *Artistry of the Mentally Ill* (*Bildnerei der Geisteskranken*), a collection of works by psychotics presented in 1922 by Hans Prinzhorn (1886–1933), a German psychiatrist trained in psychoanalysis and art history alike, was of special importance to such artists as Paul Klee, Max Ernst, and Jean Dubuffet. Most of these modernists (mis)read the art of the insane as though it were a secret part of the primitivist avant-garde, directly expressive of the unconscious and boldly defiant of all convention. Here psychoanalysts developed a more complicated understanding of paranoid representations as projections of desperate order, and of schizophrenic images as symptoms of radical self-dislocation. And yet such readings also have parallels in modernist art.

An important line of connection runs from the art of the insane, through the early collages of Ernst, to the definition of Surrealism as a disruptive "juxtaposition of two more or less disparate realities," as presented by its leader André Breton [**2**]. Psychoanalysis influenced Surrealism in its conceptions of the image as a kind of dream, understood by Freud as a distorted writing-in-pictures of a displaced wish, and of the object as a sort of symptom, understood by Freud as a bodily expression of a conflicted desire; but there are several other affinities as well. Among the first to study Freud, the Surrealists attempted to simulate the effects of madness in automatic writing and art alike [**3**]. In his first "Manifesto of Surrealism" (1924), Breton described Surrealism as a "psychic automatism," a liberatory inscription of unconscious impulses "in the absence of

4 • Karel Appel, *A Figure*, 1953
Oil and colored crayons on paper, 64.5 × 49 (25⅜ × 19¼)

After World War II an interest in the unconscious persisted among artists such as the Dutch painter Karel Appel, a member of Cobra (an acronym for the home bases of the group—Copenhagen, Brussels, Amsterdam); at the same time the question of the psyche was reframed by the horrors of the death camps and the atomic bombs. Like other groups, Cobra came to reject the Freudian unconscious explored by the Surrealists as too individualistic: as part of a general turn to the notion of a "collective unconscious" developed by Carl Jung, they explored totemic figures, mythic subjects, and collaborative projects in an often anguished search not only for a "new man" but for a new society.

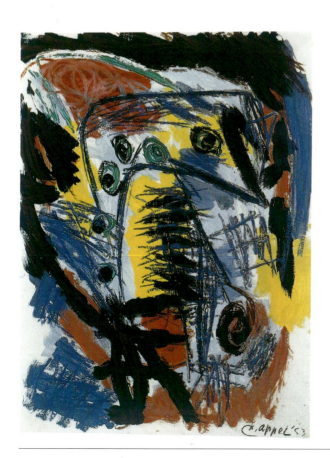

any control exercised by reason." Yet right here emerges a problem that has dogged the relation between psychoanalysis and art ever since: either the connection between psyche and art work is posited as too direct or immediate, with the result that the specificity of the work is lost, or as too conscious or calculated, as though the psyche could simply be illustrated by the work. (The other methods in this introduction face related problems of mediation and questions of causation; indeed, they vex all art criticism and history.) Although Freud knew little of modernist art (his taste was conservative, and his collection ran to ancient and Asian figurines), he knew enough to be suspicious of both tendencies. In his view, the unconscious was not liberatory—on the contrary—and to propose an art free of repression, or at least convention, was to risk psychopathology, or to pretend to do so in the name of a psychoanalytic art (this is why he once called the Surrealists "absolute cranks").

Nevertheless, by the early thirties the association of some modernist art with "primitives," children, and the insane was set, as was its affinity with psychoanalysis. At this time, however, these connections played into the hands of the enemies of this art, most catastrophically the Nazis, who in 1937 moved to rid the world ▲ of such "degenerate" abominations, which they also condemned as "Jewish" and "Bolshevik." Of course, Nazism was a horrific regression of its own, and it cast a pall over explorations of the unconscious well after World War II. Varieties of Surrealism lingered on in the postwar period, however, and an interest in the unconscious persisted among artists associated with *art informel*, ● Abstract Expressionism, and Cobra [4]. Yet, rather than the difficult mechanisms of the individual psyche explored by Freud, the focus fell on the redemptive archetypes of a "collective unconscious" imagined by Swiss psychiatrist Carl Jung (1875–1961), an old apostate of psychoanalysis. (For example, Jackson Pollock was involved in Jungian analysis in ways that affected his painting.)

Partly in reaction against the subjective rhetoric of Abstract Expressionism, much art of the sixties was staunchly antipsychological, concerned instead with ready-made cultural images, as in ■ Pop art, or given geometric forms, as in Minimalism. At the same time, in the involvement of Minimalist, Process, and Performance art with phenomenology there was a reopening to the bodily subject that prepared a reopening to the psychological subject in ◆ feminist art. This engagement was ambivalent, however, for even as feminists used psychoanalysis, they did so mostly in the register of critique, "as a weapon" (in the battle cry of filmmaker Laura Mulvey) directed at the patriarchal ideology that also riddled psychoanalysis. For Freud had associated femininity with passivity, and in his famous account of the Oedipus complex, a tangle of relations in which the little boy is said to desire the mother until threatened by the father, there is no parallel denouement for the little girl, as if in his scheme of things women cannot attain full subjecthood. And Jacques Lacan (1901–81), the French psychoanalyst who proposed an influential reading of Freud, identified woman as such with the lack represented by castration. Nonetheless, for many feminists Freud and Lacan provided the most telling account

▲ 1937a ● 1946, 1947b, 1949a, 1949b, 1957a ■ 1960c, 1964b, 1965 ◆ 1969, 1974, 1975a, 1977b

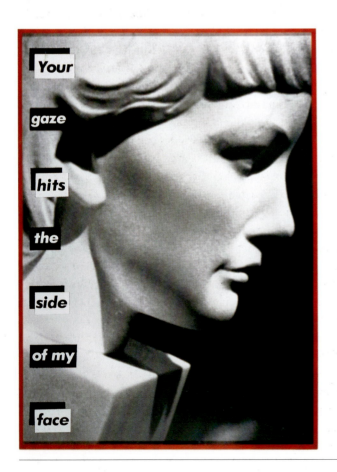

of the formation of the subject in the social order. If there is no natural femininity, these feminists argued, then there is also no natural patriarchy—only a historical culture fitted to the psychic structure, the desires and the fears, of the heterosexual male, and so vulnerable to feminist critique [**5, 6**]. Indeed, some feminists have insisted that the very marginality of women to the social order, as mapped by psychoanalysis, positions them as its most radical critics. By the nineties this critique was extended by gay and lesbian artists and critics concerned to expose the psychic workings of homophobia, as well by postcolonial practitioners concerned to
▲ mark the racialist projection of cultural others.

Approaches alternative to Freud

One can critique Freud and Lacan, of course, and still remain within the orbit of psychoanalysis. Artists and critics have had affinities with other schools, especially the "object-relations" psychoanalysis associated with Melanie Klein (1882–1960) and D. W. Winnicott (1896–1971) in England, which influenced such aestheticians as Adrian Stokes (1902–72) and Anton Ehrenzweig (1909–66) and, indirectly, the reception of such artists as Henry
• Moore and Barbara Hepworth. Where Freud saw pre-Oedipal stages (oral, anal, phallic, genital) that the child passes through, Klein saw positions that remain open into adult life. In her account these positions are dominated by the original fantasies of the child, involving violent aggression toward the parents as well as depressive anxiety about this aggression, with an oscillation between visions of destruction and reparation.

For some critics this psychoanalysis spoke to a partial turn in nineties art—away from questions of sexual desire in relation to
■ the social order, toward concerns with bodily drives in relation to life and death. After the moratorium on images of women in some feminist art of the seventies and eighties, Kleinian notions suggested a way to understand this reappearance of the body often in damaged form. A fascination with trauma, both personal and collective, reinforced this interest in the "abject" body, which also led artists and critics to the later writings of the French psychoanalyst Julia Kristeva (born 1941). Of course, social factors—the AIDS epidemic above
♦ all—also drove this pervasive aesthetic of mourning and melancholy. In the present, psychoanalysis remains a resource in art criticism and history, but its role in artmaking is far from clear.

Levels of Freudian criticism

Psychoanalysis emerged out of clinical work, out of the analysis of symptoms of actual patients (there is much controversy about how Freud manipulated this material, which included his own dreams), and its use in the interpretation of art carries the strengths as well as the weaknesses of this source. There is first the basic question of who or what is to occupy the position of the patient—the work, the artist, the viewer, the critic, or some combination or relay of all these. Then there arises the complicated issue of the different levels of a Freudian

▲ 1977b, 1989, 1993c, 1994a • 1989, 1993c, 1994a ■ 1994a ♦ 1987

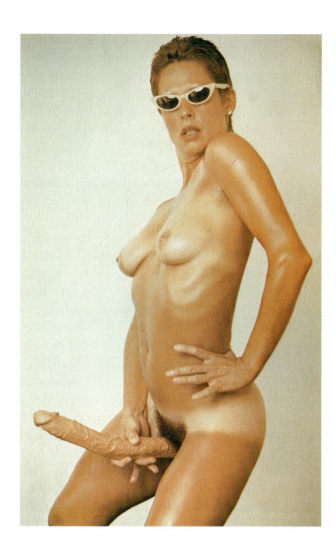

6 • Lynda Benglis, *Untitled*, 1974 (detail)
Color photograph, 25 × 26.5 (9⅞ × 10⅜)

With the rise of feminism in the sixties and seventies,
some artists attacked patriarchal hierarchies not only
in society in general but in the art world in particular:
psychoanalysis figured as both weapon—because it
offered profound insights into the relation between
sexuality and subjectivity—and target—because it tended
to associate women not only with passivity but also with
lack. In this photograph, used in a notorious advertisement
for a gallery show, the American artist Lynda Benglis
mocked the macho posturing of some Minimalist and
Postminimalist artists, as well as the increased marketing
of contemporary art; at the same time, she seized
"the phallus" in a way that both literalized its association
with plenitude and power and parodied it.

interpretation of art, which I will here reduce to three: symbolic readings, accounts of process, and analogies in rhetoric.

Early attempts in Freudian criticism were governed by symbolic readings of the art work, as if it were a dream to be decoded in terms of a latent message hidden behind a manifest content: "This is not a pipe; it is really a penis." This sort of criticism complements the kind of art that translates a dream or a fantasy in pictorial terms: art then becomes the encoding of a riddle and criticism its decoding, and the whole exercise is illustrational and circular. Although Freud was quick to stress that cigars are often just cigars, he too practiced this kind of deciphering, which fits in all too well with the traditional method of art history known as "iconography"—a reading back of symbols in a picture to sources in other kinds of texts—a method that most modernist art worked to foil (through abstraction, techniques of chance, and so on). In this regard, the Italian historian Carlo Ginzburg has demonstrated an epistemological affinity between psychoanalysis and art history based in connoisseurship. For both discourses (which developed, in modern form, at roughly the same time) are concerned with the symptomatic trait or the telling detail (an idiosyncratic gesture of the hands, say) that might reveal, in psychoanalysis, a hidden conflict in the patient and, in connoisseurship, the proper attribution of the work to an artist.

In such readings the artist is the ultimate source to which the symbols point: the work is taken as his symptomatic expression, and it is used as such in the analysis. Thus in his 1910 study *Leonardo da Vinci and a Memory of his Childhood*, Freud leads us from the enigmatic smiles of his *Mona Lisa* and Virgin Marys to posit in the artist a memory regarding his long-lost mother. In this way Freud and his followers looked for signs of psychic disturbances in art (his predecessor Jean-Martin Charcot did the same). This is not to say that Freud sees the artist as psychopathological; in fact he implies that art is one way to avoid this condition. "Art frees the artist from his fantasies," the French philosopher Sarah Kofman comments, "just as 'artistic creation' circumvents neurosis and takes the place of psychoanalytic treatment." But it is true that such Freudian criticism tends to "psychobiography," that is, to a profiling of the artist in which art history is remodeled as psychoanalytic case study.

If symbolic readings and psychobiographical accounts can be reductive, this danger may be mitigated if we attend to other aspects of Freud. For most of the time Freud understands the sign less as symbolic, in the sense of directly expressive of a self, a meaning, or a reality, than as symptomatic, a kind of allegorical emblem in which desire and repression are intertwined. Moreover, he does not see art as a simple revision of preexisting memories or fantasies; apart from other things, it can also be, as Kofman suggests, an "originary 'substitute'" for such scenes, through which we come to know them *for the first time* (this is what Freud attempts in his Leonardo study). Finally, psychobiography is put into productive doubt by the very fact that the psychoanalytic account of the unconscious, of its disruptive effects, puts all intentionality—all authorship, all biography—into productive doubt too.

Freudian criticism is not only concerned with a symbolic decoding of hidden meanings, with the semantics of the psyche. Less obviously, it is also involved with the dynamics of these processes, with an understanding of the sexual energies and unconscious forces that operate in the making as well as the viewing of art. On this second level of psychoanalytic interpretation, Freud revises the old philosophical concept of "aesthetic play" in terms of his own notion of "the pleasure principle," which he defined, in "Two Principles of Mental Functioning" (1911), in opposition to "the reality principle":

> The artist is originally a man [sic] who turns from reality because he cannot come to terms with the demand for the renunciation of instinctual satisfaction as it is first made, and who then in phantasy-life allows full play to his erotic and ambitious wishes. But he finds a way of return from this world of phantasy back to reality; with his special gifts he moulds his phantasies into a new kind of reality, and men concede them a justification as valuable reflections of actual life. Thus by a certain path he actually becomes the hero, king, creator, favorite he desired to be, without pursuing the circuitous path of creating real alterations in the outer world. But this he can only attain because other men feel the same dissatisfaction as he with the renunciation demanded by reality, and because this dissatisfaction, resulting from the displacement of the pleasure-principle by the reality-principle, is itself a part of reality.

Three years before, in "Creative Writers and Day-Dreaming" (1908), Freud had speculated on how the artist overcomes our resistance to this performance, which we might otherwise deem solipsistic, if not simply inappropriate:

> [H]e bribes us by the purely formal—that is, aesthetic—yield of pleasure which he offers us in the presentation of his phantasies. We give the name incentive bonus or fore-pleasure to a yield of pleasure such as this, which is offered to us so as to make possible the release of still greater pleasure arising from deeper psychical sources. . . . [O]ur actual enjoyment of an imaginative work proceeds from a liberation of tensions in our minds.

Let us review some of the (pre)conceptions in these statements. First, the artist avoids some of the "renunciations" that the rest of us must accept, and indulges in some of the fantasies that we must forgo. But we do not resent him for this exemption for three reasons: his fictions reflect reality nonetheless; they are born of the same dissatisfactions that we feel; and we are bribed by the pleasure that we take in the resolution of the formal tensions of the work, a pleasure that opens us to a deeper sort of pleasure—in the resolution of the psychic tensions within us. Note that for Freud art originates in a turn from reality, which is to say that it is fundamentally conservative in relation to the social order, a small aesthetic compensation for our mighty instinctual renunciation. Perhaps this

is another reason why he was suspicious of modernist art, concerned as much of it is not to "sublimate" instinctual energies, to divert them from sexual aims into cultural forms, but to go in the opposite direction, to "desublimate" cultural forms, to open them up to these disruptive forces.

Dreams and fantasies

While the semantics of symbolic interpretation can be too particular, this concern with the dynamics of aesthetic process can be too general. A third level of Freudian criticism may avoid both extremes: the analysis of the rhetoric of the art work in analogy with such visual productions of the psyche as dreams and fantasies. Again, Freud understood the dream as a compromise between a wish and its repression. This compromise is negotiated by the "dream-work," which disguises the wish, in order to fool further repression, through "condensation" of some of its aspects and "displacement" of others. The dream-work then turns the distorted fragments into visual images with an eye to "considerations of representability" in a dream, and finally revises the images to insure that they hang together as a narrative (this is called "secondary revision"). This rhetoric of operations might be brought to bear on the production of some pictures—again, the Surrealists thought so— but there are obvious dangers with such analogies as well. Even when Freud and his followers wrote only about art (or literature), they were concerned to demonstrate points of psychoanalytic theory first and to understand objects of artistic practice second, so that forced applications are built into the discourse, as it were.

Yet there is a more profound problem with analogies drawn between psychoanalysis and visual art. With his early associate Josef Breuer (1842–1925) Freud founded psychoanalysis as a "talking cure"—that is, as a turn away from the visual theater of his teacher, the French pathologist and neurologist Jean-Martin Charcot (1825–93), who staged the symptomatic bodies of female hysterics in a public display at the Salpêtrière Hospital in Paris. The technical innovation of psychoanalysis was to attend to symptomatic *language*—not only of the dream as a form of writing but also of slips of the tongue, the "free association" of words by the patient, and so on. Moreover, for Freud culture was essentially a working out of the conflicted desires rooted in the Oedipus complex, a working out that is primarily narrative, and it is not clear how such narrative might play out in static forms like painting, sculpture, and the rest. These emphases alone render psychoanalysis ill-suited to questions of visual art. Furthermore, the Lacanian reading of Freud is militantly linguistic; its celebrated axiom—"the unconscious is structured like a language"—means that the psychic processes of condensation and displacement are structurally one with the linguistic tropes of "metaphor" and ▲ "metonymy." No analogy in rhetoric, therefore, would seem to bridge the categorical divide between psychoanalysis and art.

And yet, according to both Freud and Lacan, the crucial events in subject formation are *visual* scenes. For Freud the ego is first

▲ Introduction 3

7 • Lee Miller, *Nude Bent Forward*, Paris, c. 1931
Psychoanalysis is concerned with traumatic scenes, whether actual or imagined, that mark the child profoundly—scenes where he or she discovers sexual difference, for example, scenes that are often visual but also often uncertain in nature. At different times in the twentieth century, artists, such as the Surrealists in the twenties and thirties and feminists in the seventies and eighties, have drawn on such images and scenarios as ways to trouble assumptions about seeing, expectations about gender, and so on. In this photograph by the American artist Lee Miller, a sometime associate of the Surrealists, it is not immediately clear what we see: A body? A male or a female? Or some category of being, imaging, and feeling?

a bodily image, which, for Lacan in his famous paper on "The Mirror Stage" (1936/49), the infant initially encounters in a reflection that allows for a fragile coherence—a visual coherence as an image. The psychoanalytic critic Jacqueline Rose also alerts us to the "staging" of such events as "moments in which perception *founders* … or in which pleasure in looking tips over into the register of *excess*." Her examples are two traumatic scenes that psychoanalysis posits for the little boy. In the first scene he discovers sexual difference—that girls do not have penises and hence that he may lose his—a perception that "founders" because it implies this grave threat. In the second scene he witnesses sexual intercourse between his parents, which fascinates him as a key to the riddle of his own origin. Freud called these scenes "primal fantasies"—primal both because they are fundamental and because they concern origins. As Rose suggests, such scenes "demonstrate the complexity of an essentially visual space" in ways that can be "used as theoretical prototypes to unsettle our certainties once again"—as indeed they were used, to different ends, in
▲ some Surrealist art of the twenties and thirties [7] and in some feminist art of the seventies and eighties. The important point to emphasize, though, is this: "Each time the stress falls on a problem of seeing. The sexuality lies less in the content of what is seen than in the subjectivity of the viewer." This is where psychoanalysis has the most to offer the interpretation of art, modernist or other. Its account of the effects of the work on the subject and the artist as well as on the viewer (including the critic) places the work, finally, in the position of the analyst as much as the analyzed.

In the end we do well to hold to a double focus: to view psychoanalysis historically, as an object in an ideological field often shared with modernist art, and to apply it theoretically, as a method to understand relevant aspects of this art, to map pertinent parts of the field. This double focus allows us to critique psychoanalysis even as we apply it. First and last, however, this project will be complicated—not only by the difficulties in psychoanalytic speculation, but also by the controversies that always swirl around it. Some of the clinical work of Freud and others was manipulated, to be sure, and some of the concepts are bound up with science that is no longer valid—but do these facts invalidate psychoanalysis as a mode of interpretation of art today? As with the other methods introduced here, the test will be in the fit and the yield of the arguments that we make. And here, as the psychoanalytic critic Leo Bersani reminds us, our "moments of theoretical collapse" may be inseparable from our moments of "psychoanalytic truth."

FURTHER READING
Leo Bersani, *The Freudian Body: Psychoanalysis and Art* (New York: Columbia University Press, 1986)
Sigmund Freud, *Art and Literature*, trans. James Strachey (London: Penguin, 1985)
Sarah Kofman, *The Childhood of Art: An Interpretation of Freud's Aesthetics*, trans. Winifred Woodhull (New York: Columbia University Press, 1988)
Jean Laplanche and J.-B. Pontalis, *The Language of Psychoanalysis*, trans. Donald Nicholson-Smith (New York: W. W. Norton, 1973)
Jacqueline Rose, *Sexuality in the Field of Vision* (London: Verso, 1986)

Hal Foster

▲ 1924, 1930b, 1931a, 1975a

2 The social history of art: models and concepts

Recent histories of art comprise a number of distinct critical models (for example, formalism, structuralist semiotics, psychoanalysis, social art history, and feminism) that have been merged and integrated in various ways, in particular in the work of American and British art historians since the seventies. This situation sometimes makes it difficult, if not altogether pointless, to insist on methodological consistency, let alone on a singular methodological position. The complexity of these various individual strands and of their integrated forms points firstly to the problematic nature of any claim that one particular model should be accepted as exclusively valid or as dominant within the interpretative processes of art history. Our attempts to integrate a broad variety of methodological positions also efface the earlier theoretical rigor that had previously generated a degree of precision in the process of historical analysis and interpretation. That precision now seems to have been lost in an increasingly complex weave of methodological eclecticism.

The origins of the methodologies

All these models were initially formulated as attempts to displace earlier humanist (subjective) approaches to criticism and interpretation. They had been motivated by the desire to position the study of all types of cultural production (such as literature or the fine arts) on a more solidly scientific basis of method and insight, rather than have criticism remain dependent on the various more-or-less subjective approaches of the late nineteenth century, such as the biographistic, psychologistic, and historicist survey methods.

▲ Just as the early Russian Formalists made Ferdinand de Saussure's linguistic structure the matrix of their own efforts to understand the formation and functions of cultural representation, subsequent historians who attempted to interpret works of art in psychoanalytic terms tried to find a map of artistic subject
● formation in the writings of Sigmund Freud. Proponents of both models argued that they could generate a verifiable understanding of the processes of aesthetic production and reception, and promised to anchor the "meaning" of the work of art solidly in the operations of either the conventions of language and/or the system of the unconscious, arguing that aesthetic or poetic

meaning operated in a manner analogous to other linguistic conventions and narrative structures (e.g., the folktale), or, in terms of the unconscious, as in Freud's and Carl Jung's theories, analogous to the joke and the dream, the symptom and the trauma.

The social history of art, from its very beginning in the first decades of the twentieth century, had a similar ambition to make the analysis and interpretation of works of art more rigorous and verifiable. Most importantly, the early social historians of art (Marxist scholars like the Anglo-German Francis Klingender [1907–55] and the Anglo-Hungarian Frederick Antal [1887–1954]) tried to situate cultural representation within the existing communication structures of society, primarily within the field of ideological production under the rise of industrial capitalism. After all, social art history's philosophical inspiration was the scientificity of Marxism itself, a philosophy that had aimed from the very beginning not only to analyze and interpret economic, political, and ideological relations, but also to make the writing of history itself—its historicity—contribute to the larger project of social and political change.

This critical and analytical project of social art history formulated a number of key concepts that I will discuss further: I shall also try to give their original definitions, as well as subsequent modifications to these concepts, in order to acknowledge the increasing complexity of the terminology of social art history, which results partially from the growing differentiation of the philosophical concepts of Marxist thought itself. At the same time, it may become apparent that some of these key concepts are presented not because they are important in the early years of the twenty-first century, but, rather, because of their obsolescence, withering away in the present and in the recent past. This is because the methodological conviction of certain models of analysis has been just as overdetermined as that of all the other methodological models that have temporarily governed the interpretation and the writing of art history at different points in the twentieth century.

Autonomy

▲ German philosopher and sociologist Jürgen Habermas (born 1929) has defined the formation of the bourgeois public sphere in general and the development of cultural practices within that

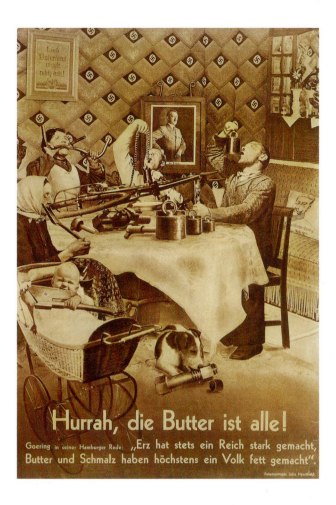

1 • John Heartfield, *"Hurray, the Butter is Finished!"*, cover for *AIZ*, December 19, 1935

Photomontage, 38 × 27 (15¼ × 10¾)

The work of John Heartfield, along with that of Marcel Duchamp and El Lissitzky, demarcates one of the most important paradigm shifts in the epistemology of twentieth-century modernism. Refiguring photomontage and constructing new textual narratives, it established the only model for artistic practice as communicative action in the age of mass-cultural propaganda. Denounced as such by the intrinsically conservative ideologies of formalists and modernists defending obsolete models of autonomy, it addressed in fact the historical need for a change of audiences and of the forms of distribution. Inevitably, it became the singular, most important example of counterpropaganda to the hegemonic media apparatus of the thirties, the only voice in the visual avant-garde to oppose the rise of fascism as a late form of imperialist capitalism.

sphere as social processes of subjective differentiation that lead to the historical construction of bourgeois individuality. These processes guarantee the individual's identity and historical status as a self-determining and self-governing subject. One of the necessary conditions of bourgeois identity was the subject's capacity to experience the autonomy of the aesthetic, to experience pleasure without interest.

This concept of aesthetic autonomy was as integral to the differentiation of bourgeois subjectivity as it was to the differentiation of cultural production according to its proper technical and procedural characteristics, eventually leading to the modernist orthodoxy of medium-specificity. Inevitably then, autonomy served as a foundational concept during the first five decades of European modernism. From Théophile Gautier's program of *l'art pour l'art* and Édouard Manet's conception of painting as a project of perceptual self-reflexivity, the aesthetics of autonomy culminate in the poetics of Stéphane Mallarmé in the 1880s. Aestheticism conceiving the work of art as a purely self-sufficient and self-reflexive experience—identified by Walter Benjamin as a nineteenth-century theology of art—generated, in early-twentieth-century formalist thought, similar conceptions that would later become the doxa of painterly self-reflexivity for formalist critics and historians. These ranged from Roger Fry's responses to Postimpressionism—in particular the work of Paul Cézanne—to Daniel-Henry Kahnweiler's neo-Kantian theories of Analytical Cubism, to the work of Clement Greenberg (1909–94) in the postwar period. Any attempt to transform autonomy into a transhistorical, if not ontological precondition of aesthetic experience, however, is profoundly problematic. It becomes evident upon closer historical inspection that the formation of the concept of aesthetic autonomy itself was far from autonomous. This is first of all because the aesthetics of autonomy had been determined by the overarching philosophical framework of Enlightenment philosophy (Immanuel Kant's [1724–1804] concept of disinterestedness) while it simultaneously operated in opposition to the rigorous instrumentalization of experience that emerged with the rise of the mercantile capitalist class.

Within the field of cultural representation, the cult of autonomy liberated linguistic and artistic practices from mythical and religious thought just as much as it emancipated them from the politically adulatory service and economic dependency under the auspices of a rigorously controlling feudal patronage. While the cult of autonomy might have originated with the emancipation of bourgeois subjectivity from aristocratic and religious hegemony, autonomy also saw the theocratic and hierarchical structures of that patronage as having their own reality. The modernist aesthetic of autonomy thus constituted the social and subjective sphere from within which an opposition against the totality of interested activities and instrumentalized forms of experience could be articulated in artistic acts of open negation and refusal. Paradoxically, however, these acts served as opposition and—in their ineluctable condition as extreme exceptions from the universal rule—they confirmed the regime of total instrumentalization. One might have

2 • El Lissitzky and Sergei Senkin, *The Task of the Press is the Education of the Masses*, 1928
Photographic frieze for the international exhibition "Pressa," Cologne

Like Heartfield, El Lissitzky transformed the legacies of collage and photomontage according to the needs of a newly industrialized collective. Especially in the new genre of exhibition design, which he developed in the twenties in works such as the Soviet Pavilion for the international exhibition "Pressa," it became evident that Lissitzky was one of the first (and few) artists of the twenties and thirties to understand that the spaces of public architecture (that is, of simultaneous collective reception) and the space of public information had collapsed in the new spaces of the mass-cultural sphere. Therefore Lissitzky, an exemplary "artist-as-producer," as Walter Benjamin would identify the artist's new social role, would situate his practice within the very parameters and modes of production of a newly developing proletarian public sphere.

to formulate the paradox that an aesthetics of autonomy is thus the highly instrumentalized form of noninstrumentalized experience under liberal bourgeois capitalism.

Actual study of the critical phase of the aesthetic of autonomy in the nineteenth century (from Manet to Mallarmé) would recognize that this very paradox is the actual formative structure of their pictorial and poetic genius. Both define modernist representation as an advanced form of critical self-reflexivity and define their hermetic artifice in assimilation and in opposition to the emerging mass-cultural forms of instrumentalized representation. Typically, the concept of autonomy was both formed by and oppositional to the instrumental logic of bourgeois rationality, rigorously enforcing the requirements of that rationality within the sphere of cultural production through its commitment to empirical criticality. Thereby an aesthetics of autonomy contributed to one of the most fundamental transformations of the experience of the work of art, initiating the shift that Walter Benjamin in his essays of the thirties called the

historical transition from cult-value to exhibition-value. These essays have come to be universally considered as the founding texts of a philosophical theory of the social history of art.

The concept of autonomy also served to idealize the new distribution form of the work of art, now that it had become a free-floating commodity on the bourgeois market of objects and luxury goods. Thus autonomy aesthetics was engendered by the capitalist logic of commodity production as much as it opposed that logic. In fact, the Marxist aesthetician Theodor W. Adorno (1903–69) still maintained in the late sixties that artistic independence and aesthetic autonomy could, paradoxically, be guaranteed only in the commodity structure of the work of art.

Antiaesthetic

Peter Bürger (born 1936), in his important—although problematic—essay, *Theory of the Avant-Garde* (1974), argued that the new spectrum of antiaesthetic practices in 1913 arose as a contestation of autonomy aesthetics. Thus—according to Bürger—the historical avant-gardes after Cubism universally attempted to "integrate art with life" and to challenge the autonomous "institution of art." Bürger perceives this project of the antiaesthetic to be at the center ▲ of the revolts of Dadaism, Russian Constructivism, and French Surrealism. Yet, rather than focusing on a nebulously conceived integration of art and life (an integration never satisfactorily defined at any point in history) or on a rather abstract debate on the nature of the institution of art, it seems more productive to focus here on the very strategies that these avant-garde practitioners themselves had propagated: in particular, strategies to initiate fundamental changes in the conception of audience and spectatorial agency, to reverse the bourgeois hierarchy of aesthetic exchange-value and use-value, and most importantly perhaps, to conceive of cultural practices for a newly emerging internationalist proletarian public sphere within the advanced industrial nation states.

Such an approach would not only allow us to differentiate these avant-garde projects more adequately, but would also help us understand that the rise of an aesthetic of technical reproduction (in diametrical opposition to an aesthetic of autonomy) emerges at that very moment of the twenties when the bourgeois public sphere begins to wither away. It is at first displaced by the progressive forces of an emerging proletarian public sphere (as was the case in the ● early phases of the Soviet Union and the Weimar Republic), only to be followed, of course, by the rise of the mass-cultural public sphere, either in its totalitarian fascist or state-socialist versions ■ in the thirties or by its postwar regimes of the culture industry and of spectacle, emerging with the hegemony of the United States and a largely dependent culture of European reconstruction.

The antiaesthetic dismantles the aesthetics of autonomy on all levels: it replaces originality with technical reproduction, it destroys a work's aura and the contemplative modes of aesthetic experience and replaces these with communicative action and aspirations toward simultaneous collective perception. The antiaesthetic (such

▲ as the work of John Heartfield [1]) defines its artistic practices as temporary and geopolitically specific (rather than as transhistorical), as participatory (rather than as a unique emanation of an exceptional form of knowledge). The antiaesthetic also operates as ● a utilitarian aesthetic (e.g., in the work of the Soviet Productivists [2]), situating the work of art in a social context where it assumes a variety of productive functions such as information and education or political enlightenment, serving the needs of a cultural self-constitution for the newly emerging audiences of the industrial proletariat who were previously excluded from cultural representation on the levels of both production and reception.

Class, agency, and activism

The central premises of Marxist political theory had been the concepts of class and class-consciousness—the most important factors to drive forward the historical process. Classes served in different moments of history as the agents of historical, social, and political change (e.g., the aristocracy, the bourgeoisie, the proletariat, and the most powerful class in the twentieth century, the *petite bourgeoisie,* paradoxically the most neglected by classical Marxist accounts). It had been Marx's argument that class itself was defined by one crucial condition: a subject's situation in relation to the means of production.

Thus, privileged access to (or, more decisively, controlling ownership of) the means of production was the constitutive condition of bourgeois class identity in the later eighteenth and the entire nineteenth centuries. In contrast, during the same period, the conditions of proletarianization identify those subjects who will remain forever economically, legally, and socially barred from access to the means of production (which would, of course, also include the means of education and the acquisition of improved professional skills).

Questions concerning the concept of class are central to the social history of art, ranging from the class identity of the artist to whether cultural solidarity or mimetic artistic identification with the struggles of the oppressed and exploited classes of modernity can actually amount to acts of political support for revolutionary or oppositional movements. Marxist political theorists have often regarded that kind of cultural class alliance with considerable skepticism. Yet this mode of class alliance determined practically all politically motivated artistic production of modernity, since very few, if any, artists and intellectuals had actually emerged from the conditions of proletarian existence at that time. Class identity becomes all the more complicated when considering how the consciousness of individual artists might well have become radicalized at certain points (e.g., the revolution of 1848, the revolutions of 1917, or the anti-imperialist struggles of 1968) and artists might then have assumed positions of solidarity with the oppressed classes of those historical moments [3]. Slightly later, however, in the wake of their cultural assimilation, the same artists might have assumed positions of complicit or active affirmation of the ruling order and simply served as the providers of cultural legitimation.

▲ 1916a, 1920, 1921b, 1924, 1930b, 1931a ● 1921b, 1923, 1925b, 1930a ■ 1934a, 1937a, 1957a, 1960c ▲ 1920, 1937c ● 1921b

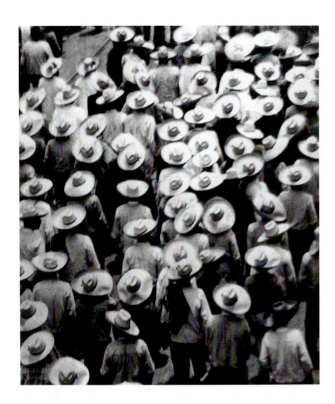

**3 • Tina Modotti, *Workers' Demonstration,
Mexico, May 1,* 1929**
Platinum print, 20.5 × 18 (8⅛ × 7⅛)

The work of the Italian-American artist Modotti in Mexico
gives evidence of the universality of the political and social
commitment among radical artists of the twenties and
thirties. Abandoning her training as a "straight" modernist
photographer in the mold of Edward Weston, Modotti
reoriented herself to make photography a weapon in the
political struggle of the Mexican peasant and working
class against the eternal deferrals and deceptions of
the country's oligarchic rulers. Expanding the tradition
of the *Taller Grafico Popular* to address that class now
with the means of photographic representation, she
nevertheless understood the necessity of making the
regionally specific and uneven development of forms
of knowledge and artistic culture the basis of her work.
Accordingly, Modotti never adopted the seemingly more
advanced forms of political photomontage, but retained
the bonds of realist depiction necessary for activist
political messages in the geopolitical context in which
she had situated herself. At the same time, as the image
Workers' Demonstration signals, she was far from falling
into the conciliatory and compensatory realisms of
"straight" and "New Objective" photography. What would
have been merely a modernist grid of serially repeated
objects of industrial manufacture in the work of her
historical peers (such as Alfred Renger-Patzsch) becomes
one of the most convincing photographic attempts
of the twenties and thirties to depict the social presence
and political activism of the working and peasant
class masses as the actual producers of a country's
economic resources.

This also points to the necessary insight that the registers of
artistic production and their latent or manifest relationships to
political activism are infinitely more differentiated than argu-
ments for the politicization of art might generally have assumed.
We are not simply confronted with an alternative between a politi-
cally conscious or activist practice on the one hand, and a merely
affirmative, hegemonic culture (as the Italian Marxist philosopher
and aesthetician Antonio Gramsci [1891–1937] called it) on the
other. Yet, the function of hegemonic culture is clearly to sustain
power and legitimize the perceptual and behavioral forms of the
ruling class through cultural representation, while oppositional
cultural practices articulate resistance to hierarchical thought,
subvert privileged forms of experience, and destabilize the ruling
regimes of vision and perception just as they can also massively
and manifestly destabilize governing notions of hegemonic power.

If we accept that some forms of cultural production can assume
the role of agency (i.e., that of information and enlightenment,
that of criticality and counterinformation), then the social history
of art faces one of its most precarious insights, if not a condition of
crisis: if it were to align its aesthetic judgment with the condition
of political solidarity and class alliance, it would inevitably be
left with only a few heroic figures in whom such a correlation
between class-consciousness, agency, and revolutionary alliance
could actually be ascertained. These examples would include
Gustave Courbet and Honoré Daumier in the nineteenth century,
▲ Käthe Kollwitz and John Heartfield in the first half of the twen-
● tieth century, and artists such as Martha Rosler [**4**], Hans Haacke
[**6**], and Allan Sekula in the second half of the twentieth century.

Thus, in recognizing that compliance with class interests and
political revolutionary consciousness can at best be considered an
exceptional rather than a necessary condition within the aesthetic
practices of modernity, it leaves the social art historian with a diffi-
cult choice. That is, either to exclude from consideration most actual
artistic practices of any particular moment of modernism, dis-
regarding both the artists and their production because of their lack
of commitment, class-consciousness, and political correctness, or to
recognize the necessity for numerous other criteria (beyond political
and social history) to enter the process of historical and critical analysis.

Since the proletarian's only means of survival is the sale of his or
her own labor like any other commodity, producing a phenomenal
accretion of surplus value to the entrepreneurial bourgeois or to
the corporate enterprise by supplying the subject's labor power, it
is, therefore, the very condition of labor and the laborer that radical
artists from the nineteenth century onward, from Gustave Courbet
■ to the Productivists of the twenties, confront. For the most part,
however, they confront it not on the level of iconography (in fact,
the almost total absence of the representation of alienated labor is
the rule of modernism) but rather with the perpetual question of
whether the labor of industrial production and the labor of cultural
production can and should be related, and, if so, how—as analo-
gous? as dialectical opposites? as complementary? as mutually
exclusive? Marxist attempts to theorize this relationship (and the

▲ 1920, 1937c ● 1971, 1972b, 1984a ■ 1921b

4 • Martha Rosler, *Red Stripe Kitchen*, from the series *Bringing the War Home: House Beautiful*, 1967–72
Photomontage printed as color photograph, 61 × 50.8 (24 × 20)

Rosler is one of the very few artists in the postwar period to have taken up the legacies of the political photomontage work of the thirties. Her series *Bringing the War Back Home: House Beautiful*, begun in 1967, explicitly responds to both a historical and an artistic situation. First of all, the work participated in the growing cultural and political opposition against the imperialist American war in Vietnam. Rather than creating the works as individual photomontages, Rosler conceived them as a series for reproduction and dissemination in a number of antiwar and countercultural journals in order to increase the visibility and impact of the images. She had clearly understood Heartfield's legacy and the dialectics of distribution form and mass-cultural iconography. Second, Rosler explicitly countered the Conceptualist's claim that photography should merely serve as a neutral document of analytical self-criticality, or as an indexical trace of the spatio-temporal stagings of the subject. Rather, she identified photography as *one* of several discursive tools in the production of ideology in the mass-cultural arsenal. By inserting sudden documentary images of the war in Vietnam into the seemingly blissful and opulent world of American domesticity, Rosler not only reveals the intricate intertwinement of domestic and militaristic forms of advanced capitalist consumption, but also manifestly challenges the credibility of photography as a truthful carrier of authentic information.

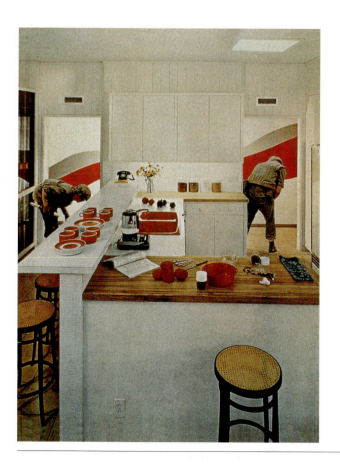

social art historian's attempts to come to terms with these theorizations) span an extreme range: from a productivist–utilitarian aesthetic that affirms the constitution of the subject as necessary in the production of use-value (as in the Soviet Productivists, ▲ the German Bauhaus, and the De Stijl movements) to an aesthetic of ludic counterproductivity (as in the simultaneous practices of ● Surrealism) which negates labor-as-value and denies it any purchase whatsoever on the territory of art. Such an aesthetic regards artistic practice as the one experience where the possibility of historically available forms of unalienated and uninstrumentalized existence shine forth, whether for the first time or as celebratory reminiscences of the bliss of rituals, games, and child's play.

It is no accident, then, that modernism has mostly avoided the actual representation of alienated labor, except for the work of great activist photographers such as Lewis Hine, where the abolition of child labor was the driving agenda of the project. In contrast, whenever painting or photography in the twentieth century celebrated the labor force or the forceful laborer, one could—and can—be sure of being in the company of totalitarian ideologies, whether fascist, Stalinist, or corporate. The heroicization of the body subjected to alienated physical labor serves to instill collective respect for intolerable conditions of subjectivation, and in a false celebration of that labor it also serves to naturalize that which should be critically analyzed in terms of its potential transformation, if not its final abolition. Conversely, the all-too-easy acceptance of artistic practices as mere playful opposition fails to recognize not only the pervasiveness of alienated labor as a governing form of collective experience, but also prematurely accepts the relegation of artistic practice to merely a pointless exemption from the reality principle altogether.

Ideology: reflection and mediation

The concept of ideology played an important role in the aesthetics of György Lukács (1885–1971), who wrote one of the most cohesive Marxist literary aesthetic theories of the twentieth century. Although rarely addressing artistic visual production, Lukács's theories had a tremendous impact on the formation of social art history in its second phase of the forties and fifties, in particular on the work of his fellow Hungarian Arnold Hauser (1892–1978) and the Austrian Marxist Ernst Fischer (1889–1972).

Lukács's key concept was that of reflection, establishing a rather mechanistic relationship between the forces of the economic and political base and the ideological and institutional superstructure. Ideology was defined as an inverted form of consciousness or—worse—as mere false consciousness. Furthermore, the concept of reflection argued that the phenomena of cultural representation were ultimately mere secondary phenomena of the class politics and ideological interests of a particular historical moment. Subsequently, though, the understanding of reflection would depart from these mechanistic assumptions. Lukács's analysis had in fact argued for an understanding of cultural production as dialectical historical operations, and he saw certain cultural practices (e.g., the

▲ 1917b, 1921, 1923 ● 1924, 1930b, 1931a

**5 • Dan Graham, *Homes for America*,
from *Arts Magazine*, 1967**
Print, 74 × 93 (29⅛ × 36⅝)

Graham's publication of one of his earliest works in the
layout and presentational format of an article in the pages
of a rather prominent American art magazine demarcates
one of the key moments of Conceptual art. First of all,
modernism's (and Conceptualism's) supposedly radical
quest for empirical and critical self-reflexivity is turned
in on itself and onto the frames of presentation and
distribution. Graham's magazine article anticipates the
fact that crucial information on artistic practices is always
already mediated by mass-cultural and commercial forms
of dissemination. Accordingly, Graham integrates that
dimension of distribution into the conception of the work
itself. The artist's model of self-reflexivity dialectically shifts
from tautology to discursive and institutional critique.
What distinguishes his approach to the problems of
audience and distribution from the earlier models of the
historical avant-garde is the skepticism and the precision
with which he positions his operations exclusively within
the discursive and institutional sphere of the given
conditions of artistic production (rather than the project
of utopian social and political transformations).
Yet the choice of prefabricated suburban tract-housing
in New Jersey first of all expands the subject matter of
Pop art from a mere citation of mass-cultural and media
iconography to a new focus on social and architectural
spaces. At the same time, Graham reveals that the spatial
organization of the lowest level of everyday suburban
experience and architectural consumption had already
prefigured the principles of a serial or modular iterative
structure that had defined the sculptural work of his
predecessors, the Minimalists.

bourgeois novel and its project of realism) as the quintessential
cultural achievement of the progressive forces of the bourgeoisie.
When it came to the development of a proletarian aesthetic,
however, Lukács became a stalwart of reactionary thought, arguing
that the preservation of the legacies of bourgeois culture would
have to be an integral force within an emerging proletarian realism.
The task of Socialist Realism in Lukács's account eventually came
simultaneously to preserve the revolutionary potential of the
progressive bourgeois moment that had been betrayed and to lay
the foundations of a new proletarian culture that had truly taken
possession of the bourgeois means of cultural production.

Since the theorizations of ideology in the sixties, aestheticians and
art historians have not only differentiated general theories of ideology,
but have also elaborated the questions of how cultural production
relates to the apparatus of ideology at large. The question of whether
artistic practice operates inside or outside ideological representations
has especially preoccupied social art historians since the seventies, all
of them arriving at very different answers, depending on the theory of
ideology to which they subscribe. Thus, for example, those social art
historians who followed the model of the early Marxist phase of Amer-
ican art historian Meyer Schapiro (1904–96) continued to operate
under the assumption that cultural representation is the mirror reflec-
tion of the ideological interests of a ruling class (e.g., Schapiro's
argument about Impressionism being the cultural expression of the
leisured share-holding bourgeoisie). According to Schapiro, these
cultural representations do not merely articulate the mental universe
of the bourgeoisie: they also invest it with the cultural authority to
claim and maintain its political legitimacy as a ruling class.

Others have taken Meyer Schapiro's Marxist social history of
art as a point of departure, but have also adopted the complex
ideas that he developed in his later work. He took the infinitely
more complicated questions of mediation between art and
ideology into account by recognizing that aesthetic formations
are relatively autonomous, rather than fully dependent upon or
congruent with ideological interests (a development that is
evident, for example, in Schapiro's subsequent turn to an early
semiology of abstraction). One result of a more complex theoriza-
tion of ideology was the attempt to situate artistic representations
as dialectical forces within their historically specific moment. That
is, in certain cases a particular practice might very well articulate
the rise of progressive consciousness not only within an individual
artist, but also the progressivity of a patron class and its self-
definition in terms of a project of bourgeois enlightenment and
ever-expanding social and economic justice (see, for example,
Thomas Crow's [born 1948] classic essay "Modernism and Mass
Culture," concerning the dialectical conception of the idiom of
neo-Impressionist divisionism in its drastic changes from affilia-
tion with the politics of radical anarchism to an indulgent style).

Social art historians of the seventies, like Crow and T. J. Clark
(born 1945), conceived of the production of cultural representation
as both dependent upon class ideology and generative of counter-
ideological models. Thus, the most comprehensive account of

6 • Hans Haacke, _MOMA-Poll_, 1970
Audience participatory installation: two transparent acrylic ballot boxes, each 40 × 20 × 10 (15¾ × 7⅞ × 3⅞), equipped with photoelectric counter, text

For the exhibition "Information" at New York's Museum of Modern Art in 1970, Haacke installed one of the first of his new works to deal with "social systems," called either _Polls_ or as _Visitors' Profiles_. In these installations, traditionally passive spectators became active participants. Haacke's subjection of the processes of production and reception to elementary forms of statistical accounting and positivist information is a clear response to the actual principles governing experience in what Adorno had called the "society of administration." At the same time, Haacke's work, like Graham's, shifts attention from the critical analysis of the work's immanent structures of meaning to the external frames of institutions. Thus Haacke repositions Conceptual art in a new critical relation to the socioeconomic conditions determining access and availability of aesthetic experience, a practice later identified as "institutional critique." Haacke's _MOMA-Poll_ is a striking example of this shift since it confronts the viewer with a sudden insight into the degree to which the museum as a supposedly neutral space guarding aesthetic autonomy and disinterestedness is imbricated with economic, ideological, and political interests. The work also reconstitutes a condition of responsibility and participation for the viewer that surpasses models of spectatorial involvement previously proposed by artists of the neo-avant-garde, while it recognizes the limitations of the spectators' political aspirations and their psychic range of experience and self-determination.

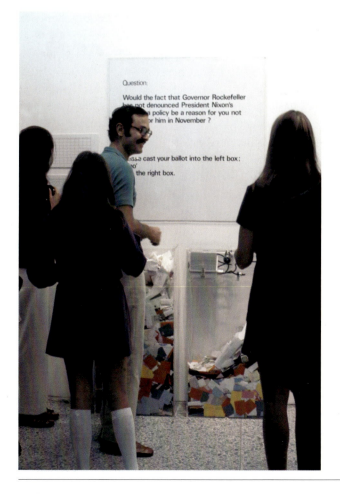

nineteenth-century modernist painting and its shifting fortunes within the larger apparatus of ideological production can still be found in the complex and increasingly differentiated approach to the question of ideology in the work of Clark, the leading social art historian of the late twentieth century. In Clark's accounts of the work of Daumier and Courbet, for example, ideology and painting are still conceived in the dialectical relations that Lukács had suggested in his accounts of the work of eighteenth and nineteenth-century literature: as an articulation of the progressive forces of the bourgeois class in a process of coming into its own mature identity to accomplish the promises of the French Revolution and of the culture of the Enlightenment at large.

Clark's later work _The Painting of Modern Life: Paris in the Art of Manet and his Followers_ (1984), by contrast, does not discuss merely the extreme difficulty of situating the work of Manet and Seurat within such a clear and dynamic relationship to the progressive forces of a particular segment of society. Rather, Clark now faces the task of confronting the newfound complexity of the relationship between ideology and artistic production, and of integrating it with the methodology of social art history that he had developed up to this point. This theoretical crisis undoubtedly resulted in large part from Clark's discovery of the work of the Marxist Lacanian Louis Althusser (1918–90). Althusser's conception of ideology still remains the most productive one, in particular with regard to its capacity to situate aesthetic and art-historical phenomena in a position of relative autonomy with regard to the totality of ideology. This is not just because Althusser theorizes ideology as a totality of linguistic representations in which the subject is constituted in a politicized version of Lacan's account of the symbolic order. Perhaps even more important is Althusser's distinction between the totality of the ideological state apparatus (and its subspheres in all domains of representation) and the explicit exemption of artistic representations (as well as scientific knowledge) from that totality of ideological representations.

Popular culture versus mass culture

One of the most important debates among social art historians concerns the question of how so-called high art or avant-garde practices relate to the emerging mass-cultural formations of modernity. And while it is of course understood that these formations change continuously (as the interactions between the two halves of the systems of representation are continuously reconfigured), it has remained a difficult debate whose outcome is often indicative of the particular type of Marxism embraced by the critics of mass culture. It ranges from the most violent rejection of mass-cultural formations in the work of Adorno, whose infamous condemnation of jazz is now universally discredited as a form of eurocentric Alexandrianism that was—worst of all—largely dependent on the author's total lack of actual information about the musical phenomena he so disdained.

The opposite approach to mass-cultural phenomena was first developed in England, in the work of Raymond Williams (1921–88),

7 • Gerhard Richter and Konrad Lueg / Fischer, *Life with Pop—Demonstration for Capitalist Realism*, at Möbelhaus Berges, Düsseldorf, October 11, 1963

In 1963, Gerhard Richter and Konrad Lueg (who later, as Konrad Fischer, became one of Europe's most important dealers of the Minimal and Conceptual generation) staged a performance in a Düsseldorf department store. It initiated a German variation on the neo-avant-garde's international reorientation toward mass culture that— since the late fifties—had gradually displaced postwar forms of abstraction in England, France, and the United States. The neologism "capitalist realism," coined by Richter for this occasion, reverberates with realism's horrible "other," the Socialist variety that had defined Richter's educational background in the Communist part of Germany until 1961. The spectacle of boredom, affirmation, and passivity against the backdrop of a totalizing system of objects of consumption took the work of Piero Manzoni as *one* of its cues, namely the insight that artistic practice would have to be situated more than ever in the interstitial spaces between objects of consumption, sites of spectacle, and ostentatious acts of artistic annihilation. But its brooding melancholic passivity was also a specifically German contribution to the recognition that from now on advanced forms of consumer culture would not only determine behavior in a way that had been previously determined by religious or political belief systems, but that in this particular historical context of Germany they would also serve as the collective permit to repress and to forget the population's recent massive conversion to fascism.

whose crucial distinction between popular culture and mass culture became a productive one for subsequent attempts by cultural historians such as Stuart Hall (1932–2014) to argue for an infinitely more differentiated approach when analyzing mass-cultural phenomena. Hall argued that the same dialectical movement that aestheticians and art historians had detected in the gradual shift of stylistic phenomena from revolutionary and emancipatory to regressive and politically reactionary could be detected in the production of mass culture as well: here a perpetual oscillation from initial contestation and transgression to eventual affirmation in the process of industrialized acculturation would take place. Hall also made it seem plausible that a fundamental first step in overcoming the eurocentric fixation on hegemonic culture (whether high bourgeois or avant-garde) was acceptance that different audiences communicate within different structures of tradition, linguistic convention, and behavioral forms of interaction. Therefore, according to the new cultural-studies approach, the specificity of audience address and experiences should be posited above all claims—as authoritarian as they are numinous—for universally valid criteria of aesthetic evaluation, that is, that hierarchical canonicity whose ultimate and latent goal would always remain the confirmation of the supremacy of white, male, bourgeois culture.

Sublimation and desublimation

The model of cultural studies that Williams and Hall elaborated, and that became known later as the Birmingham Centre for Contemporary Cultural Studies, laid the foundations for most of the work in cultural studies being done today. Even though he is not known ever to have engaged with the work of any of the British Marxists, Adorno's counterargument would undoubtedly have been to accuse their project of being one of extending desublimation into the very center of aesthetic experience, its conception and critical evaluation. Desublimation for Adorno internalizes the very destruction of subjectivity further; its agenda is to dismantle the processes of complex consciousness formation, the desire for political self-determination and resistance, and ultimately to annihilate experience itself in order to become totally controlled by the demands of late capitalism.

Another and rather different Marxist aesthetician, Herbert Marcuse (1898–1979), conceived of the concept of desublimation in almost the opposite way, arguing that the structure of aesthetic experience consisted of the desire to undermine the apparatus of libidinal repression and to generate an anticipatory moment of an existence liberated from needs and instrumentalizing demands. Marcuse's Freudo-Marxist aesthetic of libidinal liberation was situated at the absolute opposite pole of Adorno's ascetic aesthetics of a negative dialectics, and Adorno did not fail to chastize Marcuse publicly for what he perceived to be the horrifying effects of hedonistic American consumer culture on Marcuse's thoughts.

Whatever the ramifications of Marcuse's reconception of desublimation, it is certainly a term for which ample evidence could be

found in avant-garde practices before and after World War II. Throughout modernity, artistic strategies resist and deny the established claims for technical virtuosity, for exceptional skills, and for conformity with the accepted standards of historical models. They deny the aesthetic any privileged status whatsoever and debase it with all the means of deskilling, by taking recourse to an abject or a low-cultural iconography, or by the emphatic foregrounding of procedures and materials that reinsert the disavowed dimensions of repressed somatic experience back into the space of artistic experience.

The neo-avant-garde

One of the major conflicts of writing social art history after World War II derives from an overarching condition of asynchronicity. On the one hand, American critics in particular were eager to establish the first hegemonic avant-garde culture of the twentieth century; however, in the course of that project they failed to recognize that the very fact of a reconstruction of a model of avant-garde culture would inevitably affect not only the status of the work being produced under these circumstances, but also, even more profoundly, the critical and historical writing associated with it.

In Adorno's late-modernist *Aesthetic Theory* (1970), the concept of autonomy retains a central role. Unlike Clement Greenberg's remobilization of the concept in favor of an American version of late-modernist aesthetics, Adorno's aesthetics operates within a principle of double negativity. On the one hand, Adorno's late modernism denies the possibility of a renewed access to an aesthetics of autonomy, a possibility annihilated by the final destruction of the bourgeois subject in the aftermath of fascism and the Holocaust. On the other hand, Adorno's aesthetics also deny the possibility of a politicization of artistic practices in the revolutionary perspective of Marxist aesthetics. According to Adorno, politicized art would only serve as an alibi and prohibit actual political change, since the political circumstances for a revolutionary politics are de facto not accessible in the moment of postwar reconstruction of culture.

By contrast, American neomodernism and the practices of what Peter Bürger called the neo-avant-garde—most palpably advocated by Greenberg and his disciple Michael Fried (born 1939)—could uphold their claims only at the price of a systematic *geschichtsklitterung*, a manifest attempt at writing history from the perspective of victorious interests, systematically disavowing the major transformations that had occurred within the conception of high art and avant-garde culture discussed above (e.g., the legacies of Dada and the Russian and Soviet avant-gardes). But worse still, these critics failed to see that cultural production after the Holocaust could not simply attempt to establish a continuity of modernist painting and sculpture. Adorno's model of a negative dialectics (most notoriously formulated in his verdict on the impossibility of lyrical poetry after Auschwitz) and his aesthetic theory—in open opposition to Greenberg's neomodernism—suggested the ineluctable necessity of rethinking the very precarious condition of culture at large.

It appears that the strengths and successes of the social history of art are most evident in those historical situations where actual mediations between classes, political interests, and cultural forms of representation are solidly enacted and therefore relatively verifiable. Their unique capacity to reconstruct the narratives around those revolutionary or foundational situations of modernity makes the accounts of social art historians the most compelling interpretations of the first hundred years of modernism, from David in the work of Thomas Crow to the beginnings of Cubism in T. J. Clark's work.

However, when it comes to the historical emergence of avant-garde practices such as abstraction, collage, Dada, or the work of Duchamp, whose innermost *telos* it had been actively to destroy traditional subject–object relationships and to register the destruction of traditional forms of experience, both on the level of narrative and on that of pictorial representation, social art history's attempts to maintain cohesive narrative accounts often emerge at best as either incongruent or incompatible with the structures and morphologies at hand, or at worst, as falsely recuperative. Once the extreme forms of particularization and fragmentation have become the central formal concerns in which postbourgeois subjectivity finds its correlative remnants of figuration, the interpretative desire to reimpose totalizing visions onto historical phenomena sometimes appears reactionary and at other times paranoid in its enforcement of structures of meaning and experience. After all, the radicality of these artistic practices had involved not only their refusal to allow for such visions but also their formulation of syntax and structures where neither narrative nor figuration could still obtain. If meaning could still obtain at all, it would require accounts that would inevitably lead beyond the frameworks of those of deterministic causation.

FURTHER READING

Frederick Antal, *Classicism and Romanticism* (London: Routledge & Kegan Paul, 1966)

Frederick Antal, *Hogarth and His Place in European Art* (London: Routledge & Kegan Paul, 1962)

T. J. Clark, *Farewell to an Idea* (New Haven and London: Yale University Press, 1999)

T. J. Clark, *Image of the People: Gustave Courbet and the 1848 Revolution*
(London: Thames & Hudson, 1973)

T. J. Clark, *The Absolute Bourgeois: Artists and Politics in France, 1848–1851*
(London: Thames & Hudson, 1973)

T. J. Clark, *The Painting of Modern Life: Paris in the Art of Manet and his Followers*
(London: Thames & Hudson, 1984)

Thomas Crow, *Painters and Public Life in 18th-Century Paris* (New Haven and London: Yale University Press, 1985).

Thomas Crow, *The Intelligence of Art* (Chapel Hill, N.C.: University of North Carolina Press, 1999)

Serge Guilbaut, *How New York Stole the Idea of Modern Art: Abstract Expressionism, Freedom, and the Cold War* (Chicago and London: University of Chicago Press, 1983)

Nicos Hadjinicolaou, *Art History and Class Struggle* (London: Pluto Press, 1978)

Arnold Hauser, *The Social History of Art* (1951), four volumes (London: Routledge, 1999)

Fredric Jameson (ed.), *Aesthetics and Politics* (London: New Left Books, 1977)

Francis Klingender, *Art and the Industrial Revolution* (1947) (London: Paladin Press, 1975)

Meyer Schapiro, *Modern Art: 19th and 20th Century, Selected Papers, Vol. 2*
(New York: George Braziller, 1978)

Meyer Schapiro, *Romanesque Art, Selected Papers, Vol. 1* (New York: George Braziller, 1977)

Meyer Schapiro, *Theory and Philosophy of Art: Style, Artist, and Society, Selected Papers, Vol. 4*
(New York: George Braziller, 1994)

Benjamin H. D. Buchloh

▲ 1968b, 2007b ● 1942a, 1960b ■ 1960a

3 Formalism and structuralism

In 1971–2, the French literary theorist Roland Barthes (1915–80) held a year-long seminar devoted to the history of semiology, the "general science of signs" that had been conceived as an extension of linguistics by the Swiss Ferdinand de Saussure (1857–1913) in his *Course in General Linguistics* (posthumously published in 1916) and simultaneously, under the name of semiotics, by the American philosopher Charles Sanders Peirce (1839–1914) in his *Collected Papers* (also posthumously published, from 1931 to 1958). Barthes had been one of the leading voices of structuralism from the mid-fifties to the late sixties, together with the anthropologist Claude Lévi-Strauss (1908–2009), the philosopher Michel Foucault (1926–84), and the psychoanalyst Jacques Lacan, and as such had greatly contributed to the resurrection of the semiological project, which he had clearly laid out in *Elements of Semiology* (1964) and "Structural Analysis of Narratives" (1966). But he had seriously undermined that very project in his most recent books, *S/Z*, *The Empire of Signs* (both 1970), and *Sade, Fourier, Loyola* (1971).

The curiosity of Barthes's auditors (myself among them) was immense: in this period of intellectual turmoil marked by a general Oedipal desire to kill the structuralist model, they expected him to ease their understanding of the shift underway from ▲A (structuralism) to B (poststructuralism)—a term that neatly describes Barthes's work at the time, but which was never condoned by any of its participants. They anticipated a chronological summary. Logically, such a narrative, after a presentation of Saussure's and Peirce's concepts, would have discussed the work of the Russian Formalist school of literary criticism, active from around 1915 to the Stalinist blackout of 1932; then, after one of its ● members, Roman Jakobson (1896–1982), had left Russia, of the Prague Linguistic Circle grouped around him; then of French structuralism; and finally, in conclusion, it would have dealt with ■ Jacques Derrida's deconstruction.

Barthes's audience got the package they had hoped for, but not without a major surprise. Instead of beginning with Saussure, he initiated his survey with an examination of the ideological critique proposed, from the twenties on, by the German Marxist playwright Bertolt Brecht (1898–1956). Although Barthes, no less than his peers, had succumbed to the dream of scientific objectivity when the structuralist movement was at its peak, he now implicitly advocated a subjective approach. No longer interested in mapping a discipline, he endeavored instead to tell the story of his *own* semiological adventure, which had started with his discovery of Brecht's writings. Coming from someone whose assault on biographism (the reading of a literary piece through the life of its author) had always been scathing, the gesture was deliberately provocative. (The enormous polemic engendered by the antibiographism of Barthes's *On Racine* (1963), which had ended in *Criticism and Truth* (1966), Barthes's brilliant answer to his detractors, and which had done more than anything else to radically transform traditional literary studies in France, was still very much on everyone's mind.) But there was a strategic motive as well in this Brechtian beginning, a motive that becomes apparent when one turns to the essay in which Barthes had discussed Saussure for the first time.

"Myth Today" was a postscript to the collection of sociological vignettes Barthes had written between 1954 and 1956 and published under the title *Mythologies* (1957). The main body of the book had been written in the Brechtian mode: its stated purpose was to reveal, underneath the pretended "naturalness" of the *petit-bourgeois* ideology conveyed by the media, what was historically determined. But in "Myth Today" Barthes presented Saussure's work, which he had just discovered, as offering new tools for the kind of Brechtian ideological analysis he had so far been conducting. What is perhaps most striking, in retrospect, is that Barthes's exposition of Saussurean semiology begins with a plea in favor of formalism. Shortly ▲ after alluding to Andrei Zhdanov and his Stalinist condemnation of formalism and modernism as bourgeois decadence, Barthes writes: "Less terrorized by the specter of 'formalism,' historical criticism might have been less sterile; it would have understood that … the more a system is specifically defined in its forms, the more amenable it is to historical criticism. To parody a well-known saying, I shall say that a little formalism turns one away from History, but that a lot brings one back to it." In other words, right from the start Barthes conceived of what was soon to be named "structuralism" as part of a broader formalist current in twentieth-century thought. Furthermore, Barthes was denying the claims of the antiformalist champions that formalist critics, in bypassing "content" to scrutinize forms, were retreating from the world and its historical realities to the ivory tower of a humanistic "eternal present."

▲ Introduction 4 ● 1915 ■ Introduction 4 ▲ 1934a

"Semiology is a science of forms, since it studies significations apart from their content." Such is the definition that immediately precedes Barthes's passage quoted above. Its terminology is somewhat flawed, for Barthes was still a novice in structural linguistics, and he would soon know that the word "content" has to be replaced by "referent" in such a sentence. But the basic axioms are already there: signs are organized into sets of oppositions that shape their signification, independently of what the signs in question refer to; every human activity partakes of at least one system of signs (generally several at once), whose rules can be tracked down; and, as a producer of signs, man is forever condemned to signification, unable

▲ to flee the "prison-house of language," to use Fredric Jameson's formulation. Nothing that man utters is insignificant—even saying "nothing" carries a meaning (or rather multiple meanings, changing according to the context, which is itself structured).

Choosing in 1971 to present these axioms as derived from Brecht (rather than from Saussure, as he had done in 1957), Barthes had a polemical intention: he was pointing to the historical link between modernism and the awareness that language is a structure of signs. Indeed, although Brecht's star has somewhat faded in recent years, he was regarded in postwar Europe as one of the most powerful modernist writers. In his numerous theoretical statements, Brecht had always attacked the myth of the transparency of language that had governed the practice of theater since Aristotle; the self-reflective, anti-illusionistic montagelike devices that interrupted the flow of his plays aimed at aborting the identification of the spectator with any character and, as he phrased it, at producing an effect of "distanciation" or "estrangement."

The first example Barthes commented on in his 1971–2 seminar was a text in which the German writer patiently analyzed the 1934 Christmas speeches of two Nazi leaders (Hermann Goering and Rudolf Hess). What struck Barthes was Brecht's extreme attention to the form of the Nazi texts, which he had followed word for word in order to elaborate his counterdiscourse. Brecht pinpointed the efficacy of these speeches in the seamless flow of their rhetoric: the smokescreen with which Goering and Hess masked their faulty logic and heap of lies was the mellifluous continuity of their language, which functioned like a robust, gooey adhesive.

Brecht, in short, was a formalist, eager to demonstrate that language was not a neutral vehicle made to transparently convey concepts directly from mind to mind, but had a materiality of its own and that this materiality was always charged with significations. But he immensely resented the label of formalism when it was thrown at modern literature as a whole by the Marxist philosopher György Lukács, writing in the USSR at a time when calling anyone a formalist was equivalent to signing his or her death warrant. By then virulently opposed to modernism in general—but in particular to the technique of montage that Sergei Eisenstein invented in film and Brecht adapted to the theater, and to the kind of interior monologue that concludes James Joyce's *Ulysses*— Lukács had proposed nineteenth-century realist novels (those of Balzac in particular) as the model to be emulated, especially if one

was to write from a "proletarian" point of view. Yet it was Lukács who was the "formalist," wrote Brecht in his rebuttal. In calling for a twentieth-century novel with a "revolutionary" content but penned in a form that dated from a century earlier, a form that belonged to the era before the self-reflexivity and anti-illusionism of modernism, Lukács was fetishizing form.

Thus the term "formalist" was an insult that Lukács and Brecht tossed at each other, but the word did not have the same sense for each. For Brecht, a formalist was anyone who could not see that form was inseparable from content, who believed that form was a mere carrier; for Lukács, it was anyone who believed that form even affected content. Brecht's uneasiness with the term, however, should give us pause, especially since the same uneasiness has mushroomed in art history and criticism since the early seventies. (It is particularly noteworthy in this context that the art critic whose name is most

▲ associated in America with formalism, Clement Greenberg, also had such misgivings: "Whatever its connotations in Russian, the term has acquired ineradicably vulgar ones in English," he wrote in 1967.) In order to understand the ambivalence, it is useful to recall Barthes's dictum: "a little formalism turns one away from History, but that a lot brings one back to it." For what Brecht resented in Lukács's "formalism" was its denial both of history and of what the Danish linguist Louis Hjelmslev would call the "form of content"—of the fact that the very structure of Balzac's novels was grounded upon the world view of a particular social class at a particular juncture in the history of Western Europe. In short, Lukács had practiced only a "restricted" formalism, whose analysis remains at the superficial level of form-as-shape, or morphology.

The antiformalism that was prevalent in the discourse of art criticism in the seventies can thus be explained in great part by a confusion between two kinds of formalism, one that concerns itself essentially with morphology (which I call "restricted" formalism), and one that envisions form as structural—the kind embraced by Brecht when he sorted out the "continuity" of Goering's and Hess's speeches as an essential part of their ideological machine. The confusion was compounded by Greenberg's gradual turnabout. While his analyses of the dialectical role of *trompe-l'oeil* devices

● in Georges Braque's Cubist still lifes [1] or that of the alloverness
■ of Jackson Pollock's drippings) are to be counted on the structural ledger, by the late 1950s his discourse was more reminiscent of the morphological mode promulgated at the beginning of the

♦ twentieth century by the British writers Clive Bell and Roger Fry, whose concern was merely good design. The distinction between these two formalisms is essential to a retrieval of formalism (as structuralism) from the wastebasket of discarded ideas.

Structuralism and art history

Although the linguistic / semiological model provided by Saussure became the inspiration for the structuralist movement in the fifties and sixties, art history had already developed structural methods by the time this model became known in the twenties. Furthermore,

1 • Georges Braque, *Violin and Pitcher*, 1910
Oil on canvas, 117 × 73 (46 × 28¾)

One of the benchmarks of formalism is its attention to rhetorical devices, to the signification of the means of signification themselves. Examining this painting by Braque, Clement Greenberg singled out the device of the realistic nail and its shadow painted *on top* of the faceted volumes depicted on the picture's surface. Both flattening the rest of the image and pushing it back into depth, he *trompe-l'oeil* nail was for the artist a means of casting some doubt with regard to the traditional, illusionistic mode of representing space.

the first literary critics who can be called structuralists—the
▲ Russian Formalists—were particularly aware of their art-historical antecedents (much more than of Saussure, whom they discovered only after writing many of their groundbreaking works). Finally, it
● was Cubism that first helped the Russian Formalists to develop their theories: in deliberately attacking the epistemology of representation, Cubism (and abstract art in its wake) underscored the gap separating reference and meaning and called for a more sophisticated understanding of the nature of signs.

The role played by art history and avant-garde art practice in the formation of a structuralist mode of thinking is little known today, but it is important for our purpose, especially with regard to the accusations of ahistoricism often thrown at structuralism. In fact, one could even say that the birth of art history as a discipline dates from the moment it was able to structure the vast amount of material it had neglected for purely ideological and aesthetic reasons. It might seem odd today that seventeenth-century Baroque art, for example, had fallen into oblivion during the eighteenth and early nineteenth centuries, until Heinrich Wölfflin (1864–1945) rehabilitated it in *Renaissance and Baroque* (1888). Resolutely opposed to the dominant normative aesthetic of Johann Joachim Winckelmann (1717–68), for whom Greek art was an unsurpassable yardstick for all subsequent artistic production, Wölfflin endeavored to show that Baroque art had to be judged by criteria that were not only different from but resolutely opposed to those of Classical art. This idea, that the historical signification of a stylistic language was manifested through its rejection of another one (in this case, a preceding one) would lead Wölfflin to posit "an art history without names" and to establish the set of binary oppositions that constitutes the core of his most famous book, *Principles of Art History*, which appeared in 1915 (linear / painterly, plane / recession, closed / open form; multiplicity / unity; clearness / unclearness).

Wölfflin's formalist taxonomy, however, was still part of a teleological and idealistic discourse, modeled on Hegel's view of history, according to which the unfolding of events is prescribed by a set of predetermined laws. (Within every "artistic epoch," Wölfflin always read the same smooth evolution from linear to painterly, from plane to recession, etc., which left him with little room to explain how one switched from one "epoch" to the next, particularly since he denied nonartistic historical factors much of a causative role in his scheme.) But if Wölfflin's idealism prevented him from developing his formalism into a structuralism, it is to Alois Riegl (1858–1905) that ones owes the first full elaboration of a meticulous analysis of forms as the best access to a social history of artistic production, signification, and reception.

Just as Wölfflin had done with the Baroque era, Riegl undertook the rehabilitation of artistic eras that had been marginalized as decadent, most notably the production of late antiquity (*Late Roman Art Industry*, 1901). But he did more than Wölfflin to advance the cause of an anonymous history of art, one that would trace the evolution of formal / structural systems rather than merely study the output of individual artists: if the well-known works of Rembrandt and

▲ 1915 ● 1911, 1912, 1921a

Frans Hals figure in his last book, *The Group Portraiture of Holland* (1902), they are as the end-products of a series whose features they inherit and transform. Riegl's historical relativism was radical and had far-reaching consequences, not only because it allowed him to disregard the distinction between high and low, major and minor, pure and applied art, but because it led him to understand every artistic *document* as a *monument* to be analyzed and posited in relationship with others belonging to the same series. In other words, Riegl demonstrated that it was only after the set of codes enacted (or altered) by an art object had been mapped in their utmost details that one could attempt to discuss that object's signification and the way it related to other series (for example to the history of social formations, of science, and so forth)—an idea that would be of importance for both the Russian Formalists and Michel Foucault. And it is because Riegl understood meaning as structured by a set of oppositions (and not as transparently conveyed) that he was able to challenge the overwhelming role usually given to the referent in the discourse about art since the Renaissance.

A crisis of reference

A similar crisis of reference provided the initial spark of Russian Formalism around 1915. The polemical target of the Russian Formalist critics was the Symbolist conception that poetry resided in the images it elicited, independent of its linguistic form. But it was through their confrontation with Cubism, then with the first abstract paintings of Kazimir Malevich and the poetic experiments of his friends Velemir Khlebnikov and Aleksei Kruchenikh—poems whose sounds referred to nothing but the phonetic nature of language itself—that the Russian Formalists discovered, before they ever heard of Saussure, what the Swiss scholar had called the "arbitrary nature of the sign."

Allusions to Cubism abound in Roman Jakobson's writings, particularly when he tries to define poetic language as opposed to the language of communication used in everyday life. In "What is Poetry?", a lecture delivered in 1933, he writes:

> [Poeticity] can be separated out and made independent, like the various devices in say, a Cubist painting. But this is a special case…. Poeticity is present when the word is felt as a word and not a mere representation of the object being named or an outburst of emotion, when words and their composition, their meaning, their external and inner form, acquire a weight and value of their own instead of referring indifferently to reality…. Without contradiction [between sign and object] there is no mobility of concepts, no mobility of signs, and the relationship between concept and sign becomes automatized. Activity comes to a halt, and the awareness of reality dies out.

These last lines refer to the device of *ostranenie*, or "making strange," as a rhetorical figure, whose conceptualization by Viktor Shklovsky (1893–1984) in "Art as Device" (1917) is the first theoretical landmark of Russian Formalism (the family resemblance of this notion with Brecht's "estrangement effect" is not fortuitous). According to Shklovsky, the main function of art is to defamiliarize our perception, which has become automatized, and although Jakobson would later dismiss this first theory of defamilarization, it is the way he interpreted Cubism at the time. And for good reason, as one could say that the first, so-called "African," phase of Cubism was rooted in a deliberate practice of estrangement. Witness this declaration of Pablo Picasso (1881–1973): "In those days people said that I made the noses crooked, even in the *Demoiselles d'Avignon*, but I had to make the nose crooked so they would see that it was a nose. I was sure later they would see that it wasn't crooked."

For Shklovsky, what characterized any work of art was the set of "devices" through which it was reorganizing the "material" (the referent), making it strange. (The notion of "device," never rigorously defined, was a blanket term by which he designated any stylistic feature or rhetoric construction, encompassing all levels of language—phonetic, syntactic, or semantic.) Later on, when he devoted particular attention to works such as the eighteenth-century "novel" *Tristram Shandy* by Laurence Sterne, where the writer pays more attention to mocking the codes of storytelling than to the plot itself, Shklovsky began to conceive not only our perception of the world but also the daily language of communication as the "material" that literary art rearranges—but the work of art remained for him a sum of devices through which the "material" was de-automatized. For Jakobson, though, the "devices" were not simply piled up in a work but were interdependent, constituting a system, and they had a constructive function, each contributing to the specificity and unity of the work, just as each bone has a role to play in our skeleton. Furthermore, each new artistic device, or each new system of devices, had to be understood either as breaking a previous one that had become deadened and automatized, or as revealing it (laying it bare), as if it had been there all along but unperceived: in short, any artistic device (and not just the world at large or the language of daily communication) could become the "material" made strange by a subsequent one. As a result, any device was always semantically charged for Jakobson, a complex sign bearing several layers of connotations.

It is this second notion of *ostranenie* that Jakobson had in mind when he spoke of the isolation of the various devices in a Cubist work as a "special case": in laying bare the traditional mechanisms of pictorial representation, Cubism performed for Jakobson and his colleagues the same function that neurosis had played for Freud's discovery of the unconscious. Much as the special (pathological) case of neurosis had led Freud to his general theory of the psychological development of man, the special (defamiliarizing) case of Cubism was seized by the Russian Formalists as support for their antimimetic, structural conception of poetic language.

In hindsight, however, we can see that bestowing a status of "normalcy" to the traditional means of pictorial representation that Cubism fought and whose devices it laid bare is not sustainable: it would posit such traditional means of representation as constituting a

kind of ahistorical norm against which all pictorial enterprises would have to be measured (bringing us back, in effect, to Winckelmann). Perceiving the essentializing danger of this simple dualism (norm / exception), Jakobson grew more suspicious of the normative postulates upon which his early work had been based (the opposition between the language of daily use as norm, and of literature as exception). But he would always take advantage of the model offered by psychoanalysis, according to which *dysfunction* helps us understand *function*. In fact, one of his major contributions to the field of literary criticism—the dichotomy that he established between the metaphoric and metonymic poles of language—was the direct result of his investigation of aphasia, a disorder of the central nervous system characterized by the partial or total loss of the ability to communicate. He noted that for the most part aphasic disturbances concerned either "the selection of linguistic entities" (the choice of *that* sound rather than *this* one, of *that* word rather than *this* one) or "their combination into linguistic units of a higher degree of complexity." Patients suffering from the first kind of aphasia (which Jakobson terms "the similarity disorder") cannot substitute a linguistic unit for another one, and metaphor is inaccessible to them; patients suffering from the second kind of aphasia ("the contiguity disorder") cannot put any linguistic unit into its context, and metonymy (or synecdoche) is senseless for them. The poles of similarity and contiguity were directly borrowed from Saussure (they correspond in his *Course* to the terms *paradigm* and *syntagm*), but they were expressly linked by Jakobson to the Freudian concepts of displacement and condensation: just as the limit between these two activities of the unconscious remained porous for Freud, Jakobson's polar extremes do not preclude the existence of hybrid or intermediary forms. But once again it is the opposition of these two terms that structured for him the immense domain of world literature. And not only literature: he saw Surrealist art as essentially metaphoric, and Cubism as essentially metonymic.

The arbitrary nature of the sign

Before we examine a Cubist work from a structural point of view, let us at last turn to Saussure's famous *Course* and its groundbreaking exposition of what he called the arbitrariness of the sign. Saussure went far beyond the conventional notion of arbitrariness as the absence of any "natural" link between the sign (say, the word "tree") and its referent (any actual tree), even though he would have been the last to deny this absence, to which the simple existence of multiple languages attests. For Saussure, the arbitrariness involved not only the relation between the sign and its referent, but also that between the signifier (the sound we utter when we pronounce the word "tree" or the letters we trace when we write it down) and the signified (the concept of tree). His principal target was the Adamic conception of language (from Adam's performance in the Book of Genesis: language as an ensemble of names for things), which he called "chimeric" because it presupposes the existence of an invariable number of signifieds that receive in each particular language a different formal vestment.

This angle of attack led Saussure to separate the problem of referentiality from the problem of signification, understood as the enactment in the utterance (which he called *parole*, as opposed to *langue*, designating the language in which the sign is uttered) of an arbitrary but necessary link between a signifier and a "conceptual" signified. In the most celebrated passage of his *Course*, Saussure wrote:

> *In language there are only differences. Even more important, a difference generally implies positive terms between which the difference is set up; but in language there are only differences without positive terms… The idea [signified] or phonic substance [signifier] that a sign contains is of less importance than the other signs that surround it.*

This not only means that a linguistic sign does not signify by itself, but that language is a system of which all units are interdependent. "I eat" and "I ate" have different meanings (though only one letter has shifted its position), but the signified of a temporal present in "I eat" can exist only if it is opposed to the signified of a temporal past in "I ate": one would simply not be able to identify (and thus understand) a linguistic sign if our mind did not compute its competitors within the system to which it belongs, quickly eliminating the ill-suitors while gauging the context of the utterance (for "I eat" is opposed not only to "I ate," but to "I gorge," "I bite," or even—leaving the semantic realm of food—"I sing," "I walk," and so forth). In short, the essential characteristic of any sign is to be what other signs are not. But, Saussure adds,

> *the statement that everything in language is negative is true only if the signified and the signifier are considered separately; when we consider the sign in its totality, we have something that is positive in own class.*

In other words, the acoustic signifier and the "conceptual" signified are negatively differential (they define themselves by what they are not), but a positive fact results from their combination, "the sole type of facts that language has," namely, the sign. Such a caveat might seem strange, given that everywhere else Saussure insisted on the *oppositional* nature of the sign: is he not suddenly reintroducing a substantive quality here, when all his linguistics rests on the discovery that "language is form and not substance"?

Everything revolves around the concept of *value*, one of the most complex and controversial concepts in Saussure. The sign is positive because it has a value determined by what it can be compared with and exchanged with within its own system. This value is absolutely differential, like the value of a hundred-dollar bill in relation to a thousand-dollar bill, but it confers on the sign "something positive." Value is an economic concept for Saussure; it permits the exchange of signs within a system, but it is also what prevents their perfect exchangeability with signs belonging to another system (the French word *mouton*, for example, has a

different value than the English *sheep* or *mutton*, because it means both the animal and its meat).

To explain his concept of value, Saussure invoked the metaphor of chess. If, during a game, a piece is lost, it does not matter what other piece replaces it provisionally; the players can arbitrarily choose any substitute they want, any object will do, and even, depending on their capacity to remember, the absence of an object. For it is the piece's function within a system that confers its value (just as it is the piece's position at each moment of the game that gives it its changing signification). "If you augment language by one sign," Saussure said, "you diminish in the same proportion the [value] of the others. Reciprocally, if only two signs had been chosen … all the [possible] significations would have had to be divided between these two signs. One would have designated one half of the objects, the other, the other half." The value of each of these two inconceivable signs would have been enormous.

Reading such lines, it comes as no surprise that Jakobson and the
▲ Russian Formalists had arrived at similar conclusions through a examination of Cubism—that of Picasso, in particular, who almost maniacally demonstrated the interchangeability of signs within his pictorial system, and whose play on the minimal act required to transform a head into a guitar or a bottle, in a series of collages
● he realized in 1913, seem a direct illustration of Saussure's pronouncement. This metaphoric transformation indicates that, *contra* Jakobson, Picasso is not bound to the metonymic pole. Instead, he seems to particularly relish composite structures that are both metaphoric and metonymic. A case in point is the 1944 sculpture of the *Bull's Head* [**2**], where the conjunction (metonymy) of a bicycle handlebar and seat produced a metaphor (the sum of these two bicycle parts are like a bull's head), but such swift transformations based on the two structuralist operations of substitution and combination are legion in his oeuvre. Which is to say that Picasso's Cubism was a "structuralist activity," to use Barthes's phrase: it not only performed a structural analysis of the figurative tradition of Western art, but it also structurally engineered new objects.

An example is Picasso's invention of what one could call space as a new sculptural material. The fact that the Cubist constructions Picasso created in 1912–13 represent a key moment in the history of sculpture has long been recognized, but the means through which Picasso articulated space anew are not always understood. To make a story short: until Picasso's 1912 *Guitar* [**3**], Western sculpture, either carved or cast, had either consisted in a mass, a volume that detached itself from a surrounding space conceived as neutral, or retreated to the condition of bas-relief. Helped by his discovery of African art, Picasso realized that Western sculpture was paralyzed by a fear of being swallowed by the real space of objects (in the post-Renaissance system of representation, it was essential that art remained securely roped off from the world in an ethereal realm of illusions). Rather than attempting to discard the rope altogether, as Marcel Duchamp would soon do in his ready-
■ mades, Picasso answered the challenge by making space one of sculpture's materials. Part of the body of his *Guitar* is a virtual

2 • Pablo Picasso, *Bull's Head*, 1942
Assemblage (bicycle seat and handlebars),
33.5 × 43.5 × 19 (13¼ × 17⅛ × 7½)

Although he never read Saussure, Picasso discovered in his own visual terms what the father of structural linguistics had labeled the "arbitrariness of the sign." Given that signs are defined by their opposition to other signs within a given system, anything can stand for anything else if it conforms to the rules of the system in question. Using the handlebar and seat of a bicycle, Picasso remains within the realm of representation, defining the minimum required for a combination of disparate elements to be read as the horned head of a bull, while at the same time demonstrating the metaphoric power of assemblage.

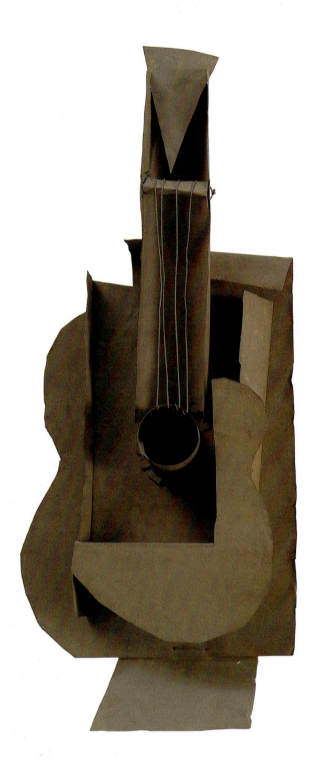

3 • Pablo Picasso, *Guitar*, Fall 1912
Construction of sheet metal, string, and wire,
77.5 × 35 × 19.3 (30½ × 13¾ × 7⅝)

For structuralism, signs are oppositional and not
substantial, which is to say that their shape and
signification are solely defined by their difference from all
other signs in the same system, and that they would mean
nothing in isolation. By the sheer contrasting juxtaposition
of void and surface in this sculpture, which marks the birth
of what would be called "Synthetic Cubism," whose major
formal invention would be collage, Picasso transforms a
void into a sign for the skin of a guitar and a protruding
cylinder into a sign for its hole. In doing so, he makes a
nonsubstance—space—into a material for sculpture.

volume whose external surface we do not see (it is immaterial) but that we intuit through the position of other planes. Just as Saussure had discovered with regard to linguistic signs, Picasso found that sculptural signs did not have to be substantial. Empty space could easily be transformed into a differential mark, and as such combined with all kinds of other signs: no longer fear space, Picasso told his fellow sculptors, shape it.

As Jakobson has noted, however, Cubism is a "special case" in which devices can be separated out (in a Cubist painting shading is emphatically independent from contour, for example), and few artists in this century were as good structuralists as Picasso was during his Cubist years. Another candidate proposed ▲ by structuralist critics was Piet Mondrian (1872–1944). Indeed, in deliberately reducing his pictorial vocabulary to very few elements, from 1920 on—black horizontal and vertical lines, planes of primary colors and of "noncolors" (white, black, or gray)—and in producing an extremely various oeuvre within such limited parameters [**4**], Mondrian demonstrated the combinatory infinitude of any system. In Saussurean terminology, one could say that because the new pictorial *langue* that he created consisted in a handful of elements and rules ("no symmetry" was one of them), the range of possibilities proceeding from such a Spartan language (his *parole*) became all the more apparent. He had limited the corpus of possible pictorial marks within his system, but this very limitation immensely accrued their "value."

Despite the fact that Mondrian seems to be a structuralist *avant la lettre* it is not the structural type of formal analysis, but rather the morphological one, that was first proposed in the study of his art. This morphological formalism, mainly concerned with Mondrian's compositional schemes, remained impressionistic in nature, though it gave us excellent descriptions of the balance or imbalance of planes in his works, the vividness of the colors, the rhythmic staccato. In the end this approach remained tautological, especially in its blunt refusal to discuss "meaning," and it is not by chance that an iconographic, Symbolist interpretation was long thought preferable, even though it ran counter to what the artist himself had to say.

A structural reading of Mondrian's work began to emerge only in the seventies. It examines the semantic function played by various combinations of pictorial elements as Mondrian's work evolved and seeks to understand how a seemingly rigid formal system engendered diverse significations. Rather than assigning a fixed meaning to these elements, as the Symbolist interpretation had wanted to do, it is able to show, for example, that from the early thirties, the "Neoplastic" pictorial vocabulary that he had coined in 1920 and used ever since was transformed into a self-destructive machine destined to abolish not only the figure, as he had done before, but color planes, lines, surfaces, and by extension every possible identity—in other words, that Mondrian's art elicited an epistemological nihilism of ever-growing intensity. In short, if art critics and historians had been more acutely attentive to the formal development of his oeuvre, they might have earlier

▲ 1913, 1917a, 1944a

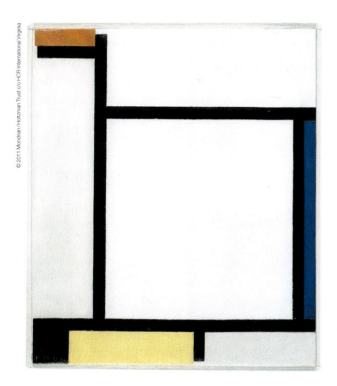

on grasped the connection he felt more inclined to make in his writings, from 1930, between what he tried to achieve pictorially and the political views of anarchism. By the same token, however, they would have understood that if his classic Neoplastic work had been governed by a structural ethos, during the last decade of his life this ethos was geared toward the deconstruction of the set of binary oppositions upon which his art had been based: they would have perceived that, like Barthes, Mondrian had began as a practitioner of structuralism only to become one of its most formidable assailants. But they would have had to be versed in structuralism itself to diagnose his attack.

Two aspects of Mondrian's art after 1920 explain why his art became an ideal object for a structuralist approach: first, it was a closed corpus (not only was the total output small, but as noted above, the number of pictorial elements he used were in a finite number); second, his oeuvre was easily distributed into series. The two first methodological steps taken in any structural analysis are the definition of a closed corpus of objects from which a set of recurrent rules can be deduced, and, within this corpus, the taxonomic constitution of series—and it is indeed only after the multiple series scanning Mondrian's oeuvre had been properly mapped that a more elaborate study of the signification of his works became possible. But what a structural analysis can do with the production of a single artist, it can also do at the microlevel of the single work, as the Russian Formalists or Barthes have amply shown, or at the macrolevel of a whole field, as Claude Lévi-Strauss has demonstrated in his studies of vast ensembles of myths. The method remains the same, only the scale of the object of inquiry changes: in each case, discrete "units" have to be distinguished so that their interrelationship can be understood, and their oppositional signification emerge.

The method has indeed its limits, for it presupposes the internal coherence of the corpus of analysis, its unity—which is why it yields its best results when dealing with a single object or with a series that remains limited in range. Through a forceful critique of the very notions of internal coherence, closed corpus, and ▲ authorship, what is now called "poststructuralism," hand in hand ● with the literary and artistic practices labeled "postmodernist," would efficiently blunt the preeminence that structuralism and formalism had enjoyed in the sixties. But, as numerous entries in this volume make clear, the heuristic power of structural and formalist analysis, especially with regard to the canonical moments of modernism, need not be discarded.

4 • Piet Mondrian, *Composition with Red, Blue, Black, Yellow, and Gray*, 1921
Oil on canvas, 39.5 × 35 cm (15½ × 13¾)

Permutation and combination are the means by which any discourse is generated and as such they constitute the two main aspects of what Barthes called the "structuralist activity." In these two canvases, Mondrian checks, just as a scientist would do, if and how our perception of a central square changes according to the modifications of its surroundings.

FURTHER READING

Roland Barthes, *Mythologies* (1957), trans. Annette Lavers (New York: Noonday Press, 1972)
Roman Jakobson, "What is Poetry?" (1933) and "Two Aspects of Language and Two Types of Aphasic Disturbances" (1956), in Krystyna Pomorska and Stephen Rudy (eds.), *Language and Literature* (Cambridge, Mass.: Harvard University Press, 1987)
Fredric Jameson, *The Prison-House of Language: A Critical Account of Structuralism and Russian Formalism* (Princeton: Princeton University Press, 1972)
Thomas Levin, "Walter Benjamin and the Theory of Art History," *October*, no. 47, Winter 1988
Ferdinand de Saussure, *Course in General Linguistics* (New York: McGraw-Hill, 1966)

Yve-Alain Bois

▲ Introduction 4 ● 1972c, 1977a, 1984b

4 Poststructuralism and deconstruction

Throughout the sixties, youthful ideals measured against official cynicism created a collision course that climaxed in the uprisings of 1968, when, in reaction to the Vietnam War, student movements throughout the world—in Berkeley, Berlin, Milan, Paris, Tokyo—erupted into action. A student leaflet circulating in Paris in May 1968 declared the nature of the conflict:

We refuse to become teachers serving a mechanism of social selection in an educational system operating at the expense of working-class children, to become sociologists drumming up slogans for governmental election campaigns, to become psychologists charged with getting "teams of workers" to "function" according to the best interests of the bosses, to become scientists whose research will be used according to the exclusive interests of the profit economy.

Behind this refusal was the accusation that the university, long thought to be the precinct of an autonomous, disinterested, "free" search for knowledge, had itself become an interested party to the kind of social engineering the leaflet imputed to both government and industry.

The terms of this indictment and its denial that discrete social functions—whether intellectual research or artistic practice—could be either autonomous or disinterested could not fail to have repercussions beyond the boundaries of the university. They imme-
▲ diately affected the art world as well. In Brussels, for example, Marcel Broodthaers (1924–76) and other Belgian artists joined their student confreres by occupying the Salle de Marbre of the Palais des Beaux-Arts and temporarily "liberating" it from its former administration into their own control. Furthermore, in a gesture that was also patterned on the action of the student movements, Broodthaers coauthored statements that were released to the public in leaflet form. One of them announced, for example, that the Free Association (as the occupiers identified themselves) "condemns the commercialization of all forms of art considered as objects of consumption." This form of public address, which he had used since 1963, was then to become increasingly the basis of his work, which he was to carry out in the name of a fictitious museum, the "Musée d'Art Moderne," under the aegis of which

he would mount a dozen sections—such as the "Section XIXème siècle ("Nineteenth-Century Section") and the "Département des Aigles" (Department of Eagles) [1]—and in the service of which he addressed the public through a series of "Open Letters." The former separations within the art world—between producers (artists) and distributors (museums or galleries), between critics and makers, between the ones who speak and the ones who are spoken for—were radically challenged by Broodthaers's museum, an operation that constantly performed a parodic but profound meditation on the vectors of "interest" that run through cultural institutions, as far-from-disinterested accessories of power.

This attitude of refusing the subordinate posture as the one who is spoken for by seizing the right to speak, and consequently of challenging the institutional and social divisions that support these separations of power, had other sources of entitlement besides student politics. There was also the reevaluation of the premises, the suppositions, of the various academic disciplines collectively called the human sciences that crystallized around the time of 1968 into what has been termed poststructuralism.

There is no "disinterest"

▲ Structuralism—the dominant French methodological position against which poststructuralism rebelled—had viewed any given human activity—language, for example, or kinship systems within a society—as a rule-governed system that is a more or less autonomous, self-maintaining structure, and whose laws operate according to certain formal principles of mutual opposition. This idea of a self-regulating structure, one whose ordering operations are formal and reflexive—that is, they derive from, even while they organize, the material givens of the system itself—can clearly be mapped onto the modernist conception of the different and separate artistic disciplines or mediums. And insofar as this parallel obtains, the intellectual and theoretical battles of 1968 are highly relevant to the developments in the world of art in the seventies and eighties.

Poststructuralism grew out of a refusal to grant structuralism its premise that each system is autonomous, with rules and operations that begin and end *within* the boundaries of that system. In

1 • Marcel Broodthaers, "Musée d'Art Moderne, Département des Aigles, Section des Figures (The Eagle from the Oligocene to the Present)," 1972
Installation view

As director of his museum, Broodthaers organized its "Section Publicité" for Documenta, as well as exhibitions of particular richness for other museums, this one for the Städtische Kunsthalle, Düsseldorf, in 1972. A collection of diverse objects, the eagles included were drawn from mass-cultural material (for example, the stamps on champagne corks) as well as precious objects (such as Roman *fibulae*), all of them captioned "This is not a work of art." As Broodthaers explained in the catalogue, the caption marries the ideas of Duchamp (the readymade) to those of Magritte (his deconstructive "This is not a pipe," as in the inscription on *The Treachery of Images* of 1929). The museum department responsible for this exhibition was the "Section des Figures" (Illustrations Section).

linguistics, this attitude expanded the limited study of linguistic structures to those modes through which language issues into action, the forms called *shifters* and *performatives*. Shifters are words like "I" and "you," where the referent of "I" (namely, the person who utters it) shifts back and forth in a conversation. Performatives are those verbal utterances that, by being uttered, literally enact their meaning, such as when a speaker announces "I do" at the moment of marriage. Language, it was argued, is not simply a matter of the transmission of messages or the communication of information; it also places the interlocutor under the obligation to reply. It therefore imposes a role, an attitude, a whole discursive system (rules of behavior and of power, as well as of coding and decoding) on the receiver of the linguistic act. Quite apart from the content of any given verbal exchange, then, its very enactment implies the acceptance (or rejection) of the whole institutional frame of that exchange—its "presuppositions," as linguistics student Oswald Ducrot, early in 1968, called them:

> The rejection of presuppositions constitutes a polemical attitude very different from a critique of what is set forth: specifically, it always implies a large dose of aggressiveness that transforms the dialogue into a confrontation of persons. In rejecting the presuppositions of my interlocutor, I disqualify not only the utterance itself, but also the enunciative act from which it proceeds.

One form of post-1968 rejection of presuppositions was that French university students now insisted on addressing their professors with the intimate form of the second person—"*tu*"—and by their first names. They based this on the university's own abrogation of presuppositions when it called in the police (which historically had no jurisdiction within the walls of the Sorbonne) to forcibly evict the student occupiers.

Unlike the idea of the autonomous academic discipline (or work of art) whose frame is thought to be necessarily external to it—a kind of nonessential appendage—the performative notion of language places the frame at the very heart of the speech act. For the verbal exchange, it was being argued, is from the very beginning the act of imposing (or failing to impose) a set of presuppositions on the receiver of that exchange. Speech is thus more than the simple (and neutral) transmission of a message. It is also the enactment of a relation of force, a move to modify the addressee's right to speak. The examples Ducrot used to illustrate the presuppositional imposition of power were a university exam and a police interrogation.

Challenging the frame

The French structural linguist Émile Benveniste (1902–76) had already done more than anyone else to bring about this transformation in the way language came to be viewed in the sixties. Dividing types of verbal exchange into *narrative* on the one hand and *discourse* on the other, he pointed out that each type has its

2 • Daniel Buren, Photo-souvenir: *"Within and beyond the frame,"* 1973 (detail)
Work in situ, John Weber Gallery, New York

By the early seventies Buren had reduced his painting practice to a type of readymade: canvases cut from commercially produced gray-and-white striped awning material (used for the awnings on French state office buildings) which he would "personalize" by hand-painting over one of the stripes at the edge of the swatch. For the John Weber installation, he ran the canvases through the gallery and out the window across the width of the street—as a kind of bannerlike advertisement for the exhibition.

own characteristic features: narrative (or the writing of history) typically engages the third person and confines itself to a form of the past tense; in contrast, discourse, Benveniste's term for live communication, typically engages the present tense and the first and second persons (the shifters "I" and "you"). Discourse is marked, then, by the existential facts of its active transmission, of the necessary presence within it of both sender and receiver.

The French historian and philosopher Michel Foucault, teaching at the Collège de France in 1969, developed this idea further. Applying Benveniste's term "discourse" to what had always been understood as the neutral communication of scholarly information contained within a given departmental discipline and—like narrative—confined to the transmission of "objective" information, Foucault took up the contrary position that "discourses" are always charged from within by power relations, and even by the exercise of force. Knowledge, according to this argument, ceases to be the autonomous contents of a discipline and now becomes *disciplinary*—that is, marked by the operations of power. Foucault's "discourse," then, like Ducrot's "presuppositions," is an acknowledgment of the discursive frame that shapes the speech event, institutionally, like the relations of power that operate in a classroom or a police station.

▲ Broodthaers's seizing of the right to speak, in his guise as "museum director," performed the kind of challenge to institutional frames that poststructuralists such as Foucault were then theorizing. Indeed, Broodthaers made his work out of those very frames, by enacting the rituals of administrative compartmentalization and by parodying the way those compartments in turn create collections of "knowledge." And as the frames were made to become apparent, not outside the work but at its very center, what indeed took place was the putting of "the very legitimacy of the given speech act at stake."

• Under each of the Museum's exhibits, the Department of Eagles affixed the Magrittean label: "This is not a work of art."

Broodthaers was not alone in this decision to make artistic practice out of the framing, as it were, of the institutional frames. Indeed, the whole practice of what came to be called "institutional critique" derived from such a practice—calling attention to the supposedly neutral containers of culture and questioning this

■ putative neutrality. The French artist Daniel Buren, for instance, adopted a strategy to challenge the power of the frames by refusing to leave their presuppositions alone, implicit, unremarked. Instead, his art, emerging in the seventies, was one of marking all those divisions through which power operates. In 1973 he exhibited *Within and beyond the frame* [2]. A work in nineteen sections, each a suspended gray-and-white-striped canvas (unstretched and unframed), Buren's "painting" extended almost two hundred feet, beginning at one end of the John Weber Gallery in New York and gaily continuing out the window to wend its way across the street, like so many flags hung out for a parade, finally attaching itself to the building opposite. The frame referred to in the title of the work was, obviously, the institutional frame of the gallery, a frame that functions to guarantee certain things about the objects it encloses.

▲ 1972a ● 1927a, 1972a ■ 1967c, 1971

3 • Robert Smithson, *A Non-site*
(Franklin, New Jersey), 1968

Painted wooden bins, limestone, silver-gelatin prints and typescript on paper with graphite and transfer letters, mounted on mat board. Bins installed 41.9 × 208.9 × 261.6 (16½ × 82¼ × 103); frames 103.5 × 78.1 (40¾ × 30¾).

Smithson's *Non-sites* have been productively related to the dioramas in the Museum of Natural History in New York, in which samples of the natural world are imported into the Museum as exhibits that necessarily contaminate the "purity" of the aesthetic space. The bins or containers of his *Non-sites* comment ironically on Minimalism, accusing it of an aestheticism that Minimalist artists like Donald Judd and Robert Morris would have energetically denied.

These things—like rarity, authenticity, originality, and uniqueness—are part of the value of the work implicitly asserted by the space of the gallery. These values, which are part of what separates art from other objects in our culture, objects that are neither rare, nor original, nor unique, operate then to declare art as an autonomous system within that culture.

Yet rarity, uniqueness, and so forth are also the values to which the gallery attaches a price, in an act that erases any fundamental difference between what it has to sell and the merchandise of any other commercial space. As the identically striped paintings (themselves barely distinguishable from commercially produced awnings) breached the frame of the gallery to pass beyond its confines and out the window, Buren seemed to be asking the viewer to determine at what point they ceased being "paintings" (objects of rarity, originality, etc.) and started being part of another system of objects: flags, sheets hung out to dry, advertisements for the artist's show, carnival bunting. He was probing, that is, the legitimacy of the system's power to bestow value on work.

▲ The question of frames was also at the heart of Robert Smithson's thinking about the relation between the landscape, or natural site, to its aesthetic container, which the artist labeled "non-site." In a series of works called *Non-sites*, Smithson imported mineral material—rocks, slag, slate—from specific locations into the space of the gallery by placing this material into geometrically shaped bins, each one visually connected, by means of its form, to a segment of a wall map indicating the area of the specimens' origin [3]. The obvious act of aestheticizing nature, and of turning the real into a representation of itself through the operations of the geometrical bin to construct the raw matter of the rocks into a sign—trapezoid—that comes to "stand for" the rocks' point of extraction, and thus for the rocks themselves, is what Smithson consigns to the system of the art world's spaces: its galleries, its museums, its magazines.

The ziggurat-like structures of Smithson's bins and maps might imply that it was only an ironic formal game that was at issue in this aspect of his art. But the graduated bins were also addressing a kind of natural history that could be read in the landscape, the successive stages of extracting the ore from the initial bounty, to the progressive barrenness, to a final exhaustion of supply. It was this natural history that could not be represented within the frames of the art world's discourse, concerted as it is to tell quite another story—one of form, of beauty, of *self*-reference. Therefore, part of Smithson's strategy was to smuggle another, foreign mode of representation into the frame of the gallery, a mode he took, in fact, from the natural history museum, where rocks and bins and maps are not freakish, aestheticized abstractions but the basis of an altogether different system of knowledge: a way of mapping and containing ideas about the "real."

The effort to escape from the aesthetic container, to break the chains of the institutional frame, to challenge the assumptions (and indeed the implicit power relations) established by the art world's presuppositions was thus carried out in the seventies in

▲ 1967a, 1970

By going out into the landscape for the materials of his *Non-sites*, Smithson introduced the idea that the landscape itself might be a sculptural medium. Earthworks were a result of this suggestion, in which artists such as Long, Walter De Maria, Christo, or Michael Heizer operated directly on the earth, often making photographic records of their activities. This dependence on the photographic document was the confirmation of Walter Benjamin's predictions in the 1936 essay "The Work of Art in the Age of Mechanical Reproduction."

relation to specific sites—gallery, museum, rock quarry, Scottish Highlands, California coast—which the work of art functioned to *reframe*. This act of reframing was meant to perform a peculiar kind of reversal. The old aesthetic ideas that the sites used to frame (although invisibly, implicitly) now hovered over these real places like so many exorcised ghosts, while the site itself—its white walls, its neoclassical porticos, its picturesque moors, its rolling hills and rocky outcroppings [4]—became the material support (the way paint and canvas or marble and clay used to be) for a new kind of representation. This representation was the image of the institutional frames themselves, now forced into visibility as though some kind of powerful new developing fluid had unlocked previously secret information from an inert photographic negative.

Derrida's double session

Jacques Derrida (1930–2004), a philosopher teaching at the École Normale Supérieure in Paris, seized upon Benveniste's and Foucault's radicalization of structural linguistics to fashion his own brand of poststructuralism. He started out from the very terms of structuralism itself, in which language is marked by a fundamental bivalency at the heart of the linguistic sign. According to structuralist logic, while the sign is made up of the pairing of signifier and

▲ Introduction 3

signified, it is the signified (the referent or concept, such as a cat or the idea of "cat") that has privilege over the mere material form of the signifier (the spoken or written letters *c, a, t*). This is because the relationship between signifier and signified is arbitrary: there is no reason why *c, a, t* should signify "catness"; any other combination of letters could do the job just as well, as the existence of different words for "cat" in different languages demonstrates ("*chat,*" "*gatto,*" "*Katze,*" etc.).

But this inequality between signifier and signified is not the only one at the heart of language. Another feature to emerge from the structuralist model is the unevenness of terms that make up opposing binary pairs such as "young/old" or "man/woman." This inequality is between a *marked* and an *unmarked* term. The marked half of the pair brings more information into the utterance than the unmarked half, as in the binary "young/old" and the statement "John is as young as Mary." "As young as" here implies youth, whereas "John is as old as Mary" implies neither youth nor advanced age. It is the unmarked term which opens itself to the higher order of synthesis most easily, a condition that becomes clear if we look at the binary "man/woman," in which it is "man" that is the unmarked half of the pair (as in "mankind," "chairman," "spokesman," etc.).

That the unmarked term slips past its partner into the position of greater generality gives that term implicit power, thus instituting a hierarchy within the seemingly neutral structure of the binary pairing. It was Derrida's determination not to continue to let this inequality go without saying, but rather to say it, to "mark" the unmarked term, by using "she" as the general pronoun indicating a person, and—in the theorization of "grammatology" (see below)—to put the signifier in the position of superiority over the signified. This marking of the unmarked Derrida called "*deconstruction,*" an overturning that makes sense only within the very structuralist frame that it wants to place at the center of its activity by framing that frame.

Derrida's extremely influential book *Of Grammatology* (1967) proceeded from such a deconstructive operation to mark the unmarked, and thus to expose the invisible frame to view. If we compare the status of "he says" to that of "he writes," we see that "says" is unmarked, while "writes," as the specific term, is thus marked. Derrida's "grammatology" intends to mark speech (*logos*) and thus to overturn this hierarchy, as well as to analyze the sources of speech's preeminence over writing. This analysis had begun with Derrida's doctoral thesis, *Speech and Phenomenon,* in which he analyzed the phenomenologist Edmund Husserl's (1859–1938) dismissal of writing as an infection of the transparency and immediacy of thought's appearance to itself. And as he analyzed the privilege of *logos* over the dismissed sign of the memory trace (writing, *grammé*), Derrida developed the logic of what he called the *supplement,* an aid brought in to help or extend or supplement a human capacity—as writing extends memory or the reach of the human voice—but which, ironically, ends by supplanting it. Such a hierarchy is also behind the Derridean term

différance, itself aurally indistinguishable from *différence,* the French word for that difference on which language is based. *Différance,* which can only be perceived in its written form, refers, precisely, to writing's operation of the trace and of the break or spacing that opens up the page to the articulation of one sign from another. This spacing allows not only for the play of difference between signifiers that is the basis of language ("cat," for example, can function as a sign and assume its value in the language system only because it *differs* from "bat" and from "car"), but also for the temporal unfolding of signifieds (meaning being elaborated in time through the gradual iteration of a sentence): *différance* not only differs, then, it also defers, or temporalizes.

If deconstruction is the marking of the unmarked, which Derrida sometimes called the *re-mark,* its striving to frame the frames took the analytical form of the essay "The Parergon," which attends to Immanuel Kant's major treatise "The Critique of Judgment" (1790), a treatise that not only founds the discipline of aesthetics but also powerfully supplies modernism with its conviction in the possibility of the autonomy of the arts—the art work's self-grounding and thus its independence from the conditions of its frame. For Kant argues that "Judgment," the outcome of aesthetic experience, must be separate from "Reason"; it is not dependent on cognitive judgment but must reveal, Kant argues, the paradoxical condition of "purposiveness without purpose." This is the source of art's autonomy, its disinterestedness, its escape from use or instrumentalization. Reason makes use of concepts in its purposive pursuit of knowledge; art, as self-grounding, must abjure concepts, reflecting instead on the sheer purposiveness of nature as a transcendental concept (and thus containing nothing empirical). Kant argues that the logic of the work (the *ergon*) is internal (or proper) to it, such that what is outside it (the *parergon*) is only extraneous ornament and, like the frame on a painting or the columns on a building, mere superfluity or decoration. Derrida's argument, however, is that Kant's analysis of aesthetic judgment as self-grounding is not itself self-grounding but imports a frame from the writer's earlier essay "The Critique of Pure Reason" (1781), a cognitive frame on which to build its transcendental logic. Thus the frame is not extrinsic to the work but comes from *outside* to constitute the inside as an inside. This is the parergonal function of the frame.

Derrida's own reframing of the frame was perhaps most eloquently carried out in his 1969 text "The Double Session," referring to a double lecture he gave on the work of the French poet Stéphane Mallarmé (1842–98). The first page of the essay shows Derrida's almost modernist sensitivity to the status of the signifier, a sensitivity that parallels the poststructuralist's canny assessment of the "truths" of structuralism **[5]**. Like a modernist monochrome, the page presents itself as a buzz of gray letters as it reproduces a page from the Platonic dialogue "Philebus," a dialogue devoted to the theory of mimesis (representation, imitation). Into the lower-right corner of this field of gray, however, Derrida inserts another text, also directed at the idea of mimesis: Mallarmé's "Mimique,"

SOCRATES: And if he had someone with him, he would put what he said to himself into actual speech addressed to his companion, audibly uttering those same thoughts, so that what before we called opinion (δόξαν) has now become assertion (λόγος).—PROTARCHUS: Of course.—SOCRATES: Whereas if he is alone he continues thinking the same thing by himself, going on his way maybe for a considerable time with the thought in his mind.—PROTARCHUS: Undoubtedly.—SOCRATES: Well now, I wonder whether you share my view on these matters.—PROTARCHUS: What is it?—SOCRATES: It seems to me that at such times our soul is like a book (Δοκεῖ μοι τότε ἡμῶν ἡ ψυχὴ βιβλίῳ τινὶ προσεοικέναι).—PROTARCHUS: How so?—SOCRATES: It appears to me that the conjunction of memory with sensations, together with the feelings consequent upon memory and sensation, may be said as it were to write words in our souls (γράφειν ἡμῶν ἐν ταῖς ψυχαῖς τότε λόγους). And when this experience writes what is true, the result is that true opinion and true assertions spring up in us, while when the internal scribe that I have suggested writes what is false (ψευδῆ δ᾽ ὅταν ὁ τοιοῦτος παρ᾽ ἡμῖν γραμματεὺς γράψῃ), we get the opposite sort of opinions and assertions.—PROTARCHUS: That certainly seems to me right, and I approve of the way you put it.—SOCRATES: Then please give your approval to the presence of a second artist (δημιουργὸν) in our souls at such a time.—PROTARCHUS: Who is that?—SOCRATES: A painter (Ζωγράφον) who comes after the writer and paints in the soul pictures of these assertions that we make.—PROTARCHUS: How do we make out that he in his turn acts, and when?—SOCRATES: When we have got those opinions and assertions clear of the act of sight (ὄψεως) or other sense, and as it were see in ourselves pictures or images (εἰκόνας) of what we previously opined or asserted. That does happen with us, doesn't it?—PROTARCHUS: Indeed it does.—SOCRATES: Then are the pictures of true opinions and assertions true, and the pictures of false ones false?—PROTARCHUS: Unquestionably.—SOCRATES: Well, if we are right so far, here is one more point in this connection for us to consider.—PROTARCHUS: What is that?—SOCRATES: Does all this necessarily befall us in respect of the present (τῶν ὄντων) and the past (τῶν γεγονότων), but not in respect of the future (τῶν μελλόντων)?—PROTARCHUS: On the contrary, it applies equally to them all.—SOCRATES: We said previously, did we not, that pleasures and pains felt in the soul alone might precede those that come through the body? That must mean that we have anticipatory pleasures and anticipatory pains in regard to the future.—PROTARCHUS: Very true.—SOCRATES: Now do those writings and paintings (γράμματά τε καὶ ζωγραφήματα), which a while ago we assumed to occur within ourselves, apply to past and present only, and not to the future?—PROTARCHUS: Indeed they do.—SOCRATES: When you say 'indeed they do', do you mean that the last sort are all expectations concerned with what is to come, and that we are full of expectations all our life long?—PROTARCHUS: Undoubtedly.—SOCRATES: Well now, as a supplement to all we have said, here is a further question for you to answer.

MIMIQUE

Silence, sole luxury after rhymes, an orchestra only marking with its gold, its brushes with thought and dusk, the detail of its signification on a par with a stilled ode and which it is up to the poet, roused by a dare, to translate! the silence of an afternoon of music; I find it, with contentment, also, before the ever original reappearance of Pierrot or of the poignant and elegant mime Paul Margueritte.

Such is this PIERROT MURDERER OF HIS WIFE composed and set down by himself, a mute soliloquy that the phantom, white as a yet unwritten page, holds in both face and gesture at full length to his soul. A whirlwind of naive or new reasons emanates, which it would be pleasing to seize upon with security: the esthetics of the genre situated closer to principles than any! (no)thing in this region of caprice foiling the direct simplifying instinct... This—"The scene illustrates but the idea, not any actual action, in a hymen (out of which flows Dream), tainted with vice yet sacred, between desire and fulfillment, perpetration and remembrance: here anticipating, there recalling, in the future, in the past, *under the false appearance of a present*. That is how the Mime operates, whose act is confined to a perpetual allusion without breaking the ice or the mirror: he thus sets up a medium, a pure medium, of fiction." Less than a thousand lines, the role, the one that reads, will instantly comprehend the rules as if placed before the stageboards, their humble depository. Surprise, accompanying the artifice of a notation of sentiments by unproffered sentences—that, in the sole case, perhaps, with authenticity, between the sheets and the eye there reigns a silence still, the condition and delight of reading.

175

5 • Jacques Derrida, *Dissemination*, trans. Barbara Johnson, page 175 ("The Double Session")

Derrida, whose deconstructive theory consisted of an assault on the visual—as a form of presence that his idea of spacing as an aspect of deferral (or *différance*) was meant to dismantle—often invented surprisingly effective visual metaphors for his concepts. Here, the insertion of Mallarmé's "Mimique" into a corner of Plato's "Philebus" suggests, visually, the idea of the fold, or redoubling, that Derrida produces as a new concept of mimesis, in which the double (or second-order copy) doubles no single (or original). Another example occurs in the essay "The Parergon," where a succession of graphic frames is interspersed throughout a text focused on the function of the frame of the work of art, a frame that attempts to essentialize the work as autonomous but which does nothing more than connect it to its context or nonwork.

the poet's account of a performance he saw carried out by a famous mime and based on the text "Pierrot, Murderer of His Wife." Behind Derrida, on the blackboard of the classroom, had appeared a three-fold introduction to the lecture, hanging above his words, he said, like a crystal chandelier:

> *l'antre de Mallarmé*
> *l'"entre" de Mallarmé*
> *l'entre-deux "Mallarmé"*

Because in French there is no aural distinction between *antre* and *entre*, this textual ornament depends on its written form in order to make any sense, in the same way that *différance* must be written in order to register *its* signified. This homophonic condition is itself "between-two," as in Mallarmé's "*entre-deux*," a between-ness that Derrida will liken to the fold in a page, a fold which turns the singleness of the material support into an ambiguous doubleness (a fold materialized in turn by the insertion of "Mimique" into the "Philebus" at its corner).

In the text of "The Double Session" itself, Derrida plays, like any good modernist, with the material condition of the numbers that emerge from Plato's and Mallarmé's definitions of mimesis. Plato's definition turns on the number four, while the poet's turns on the double, or the number two. And like any good modernist, Derrida materializes the classical foursome, understanding it as a frame: Plato says that (1) the book imitates the soul's silent dialogue with the self; (2) the value of the book is not intrinsic but depends on the value of what it imitates; (3) the truth of the book can be decided, based on the truthfulness of its imitation; and (4) the book's imitation is constituted by the form of the double. Thus Platonic mimesis doubles what is single (or simple) and, being thus decidable, institutes itself within the operations of truth. Mallarmé's imitation, on the other hand, doubles what is already double or multiple and is, therefore, undecidable: between-two. The text of the mime-drama that Mallarmé recounts in "Mimique" tells of Pierrot's discovery of his wife Columbine's adultery, which he decides to avenge by killing her. Not wanting to be caught, however, he refuses the obvious possibilities of poison, strangling, or shooting, since all of them leave traces. After kicking a rock in frustration, he massages his foot to assuage the pain and inadvertently tickles himself. In his helpless laughter, the idea dawns on him that he will tickle Columbine to death and she will thus die laughing. In the performance, the actual murder is mimed with the actor playing both parts: the diabolical tickler and the convulsively struggling victim, writhing with pleasure. Since such a death is impossible, the imitation imitates not what is simple but rather a multiple, itself a pure function of the signifier, a turn of speech ("to die laughing"; "to be tickled to death"), rather than of actuality. As Mallarmé writes: "The scene illustrates only the idea, not a positive action, in a marriage that is lewd but sacred, a marriage between desire and its achievement, enactment and its memory: here, anticipating, recollecting, in the future, in the past, under a

false appearance of the present. In this way the mime acts. His
game ends in a perpetual allusion without breaking the mirror. In
this way it sets up a pure condition of fiction."

Imitation that folds over what is already double, or ambiguous,
does not, then, enter the realm of truth. It is a copy without a
model and its condition is marked by the term *simulacrum*: a copy
without an original—"a false appearance of the present." The fold
through which the Platonic frame is transmuted into the
Mallarméan double (or between-two) is likened by both poet and
philosopher to the fold or gutter of a book, which in its crevice was
always sexualized for Mallarmé, hence his term "lewd but sacred."
This is the fold—"false appearance of the present"—that Derrida
will call *hymen*, or will refer to at times as "invagination," by which
the condition of the frame will be carried into the inside of an
argument, which will, in turn, frame it.

Art in the age of the simulacrum

Terms like *parergon*, *supplement*, *différance*, and *re-mark* grounded
new artistic practice in the wake of modernism. All of these ideas—
from the simulacrum to the framing of the frame—became the
staple not just of poststructuralism but of postmodernist painting.
David Salle, who is perhaps most representative of that painting,
developed in a context of young artists who were highly critical
of art's traditional claims to transcend mass-cultural conditions.
This group—initially including figures like Robert Longo, Cindy
▲ Sherman, Barbara Kruger, Sherrie Levine, and Louise Lawler [**6**]
—was fascinated by the reversal between reality and its represent-
ation that was being effected by a late-twentieth-century culture of
information.

Representations, it was argued, instead of coming *after* reality,
in an imitation of it, now precede and construct reality. Our "real"
emotions imitate those we see on film and read about in pulp
romances; our "real" desires are structured for us by advertising
images; the "real" of our politics is prefabricated by television news
and Hollywood scenarios of leadership; our "real" selves are
congeries and repetition of all these images, strung together by
narratives not of our own making. To analyze this structure of the
representation that precedes its referent (the thing in the real
world it is supposed to copy) would cause this group of artists to
ask themselves probing questions about the mechanics of the
image-culture: its basis in mechanical reproduction, its function as
serial repetition, its status as multiple without an original.

"Pictures" was the name given to this work in an early reception
of it by the critic Douglas Crimp. There, for example, he examined
• the way Cindy Sherman, posing for a series of photographic "self-
portraits" in a variety of different costumes and settings, each with
the look of a fifties movie still and each projecting the image of a
stereotypical film heroine—career girl, highly strung hysteric,
Southern belle, outdoor girl—had projected her very self as always
mediated by, always constructed through, a "picture" that preceded
it, thus a copy without an original. The ideas that Crimp and other

critics versed in theories of poststructuralism came to identify with such work involved a serious questioning of notions of authorship, originality, and uniqueness, the foundation stones of institutionalized aesthetic culture. Reflected in the facing mirrors of Sherman's photographs, creating as they did an endlessly retreating horizon of quotation from which the "real" author disappears, these critics saw what Michel Foucault and Roland Barthes had analyzed in the fifties and sixties as "the death of the author."

The work of Sherrie Levine was set in this same context, as she rephotographed photographs by Elliot Porter, Edward Weston, and Walker Evans and presented these as her "own" work, questioning by her act of piracy the status of these figures as authorial sources of the image. Folded into this challenge is an implicit reading of the "original" picture—whether Weston's photographs of the nude torso of his young son Neil, or Porter's wild technicolor landscapes—as itself always already a piracy, involved in an unconscious but inevitable borrowing from the great library of images—the Greek classical torso, the windswept picturesque countryside—that have already educated our eyes. To this kind of radical refusal of traditional conceptions of authorship and originality, a critical stance made unmistakable by its position at the margins of legality, the name "appropriation art" has come to be affixed. And this type of work, building a critique of forms of ownership and fictions of privacy and control came to be identified as postmodernism in its radical form.

The question of where to place this widely practiced, eighties tactic of "appropriation" of the image—whether in a radical camp, as a critique of the power network that threads through reality, always already structuring it, or in a conservative one, as an enthusiastic return to figuration and the artist as image-giver—takes on another dimension when we view the strategy through the eyes of feminist artists. Working with both photographic material appropriated from the mass-cultural image bank and the form of direct address to which advertising often has recourse—as it cajoles, or hectors, or preaches to its viewers and readers, addressing them as "you"—Barbara Kruger elaborates yet another of the presuppositions of the aesthetic discourse, another of its institutional frames. This is the frame of gender, of the unspoken assumption set up between artist and viewer that both of them are male. Articulating

▲ this assumption in a work like *Your gaze hits the side of my face* (1981), where the typeface of the message appears in staccato against the image of a classicized female statue, Kruger fills in another part of the presuppositional frame: the message transmitted between the two poles classical linguistics marks as "sender" and "receiver," and assumes is neutral but presupposes as male, is a message put in play by something we could call an always-silent partner, namely, the symbolic form of Woman. Following a poststructuralist linguistic analysis of language and gender, Kruger's work is therefore interested in woman as one of those subjects who do not speak but is, instead, always spoken for. She is, as critic Laura Mulvey writes, structurally "tied to her place as bearer of meaning, not maker of meaning."

This is why Kruger, in this work, does not seize the right to speech the way that Broodthaers had in his open letters but turns instead to "appropriation." Woman, as the "bearer of meaning" is the locus of an endless series of abstractions—she is "nature," "beauty," "motherland," "liberty," "justice"—all of which form the cultural and patriarchal linguistic field; she is the reservoir of meanings from which statements are made. As a woman artist, Kruger acknowledges this position as the silent term through her act of "stealing" her speech, of never laying claim to having become the "maker of meaning."

This question of the woman's relation to the symbolic field of speech and the meaning of her structural dispossession within that field has become the medium of other major works by feminists. One of these, Mary Kelly's *Post-Partum Document* (1973–9), tracks the artist's own connection to her infant son through five years of his development and the 135 exhibits that record the mother–child relationship. This recording, however, is carried on explicitly along the fault line of the woman's experience of the developing autonomy of the male-child as he comes into possession of language. It wants to examine the way the child himself is fetishized by the mother through her own sense of lack.

Two kinds of absences structure the field of aesthetic experience at the end of the twentieth century and into the twenty-first. One of them we could describe as the absence of reality itself as it retreats behind the miragelike screen of the media, sucked up into the vacuum tube of a television monitor, read off like so many printouts from a multinational computer hook-up. The other is the invisibility of the presuppositions of language and of institutions, a seeming absence behind which power is at work, an absence which artists from Mary Kelly, Barbara Kruger, and

• Cindy Sherman to Hans Haacke, Daniel Buren, and Richard Serra attempt to bring to light.

FURTHER READING

Roland Barthes, *Critical Essays*, trans. Richard Howard (Evanston: Northwestern University Press, 1972)

Roland Barthes, *Image, Music, Text*, trans. Stephen Heath (New York: Hill and Wang, 1977)

Douglas Crimp, "Pictures," *October*, no. 8, Spring 1979

Jacques Derrida, *Of Grammatology*, trans. Gayatri Spivak (Baltimore: The Johns Hopkins University Press, 1976)

Jacques Derrida, "Parergon," *The Truth in Painting*, trans. Geoff Bennington (Chicago and London: University of Chicago Press, 1987)

Jacques Derrida, "The Double Session," *Dissemination*, trans. Barbara Johnson (Chicago and London: University of Chicago Press, 1981)

Michel Foucault, *The Archaeology of Knowledge* (Paris: Gallimard, 1969; translation London: Tavistock Publications; and New York: Pantheon, 1972)

Michel Foucault, "What is an Author?", *Language, Counter-Memory, Practice*, trans. D. Bouchard and S. Simon (Ithaca, N.Y.: Cornell University Press, 1977)

Mary Kelly, *Post-Partum Document* (London: Routledge & Kegan Paul, 1983)

Laura Mulvey, "Visual Pleasure and Narrative Cinema," *Visual and Other Pleasures* (Bloomington: Indiana University Press, 1989)

Craig Owens, "The Allegorical Impulse: Towards a Theory of Postmodernism," *October*, nos 12 and 13, Spring and Summer 1980

Ann Reynolds, "Reproducing Nature: The Museum of Natural History as Nonsite," *October*, no. 45, Summer 1988

Rosalind Krauss

▲ Introduction 1 ▲ 1975a ● 1967c, 1969, 1970, 1971, 1972b, 1993a

5 Globalization, networks, and the aggregate as form

Transregional cultural interchange is as old as human history. "Globalization," on the other hand, refers to a historically specific development typically dating from the period of the eighties and nineties, when financial markets were deregulated to an unprecedented degree through the economic policies known as neoliberalism. Under pressure from nongovernmental agencies such as the World Bank and the International Monetary Fund, many developing nations opened—or "liberalized"—markets in order to attract foreign investment, in the process exposing themselves to significant political influence from the West and to financial volatility arising from unsustainable levels of debt. The objective of these policies was to allow capital, including that of multinational corporations, to move more easily from place to place, in pursuit of the least expensive labor and the most profitable consumer markets. Garments sold in Europe and the United States, for instance, might be manufactured one year in China and the next in Pakistan under work conditions that would be unacceptable in the West, while outsourced business services could be provided from India to the entire English-speaking world. Culturally, globalization has led to two diametrically opposed conditions: first, homogenization or what is often called the "McDonaldization" of life; and second, greater diversity and heightened awareness of cultural difference on account of increased and accelerated contact between geographically distant regions. It is within the terms of this paradox—growing infrastructural homogeneity on the one hand, and expanded consciousness of cultural diversity on the other—that a globalized art world arises. Its contravening forces, one moving toward sameness and the other toward difference, need to be recognized and carefully addressed when approaching global contemporary art.

To do so, we must acknowledge the different chronologies of modern art's adoption in different parts of the world. The European avant-gardes of the early twentieth century, including ▲ Cubism, Constructivism, and Surrealism, were arguably devoted to representing and indeed critically challenging the experience of modernization's uneven development from the late nineteenth through the mid-twentieth centuries (including rapid industrialization and mass urbanization). In whole regions, including significant areas of Asia and Africa, modern European art was introduced as a belated, but hegemonic, or neocolonial language as opposed to a form of avant-garde protest. In these places, modern art was typically pressed into service as an agent of cultural and economic modernization rather than as an opponent to its many devastating consequences. In this regard, it seems ▲ no coincidence that international booms in Chinese and Russian contemporary art accompanied those nations' market liberalization in the late eighties and nineties. A thriving art market may serve as a bellwether of full-fledged membership in the neoliberal global economy, as well as a prestigious sign of cultural development attractive not only to tourists, but to foreign investment as well. When we refer to "modern art" or "contemporary art," then, we are eliding a wide range of distinct visual dialects, each with its own local histories and semantics. These may be mutually intelligible, but they nonetheless remain significantly different—and often even contradictory.

Not one but many histories

Let us consider one example of this complexity. During the Meiji Dynasty in Japan (1868–1912), two opposing types of painting emerged: *nihonga*, or Japanese-style painting [1], which arose in opposition to *yōga*, or Western-style painting using oil on canvas, which was informed by European movements like Impressionism and Postimpressionism [2]. While *nihonga* sought to preserve historically Japanese materials and themes, it may be seen as just as modern as *yōga* in its efforts to adapt traditional techniques to contemporary conditions. The opposition between modernized forms of indigenous traditions in *nihonga* and "indigenized" reinventions of modern European forms in *yōga* persisted through the mid-twentieth century in the underlying dynamic of one • of Japan's best-known post-World War II movements, Gutai, where the gesturalism associated with long traditions of ink drawing is scaled up in part as a riposte to Western practices ■ of Abstract Expressionism [3]. Although Gutai superficially resembles "American-type painting," Japanese artists at mid-century expressed significantly different attitudes toward matter and art than their American contemporaries, emphasizing the meeting of

▲ 1911, 1912, 1921a, 1921b, 1924, 1925a, 1926, 1927a, 1928a, 1930b, 1931a, 1934b, 1942b ▲ 1975b, 2010a ● 1955a ■ 1947b, 1949a, 1951

1 • Hishida Shunso, *Cat and Plum Blossoms*, 1906
Color on silk, hanging scroll, 1180 × 498 cm (46½ × 19⅝)

One of the leading proponents of the *nihonga* style, Shunso integrated the thousand-year-old traditions and conventions of Japanese art with a more modern concern for realism, typified by his use of gradations of color instead of the more restrictive monochrome line drawing of traditional Japanese painting.

2 • Kuroda Seiki, *Lakeside*, 1897
Oil on canvas, 69 × 84.7 cm (27¼ × 33⅜)

Meaning literally "Western-style painting," *yōga* encompassed work produced with a range of techniques, materials, and theories developed in the West, in contrast with the indigenous *nihonga* style. In particular, *yōga* artists such as Seiki, who studied in Paris for a decade from the mid-1880s, emulated the appearance of contemporary Impressionist and Postimpressionist painting from Europe and the United States. As such, the style represents one side of the two-way exchange of visual cultures between Japan and Europe in the second half of the nineteenth century.

3 • Gutai artists, overseen by Michel Tapié (left) and Jiro Yoshihara (right), preparing for the "International Sky Festival" in Osaka in 1960

As Yve-Alain Bois writes in this book, Yoshihara formed the Gutai group, of which he would be both mentor and financial backer, in 1954. He had been inspired by the famous 1949 *Life* article about Jackson Pollock, who became the standard by which Yoshihara would judge the work of his young disciples. The French critic Tapié, the champion of *art informel* painting in France, became an advisor and advocate of Gutai, organizing exhibitions and writing publications that coopted the group as part of a global *informel* movement—one naturally dominated and led by Western figures. And yet despite being "deemed, somewhat condescendingly, the mere oriental offspring of Abstract Expressionism," as Bois puts it, the transgressive and ludic work of Gutai was in fact the product of a particular and specific context: the unique traditions and rituals of Japanese society and culture.

the artist with his or her material at the expense of making discrete paintings in the Western tradition, which was still the objective of Abstract Expressionism. In China, there was a similar encounter of Western and indigenous traditions from the New Culture Movement during the 1920s onward, but their interaction was nearly extinguished by the forcible expurgation of traditional Chinese painting during the Cultural Revolution (1966–76), ▲ in which a Soviet-derived idiom of figurative Socialist Realism was adopted as Chairman Mao's official art. After this period of imposed "tabula rasa," the Chinese art world gained knowledge of Western art and theory through the greatly increased appearance of translations of various texts in the eighties, leading to an efflorescence of commercially successful and globally circulated ● Chinese contemporary art in the nineties, some of whose most popular practitioners flaunted kitsch references to the Cultural Revolution informed by various Western practices of Pop and ■ appropriation art.

What these brief, partial, and highly schematic genealogies are meant to indicate is that seemingly comparable visual idioms—such as oil painting, ink painting, or even Socialist Realism and Pop—may look similar when presented side by side in art settings such as blockbuster exhibitions, biennials, and art fairs but, in fact, they grow out of distinctly different, and even contradictory, histories. Recognizing both what is common and what is singular about such practices is a fundamental methodological challenge in writing the history of "global" modern or contemporary art.

One way to address this challenge is to develop a multipolar worldwide art history. While this would seem to be an obvious and attainable goal under the cosmopolitan conditions of globalization, it turns out to be very difficult in practice, partly because the geopolitical alignments of the twentieth century were organized as a succession of bipolar and, more recently, monolithic structures that have profoundly affected the infrastructure as well as the underlying critical value system of the global art world. During the late nineteenth century, much of the developing world experienced colonization of various types, formal and informal. Immediately after the mid-twentieth-century period of decolonization—and indeed perhaps as a result of it—world alliances were forcibly reorganized into a Cold War opposition that pitted the Soviet Union, as the leader of world Communism, against the United States' promotion of democratic values. This simplistic Manichaean split had dramatic effects on global art practices, not least because it isolated entire regions of the world from one another. Despite efforts to build a movement of nonaligned nations and related cultural policies, the political pressure to take sides and the lure of developmental aid drew a vast proportion of the world into the orbit of either the United States or the Soviet Union between World War II and 1989. Many of these countries were devastated by the effects of not-so-cold proxy wars around the world—in Vietnam, Central America, and Afghanistan to name only a few. With the end of the Cold War, it has been widely accepted that there now exists only one world superpower—the

4 • Kwon Young-woo, *Untitled*, 1977
Korean paper on plywood, 116.8 × 91 cm (46 × 35⅞)

Kwon Young-woo (1926–2013) was a pioneer of
tansaekhwa, meaning "monochromatic painting." From
the mid-1960s into the 1970s, artists such as Young-woo
manipulated various materials, including soaked canvas
and torn paper, in innovative ways to create a distinctively
Korean form of abstract art in white, cream, brown,
black, or other neutral colors. Although never an official
group with a clearly defined set of members or manifesto,
tansaekhwa was the first Korean art movement to find
recognition on the world stage. Its international success
was in part because several of the artists lived, studied,
and worked in Paris, but also because of the association
with Lee Ufan, a Korean artist based in Japan who was
the main theorist of the Mono-ha tendency of Japanese
art, itself influenced by Arte Povera and Process art.

United States—and that its quasi-imperial power is expressed not
in the structural colonialism of explicit governmental administra-
tion, but rather through economic pressure (often in collaboration
with the World Bank and the International Monetary Fund) and
perpetual military "police actions."

A global art world?

The "official" or hegemonic art world whose capital and
infrastructural power is still centered in the developed nations
can also feel monolithic. Despite their far-flung locations, its
outposts resemble one another architecturally and programmati-
cally (leading to the desire for museums around the world to seek
out a shortlist of star architects or "starchitects"). Art works on
exhibit tend to share a formal idiom, belonging to what might be
called an international style. Since the late sixties, artists from
all continents have adapted the lexicon of Conceptual art to a wide
variety of local and historically particular questions and themes—
forming textual propositions, staging actions, and combining
readymade components, instead of producing new or "original"
objects. Such works tend to emphasize documentary and research-
based procedures; they are often structured in series, and may
combine a variety of media ranging from text to video. Regardless
of their specific content, such works by "global artists" must
communicate across borders if they are to migrate successfully
from place to place. This system, which tends toward concentra-
tions of power through the formal requirements it establishes
for a work to pass into global circulation, reinscribes the new impe-
rial order within ostensibly open markets and fungible assets. There
are, of course, many sorts of art practices flourishing all over the
globe that do not enter into circulation within the "official" global
art world, or do so only rarely and outside the category of art:
as indigenous objects, outsider art, or tourist art. Even when they
do gain access to the realm of contemporary art, the frame of
reference and values according to which works emerging from
cultures that are unfamiliar to global art audiences are judged are
not necessarily adjusted from those at play in neoliberal markets.
This is because the "art world"—as a mixed configuration
composed of market institutions like auction houses, galleries, and
art fairs; public institutions like museums and independent spaces;
and information outlets ranging from traditional print magazines
and newsletters to a broader range of online aggregators and
blogs—tends toward uniform principles of judgment. We should
remain conscious of the fact that what we call "global contempo-
rary art" can only ever denote a subset of world art production.

In his important book *Asia As Method*, Kuan-Hsing Chen
argues against the kind of implicit standard of judgment
associated with globalism—whereby Asia, for instance, is judged
in dichotomous opposition to the West—in favor of a more
fine-grained intraregional analysis. He writes: "The potential of
Asia as method is this: using the idea of Asia as an imaginary
anchoring point, societies in Asia can become each other's points

▲ 1972c, 2015　● 1967c, 1968a, 1968b, 1970, 1971, 1972a, 1972b, 1975b, 1984a　■ 1992, 1997, 2003, 2010b

5 • The catalogue of the Third Havana Biennial, 1989

The 1980s saw the birth of a new kind of exhibition that redefined the established model of the international biennial. Notable among them were the Havana, Cairo, and Istanbul biennials, all founded in that decade. These new institutions had a global outlook and political ambition, and they sought to challenge the unequal power relations at play in the art world and in wider society. The main theme of the Third Havana Biennial in 1989 was "Tradition and Contemporaneity," and it included a conference on "Tradition and Contemporaneity in the Arts of the Third World." It was one of the first large-scale exhibitions to aspire to an international reach from outside the European and North American art system, and it featured three hundred artists from forty-one countries. As well as its global nature, it included traditional folk arts alongside the work of recognized artists, thereby extending the territory of contemporary art in other ways too.

of reference, so that the understanding of the self may be transformed, and subjectivity rebuilt." In the context of art history, Joan Kee's 2013 book *Contemporary Korean Art: Tansaekhwa and the Urgency of Method* pursues such an objective by charting the triangulated history of *tansaekhwa*, or Korean monochrome painting, during the seventies as it moves between a rapidly developing Korea whose leading artists both desire to enter the Japanese art world but wish nonetheless to maintain a distinctive Korean identity; Japan, as a recent imperial power and sophisticated art center; and Paris, as the enduringly iconic European art capital whose recognition of a Korean artist remained highly significant for his or her reputation. One of the important distinctions Kee makes is that while many players in the Japanese art scene were particularly interested in establishing a consciousness of Asian versus Western contemporary art—with Japan implicitly representing "Asia"—in Korea, on the other hand, establishing national identity remained extremely important, as marked, for instance, by the distinctive quality of whiteness of *tansaekhwa* monochromes (which was associated with Korean heritage) [4]. Paradoxically, the Japanese art infrastructure, which was then more developed than Korea's, offered an important tool in establishing a visible program of exhibitions that could assert Korean identity. The lesson of Chen and Kee is relevant well beyond Asia: in charting the history of global modern and contemporary art, we cannot remain satisfied with marking the passage of artists from various regions of the world across the threshold of global standards; instead we must learn to understand the complex histories in which global and local networks are articulated together. Indeed, some scholars prefer the term "translocal" as opposed to "global" in order to encompass the heterogeneous mixture of cultures, infrastructures, and aesthetics that any art world assembles.

New networks, new models

The period around 1989 marked a shift in global politics, characterized by such seismic historical events as the collapse of the Cold War, the Tiananmen Square protests in Beijing, and the unbanning of the African National Congress, which ultimately led to the ▲ dismantling of apartheid in South Africa. That was also the year of two exemplary exhibitions, the Third Havana Biennial and ● "Les Magiciens de la terre" in Paris, which both broke open the Eurocentrism of the international art world while, somewhat paradoxically, preparing the way for a worldwide explosion of biennials and commercial art fairs. Since this book includes an entry devoted to "Les Magiciens de la terre," I will concentrate here on the Havana Biennial. The latter is distinctive in that it emerges from and produces a new model for art of the Third World (a term used by the Havana organizers, which has since been widely replaced by less hierarchal categories such as the "Global South" or the "developing world"). The Third Havana Biennial was explicitly intended to do what Chen proposes in *Asia As Method*: to build a horizontal network within regions that are marginalized by the

**6 • A public print workshop organized as part of
the Third Havana Biennial, Calle Cuba, Havana, 1989**

As one of the Biennial's ephemeral events, the local
Taller de Serigrafía Artística René Portocarrero print
workshop organized a public event in the historic center
of Havana, during which enormous engravings were
made by driving a steamroller over printing plates.
Participants could place personal items under the plates
to become part of the printed impression.

official international art world, namely Latin America, Africa,
and Asia [5]. Instead of writing histories based on the presumption
that a Center (the West) transmits its aesthetic forms, institutions,
and values to a Periphery (the rest of the world), the organizers in
Havana were devoted to serious research in vast, but under-
represented places, building in part on their experience in
producing the two previous Havana biennials, which, while
physically larger, were less thematically and curatorially focused
than the 1989 version. The scope of the event was enabled by
Cuba's special position as a Communist state that, while a client
or protégé of the Soviet Union, was also devoted to communi-
cating and exporting its own revolution as broadly as possible,
especially, though not exclusively, in Latin America. Consequently,
while the Biennial had a small budget by European or US
standards, it could take advantage of Cuba's broad cultural and
diplomatic networks, which spanned much of the so-called
Third World, to make contacts with artists' communities that had
previously worked in relative isolation.

The innovations introduced by the Third Havana Biennial were
threefold: first, it developed a new structure that was no longer
based on the competitive model of discrete national pavilions or
presentations that characterized the most venerable biennials in
Venice and São Paulo. The nation as an organizing principle was
replaced by concepts and themes that connected diverse cultures:
in 1989, the theme was "Tradition and Contemporaneity." Unlike
at previous biennials elsewhere (and its own two first editions),
prizes were abolished in order to reduce competitiveness across
the diverse and even incommensurable range of works on display.
The second important innovation was to include so-called folk or
traditional arts. This decision was at the heart of the organizers'
efforts to consider questions raised by their theme since the
culture of developing nations is often stereotypically aligned with
folkloric, self-trained artists, or religious artifacts such as masks or
effigies. By focusing on the ideological meanings of the traditional
versus the contemporary, this biennial (and to a large extent
▲ "Les Magiciens de la terre" as well) demonstrated that what looks
traditional to Western eyes may in fact constitute a complex
response to contemporary conditions couched in historical idioms,
but serving the same objectives and purposes as other forms of
contemporary art. Finally, a third innovation of the Havana Bien-
nial was its emphasis on live interaction among artists, and between
them and the general public through conferences, lectures, and
workshops. In addition to the main exhibition "Tres Mundos,"
the Biennial included four thematic clusters, or *núcleos*, the fourth
of which was entirely devoted to ephemeral events [6]. By most
accounts, one of the Biennial's most significant long-term effects
was the vitality of the debate it inspired with regard to "Third
World art." Such an emphasis on the international exhibition as
an opportunity for connection and dialogue has had a huge impact
• on subsequent exhibitions, which have often organized elaborate
worldwide platforms for debate and interchange, thus broadening
the reach of an exhibition beyond its physical precincts.

▲ 1989 ● 1997, 2003, 2009a, 2010a

7 • The exhibition "Global Conceptualism: Points of Origin, 1950s–1980s," Queens Museum of Art, 1999, showing the sections for Australia and New Zealand (top), Japan (center), and Russia (bottom)

Curated by Jane Farver, Rachel Weiss, Luis Camnitzer and a team of international curators, "Global Conceptualism" began life as an exhibition of Latin American Conceptual art. It soon grew, however, into a broader show of conceptualist practices from other parts of the world that were generally unfamiliar to a Western audience. While these separate movements were connected in myriad ways, they had all emerged out of their own specific local conditions. As Farver remembers, from the beginning, the curators understood "the territory of 'globalism' as having multiple centers in which local events were crucial determinants."

As important as the Third Havana Biennial was in establishing new kinds of networks, its sprawling structure and multiple foci could not be reconciled into any tidy image of global contemporary art. This has been a challenge in large international exhibitions and academic histories ever since. When one's art-historical objective is to reach beyond national and ethnic identity or physical location as the privileged frameworks for a work of art's meaning, in order to tell a truly global story of art's dissemination and migration *across* the borders of such identities, it is difficult to determine what kind of methodology is appropriate. In recent years, one successful approach has been to trace the variations of a particular aesthetic format as it passes through a variety of cultural contexts. The "Global Conceptualism: Points of Origin, 1950s–1980s" exhibition and related catalogue organized by Queens Museum of Art, New York, of 1999, for instance, was an excellent model for addressing what was common in conceptual practices from around the world without erasing their differences [7]. The ultimate objective of a global art history is not only to develop a broader range of local histories, based on new research and the expertise of a more diverse profession of art historians, but also to develop methods that see past the *innovation* of form (which tends to prioritize the first enunciation of an aesthetic idiom) and value instead its *transitivity* (or, in other words, how its meaning is precisely produced through movement). Under such criteria, the notion of the "derivative" as a negative designation of art works would be replaced by the semantic value of an utterance rooted within a particular historical and cultural context.

The aggregate as idea and form

Traditionally, one of the primary purposes of art history has been to discover whether a particular historical epoch, such as the current moment of globalization, generates its own unique set of aesthetic forms and practices. Making such a determination is especially difficult with regard to contemporary art, since its recentness affords little historical perspective. Nonetheless, I wish to propose "the aggregator" as one such form. It is instructive to browse the definitions of "aggregate" in the *Oxford English Dictionary*. The first entry states: "Constituted by the collection of many particles or units into one body, mass, or amount; collective, whole, total." In legal terms, an aggregate is "Composed of many individuals united into one association," and grammatically it signifies "collective." In each sense, an aggregate selects and configures relatively autonomous elements. It presents, therefore, an objective correlative to the influential political concept of the multitude, as developed by philosophers Paolo Virno, Antonio Negri, and Michael Hardt. The multitude, defined by these theorists as a resistant social force indigenous to globalization, is distinct from both national citizenship and class membership along traditional Marxian lines. Instead of establishing common cause based on a unified *identity* (as an American, for instance, or a proletarian), multitudes constitute themselves from independent

▲ 2009a, 2009b ● 1967c, 1968a, 1968b, 1970, 1971, 1972a, 1972b, 1975b, 1984a

individuals drawn from a variety of communities and locations in response to shared conditions or provocations. As Hardt and Negri put it:

> *The concept of multitude, then, is meant in one respect to demonstrate that a theory of economic class need not choose between unity and plurality. A multitude is an irreducible multiplicity; the singular social differences that constitute the multitude must always be expressed and can never be flattened into sameness, unity, identity, or indifference…. This is the definition of the multitude … singularities that act in common.*

One need not subscribe wholeheartedly to Hardt and Negri's utopian claims on behalf of the multitude to recognize its exemplary structure. Like a search engine, the multitude aggregates heterogeneous entities (in this case, persons) through the action of a filter. That the multitude's filter is a shared social demand (such as immigration rights) makes them no less homologous to the algorithms and page rankings more cynically employed by search engines like Google as filters. Both the multitude and the search engine are mechanisms by which singular entities (both persons and objects) may act in common.

With the dramatic expansion of global contemporary art, ▲ online content aggregators like Contemporary Art Daily or e-flux have emerged as major sources of art-world information. These services help to compensate for the limited capacity to travel around the globe in pursuit of contemporary art for even the most privileged and peripatetic person. Their criteria of selection are more intuitive and less mathematically sophisticated than Google's algorithms—they "curate" rather than calculate their inclusions. And while the term narrowly denotes such online tools, the logic of the aggregator is present on many scales of the art world at once: from individual works of art constituted from an array of discrete components, often readymades, right up to biennials and art fairs. These latter differ from conventional museum presentations in that their structures are explicitly aggregative: they provide a common space for singular or autonomous pavilions and national exhibitions (in the case of biennials) and participating galleries (in the case of art fairs), rather than attempting to synthesize their presentations into an overarching theme or narrative as in most museum installations. Two interrelated syntactic structures persist across these scales, from the individual art work to the largest of art fairs. First, the aggregate is a format that accommodates and manifests singularity among its elements—components do not need to be integrated into an overall "composition" to which they would be subordinated. And second, the aggregator provides some kind of common space in which these singular elements are held together in productive, often contradictory association.

Indeed, the virtue of aggregates is their capacity to furnish platforms where the differences among semiautonomous and asynchronous elements can be highlighted and, hopefully, through thoughtful consideration, negotiated. Their contradictions are not resolved, but rather put on display in order to provoke honest and open-ended dialogue between various positions. Examples of such a strategy abound in recent art, including Mexican artist ▲ Gabriel Orozco's "working tables" holding several distinct objects ● he has made or found; American Rachel Harrison's use of pedestals and eccentric, monolith-like forms to carry an array of objects and pictures; or the Chinese artist Song Dong's cataloguing of the contents of his mother's house in China, by laying them all out on a gallery floor around a facsimile of the structure they were once housed in. Since the elements in such works are not integrated into a coherent composition but rather heighten conceptual unevenness, aggregates beg the question of how a common ground may be established within a discontinuous field of singular and often ideologically saturated objects. The aggregate form described here thus differs from two of its ■ close modern cognates: montage and the archive. In montage, individual elements are subsumed within an overall compositional logic; even if the different sources of its constituent elements remain apparent, these components do not typically maintain the disarming quality of independence characteristic of an aggregate, which seems always in danger of falling apart. And unlike an archive, whose principle of selection is inclusive with regard to a theme, institution, period, or event, aggregates proceed from an obscure principle of intuitive selection, typically staging confrontations among a variety of objects that embody entirely different values or epistemologies. An archive, on the other hand, serves to collect, preserve, and even constitute evidence as a pillar of epistemological stability.

I will discuss just one example of the logic of aggregates in practice. Slavs and Tatars are an artist collective whose work engages directly in questions of globalization by addressing an often overlooked geopolitical region: what they define as the area east of the Berlin Wall and west of the Great Wall of China, which witnessed one of the epic ideological contests of the twentieth century, between Islam and Communism. Through texts (transmitted in books as well as in artifacts in exhibitions) and objects, the group explores, among other themes, syncretic expressions of Islam developed in central Asia under Soviet policies of religious suppression. Often Slavs and Tatars heighten the asynchrony of this ideological collision through the citation of medieval scripture as a means of drawing out mystical strands in modern and contemporary art through a logic of what they call "substitution." Indeed, in the catalogue for the 2012 exhibition "Not Moscow Not Mecca" they describe their work as explicitly aggregative: "The collision of different registers, different voices, different worlds, and different logics previously considered to be antithetical, incommensurate, or simply unable to exist in the same page, sentence, or space is crucial to our practice." This desire to bring "different registers" onto the "same page, sentence, or space" is what I have identified as the aggregator's impulse to furnish a platform where unlike things may occupy a common space. In the

8 • Slavs and Tatars, installation shot of the exhibition "Not Moscow Not Mecca," Vienna Secession, 2012

In their exhibitions and texts, Slavs and Tatars assemble an array of ideas, artifacts, and cultural objects that seem to have been collected on journeys to faraway times and places—a visual form, one might say, of travel writing. Asked if their presentations, which are based on extensive research, could be described as archival, the artists say that they prefer to see them as "restorative." They explain the impulse behind their practice: "Despite its recent critical renaissance or promiscuity … the word 'archival' still implies a dusty collection of documents and records and the aura that accompanies this material. We believe it is equally important to disrespect one's sources as to respect them. That is, to reconfigure, resituate, reinterpret, and collide the archival material with the aim of making it relevant and urgent—not just to the specialist in the field, nor just to the intellectual, but also to the layperson who might not otherwise be interested."

exhibition component of "Not Moscow Not Mecca" at the Vienna Secession, the group generated an exhibition based on the transregional histories of fruits in Central Asia, including the apricot, the mulberry, the persimmon, the watermelon, the quince, the fig, the melon, the cucumber, the pomegranate, the sour cherry and the sweet lemon, which they wittily called "The Faculty of Fruits." The gallery presentation included arrays of readymade (or seemingly readymade) fruits distributed on mirrored platforms in a cross between veiled allegory and blinged-out cornucopia [8]. They also produced a book, which in part documents the fascinating histories of how these fruits grew out of and into various Central Asian cultures, both agriculturally and through myth or legend. Slavs and Tatars' work thus adapts several of the fundamental strategies of Conceptual art: the *proposition* (how does fruit embody the historical asynchronies of Central Asia?), the *document* (through an account of each fruit's geographical

THE APRICOT

17th century Armenian tile. *Armenien: Wiederentdeckung einer alten Kulturlandschaft*, 1995

A small, yellowish fruit, cleaved down the middle, is caught up in a custody battle of seismic proportions—and the claimants could not be more mismatched. In one corner, a country whose only instance of independence

The invigilator of the Nodira museum in Kokand goes to great lengths to shake some apricots from the tree in the courtyard, Uzbekistan, 2011

before 1991 dates to the first century CE; in the other, the world's most populous nation. In the middle, like a child unwilling to choose between (a

petite) mommy and (towering) daddy, the apricot tries to please, providing medicinal relief to both. According to an old Armenian tradition, over twelve maladies can be treated with the flesh and seeds of the apricot. The Hayer (Հայեր) have raised their orange, blue, and red flag on the genus and species (*Prunus armeniaca*) with a dollop of Biblical bathos to boot: Noah was not just any tree hugger, but an apricot-tree hugger (the only one to make it into the Ark).

The Chinese, though, give the Caucasus, a land renowned for its poetic streak, a run for its (highly

Apricots drying in Capadoccia, photo by Bjørn Christian Tørrissen

leveraged) money. Via the velvety skinned fruit, the Middle Kingdom brings together what might seem two disparate worlds to Western eyes—that of medicine and education—for a one-two punch of holistic healing for the body and brain alike. It is no coinci-

My Courtyard by M. Saryan. Source: Iskusstvo Armenii, 1962

dence that the fruits here hail from Xinjiang, aka Uighuristan, the westernmost region of China, sometimes lumped into Central Asia under the contested name of East Turkestan. A particularly lyrical way of addressing a doctor in Mandarin is "Expert of the Apricot Grove." Dong Feng, a doctor in the third century CE, asked his patients to plant apricot trees

instead of paying fees. The legend lived on for centuries: When patients sought treatment, they said they were going to the Xong Lin, or Apricot Forest. Meanwhile, school children, in lieu of flowers, often bring their teachers dried apricots to bless the 'apricot altar' or 'educational circle.'

Between the diasporic duels of the Armenians and the Chinese, a third contender permits a welcome turn of triangulation, one which helps us to move beyond the partisan battles over the precocious, early-ripening fruit. For much of the Latin American world, apricots are called *damasco*, in reference to their Syrian origins and the early-twentieth-century migrations to that region from the Middle East.

If the fresh fruit incites juicy rivalries, the dried version doesn't disappoint either. When thinking of Damascus today, we turn helplessly to the Turks to will their former Ottoman influence over the restive Syrian capital. In far rosier times, they would turn to the pitted yellow prune and say—*bundaniyisi Şam'dakayısı*—the only

thing better than this is an apricot in Damascus.

THE MULBERRY

A worm with a voracious but selective appetite has proven to have had more of a Eurasian geographical bite than Ghenghis Khan himself. Gobbling up all the white mulberry tree leaves in its path, the castoffs of every little silkworm's metamorphosis

Uzbek girls in Khan-Atlas patterned textiles. *Sovetsky Soyuz Uzbekistan*, 1967

9 • Slavs and Tatars, spread from the artists' book *Not Moscow Not Mecca*, 2012

migration and cultural associations published in the related artists' book [9]), and the *readymade* (manifest in "real and imagined" fruits displayed on the platforms). But the syntax of the work established parallel singular profiles among adjacent things; their physical copresence and conceptual unevenness begs the question of the common, thus making "Not Moscow Not Mecca" aggregative according to the definition set out above.

Given the vast scale of global contemporary art production, and the wide range of cultural histories from which it emerges, any attempt at a tidy or coherent reading will be speculative at best. The principal challenge in confronting the contemporary art made under conditions of globalization is to hold together two ostensibly contradictory qualities: first, a shared international language of aesthetic form spoken in common; and second, the texture and nuance of different histories and dialects that can make the same image or format mean dramatically different things. Such accommodation of singularity within a common space will always be—even in the world of politics and finance—an art rather than a science.

FURTHER READING

Luis Camnitzer, Jane Farver, and Rachel Weiss, *Global Conceptualism: Points of Origin, 1950s–1980s* (New York: Queens Museum of Art, 1999)

Kuan-Hsing Chen, *Asia As Method: Toward Deimperialization* (Durham, N.C.: Duke University Press, 2010)

Michael Hardt and Antonio Negri, *Multitude: War and Democracy in the Age of Empire* (New York: Penguin, 2004)

Joan Kee, *Contemporary Korean Art: Tansaekhwa and the Urgency of Method* (Minneapolis: University of Minnesota Press, 2013)

Gao Minglu, *Total Modernity and the Avant-Garde in Twentieth-Century Chinese Art* (Cambridge, Mass.: MIT Press, 2011)

Slavs and Tatars, *Not Moscow Not Mecca* (Vienna: Secession, 2012)

Rachel Weiss et al., *Making Art Global (Part 1); The Third Havana Biennial 1989* (London: Afterall Books, 2011)

Bert Winther-Tamaki, *Maximum Embodiment: Yōga, The Western Painting of Japan* (Honolulu: University of Hawaii Press, 2012)

David Joselit

1900—1909

1900ₐ

Sigmund Freud publishes *The Interpretation of Dreams*: in Vienna, the rise of the expressive art of Gustav Klimt, Egon Schiele, and Oskar Kokoschka coincides with the emergence of psychoanalysis.

Sigmund Freud declares in the epigraph to *The Interpretation of Dreams*, "If I cannot move the higher powers, I will stir up hell." With this passage, taken from *The Aeneid*, the Viennese founder of psychoanalysis "intended to picture the efforts of the repressed instinctual impulses." And right here, we might think, lies the connection between this intrepid explorer of the unconscious and such brazen innovators in Viennese art as Gustav Klimt (1862–1918), Egon Schiele (1890–1918), and Oskar Kokoschka (1886–1980). For they too seemed to stir up hell, in the early years of the century, through a liberatory expression of repressed instincts and unconscious desires.

These artists did stir up hell, but it was no simple liberation. Unfettered expression is rare in art, let alone in psychoanalysis, and Freud would not have supported it in any case: a conservative collector of ancient, Egyptian, and Asian artifacts, he was wary of modernist artists. The connection between these four Viennese contemporaries is better drawn through the notion of the "dream-work" developed by Freud in *The Interpretation of Dreams*. According to this epochal study, a dream is a "rebus," a broken narrative-in-images, a secret wish struggling to be expressed and an internal censor struggling to suppress it. Such a conflict is often suggested in the most provocative paintings by Klimt, Schiele, and Kokoschka, which are frequently portraits: a struggle between expression and repression in sitter and painter alike. Perhaps more than any other modernist style, this art places the viewer in the position of psychoanalytic interpreter.

Oedipal revolt

Although Paris is more celebrated as a capital of modernist art, Vienna witnessed several events that are paradigmatic of turn-of-the-century avant-gardes. First was the very act of "secession" —the withdrawal from the Academy of Fine Arts in 1897 of a group of nineteen artists (including Klimt) and architects (including Joseph Maria Olbrich [1867–1908] and Josef Hoffmann [1870–1956]) into an order of its own, replete in this case with its own building [1]. In opposition to the old academic guard, the Secession advocated the new and the youthful in the very names of the international style that it adopted, which was called *art nouveau*

1 • Joseph Maria Olbrich, *House of the Vienna Secession*, 1898
A view of the main entrance

in French and *Jugendstil* in German (literally, "youth style"). Also typical of avant-gardes was that this advocacy provoked great scandal. First, in 1901, the University of Vienna rejected a grim painting on the subject of philosophy that it had commissioned from Klimt, who responded with a second painting on the subject of medicine that was even more outrageous. Then, in 1908, the School of Arts and Crafts expelled Kokoschka after a performance of his lurid drama of passion and violence, *Murderer, the Hope of Woman*—the first banishment in his long, nomadic life. And finally, in 1912, the authorities charged Schiele with kidnapping and corrupting a minor, jailed him for twenty-four days, and burned many of his sexually explicit drawings.

These controversies were not staged for bourgeois titillation; they pointed to genuine rifts between private reality and public morality in Vienna at the time. For the new art emerged as the Austro-Hungarian Empire was collapsing; it was symptomatic, the historian Carl E. Schorske has suggested, of "the crisis of the liberal ego" in the old order. Here lies a further connection with Freud: more than a liberation of the self, this art attests to a conflict within the individual subject regarding its threatened authorities, the academy and the state—in Freudian terms the superego that

surveys us all—"a crisis of culture characterized by an ambiguous combination of collective oedipal revolt and narcissistic search for a new self" (Schorske).

This crisis was hardly punctual or uniform. Differences existed not only between the Secession and the Academy but also between the Expressionist aesthetic of young painters such as Schiele and Kokoschka and the Art Nouveau ethos of Secession artists such as Klimt, who advocated a "total work of the arts." (This *Gesamtkunstwerk* was exemplified by the Palais Stoclet in Brussels, designed by Hoffmann in 1905–11 with arboreal mosaic murals created by Klimt [2]). The Secession was divided internally as well. In its craft studios (or *Werkstätte*), it promoted the decorative arts, which other modernist styles often suppressed ("the decorative" became a term of anxious embarrassment for many proponents of abstract art); for example, Klimt used such archaic media as tempera and gold-leaf as well as mosaic. On the other hand, in its expressive use of line and color, the Secession also encouraged modernist experiments in abstract form. In this way, it was caught up in contradiction: in style between figuration and abstraction; in mood between fin-de-siècle malaise and early-twentieth-century *joie de vivre*. And this conflict tended to be evoked in the edgy, almost neurasthenic line that Klimt passed on to Schiele and Kokoschka.

In these tensions with the Art Nouveau style of the Secession, the great German critic Walter Benjamin (1892–1940) later glimpsed a basic contradiction between the individual basis of crafted art and the collective basis of industrial production:

> The transfiguration of the lone soul was [the] apparent aim [of Art Nouveau]. Individualism was its theory. With [the Belgian designer Henry] van de Velde, there appeared the house as expression of the personality. Ornament was to such a house what the signature is to a painting. The real significance of Art Nouveau was not expressed in this ideology. It represented the last attempt at a sortie on the part of Art imprisoned by technical advance within her ivory tower. It mobilized all the reserve forces of interiority. They found their expression in the mediumistic language of line, in the flower as symbol of the naked, vegetable Nature that confronted the technologically armed environment.

If Art Nouveau represented a last sortie on the part of Art, the Secession signaled its full embrace of the Ivory Tower, as exemplified by its white building, replete with floral facade ornament and grill dome, intended by its designer Olbrich as "a temple of art which would offer the art-lover a quiet, elegant place of refuge." Thus, even as the Secession broke with the Academy, it did so only to retreat to a more pristine space of aesthetic autonomy. And yet, in a further contradiction, the Secession took this autonomy to be expressive of the spirit of its time, as announced by the motto inscribed beneath the dome: "TO EACH AGE ITS ART, TO ART ITS FREEDOM." Here is, as art historians in Vienna might have said at the time, the very "artistic will" (or *Kunstwollen*) of this new movement.

2 • Josef Hoffmann, Palais Stoclet, Brussels, 1905–11
Dining room murals by Gustav Klimt, furniture by Josef Hoffmann

Defiance tinctured by impotence

The first president of the Vienna Secession was Gustav Klimt, whose career passed from the historical culture of the Austro-Hungarian Empire, through the antitraditional revolt of the avant-garde at the turn of the century, to an ornamental portraiture of Viennese high society after this modernist revolt appeared, to him at least, to be routed. His father, an engraver, had sent him to the School of Arts and Crafts, from which he emerged as an architectural decorator in 1883, just as the monumental buildings of the central Ringstrasse of remodeled Vienna came to completion. His early works included allegorical paintings for two new Ringstrasse buildings—a painting of dramatic figures (including Hamlet) for the ceiling of the City Theater (1886–8) and a painting of cultural representatives (including Athena) for the lobby of the Museum of Art History (1891). In 1894, on the basis of these successes, the new University of Vienna commissioned him to produce three ceiling paintings—representing Philosophy, Medicine, and Jurisprudence, respectively—on the Enlightenment theme of the "Triumph of Light over Darkness." Klimt worked intermittently on the project for the next ten years, exhibiting the first painting, *Philosophy*, in 1900. By this time, however, he was caught up in the Secession, and the finished painting was hardly what the University had in mind. Rather than a pantheon of philosophers, Klimt presented an anguished passage of commingled bodies through an amorphous space overseen by an obscure sphinx in the center and a luminous head (which evoked Medusa more than Athena) at the bottom. In this world, Darkness seemed to triumph over Light.

If Klimt questioned rationalist philosophy in this commission for the University, he mocked therapeutic medicine in the next,

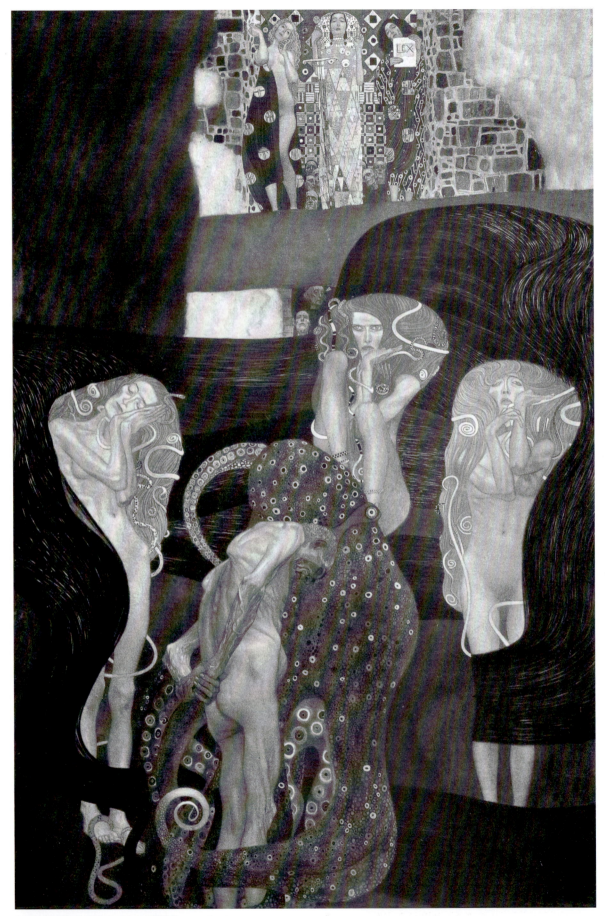

3 • Gustav Klimt, *Jurisprudence,* **1903–7**
Oil on canvas, dimensions unknown (destroyed 1945)

unveiled in 1901. Here Medicine is represented as yet another hell, with even more bodies, some slung in sensuous slumber, others massed with cadavers and skeletons—a grotesque phantasmagoria of "the unity of life and death, the interpenetration of instinctual vitality and personal dissolution" (Schorske). An even stronger slap in the face of the University, the painting was again rejected and Klimt rebuked. His rejoinder was to rework the final representation of Jurisprudence [3] into one last hell of criminal punishment, with three large, intense furies around an emaciated man, all naked in a dark space below, and three small, impassive graces gowned in a hieratic space above. These allegorical figures of Truth, Justice, and Law hardly assist the male victim, who, surrounded by octopus tentacles, is at the mercy of the three furies of punishment (one sleeps obliviously, one stares vengefully, one winks as if on the take). Here punishment appears psychologized as castration: the man is gaunt, his head bowed, his penis near the maw of the octopus. In a sense, it is this constricted man whom Schiele and Kokoschka will attempt to liberate, though in their art too he will remain broken. "His very defiance was tinctured by the spirit of impotence," Schorske writes of Klimt. This is true of Schiele and Kokoschka as well.

These failed commissions signaled a general crisis in public art at this time: clearly, public taste and advanced painting had parted company. For the most part, Klimt then withdrew from the avant-garde in order to paint realistic portraits of stylish socialites, ornamental people set against ornamental backgrounds. His withdrawal left it to Schiele and Kokoschka to probe "repressed instinctual impulses," and they did so in the guise of often anguished figures stripped of historical reference and social context. (To look at his figures, Schiele once remarked, is "to look inside.") Skeptical of the decorative refinements of Art Nouveau, both Schiele and Kokoschka turned to Postimpressionist and Symbolist painters for expressive precedents. (As in other capitals, retrospective exhibi-
▲ tions of Vincent van Gogh and Paul Gauguin were influential, as were Secession shows of the Norwegian Edvard Munch [1863–1944] and the Swiss Ferdinand Hodler [1853–1918].)

Symptomatic portraiture

Having grown up in a bourgeois family of railway officials, Egon Schiele met Klimt in 1907 and soon adapted the sinuous, sensuous line of his mentor into his own angular, anxious mode of drawing; in the ten years before his death (Schiele died in the Spanish Flu epidemic of 1918) he produced some three hundred paintings and three thousand works on paper. In bloody reds and earthy browns, pale yellows and bleak blacks, Schiele attempted to paint pathos directly in melancholic landscapes with blighted trees, as well as desperate pictures of aggrieved mothers and children. More notorious are his drawings of adolescent girls, often sexually exposed, and his self-portraits, sometimes in similarly explicit positions. If Klimt and Kokoschka explored the reciprocal relation between sadistic and masochistic drives, so Schiele probed another Freudian pair of

perverse pleasures—voyeurism and exhibitionism. Often he stares so intently—into the mirror, at us—that the difference between his gaze and ours threatens to dissolve, and he seems to become his only viewer, the solitary voyeur of his own display. But for the most part, Schiele does not seem defiantly proud of his self-image so much as pathetically exposed by its damage.

Consider his *Nude Self-Portrait in Gray with Open Mouth* [4]. The figure recalls the emaciated victim of *Jurisprudence* turned round and made younger. He has broken free; yet free, he is broken: his arms are no longer bound—they are amputated. Less an angel in flight, he is a scarecrow pinioned and cut at the knees. His slight asymmetry skews other oppositions as well: although male, his penis is retracted, and his torso is more feminine than not. With rings around his eyes, his face resembles a death-mask, and his open mouth could be interpreted equally as a vital scream or as a deathly gaping. This self-portrait seems to capture the moment when vitality and mortality meet in neurotic morbidity.

This transformation of the figure is the primary legacy of Viennese art at this time. It might seem conservative in relation to other

4 • Egon Schiele, *Nude Self-Portrait in Gray with Open Mouth***, 1910**
Gouache and black crayon on paper, 44.8 × 31.5 (17⅝ × 12⅜)

modernist art, but it provoked the Nazis to condemn it as "degenerate" thirty years later. Well past its service as classical ideal (the academic nude) and a social type (the proper portrait), the figure here becomes a cipher of psychosexual disturbance. Without direct influence from Freud, these artists developed a sort of symptomatic portraiture that extended van Gogh's expressive renderings of people, a portraiture that evokes less the desires of the artist than the repressions of the sitter—indirectly, through tics and tensions of the body. Here, what the attenuated, often emaciated line is in Klimt and Schiele, the agitated, often scratched line is in Kokoschka: a sign of a tortuous surfacing of subjective conflict.

Also influenced by Klimt, Oskar Kokoschka developed this symptomatic portraiture further than Schiele, and he probed its disruptive dimension further too—to the point where he was forced to leave Vienna altogether. During his troubles, Kokoschka was supported by the modernist architect and critic Adolf Loos (1870–1933), already notorious for his austere designs and fierce polemics, and the 1909 Kokoschka portrait of this great purist could be said to capture their "partnership of opposites" [5]. Similar to the Schiele self-portrait in stylistic respects (down to the ringed eyes), the painting evokes a subjectivity that is nonetheless quite different. The clothed Loos gazes inward: he is composed, but one senses he is under great pressure. Indeed, rather than *ex*pressed, or pressed outward, his being seems *com*pressed, or pressed inward. Self-possessed in both senses of the term, he reins in his energies with an intensity that seems to deform his wrung hands.

A year before the portrait was painted, Loos had published his diatribe against the Art Nouveau of the Secession; titled "Ornament and Crime" (1908), it might as well have read "Ornament *is* Crime." Loos deemed ornament not only erotic in origin but excremental as well, and though he excused such amorality in children and "savages," "the man of our day who, in response to an inner urge, smears the walls with erotic symbols is a criminal or a degenerate." Not coincidentally, in this land given the excremental nickname "Kakania" by the novelist Robert Musil, Freud published his first paper on "character and anal eroticism" in 1908 as well. Yet, whereas Freud wanted merely to *understand* the civilized purposes of this repression of anal-erotic drives, Loos wanted to *enforce* them: "A country's culture can be assessed by the extent to which its lavatory walls are smeared," he wrote. "The evolution of culture is synonymous with the removal of ornament from utilitarian objects." Loos was not sympathetic to psychoanalysis; his friend and compatriot the critic Karl Kraus (1874–1936) once called it "the disease of which it thinks it is the cure." But like Freud, Loos did imagine the anal as a messy zone of indistinctness, and this is why he implied that the applied arts of the Secession and the violent outbursts of Expressionism were excremental. Against such confusion, Loos and Kraus demanded a self-critical practice in which each art, language, and discipline would be made ever more distinct, proper, and pure. We do well to remember that Vienna was the home not only of such disruptive painters as

5 • Oskar Kokoschka, *Portrait of the Architect Adolf Loos,* **1909**
Oil on canvas, 73.7 × 92.7 (29 × 36½)

Klimt, Schiele, and Kokoschka, but also of such disciplinary voices as Loos in architecture, Kraus in journalism, Arnold Schoenberg (1874–1951) in music, and Ludwig Wittgenstein (1889–1951) in philosophy (who once wrote that "all philosophy is the critique of language"). Already at the beginning of the century, then, we find in Vienna an opposition fundamental to much modernism that followed: an opposition between expressive freedoms and rigorous constraints. HF

FURTHER READING
Walter Benjamin, "The Paris of the Second Empire in Baudelaire," in *Charles Baudelaire: A Lyric Poet in the Era of High Capitalism* (London: New Left Books, 1973)
Allan Janik and Stephen Toulmin, *Wittgenstein's Vienna* (New York: Simon and Schuster, 1973)
Adolf Loos, "Ornament and Crime," in Ulrich Conrads (ed.), *Programs and Manifestoes on 20th-Century Architecture* (Cambridge, Mass.: MIT Press, 1975)
Carl E. Schorske, *Fin-de-Siècle Vienna: Politics and Culture* (New York: Vintage Books, 1980)
Kirk Varnedoe, *Vienna 1900: Art, Architecture, and Design* (New York: Museum of Modern Art, 1985)

▲ 1937a ● 1962b ■ 1903, 1922

▲ 1958

1900b

Henri Matisse visits Auguste Rodin in his Paris studio but rejects the elder artist's sculptural style.

When Henri Matisse (1869–1954) visited Auguste Rodin (1840–1917) in his studio in 1900, the sixty-year-old artist was a towering figure. Rodin had long enjoyed a considerable reputation as the lone sculptor who had been able to rejuvenate a moribund medium after a full century of tedious academic monuments and predictable kitsch statues. But his sculptural production was split, as American art historian Leo Steinberg has noted, between a public and a private one: while his reputation had been largely based on his marble works, which in some ways continued rather than overturned the academic tradition, the larger and more innovative part of his output (in numerous plasters rarely cast in bronze) was kept in the secrecy of his studio. His *Monument to Balzac*, with its thick column of a body cloaked in an overcoat depriving it of any traditional expressive attribute, was perhaps the first public sculpture in which Rodin revealed his preferred, private style: its unveiling in 1898, which created an enormous scandal, may be considered the birth of modern sculpture. Rodin had worked assiduously on the monument for seven years and was wounded (though perhaps not entirely surprised) when it was dismissed as a "crude sketch" by the members of the Société des Gens de Lettres who had commissioned it and was recklessly caricatured by the press (it would not be installed in its present public location in Paris until 1939). Rodin responded to the criticism by erecting a pavilion at the 1900 Universal Exhibition, held at various sites across Paris from April to November of that year, to house a retrospective of his works: for Matisse and many others at this point, Rodin represented the romantic ideal of the uncompromising artist, refusing to yield to the pressures of a bourgeois society.

Legend has it that when Matisse, encouraged by an admiring friend who was one of Rodin's many assistants, visited the elder sculptor, he brought with him a selection of his rapid sketches after the model in order to obtain feedback, and that Rodin did not much like what he saw. The advice he gave—that Matisse should "fuss" more over his drawing and add details—met a resolutely deaf ear: there was not much difference between this precept and the École des Beaux-Arts instruction that Matisse had already definitively rejected (and which he would have expected Rodin to scorn as well).

In the footsteps of the master

But whatever guidance Matisse had sought from Rodin concerning his drawing method, his visit must have been prompted above all by a curiosity with regard to Rodin's sculptural practice. It is uncertain if Matisse was already working on *The Serf* [1] at that point; but, whether as the underlying cause of the visit or as its immediate effect, this sculpture marks both Matisse's first serious

1 • Henri Matisse, *The Serf*, 1900–3 (1908 cast)
Bronze, height 92.4 (36⅜)

engagement with Rodin's art and his definitive departure from it, for it is a direct answer to Rodin's armless *The Walking Man* [**2**], which was exhibited as a study for *Saint John the Baptist*, along with the much tamer, anatomically whole *Saint John* itself, in the 1900 pavilion. By using the same model—a man nicknamed Bevilaqua, long known to be a favorite of Rodin's—in approximately the same pose, Matisse underlined both his debt to Rodin and their differences, a dialectic later sharpened by the amputation of *The Serf*'s arms at the time of its casting, in 1908.

Even though Rodin's *Walking Man* is not really walking—as Leo Steinberg pointed out, both his feet are anchored onto the ground, much like those of a "prizefighter in a delivery of a blow"—the illusion is that of bound energy: the movement is arrested, but the figure is ready to spring. Matisse's *Serf*, by contrast, is irremediably static, self-contained. The spectator is never tempted to imagine the figure moving, never tempted to animate it in his or her mind. The body itself seems malleable: the ungracious proportions of the model are accentuated by the sinuous curve traced in space by the whole figure, a general undulation stemming from the prominent belly and spanning the height of the whole body, up through the recessed thorax and the hunched back to the tilted head in one direction, and down to the right shin functioning as a break under the inward-bent knee in the other. It suggests no extension of any kind, into neither mental nor physical space: one of the first resolutely modernist antimonuments, the sculpture asserts its autonomy as an object.

This is not to say that *The Serf* owes nothing to Rodin's craft. The sculpture's very impression of malleability comes in great part from the surface agitation of the work, a stylistic feature essential to Rodin's "private" art and signaling one of the greatest upheavals of the Western sculptural tradition since antiquity—a tradition that demanded of the sculptor that he "give life" to the marble (the myth of Pygmalion), that he make one believe (or rather *pretend* to make one believe, since nobody is ever fooled) that his statue is endowed with organic life. While the public Rodin is wholly heir to this tradition, the private Rodin is a master of "process art," his sculpture being a catalog of the procedures, accidental or not, that make up the art of modeling or casting. The gaping wound in the back of *The Walking Man*, the great scrape across that of *Flying Figure* (1890–1), the excrescences on the forehead of his 1898 *Baudelaire*, and many other "anomalies" set into the bronze testify to Rodin's determination to treat sculptural processes as a language whose signs are manipulable. In other words, the public Rodin champions the transparency of sculpture as a language, whereas the private Rodin insists on its opacity, on its materiality.

Matisse, no doubt stimulated by these examples, accentuates the agitation of *The Serf*'s surface; he amasses muscular discontinuities, conceiving all his sculpture as an accumulation of more or less even, small round shapes, or of knife-strokes on which light falters. But in doing so, he goes too far and approaches the style of Medardo Rosso (1858–1928), the Italian self-proclaimed rival of Rodin who labeled himself an Impressionist and indeed aspired to imitate

2 • Auguste Rodin, *The Walking Man*, 1900
Bronze, 84 × 51.5 × 50.8 (33 × 20¼ × 20)

Impressionist brush-strokes in his wax sculptures. Unlike Rodin's, Rosso's sculpture is pictorial, and it is strictly frontal. The dematerializing effect of light on Rosso's surfaces, the way the contours of his figures are eaten up by shadow and can only be experienced from a single point of view—these are features that Matisse comes to reject at the very moment he is flirting with their possibility.

The Serf, one of the two pieces through which Matisse learned the art of sculpture (it necessitated between three and five hundred sessions with the model!), is thus a paradoxical work: in his uncontrolled imitation of Rodin's "processual" marks, Matisse is more royalist than the king. The surface agitation itself comes dangerously close to destroying the integrity of the figure and its overall arabesque, and to transforming it, as Rosso would have it, into an ersatz picture. From then on, Matisse would understand better the principle of Rodin's materiality, and never abuse it again in this way. Almost all of his future bronzes would continue to bear the marks of his manipulation of the clay, but without endangering the physicality of the sculpture. Perhaps the most striking example of this effect is the exaggeration of the forehead of *Jeannette V* [**3**], which had such a vivid impact on Picasso when he discovered it in 1930 that he set out to emulate it in a series of heads or busts he modeled shortly thereafter.

But during his visit to Rodin's studio Matisse also learned what fundamentally differentiated his aesthetic from that of the master: "I could not understand how Rodin could work on his *Saint John*, cutting off the hand and holding it on a peg; he worked on the details holding it in his left hand, it seems, anyhow keeping it detached from the whole, then replacing it on the end of the arm; then he tried to find its direction in accord with his general movement. Already, for myself I could only envisage the general architecture, replacing explanatory details by a living and suggestive synthesis." Matisse had already realized that he was not a "realist" when he modeled a jaguar after a work by the nineteenth-century French sculptor Antoine-Louis Barye and failed to understand the anatomy of a flayed cat he had secured for the occasion (*Jaguar Devouring a Hare* [1899–1901], the other sculpture through which he learned this art and bid farewell to anatomic verisimilitude). So it was not the bare artificiality of Rodin's method that Matisse resented but his combination of grafted fragments and his endless fascination with the partial figure.

Which is to say that Matisse ignored one of the most modern
▲ aspects of Rodin's practice, one that Constantin Brancusi, on the

4 • Aristide Maillol, *La Méditerranée* (The Mediterranean), 1902–5
Bronze, 104.1 × 114.3 × 75.6 (41 × 45 × 29¾) including base

contrary, would emulate and refine (it is not by chance that Brancusi, after a brief apprenticeship in Rodin's studio, had fled under the spell of a veritable "anxiety of influence," claiming that "nothing grows under the shadows of the great trees"). One could even say that the cut-and-paste aspect of Rodin's sculpture, by which the cast of the same figure or fragment of figure is reused in different groups and different orientations in space, represents the
▲ first bout of what would become, with Picasso's Cubist constructions, one of the main tropes of twentieth-century art.

Matisse resisted Rodin's metonymic fragmentation, and in some ways his sculpture represents the opposite approach. With other sculptors, such a desire to think the figure as an indivisible whole developed into an academic fashion, especially since it went along with an entrenched attachment to the traditional motif of the female nude. It brought about, for instance, the plump nudes of Aristide Maillol (1861–1944) [4], or the much leaner silhouettes, on the other side of the Rhine, of Wilhelm Lehmbruck (1881–1919)—both sculptors strongly leaning on the Greco-Roman tradition and opting, against Rodin and Matisse, for resolutely smooth surfaces by which the bronze is required to imitate marble. This reaffirmation of the whole even engendered a kind of hybrid sculpture that one could call pseudo-Cubist, or proto-Art Deco: Jacques Lipchitz, Raymond Duchamp-Villon, and Henri Laurens in Paris and, to a certain extent, Jacob Epstein
• and Henri Gaudier-Brzeska in England all produced works that seem to rely upon a Cubist mode of articulation but in effect magnify the solidity of the mass, their planar discontinuity remaining at the superficial level of a stylistic wrapping and never fully engaging the volume in space.

The fundamental trait that distinguishes their works from Matisse's is that they are fully frontal—made to be seen from a single point of view (or sometimes four distinct ones, in the case of Maillol

3 • Henri Matisse, *Jeannette V*, 1916
Bronze, height 58 (22⅞)

<div style="writing-mode: vertical-rl">1900–1909</div>

5 • Henri Matisse, *The Back (I)*, c. 1909
Bronze, 188.9 × 113 × 16.5 (74⅜ × 44½ × 6½)

6 • Henri Matisse, *The Back (II)*, 1916
Bronze, 188.5 × 121 × 15.2 (74¼ × 47⅝ × 6)

or Laurens)—while Matisse's are eloquently not. To understand this point, it would be helpful to consider what German-American art historian Rudolf Wittkower proposed, along with the example of Rodin, as one of only two avenues offered to Matisse's generation by the sculpture of the nineteenth century, that is, the theories of German sculptor Adolf von Hildebrand (1847–1921)—unlikely as it may be that Matisse ever knew of Hildebrand except by hearsay. Hildebrand held that all sculpture should be a disguised relief, made of three planes staggered in depth, whose legibility must be immediately accessible from a set point of view. (In his eyes, the greatness of Michelangelo is that he always allows us to discern the virtual presence of the block of marble: his figures are "sandwiched" between the front and back of the original stone mass.) An actual relief is even better, Hildebrand wrote, since, in this, the (framed) figures are virtually freed from having to deal with the anxieties of the infinite surrounding space. In short, Hildebrand thought in terms of planes (and held modeling in contempt as too physical).

Even in the series of four *Back* reliefs that he produced from 1909 to 1930, Matisse disobeyed Hildebrand's instructions (he was in fact closer here than ever to Rodin, whose other famous "failed" monument, *The Gates of Hell*, is an opaque confusion of forms against which the eye, allowed no progression in depth, can only come to an abrupt halt). As conceived by Hildebrand and by the entire academic tradition, the relief presupposes a background representing an imaginary space from which the figures emerge, with the anatomical knowledge of the beholder providing all the necessary information concerning what is concealed from view. The relief's background functions like the picture plane in the system elaborated during the Renaissance by Leon Battista Alberti: it is a virtual plane, assumed to be transparent. In some respects, in fact, the *Backs* could be seen as an ironic response to Hildebrand in that the figure gradually becomes identified with the wall bearing it: in *The Back (I)* [5], the figure is leaning on the wall (there is a realist justification for this strange pose that so willfully ignores the conventions of the genre);

7 • Henri Matisse, *The Back (III)*, 1916
Bronze, 189.2 × 111.8 × 15.2 (74½ × 44 × 6)

8 • Henri Matisse, *The Back (IV)*, 1931
Bronze, 188 × 112.4 × 15.2 (74 × 44¼ × 6)

in *The Back (II)* [**6**], the differentiation between the modeling of the back and the treatment of the background begins to blur (in certain light conditions, the vertebral column disappears almost entirely); in *The Back (III)* [**7**], the figure is almost completely aligned with the limits of the "support"; in *The Back (IV)* [**8**], it has become a simple modulation of the support (there is no difference between the braid of hair and the space that continues it between the legs—simply a difference in degree of protrusion). In short, if for once Matisse actually did sculpt as a painter here (as he wrongly claimed he always did), he in no sense forgot the pictorial revolution he had carried out beforehand: he borrowed from his painting the anti-illusionism and the "decorative" effect (Matisse's name for the *allover*) that characterizes it. Needless to say, this is a far cry from Hildebrand.

But the *Backs*, being reliefs, are an exception. Most of Matisse's bronzes command the beholder to move round them. A case in point is *The Serpentine* [**9**]. If the critics have long since noted that the title refers to the "S" traced by the figure in space and to the

reduction of its anatomy to mere ropes, the allusion to the *figura serpentinata*—a principle established by Michelangelo and taken to extremes by Mannerism—has often escaped them. Matisse, however, was fully conscious of his historical borrowing ("Maillol worked through mass like the Ancients, while I work through the arabesque, like the Renaissance artist," he used to say). Right at the end of his life, noting that the model of *The Serpentine* (taken from a photograph) was "a small plump woman," he explained that he had ended up "doing her that way so that everything was visible, regardless of the point of view." He also talked of "transparency," even going as far to suggest that the work anticipates the Cubist revolution. But Matisse was mistaken on this point, for at least two reasons.

The inaccessible "thing-in-itself"

We have seen that Matisse rejected (with Rodin) the ideal of the imaginary transparency of the material cherished by both the

9 • Henri Matisse, *The Serpentine*, 1909
Bronze, 56.5 × 28 × 19 (22¼ × 11 × 7½)

academic tradition and by Hildebrand, but when he speaks of transparency here he has two other meanings of the word in mind. One encapsulates the related dream of an *ideational* transparency, that of a full and immediate grasp of the work of art's signification; and the other designates, in studio parlance, the use of empty space by modern sculptors. To start with the latter, *The Serpentine*'s "transparency" has nothing to do with the way in which empty ▲ space—in the wake of Picasso's famous *Guitar* from the fall of 1912—is transformed in Cubist sculpture into one of the major constitutive elements in a system of oppositional signs. In *The Serpentine*, empty space is only a secondary effect of the pose, and Matisse never used it again. The other issue is more important, for what actually happens is the opposite of what Matisse claims: you can *never* see everything at once; whatever your point of view, you can *never* fully grasp the work's signification. As one moves around *The Serpentine*, one sees a kind of spatial accordion, constantly expanding and contracting (or, to employ another metaphor, the negative spaces open and close like butterfly wings). One is constantly surprised by the multiplicity of aspects that are each time absolutely unforeseeable. From the back, its minuscule insect-head (that of a praying mantis?) reveals a massive head of hair that comes as a complete shock; the joins of the arabesques formed by the torso, the arms, and the left leg ceaselessly break the body without ever negating its plumb line (the right leg is rigorously parallel to the vertical pillar on which the elbow rests). In short, you can circle *The Serpentine* a hundred times, but you will never finally manage to possess it; its curvilinear dance in space ensures its wholeness but also its distance: this wholeness, that of the thing-in-itself, is made inaccessible to us.

And it is precisely here that one pinpoints the major difference between Matisse's sculpture and the art of Michelangelo, for example, or of Giambologna, to which it has been compared. For Giambologna also forces you to move around his sculptures, but there always comes a moment when your journey around a piece reaches a discernible endpoint, always a moment when you realize what is going on. The reason is simple: on the one hand, the distortions produced by the *contrapposto* always remain within the limits of anatomical knowledge (thanks to which we "overlook" a certain conspicuously elongated leg or an impossibly foreshortened knee, and read the figure as a continuous form); on the other hand, the gestures represented always have some kind of justification, either realist or rhetorical (like a kneeling bather drying herself, or the *Sabine* whose pathetic gesture, calling on heaven to rescue her from the colossus who is carrying her off, completes the spiral of the sculptor's most famous group). Matisse cares little for all of this—for anatomy (he simply ignores it, once again driving home the lesson learned from the private Rodin) or for evocative gestures.

The fact that there is no climax to our circumnavigation around a sculpture by Matisse, nor any privileged view afforded at any time, and, moreover, that the different aspects are unpredictable from one point of view to the next, explains the difficulty one experiences when trying to photograph it: only a film, perhaps, would do justice

▲ Introduction 3, 1912

10 • Henri Matisse, *Reclining Nude I (Aurora)*, 1907
Bronze, height 34.5 (13½)

to the absence of arris—sharp planar edges—that characterizes Matisse's flow. Conscious of this difficulty, Matisse offered to help photographers charged with publicizing his sculptures. Not surprisingly, he rarely chose a frontal view (he showed the five *Jeannettes* in profile, for example, or from behind). Or if he did, it is when the axis of the figure itself was not organized frontally. It seems that what mattered most to him was to find the most eccentric, least expected point of view, which is often the one where the arabesques close the sculpture in on itself (and which therefore provides the least information on its contortions). Matisse often had several photographs taken of the same work, and seemed to take pleasure in the sharp discordances from one to the next. He chose three points of view for *Reclining Nude I* [**10**]: frontal (as it appears in the background of the painting *The Music Lesson* [1916/17] at the Barnes Foundation); in three-quarter profile angled toward the back, which folds in on itself the arm raised in a simple vertical and reveals the "helmet" of hair; but also in full profile (facing the feet), from an angle that enlarges the whole figure, crushes the torso and the bulge of the thigh, fills out the shoulders and, above all, blocks all access to the length of the belly. It is as if he were playing a game with cognition, teasing our desire for its fullness, and declaring its necessary incompleteness—the very condition of modernity. YAB

FURTHER READING
Adolf von Hildebrand, "The Problem of Form in the Visual Arts" (1893), translated in Harry Mallgrave and Eleftherios Ikonomou (eds), *Empathy, Form, and Space: Problems in German Aesthetics, 1873–1893* (Los Angeles: Getty Institute, 1994)
Rosalind Krauss, *Passages in Modern Sculpture* (New York: Viking Press, 1977; reprint Cambridge, Mass.: MIT Press, 1981)
Isabelle Monod-Fontaine, *The Sculpture of Henri Matisse* (London: Thames & Hudson, 1984)
Leo Steinberg, "Rodin," *Other Criteria: Confrontations with Twentieth-Century Art* (London, Oxford, and New York: Oxford University Press, 1972)
Rudolf Wittkower, *Sculpture* (London: Allen Lane, 1977)

1903

Paul Gauguin dies in the Marquesas Islands in the South Pacific: the recourse to tribal art and primitivist fantasies in Gauguin influences the early work of André Derain, Henri Matisse, Pablo Picasso, and Ernst Ludwig Kirchner.

Four painters of the late nineteenth century influenced modernists in the early twentieth century more than all others: Georges Seurat (1859–91), Paul Cézanne (1839–1906), Vincent van Gogh (1853–90), and Paul Gauguin (1848–1903). Each proposed a new purity in painting, but each did so according to a different priority: Seurat stressed optical effects; Cézanne, pictorial structure; van Gogh privileged the expressive dimension of painting; Gauguin, its visionary potential. Although not as generative in terms of style, Gauguin was more influential as a persona: the father of modernist "primitivism," he reformulated the vocation of the Romantic artist as a kind of vision-quest among tribal cultures. Inspired by his example, some modernist artists attempted to go native, or at least to play at it. Two German Expressionists, Emil Nolde (1867–1956) and Max Pechstein (1881–1955), traveled to the South Pacific in ▲ emulation of Gauguin, while two others, Ernst Ludwig Kirchner (1880–1938) and Erich Heckel (1883–1970), restaged primitive life in their studio decor or on nature outings. But many modernists drew on tribal art for forms and motifs: some, like Henri Matisse and Pablo Picasso, did so in profound, structural ways; others, in superficial, illustrational ways.

All of these artists sought to challenge European conventions that they felt to be repressive, and all imagined the primitive as an exotic world where style and self might be refashioned dramatically. Here primitivism extends well beyond art: it is a fantasy, indeed a whole cluster of fantasies, concerning return to origin, escape into nature, liberation of instinct, and the like, all of which were projected onto the tribal cultures of racial others, especially in Oceania and Africa. But even as a fantasy-construction, primitivism had real effects: it was not only part of the global project of European imperialism (on which the very passageways to the colonies, the very appearance of tribal objects in the metropolises, depended), but also part of the local maneuverings of the avant-garde. Like prior returns *inside* Western art (e.g., the Romantic recovery of medieval art in the nineteenth century by artists such as the Pre-Raphaelites), these primitivist sojourns *outside* Western art were strategic: they appeared to offer a way not only to exceed old academic conventions of art but also to trump recent avant-garde styles (e.g., Realism, Impressionism, neo-Impressionism)

that were deemed to be too concerned with strictly modern subjects or purely perceptual problems.

Primitivist pastiche

Gauguin came to his primitivist quest late, only after he had lost a lucrative position on the Paris Stock Exchange in 1883, at the age of thirty-five. Initially, he worked in Brittany in western France, still a folkloric region then, along with other Symbolist artists such as Émile Bernard (1868–1941), first in 1886 and, after a failed trip to Panama and Martinique in 1887, again in 1888. Gauguin was inspired to go to Tahiti in part by the "native villages" that were set up like zoo displays of indigenous peoples at the 1889 Universal Exhibition in Paris; he was also very taken by Buffalo Bill's Wild West show. For all its rhetoric of purity, primitivism was often just such a mix of kitsch and cliché (legend has it that Gauguin arrived in Tahiti wearing a cowboy hat). Apart from an eighteen-month return to Paris in late 1893 to manage the market for his art, he lived in Tahiti from 1891 until his final move to the Marquesas Islands in 1901. In effect, Gauguin pushed beyond the folk culture of Brittany to the tropical paradise of Tahiti (such was its legendary status, at least since Denis Diderot's *Supplement to the Voyage of Bougainville* was published in 1796), and then on to the Marquesas, which he saw as a place of sacrifice and cannibalism, dark complement to light Tahiti. As he did so, Gauguin understood his voyage out in space as a voyage back in time: "Civilization is falling from me little by little," he wrote in his Tahitian memoir *Noa-Noa* (1893). This conflation, as if *farther away* from Europe equaled *farther back* in civilization, is characteristic of primitivism, indeed of the racialist ideology of cultural evolution still pervasive at the time.

Yet Gauguin also proposed a partial revaluation of this ideology. For in his paintings and writings the primitive became the pure term and the European, the corrupt. In "the kingdom of gold," he wrote of Europe just prior to his first departure for Tahiti, "everything is putrefied, even men, even the arts." This is the source of both his stylistic rejection of Realism and his Romantic critique of capitalism, two positions that his Expressionist followers held as well. Of course, to reverse this opposition of primitive and European was not to undo or to deconstruct it. The two terms remained

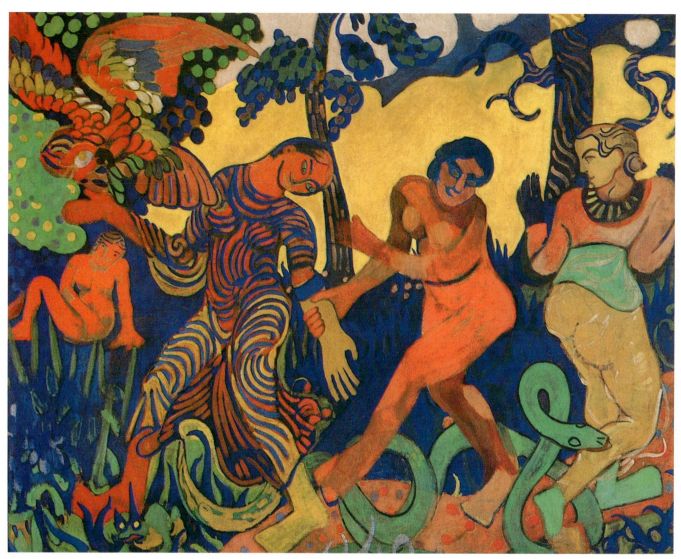

1 • André Derain, *The Dance*, 1905–6
Oil and distemper on canvas, 179.5 × 228.6 (70¾ × 90)

very much in place, and his revision of this binarism only forced Gauguin into an ambivalent position. "I am the Indian and the man of sensitivity [in one]," he once wrote to his abandoned wife Mette, with a special emphasis on his partial Peruvian ancestry. His myth of Tahitian purity also flew in the face of the social facts. In 1891, after ten years as a French colony, Tahiti was hardly the "unknown paradise" where "to live is to sing and to love," and the Tahitians hardly a new race after the biblical Flood, as Gauguin presented them in the pages of *Noa-Noa*.

If Polynesia was polyglot, so was his art. Less purist than eclectic, Gauguin drew on the courtly art of Peru, Cambodia, Java, and Egypt more than on the tribal art of Oceania or Africa. ("Courtly" and "tribal" suggest different sociopolitical orders, though both terms are now almost as disputed as "primitive.") Often motifs from these various cultures appear in strange ensembles; the Tahitian women in his *Market Day* (1892), for example, sit in poses derived from a tomb painting of Eighteenth-Dynasty Egypt. Nor did his arrival in Tahiti transform his style dramatically: the bold contours Gauguin derived from the stone sculptures of Breton

churches, as well as the strong colors he developed from Japanese prints, persisted. So did many of his subjects: the visionary spirituality of the Breton womenfolk in *Vision after the Sermon* (1888), for example, becomes the saintly simplicity of the native Tahitian women in *We Hail Thee, Mary* (1891), only here pagan innocence rather than folk belief redefines Christian grace. Such syncretism of style and subject matter might suggest a primordial sharing of aesthetic and religious impulses across cultures (this possibility interested other primitivists, like Nolde, too), but it also points to a paradox of much primitivist art: that it often pursues purity and primacy through hybridity and pastiche. Indeed, primitivism is often as mixed stylistically as it is contradictory ideologically, and it is this eclectic construction that Gauguin passed on to his legatees.

Avant-garde gambits

A large Gauguin retrospective was held at the Salon d'Automne in Paris in 1906, yet artists such as Picasso had begun to study him as early as 1901. Already in a painting such as *The Dance* [1]—

The exotic and the naive

Primitivism was hardly the first exoticism in modern Europe: phantasmatic versions of the East abounded in art and literature alike. The eighteenth century saw a fashion for Chinese porcelain (*chinoiserie*), and nineteenth-century artists were drawn first to North Africa and the Middle East (Orientalism) and then to Japan (*japonisme*). These fascinations often followed historic conquests (e.g., the Napoleonic campaign in Egypt in 1798, and the forced opening of Japan to foreign trade in 1853) and imperial byways (e.g., French artists tended to head to French colonies, German artists to German, and so on). But these places were "imaginary geographies" (in the words of Edward Said in his 1978 book *Orientalism*); that is, they were space–time maps onto which psychological ambivalence and political ambition could be projected.

Thus Orientalist art often depicted the Middle East as ancient, a cradle of civilization, but also as decrepit, corrupt, feminine, in need of imperial rule. Japan was known to be an ancient culture too, but *japonistes* perceived its past as innocent, with a pure vision that, retained in Japanese prints, fans, and screens, might be accessed by Europeans clouded by Western conventions of representation. Primitivism projected an even more primordial origin, but here too the primitive was divided into a pastoral or noble savage (in the sensuous paradise of the tropics, often associated with Oceania) and a bloody or ignoble savage (in the sexual heart of darkness, usually connected to Africa). Each of these exotic theaters persists to this day, however muted or inflected, and others have joined them, propagated, as was the case then, by mass media. Avant-gardists appealed to these imaginary geographies for tactical reasons. The Impressionists and Postimpressionists had already occupied Japan, Picasso once suggested, so his generation grabbed up Africa instead, though some like Matisse and Paul Klee retained Orientalist settings as well. By the same token, the Surrealists turned to Oceania, Mexico, and the Pacific Northwest because the arts there were more surrealistic, so they said, but it was also in order to circumvent the Cubists and the Expressionists. The rule that a step outside a tradition is also a strategy within it holds for the frequent turn to folk art as well—whether it is Gauguin and Breton crucifixes, Wassily Kandinsky and Bavarian glass painting, or Kazimir Malevich and Vladimir Tatlin and Byzantine icons.

A special case is the modernist celebration of the "naive" artist, such as Henri Rousseau (1844–1910), also known as Le Douanier (customs officer), so named after his day job for fifteen years. Naive art was often associated with child, tribal, and folk art as untutored and intuitive. And yet Rousseau was a Parisian, not a peasant, who, far from oblivious to academic art, attempted a realist representation based on studio photographs and Salon compositions. In part his painting seemed surreal to his avant-garde contemporaries simply because it was technically awkward. Guillaume Apollinaire tells us that Rousseau measured the features of his portrait sitters, then transferred the lengths directly to the canvas, only to produce, in the pursuit of a realist effect, a surreal one. His jungle pictures also have an anxious intensity, as everyday house plants are transformed, with each vine and leaf meticulously contoured and flattened whole to the canvas, into an eerily animate forest. Rousseau was sincere, as was the appreciation of his modernist friends—among them Picasso, who hosted a banquet in his honor in 1908. Sincere, but, again, these identifications were often tactical and temporary. Here the last word might be given to the sociologist Pierre Bourdieu: "The artist agrees with the 'bourgeois' in one respect: he prefers naïveté to 'pretentiousness.' The essential merit of the 'common people' is that they have none of the pretensions to art (or power) which inspire the ambitions of the 'petit bourgeois.' Their indifference tacitly acknowledges the monopoly. That is why, in the mythology of artist and intellectuals, whose outflanking and double-negating strategies sometimes lead them back to 'popular' tastes and opinions, the 'people' so often play a role not unlike that of the peasantry in the conservative ideologies of the declining aristocracy."

a rhythmic arrangement of ornamental women set in an imaginary tropical scene replete with parrot and snake—André Derain (1880–1954) treated the primitivism of Gauguin as if it were a Fauvist theme park of decorative freedom and feminine sensuality. Matisse also painted such idylls in *Luxe, calme et volupté* (1904–5) ▲ and *Le Bonheur de vivre* (1905–6), but his scenes are more pastoral than primitivist, and, like Picasso, when he engaged tribal art directly in 1906, his interest was more formal than thematic. Ironically, this formal interest led both Matisse and Picasso away from Gauguin around the time of his retrospective. Concerned to strengthen the structural basis of their art, both turned from Gauguin and Oceanic motifs to Cézanne and African objects, which they read in terms of each other—partly to defend against the excessive influence of either term. Indeed, Picasso later insisted
• that the African objects—which he, like Matisse, collected—were "witnesses" to the development of his art rather than "models" for

it—a defensive recognition of the importance of tribal art that other primitivists would also make.

The primitivist trajectories of Matisse and Picasso were divergent. Initially, both were interested in the Egyptian sculpture they ▲ saw at the Louvre. But Picasso soon turned to Iberian reliefs, whose broad contours influenced his portraits of 1906–7, while Matisse, who was always more involved in the Orientalist dimension of French painting, traveled to North Africa. From late 1906, however, both artists were prepared to learn from African masks and figures. "Van Gogh had Japanese prints," Picasso once remarked succinctly, "we had Africa." But, again, they developed different lessons from its art. Whereas African sculpture was • crucial to Cubist collage and construction in particular, Matisse used it to stake out a plastic alternative to Cubism. Above all, he admired its "invented planes and proportions." This is apparent in his sculptures of the time, such as *Two Negresses* (1908), which

possesses the large heads, round breasts, and prominent buttocks of some African figures. But "invented planes and proportions" are also evident in his contemporaneous paintings, where they helped Matisse to simplify his drawing and to free his color from descriptive functions. This is evident in his foremost primitivist canvas, *The Blue Nude: Souvenir of Biskra*, which, like its sculptural ▲ counterpart, *Reclining Nude I* (1907), is a radical revision of the academic nude.

Ever since Édouard Manet (1832–83) cast the academic nude—from the Venuses of Titian to the *Odalisques* of Ingres—onto the lowly divan of a Parisian prostitute in *Olympia* (1863), avant-garde painting staked its transgressive claims on the subversion of this genre more than any other. Gauguin copied *Olympia* on canvas [2] as well as in a photograph, which he took to Tahiti as a kind of talisman, and he painted his adolescent Tahitian wife Teha'amana in a scene that cites Manet's painting. But *The Spirit of the Dead Watching* [3] recalls *Olympia* mostly in order to trump it. For the art historian Griselda Pollock this is an "avant-garde gambit" of

2 • Paul Gauguin, *Copy of Manet's Olympia*, 1890–1
Oil on canvas, 89 × 130 (35 × 51¾)

3 • Paul Gauguin, *The Spirit of the Dead Watching* (*Manao Tupapau*), 1892
Oil on burlap mounted on canvas, 73 × 92 (28½ × 36⅜)

▲ 1900b

three moves in one: Gauguin makes *reference* to a tradition, here not only the tradition of the academic nude but also its avant-garde subversion; he also shows *deference* to its masters, here not only Titian and Ingres but also Manet; and finally, he proposes his own *difference*, an Oedipal challenge to all these paternal precedents, a claiming of master status alongside them. Clearly, Matisse with ▲ *The Blue Nude*, Picasso with *Les Demoiselles d'Avignon* (1907), and Kirchner with *Girl under a Japanese Umbrella* [4] are also involved in a pictorial competition with artistic forebears and with each other, one staged, as it were, on the bodies of women. Each artist looks outside the Western tradition—in a turn to tribal art, in a fantasy of a primitive body—as a way to advance inside the Western tradition. In retrospect, this outside, this other, is then incorporated into the formal dialectic of modernist art.

First Gauguin revises Manet, reworks his blunt scene of a Paris prostitute into an imaginary vision of a Tahitian "spirit of the dead." He inverts the figures, substitutes a black spirit for the black maid in *Olympia*, and replaces the white body of the prostitute with the black body of the primitive girl. Gauguin also averts her gaze (this is crucial: Olympia returns our gaze, stares the male viewer down as if he were a customer), and rotates her body so as to expose her buttocks (this, too, is crucial: it is a sexual pose that Teha'amana, unlike Olympia, does not control—the implied male viewer does). It is with this double precedent of *Olympia* and *Spirit* that, in quick succession after the Gauguin retrospective, Matisse, Picasso, and Kirchner all wrestle. In *The Blue Nude:*

4 • Ernst Ludwig Kirchner, *Girl under a Japanese Umbrella,* **1909**
Oil on canvas, 92.5 × 80.5 (36½ × 31½)

▲ 1907

Souvenir of Biskra [5], Matisse moves the newly forged figure of the prostitute/primitive to an Orientalist site, the oasis of Biskra in North Africa (which he had visited in 1906), whose ground lines and palm fronds echo the contours of the bent elbow and prominent buttocks of his nude. In doing so, he recalls the odalisque term in this particular dialectic of the primitive body (an odalisque was a female slave, usually a concubine, in the Near East, a fantasy figure for many nineteenth-century artists); and yet, as noted above, his figure is more Africanist than Orientalist (as if to underscore this point, Matisse added the subtitle in 1931). So, even as Matisse recovers the pose of *Olympia*, he also deepens the primitivizing of feminine sexuality begun in *Spirit*, the principal sign of which is the prominent buttocks (made so by the violent rotation of her left leg across her pubic area). In this way *The Blue Nude* trumps both Manet and Gauguin—another modernist victory won on the battleground of the prostitute/primitive nude.

Primitivist ambivalence

Shown to great uproar in the Salon des Indépendants of 1907, *The Blue Nude* then provokes Picasso to an extreme of rivalry with *Les Demoiselles d'Avignon*, which returns the primitive body to a brothel, and so "resolves" prostitute and primitive in one figure. Moreover, Picasso multiplies this figure by five—three visaged in his Iberian manner, two in his African—and pushes them vertically to the frontal plane of the canvas where they gaze at the viewer with a sexual threat that exceeds not only the Gauguin and the Matisse but also the Manet. In *Girl under a Japanese Umbrella,* Kirchner, too, responds to *The Blue Nude* (he could not have seen *Les Demoiselles*); he inverts the pose but retains the signal rotation of the body that raises the buttocks. Kirchner also replaces the Orientalist setting of *The Blue Nude* with *japoniste* props like the parasol. But the telling element of the decor is the frieze of sketchy figures above the nude. This recalls the wall hangings that decorated his studio with sexually explicit images, some inspired by house beams from the German colony of Palau that Kirchner had studied in the ethnographic museum in Dresden. In this frieze, Kirchner points to a fantasy of anal eroticism only implied by *Spirit* and *The Blue Nude*, and so points as well to a narcissistic dimension of modernist primitivism that is not simply formal—and perhaps not as masterful as it first seems. For the prostitute/primitive is such a fraught image not only because it disrupts an academic genre but also because it provokes great ambivalence concerning sexual and racial differences.

Although subordinated as a prostitute, Olympia commands her sex, which she covers with her hand, and this partial power is crucial to the provocation of the painting. In *Spirit*, Gauguin takes this female power away: Teha'amana is prone, subordinate to the gaze of the viewer. Yet the tradition of the primitive body is not simply about voyeuristic mastery. Gauguin concocted a story of religious dread to accompany his painting, but this diverts us from its sexual significance: *Spirit* is a dream of sexual mastery, but this

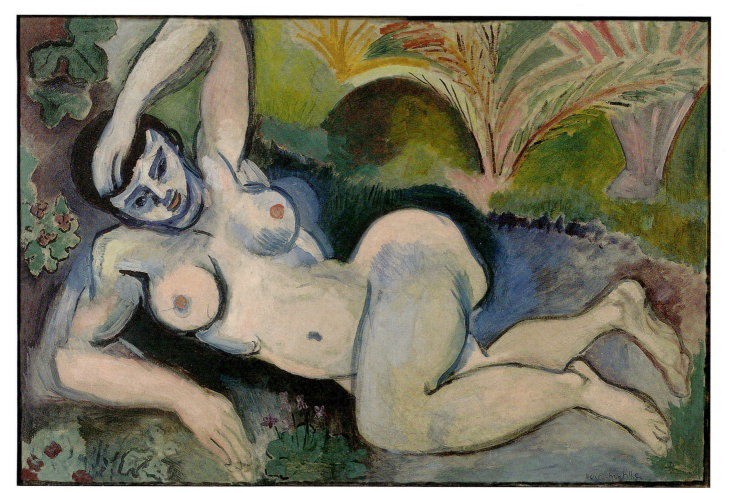

5 • Henri Matisse, *The Blue Nude: Souvenir of Biskra*, 1907
Oil on canvas, 92.1 × 142.5 (36¼ × 56⅛)

mastery is not actual; its pictorial performance may even compensate for a felt lack of such mastery in real life. This suggests that the painting works on an anxiety or an ambivalence that Gauguin secretly, maybe unconsciously, presumed. This ambivalence—perhaps a simultaneous desire and dread of feminine sexuality—is more active in *The Blue Nude*, and Matisse defended against it more actively, too. "If I met such a woman in the street," he stated unequivocally after his painting was attacked, "I should run away in terror. Above all I do not create a human, I make a picture." Kirchner seems not to have needed such a defense; at least in *Girl under a Japanese Umbrella* he paraded an erotic fantasy without much anxiety—but also without much force.

It was the problematic genius of Picasso that led him to work his sexual and racial ambivalences into thematic and formal experiments. In effect, *Les Demoiselles* maps two memory-scenes onto one another: a distant visit to a bordello in Barcelona (his student home) and a recent visit to the Musée d'Ethnographie du Trocadéro in Paris (now the Musée de l'Homme), both apparently traumatic for Picasso—the first sexually, the second racially, in ways that the painting conflates. The encounter in the ethnographic museum was momentous: among other effects, Picasso transformed *Les Demoiselles* in its wake. Such visits—to tribal exhibits at museums, fairs, circuses, and the like—were important

to many primitivists, and a few were later narrated precisely as traumatic encounters in accounts in which the full significance of tribal art is revealed in retrospect, only to be denied in part (again, the claim that such objects are "witnesses," not "models"). In one version of the tale of his visit to the Trocadéro, Picasso called *Les Demoiselles* his "first exorcism painting." This term is suggestive in ways that he did not suspect, for much modernist primitivism engages tribal art and primitive bodies only at times to exorcise them formally, just as it recognizes sexual, racial, and cultural differences only at times to disavow them fetishistically. HF

FURTHER READING
Stephen F. Eisenman, *Gauguin's Skirt* (London and New York: Thames & Hudson, 1997)
Hal Foster, *Prosthetic Gods* (Cambridge, Mass.: MIT Press, 2004)
Sander L. Gilman, *Difference and Pathology: Stereotypes of Sexuality, Race and Madness* (Ithaca, N.Y.: Cornell University Press, 1985)
Robert Goldwater, *Primitivism in Modern Art* (New York: Vintage Books, 1967 [originally published 1938])
Jill Lloyd, *German Expressionism: Primitivism and Modernity* (New Haven and London: Yale University Press, 1991)
Griselda Pollock, *Avant-Garde Gambits 1883–1893: Gender and the Colour of Art History* (London and New York: Thames & Hudson, 1992)
William Rubin (ed.), *"Primitivism" in 20th Century Art: Affinity of the Tribal and the Modern* (New York: Museum of Modern Art, 1984)

1906

Paul Cézanne dies at Aix-en-Provence in southern France: following the retrospectives of Vincent van Gogh and Georges Seurat the preceding year, Cézanne's death casts Postimpressionism as the historical past, with Fauvism as its heir.

Henri Matisse was very fond of a particular Cézanne dictum: "Beware of the influential master!" He often quoted it when addressing the issue of inheritance and tradition. Noting that Cézanne had revisited Poussin in order to escape from the spell of Courbet, he would take pride in the fact that he, Matisse, had "never avoided the influence of others," emphasizing the importance of Cézanne in his own formation (he is "a sort of god of painting," "the master of us all"; "if Cézanne is right, I am right," and so on). But Matisse's claim that he was strong enough to assimilate the example of a master without succumbing to it is disingenuous when it comes to Cézanne. Unlike his friend, and future fellow Fauve, Charles Camoin (1879–1965), who jauntily visited the aging painter in Aix several times, Matisse was acutely aware of the potential danger that Cézanne represented for young admirers like himself. Looking at Matisse's *Still Life with a Purro I*, or his *Place des Lices, Saint-Tropez*, both painted in the summer of 1904, one cannot help but think of a statement he made half a century later (it was one of his last): "When one imitates a master, the technique of the master strangles the imitator and forms around him a barrier that paralyzes him."

The four evangelists of Postimpressionism

The year 1904 was when Cézanne, cut off from a world that had ridiculed him all his life, finally attained celebrity. Imposing articles were published about him (notably an essay by Émile Bernard [1868–1941]); dealers other than Ambroise Vollard, his lone official supporter since 1895, started gambling on him (he had a one-man show in Berlin); and in the fall, a mini-retrospective of his work (with thirty-one paintings) was presented at the Salon d'Automne, one of the two annual Parisian art fairs of the time (three years later, in 1907, its spring equivalent, the Salon des Indépendants, would top this event with an exhibition double in size).

A document from 1905 provides a window onto the atmosphere of the Parisian art world at the time. The poet-critic Charles Morice's "Enquête sur les tendances actuelles des arts plastiques" (Investigation of Current Trends in the Plastic Arts) presented the answers to a questionnaire that its author had sent to artists of various persuasions. The question that received the longest and most passionate replies was "What do you think of Cézanne?" (Matisse did not bother to give his obvious answer). The rise of Cézanne's reputation was then unstoppable: by the time he died, in October 1906, his appeal was so pervasive that his foremost champion, the painter-theoretician Maurice Denis (1870–1943)—who had paradoxically seen him as the savior of the moribund tradition of French classicism—cried foul and berated the work of his many followers as either too derivative or, in the case of Matisse, nothing less than a betrayal.

Morice's "Investigation" helps us to put this sudden hype surrounding Cézanne into context. He had bluntly asked: "Is Impressionism finished?" Then, more diplomatically: "Are we on the eve of something?" and "Must the painter expect everything from nature, or must he only ask from it the plastic means to realize the thought that is in him?" These questions were followed by a request for an evaluation of the work of Whistler, Fantin-Latour, and Gauguin, as well as that of Cézanne. If the query about Gauguin was to be expected, since Morice had long been a close ally of the painter's (he had coauthored *Noa-Noa* with him), those concerning Whistler and Fantin-Latour, testifying to Morice's active participation in the Symbolist movement twenty years earlier, were incongruous (as the answers confirmed). A more savvy critic would have juxtaposed the names of van Gogh and Seurat with those of Cézanne and Gauguin in such a questionnaire, for by then it had become obvious that the new generation's loud "Yes" to Morice's sequence of anti-Impressionism questions was a cumulative effect of this quartet's coeval work.

It should be noted that van Gogh and Seurat were long dead—the first in 1890, the second, the following year—and that Gauguin, who died in 1903, had been abroad for more than a decade. It comes as no surprise, therefore, that, among the four evangelists of Postimpressionism, Cézanne should be the most present at this point. Yet, for Matisse and his peers, it was urgent to reckon with them all. Between 1903 and Cézanne's death in 1906, van Gogh, Gauguin, and Seurat had each been celebrated by several retrospective exhibitions (with their attendant string of publications), sometimes with the direct involvement of Matisse. And while the personal relationships between these four father-figures of modernist painting had been marred by hostile

▲ 1903

ignorance, if not outright conflict, it now seemed possible to grasp what they had in common.

Their direct epigones had already done some of the groundwork as far as art theory was concerned. Both Denis and Bernard had advocated a synthesis between the art of Gauguin and that of Cézanne; but the most important event for Matisse and his cohorts was the serialization of Paul Signac's *D'Eugène Delacroix au néo-impressionnisme* (From Eugène Delacroix to neo-Impressionism) in *La Revue blanche* in 1898. Not only did this treatise present Seurat's method (indifferently labeled "divisionism" or "neo-impressionism") in an orderly, accessible fashion, but, as its title made clear, it was conceived as a teleological account, as a genealogy of the "new" in art from the early nineteenth century on. There was surprisingly little emphasis on Seurat's dream or on the optical physiology theories on which it was based—the idea that the human eye could perform something like the prismatic decomposition of light in reverse, that the "divided" colors would resynthesize on the retina in order to attain the luminosity of the sun—perhaps because Signac had already admitted to himself that this was a chimera. Rather, Signac insisted on the successive "contributions" of Delacroix and of the Impressionists, understood as having paved the way for the total emancipation of pure color performed by neo-Impressionism. Within such a context, Cézanne's idiosyncratic, atomistic brush-strokes (one color per stroke, each kept conspicuously discrete) were deemed a congruent contribution consolidating the ban on the mixing of colors that had still been standard practice during Impressionism.

Matisse's first encounter with Signac's gospel was premature. After a trip to London in order to see Turner's paintings (on the advice of Cézanne's mentor, the old Camille Pissarro), he had headed for Corsica, where his art—then a murky and not-so-competent form of Impressionism—turned "epileptic," as he wrote in a panic to a friend, upon his sudden discovery of southern light. In the numerous paintings he completed in Corsica and then in Toulouse in 1898 and 1899, the feverish brush-strokes are thick with impasto, and the colors ineluctably lose their intended incandescence as the pastes mix directly on the canvas. The cardinal axiom of Postimpressionism (of whatever persuasion), that one had to "organize one's sensation," to use Cézanne's celebrated phrase, came to Matisse via Signac precisely at this point. But his attempt at following the minute procedures required by the divisionist system, during the next few months, remained frustrating. Yet this failure exacerbated his desire to comprehend the whole of Postimpressionism (he notably purchased several works by its masters—then a considerable financial sacrifice for him—including a small painting by Gauguin and, above all, Cézanne's *Three Bathers*, a painting from the mid- to late 1870s that he would treasure like a talisman until he donated it to the city of Paris in 1936).

Cohabiting with these few works and never missing a Postimpressionist show constituted the major part of Matisse's modernist education prior to his second bout of divisionism. He gradually understood that despite major differences in their art, the four major Postimpressionists had all stressed that if color and line were to be celebrated, if their expressive function were to be enhanced, they had to become independent from the objects they depicted. Further, these artists showed Matisse that the only way to assert this autonomy of the basic elements of painting was first to isolate them (as a chemist would do) and then to recombine them into a new synthetic whole. Although Seurat had erred when he sought to apply this experimental method to the immateriality of light, that unreachable Holy Grail of painters, his analysis/synthesis process resulted in the apotheosis of the physical, nonmimetic components of painting, and it was such a return to basics, Matisse was now ready to see, that governed Postimpressionism in general. Because divisionism was the only Postimpressionist branch that came with an explicit method, it was a good place from which to start again. When Signac invited Matisse to spend the summer of 1904 in Saint-Tropez, Matisse was still trying out the various Post-impressionist dialects, but he was a far more seasoned modernist than he had been in 1898. Even though it was now harder for Matisse to play the apprentice, the timing was right.

Matisse comes of age to lead the Fauves

As far as Signac was concerned, the anxious and reluctant Matisse was finally turning out to be his best pupil: Signac purchased *Luxe, calme et volupté* [1], the major canvas that Matisse completed in Paris upon his return from Saint-Tropez and exhibited at the 1905 Salon des Indépendants (where both van Gogh and Seurat had a retrospective). Was it the idyllic subject matter that particularly seduced Signac—five naked nymphs picnicking by the seashore under the eyes of a crouched, dressed Madame Matisse and those of a standing child wrapped in a towel? Or was it the title derived from Charles Baudelaire (1821–67), a rare direct literary allusion in Matisse's oeuvre? Whatever the case, Signac chose not to notice the heavy colored contours wriggling all over the composition in defiance of his system. But when Matisse sent *Le Bonheur de vivre* to the Salon des Indépendants of the subsequent year, Signac was incensed by precisely such elements in this canvas, and by the undivided flat planes of color. Between these two events, the Fauve scandal had taken place at the infamous 1905 Salon d'Automne.

As the British critic, painter, and teacher Lawrence Gowing remarked, "Fauvism was the best prepared of all the twentieth-century revolutions." But one should add that it was also one of the shortest: it lasted but a season. True, most of the Fauves had known each other for years and had long considered the older Matisse as their leader (between 1895 and 1896, Albert Marquet [1875–1947], Henri Manguin [1874–1949], and Charles Camoin were his colleagues in the studio of Gustave Moreau, the only oasis of freedom at the École des Beaux-Arts, and when he switched to the Académie Carrière after Moreau's death in 1898, he met André Derain, who soon introduced him to Maurice de Vlaminck [1876–1958]). But the initial spark can be traced to Matisse's visit to Vlaminck's studio, at Derain's urging, in February 1905. Matisse had then just

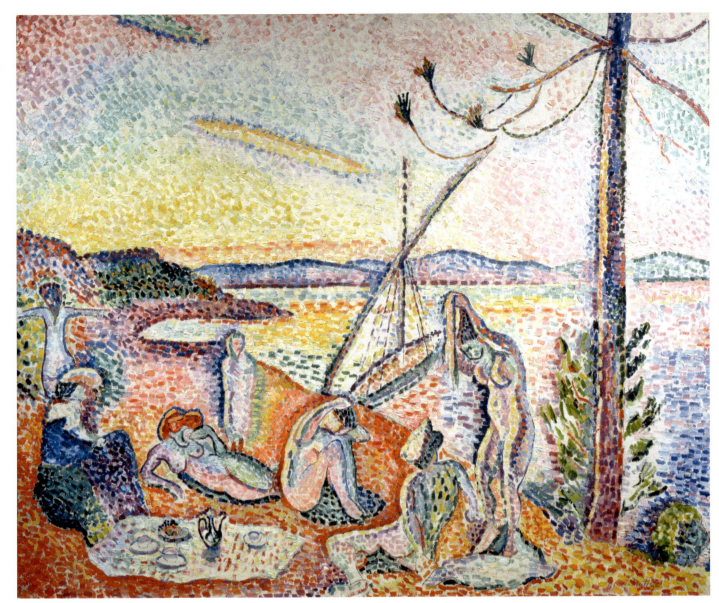

1 • Henri Matisse, *Luxe, calme et volupté*, 1904–5
Oil on canvas, 98.3 × 118.5 (38¾ × 46⅝)

finished *Luxe, calme et volupté*, of which he was rightfully proud, but now he felt unsettled by the coloristic violence of Vlaminck's production. It would take him the whole summer, which he spent with Derain in Collioure, close to the Spanish border, to get over Vlaminck's jejune audacity. Spurred by Derain's presence, and by the visit they paid together to a trove of Gauguin's works, he painted nonstop for four consecutive months. The results of this strikingly productive campaign were the key works of what was soon to be called Fauvism.

Upon seeing the academic marbles of a now long-forgotten sculptor in the middle of the room where the work of Matisse and his friends Derain, Vlaminck, Camoin, Manguin, and Marquet was exhibited at the 1905 Salon d'Automne, a critic exclaimed "Donatello chez les fauves!" ("Donatello among the wild beasts!"). The label stuck—perhaps the most celebrated baptismal episode of twentieth-century art—in large part because the uproar was considerable. Matisse's Fauve canvases—*The Woman with the Hat* [2] in particu-

lar, painted shortly after his return from Collioure—provoked the crowd's hilarity as no work had done since the public display of Manet's *Olympia* in 1863, and news that this infamous painting had been purchased (by Gertrude and Leo Stein) did not calm the sarcasm of the press. Not only did Matisse's associates benefit from his sudden fame, but the idea that he was the head of a new school of painting crystallized, and indeed his art was emulated (the initial Fauves were soon joined by others such as Raoul Dufy [1877–1953], Othon Friesz [1879–1949], Kees van Dongen [1877–1968] and, momentarily, Georges Braque [1882–1963]). But while his acolytes, with the exception of Braque, got forever stuck in the exploitation (and banalization) of the pictorial language invented during the summer of 1905, for Matisse the Collioure explosion had been only a beginning: it marked the moment when he finally achieved the synthesis of the four trends of Postimpressionism that had captivated him, and laid the ground for his own system, whose first fully fledged pictorial manifestation would be *Le Bonheur de vivre*.

▲ 1907 ● 1911, 1912, 1921a, 1944b

Roger Fry (1866–1934) and the Bloomsbury Group

Undoubtedly the most passionate supporter of advanced French painting in the English-speaking world at the beginning of the twentieth century was the British artist and critic Roger Fry. It was he who, with his 1910 exhibition "Manet and the Post-Impressionists" at the Grafton Gallery, first introduced the work of Cézanne, van Gogh, Gauguin, Seurat, Matisse, and others to an incredulous London public, in the process coining the now-familiar term "Postimpressionism." He followed the show with a second in 1912, again at the Grafton Gallery, "The Second Post-Impressionist Exhibition."

Fry was one of the most prominent members of the Bloomsbury Group, a shifting community of artists and writers in London during the opening decades of the twentieth century that included the novelist Virginia Woolf and her husband Leonard; her sister, the painter Vanessa Bell, and Bell's lover Duncan Grant; the Strachey brothers, James and Lytton, both writers; and the economist John Maynard Keynes.

Fry's aestheticism and passion for avant-garde French art formed part of the Group's model for a life devoted to the minute analysis of sensation and of consciousness. As the poet Stephen Spender described it: "Not to regard the French Impressionist and Post-Impressionist painters as sacrosanct, not to be an agnostic and in politics a Liberal with Socialist leanings, was to put oneself outside Bloomsbury." In his 1938 essay "My Early Beliefs," Keynes tried to convey the sensibility of the Group:

Nothing mattered except states of mind, our own and other people's of course, but chiefly our own. These states of mind were not associated with action or achievement or with consequences. They consisted in timeless, passionate states of contemplation and communion, largely unattached to "before" and "after." Their value depended, in accordance with the principle of organic unity, on the state of affairs as a whole which could not be usefully analyzed into parts."

The example Keynes gives of such a state is of being in love:

The appropriate subjects of passionate contemplation and communion were a beloved person, beauty and truth, and one's prime objects in life were love, the creation and enjoyment of aesthetic experience and the pursuit of knowledge.

Virginia Woolf's recollection of Fry illustrates many of Keynes's characterizations of Bloomsbury, such as the pursuit of "timeless, passionate states of contemplation and communion, largely unattached to 'before' and 'after'" whose "value depended, in accordance with the principle of organic unity, on the state of affairs as a whole which could not be usefully analyzed into parts." Accordingly, she describes Fry's lectures at the Queen's Hall in London in 1932, and the effect they had on their audience:

He had only to point to a passage in a picture and to murmur the word "plasticity" and a magical atmosphere was created. He looked like a fasting friar with a rope round his waist in spite of his evening dress: the religion of his convictions. "Slide, please," he said. And there was the picture— Rembrandt, Chardin, Poussin, Cézanne—in black and white upon the screen. And the lecturer pointed. His long wand, trembling like the antenna of some miraculously sensitive insect, settled upon some "rhythmical phrase," some sequence; some diagonal. And then he went on to make the audience see—"the gem-like notes; the aquamarines; and topazes that lie in the hollow of his satin gowns; bleaching the lights to evanescent pallors." Somehow the black-and-white slide on the screen became radiant through the mist, and took on the grain and texture of the actual canvas.

He added on the spur of the moment what he had just seen as if for the first time. That, perhaps, was the secret of his hold over his audience. They could see the sensation strike and form; he could lay bare the very moment of perception. So with pauses and spurts the world of spiritual reality emerged in slide after slide—in Poussin, in Chardin, in Rembrandt, in Cézanne—in its uplands and its lowlands, all connected, all somehow made whole and entire, upon the great screen in the Queen's Hall.

Fry's conviction that aesthetic experience could be communicated by bringing another to perceive a work's organic unity, and its accompanying feature of "plasticity," led to a style of verbal exposition focused exclusively on the formal character of a given work. Consequently, his writing has been labeled "formalist." Trying to convey Fry's pursuit of perceptual immediacy, Woolf recounts his words about looking at pictures: "I spent the afternoon in the Louvre. I tried to forget all my ideas and theories and to look at everything as though I'd never seen it before.... It's only so that one can make discoveries.... Each work must be a new and a nameless experience." It is possible to discover Fry's capture of this "new and nameless experience" in the essays he wrote, some of which are collected in *Vision and Design* (1920) and *Transformations* (1926).

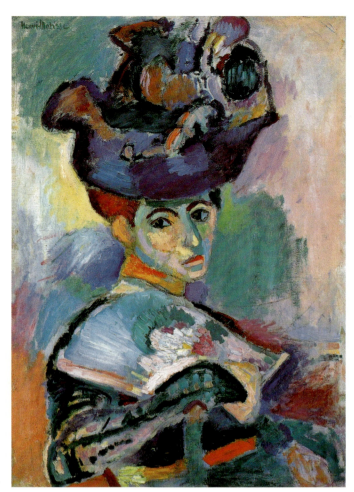

2 • Henri Matisse, _The Woman with the Hat_, 1905
Oil on canvas, 81.3 × 60.3 (32 × 23¾)

Matisse's system

What one witnesses first in Matisse's Fauve output is the progressive abandonment of the divisionist brush-stroke: Matisse retains from Signac's tutoring the use of pure color and the organization of the picture plane through contrasts of complementary pairs (this is what ensures the picture's coloristic tension), but he relinquishes the most easily recognizable common denominator of Cézanne and Seurat: their search for a unitary mode of notation (the pointillist dot, the constructive stroke) that could be used indifferently for the figures and the ground. And other major traits of Postimpressionism are summoned: from Gauguin and van Gogh, flat, unmodulated planes of nonmimetic color and thick contours with a rhythm of their own; from van Gogh's drawings, a differentiation of the effect of linear marks through variations in their thickness and their closeness to one another; from Cézanne, a conception of the pictorial surface as a totalizing field where everything, even the unpainted white areas, plays a constructive role in bolstering the energy of the picture.

The moment when Matisse "gets" Cézanne—and stops merely trying to imitate him, as he had done in the past—is also his farewell to the tedium of pointillism: while Signac had advocated filling the composition outward from any area (or more precisely,

from any line of demarcation) chosen as a point of departure, the myriad dots being patiently added in a sequence preordained by the "law of contrasts," Matisse found out that he could not follow this myopic, incremental procedure. As is made clear by one of the few unfinished canvases from the Fauve season, _Portrait of Madame Matisse_ [3], Matisse, like Cézanne, works on all areas of his picture at once and distributes his color contrasts so that they echo all over the surface (note, for example, the way the triad orange / green-ocher / red-pink is disseminated and calls in turn for various neighboring greens). There is a gradual process, to be sure, but it concerns the level of color saturation: a color harmony is determined at first in a subdued mode (it was at this point that _Portrait of Madame Matisse_ was interrupted), then it is heated up, all parts of the canvas being simultaneously brought to a higher pitch. Would the public of the Salon d'Automne have found _The Woman with the Hat_ less offensive if Matisse had shown with it this abandoned work? Would the piercing dabs of vermilion, the palettelike fan, the rainbow mask of the face, the harlequin background, the dissolution of the very hat's unity into a shapeless bouquet, the telescoped anatomy, as seen through a zoom lens— would all this have seemed less arbitrary to the laughing crowd if Matisse had allowed them a glimpse at his working method? Nothing is less certain. _The Open Window_ [4], now perhaps the most celebrated of the Fauve canvases, was no less decried at the

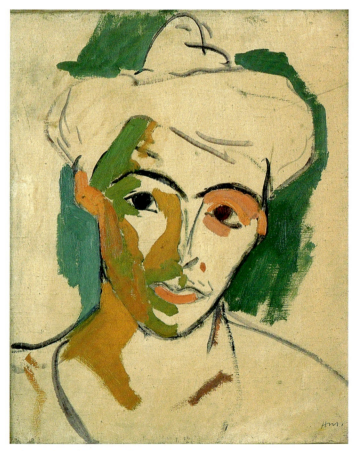

3 • Henri Matisse, _Portrait of Madame Matisse_, 1905
Oil on canvas, 46 × 38 (18⅛ × 15)

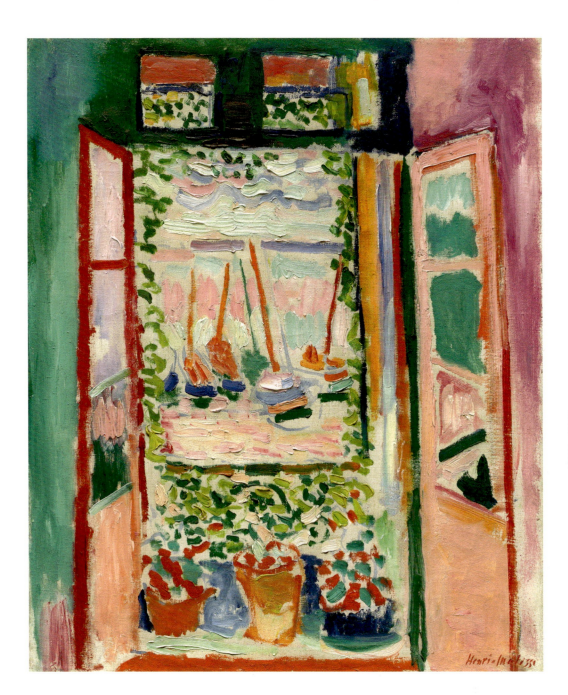

Salon, and yet it is less aggressive than the others, and more transparent about its procedures: it is easy to sort out the pairs of complementary colors that structure it, make it vibrate and visually expand, and that order our gaze never to stop at any given point.

Shortly after the Fauve salon, Matisse, reflecting upon his achievement of the past few months, stumbled upon an axiom that would remain one his guidelines all his life. It can be summarized by the statement, "One square centimeter of any blue is not as blue as a square meter of the same blue," and indeed, speaking about the red planes of his _Interior at Collioure (The Siesta)_ from c.1905–6, Matisse would marvel at the fact that, although they looked to be of a different hue, they had all been painted straight out of the same tube. Discovering that color relations are above all surface-quantity relations was a major step. Struck by a statement Cézanne had made about the foundational unity of color and

drawing, he had been complaining to Signac that in his work, and particularly in _Luxe, calme et volupté_, so cherished by the older artist, the two components were split and even contradicting each other. Now, through his equation "quality = quantity," as he often put it, he understood why for Cézanne the traditional opposition between color and drawing was necessarily annulled: since any single color can be modulated by a mere change of proportion, any division of a plain surface is in itself a coloristic procedure. "What counts most with colors are relationships. Thanks to them and them alone a drawing can be intensely colored without there being any need for actual color," wrote Matisse. In fact, it is very probable that Matisse made this discovery about color while working on a series of black-and-white woodcuts in the beginning of 1906, and then set himself up to apply or to verify it in _Le Bonheur de vivre_ [5].

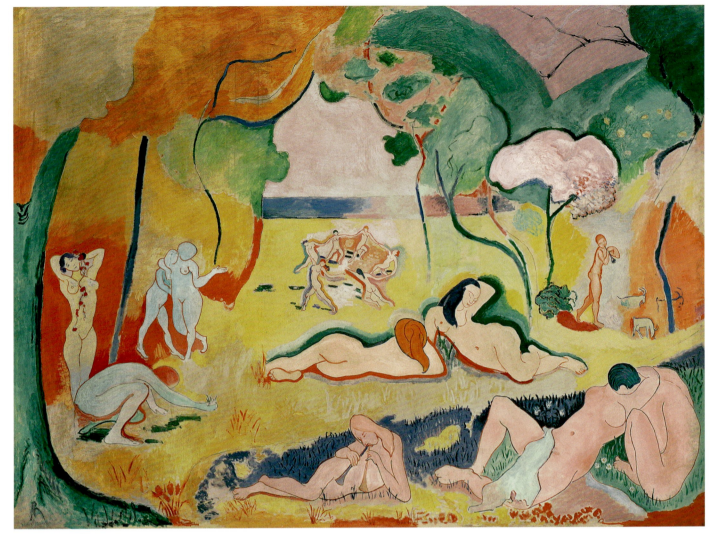

5 • Henri Matisse, *Le Bonheur de vivre* (The Joy of Life), 1906
Oil on canvas, 174 × 240 (68½ × 94⅞)

A parricide in paint

The largest and most ambitious work he had painted so far, *Le Bonheur de vivre* constituted his sole entry at the 1906 Salon des Indépendants. Six months after the Fauve scandal, the stakes were high: it was all or nothing, and Matisse carefully planned his composition in the most academic fashion, establishing first the decor from sketches made at Collioure and then planting, one by one, the figures or groups of figures that he had studied separately. But if the elaboration of this vast machine had been academic, the result was not. Never had flat planes of unmodulated pure color been used on such a scale, with such violent clashes of primary hues; never had contours so thick, also painted in bright hues, danced such free arabesques; never had anatomies been so "deformed," bodies melting together as if made of mercury— except perhaps in Gauguin's prints, which Matisse had revisited during the summer. With this bombshell, he wanted definitively to turn over a page of the Western tradition of painting. And to make sure that one got the message, he reinforced it by means of a cannibalistic attack at the iconographic level.

Scholars have painstakingly pursued the vast array of sources that Matisse convoked in this canvas. Ingres is predominant (he had a retrospective at the 1905 Salon d'Automne, with his *The Turkish Bath* and *The Golden Age* prominently displayed), as is the Postimpressionist quartet; but Pollaiuolo, Titian, Giorgione, Agostino Carracci, Cranach, Poussin, Watteau, Puvis de Chavannes, Maurice Denis, and many more painters are also invited to this ecumenical banquet. New guests keep being discovered; the whole pantheon of Western painting seems to be quoted—back to the very origin, since even prehistoric cave painting can be traced in the contours of the goats on the right. This medley of sources goes hand in hand with the stylistic disunity of the canvas and the discrepancies of scale—yet further rules of the pictorial tradition that Matisse deliberately upsets.

And that is not all: behind the paradisiacal imagery of the frolicking nymphs, behind the happy theme (the Joy of Life), the painting has a somber ring to it. For if the pastoral genre to which the canvas refers established a direct connection between physical beauty, visual pleasure, and the origin of desire, it was also based on a solid anchoring of sexual difference—something that, as Margaret Werth

has shown, Matisse perturbs here in countless ways. Werth starts by observing that the shepherd flutist, the only male figure in the painting, had initially been conceived as a female nude; she then notes that the sexual attributes of the other flutist, the large nude in the foreground, also clearly female in a study, were suppressed; that all the figures either have counterparts or form couples, but that all of them—apart from the shepherd and the "Ingresque" nude standing on the left, gazing at the spectator—are de-anatomized. (The culmination of this sadistic assault on the body is provided by the couple kissing in the foreground, two bodies—one of indeterminate sex—virtually melded with a single head.) The montagelike nature of the composition, with "disjunctive transitions" that are "characteristic of dream images or hallucination," leads Werth to construct a psychoanalytic interpretation of the painting as a phantasmatic screen, a polysemic image conjuring up a series of contradictory sexual drives corresponding to the polymorphous infantile sexuality that Freud uncovered (narcissism, auto-eroticism, sadism, exhibitionism)—a catalog that revolves around the Oedipus complex and the concomitant castration anxiety.

At all levels (formal, stylistic, thematic), the painting is parricidal. The dancers of *Le Bonheur de vivre* celebrate the definite toppling of a dreaded authority—that of the academic canon legislated by the École des Beaux-Arts. But Matisse let us know that the resulting freedom is not without risks, for whoever kills the symbolic father is left without guidance and must endlessly reinvent his own art in order to keep it alive. As such, this canvas opens the gates of twentieth-century art. YAB

FURTHER READING
Roger Benjamin, *Matisse's "Notes of a Painter": Criticism, Theory, and Context, 1891–1908* (Ann Arbor: UMI Research Press, 1987)
Catherine C. Bock, *Henri Matisse and Neo-Impressionism 1898–1908* (Ann Arbor: UMI Research Press, 1981)
Yve-Alain Bois, "Matisse and Arche-drawing," *Painting as Model* (Cambridge, Mass.: MIT Press, 1990) and "On Matisse: The Blinding," *October*, no. 68, Spring 1994
Judi Freeman (ed.), *The Fauve Landscape* (New York: Abbeville Press, 1990)
Richard Shiff, "Mark, Motif, Materiality: The Cézanne Effect in the Twentieth Century," in Felix Baumann et al., *Cézanne: Finished/Unfinished* (Ostfildern-Ruit: Hatje Cantz Verlag, 2000)
Margaret Werth, "Engendering Imaginary Modernism: Henri Matisse's *Bonheur de vivre*," *Genders*, no. 9, Autumn 1990

1907

With the stylistic inconsistencies and primitivist impulses of *Les Demoiselles d'Avignon*, Pablo Picasso launches the most formidable attack ever on mimetic representation.

Picasso's *Les Demoiselles d'Avignon* [1] has acquired a mythical status: it is a manifesto, a battlefield, a herald of modern art. Fully conscious that he was producing a major work, Picasso threw everything into its elaboration: all his ideas, all his energy, all his knowledge. We now know *Les Demoiselles d'Avignon* as one of the "most worked-upon" canvases ever, and due attention is paid to the sixteen sketchbooks and numerous studies in various media that Picasso devoted to its making—not counting the drawings and paintings produced in the picture's immediate wake, in which Picasso further explored a whole range of avenues opened up by the painting during its fast-paced genesis.

But if no modern picture has been as much discussed during the last quarter of a century—with book-length essays and even an entire exhibition with a two-volume catalogue glorifying it—this plethora of commentary follows a striking dearth of discussion. Indeed, the painting long remained in quasi obscurity—one could even say that it was *resisted*. (A telling anecdote of this resistance: it seems that at the end of the twenties, two decades after *Les Demoiselles*'s completion, the collector Jacques Doucet intended to bequeath the picture to the Musée du Louvre, but the museum refused the offer, as it had done with the Cézannes of the Gustave Caillebotte bequest in 1894). Late recognition is the stuff of which legends are made, but what is so particular in this case is that the painting's deferred reception is not just linked to but also commanded by its subject matter and formal structure: *Les Demoiselles* is above all a work about beholding, about the trauma engendered by a visual summons.

Circumstances played a role in this spectacular delay. To begin with the painting had almost no public life for thirty years. Until Doucet bought it from Picasso for a song in 1924—at the urging of André Breton and to the immediate regret of the artist—*Les Demoiselles* had moved out of the artist's studio only once or twice, and then only during World War I: for two weeks in July 1916, in a semiprivate exhibition organized by the critic André Salmon at the Salon d'Antin (during which the painting acquired its present title), and possibly in the joint exhibition of Matisse's and Picasso's work in January–February 1918, organized by the dealer ▲ Paul Guillaume and with a catalogue prefaced by Guillaume Apollinaire. In the fall and winter of 1907, friends and visitors had seen the painting in Picasso's studio immediately after its completion, but access to it had rapidly dwindled (because of Picasso's numerous moves, often to cramped quarters, and his understandable desire always to show the latest crop of his protean and ever-changing production, the canvas was rarely on view even for the circle of the artist's intimates, which accounts for the paucity of their comments). Once in Doucet's possession, the painting was visible only by appointment, until it was sold by his widow to a dealer in the fall of 1937. Immediately shipped to New York, it was then bought by the Museum of Modern Art, where it became the museum's most precious fixture—the end of *Les Demoiselles*'s private life.

The literature roughly follows a similar pattern. The painting was not even specifically named in the rare early articles that devoted a passage to it (by Gelett Burgess in 1910, André Salmon in 1912, and Daniel-Henry Kahnweiler in 1916 and 1920). Furthermore, it was only very rarely reproduced before its landing in New York: after Burgess's journalistic piece ("The Wild Men in Paris," in the May 1910 issue of the *Architectural Record*), its reproduction was not published until 1925, in the journal *La Révolution surréaliste* (by no means a bestseller), and to appear in a monograph on the artist it had to await Gertrude Stein's [2] *Picasso* of 1938. Shortly thereafter, ▲ Alfred H. Barr's *Picasso: Forty Years of His Art*, which functioned as the catalogue of the Museum of Modern Art's 1939 Picasso retrospective, began the process of *Les Demoiselles*'s canonization. But Barr's seminal account, which received its definitive touch in 1951, when his text was revised for the publication of *Picasso: Fifty Years of His Art*, and which became the standard view of the painting, consolidated rather than broke down the walls of resistance that had encircled the work since its inception. Barr's view was • not fundamentally challenged until Leo Steinberg's (1920–2011) groundbreaking essay "The Philosophical Brothel" appeared in 1972. No previous text had done as much to transform the status of *Les Demoiselles*, and all subsequent studies are appendages to it.

A "transitional picture"?

Before the publication of Steinberg's study, the consensus was that *Les Demoiselles* was the "first Cubist painting" (and thus, as Barr puts it, a "transitional picture," perhaps more important for what it

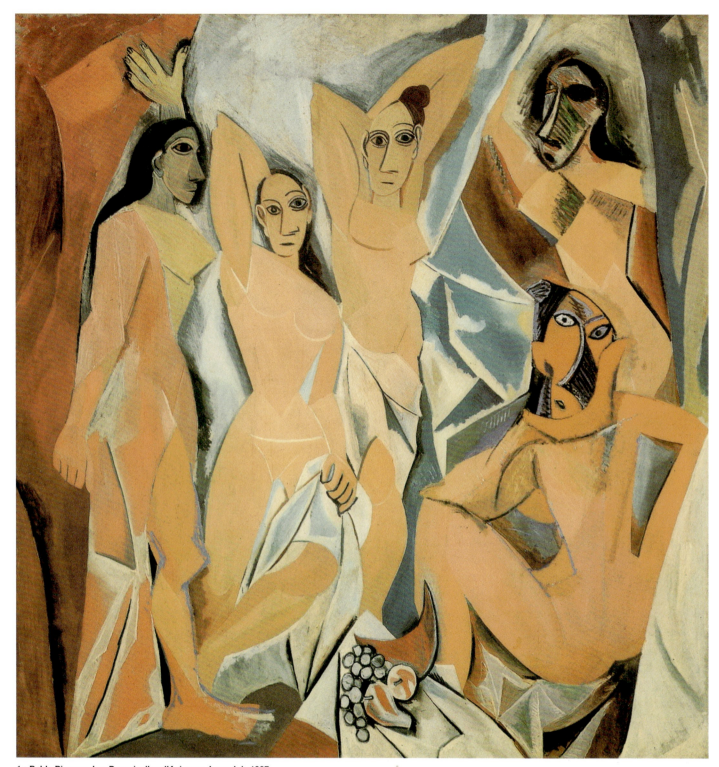

1 • Pablo Picasso, *Les Demoiselles d'Avignon*, June–July 1907
Oil on canvas, 243.8 × 233.7 (80 × 78)

announced than as a work in itself). Barr had ignored the corollary of this notion in Kahnweiler's account, namely that the picture had been left unfinished, but this idea was nevertheless accepted by everyone else, and most authors marked it by criticizing the picture's "lack of unity." The stylistic discrepancy between the canvas's left and right sides was seen as a function of Picasso's rapid shift of interest from the archaic Iberian sculpture that had helped him finish his *Portrait of Gertrude Stein* [2] in the late summer of 1906 to

African art, which he had finally encountered with a new impact and coherence during a visit to the Musée d'Ethnographie du Trocadéro midway through the elaboration of *Les Demoiselles*. The quest for sources did not stop there: Barr had named Cézanne, Matisse, and El Greco; others would add Gauguin, Ingres, and Manet.

Though Barr had published three of Picasso's preliminary studies for *Les Demoiselles*, he had merely paid lip service to them and no attention at all to the many others already made available in

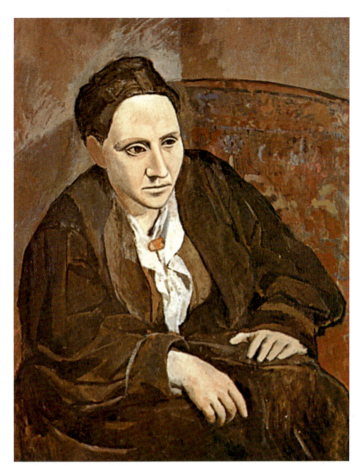

2 • Pablo Picasso, *Portrait of Gertrude Stein*, late summer 1906
Oil on canvas, 100 × 81.3 (39⅜ × 32)

Christian Zervos's *catalogue raisonné* of Picasso's work, then in progress. In its early state, the composition consisted of seven figures in a theatrical arrangement derived from the Baroque tradition, replete with the usual curtains opening onto a stage [3]. In the center, a clothed sailor was seated among five prostitutes, each of whom was turning her head toward an intruder, a medical student entering at the left holding a skull in his hand (replaced by a book in some studies). For Barr, this morbid scenario, which he saw as "a kind of *memento mori* [reminder of death] allegory or charade" on the wages of sin, could be all the more easily dispensed with since Picasso himself had quickly dropped it. In the final version, Barr wrote, "all implications of a moralistic contrast between virtue (the man with the skull) and vice (the man surrounded by food and woman) have been eliminated in favour of a purely formal figure composition, which as it develops becomes more and more dehumanized and abstract."

In his essay, Steinberg dismissed most of these views, which by then had turned into clichés. The picture could not be reduced to a "purely formal figure composition" that would make it (according to the rather unsophisticated view offered of Cubism at the time) a mere forerunner of things to come. Picasso had indeed abandoned the "*memento mori* allegory," but not the sexual thematics of the painting (which is undoubtedly why Steinberg borrowed as the title of his piece one of the first names given to the picture by Picasso's friends, "Le Bordel philosophique" [The Philosophical Brothel]). Furthermore, *Les Demoiselles*'s lack of stylistic unity was not an effect of haste but a deliberate strategy: it was a late decision, to be sure, but in keeping with the elimination of the two male figures and the adoption of an almost square, vertical format, less "scenic" than that of all the studies for the general composition of the picture. And the primitivizing appeal to African art was not just happenstance (Picasso had been introduced to African art by Matisse in 1906 [4], months before his decision to shift the masklike faces of the two *demoiselles* on the right from an "Iberian" to an "African" model [5]): it shared in the thematic organization of the painting, even if Picasso later denied its significance.

Rejecting Barr's "*memento mori*," Steinberg changed the terms of the allegory put aside by Picasso from those of "death versus hedonism" to those of "cool, detached learning versus the demands of sex." Both the book and the skull present in Picasso's studies indicate that the medical student is the one who does not participate; he does not even look at the *demoiselles*. As for the timid sailor, he is there to be initiated by the fearsome females. His androgyny in many sketches sharply contrasts with his phallic attribute: the *porron* (a wine flask with an erect spout) on the table. Soon the sailor disappeared and the student underwent a gender switch. In the completed canvas he is replaced by the standing nude opening the curtain on the left. Conversely, the bodies of several *demoiselles*

▲ 1903

Below left
4 • Photograph of Picasso in his studio in the Bateau-Lavoir, Paris, 1908

Below
5 • Pablo Picasso, *Study for the Head of the Crouching Demoiselle*, June–July 1907
Gouache on paper, 63 × 48 (24⅖ × 18⅞)

3 • Pablo Picasso, *Medical Student, Sailor, and Five Nudes in a Bordello* (composition study for *Les Demoiselles d'Avignon*), March–April 1907. Crayon drawing, 47.6 × 76.2 (18¾ × 30)

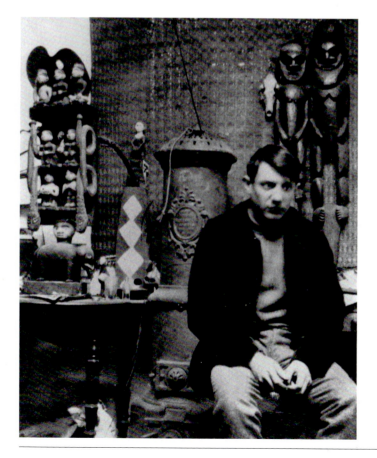

1900–1909

were masculine in many drawings. There is enough cumulative evidence, then, to determine that while he was working on the picture Picasso's thematic concern revolved around the primordial question of sexual difference, and that of the fear of sex. So his problem seems to have been how to hold onto this theme while relinquishing the allegory.

This is where the stylistic disjunction of the final canvas comes into play, and not only that but also the utter isolation of the five prostitutes vis-à-vis one another, and the suppression of clear spatial coordinates. (On close inspection, the discrepancies are even stronger than Barr had noted, and they do not concern only the right-hand "African" side of the picture: the hand of the standing *demoiselle* who replaced the student at the far left seems severed from her body, and the sketchbooks reveal, as Steinberg notes, that her immediate neighbor, most often read as standing, is in fact lying down even though she has been verticalized and made parallel to the picture's surface.) Whereas in the first scenario the characters react to the student's entrance and the spectator looks on from outside, in the finished painting "this rule of traditional narrative art yields to an anti-narrative counter-principle: neighboring figures share neither a common space nor a common action, do not communicate or interact, but relate singly, directly, to the spectator.... The event, the epiphany, the sudden entrance, is still the theme—but rotated through 90 degrees towards a viewer conceived as the picture's opposite pole." In other words, it is the work's lack of stylistic and scenic unity that binds the painting to the spectator: the core of the picture is the frightful gaze of the *demoiselles*, particularly those with the deliberately monstrous faces on the right. Their "Africanism," according to the ideology of the time that made Africa the "dark continent," is a device designed to fend off the beholder. (An old word derived from the Greek and meaning "having the power to avert evil" describes the intimidating glare of Picasso's nudes particularly well: it is *apotropaïc*.) The picture's complex structure, as William Rubin showed in the longest study ever devoted to the work (which emphasized Picasso's deep-seated death anxiety), concerns the link that ties Eros to Thanatos, that is, sex to death.

The trauma of the gaze

▲ We are now moving into Freudian territory, a fairly recent step in the literature devoted to the painting. Several psychoanalytic scenarios dealing with the "primal scene" and the "castration complex" apply amazingly well to *Les Demoiselles d'Avignon*. They help us understand both the suppression of the allegory and the brutality of the finished picture. One thinks, here, either of the remembered childhood dream of Freud's most famous patient, Sergei Pankejeff (1887–1979)—the "Wolf-Man" [6]—in which the boy found himself petrified as his window opened and he was stared at by motionless wolves (the dream being the aftereffect of the shock of the primal scene [his witnessing parental intercourse])—or of Freud's short text on the head of the Medusa, with all its multitude of meanings.

These include the notion that the Medusa's head is the female sex organ—the sight of which arouses castration anxiety in the young male; the image of castration itself (decapitation); and the denial of castration, on the one hand by a multiplication of penises (her hair consists of snakes) and, on the other, by its power to turn the spectator to stone, in other words, into an erect, albeit dead, phallus.

In front of Picasso's painting, too, the beholder is nailed to the floor by the whores who address him more violently, as Steinberg points out, than by any picture since Velázquez's *Las Meninas*. In switching from the "narrative" (allegory) to the "iconic" mode, to use the terms employed by Rubin, that is, from the historical tone of stories ("Once upon a time") to the personal threat ("Look at me; I'm watching you"), Picasso both revealed the fixity of the viewer's position as established by the monocular perspective on which Western painting had been based and, by recasting it as petrification, demonized it. The undiminished power of *Les Demoiselles d'Avignon* lies in this very operation, called the "return of the repressed": in it, Picasso highlighted the contradictory libidinal forces at work in the very act of beholding, making of his whole picture the Medusa's head. Bordello pictures are part of a long tradition within the genre of erotic art (a tradition that Picasso knew well: he had long admired Degas's monotypes and for years had yearned to collect them—a dream he could fulfill only late in life). These soft-porn scenes are meant to gratify the voyeurism of male, heterosexual, art lovers. Picasso overthrows this tradition: interrupting the story, the gaze of his *demoiselles* challenges the (male) spectator by signifying to him that his comfortable position, outside the narrative scene, is not as secure as he might think. No wonder the painting was resisted for so long.

One of its early adversaries no doubt understood, at least partially, what was going on. Matisse was furious when he saw the painting (some accounts say he was in stitches, but this amounts to

6 • Sergei C. Pankejeff's sketch of his remembered childhood dream (c. 1910), published in Sigmund Freud's "From the History of an Infantile Neurosis," 1918

▲ Introduction 1, 1900a

7 • Pablo Picasso, *Three Women*, 1908
Oil on canvas, 200 × 178 (78¾ × 70⅛)

the same thing). He was a bit like Poussin saying of Caravaggio (to whom we owe the best representation of Medusa's head, and who was criticized in his time for being unable to "compose a real story") that he had been "born to destroy painting." Undoubtedly, rivalry was a sting that sharpened Matisse's perception (just as it had stimulated Picasso's), for just a year and a half earlier Matisse

▲ had completed his breakthrough canvas *Le Bonheur de vivre*, whose thematic is in many ways very close to that of Picasso's picture (one detects in it the same conflictual imagery revolving around the castration complex). Matisse knew that this canvas (which Picasso saw every time he went to dinner at the house of Gertrude and Leo Stein) had strongly impressed the younger artist, notably for its syncretic cannibalizing of a whole array of historical sources. For Picasso, one of the most devastating challenges must have been the forceful way in which Matisse had co-opted Ingres's *The Turkish Bath*, which had struck both artists at the 1905 Salon d'Automne: how tame was the Ingrism of his own Rose period, by comparison, particularly of *The Harem*, painted in Gosol in the summer of 1906, just a few months before he tackled *Les Demoiselles d'Avignon* and only a few weeks before he "painted in" the face of Gertrude Stein's portrait! Meanwhile, Matisse had also thrown in another challenge:

● shortly after introducing Picasso to African art he had painted his *Blue Nude*, the first canvas ever to de-aestheticize the traditional motif of the female nude explicitly by way of "primitivism." And now Picasso was combining both acts of parricide against the Western tradition: juxtaposing contradictory sources into a medley that annulled their decorum and their historical significance, and at the same time borrowing from other cultures. In both *Le Bonheur de vivre* and *Les Demoiselles d'Avignon*, the parricide was astutely linked to an Oedipal thematics, but Picasso, in focusing his attack on the very condition of beholding, had carried the struggle against mimesis much further.

The crisis of representation

We can now return to the standard, pre-Steinberg assumption that *Les Demoiselles* was the "first" Cubist painting. While certainly wrong if one reads early Cubism as a kind of geometric stylization of volumes, this assumption makes sense if Cubism is understood as a radical questioning of the rules of representation. In grafting an Iberian masklike face onto the bust of Gertrude Stein, in conceiving of a face as a given sign that could be borrowed from a vast repertory, Picasso had called the illusionistic conventions of depiction into question. But in *Les Demoiselles* he pushed the idea that signs are migratory and combinatory, and that their signification depends upon their context, even further, though he did not fully explore it. This would be the work of Cubism as a whole, whose origin can then be located in *Three Women* of 1908 [7], in which Picasso strove to display a single signlike unit (the triangle) for every element of the painting, whatever it was supposed to depict. But several studies for the face of the crouching *demoiselle* at the lower right—the site of the most startling attack on the very idea of

beauty in relation to woman—reveal that he had sensed the endless metaphoric possibilities of the sign system he was inventing: in these studies, we can see that face is in the process of being transformed into a torso [5]. Yet these amorphic experiments were

▲ put aside and one had to wait for Picasso's second examination of African art in his collages, in 1912, for the full implication of his semiological impulse to be reached. Thus *Les Demoiselles d'Avignon* was a traumatic event; and its profound effect was deferred for Picasso as well: it took him the whole adventure of Cubism to be able to account for what he had done. YAB

FURTHER READING
William Rubin, "From 'Narrative' to 'Iconic' in Picasso: The Buried Allegory in *Bread and Fruitdish on a Table* and the Role of *Les Demoiselles d'Avignon*," *The Art Bulletin*, vol. 65, no. 4, December 1983
William Rubin, "The Genesis of *Les Demoiselles d'Avignon*," *Studies in Modern Art* (special *Les Demoiselles d'Avignon* issue), Museum of Modern Art, New York, no. 3, 1994 (chronology by Judith Cousins and Hélène Seckel, critical anthology of early commentaries by Hélène Seckel)
Hélène Seckel (ed.), *Les Demoiselles d'Avignon*, two volumes (Paris: Réunion des Musées Nationaux, 1988)
Leo Steinberg, "The Philosophical Brothel" (1972), second edition *October*, no. 44, Spring 1988

▲ 1906 ● 1903 ▲ 1912

1908

Wilhelm Worringer publishes *Abstraction and Empathy*, which contrasts abstract art with representational art as a withdrawal from the world versus an engagement with it: German Expressionism and English Vorticism elaborate this psychological polarity in distinctive ways.

"I caught a strange thought," the German Expressionist Franz Marc (1880–1916) wrote from the front during World War I (where he would soon be killed), "it had settled on my open hand like a butterfly—the thought that people once before, a long time ago, like alter egos, loved abstractions as we do now. Many an object hidden away in our museums of anthropology looks at us with strangely disturbing eyes. What made them possible, these products of a sheer will to abstraction?" However strange, this thought was not entirely new: Marc echoes French poet Charles Baudelaire on poetic "correspondences," and the notions of an affinity between abstract arts, of the tribal artist as alter ego of the modern artist, and of a primordial will to abstraction are all in keeping with a dissertation written in 1908 by the German art historian Wilhelm Worringer (1881–1965). The connection is not accidental, as another letter from Marc makes clear. In early 1912 he wrote his Russian colleague Wassily Kandinsky (1866–1944), with whom he had founded the association of artists Der Blaue Reiter (The Blue Rider) in Munich in 1911: "I am just reading Worringer's *Abstraktion und Einfühlung* [Abstraction and Empathy], a good mind, whom we need very much. Marvelously disciplined thinking, concise and cool, extremely cool."

Worringer was not an unambiguous advocate of the German Expressionists. When they were attacked by a jingoistic antimodernist in 1911, he defended them as harbingers of a new age marked by an embrace of elemental forms, an interest in tribal art, and, above all, a rejection of the "rationalized sight" that he deemed too dominant from the Renaissance through neo-Impressionist painting. Otherwise Worringer left the terms of his affiliation vague; for example, in a 1910 foreword to *Abstraction and Empathy*, he noted only a "parallelism" with "the new goals of expression." However, this parallelism did point to an "inner necessity" in the age, and this metaphysical bent was shared by the Blaue Reiter artists, who often wrote of their art in terms of a "spiritual awakening." This was most evident in the *Blaue Reiter Almanach* that Marc and Kandinsky published in 1912 with a cover image of a blue rider by Kandinsky inspired by folk images of Saint George [1]. Apart from Expressionist work, this influential collection of essays and illustrations featured tribal art from the Pacific Northwest, Oceania, and Africa, the art of children, Egyptian puppets, Japanese masks and prints, medieval

1 • Wassily Kandinsky, final study for the cover of the *Blaue Reiter Almanach*, 1911
Watercolor, india ink and pencil, 27.6 × 21.9 (10⅞ × 8⅝)

German sculpture and woodcuts, Russian folk art, and Bavarian devotional glass paintings. Kandinsky was especially drawn to the latter two forms, while his partner, Gabrielle Münter (1877–1962), was strongly attracted to the art of children, the emotive immediacy of which she sought to convey in her own painting.

A metaphysical approach to art was also practiced by Die Brücke (The Bridge), the other primary group of German Expressionists. Headed by Ernst Ludwig Kirchner, it was founded in Dresden in 1905, included Fritz Beyl (1880–1966), Erich Heckel, and Karl Schmidt-Rottluff (1884–1976), all of whom were once architectural students, and was disbanded in Berlin eight years later. The metaphysical bent is clear from the names of the two groups:

▲ 1903

the Blaue Reiter was titled after a traditional figure of Christian revelation ("one stands before the new works as in a dream," Marc wrote in a prospectus for the *Almanach*, "and hears the horsemen of the Apocalypse"), while Die Brücke derived its name from Friedrich Nietzsche, who stated in *Thus Spoke Zarathustra* (1883–92) that "man is a rope, fastened between animal and Superman—a rope over an abyss … he is a bridge and not an end." German Expressionism echoed the metaphysical concerns of *Abstraction and Empathy* in other ways too. Like Worringer, Marc expressed the natural world as a place of primal flux, while Kirchner expressed the urban world as a place of primitive vitality. However, this very insistence on *expression* did not fully correspond with the Worringerian conception of abstraction.

Opposed styles

Abstraction and Empathy develops two notions—*Einfühlung* or "empathy," derived from the German psychologist and philosopher Theodor Lipps (1851–1914), and *Kunstwollen* or "artistic will," derived from the Viennese art historian Alois Riegl—in order to relate different artistic styles to different "psychic states." Across history and culture, Worringer argues, two opposed styles—naturalistic representation and geometric abstraction—have expressed two opposed attitudes—an empathic engagement with the world and a shocked withdrawal from it. "Whereas the precondition for the urge to empathy is a happy pantheistic relationship of confidence between man and the phenomena of the external world," Worringer writes, "the urge to abstraction is the outcome of a great inner unrest inspired in man by the phenomena of the outside world … We might describe this state as an immense spiritual dread of space." This condition of dread before nature (Worringer was influenced here by Georg Simmel [1858–1918], the great German sociologist of alienation) is very different from the state of intimacy with nature that Gauguin, for example, projected onto the primitive. According to Worringer, primitive man sees nature as a hostile chaos: "dominated by an immense need for tranquility," the tribal artist turns to abstraction as "a refuge from appearances." This notion led Worringer to construct a problematic hierarchy of culture (as outlined in *Form in Gothic* [1910], his sequel to *Abstraction and Empathy*), with the primitive at the bottom. The modern, however, was not placed at the top: on the contrary, "slipped down from the pride of knowledge, [modern] man is now just as lost and helpless vis-à-vis the world-picture as primitive man." As a consequence, according to Worringer, the modern artist also struggles to arrest and separate the flux of phenomena, to abstract and preserve the stability of forms: driven once more by "inner unrest" and "spatial dread," he too turns to abstraction. This account is very different from later celebrations of abstract art, the triumphal humanism of which Worringer challenges before the fact.

But does this account of abstraction really suit the Blaue Reiter, as Marc and Kandinsky [2] hoped it might? It might be more relevant to Die Brücke, for it could be argued that Kirchner and colleagues used abstract elements—unreal colors, uneasy perspec-

2 • Wassily Kandinsky, *With Three Riders*, 1911
Ink and watercolor on paper,
25 × 32 (9⅞ × 12⅝)

▲ 1903

tives—in order to register "inner unrest" and "spiritual dread." Like Worringer, Kirchner often pictured modernity as primitive, not only in the figure of the primitive prostitute that he inherited from Manet and Gauguin by way of Matisse and Picasso, but also in the streets of the modern city where, for observers such as Simmel, the prostitute was only emblematic of a general regression. Just as, according to Worringer, the natural world appeared chaotic to primitives, so, too, according to Kirchner, did the urban world appear chaotic to moderns (German industrialization was fast and furious during the first two decades of the century). In *The Street, Dresden* [3], Kirchner evokes Dresden as a vital but nervous confrontation: huddled masses border the picture and block its expanse, while several figures, mostly women with faces that resemble masks, bear down on us (the little girl here is especially bizarre). With its distorted space and lurid orange-red, the picture is tinged with the anxiety often associated with the painting of Edvard Munch, the Norwegian forerunner of the Expressionists. At the same time the figures also suggest the "blasé attitude" that Simmel ascribed to "the mental life" of the modern city. "The metropolitan type," Simmel argued in a famous essay of 1903, "develops an organ protecting him against the threatening currents and discrepancies of his external environment." *The Street* might evoke such a current in the electric line that courses around the figures and through the avenue in orange, green, and blue. Part nervous stimulation, part protective shield, this line isolates these urban dwellers even as it also connects them: it suggests a paradoxical kind of alienation that unites. This effect becomes more extreme in "The Street" paintings that Kirchner produced in Berlin after his move there, with other Die Brücke members, in 1911: the colors of these pictures are more acrid, the perspectives are more perverse (he adapted Cubism and Futurism for this effect), and the figures (often prostitutes and clients) are more anxious-blasé. If there is a new kind of modern beauty here, as art historian Charles Haxthausen has argued, it is also, at least in part, a terrible beauty.

Again, for Worringer, abstraction served to ease the stimulation provoked by the chaos of the world. Kirchner, on the other hand, approached abstraction in order to register this stimulation, indeed to heighten it. The abstraction of the Blaue Reiter is different again: Marc moved toward abstraction in pursuit of a connection with the natural world, while Kandinsky did so in search of a communion with the spiritual realm. For both artists, the isolation of human beings was a problem to overcome, not a condition to deepen. "We search," Kandinsky wrote in 1909, "for artistic forms that reveal the penetration of these collected forces." Rather than abstraction *versus* empathy, then, the Blaue Reiter proposed an aesthetic of abstraction *as* empathy—empathy with nature and/or spirit. (In this respect they were in line with the "abstract empathy" already suggested in the *Jugendstil* or Art Nouveau style in Munich that influenced Kandinsky.) The Blaue Reiter artists sought an equation of feeling and form, a reconciliation between "inner necessity" and outer world; Kandinsky insisted that the very "contents" of his art are "what the spectator *lives* or *feels* while

3 • Ernst Ludwig Kirchner, *The Street, Dresden*, 1908
Oil on canvas, 150.5 × 200 (59¼ × 78⅞)

under the effect of the *form and color combinations* of the picture." And this is one reason why they took music, which featured prominently in the *Almanach*, as an aesthetic paragon. Again, this was not to reverse the Worringerian poles of abstraction and empathy but to force them together: as Kandinsky states in the *Almanach*, "Realism = Abstraction; Abstraction = Realism."

Pantheistic penetration

If Kandinsky aspired to a transcendental world of spirit, Marc delved into the immanent world of nature. Guided at first by Gauguin, Marc defined his project in 1910 as "a pantheistic penetration into the pulsating flow of blood in nature, in trees, in animals, in the atmosphere." To trace this flow he elaborated two kinds of drawing: first, a fluent, organic, and airy line influenced by Matisse and Kandinsky; then, a more constricted, geometric, and anxious line influenced by Picasso and Robert Delaunay (like Kirchner, Marc adapted Cubism to his own ends). Marc also devised a color symbolism to modulate the moods of this flow: blue was "severe" and "spiritual"; yellow, "gentle" and "sensual"; red, "brutal" and "heavy." Although this intuitive system was gendered reductively (blue as masculine, yellow as feminine), it led Marc, in the few years left to him, to produce a number of animal paintings that are among the finest in the Western tradition. Finally, however, these pictures do not convey an "animalization of art" (Marc) so much as a humanization of nature: less than empathic communion with nature, they suggest an expressive projection on the part of the artist. In 1853 the English aesthetician John Ruskin critiqued this projection as "the pathetic fallacy"; some time after 1913 Marc also came to question it:

Is there a more mysterious idea for an artist than to imagine how nature is reflected in the eyes of an animal? How does a horse see the world, how does an eagle, a doe, or a dog?… Who says the doe feels the world to be Cubistic? It's the doe that feels,

therefore the landscape must be "doelike." The artistic logic of Picasso, Kandinsky, Delaunay, Burliuk [a Russian associate of the Blaue Reiter], etc., is perfect. They don't "see" the doe and they don't care. They project their inner world—which is the noun of the sentence. Naturalism contributes the object. The predicate … is rendered but rarely.

Rather than an imposed expression, Marc sought an empathic abstraction that might resolve self and other pictorially. No doubt this is an impossible ideal, but a painting such as *The Fate of Animals* [4] does evoke one kind of "pantheistic penetration." Here, however, the common point between human and animal seems to be pain or agony—even the trees appear to be butchered. Indeed, on the back of the canvas Marc scrawled "and all being is flaming suffering," as if, like urban tension in Kirchner, natural suffering in Marc was the one thing that united all creatures. And yet, the very desperation of this work points to the ultimate *separation* between beings: after all, suffering is singular and solitary in its effects. In his pursuit of empathy, Marc touches

its limit: the animal other is revealed as precisely other, inhuman, beyond empathy. This is still not abstraction versus empathy, but it is no longer abstraction as empathy. Empathy has failed, and here abstraction becomes the sign of this limit.

Dehumanization as diagnostic

In the end, the model of abstraction versus empathy might pertain less to German Expressionism than to English Vorticism, a movement—named by the poet-critic Ezra Pound (1885–1972) and directed by the prolific painter-novelist-critic Wyndham Lewis ▲ (1882–1957)—that included the sculptors Jacob Epstein (1880–1959) and Henri Gaudier-Brzeska (1891–1915) and the painter David Bomberg (1890–1957), among others. The connection here to Worringer is not as attenuated as it might seem. In January 1914, the poet-critic T. E. Hulme (1883–1917), an associate of the Vorticists, delivered a lecture in London on "Modern Art and its Philosophy" that adapted *Abstraction and Empathy* toward an advocacy of Vorticism. Here Hulme—who, like Gaudier-Brzeska

4 • Franz Marc, *The Fate of the Animals*, 1913
Oil on canvas, 194.3 × 261.6 (76½ × 103)

▲ 1934b

and Marc, would soon die in the war that effectively ended both Vorticism and Expressionism—divided modern art into two opposed styles—the organic (his version of the empathic) and the geometric (his version of the abstract). Like Worringer, he then argued that these styles correspond to two opposed "attitudes"— an "insipid optimism," dominant since the Renaissance, that placed man at the center of nature, and a steely antihumanism, emergent in Vorticist art, that valued "a feeling of separation in the face of outside nature."

"What he said," Lewis remarked of Hulme, "I *did*"—though, again, it was Worringer who set the aesthetic terms for both men. In "The New Egos," a text published in *Blast* (1914), his vitriolic journal of Vorticism, Lewis presented his own Worringerian parable. It concerns two complementary figures, "a civilized savage" and a "modern town-dweller"; neither is "secure" as both live in a "vagueness of space." Yet the civilized savage is able to ease his insecurity with an art of the figure abstracted to a "simple black human bullet," whereas the modern town-dweller only senses that "the old form of egotism is no longer fit for such conditions as now prevail." Lewis concludes his parable with a Worringerian credo: "All clean, clear-cut emotions depend on the element of strangeness, and surprise, and primitive detachment. Dehumanization is the chief diagnostic of the World." The Expressionists agreed with this diagnosis, but Lewis saw dehumanization as a solution as much as a problem: if the modern age is to survive its own dehumanization, it must dehumanize further; it must take "strangeness, and surprise, and primitive detachment" to the limit.

Lewis rarely forgoes the human figure altogether. His early "designs" often manifest a tension between figure and surround, as if the body, never secure, were caught between definition, about to break free as an autonomous form, and dispersal, about to be invaded by space. Slowly, however, Lewis abstracts the figure, as if to harden it into a "simple black human bullet." Sometimes this hardening appears to come from without—outside in—as in *The Vorticist* (1912), in which the body seems to be shocked into abstraction by a hostile world. Sometimes it appears to come from within—inside out—as in *Vorticist Design* (c. 1914), in which the body seems to be driven to abstraction by some innate will. In one especially concentrated figure, *The Enemy of the Stars* [5], the two kinds of armorings appear to converge. On the one hand, with a head like a receiver, the figure looks reified from without, its skin turned into a shield; on the other hand, stripped of organs and arms, it also looks reified from within, its bone structure turned into a "few abstract mechanical relations" (as Hulme once remarked of these figures). In either case, this "enemy of the stars" is the opposite of the Blue Rider whom Kandinsky evokes on an ascent toward the heavens: here Lewis suggests an abstraction of the figure that is indeed antiempathic. HF

FURTHER READING
Charles W. Haxthausen (ed.), *Berlin: Culture and Metropolis* (Minneapolis: University of Minnesota Press, 1990)
T. E. Hulme, *Speculations: Essays on Humanism and the Philosophy of Art*, ed. Herbert Read (London: Routledge & Kegan Paul, 1987 [first published 1924])

5 • Wyndham Lewis, *The Enemy of the Stars*, 1913
Pen and ink, ink wash, 44 × 20 (17¼ × 7⅞)

Fredric Jameson, *Fables of Aggression: Wyndham Lewis, the Modernist as Fascist* (Berkeley and Los Angeles: University of California Press, 1979)
Wilhelm Worringer, *Abstraction and Empathy* (Cleveland: Meridian Books, 1967)
Wassily Kandinsky and Franz Marc (eds), *The Blaue Reiter Almanac* (London: Thames & Hudson, 1974)
Jill Lloyd, *German Expressionism: Primitivism and Modernity* (New Haven and London: Yale University Press, 1991)
Rose-Carol Washton Long (ed.), *German Expressionism: Documents from the End of the Wilhelmine Empire to the Rise of the National Socialism* (Berkeley and Los Angeles: University of California Press, 1995)

1909

F. T. Marinetti publishes the first Futurist manifesto on the front page of *Le Figaro* in Paris: for the first time, the avant-garde associates itself with media culture and positions itself in defiance of history and tradition.

On February 20, 1909, Filippo Tommaso Marinetti (1876–1944) published his "Manifeste de fondation du Futurisme," the first Futurist manifesto, on the front page of the French newspaper *Le Figaro* [1]. This event signaled the public arrival of Futurism, and pointed in multiple ways to its specific project.

First of all, it showed that, from its very outset, Futurism wished to establish the avant-garde's liaison with mass culture. Second, it demonstrated a conviction that all techniques and strategies operative in mass-cultural production would henceforth be essential for the propagation of avant-garde practices as well; the mere decision to publish the manifesto in the widest-circulation newspaper in France demonstrated the triple embrace of advertising, journalism, and forms of mass distribution. Third, it indicated that, from its initial stages, Futurism was committed to a fusion of artistic practices with advanced forms of technology in a way that Cubism, while confronting this question in the development of collage, would never wholly embrace. The slogans of Futurism that celebrated "congenital dynamism," "the break-up of the object," and "light as a destroyer of forms," while also lauding the mechanical, famously declared that a speeding automobile is "more beautiful than the Victory of Samothrace": this was to prefer the industrialized object to the unique rarity of the cult statue. And last, although not yet visible in 1909, it prepared the way for Futurism to overturn traditional assumptions about the avant-garde's innate tendency toward, and association with, progressivist, leftist—if not Marxist—politics. For Futurism was to become, in Italy in 1919, the first avant-garde movement of the twentieth century to have its own political and ideological project assimilated into the formation of fascist ideology.

From backwater to frontrunner

In terms of its artists' models, the background of Futurism is complex. Its sources are to be found in nineteenth-century French Symbolism, in French neo-Impressionist or divisionist painting, and in early-twentieth-century Cubism, which was evolving contemporaneously with Futurism and was clearly known to the majority of the artists in the Italian movement. What was specifically Italian in Futurism's formation, however, was the very belatedness of this modernist avant-garde. Thus, at the moment of the manifesto's first publication, the key figures of Futurist painting, such as Umberto Boccioni (1882–1916), Giacomo Balla (1871–1958), and Carlo Carrà (1881–1966), were still working in the rather *retardataire* manner of 1880s divisionism. None of the strategies that had emerged in Paris in the wake of Cézanne's discoveries, or in the development of Fauvism or early Cubism, entered Futurist painting at its earliest moment, that is to say, prior to 1910. Furthermore, Futurism was typified by the eclecticism with which these belatedly discovered avant-garde strategies were adapted. Indeed, the speed with which they were then patched together in order to reformulate a new Futurist pictorial and sculptural aesthetic is indicative of that very eclecticism.

In the wake of Marinetti's manifesto, several other Futurist manifestos followed, written by artists who had joined the group. Among them were *Futurist Painting: Technical Manifesto*, published in 1910 and signed by Boccioni, Balla, Carrà, Luigi Russolo (1885–1947), and Gino Severini (1883–1966); the *Technical Manifesto of Futurist Sculpture*, published in 1912 by Boccioni; *Fotodinamismo futurista*, also published in 1912, by the photographer Anton Giulio Bragaglia; a 1912 manifesto of Futurist music by Ballila Pratella (1880–1955); Russolo's "The Art of Noises" in 1913; and a manifesto of Futurist architecture by Antonio Sant'Elia (1888–1916) in 1914.

As pronounced in these documents, the strategies of Futurism revolved around three central issues. First, there was an emphasis on synesthesia (the breaking down of the boundaries between the different senses, for instance, between sight, sound, and touch) and kinesthesia (the breaking down of the distinction between the body at rest and the body in motion). Second, Futurism tried to construct an analogue between pictorial signification and existing technologies of vision and representation, such as those being developed by photography—particularly in its extended forms, such as chronophotography—and by early cinema. Third, Futurism's rigorous condemnation of the culture of the past, its violent attack on the legacies of bourgeois tradition, organized an equally passionate affirmation of the need to integrate art with advanced technology, even the technology of warfare, opening up the movement to fascism.

▲ 1912 ● 1907, 1911 ▲ 1906, 1907

Gaston CALMETTE
Directeur-Gérant

RÉDACTION — ADMINISTRATION

POUR LA PUBLICITÉ

ET POUR LES ANNONCES ET RÉCLAMES
Chez MM. LAGRANGE, CERF & Cie
8, place de la Bourse

LE FIGARO

« Loué par ceux-ci, blâmé par ceux-là, me moquant des sots, bravant les méchants, je me hâte
de rire de tout... de peur d'être obligé d'en pleurer. » (BEAUMARCHAIS.)

H. DE VILLEMESSANT
Fondateur

RÉDACTION — ADMINISTRATION
26, rue Drouot, Paris (9e Arrt)

SOMMAIRE

Le Futurisme

M. Marinetti, le jeune poète italien et français, au talent remarquable et fougueux, que le retentissantes manifestations ont fait connaître dans tous les pays latins, vient de lancer à l'adhésion des disciples, sous le titre « l'École de « Futurisme » dont les théories dépassent en hardiesse toutes les théories et les écoles antérieures ou contemporaines...

[Article continues — body text not fully legible]

F.-T. Marinetti

LA VIE DE PARIS

"Le Roi" à l'Élysée... Palace

Il y eut avant-hier soir dans tous les théâtres de Paris, à l'heure où généralement s'ouvre ou se referme le rideau sur le mystère remplaçant en hâte par leurs sombres vêtements familiers les somptueux et éclatants oripeaux professionnels, un inusité et tout à fait surprenant branle-bas !

[Article continues]

Un Monsieur de l'Orchestre.

Échos

La Température

Encore une très belle journée, hier, à Paris. Le ciel est de la plus grande pureté, et le soleil — y pouvons-nous préluder du printemps — brille du plus vif éclat.

[Article continues]

Les Courses

Aujourd'hui, à 2 heures, Courses à Vincennes. — Gagnants du Figaro :

Prix Michelet : Frivole ; Fringante.
Prix de Mayenne : Faço ; Bourgogne.
Prix de Sillé : Fantaisie ; Fregoli.
Prix Pomone : Favorie ; Escapade.
Prix de Maisons-Laffitte : Electra ; Eclaireur.
Prix des Plateux : Fred Leybœrn ; Elisabeth.
Prix de La Varenne : Elysée ; Etendard.

À Travers Paris

Le roi des Bulgares a chargé M. Stancioff, ministre de Bulgarie à Paris, de déposer en son nom une couronne sur le cercueil du marquis Costa de Beauregard.

[Article continues]

Le complot Caillaux

M. Caillaux fomente un petit complot (tout petit) contre ses collègues du ministère, et en particulier contre le président du Conseil auquel il voudrait bien succéder.

[Article continues]

Nouvelles à la Main

— On assure que M. Caillaux et M. Picard ne s'entendent guère. Il y a choc.
— Il y a même abordage...

Le Masque de Fer.

2 • Giacomo Balla, *Girl Running on a Balcony*, 1912
Oil on canvas, 125 × 125 (49¼ × 49¼)

Futurism's stress on synesthesia and kinesthesia followed directly from its critique of the bourgeois aesthetic according to which painting and sculpture were traditionally understood as static arts. It was in contradistinction to this that Futurism strove to incorporate the experience of simultaneity, temporality, and bodily movement within the boundaries of the art object. Such an attempt to make the perception of movement an integral element of the representation of the body in space was informed by Futurism's discovery of the French scientist Étienne-Jules Marey's "chronophotography," an early form of stroboscopic work. Paradoxically, however, it was the literalness with which Balla and Boccioni used a divisionist pictorial idiom to interpret Marey's scientific device that marked their work as strangely delayed and limited, since the very status of the painting as a singular static object was something the Futurist painters never challenged. Further, in trying to adopt chronophotography to their own art, the Futurists bound the pictorial signifier into a purely *mimetic* relationship with the technological field—picturing movement by

blurring outlines, for example—rather than into a *structural* one, such as adopting the serial forms of industrial production.

Futures without a past

Balla was undoubtedly the most interesting painter in the movement, even though at the time of the first manifesto in 1909 he was still working in a very traditional way, as he literally applied divisionist methods to the perception of light and public urban space. This is most evident in his painting *Street Light* (1909–10), where the juxtaposition between nature and culture is programmatically stated in the opposition between a street lantern and the moon, and where the dynamism of light waves is executed in a painfully literal manner by swallowlike wedges that surge away from the luminous source, which are transformed chromatically as they move from the iridescence at the picture's center toward the complete absence of chroma at its margins, a representation of darkness and night.

4 • Giacomo Balla, *Dynamism of a Dog on a Leash*, 1912
Oil on canvas, 89.9 × 109.9 (35⅜ × 43¼)

By 1912 Balla had redefined his pictorial syntax by folding the repetitive contours characteristic of chronophotography into his own representation of objects. Paintings such as *Girl Running on a Balcony* [**2**] or *Dynamism of a Dog on a Leash* [**4**], both from 1912, are significant for the literal way they inscribe the simultaneity of the perception of movement onto the spatial organization of the painting. In 1913, Balla's step to abandon representation altogether in order to find a more adequate way to depict speed, temporality, movement, and visual transformation led to one of the first valid models of nonrepresentational painting. With all figuration deleted, these works were devoted both to the repetition of a structural armature in order to articulate sequence and speed and to a nonrepresentational chromatic idiom that abandoned all references to local color. The compositional and coloristic matrix thus formed no longer participates in what could be called ▲ Cubism's transformation of Renaissance perspective into a new phenomenological space; rather, Balla attempts a transformation of pictorial space into a mechanical, optical, or a temporal space by means of fully nonrepresentational strategies.

Two examples of Boccioni's sculpture clarify the Futurist relationship to the kinesthetic perception of objects in space. The first, *Unique Forms of Continuity in Space* [**3**], in its peculiar ambiguity between a robot and an amphibious figure, once again attempts to incorporate the traces visible in Marey's chronophotography into the sculptural body. Yet, at the same time as it inserts the fluidity of perception into a static representation, it generates the peculiar hybrid between spatial contiguity and the singular, holistic, sculptural object. In Boccioni's *Dynamism of a Speeding Horse and House* [**5**], Futurism's susceptibility to the illusionistic adaptation of motion photography is rejected, however, in favor of a static object in which the effects of simultaneity and kinesthesia are produced by the mere juxtaposition of different materials and the degree of fragmentation to which they are presented. Unlike

3 • Umberto Boccioni, *Unique Forms of Continuity in Space,* 1913 (1931 cast)
Bronze, 111.2 × 88.5 × 40 (43⅞ × 34⅞ × 15¾)

1900-1909

Eadweard Muybridge (1830–1904)
and Étienne-Jules Marey (1830–1904)

The Englishman Eadweard Muybridge and the Frenchman Étienne-Jules Marey are yoked in time and by work: not only do they share the same birth and death dates, but also together they pioneered the photographic study of movement in ways that influenced not only the development of Futurist art but also the modern rationalization of labor and, it could be argued, of space–time in general.

First known as a photographer of American West and Central American landscapes, Muybridge was enlisted in 1872 by Leland Stanford, the millionaire ex-governor of California, in a racing dispute about the gait of horses. In Palo Alto, Muybridge photographed horses with a battery of cameras; typically, he arranged the images in rows and reshot them in a grid that could be scanned both horizontally and vertically. A book, *The Horse in Motion*, which Stanford bowdlerized, appeared in 1882, the same year that Muybridge sailed to Europe for a lecture tour. In Paris he was welcomed by Marey, the famous photographer Nadar, the Salon painter Ernest Meissonier, and the great physiologist Hermann von Helmholtz—some indication of the range of interest in this work that registered perceptual units beyond the limits of human vision.

Unlike Muybridge, who considered himself an artist, Marey was a physiologist by training who had previously worked on graphic methods to record motion. When he first saw work by Muybridge in the science journal *La Nature* in 1878, he turned to photography as a more precise and neutral way to register discrete movement. Marey first devised a photographic gun with a circular plate that yielded near-instantaneous serial photographs from a singular viewpoint. He then used a slotted disk in front of the camera to break up movement in set intervals that could be registered on a single photographic plate; it was this work that he first described as "chronophotography." In order to avoid superimposition, Marey clad his subjects entirely in black, with metal-studded strips along arms and legs (bits of paper were used for animals). Along with the singular viewpoint, this device effectively restored a spatio-temporal coherence to the very perceptual field that was otherwise fragmented. It was more scientific than the Muybridge approach, which did not have a consistent point of view or interval between images, but it was also less radical in its disruption of the apparent continuum of vision.

It was this disruption that most intrigued the modernists—the Futurists in their pursuit of a subversive speed, and artists like Marcel Duchamp in their search for spatio-temporal dimensions not previously perceived. But could it be that, like Muybridge and Marey, these artists were also involved in a historical dialectic that far exceeded their work as individuals —a modern dialectic of a ceaseless renovation of perception, of a perpetual liberating and redisciplining of vision that would persist throughout the twentieth century?

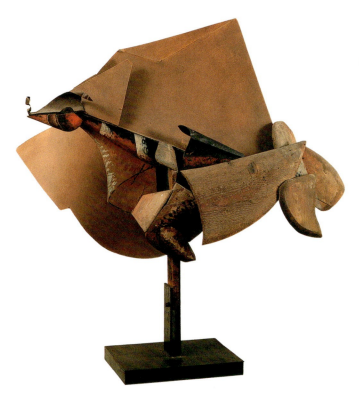

5 • Umberto Boccioni, *Dynamism of a Speeding Horse and House*, 1914–15
Gouache, oil, wood, paste-board, copper, and painted iron, 112.9 × 115 (44½ × 45¼)

analysis of the phonetic, the textual, and the graphic components of language in Russian Cubo-Futurist poetry or the *calligrammes* of ▲ Apollinaire. The juxtaposition of anti-German war slogans ("Down with Austro-Hungary") with found advertising material, or the concatenation of Italian patriotic declarations ("Italia Italia") with musical fragments, continues the technique of Cubist collage but turns this aesthetic into a new model of mass-cultural instigation and propaganda. Its glorification of war is further registered in the drum beats evoked by the words "ZANG TUMB TUUM."

A liberation of language: *parole in libertà*

Zang Tumb Tuum of 1914, the first collection of Marinetti's "free word poetry" was prefaced by his slightly earlier manifesto of Futurist poetry, *Destruction of Syntax—Imagination without Strings—Words-in-Freedom*. Using a set of expressive typographic and orthographic variations and an unstructured spatial organization, *Zang Tumb Tuum* tries to express the sights, sounds, and smells of the poet's experience in Tripoli. This assertion of "words-in-freedom" emerged from a long and complicated dialogue with late-nineteenth-century Symbolist poetry and its early-twentieth-century legacy in France. Although deeply influenced by, and dependent upon, the example of Mallarmé, Marinetti publicly declared his opposition to the French poet's project. Insisting that

Unique Forms of Continuity in Space, which retains the traditional sculptural methods of modeling and bronze-casting, the work incorporates industrially produced materials as called for in Boccioni's own manifesto: leather, found fragments of glass, shards of metal, preformed elements of wood. One of the first fully nonrepresentational sculptures of the twentieth century, it compares most adequately with the abstract sculpture produced in ▲ Russia at that time by Vladimir Tatlin.

Insofar as collage surfaced as the key technique in the contradictory range of Futurism's attempts to fuse avant-garde sensibilities with mass culture, Carrà's *Interventionist Demonstration* [6] is a central example of the Futurist aesthetic as it came to a climax just before World War I. Indeed, the work incorporates all of the devices with which Futurism was most engaged: the legacy of divisionist painting; the Cubist fragmentation of traditional perceptual space; • the insertion of clippings from newspapers and found materials from advertising; the suggestion of kinesthesia through a visual dynamic set up by the collage's construction as both a vortex and a matrix of crisscrossing power lines set as mutually counteractive diagonals; and last, but not least, the juxtaposition of the separate phonetic dimension of language with its graphic signifiers.

Typically enough, the phonetic performance of language in *Interventionist Demonstration* is in almost all instances onomatopoeic. In directly imitating the sounds of sirens (the wail evoked by "HU-HU-HU-HU"), the screeches of engines and machine guns ("TRrrrrrrr" or "traaak tatatraak"), the screams of people ("EVVIVAAA"), it is distinctly different from the structural

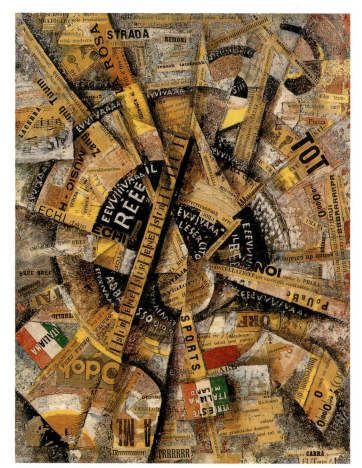

6 • Carlo Carrà, *Interventionist Demonstration*, 1914
Tempera and collage on cardboard, 38.5 × 30 (15⅛ × 11¾)

words must be liberated from the static and esoteric models of language with which Mallarmé had been engaged, Marinetti promoted a new dynamic of "wireless imagination" intended to assimilate the simultaneity of perception to the new sounds of advertising and technological experience. *Words-in-Freedom* is the programmatic declaration by Marinetti in which all of the traditional fetters to which language had been subjected—lexicality, the production of meaning, syntax, grammar—are supposedly ruptured in favor of a purely phonetic, purely textual, purely graphic performance. But in fact, against Marinetti's will, the mimetic relationship to the technological apparatus binds this model of poetry all the more into the traditional determinants of linguistic representation.

This was the source of one of the conflicts that arose between ▲ Marinetti and the Russian avant-garde when in 1914 the Italian poet went to Moscow in an attempt to proselytize for Futurism. What the Russian Cubo-Futurist poets criticized Marinetti for was the relationship manifested in his work between poetry and the mimetic operations of language, particularly his use of onomatopoeia—the formation of words imitating sounds associated with the act or objects to be denoted. At that time, the Russian Futurists had already moved to a structuralist understanding of ● the arbitrary logic of language, which meant that they enforced a strict separation of both the phonetics and the graphics of signs—the way language sounds and the way it looks—from the natural world to which those signs might refer. So insistent were the Russian Futurists on making this separation the subject of their own writing that they carried it to the point of constructing a new ■ antisemantic and antilexical poetry.

Fascism and Futurism

The rise of fascism in Italy at the end of World War I brought the ideological and political orientation of Futurism into focus. The celebration of technology, the anti-*passatista* (antitraditionalist) position, the rigorous condemnation of the culture of the past, the violent deformation of the legacies of bourgeois culture, were all essential elements of Futurism from its inception. But these were now linked with an equally passionate affirmation of the necessity to integrate art and warfare as the most advanced instance of the technological. If in the first manifesto Marinetti had constructed a myth of origin for the Futurist movement—he recounts the moment of his awakening when, racing in his sports car, he overturned in the muddy waters of a suburban ditch thereupon to emerge, reborn, as a post-Symbolist artist and Futurist poet—this had already announced a deep commitment to the irrationality of violence and power.

Marinetti's espousal of advanced industrial technology and the aesthetic of the machine led him to welcome the outbreak of war as a great purification in line with his overall hatred of tradition and bourgeois cultural subjectivity. As the first avant-gardist to set out deliberately to destroy tradition, Marinetti declared his own war by calling for the destruction of cultural institutions—opera houses, theaters, libraries, museums. In doing so, he positioned Futurist culture at the forefront of a newly emerging rupture between the avant-garde and tradition by organizing the avant-garde as the stage for the annihilation of historical continuity and historical memory. Further, Marinetti's subsequent, postwar attempt to synchronize art and advanced technology with fascist ideology was to be the only occasion in the history of twentieth-century avant-gardes where a link between these elements was positioned explicitly in the perspective of reactionary right-wing politics.

In the embrace of fascism by Marinetti—who unsuccessfully stood for parliament as a Fascist Party candidate in 1919, and who eventually became Mussolini's cultural adviser—one of the key problems facing twentieth-century avant-gardes thus emerged. This is the question of whether avant-garde practices are still to be situated within the bourgeois public sphere or whether they should aim to contribute to the formation of different mass-cultural public spheres, be they fascist public spheres (if there could ever be such a ▲ thing) or proletarian public spheres, the goal of Russian and Soviet ● artists working at that time. Alternatively, as in the case of Dada, the avant-garde could rally for the destruction of the bourgeois public sphere, including its institutions and discursive formations.

With the accidental death of Boccioni in 1916, the death in battle of Sant'Elia in the same year, and the radical change in political and aesthetic orientation on the parts of Severini and Carrà around the same time, Futurism lost its way as an avant-garde movement (although Marinetti would continue to pursue a Futurist agenda in art, literature, and politics throughout the twenties and thirties). Severini, living in Paris, abandoned his Cubo-divisionist pictorial strategies in 1916 and adopted pure, classical forms inspired by ■ the art of the Italian Renaissance. By returning to tradition in this way, and by using quattrocento painting as the matrix of *italianità*, he was a harbinger of the later, gradual secession of fascist ideology ◆ from modernist practices. This ideology of the nation state would undertake to connect itself instead to the roots of local cultures, whose origins it would seek to recover.

The encounter between Carrà and Giorgio de Chirico in a military hospital in Ferrara in 1917 triggered a further instance of counterreaction within the avant-garde. Carrà had already become restless under the yoke of Futurism and had written that he no longer cared for "emotional electricians' games." Now, he absorbed de Chirico's attention to form [7]. Practically overnight, Carrà abandoned all the Futurist projects with which he had been involved to practice the older man's *pittura metafisica*. In this sense, the discovery of de Chirico has to be recognized as an integral element of Italian avant-garde thinking at that time. Turning to the geometric solidity of "primitivist" painters such as Le Douanier Rousseau and the early Renaissance artists Giotto and Uccello, Carrà spoke of them as the creators of "plastic worlds," or better, "plastic tragedies." His article on Giotto in the newspaper *La Voce* (1915) addressed Giotto as a man devoted to "pure plasticity," the "fourteenth-century visionary" who brought the "magic silence of forms" back to life. Giotto, he wrote, was dedicated to "the original

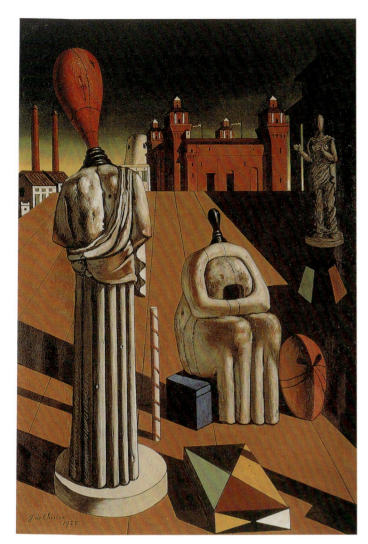

7 • Giorgio de Chirico, *The Disquieting Muses*, 1925
Oil on canvas, 97 × 67 (38¼ × 26½)

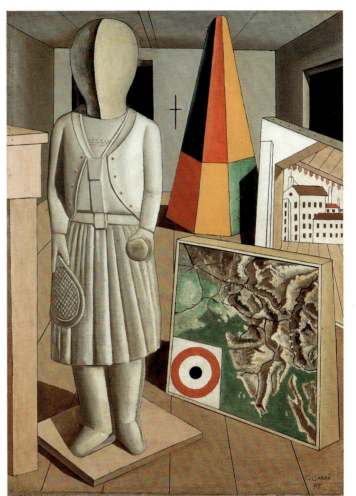

8 • Carlo Carrà, *Metaphysical Muse*, 1917
Oil on canvas, 90 × 66 (35⅜ × 26)

solidity of things." Carrà's celebration of formal solidity as the anti-dote to Futurist disintegration repeats the terms through which modernist painting had originally developed pictorial stability in reaction against a pursuit of the evanescence of light. "We, who feel that we are the nondegenerate offspring of a great race of builders," Carrà wrote in the catalogue of his 1917 exhibition in Milan, "have always sought precise, substantial figures and terms, and the ideal atmosphere without which a painting does not go beyond elaborate technicalism and episodic analysis of external reality." Thus does Carrà reject Impressionism and the Futurist imitation of its effects. In 1918, Carrà theorized the method that he and de Chirico had developed in the essay "Contributo a un nuove arte metafisica."

Carrà's *Metaphysical Muse* [8] demonstrates his absorption of de Chirico's visual repertory. On the slanting floorboards of a shallow stage, he places the plaster mannequin of a tennis player, in combination with geometrical solids and painted stage sets of maps and buildings. In fact, all the paintings he showed in the Milan exhibition shared the nocturnal silence of de Chirico's palace courtyards and city squares, interrupted by nothing except long, isolated shadows.

After noise, silence; after the celebration of the mass displacements imposed by war, praise for the patrician sensibilities of tradition. Carrà's and Severini's emergence from the very ranks of Futurism to become key followers of de Chirico was the first and perhaps the most intense example of the antimodernism or countermodernism that subsequently spread throughout Europe in ▲ various parallel movements, to which the collective name "*rappel à l'ordre*" was given. Paradoxically, it was within the art of de Chirico and Carrà that the dimension of historical memory so vituperatively prosecuted and eroded within the first four years of Futurist activity returned with a vengeance, to become the central issue within which these artists would continue to operate. BB/RK

FURTHER READING

Umbro Apollonio (ed.), *Futurist Manifestos* (London: Thames & Hudson, 1973)
Anne Coffin Hanson (ed.), *The Futurist Imagination* (New Haven: Yale University Art Gallery, 1983)
Pontus Hulten (ed.), *Futurism and Futurisms* (New York: Abbeville Press; and London: Thames & Hudson, 1986)
Marianne Martin, *Futurist Art and Theory 1909–1915* (Oxford: Clarendon Press, 1968)
Christine Poggi, *In Defiance of Painting* (New Haven and London: Yale University Press, 1992)

▲ 1919

1910—1919

1910

Henri Matisse's *Dance II* and *Music* are condemned at the Salon d'Automne in Paris: in these pictures, Matisse pushes his concept of the "decorative" to an extreme, creating an expansive visual field of color that is difficult to behold.

"My picture threw me out onto the streets!" Matisse declared to a friend who was surprised by his impromptu visit. Two days earlier this friend had left him carefully preparing his material and, stockpiling groceries, vowing to lock himself up for a month in order to realize an important commission he had just received—and now Matisse felt he could not add a single stroke to his hastily brushed canvas. The picture in question was either *Seville Still Life* or *Spanish Still Life* [1], both painted "in a fever" in December 1910 while the artist was resting in Spain. "This is the work of a nervous man," Matisse would later say of the pair, and indeed there is perhaps no more agitated painting in his entire production than these two still lifes.

The circumstances of their making are worth recalling. Coming back to Paris elated from a trip to Munich, where he had gone to see the first major exhibition ever devoted to Islamic art, Matisse was confronted with an almost unanimously negative critical response to *Dance II* [2] and *Music* [3], the canvases he had sent to the 1910 Salon d'Automne, the annual showcase for contemporary art established seven years earlier (his sole supporter was the poet Guillaume
▲ Apollinaire, for whom he felt no sympathy). By then he was used to such turmoil surrounding his work, to some extent even thriving on it; but this time the hostile consensus hit him hard. Not only did it catch Matisse at a moment when he was particularly fragile (his father had died a day after his return to Paris), it also had an immediate effect on his most courageous and faithful patron, the Russian collector Sergei Shchukin, who had commissioned the two large paintings and had been enthusiastically following their progress from afar. Shchukin arrived in Paris in the midst of this public uproar, and, balking, decided at the eleventh hour not to accept them. (Adding to Matisse's injury, his dealers borrowed his studio to display the work they had convinced Shchukin to purchase instead, the large *grisaille* sketch for a mural by Puvis de Chavannes.)

Feeling guilty on his way back to Moscow, Shchukin sent a telegram rescinding his decision and asking for *Dance II* and *Music* to be shipped at great speed, followed by a letter canceling the purchase of the Puvis and apologizing for his momentary weakness. The immediate danger of the end of Shchukin's support was averted, but Matisse was shaken by these about-faces. Mulling over the fickleness of collectors and the treachery of art dealers, he left

1 • Henri Matisse, *Spanish Still Life*, 1910–11
Oil on canvas, 89 × 116 (35 × 45⅝)

for Spain, where for a whole month he was unable to sleep or work. There, he received Shchukin's latest commission for two still lifes (which would be very handsomely paid), as well as the news that *Dance II* and *Music* had arrived safely in Moscow ("I hope to come to like them one day," Shchukin wrote).

Rather than taming his style for the new commission, Matisse took a huge gamble—a true "all or nothing"—in carrying one of its features to the extreme, namely the decorative profusion that had characterized many of his works from the previous years, such as the 1908 *Harmony in Red*, which already belonged to Shchukin. As if he had nothing to lose (which was very far from being the case), Matisse refused to retreat toward the neoclassical conception of the decorative represented by Puvis: it is as if he were warning his patron—who had suddenly become worried about the nudity of the figures in *Dance II* and *Music*, and about what was called at the time their "Dionysian" character—that a still life could be just as visually disquieting. One could even argue that, in proposing *Seville Still Life* and *Spanish Still Life* to Shchukin immediately after the two panels the Russian collector had found so hard to swallow, Matisse was deliberately alternating between two modes—one austere, one swarming—as if to demonstrate that they were two sides of the

2 • Henri Matisse, *Dance II*, 1910
Oil on canvas, 260 × 391 (101⅝ × 153½)

same coin. The prior holdings of the Shchukin Collection suggest that this might have been a consistent strategy on the part of Matisse (compare the sparse 1908 *Game of Bowls* and the 1909 *Nymph and Satyr* with *Harmony in Red*, bought shortly before the still-life commission); and Shchukin's subsequent purchases followed the same pattern (compare the austere 1912 *Conversation* with *The Painter's Family* or *The Pink Studio* of 1911, bought at the same time).

An "aesthetic of blinding"

Both *Seville Still Life* and *Spanish Still Life* are difficult to behold—that is, the viewer cannot gaze at their pullulating arabesques and color flashes for very long. As had already happened in *Le Bonheur de vivre*, but now much more so, these paintings appear to spin before the eye; nothing there ever seems to come to rest. Flowers, fruits, and pots pop up like bubbles that dissolve into their busy, swirling background as quickly as one manages to isolate them. The centrality of the figure is dismantled: the viewer feels compelled to look at everything at once, at the whole visual field, but at the same time feels forced to rely on peripheral vision to do so, at the expense of control over that very field.

Now, compare this turbulence with *Music* [3]. At first sight nothing could be more dissimilar to the frantic still lifes than the sobriety of this large composition. But this difference dwindles once actual scale is taken into consideration. For when confronted with *Music*'s one hundred-plus square feet of saturated color, and its frieze of five musicians evenly distributed on the surface, once again one stumbles upon an aporia of perception: either one tries to contemplate the figures one by one but cannot do so because of the sheer coloristic summons of the rest of the canvas; or, conversely, one attempts to take in the vast surface at a glance but cannot prevent the optical vibrations that are caused by the figures' vermilion forms as they clash with the blue-and-green ground from deflecting our grasp of the visual field. Figure and ground constantly annul each other in a crescendo of energies—that is, the very opposition upon which human perception is based is deliberately destabilized—and our vision ends up blurred, blinded by excess.

This "aesthetic of blinding" was already in place in 1906—it was the result of Matisse's complex negotiations, during the heyday of Fauvism, with the legacy of Postimpressionism. But it assumed a new urgency around 1908, at which time Matisse reflected upon it in his famous "Notes of a Painter," one of the most articulate artistic manifestos of the twentieth century. There, among other things, Matisse defined the diffraction of the gaze that he was aiming for as the core of his concept of expression: "Expression, for me,

3 • Henri Matisse, *Music*, 1910
Oil on canvas, 260 × 389 (101⅝ × 153¼)

does not reside in passions glowing in a human face or manifested by a violent movement. The entire arrangement of my picture is expressive: the place occupied by the figures, the empty spaces around them, the proportions, everything has its share." In other words, as he would keep saying all his life, "expression and decoration are one and the same thing."

Matisse answers the younger Picasso

Many factors contributed to the sudden acceleration of Matisse's art and theoretical sophistication in 1908. One of them, perhaps the most important, was his competition with Picasso. In the fall
▲ of 1907 he had seen *Les Demoiselles d'Avignon*, Picasso's direct
● answer to both his *Le Bonheur de vivre* and his *Blue Nude*. The painting had made Matisse uneasy, in part because it had carried primitivism further than any of his own previous attempts, and he had to respond.

His first reply was the large *Bathers with a Turtle* [4], one of his barest and eeriest canvases (the primitivism of the central, standing nude has been noted by all commentators). Countering Picasso's "Medusa effect," Matisse turned the glare of his giant nudes away from the beholder—but not without signaling that a simple retreat

to the traditional regime of mimetic identification was no longer an available option (on this point he was concurring with Picasso). The picture is not the depiction of a bucolic scene, nor is it an allegory. What are these huge creatures doing, feeding a turtle they do not even look at? We cannot understand the motive of their action any more than they seem able to communicate it among themselves. The spectator is left to ponder over the enigmatic "expression" of the standing nude or that of her seated neighbor. But no clue is given by their surroundings. For the first time in Matisse's work the decor is reduced to modulated bands of plain color, as in Byzantine mosaics: green for the grass, blue for the water, blue-green for the somber sky—a cipher of a landscape, frontally facing us. This is an uninhabitable world, into which we are not invited.

Shchukin had perceived the profound melancholy of this work and, saddened that it had been sold to another collector, he asked Matisse for a substitute. That was to be *Game of Bowls*, a far less powerful painting, but indicative of the direction Matisse's work was to take. The "landscape" is as bare as in *Bathers with a Turtle* (though the color spectrum is much lighter), but now formal rhythms set the composition in motion (the three dark-haired heads of the players being ironically echoed by their three green bowls). There are no mysterious expressions here: the distorted

faces of Picasso's *Les Demoiselles* are no longer Matisse's concern; the features of the bowlers are written in shorthand. The visual rhythm, whose function was still embryonic in *Bathers with a Turtle*, is now what unifies the canvas.

The next step was *Harmony in Red* [5], Matisse's first fully successful realization of what would be his lifelong pictorial program: a surface so tense that our gaze rebounds from it; a composition so dispersed, so rippled with echoes in all directions, that we cannot gaze at it selectively; a maze so energetic that it always seems to expand laterally. Matisse made one last attempt at painting in Picasso's centripetal mode in his *Nymph and Satyr* of late 1908 (again for Shchukin), one of his very few paintings with a violent theme. But this was to remain an exception (matched only by a series of drawings and unfinished canvases on the same theme from 1935, and by the studies for *The Stations of the Cross* ceramic panel in the Vence Chapel from 1949): after it, we will not be asked to look at an action from a distance; instead, we will be confronted with a wall of painting forcing its color saturation onto us.

A certain form of violence is implied by this kind of address. Today, after so many pages praising Matisse as the painter of "happiness" (or, conversely, berating his "hedonism"), the particular type of aggressiveness embedded in his art is somewhat veiled. But the fiercely negative response that he received at the time— ▲ which kept accelerating from the reception of *Luxe, calme et volupté* at the 1905 Salon des Indépendants, through the Fauve scandal of 1905 and the cries that greeted *Le Bonheur de vivre* in 1906 and *Blue Nude* in 1907, to the nearly universal condemnation of *Dance II* and *Music* in 1910—is a clear indication that he was touching a sensitive nerve. What became obvious in the case of the reception of these last two works is that it was precisely Matisse's conception of the "decorative" that was perceived as a slap in the face of tradition—the tradition of painting as well as the tradition of beholding.

4 • Henri Matisse, *Bathers with a Turtle*, 1908
Oil on canvas 179.1 × 220.3 (70½ × 87¾)

▲ 1906

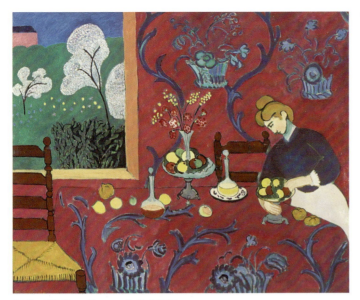

5 • Henri Matisse, *Harmony in Red*, 1908
Oil on canvas, 180 × 220 (70⅞ × 86⅝)

Hypnotic "decorations"

It was not by chance that Matisse's dealers had been quick to offer Shchukin a Puvis in replacement for his two panels. High expectations were vested in the notion of the "decorative" at that very moment, the 1910 Salon marking the climax of the numerous debates that had been raging on the issue since the turn of the century (it was deemed capable of restoring the greatness of French art after the crisis of representation engendered by Postimpressionism and further deepened by Fauvism and Cubism). A return to Puvis—"decorative" compositions draped in a neoclassical rhetoric—was called for, but this is exactly what Matisse refused to condone. He labeled *Dance II* and *Music* "decorative panels" when sending them to the Salon, and this enraged the critics: the paintings were not made to soothe the eye, to gently adorn a wall; they were the crude product of a madman, posterlike bacchanals that threatened to swirl out of their frame.

The high-pitched color was obviously a major cause of this resistance, but it would not have had such an impact if it had not been for the ample scale of the works (not only are they large but also the number of elements they display are reduced: in each canvas there are only five figures of the same "lobster" color, as was said at the time, and two background zones—blue for the sky and green for the land). In fact, the coloristic impact of *Dance II* and *Music*, which remained unequaled in painting until the large canvases of Mark
▲ Rothko and Barnett Newman in the late forties, provided the clearest confirmation of Matisse's principle according to which "a square centimeter of blue is less blue than a square meter of the same blue."

But if the anticlassical decenteredness of these works was perceived as a threat, and criticized in *Music* even more than in *Dance II*, it is also because with them Matisse finally found a means to emulate properly, though with different means, Picasso's
• apotropaïc stance in *Les Demoiselles d'Avignon*. Although it is just as bare as *Music*, *Dance II* partakes in the profuse mode of Matisse's

notion of the "decorative." Looking at it, we are condemned to endless motion, forbidden to let our gaze ever break the circling round of its feverish arabesque. The only escape from this hypnotic frenzy is to recoil, just as Matisse had done, panicked in front of his own Spanish still lifes. Yet *Music* is more powerful, though in a subtler fashion, in this interdiction to join in peacefully.

Like Picasso's *Les Demoiselles*, this painting had begun as a genre scene, the five musicians (among them a woman) looking at each other, interacting. In the final canvas, the figures, now all male, have undergone the same ninety-degree rotation that Leo Steinberg discussed in Picasso's painting: stilted in their pose, ignoring each other, they stare terrifyingly at us. Matisse himself is said to have been afraid by what he called the "silence" of this canvas: in contrast with the sweeping movement of *Dance II*, in *Music* everything is arrested. The black holes of the three singers' mouths are unequivocally morbid (closer to signaling death than sound); the violinist's bow poised before the downstroke is nothing but ominous. In his review of the Salon, Yakov Tugenhold, one of the most gifted Russian critics of the time (Shchukin paid careful attention to his prose), described the figures of *Music* as "boy were-wolves hypnotized by the first-ever strains of the first instruments." No critical metaphor could better indicate that in this canvas Matisse is charting the same Freudian territory as Picasso had done in his brothel scene, for, even more than *Les Demoiselles*, *Music*
▲ is akin to the image of the Wolf-Man's dream. We have to add a proviso to Tugenhold's metaphor, however: it is not the musicians but the spectators who are hypnotized.

This hypnosis is based on a pendulum in our perception that makes us switch from our incapacity to focus on the figures to that of seizing the whole visual field at once, an oscillation that defines the very invention of Matisse's concept of the "decorative," and which is particularly difficult to obtain in a sparse composition. It is thus not surprising that Matisse should have preferred the overcrowded mode as a surefire means to keep the beholder's gaze moving. It should be noted, however, that he never totally relinquished the barren version of the decorative, that it played a major role in his production at several key moments of his career, most notably when his rivalry with Picasso was at stake. One such moment was when he was trying to learn the language of Cubism, from 1913 to 1917 (after which he retreated to Nice and into Impressionism until 1931, when the conjoined commissions of an illustrated Mallarmé book and that of a mural on the theme of Dance for the Barnes Foundation led him back to the aesthetics of his youth). From Matisse's "Cubist" years date works such as *French Window in Collioure* (1914) or *The Yellow Curtain* (c. 1915), so strikingly similar, once again, to works by Rothko or Newman, or *The Blue Window* (1913) and *The Piano*
• *Lesson* (1916), whose oneiric atmosphere the Surrealist poet André Breton found so appealing.

The works immediately following *Dance II* and *Music*, however, swung in the other direction. After the two "nervous" Spanish still lifes came the famous large interiors of 1911, *The Red Studio*, *Interior with Eggplants* [6], *The Pink Studio*, and *The Painter's Family* (the last

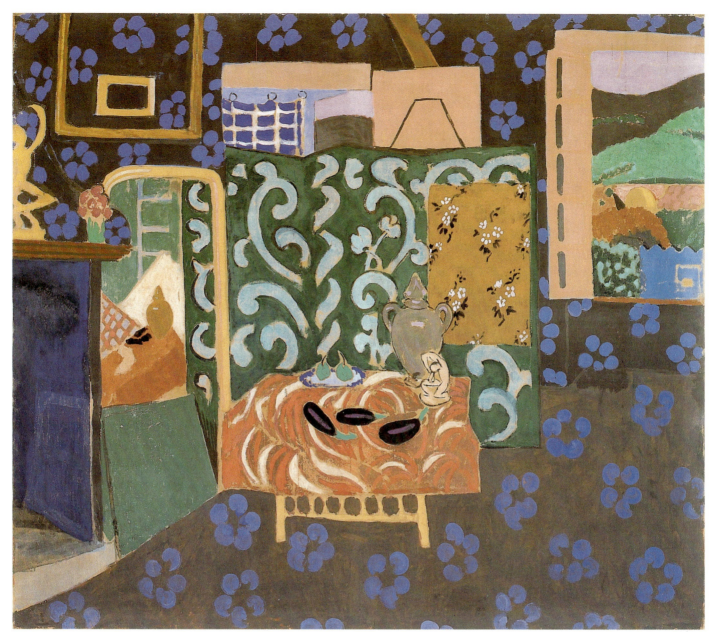

6 • Henri Matisse, *Interior with Eggplants*, 1911
Oil on canvas, 212 × 246 (82⅜ × 96⅞)

two immediately purchased by Shchukin). Less frenetic than the pictures done at Seville, and considerably larger, they explore the same isotropic universe in expansion. In *The Red Studio*, a monochrome bath of redness floods the field, annulling even the possibility of contour (which exists only negatively, as unpainted, reserved areas of the canvas); in *The Painter's Family*, the multiplication of decorative patterns that surround the figure makes us oblivious to the most violent color contrasts, such as the opposition between the unmitigated black dress of the standing figure and the lemon-yellow book she holds; in *Interior with Eggplants*, the most underrated but most radical work of the series, everything cooperates in leading us astray: the pulsating repetition of the flower motif that invades floor and walls and blurs their demarcation; the reflection in the mirror that coloristically matches the landscape outside the window and confuses levels of reality; the syncopated rhythm and different

scales of the ornamental fabrics; the gestures of the two sculptures (one on the table, the other on the mantelpiece) that rhyme with the arabesques of the folded screen. The three eggplants that give the painting its title are right in the middle of the canvas, but Matisse has blinded us to them and it is only through a conscious effort that we manage, only fleetingly, to locate them. **YAB**

FURTHER READING
Alfred H. Barr, Jr., *Matisse: His Art and His Public* (New York: Museum of Modern Art, 1951)
Yve-Alain Bois, "Matisse's Bathers with a Turtle," *Bulletin of the Saint Louis Art Museum*, vol. 22, no. 3, Summer 1998
Yve-Alain Bois, "On Matisse: The Blinding," *October*, no. 68, Spring 1994
John Elderfield, "Describing Matisse," *Henri Matisse: A Retrospective* (New York: Museum of Modern Art, 1992)
Jack D. Flam, *Matisse: The Man and His Art, 1869–1918* (Ithaca, N.Y. and London: Cornell University Press, 1986)
Alastair Wright, "Arche-tectures: Matisse and the End of (Art) History," *October*, no. 84, Spring 1998

1911

Pablo Picasso returns his "borrowed" Iberian stone heads to the Louvre Museum in Paris from which they had been stolen: he transforms his primitivist style and with Georges Braque begins to develop Analytical Cubism.

During 1907, the year in which the poet-critic Guillaume Apollinaire employed him as a secretary, the young rascal Géry Pieret would regularly ask Apollinaire's artist- and writer-friends if they would like anything from the Louvre. They assumed, of course, that he meant the Louvre Department Store. In fact, he meant the Louvre Museum, from which he had taken to stealing various items displayed in undervisited galleries.

It was on his return from one of these pilfering trips that Pieret offered two archaic Iberian stone heads to Picasso, who had discovered this type of sculpture in 1906 in Spain and had used it for his portrait of the American writer Gertrude Stein. Substituting the prismatic physiognomy of its carving—the heavily lidded, staring eyes; the continuous plane that runs the forehead into the bridge of the nose; the parallel ridges that form the mouth—for the sitter's face, Picasso was convinced that this impassive mask was "truer" to Stein's likeness than any faithfulness to her actual features could be. He was thus only too happy to acquire these talismanic objects; and "Pieret's heads" went on to serve as the basis for the features of the three left-hand nudes in *Les Demoiselles d'Avignon*.

But in 1911, when Pieret disastrously popped back up in the lives of both Apollinaire and Picasso, primitivism had been left behind in the artist's development of Cubism, and thus the heads had long since vanished from his pictorial concerns, if not from the back of his cupboard. Picasso's sudden problem was that at the end of August 1911 Pieret had taken his latest Louvre "acquisition" to the offices of *Paris Journal*, selling the newspaper his story about how easy it was to filch from the museum. Since the Louvre had just suffered, one week earlier, the theft of its most precious object, Leonardo's *Mona Lisa*, and a dragnet was being set up by the Paris police, Apollinaire panicked, alerted Picasso, and the two of them handed Picasso's Iberian heads over to the newspaper, which, publishing this turn of events as well, led the authorities to both poet and painter. They were taken in for questioning, Apollinaire being held far longer than Picasso, but were eventually released without charge.

The rise of analysis

The artistic distance that separated Picasso in late 1911 from the primitivism for which the heads had served him earlier was enormous. The Iberian heads and African masks that Picasso had used as models in 1907 and 1908 had been a means of "distortion," to use the term of art historian Carl Einstein when, in 1929, he tried to understand the development of Cubism. But this "simplistic" distortion, Einstein wrote, gave way "to a period of analysis and fragmentation and finally to a period of synthesis." *Analysis* was also the word applied to the shattering of the surfaces of objects and their amalgamation to the space around them when Daniel-Henry Kahnweiler, Picasso's dealer during Cubism's development, sat down to write the most serious early account of the movement, *The Rise of Cubism* (1920). And so the term *analytical* got appended to Cubism, and "Analytical Cubism" became the rubric under which to contemplate the transformation Picasso and Georges Braque had achieved in 1911. For by that time, they had swept away the unified perspective of centuries of naturalistic painting and had invented instead a pictorial language that would translate coffee cups and wine bottles, faces and torsos, guitars and pedestal tables into so many tiny, slightly tilted planes.

To look at any work from this "analytical" phase of Cubism, Picasso's *Daniel-Henry Kahnweiler* of 1910 [1], for instance, or Braque's *The Portuguese (The Emigrant)* from 1911–12 [2], is to observe several consistent characteristics. First, there is a strange contraction of the painters' palettes, from the full color spectrum to an abstemious monochrome—Braque's picture is all ochers and umbers like a sepia-toned photograph; Picasso's, mainly pewter and silver with a few glints of copper. Second, there is an extreme flattening of the visual space as though a roller had pressed all the volume out of the bodies, bursting their contours open in the process so that what little surrounding space remains could flow effortlessly inside their eroded boundaries. Third, there is the visual vocabulary used to describe the physical remains of this explosive process.

This, given its proclivity for the geometrical, supports the "Cubist" appellation. It consists, on the one hand, of shallow planes set more or less parallel to the picture surface, their slight tilt a matter of the patches of light and shade that flicker over the entire field, darkening one edge of a given plane only to illuminate the other but not doing this in any way consistent with a single light source. On the other, it establishes a linear network that scores the

entire surface with an intermittent grid: at certain points, identifiable as the edges of described objects—Kahnweiler's jacket lapels or his jawline, for instance, or the Portuguese sitter's sleeve or the neck of his guitar; at others, the edges of planes that, scaffoldlike, seem merely to be structuring the space; and at still others, a vertical or horizontal trace that attaches to nothing at all but continues the grid's repetitive network. Finally, there are the small grace-notes of naturalistic details, such as the single arc of Kahnweiler's mustache or the double one of his watch-chain.

Given the exceedingly slight information we can gain from this about either the figures or their settings, the explanations that grew up around Picasso's and Braque's Cubism at this time are extremely curious. For whether it was Apollinaire in his essays collected as *The Cubist Painters* (1913), or the artists Albert Gleizes (1881–1953) and Jean Metzinger (1883–1956) in their book *On Cubism* (1912), or any of the critics and poets gathered around the movement, such as André Salmon (1881–1969) or Maurice Raynal (1884–1954), all the writers attempted to justify this swerve away from realism by arguing that what was being delivered to the viewer was *more* not less knowledge of the depicted object. Stating that natural vision is impoverished since we can never see the whole of a three-dimensional object from any single vantage point—the most we see of a cube, for example, is three of its faces—they argued that Cubism overcomes this handicap by breaking with a single perspective to show the sides and back simultaneously with the front, so that we apprehend the thing from everywhere, grasping it conceptually as a composite of the views we would have if we actually moved around it. Positing the superiority of conceptual knowledge over merely perceptual realism, these writers inevitably gravitated toward the language of science, describing the break with perspective as a move toward non-Euclidean geometry, or the simultaneity of distinct spatial positions as a function of the fourth dimension.

The laws of painting as such

Kahnweiler, who had exhibited the 1908 Braque landscapes that gave Cubism its name (the journalist-critic Louis Vauxcelles wrote that Braque had reduced "everything to geometric schemas, to cubes"), and who had been active as Picasso's dealer since 1909, had a very different argument to make about the inner workings of Cubism, one far easier to reconcile with how the paintings actually look. Cut off by the outbreak of World War I from his Paris gallery and the pictorial movement he had followed so closely, Kahnweiler used his time in Switzerland to reflect on the meaning of Cubism, composing his explanation in 1915–16.

Arguing that Cubism was exclusively concerned with bringing about the unity of the pictorial object, *The Rise of Cubism* defines this unity as the necessary fusion of two seemingly irreconcilable opposites: the depicted volumes of "real" objects and the flatness of the painter's own physical object (just as "real" as anything in the world before the artist), which is the canvas plane of the picture. Reasoning that the pictorial tool to represent volume had always

Guillaume Apollinaire (1880–1918)

Born the illegitimate son of a member of the lesser Polish nobility, Guillaume Albert Apollinaire de Kostrowitzky grew up on the French Riviera among the cosmopolitan *demi-monde*. At seventeen, deeply affected by the poets Paul Verlaine and Stéphane Mallarmé, he composed a handwritten anarcho-symbolist "newspaper" filled with his own poems and articles. Apollinaire soon became an active figure in a Parisian avant-garde that included Alfred Jarry and André Salmon, and he met Picasso in 1903. Together with Salmon and Max Jacob, he formed the group known as the *bande à Picasso* (the Picasso gang). Having started to write art criticism in 1905, he steadily campaigned for advanced painting, publishing *The Cubist Painters* in 1913, the same year in which he published the major collection of his poems *Alcools*. At the outbreak of World War I, Apollinaire enlisted in the French Army and was sent to the front in early 1915. From there, he mailed a stream of postcards to his friends containing his notes and *calligrammes*, the typographically experimental poems he published in 1918.

Hit by shrapnel in the trenches in early 1916, Apollinaire was trepanned and returned to Paris. In 1917, he delivered the lecture "L'esprit nouveau et les poètes," and in 1918 he staged the play *Les Mamelles de Tirésias*, both of them anticipating the aesthetics of Surrealism. Weakened by his wounds, he succumbed to an influenza epidemic that swept Paris in November 1918.

been the shading that brings forms into illusionistic relief, and that shading was a matter of the gray- or tonal-scale alone, Kahnweiler saw the logic of banishing color from the Cubist "analysis" and of solving the problem in part by using the shading tool against its own grain: creating the lowest possible relief so that depicted volume would be far more reconcilable with the flat surface. Further, he explained the logic of piercing the envelopes of closed volumes in order to override the gaps opened up between the edges of objects and thus to be able to declare the unbroken continuity of the canvas plane. If he ended by declaring that "this new language has given painting an unprecedented freedom," this was not as an argument about conceptual mastery over the world's empirical data—as in Apollinaire's notion of Cubism keeping up with

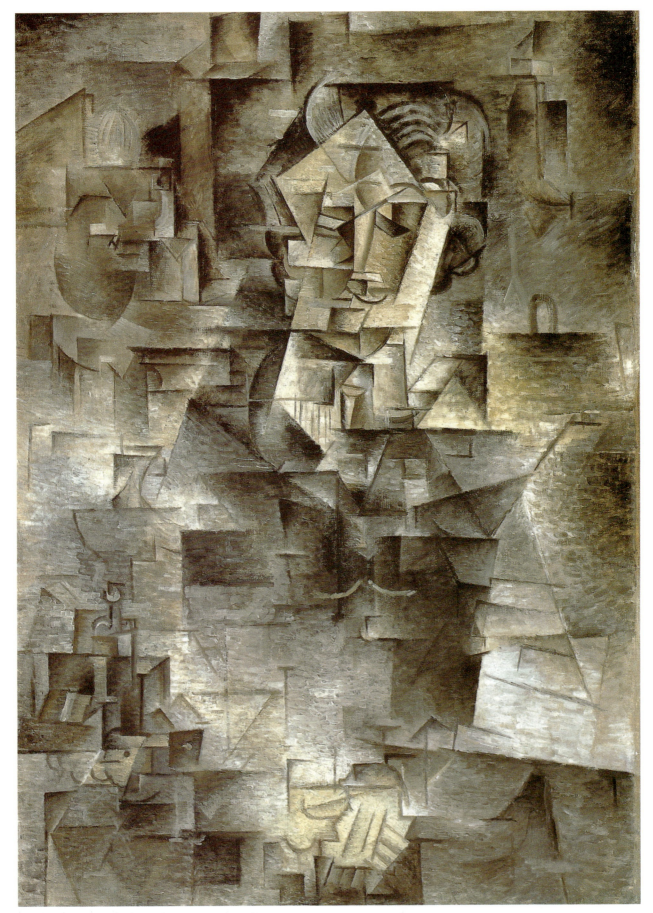

1 • Pablo Picasso, *Daniel-Henry Kahnweiler,* **Fall–Winter 1910**
Oil on canvas, 100.6 × 72.8 (39½ × 28⅝)

modern science—but one of securing the autonomy and internal logic of the picture object.

This explanation, dismissing extra-pictorial motivations for Cubism, accorded with the understanding of those who used the ▲ new style, as Piet Mondrian would, as the basis for developing a purely abstract art. Not that Mondrian was disengaged from the world of modernity, such as developments in science and industry, but he believed that for a painter to be modern he needed first and foremost to understand the logic of his own domain and to make this understanding evident in his work. Such a theory would later emerge as the doctrine of "modernism" (as opposed to modernity) • that the American critic Clement Greenberg would enunciate in the early sixties by arguing that modernist painting had adopted the approach of scientific rationalism and of Enlightenment logic by limiting its practice to the area of "its own competence" and thus—exhibiting "what was unique and irreducible in each particular art"—to demonstrating the laws of painting rather than those of nature.

It is not surprising, then, that Greenberg's discussion of how Cubism developed would reinforce Kahnweiler's. Tracing an unbroken progression toward the compression of pictorial space, beginning with *Les Demoiselles d'Avignon* and ending with ■ the 1912 invention of collage, Greenberg saw Analytical Cubism as the increasing fusion of two types of flatness: the "depicted flatness" by which the tilted planes shoved the fragmented objects closer and closer to the surface; and the "literal flatness" of that surface itself. If by 1911 in a picture such as Braque's *The Portuguese* [2], Greenberg said, these two types of flatness threatened to have become indistinguishable, so that the grid would seem to be articulating only one surface and one flatness, the Cubists responded by adding illusionistic devices, only now ones that would "undeceive the eye," rather than, as in traditional practice, continuing to fool it. Such devices consisted of things like a depicted "nail" seeming to pierce the top of a canvas so as fictively to cast its shadow onto the surface "beneath" it; or they are to be found in the stenciled lettering of *The Portuguese*, which, by demonstrably sitting on top of the canvas surface (the result of the letters' semimechanical application), pushes the little patches of shading and the barely tilted geometric shapes back into the field of depicted relief just "below" that surface.

A mountain to climb

In pointing to the fact that Braque adopted these devices earlier than Picasso—not only the stenciled lettering and the nails illusionistically tacking the whole canvas to the studio wall but also the wood-graining patterns employed by house painters—Greenberg set up an internal competition between the two artists, thereby rupturing their "*cordée,*" or self-proclaimed posture of having been roped together like mountaineers as they explored their new pictorial terrain (their collaboration was so shared that they often did not sign their own paintings). This vision of a race toward flatness was further enhanced by the question of which of the two first

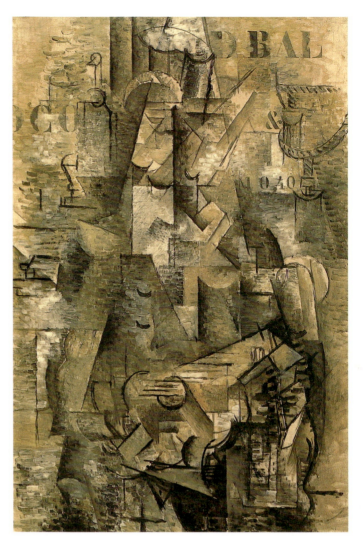

2 • Georges Braque, *The Portuguese (The Emigrant)*, Fall 1911–early 1912
Oil on canvas, 114.6 × 81.6 (45⅛ × 32⅛)

internalized the lessons of late Cézanne by adopting the practice of visual slippage between adjacent elements (called *passage*, in French) that was an early version of the Cubist piercing of the spatial envelopes of objects.

Yet as our eyes become increasingly accustomed to this group of paintings, we realize that the works of the two men are consistently differentiated by the greater concern for transparency in Braque's and the denser, more tactile quality of Picasso's—something underscored by the latter's interest in exploring the possibilities of Cubism for sculpture. This compressed sense of density, this ▲ interest in the experience of touch, made art historian Leo Steinberg protest against the merging of the two artists' concerns and thus the blurring of our vision of individual pictures.

Indeed, Picasso's overwhelming concern with a vestigial kind of depth—manifested most dramatically in the landscapes he painted in Spain at Horta de Ebro in 1909 [3]—makes the whole schema of Cubism's development by a progressive flattening of pictorial space seem peculiarly incomplete. For in these works, where we seem to be looking upward—houses ascending a hill toward the top of a mountain, for example, their splayed-apart roof and wall planes

▲ 1913, 1917a, 1944a ● 1942a, 1960b ■ 1907, 1912 ▲ 1907, 1960b

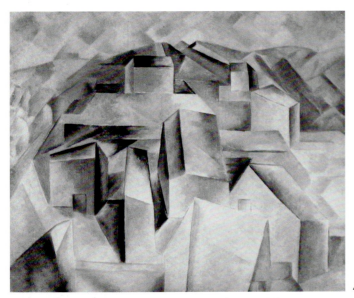

3 • Pablo Picasso, *Houses on the Hill, Horta de Ebro*, Summer 1909
Oil on canvas, 65 × 81.5 (25⅝ × 31⅞)

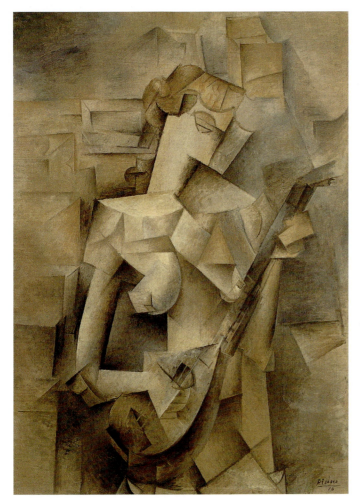

4 • Pablo Picasso, *Girl with a Mandolin (Fanny Tellier)*, Spring 1910
Oil on canvas, 100.3 × 73.6 (39½ × 29)

allying them with the frontal picture surface—and yet, in total contradiction, to be precipitously plunging downward through the full-blown spatial chasm opened between the houses, it is not flatness that is at issue but quite another matter. This could be called the rupture between visual and tactile experience, something that had obsessed nineteenth-century psychology with the problem of how the separate pieces of sensory information could be unified into a single perceptual manifold.

This problem enters the writing on Cubism as well, as when Gleizes and Metzinger say in *On Cubism* that "the convergence which perspective teaches us to represent cannot evoke the idea of depth," so that "to establish pictorial space, we must have recourse to tactile and motor sensations." However, the idea of a simultaneous spatial composite, the solution they thought Cubism had reached, was very far from Picasso's results at Horta, where, as Gertrude Stein insisted, the style was born. For the Horta paintings tear the composite apart. They make depth something tactile, a matter of bodily sensation, a vertiginous plunge down through the center of the work. And they make vision something veil-like (and thus strangely compressed to the flatness of a screen): the array of shapes hung always parallel to our plane of vision to form that shimmering, curtainlike veil that James Joyce called the "diaphane."

Thus, if for his part Picasso *was* interested in late Cézanne, his focus was on something different from Braque's interest in the reconciliatory effect of *passage*. It was, instead, on the effect of divisiveness to be found in Cézanne's late paintings, as when in many still lifes the objects on the table hang decorously in visual space but, as the floor on which that table sits approaches the position of the painter / viewer, the boards seem to give way beneath our feet. In doing so, the works dramatize the separation of sensory channels of experience—visual versus tactile—thereby bringing the painter up against the problem of visual skepticism, namely that the only tool at his or her command is vision, but that depth is something vision can never directly *see*. The poet and critic Maurice Raynal had touched on this skepticism in 1912 when he referred to "Berkeley's idealism" and spoke of the "inadequacy" and "error" of painting dependent on vision. As we have seen, the consistent position of such a critic was to substitute "conception" for vision, and thus "to fill in a gap in our seeing." Picasso, however, seemed not to be interested in filling in this gap, but instead, in exacerbating it, like a sore that will not heal.

Unlike Braque's attention to still life, Picasso therefore returned again and again to the subject of portraiture. There he pursued the logic of the way his sitters—his lovers and closest friends—were fated to vanish from his tactile connection to them behind the visual veil of the "diaphane" with its frontalized shapes; but at the same time he expressed his dismay at this fact by the display of gratuitously "helpless" pockets of shading, a velvety voluptuousness increasingly detached from the volumes they would formerly have described. This is to be found behind the right arm and breast of Fanny Tellier (the sitter for *Girl with a Mandolin* [4]) or in the area around Kahnweiler's chin and ear.

▲ 1907

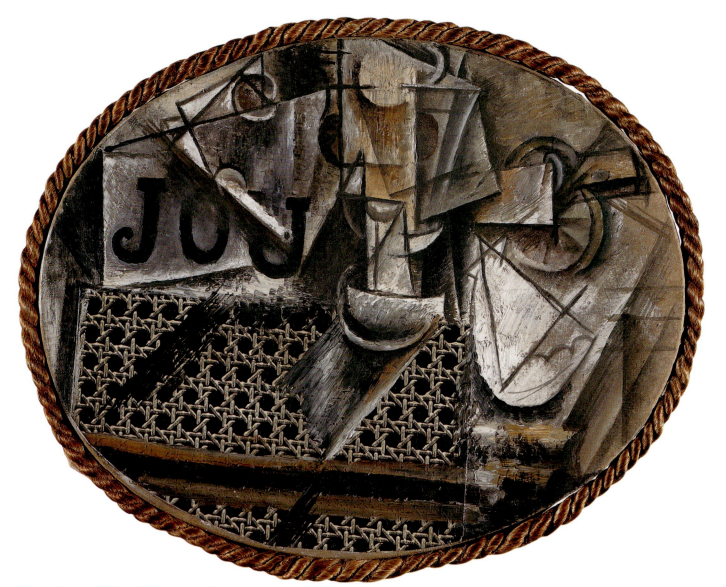

5 • Pablo Picasso, *Still Life with Chair Caning*, 1912
Oil and pasted oilcloth on canvas, surrounded with rope, 27 × 34.9 (10⅝ × 13¾)

And nowhere is this disjunction between the visual and the tactile as absolute *and* as economically stated than in the *Still Life with Chair Caning* [5] that Picasso painted in the spring of 1912, near the very end of Analytical Cubism. Affixing a length of rope around the edge of an oval canvas, Picasso creates a little still life that appears both to be set within the carved frame of a normal painting, and thus arranged in relation to the vertical field of our plane of vision, and to be laid out on the surface of an oval table, the carved edge of which is presented by the same rope and the covering for which is given literally by a glued-on section of printed oilcloth. Like the downward plunge at Horta, the table-top view is presented as one alternative here, a horizontal in direct opposition to the "diaphane's" vertical, a bodily perspective declaring the tactile as separate from the visual.

Braque's commitment to transparency declares his fidelity to the visuality of the visual arts, his obedience to the tradition of painting-as-diaphane. His *Homage to J. S. Bach* (1911–12) places a violin (signaled by the telltale "f"-holes and the scroll of its neck)

on a table behind a music-stand holding the score titled "J. S. BACH" (a slant rhyme on Braque's name). Because of the patchy shading, each object reads clearly behind the other and the still life falls before our eyes like a lacy curtain. RK

FURTHER READING
Yve-Alain Bois, "The Semiology of Cubism," in Lynn Zelevansky (ed.), *Picasso and Braque: A Symposium* (New York: Museum of Modern Art, 1992)
Clement Greenberg, "The Pasted-Paper Revolution," *The Collected Essays and Criticism, Vol. 4: Modernism with a Vengeance, 1957–1969*, ed. John O'Brian (Chicago: University of Chicago Press, 1993)
Daniel-Henry Kahnweiler, *The Rise of Cubism*, trans. Henry Aronson (New York: Wittenborn, Schultz, 1949)
Rosalind Krauss, "The Motivation of the Sign," in Lynn Zelevansky (ed.), *Picasso and Braque: A Symposium* (New York: Museum of Modern Art, 1992)
Christine Poggi, *In Defiance of Painting* (New Haven and London: Yale University Press, 1992)
Robert Rosenblum, *Cubism and Twentieth-Century Art* (New York: Harry N. Abrams, 1960, revised 1977)
William Rubin, "Cézannisme and the Beginnings of Cubism," in William Rubin (ed.), *Cézanne: The Late Work* (New York: Museum of Modern Art, 1977)
Leo Steinberg, "Resisting Cézanne: Picasso's *Three Women*," *Art in America*, vol. 66, no. 6, November–December 1978

1912

Cubist collage is invented amid a set of conflicting circumstances and events: the continuing inspiration of Symbolist poetry, the rise of popular culture, and Socialist protests against the war in the Balkans.

If modernism consistently allied itself with "the shock of the new," the form this took in poetry was expressed by Guillaume Apollinaire in the summer of 1912 as he abruptly changed the title of his forthcoming book of poems from the Symbolist-sounding *Eau de vie* to the more popularly jazzy *Alcools* and hastily wrote a new work to add to the collection. This poem, "Zone," registered the jolt that modernity had delivered to Apollinaire by celebrating the linguistic pleasures of billboards and street signs.

Apollinaire's announcement came at the very moment when a former literary avant-garde was transforming itself into the establishment through the newly formed magazine *La Nouvelle Revue Française* (*N. R. F.*) and its championing of writers such as André Gide, Paul Valéry, and most importantly—with Albert Thibaudet's scholarly study now devoted to him—Stéphane Mallarmé. But what Apollinaire was signaling was that the barricade that Symbolism—and Mallarmé in particular—had tried to erect between newspaper journalism and poetry had now broken open. One had only to look at "Zone" to see this. "The handbills, catalogs, posters that sing out loud and clear," it proclaims, "that's the morning's poetry, and for prose there are the newspapers … tabloids lurid with police reports."

Newspapers, which "Zone" celebrated as a source for literature, proved the turning-point for Cubism as well, particularly Picasso's, as, in the fall of 1912, he transformed Analytical Cubism into the new medium of collage. If collage literally means "gluing," Picasso had, of course, already begun this process earlier in the year with his *Still Life with Chair Caning*, an Analytical Cubist painting onto which he had glued a swathe of mechanically printed oilcloth. But the mere attachment of foreign matter to an unchanged pictorial conception—as in the case of the Futurist painter Gino Severini, who, in 1912, fixed real sequins onto his frenetic depictions of dancers—was quite distinct from the path Cubism was to follow once Braque introduced [1], and Picasso took up, the integration of relatively large-scale paper shapes onto the surfaces of Cubist drawings.

With this development—called *papier collé*—the entire vocabulary of Cubism suddenly changed. Gone were the little canted planes with fractured patches of modeling, sometimes attached at their corners, sometimes floating freely or gravitating toward a section of the picture's gridded surface. In their place now were papers of various shapes and descriptions: wallpapers, newspapers, bottle labels, musical scores, even bits of the artist's old, discarded drawings. Overlaying each other the way papers would on a desk or work table, these sheets align themselves with the frontality of the supporting surface; and beyond signaling the surface's frontal condition, they also declare it to be paper-thin, only as deep as the distance from the topmost sheet to the ones below it.

Visually, however, the operations of *papier collé* work against this simple literalism, as when, for instance, several papers combine to force the background sheet to read as the frontmost element by defining it—against the grain of its material position—as the surface of the leading object on the still life's table, a wine bottle, perhaps, or a musical instrument [2]. The visual play of such a "figure–ground reversal" had also been a staple of much of Analytical Cubism. But collage now went beyond this into the declaration of a rupture with what could be called—using the semiological term for it—the "iconic" itself.

Visual representation had always presumed that its domain was the "iconic," in the sense of the image's possessing some level of resemblance to the thing it portrayed. A matter of "looking like," resemblance could survive many levels of stylization and remain intact as a coherent system of representation: that square attached to that inverted triangle joined to those zigzag shapes producing, say, the visual identities of head, torso, and legs. What seemed to have nothing to do with the iconic was the domain the semiologists call "symbolic," by which they mean the wholly arbitrary signs (because in no way resembling the referent) that make up, for example, language: the words *dog* and *cat* bearing no visible or audible connection to the meanings they represent or to the objects to which those meanings refer.

Swept away

It was by adopting just this arbitrary form of the "symbolic" that Picasso's collage declared its break with a whole system of representation based on "looking like." The clearest example brings this about by deploying two newspaper shapes in such a way as to declare that they were cut, jigsaw-puzzle fashion, from a single

original sheet [**2**]. One of these fragments sits within a passage of charcoal drawing to establish the solid face of a violin, the paper's lines of type functioning as a stand-in for the grained wood of the instrument. The other, however, gravitating to the upper right of the collage, declares itself not the continuation of its "twin" but, instead, the contradictory opposite, since *this* fragment's lines of type now appear to assume the kind of broken or scumbled color through which painters have traditionally indicated light-filled atmosphere, thereby organizing the newsprint piece as a sign for "background" in relation to the violin's "figure."

▲ Using what semiologists would call a "paradigm"—a binary opposition through which each half of the pair gains its meaning by *not* signifying the other—the collage's manipulation of this pair declares that what any element in the work will mean will be entirely a function of a set of negative contrasts rather than the positive identification of "looking like." For even if the two elements are literally cut from the same cloth, the oppositional system into which they are now bound contrasts the meaning of one—opaque, frontal, objective—with that of the other—transparent, luminous, amorphous. Picasso's collage thus makes the elements of the work function according to the structural-linguistic definition of the sign itself as "relative, oppositive, and negative." In doing so, collage seems not only to have taken on the visually arbitrary condition of

1 • Georges Braque, *Fruit Dish and Glass*, 1912
Charcoal and pasted paper, 62 × 44.5 (24⅜ × 17½)

2 • Pablo Picasso, *Violin*, 1912
Pasted paper and charcoal, 62 × 47 (24⅜ × 18½)

▲ linguistic signs but also to be participating in (or, according to the Russian-born linguist Roman Jakobson, even initiating) a revolution in Western representation that goes beyond the visual to extend to the literary, and past that into the political economy.

Off the gold standard

For if the meaning of the arbitrary sign is established by convention rather than what might seem the natural truth of "looking like," it can, in turn, be likened to the token money of modern banking systems, the value of which is a function of law rather than a coin's "real" worth as a given measure of gold or silver or a note's redeemable relation to precious metal. Literary scholars have thus set up a parallel between naturalism as an aesthetic condition and the gold standard as an economic system in which monetary signs, like literary ones, were understood to be transparent to the reality that underwrote them.

If the point of this parallel is to prepare the literary critic for the modernist departure from the gold standard and its adoption of "token" signs—arbitrary in themselves and thus convertible to any value set by a signifying matrix or set of laws—no one effected this break with linguistic naturalism as radically or as early as did Stéphane Mallarmé, within whose poetry and prose the linguistic

▲ Introduction 3

▲ Introduction 3, 1915

sign was treated as wildly "polysemic," or productive of multiple—and often opposed—meanings.

Just to stay with the term *gold*, Mallarmé used it not only to explore the phenomenon of the metal and its related concepts of richness or luminosity but also to take advantage of the fact that the word in French for gold ("*or*") is identical to the conjunction translated as "now"; it is thus productive of the kind of temporal or logical deflection of the flow of language that the poet went on to exploit, not just at the level of meaning (that is, the signified) but also at that of the material support for the sign (the signifier). Thus in the poem titled "Or" this element appears everywhere, both freestanding and embedded within larger signs, a signifier that sometimes folds over onto its signified—"*trésOR*"—but more often one that does not—"*dehOR*," "*fantasmagORique*," "*hORizon*," "*majORe*," "*hORs*"—seeming thereby to demonstrate that it is the very uncontrollability of the physical spread of *or* that makes it a signifier truly cut free of the gold standard of even its most shifting signified.

There is of course a paradox in using this example within the larger account of modernity—including that of Picasso's collage—as something established by the arbitrariness of the token-money economy. For Mallarmé deploys the very marker of what token-money set out to replace, namely (outmoded) gold, to celebrate the freely circulating meaning of the new system. Yet the value he continues to accord to gold is not that of the old naturalism but rather that of the sensuous material of poetic language in which nothing is transparent to meaning without passing through the carnality of the signifier's flesh, its visual outline, its music: /gold/ = sound; *or* = son*or*e. This was the poetic gold that Mallarmé explicitly contrasted with what he called the *numéraire*, or empty cash value, of newspaper journalism in which, in his eyes, language had reached its zero point of being a mere instrument of reporting.

Prospecting on the fringes

The interpretation of Picasso's collage is, within art-historical scholarship, a battleground in which various parts of the foregoing discussion are pitted against one another. For on the one hand there is the bond between Picasso and Apollinaire, the painter's great friend and most active apologist, which would support the model of Picasso's having a "make it new" (or, as Apollinaire called it, an *esprit nouveau*) attitude toward journalism and the newspaper—almost, as it were, throwing "the morning's poetry" in Mallarmé's face. Emphasizing Apollinaire's exultation in what was modern, both in the sense of what was most ephemeral and what was most at odds with traditional forms of experience, this position would ally Picasso's use of newsprint and other cheap papers with a willful attack on the fine-arts medium of oil painting and its drive for both permanence and compositional unity. The highly unstable condition of newsprint condemns collage from the outset to the transitory; while the procedures for laying out, pinning, and gluing *papiers collés* resemble commercial design strategies more than they do the protocols of the fine arts.

3 • Pablo Picasso, *Table with Bottle, Wine Glass, and Newspaper*, Fall–Winter 1912
Pasted paper, charcoal, and gouache, 62 × 48 (24⅜ × 18⅞)

This position would also see Picasso, like Apollinaire, as being caught up in a drive to find aesthetic experience at the margins of what was socially regulated, since it was only from that place that the advanced artist could construct an image of freedom. As the art historian Thomas Crow has argued, this drive has consistently led the avant-garde toward "low" forms of entertainment and unregimented spaces (for Henri de Toulouse-Lautrec [1864–1901] this had been the twilight-zone nightclub; for Picasso, it was the working man's café), even though, ironically, such prospecting has always ended by opening up such spaces for further socialization and commodification by the very forces the advanced artist sought to escape.

If these arguments posit Picasso's embrace of both the "low" and the "modern" values of the newspaper, there are also those commentators who picture his reasons for exploiting this material as primarily political. Picasso, they say, cut the columns of newsprint so that we can read the articles he selected, many of which in the fall of 1912 reported on the war then raging in the Balkans. This is true, of course, at the level of the headlines—an early collage [3] presents us with "*Un Coup de Thé*[*âtre*], *La Bulgarie*, *La Serbie*, *Le Monténégra sign*[*ent*]" ("A Turn of Events, Bulgaria, Serbia, Montenegro Sign")—but also in the small type where battlefield reports are grouped around a café table that faces accounts of a social antiwar rally in Paris [4]. In giving what she sees as Picasso's reasons for this,

4 • Pablo Picasso, *Glass and Bottle of Suze*, **1912**
Pasted paper, gouache, and charcoal, 65.4 × 50.2 (25¾ × 19¾)

5 • Pablo Picasso, *Bottle of Vieux Marc, Glass, and Newspaper*, 1913
Charcoal and pasted and pinned paper, 63 × 49 (24¾ × 19¼)

Picasso's politics during this period are themselves open to dispute), but we have lost Picasso as the artistic innovator at the level of importance to the whole history of representation with whom we were engaging at the outset.

This is where the claims of Mallarmé begin to challenge those of Apollinaire, even the Apollinaire who seemed to respond to Picasso's collage by inventing his own fusion of the verbal and the visual in the *calligrammes* he began to fashion in 1914. For constellating written signs into graphic images, the *calligrammes* become doubly "iconic": the letters forming the graphic shape of a pocket watch, for example, merely reinforce at the level of the visual what they express in textual form: "It's five to noon, at last!" And if they thereby take on the graphic excitement of advertisements or product logos, the *calligrammes* nonetheless betray what is most radical in Picasso's challenge to representation: his refusal of the unambiguous "icon" in favor of the endlessly mutational play of the "symbol."

Like Mallarmé's mutational play, where nothing is ever just one thing—as when signifiers divide, doubling "*son or*" (his or her gold) with "*son or*" (the sound "or" and by implication the *sonor*ity of poetry)—Picasso's signs mutate visually by folding over onto one another to produce the oppositional pair of the paradigm. As in the earlier *Violin*, this is apparent in the *Bottle of Vieux Marc, Glass, and Newspaper* [5], where a toquelike shape, cut from a sheet of wallpaper, reads as *transparency* by articulating both the lip of the wine glass and its liquid contents, while below, the upside-down silhouette left by the "toque's" excision from the sheet registers the *opacity* of the stem and base of the object, declaring itself a figure (no matter how ghostly) against the wallpaper's tablecloth ground. The paradigm is perfectly expressed, as the signifiers—identical in shape—produce each other's meaning, their opposition in space (right side up / upside down) echoing their semantic reversal.

If the play of visual meaning in the collages is thus mutational, the textual play mobilized by Picasso's use of newsprint is also cut free from the fixity of any one "speaker" to whose voice, or opinion, or ideological position we might attribute it. For no sooner do we decide that Picasso has cut an item from the financial pages to denounce the exploitation of the worker, and thereby to "speak" through the means of this clipping, than we have to remember that Apollinaire, from his perch as writer for a half-fraudulent financial magazine, was famous for handing out spurious advice about the stock market and that the voice the collage plants here could just as easily be "his." Picasso had, indeed, let Mallarmé himself speak from the surfaces of various of these collages, as when "*Au Bon Marché*" doubles a voice like Fernande Olivier's (Picasso's ex-mistress)—speaking of white sales and a trousseau—with the various voices that Mallarmé used as pen-names in his elegant fashion magazine *La Dernière Mode*, or when the headline *Un coup de thé* sounds the title of Mallarmé's most radical poem: "Un coup de dés."

Much has been made of Picasso's recourse to the models of ▲ distortion and simplification offered by African tribal art.

▲ 1907

art historian Patricia Leighten has argued, variously, that he is bringing the reader / viewer into contact with a politically charged reality in the Balkans; or that he is presenting the reader / viewer with the kind of heated discussion that would be going on in a Parisian café where workers, unable to afford a newspaper subscription, would go for their daily news; or again, that Picasso is taking apart the managed cacophony of the newspaper—with its interests in serving up news as so many disjointed entertainments—and is using collage as a means of "counterdiscourse" that will have the power to rearrange the separate stories into a coherent account of capital's manipulation of the social field.

With these propositions we have come progressively further away from the idea of collage as performing a rupture with an older naturalistic, "iconic" system of representation. For whether we imagine Picasso deploying newspaper reports to picture a faraway reality, or using them to depict people conversing in a café, or making them into a coherent ideological picture where previously there had been nothing but confusion, we still think of visual signs as connecting directly to the things in the world they are supposed to be depicting. Picasso's only innovation would be, then, to replace his disputants with speech-balloons for their arguments as he seats them with perfect representational decorum around a more or less conventionally drawn café table. We have, that is, an example of the politically committed artist (although

Kahnweiler insisted, however, that it was a particular mask in Picasso's collection that "opened these painters' eyes." This mask from the Ivory Coast tribe called Grebo is a collection of "paradigms."

Picasso's own venture into constructed sculpture shows the effect of the Grebo example. Made of sheet metal, string, and wire, ▲ his *Guitar* of 1912 [6] establishes the instrument's shape through a single plane of metal from which the sound-hole projects, much like the eyes of the Grebo mask. Each plane hovers against the relief-plane as figure against ground, a form of paradigm which the earlier *Violin* had so brilliantly explored. The earliest collage to reflect the lesson of the Grebo mask is *Guitar, Sheet Music, and Glass* [7], in which each collage piece reads as hovering against the flat sheet of the background, the black crescent of the guitar's lowest edge doubling as its shadow cast on the supporting table; its sound-hole seeming to project as a solid tube in front of the instrument's body. RK

FURTHER READING

Yve-Alain Bois, "Kahnweiler's Lesson", *Painting as Model* (Cambridge, Mass.: MIT Press, 1990)

Yve-Alain Bois, "The Semiology of Cubism," in Lynn Zelevansky (ed.), *Picasso and Braque: A Symposium* (New York: Museum of Modern Art, 1992)

Thomas Crow, "Modernism and Mass Culture," in Serge Guilbaut, Benjamin H. D. Buchloh, and David Solkin (eds), *Modernism and Modernity* (Halifax: The Press of the Nova Scotia College of Art and Design, 1983)

Rosalind Krauss, *The Picasso Papers* (New York: Farrar, Straus & Giroux, 1998)

Patricia Leighten, *Re-Ordering the Universe: Picasso and Anarchism, 1897–1914* (Princeton: Princeton University Press, 1989)

Robert Rosenblum, *Cubism and Twentieth-Century Art* (New York: Harry N. Abrams, 1960, revised 1977)

7 • Pablo Picasso, *Guitar, Sheet Music, and Glass*, **Fall 1912**
Pasted paper, gouache, and charcoal, 47.9 × 36.5 (18⅞ × 14¾)

6 • Construction mounted in Picasso's studio at 5 bis, rue Schoelcher, 1913
Includes cardboard maquette for *Guitar* (destroyed)

▲ Introduction 3

8 • Guillaume Apollinaire, "La Cravate et la montre," 1914
From *Calligrammes: Poèmes de la paix et de la guerre, 1913–16, Part I: Ondes*, 1925

1913

Robert Delaunay exhibits his "Windows" paintings in Berlin: the initial problems and paradigms of abstraction are elaborated across Europe.

"Cézanne broke the fruit dish," Robert Delaunay (1895–1941) once remarked, "and we should not glue it together again, as the Cubists do." This call for abstraction is clear enough, yet its actual development was complicated: centered on painting, abstraction was driven by diverse motivations, methods, and models. Some artists deepened the painterly aspect of Impressionism; others, the expressive dimension of ▲ Postimpressionism; still others, the linear design of Art Nouveau. The fragmented "fruit dish" of Cézanne and Picasso was influential to many painters on the verge of nonrepresentational art; the broad color fields of Matisse were inspirational to others; and the bold geometric forms of African sculpture also served as an important provocation, sometimes replaced or supplemented by folk art (and, in Russia, by religious icons). In 1912–13 such precedents and provocations converged to allow the recognition of abstraction as a value, even a necessity, in its own right. Since abstraction is primordial to the arts of several cultures, there is no question of a single origin or a first abstraction: in this sense, abstraction was found as much as it was invented. In a famous ● anecdote Wassily Kandinsky told how, when he returned one night to his studio in Murnau, Germany (he dated the event to 1910), he failed to recognize one of his paintings upside down in the dim light—only to discover the expressive potential of abstract forms through this experience.

If there was no one parent of abstraction, there were several midwives, in particular the Frenchman Delaunay, the Russian Sonia Terk (1885–1979; she married Delaunay in 1910), the Dutchman ■ Piet Mondrian, and the Russians Kandinsky and Kazimir Malevich (1878–1935). The last three are often given pride of place as the most committed, but other early abstractionists include the Czech František Kupka (1871–1957), the Frenchman Fernand Léger (1881–1955), the Russian Rayonists Mikhail Larionov (1881–1964) and Natalia Goncharova (1881–1962), the English Vorticist Wyndham Lewis, the Italian Futurists Giacomo Balla and Gino Severini, the German-Swiss Paul Klee (1879–1940), the Alsatian Hans ◆ Arp (1888–1966), the Swiss Sophie Taeuber (1889–1943; she married Arp in 1921), the American Synchromists Morgan Russell (1886–1953) and Stanton Macdonald-Wright (1890–1973), and still others like the American Arthur Dove (1880–1946), who called

his near-abstractions "extractions." This list makes two points obvious at once: abstraction was international, and many of its innovators were not formed in avant-garde Paris. Why would this ▲ be so? Although Matisse and Picasso opened the way to abstraction, they were too invested in the world of objects—or, more precisely, in the visual play of figures and signs that this world afforded—to enter into abstraction fully. On the other hand, Kandinsky, Malevich, Mondrian, Klee, and Kupka were formed in cultures (Russian, Dutch, German, Czech) whose metaphysical imperatives and/or iconoclastic impulses might have made abstraction less alien.

In this respect Russia was especially important as a crucible for abstraction. There were important collections of avant-garde painting (the Shchukin Collection alone boasted thirty-seven ● Matisses and forty Picassos), vigorous exhibitions of international art not only in St. Petersburg and Moscow but in provincial cities too, and a range of groups eager to assimilate the lessons of Symbolism, Fauvism, Futurism, and Cubism, as well as to elaborate on folk art, children's drawings, and medieval icons (an exhibition of restored icons was staged in Moscow in 1913). The latter interests were strong in Larionov, who was drawn to the popular woodcarvings known as *lubki*, and Goncharova, whose early paintings of peasant life also reflect the simple forms and strong outlines of peasant carvings, embroidery, and enamels. Larionov and Goncharova were very active in exhibition-making too ("Knave of Diamonds" in 1910 and "The Donkey's Tail" in 1912 were the ■ most important); and inspired by Cubist and Futurist works, they moved away from primitivist experiments toward a form of abstraction marked by fractured lines and luminous colors—a style that Larionov dubbed Rayonism for the manner in which the surface of the painting seems to be struck by multiple rays of light that cross, crystallize, and sometimes dissolve there. The structure of these paintings owes much to Cubism, but the dynamism is Futurist (as is the rhetoric that supported them), and this combination of Cubist faceting and Futurist movement resulted in paintings that are among the earliest abstractions anywhere. Only a few such works were made, however, before Larionov and Goncharova fled the war for Paris (where they were often commissioned to design sets and costumes for the Ballets Russes produced ◆ by Sergei Diaghilev).

▲ 1903, 1906 ● 1908 ■ 1908, 1915, 1917a, 1944a ◆ 1908, 1909, 1916a, 1918, 1922, 1925c ▲ 1906, 1910, 1911, 1912 ● 1910 ■ 1909, 1911 ◆ 1919

Even as abstraction moved away from a mimetic relation to the world, it did not necessarily embrace the "arbitrary" nature of the visual sign as explored in Cubist collage and construction. Abstract artists might have declined to depict worldly things, but they often aspired to evoke transcendental concepts—such as "feeling," "spirit," or "purity"—and in this way they replaced one type of grounding, one form of authority, with another. (In such influential texts as "Concerning the Spiritual in Art" [1911], Kandinsky called this new authority "internal necessity," and others came up with similar coinages.) Such insistence on transcendental truths betrays an anxiety that abstraction might be arbitrary in two additional senses. First, arbitrary in the sense of *decorative*: in a 1914 lecture in Cologne, Kandinsky cautioned that "ornamental" abstraction might impede rather than produce the requisite transcendental effect of art. And, second, arbitrary in the sense of *meaningless*: faced with the charge, actual or anticipated, that abstraction had no meaning at all, its proponents often overcompensated with tendentious claims of absolute meanings—transcendental for Kandinsky, revelatory for Malevich, utopian for Mondrian, and so on. When not defined in such grandiose terms, abstraction was often framed negatively—against art based in mimesis (which was regarded as academic) and against design intended as decoration (which was regarded as a low or applied form). But many exceptions qualify this rule. For example, how are we to categorize the grids of Sophie Taeuber [1], who sometimes based these works (which predate the first modular abstractions by Mondrian) on the quasi-spontaneous arrangements of collaged squares of Hans Arp? For his part, Arp called them "probably the first examples of 'concrete art,'" at once "pure and independent" and "elementary and spontaneous." Are they high art? Low? Transcendental in ambition? Decorative? Programmatic? Aleatory? These works complicated such hierarchical oppositions almost before they were in place.

1 • Sophie Taeuber, *Horizontal Vertical*, 1917
Watercolor, 23 × 15.5 (9 × 6⅛)

Definitions and debates

Standard definitions favor the idea of abstraction as idealization. The *Oxford English Dictionary* offers "separated from matter," "ideal," and "theoretical" for the adjective *abstract*, and "deduct," "remove," and "disengage" for the verb. Appropriate for some artists who evoked ideal states through disengagement from the world, these meanings did not suit others who privileged the opposite terms—the materiality of paint on canvas, or the worldliness of utilitarian designs. This tension between idealist and materialist imperatives runs throughout modernist abstraction, and it is not solved by related terms such as "nonobjective" or "pure." Abstraction approaches the nonobjective by definition; on the other hand, many artists sought "objectivity" above all—to make an art as "concrete" and as "real" as an object in the world. Indeed, Delaunay, Léger, Arp, Malevich, and Mondrian all declared abstraction the most *realist* of modes for this very reason. So, too, abstraction was often promoted as "pure," the final refinement of art for its own sake; on the other hand, purity was often associated with reduction to the constituent materials of a medium, the stuff of paint and canvas, which are difficult to see as pure. In the end, these tensions are integral to abstraction, which is best defined as a category that manages such contradictions—holds them in suspension, or puts them into dialectical play.

The materialist/idealist opposition governed discourses around abstraction as well. Some artists were guided by Platonic, Hegelian, or spiritualist philosophies. For instance, Malevich, Kandinsky, Mondrian, and Kupka were all influenced by Theosophy, which held (among other beliefs) that man evolved from physical to spiritual states in a series of stages that could be evoked by geometric forms; in *Evolution* (1911), Mondrian imaged the geometric sublimation of a female figure in this way. Perhaps paradoxically, some artists also looked to science to support the idealist version of abstraction. "Why should we continue to follow nature," Mondrian asked around 1919, "when many other fields have left nature behind?" In this regard non-Euclidean geometry interested artists as diverse as Malevich and Marcel Duchamp for its nonperspectival conception of space and its antimaterialist idea of form. In addition, analogies were made to other arts, especially music.

"All art," the English aesthetician Walter Pater famously remarked, "constantly aspires towards the condition of music"; so it was still for some artists in the first generation of abstractionists. (This points to a further paradox: can the essence of one art, painting, be found via another art, such as music?) Klee and Kupka were drawn to Baroque and classical music, Johann Sebastian Bach in particular;

▲ Kandinsky, to late-Romantic and modern music, especially Richard Wagner and Arnold Schoenberg. Indeed, Kandinsky patterned the categories of his early abstractions—"Improvisations," "Impressions," "Compositions"—on music, which also influenced his emphasis on color tone, linear rhythm, "thorough-bass" (a notion derived from Goethe), and immediacy to feeling. Kupka, too, stressed the Symbolist analogy between pure music and pure painting, with the attendant implication that such art could act directly "on the soul" without the distraction of content or subject matter; his large canvas *Amorpha, Fugue in Two Colors* [2] is often claimed as the first nonfigurative painting to be exhibited publicly in Paris, at the Salon d'Automne in 1912, though it was inspired in part by the mundane movements of a multicolored ball (a plaything of his stepdaughter), as well as by the celestial motions of the planets (which had also informed his previous *Disks of Newton* paintings).

● For his part, Mondrian adored jazz: he found its syncopated rhythm analogous to his asymmetrical equilibrium of color planes, and its resistance to melodic narratives parallel to his resistance to temporal readings of visual art.

Other abstract artists were driven by materialist concerns. Some looked to abstraction as the only mode adequate to the becoming-abstract of the object-world in a world transfigured by new modes of commodity production, public transportation, and image reproduction. The project to capture the increased mobility of products, people, and images in the modern city was not strictly

■ Futurist; it also provoked artists such as Léger to a paradoxical type of realist abstraction. In his *Contrast of Forms* [3], we see a symbiosis of human and mechanical forms abstracted as if to the geometric specifications of the canvas. Indeed, by the end of the decade Léger would conceive painting, in analogy with the machine, as a device of interrelated parts. Yet already in 1913 he referred the abstraction of his painting, as well as the separation of all modernist arts, to a capitalist division of labor—a modern condition that he sought to make a modernist virtue:

> *Each art is isolating itself and limiting itself to its own domain. Specialization is a modern characteristic, and pictorial art, like all other manifestations of human genius, must submit to its law; it is logical, for by limiting each discipline to its own purpose, it enables achievements to be intensified. In this way pictorial art gains in realism. The modern conception is not simply a passing abstraction, valid only for a few initiates; it is the total expression of a new generation whose needs it shares and whose aspirations it answers.*

◆ Cubism was the first style to perform this paradox of an art that appears both abstract and realist, and it remained the crucible for most abstract artists. Yet "Cubism did not accept the logical conse-

2 • František Kupka, *Amorpha, Fugue in Two Colors*, 1912
Oil on canvas, 211.8 × 220 (83⅜ × 86⅝)

3 • Fernand Léger, *Contrast of Forms*, 1913
Oil on canvas, 55 × 46 (21⅝ × 18)

4 • Piet Mondrian, *TABLEAU No. 2 / COMPOSITION No. VII*, 1913
Oil on canvas, 104.4 × 113.6 cm (41⅛ × 44¾")

quences of its own discoveries," Mondrian remarked in a retrospect shared by others, "it was not developing towards its own goals, the
▲ expression of pure plastics." Thus in 1912–13 some artists pushed the "analytical" aspect of Cubism to dissolve the motif altogether. They did so either in linear coordination with the implicit grid of the canvas, as with Mondrian in a work such as *Tableau No. 2/Composition VII* [**4**], or through prismatic effects of color seen as light, as with Delaunay in a work such as *Fenêtres simultanés sur la ville* (*Simultaneous Windows on the City*) [**5**]. If Mondrian explicated the grid in a way that exceeded the faceted planes of Cubism, Delaunay intensified color in a manner that was alien to its muted palette. Meanwhile, other artists pushed the "synthetic" aspect of Cubism: the flat shapes

▲ of Cubist collage were the immediate precedent for the abstract color planes of Malevich, while the factual elements of Cubist construction, which Picasso showed Vladimir Tatlin in Paris in the spring of
● 1914, were one provocation of his Constructivist "analysis of materials." Some kind of passage through Cubism became almost a prerequisite for followers: "From a [Cubist] analysis of the volume and space of objects to the [Constructivist] organization of elements," the Russian Liubov Popova (1889–1924) wrote in a 1922 studio note, as if this development were already a catechism.

In most instances one element of painting was made dominant, even turned into a medium of meaning in its own right: thus the privileging of verticals and horizontals in Mondrian, of color as

light in Delaunay, of monochrome geometries in Malevich. Soon these elements were refined further into two relatively stable ▲ paradigms of abstract painting: the grid and the monochrome. To a great extent they became fixed because the grid worked to undo the primordial oppositions of line and color, figure and ground, motif and frame (it was the genius of Mondrian to explore these possibilities), and the monochrome worked to negate the two dominant paradigms of Western painting since the Renaissance: the window and the mirror (it was the hubris of Malevich to announce the end of these old orders).

In 1913, as they advanced toward the grid and the monochrome respectively, Delaunay and Malevich provide an instructive contrast. Delaunay mostly scoffed at models extrinsic to painting: "I never speak of mathematics and never bother with spirit"; "I am horrified by music and noise." Concerned with "pictorial realities" alone, he looked to color to carry all aspects of painting: "color gives depth (not perspective, nonsequential but simultaneous) and form and movement." To this end, Delaunay developed "the law of simultaneous contrasts," which French artists from Delacroix to Seurat had adapted from an 1839 treatise by the chemist Michel-Eugène Chevreul, into his own notion of *simultanéisme*. Besides color contrasts, this "simultaneity" pertains to the immediacy of pictorial image to retinal image, indeed to the transcendental simultaneity of the visual arts as opposed to the mundane temporality of the verbal arts (this opposition is a persistent one in modern aesthetics from the German Enlightenment philosopher Gotthold Ephraim Lessing [1729–81] to the late-modernist critics

▲ Clement Greenberg and Michael Fried). In some of these interests Delaunay was joined by Morgan Russell and Stanton Macdonald-Wright, who were also active in Paris in these years. They too treated light in terms of prismatic color, though they allowed for effects of spatial projection and even temporal duration that Delaunay tended to resist; they also pursued musical analogies for abstraction that Delaunay tended to dismiss.

Delaunay made his breakthrough in his "Windows" series, some twenty-three paintings and drawings executed in 1912, thirteen of which were shown to great effect in Berlin in January 1913 (he had ● previously exhibited with the Blaue Reiter in Munich). To coincide with the show, Klee translated a text by Delaunay titled "Light" that presented a series of equations among color, light, eye, brain, and soul. In his aesthetic the painting is the "window" of all these "transparencies"—a medium abstracted into *im*mediacy, dissolved into what it mediates. In this way Delaunay hardly rejected the old paradigm of painting-as-window; on the contrary, he *purified* it: the reality of vision is delivered in the abstraction of painting. Consider *Simultaneous Windows on the City*, which set the compositional type for the series. The Eiffel Tower, the central motif of his entire oeuvre, is now vestigial, its green arcs caught up in a play of opaque and transparent color planes pushed beyond Cubist faceting toward a post-Cubist grid (which, in the neo-Impressionist fashion of Seurat, Delaunay extended to the frame). The windows are thus referential, pictorial, and objective all at once; they reconcile the "sublime subject" of Paris with the "self-evident structure" of painting, as the ■ poet-critic Guillaume Apollinaire, a great Delaunay supporter, once remarked. Delaunay rendered the medium opaque, only to make it disappear again in the interests of transparent immediacy. In effect, *Simultaneous Windows on the City* are windows without curtains, almost eyes without lids: color as light is nearly blinding here. The next step was to do away altogether with the windows in order to present the painting in direct analogy with the retina. This is what Delaunay did in *Disk* [6], the purest of abstractions at this time, a circular painting of seven concentric bands of solid colors divided into quarters, with the more intense primaries and complementaries closer to the center. Although sometimes dismissed as a mere demonstration of color theory—a color chart in fact—*Disk* contains resources for abstraction (utter nonreferentiality and opticality, structured canvas and composition) that would not be developed fully for another fifty years or more. The year 1913 was also a significant one for Sonia Terk Delaunay, who, already active in design (primarily books and embroidery), illustrated *The Prose of the Transsiberian and of the Little Jeanne of France* by the avant-garde poet Blaise Cendrars [7]. Published on a single sheet of paper two meters long folded into twelve panels, this object-book combined avant-garde abstraction and typography (the same text was set in ten typefaces, and a railroad map was included) in order to evoke the prismatic simultaneity of modern life. Often exhibited and reproduced, the book cover was widely influential (Terk may have affected German modernists almost as much as her husband did), and its success encouraged her to apply the same "simultaneist"

5 • Robert Delaunay, *Fenêtres simultanées sur la ville*, 1911–12
Oil on canvas and wood, 46 60 (18⅛ × 23⅝)

6 • Robert Delaunay, *Premier disque simultané* (Disk [The First Disk]), 1913–14
Oil on canvas, diameter 135 (52¾)

rhythms of abstract colors to other designs—clothes, posters, even electric lamps devised to diffuse light into color on Paris streets.

Malevich took a different course: not to purify painting-as-window but to paint it out. He referred his first total abstraction, ▲ *Black Square* (1915), to a sketch for a backdrop that he designed for a Futurist opera, *Victory over the Sun* (1913), an opera opposed to Symbolist art ("the old, accepted concept of the beautiful sun," its composer V. N. Matiushin once scoffed) as well as to naturalist theater. Here Malevich places, in a perspectival box, a square divided diagonally into a black triangle above and a white triangle

below in order to evoke the "victory over the sun," the eclipse of light by dark, perhaps the overcoming of empirical vision and perspectival space by transcendental vision and modernist infinity [**8**]. In this sketch the countdown to his own private *tabula rasa* begins: on the other side of this "zero of form," Malevich announced, lies "the supremacy of pure feeling in creative art"—hence his term for his abstract style, Suprematism.

Thus Delaunay and Malevich appear to be opposed: the first proclaims the transparency of the window to color as light; the second, the victory over the sun in the triumph of the black square. But both

▲ 1915

7 • Sonia Terk Delaunay, *La Prose du Transsiberian et de la Petite Jehanne de France* **(The Prose of the Transsiberian and of the Little Jeanne of France), 1913**
Watercolor on paper, 193.5 × 37 (76⅛ × 14⅝)

8 • Kazimir Malevich, sketch for *Victory over the Sun*, **Act 2, Scene I, 1913**
Graphite pencil on paper, 21 × 27 (8¼ × 10⅝)

render it transparent again—to feeling, spirit, or purity, all of which these abstractions are asked to signify at one time or another.

In the end abstraction is a paradoxical mode that suspends such oppositions—between spiritual effect and decorative design, between material surface and ideal window, between singular work and serial repetition (bereft of external referents, abstract paintings tend to be read internally, in terms of one another, in sets, and they are often designated in this manner too: "*Untitled # 1, 2, 3 …*"). The materialist / idealist contradiction might be the most profound of all: painting as a plane covered with paint, the medium disclosed in its empirical materiality, versus painting as a map of a transcendental order, a window to a world of spirit. For the French philosopher Michel Foucault, however, this relation is less contradictory than complementary: modern thought, he argues, often comprehends both kinds of investigations, empirical and transcendental, and both kinds of dispositions, materialist and idealist. Nonetheless, this tension is *experienced* as a contradiction not only in modernist art but also in modern culture at large, and it suggests one reason why this culture has privileged artists who, like Mondrian, are able to hold on to both poles at once, who offer aesthetic resolutions to this apparent contradiction. HF

FURTHER READING
Yve-Alain Bois, "Malevitch: le carré, le degré zero," *Macula,* no. 1, 1978
Arthur A. Cohen (ed.), *The New Art of Color: The Writings of Robert and Sonia Delaunay* (New York: Viking Press, 1978)
Michael Compton (ed.), *Towards a New Art: Essays on the Background of Abstract Art 1910–1920* (London: Tate Gallery, 1980)
Gordon Hughes, "The Structure of Vision in Robert Delaunay's 'Windows'," *October,* no. 102, Fall 2002
Rosalind Krauss, "Grids," *The Originality of the Avant-Garde and Other Modernist Myths* (Cambridge, Mass.: MIT Press, 1985)
Fernand Léger, *Functions of Painting,* trans. Alexandra Anderson (New York: Viking Press, 1973)
Kazimir Malevich, *Essays on Art 1915–1933,* ed. Troels Andersen (London: Rapp and Whiting, 1969)

are high priests of pure vision, and this renders them opposites that belong together. Even as Delaunay atomizes the motif in his color as light, while Malevich darkens it through his eclipse of the sun, both cancel one relation to reality only to affirm another, higher relation, and in this transformation they are joined by others such as Kandinsky and Mondrian for whom abstraction is the apotheosis of the real, not its downfall. They may render the medium opaque, self-evidently material as canvas and paint, but they do so in order to

▲ 1971

1914

Vladimir Tatlin develops his constructions and Marcel Duchamp proposes his readymades, the first as a transformation of Cubism, the second as a break with it; in doing so, they offer complementary critiques of the traditional mediums of art.

The years 1912–14 were momentous ones in the avant-garde. New forms of picture-making such as abstraction and collage broke with representational painting, and new forms of object-making such as the construction and the ready-made challenged figurative sculpture, as the old focus on the human body was displaced by new explorations of industrial materials and commercial products. These developments were internal to modernist art, but they were also influenced by external events, such as the increased industrialization and commodification of everyday life, which was far more advanced in the Paris of Marcel Duchamp (1887–1968) than in the Moscow and St. Petersburg of Vladimir Tatlin (1885–1953). At the same time, these new objects seemed almost to anticipate such worldly transformations. The first Tatlin constructions preceded the Russian Revolution in 1917, while the first Duchamp readymades predated the commodity culture of the twenties. "What happened from the social aspect in 1917," Tatlin wrote, "was realized in our work as pictorial artists in 1914, when 'materials, volume, and construction' were accepted as our foundations." Such materialist foundations were achieved in Constructivist art, Tatlin implies, *before* they were established in Communist society.

Yet the breaks marked by the construction and the readymade were not as punctual or as final as we often like to think. Art historians favor the dramatic convenience of the signal event: Duchamp, pressed by his own brothers to withdraw his Cubist painting *Nude Descending a Staircase No. 2* [1] from the Salon des Indépendants in the spring of 1912, abandons painting altogether; or Tatlin, on a visit to Paris in the spring of 1914, encounters the Cubist constructions of Picasso and proceeds directly to his own reliefs. These events did occur, but they were not simple causes; indeed, the readymade and the construction must be seen as complementary responses to two overdetermined developments. First, Duchamp and Tatlin were responding in different ways to a crisis in representation signaled by Cubism. Second, that crisis had revealed a truth about "bourgeois" art, both academic and avant-garde, to which the two artists were also responding—that it was presumed to be autonomous, separate from social life, an institution in its own right. "The category *art as institution* was not invented by the avant-garde movements," the German critic Peter

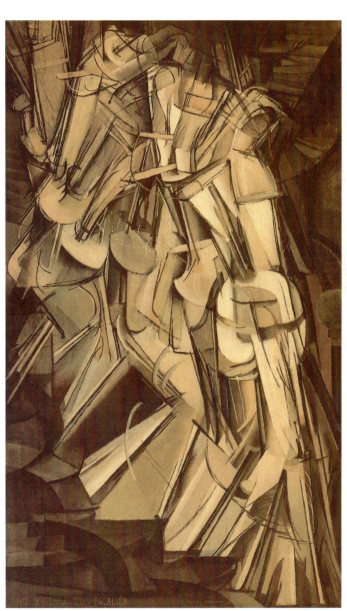

1 • Marcel Duchamp, *Nude Descending a Staircase No. 2*, 1912
Oil on canvas, 147 × 89.2 (57⅞ × 35⅛)

2 • Vladimir Tatlin, *Selection of Materials: Iron, Stucco, Glass, Asphalt,* **1914**
Dimensions unknown

▲ Bürger writes in *Theory of the Avant-Garde* (1974). "But it only became recognizable after the avant-garde movements had criticized the autonomy status of art in developed bourgeois society." Once valued as the sign of artistic freedom, according to Bürger, this autonomy had become the mark of its "social ineffectuality," and this in turn prompted "the self-critique of art" advanced paradigmatically by Duchamp and Tatlin.

The material dictates the form

Tatlin was born in the Ukrainian city of Khar'kov to a poet-mother and an engineer-father who was an expert on American railroads. Although active in the Cubo-Futurist avant-garde by 1907–8, Tatlin remained a sometime sailor (likely a ship's carpenter) until 1914–15. These facts are more than anecdotal: his work was oriented by the parental poles of poetics and engineering, and directed by his keen sense of crafted materials. His 1914 sojourn to Paris was epiphanic—

• he probably saw such Picasso constructions as *Guitar* (1912)

—although he was already acquainted with Cubism from the great
▲ Shchukin Collection in Moscow. This is evident from such early paintings as *The Sailor: A Self-Portrait* (1911–12), which shows some quasi-Cubist faceting. Yet his first monumental figures are pushed toward the picture plane in a way more suggestive of archaic Russian pictures than contemporary Cubist ones—not only the folkloric woodprints that were popular in his Cubo-Futurist milieu but also religious icons, whose muted palette of colors, flat application of paint, and sheer materiality appealed to Tatlin. Sculptor and critic Vladimir Markov suggested why as early as 1914: "Let us remember icons; they are embellished with metal halos, metal casings on the shoulders, fringes and incrustations; the painting itself is decorated with precious stones and metals, etc. All of this destroys our contemporary conception of painting." In this modernist rereading of the medieval icon, its very materiality disallows any illusion of the real world and instead conducts "the people to beauty, to religion, to God." In his constructions Tatlin reversed the thrust of this anti-illusionism in order to direct the viewer not to a transcendental realm of God but to an immanent reality of materials. In effect, he
• used the Russian icon as Picasso had used the African mask: as a "witness" to his own analytical development of modernist precedents, as a guide to an art no longer governed by resemblance.

His first known relief, *The Bottle* (1913, now lost), remains a Cubist still life, with different materials used to signify different objects (e.g., glass for bottle). Set within a frame, it is still more pictorial composition than material construction, though his basic repertoire of wood, metal, and glass is in place. In *Selection of Materials: Iron, Stucco, Glass, Asphalt* [2], Tatlin is already on the threshold of Constructivism. The frame remains, but the materials are no longer composed pictorially. An iron triangle projects into space, in contrast with a wooden rod set at an angle in the stucco surface; below and above are two further juxtapositions of curved metal and cut glass. *Selection* has the character of a demonstration: it first lists its materials, then allows intrinsic properties to suggest appropriate forms. "The material dictates the forms, and not the opposite," critic Nikolai Tarabukin wrote in a 1916 definition of Constructivism based on such works. "Wood, metal, glass, etc. impose different constructions." For Tatlin, machined wood was square and planar, and so suggested rectilinear forms; metal could be cut and bent, and so suggested curvilinear forms; glass was somewhere in between, with a transparency that might also mediate between interior and exterior surfaces. How different this materialism is from the ambiguity of Cubist constructions! Far from the "arbitrary," Tatlin sought to make his constructions "necessary" through this "truth to materials," an ur-modernist aesthetic that tended also to be an ethics and, after the Russian Revolution, a politics as well.

Yet this was not merely a positivistic reduction to materials, as would often be the case in postwar versions of the aesthetic. For along with Cubist constructions and Russian icons, a third model was in play here—the contemporaneous language experiments of
■ "transrational" poets such as Aleksei Kruchenikh and Velemir

Khlebnikov, whose play *Zangezi* Tatlin directed and designed in 1923. Khlebnikov not only shattered syntax but also broke language down into phonemes, the basic units of speech. He did ▲ so, however, not with a Futurist or Dadaist delight in destruction but in order to reassemble these pieces of sound and script into new "word-constructions" suggestive of new meanings. It was this constructive act that Tatlin affirmed: "Parallel to his word-constructions, I decided to make material constructions."

After 1914 Tatlin adopted the term "counter-relief," as if to signal a dialectical advance in his constructions: just as the first "painterly reliefs" exceeded painting, so the new "counter-reliefs," which extended from the wall, exceeded the painterly reliefs. Sometimes these counter-reliefs were suspended across corners with axial wires and rods [**3**]. These "corner counter-reliefs" were complex constructions of metal planes, squared and curved, perpendicular and angular. Not painting, sculpture, or architecture, they were "counters" to all three arts that activated materials, spaces, and viewers in new ways. First shown in December 1915 ● at "0.10: The Last Futurist Exhibition of Paintings" in Petrograd (once St. Petersburg, soon to be Leningrad), where Tatlin vied with Kazimir Malevich for leadership of the Russian avant-garde, the counter-reliefs drew young artists into the experimental ■ ("laboratory") phase of Constructivism. If the painterly reliefs advanced the Constructivist notion of *faktura*, which, in contradistinction to Western "facture," stressed the mechanical aspect of the painterly mark rather than its subjective side, the counter-reliefs advanced the Constructivist notion of *construction*, which, in opposition to Western "composition," stressed active engagement with art rather than contemplative reflection of it. Yet to be developed was the third notion of Constructivism, *tectonics*, the dialectical connection of Constructivist formal experimentation with Communist principles of socioeconomic organization, but this most difficult step in the Constructivist program had to await the Revolution.

Works of art without the artist

Son of a supportive notary-father, Duchamp had three siblings who were also artists. His two older brothers, Jacques Villon (1875–1963) and Raymond Duchamp-Villon (1876–1918), drew Marcel into the "Puteaux Group" of Cubists around Albert Gleizes and Jean Metzinger. This circle had begun to turn Cubism into a doctrine by 1912, and Duchamp withdrew over its rejection of his *Nude Descending a Staircase No. 2*. Stung by the controversy, Duchamp would never again be its victim; on the contrary, he became a master of the art of provocation—one of his more ambiguous legacies to twentieth-century art. The mysterious move from his Cubist paintings, which are mostly "nudes," "virgins," and "brides" tinctured with personal eroticism, to his readymades, which are mostly banal products distanced from subjectivity, remains a provocation in its own right. We have only a few pieces of this puzzle. In the summer of 1912 Duchamp lived in Munich,

3 • Vladimir Tatlin, *Corner Counter-Relief*, 1915
Iron, aluminum, primer, dimensions unknown

1910–1919

which he later called "the scene of my complete liberation"—perhaps from the strictly "retinal" concerns of the Parisian avant-garde ("retinal" was his term for painting that did not engage the "gray matter" of the mind). Earlier, in 1911, he had befriended ▲ the wealthy Francis Picabia (1879–1953), who had introduced him to the idea of the artist as dandyish "negator," an attitude that Duchamp would later adopt and develop. Also in 1911 he had attended a play by Raymond Roussel (1877–1933) based on his novel *Impressions of Africa* (1910). Extremely eccentric, Roussel made a method out of the arbitrary: he would select a phrase, construct a homophone of it (that is, a phrase similar in sound but not in sense), use one of the phrases to begin the story and the other to end it, and then concoct a narrative to connect the two. Writing here became a dysfunctional kind of machine. "Roussel showed me the way," Duchamp insisted, not only to the homophonic puns and ● dysfunctional machines of his "rotoreliefs," but more generally to his various stratagems that combined chance and choice, the arbitrary and the given. These stratagems, such as his mechanical drawings and readymade objects, put conventional notions of art and artist alike into radical doubt; they were "works of art without an artist to make them," he once remarked.

Two further anecdotes are telling in this regard. In 1911 Duchamp painted an "exploded" coffee grinder; in its "diagrammatic aspect," he commented later, "I began to think I could avoid all contact with traditional pictorial painting." Then, in 1912, at the Salon de la locomotion aérienne, he remarked to his friend, the ■ sculptor Constantin Brancusi: "Painting is over. Who'd do better than this propeller? Tell me, could you do that?" This was not an endorsement of machine art before the fact—again, the machines that interested Duchamp were dysfunctional figures of frustrated desire (like the ones that populate his *The Bride Stripped Bare by her* ◆ *Bachelors, Even*, also known as the *Large Glass*, 1915–23). But the question does point to the queries soon posed in his own work: What is the relation of utilitarian objects to aesthetic objects, of

The "Peau de l'Ours"

The readymade, perhaps more than other art form, exposes the complicated relationship between art and the market. On the one hand, endowing an object (even, as Duchamp showed, a mass-produced one such as a urinal) with aesthetic value, could inflate its price from lowly work to masterpiece. On the other, the buying and selling of these expensive works has the same structure as the marketing of any other luxury item, thus lowering the object (aesthetically speaking) to the level of any other commodity. Hence the avant-garde found itself trapped within a structural condition in which it was in an endless race with the very capital logic it wished to expose.

That the avant-garde would prove to be an excellent investment was the bet that businessman André Level made in 1904 when, with twelve other speculators, he founded the "Peau de l'Ours" [Skin of the Bear], a consortium to buy avant-garde works, hold them for ten years, and then sell them off at auction. By 1907, Level's group had already been buying Matisse and Picasso heavily, and in that year it acquired Picasso's *Family of Saltimbanques* directly from the artist for 1,000 francs (expending the whole of its budget for the year). When it came to the time for the sale, held at the Hôtel Drouot in Paris on March 2, 1914, their collection of 145 items, consisting primarily of Fauvist and Cubist works, went under the hammer. Level advertised the event heavily, drawing large crowds to the presale exhibition and the auction itself, making it a kind of verdict on avant-garde art. In the event, the *Family of Saltimbanques*—the success of the evening—was sold for 12,650 francs, while the whole collection had increased its price fourfold, the initial investment of 27,500 francs now returning an impressive total of 116,545 francs.

commodities to art? Can a picture be made as anonymous, as non-subjective, as "perfect" as a propeller? From this point on he did prefer objects that were given, not made, and images that were scripted, not invented (not "retinal" at all), such as his two *Chocolate Grinders* diagrammed in projection in 1913 and 1914. Sly allusions to sex and scatology, these grinders of colored substances also parodied painting, reduced it to the status of an industrial diagram—which, as art historian Molly Nesbit has shown, informed the teaching of drawing in French schools when Duchamp was a child.

He chose it

Duchamp used chance to decenter authorship, but his quintessential device in this respect was the readymade, an appropriated product positioned as art. This device allowed him to leap past old aesthetic questions of craft, medium, and taste ("is it good or bad painting or sculpture?") to new questions that were potentially ontological ("what is art?"), epistemological ("how do we know it?"), and institutional ("who determines it?"). Two of his notes are

especially important here. The first, written in 1913, is a programmatic question: "Can one make works that are not 'works' of art?" The second, from 1914, is an obscure fragment: "A kind of pictorial Nominalism." Both notes suggest that Duchamp had begun to construe *naming* art—that is, nominating a given image or object as art—as tantamount to *making* art. Although the term was not yet in place, the first "readymade" was a bicycle wheel set upside down on a stool [**4**]. He would find the name for his new technique, precisely readymade, only when he moved to New York in 1915 for the war, as a label for clothing bought off the rack, potentially mass produced and consumed. How are we to read this wheel? As "art" at all? Indeed, as a "work" at all (for it involved almost no labor of his own)? Or is this wheel that spins freely nothing but work, nothing but function? *Bottlerack* (1914) pushed the question of use further. Although it might suggest an abstract sculpture, this bottle-dryer remains both a utilitarian object and a simple commodity, and so compels us to consider the complex relationships between aesthetic ▲ value, use-value, and exchange-value.

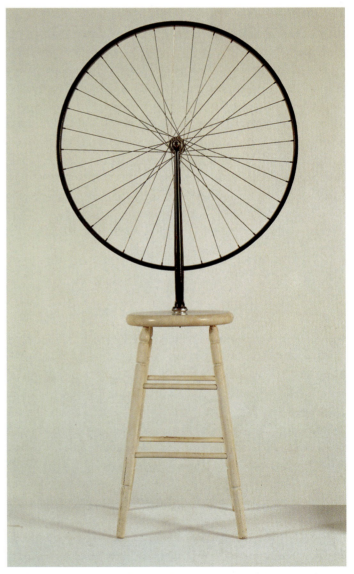

4 • Marcel Duchamp, *Bicycle Wheel*, 1913 (1964 replica, original lost)
Readymade: bicycle wheel fixed to a stool, height 126 (49⅝)

▲ 1986

The most notorious readymade was a urinal named *Fountain* [5], which compounded the provocative questions of the other ready-mades with a scandalous evocation of the bathroom. Duchamp chose the urinal from a New York showroom of J. L. Mott Iron Works, a manufacturer of such fixtures, rotated it ninety degrees, signed it R. Mutt ("R" for Richard, slang for a rich man, and "Mutt" to refer both to Mott and to Mutt, a popular cartoon character of the time), set it on a pedestal, and submitted it to the American Society of Independent Artists for its first exhibition in April 1917. Duchamp was the chair of the hanging committee, but the show was unjuried, that is, it accepted all 2,125 works by 1,235 artists that were offered … except for *Fountain* by the unknown R. Mutt. It was rejected on grounds that Duchamp rebutted, through his proxy Beatrice Wood, in a defense titled "The Richard Mutt Case," published in the May issue of their short-lived maga-zine *The Blind Man.* It reads in full:

> *They say any artist paying six dollars may exhibit.*
> *Mr Richard Mutt sent in a fountain. Without discussion this article disappeared and never was exhibited.*
> *What were the grounds for refusing Mr Mutt's fountain:-*
> *1 Some contended it was immoral, vulgar.*
> *2 Others, it was plagiarism, a plain piece of plumbing.*
> *Now Mr Mutt's fountain is not immoral, that is absurd, no more than a bathtub is immoral. It is a fixture that you see every day in plumbers' show windows.*
> *Whether Mr Mutt with his own hands made the fountain or not has no importance. He* CHOSE *it. He took an ordinary article of life, placed it so that its useful significance disap-peared under the new title and point of view—created a new thought for that object.*
> *As for plumbing, that is absurd. The only works of art America has given are her plumbing and her bridges.*

The principal questions here—of immorality and utility, of origi-nality and intentionality—are contested in art to this day. So, too, are the related problems of "choice," that is, of art as a process of nomination by the authority of the artist. Were the readymades art because Duchamp declared them to be, or were they "based on a reaction of visual indifference, a total absence of good or bad taste, a complete anaesthesia," as he argued much later, and so a challenge to such authority? Never shown in its initial guise, *Fountain* was suspended in time, its questions deferred to later moments. In this way it became one of the most influential objects in twentieth-century art well after the fact.

In the dominant tradition of bourgeois aesthetics from the Enlightenment to the present, art cannot be utilitarian because its value depends on its autonomy, on its "purposiveness without ▲ purpose" (in the famous phrase of the philosopher Immanuel Kant), precisely on its uselessness. In this tradition, to use art is almost nihilistic—a point that Duchamp dramatized in another note from 1913 where he proposed to "use a Rembrandt as an

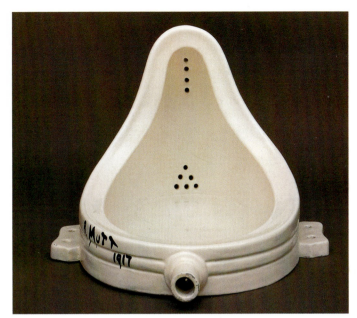

5 • Marcel Duchamp, *Fountain*, 1917 (1964 replica)
Readymade: porcelain, 36 × 48 × 61 (14⅛ × 18⅞ × 24)

ironing-board." In this regard the readymade may be only a gesture of bourgeois radicality; as the German critic Theodor Adorno once remarked (as though he had the Rembrandt ironing-board in mind): "It would border on anarchism to revoke the reification of a great work of art in the spirit of immediate use-values." This is the great difference between the critiques of the institution of art advanced by Duchamp and Tatlin, which is also to say, the great difference between the contexts in which they worked. In bourgeois Paris and New York, Duchamp could only attack the institution of autonomous art, sometimes dandyishly, sometimes nihilistically, while in revolutionary Russia, Tatlin could hope, at least for a time, to see this institution transformed. Like the dandy Charles Baudelaire and the engaged Gustave Courbet in mid-nineteenth-century France, Duchamp and Tatlin posed two complementary models of the artist: the ambivalent consumer who seeks to rename art within a horizon of a commodity culture versus the active producer who seeks to reposition art vis-à-vis industrial produc-tion within a horizon of Communist revolution. What others would make of these possibilities, within their own historical limits, is a most important story in twentieth-century art. HF

FURTHER READING
John Bowlt (ed.), *Russian Art of the Avant-Garde: Theory and Criticism 1902–1934* (London: Thames & Hudson, 1976)
Pierre Cabanne, *Dialogues with Marcel Duchamp* (London: Thames & Hudson, 1971)
Marcel Duchamp, *The Essential Writings of Marcel Duchamp* (London: Thames & Hudson, 1975)
Thierry de Duve, *Pictorial Nominalism: On Duchamp's Passage from Painting to the Readymade*, trans. Dana Polan (Minneapolis: University of Minnesota Press, 1991)
Thierry de Duve (ed.), *The Definitively Unfinished Marcel Duchamp* (Cambridge, Mass.: MIT Press, 1991)
Christina Lodder, *Russian Constructivism* (New Haven and London: Yale University Press, 1983)
Molly Nesbit, *Their Common Sense* (London: Black Dog Publishing, 2001)
Francis M. Naumann and Hector Obalk (eds), *Affect t | Marcel.: The Selected Correspondence of Marcel Duchamp* (London: Thames & Hudson, 2000)

1915

Kazimir Malevich shows his Suprematist canvases at the "0.10" exhibition in Petrograd, thus bringing the Russian Formalist concepts of art and literature into alignment.

When Aleksei Kruchenikh's (1886–1968) *Zaumnaya gniga* appeared in Moscow in 1915, little distinguished its content from that of a dozen previous books of his poems illustrated by one of his avant-garde artist-friends, including Kazimir Malevich and, from 1913, his own wife Olga Rozanova (1886–1918). Although Rozanova was already one of the most inventive participants in the Suprematist movement launched by Malevich in 1915, her illustrations for *Zaumnaya gniga* belonged to an earlier phase of the Russian avant-garde, called "neo-primitivist," during which the idiom of early Cubism was grafted onto the Russian *lubki* (popular broadsides, usually woodprints, whose folkloric tradition goes back to the early seventeenth century).

The title itself, *Zaumnaya gniga*, would not have surprised any follower of Kruchenikh's activity, or that of any other "Cubo-Futurist" poet (as he and his friends called themselves at the time): one could translate it as *Transrational Boog* (*boog*, not *book*—the typo is intended, as the neologism *gniga* is an obvious deformation of *kniga* [book]). In the "transrational" tongue invented by Kruchenikh and his peers, which was aimed at "defying reason" and at freeing the word from the common rules of language, it was indeed appropriate that a boo*k* should become just a boo*g*, a combination of letters whose indeterminate meaning would be the sheer product of associations in the mind of the reader. Kruchenikh's phonetic verses, devoid of any direct connection to a referent ("*Dyr bul shchyl/ubeshchur/skum/vy so bu/ r l ez*"), had been one of the rallying points of the Russian avant-garde ever since he had officially launched the "concept" of *zaum* ("beyond reason") in 1913 (and even before that, in 1912, with the deliberately outrageous publication of *Slap in the Face of Public Taste*, a collective poetic almanac coauthored with David Burliuk, Vladimir Mayakovsky, and Velemir Khlebnikov).

Rozanova's illustration for the cover of *Zaumnaya gniga*, however, was not typical in this context (it could easily be mistaken ▲ for a product of the not-yet-born Dada): it is a collage consisting of the silhouette of a heart (cut out of red paper) onto which a real button has been glued. Besides those of the artist and her husband, a third name adorns the cover, that of an apprentice *zaum* poet, Alyagrov, who contributed two texts to the volume, his first (and last) publication under this pseudonym.

The fact that Alyagrov was none other than the very young Roman Jakobson, who, fresh out of high school, had just founded the Moscow Linguistic Circle (he was later to become one of the ▲ founders of structuralism), may come as a surprise. But even more is in store: even though Jakobson's lifelong passion for language stemmed from his early interest in poetry (notably that of Stéphane Mallarmé, whom he was translating at the age of twelve), his real inspiration had come from painters—and particularly from Malevich, with whom he had planned a trip to Paris just before World War I. The trip was canceled, but weekly visits with Malevich to the Shchukin Collection, host of so many Cubist masterpieces, buttressed Jakobson's firm belief that the relationships between signs are more significant than their potential connection to a referent. It is necessary to underline the nonidentity of the sign and the object, as Jakobson kept repeating all his life, because "without contradiction there is no mobility of concepts, no mobility of signs, and the relationship between concept and sign becomes automatized."

The concepts of Russian Formalism

Along with Opoyaz (the Society of Poetical Language), established in Petrograd in 1916 (of which Jakobson was also a member), the Moscow Linguistic Circle became one of the two birthplaces of the school of literary criticism known as Russian Formalism (the label was coined by enemies, as is often the case: it presupposes a dichotomy between form and content, the very opposition that the Russian Formalists wanted most to annul, as did their fellow *zaum* poets). Right from the start, the issue at stake seems to have been: "What is it that makes a work literary; what is literariness as such?"

The question was polemical, directed against almost any trend of literary studies at the time: against the Symbolists, for whom the text was a transparent vehicle for a transcendent image; against the positivists and the psychologists, for whom the biography of the writer or his putative intention were the determining factors; and against the sociologists, for whom the truth of a literary text was to be found in the historical context of its formation and the political-ideological content it conveyed. For the Formalists, the literariness of a text was a product of its structure, from the phonetical level to the syntactic, from the microsemantic unit of the word to that of

the plot. The text for them was an organized whole, whose elements and devices had first to be analyzed, almost in a chemical fashion ("isolated and laid bare just as they are in a Cubist painting," as Jakobson wrote) before anything could be said of its signification.

In his "Art as Device" (1917), Viktor Shklovsky, an important member of Opoyaz, formulated one of the first concepts of Formalist literary analysis: *ostranenie*, or "making strange." Long exploited by *zaum* poets, *ostranenie* best marks the early convergence of views between Formalist critics and avant-garde poets and painters, most particularly their common opposition to a conception of language that reduces it to its pure value as instrument: for communication, for narration, for teaching, and so on. It is to be noted that their shared credo yielded unprecedented collaborations: not only were the Formalist critics the strongest defenders of *zaum* poetry, but also both Jakobson and Shklovsky were ardent apologists of Malevich's Suprematism; and if Malevich designed the set and costumes for Kruchenikh's opera *Victory over the Sun*, he also wrote *zaum* poems throughout his life. The real source of this parallel was the belief on the part of painter and critic alike in the power of art to renew perception. For the Formalist critic this meant showing how an author's use of language differs from our ordinary use, how commonsense language is "made strange" within the text; Shklovsky called such a critical move one of laying bare the aesthetic "device." For the painter this meant "de-automatizing" vision so as to confront the viewer with the fact that pictorial signs are not transparent to their referents but have an existence of their own, that they are "palpable," as Jakobson would say.

Malevich's Suprematism: the zero of painting

After a quick-paced autodidact education through all the previous "isms" of modern art—from Symbolism to Impressionism, Post-impressionism, Cubism, and Futurism—Malevich attempted to create a *zaum* brand of painting. He first focused on a particular aspect that had been overlooked in the collage aesthetic of Synthetic Cubism, the discrepancy of scale and style it allows. Thus, in *Cow and Violin* (1913), a small and realistic profile of a cow, as if lifted from a children's encyclopedia, is painted over the much larger image of a violin, itself superimposed over a concatenation of geometric color planes. Soon after, Malevich deemed the "transrational" absurdity of these juxtapositions insufficient if he were to attain, in a Formalist fashion, the "pictorial" as such—which he called "the zero of painting."

He ended up his *zaum* phase with two types of experiments (later pursued by his numerous followers) that were destined to push the very notion against which he was struggling—that of the transparency of the pictorial language, essential in any mimetic conception of painting—to its limit. One of these experiments consisted of the simple inscription of a sentence, or a title, in place of the representation of the objects it named. There are several of these nominalist propositions that never went beyond the stage of

drawing, such as the notation "Fight on the Boulevard" hastily jotted down and framed on a piece of paper. The second of these last *zaum* attempts consisted in the collage of actual whole objects, such as a thermometer or a postage stamp, transforming the picture itself into an envelope, as in *Warrior of the First Division, Moscow* from 1914 [1]. In both cases (nominalist inscription or readymade objects), the ironical emphasis is on the tautology: the only purely transparent sign is that which refers to itself word for word, object for object. The shirt button in Rozanova's cover for *Zaumnaya gniga* probably refers to Malevich's assemblage, but also to reliefs by Ivan Puni (1892–1956), another of Malevich's followers (for example, *Relief with Plate* of 1919). Puni's painting *Baths* (1915), even combines assemblage and nominalism, being at once the sign-board for a public bathhouse (thus an object) and the inscription of the word "bath."

But rather than the aesthetic disjunctions of collage, it is the large, undivided planes of color that are most striking in Malevich's works such as *Warrior of the First Division, Moscow* or *Composition with Mona Lisa* (1914), in which the only figurative element, a reproduction of Leonardo's painting, is blocked out in red. And it is these color planes that Malevich will "isolate" in giving birth to his own version of abstraction, which he called Suprematism. The founding moment of Suprematism occurred in December 1915, at the "0.10" exhibition in Petrograd (subtitled "The Last Futurist Exhibition of Paintings," the show owes its name to the fact that its ten participants—including Vladimir

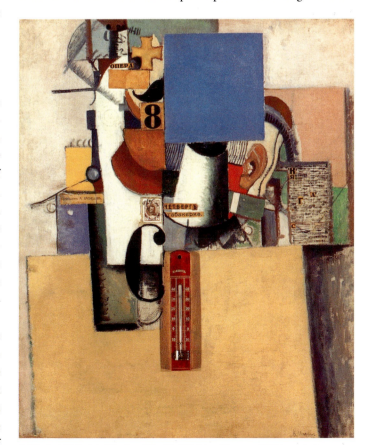

1 • Kazimir Malevich, *Warrior of the First Division, Moscow*, 1914
Oil and collage on canvas, 53.6 × 44.8 (21⅛ × 17⅝)

▲ Tatlin, who showed his first corner counter-relief there—were all seeking to determine the "zero degree," the irreducible core, the essential minimum of painting or of sculpture).

• Thus, almost half a century before Clement Greenberg, Malevich posited that the "zero" condition of painting in the culture of his time is that it is flat and delimited. From this critical reduction there stems Malevich's emphasis on the textural quality of his surfaces, his attention to painterly facture, but also his predilection for the figure of the square, a form long conceived, as its Latin name attests, as the result of one of the simplest geometrical acts of delimitation (*quadrum* means both "square" and "frame"). And from this identification of the figure of the square with the ground of the picture itself—in Malevich's *Black Square*, for example, which hovered over his other works at "0.10," parodying the placement of icons in traditional Russian houses [2]—there developed in
■ Malevich's work the very inquiry into what Michael Fried, writing in 1965 about Frank Stella's black paintings, would call "deductive structure" (in which the internal organization of the picture—the placement and morphology of its figures—is deducted from, and thus an indexical sign of, the shape and proportions of its support). Malevich's 1915 *Black Cross*, his *Four Squares* (one of the first regular grids of twentieth-century art), and many other "noncompositions" presented at "0.10" are indexical paintings; that is, the division of the picture's surface, the marks it received, are not
▲ determined by the artist's "inner life" or mood (as was the case for Kandinsky's abstract paintings), but by the logic of the "zero"—they refer directly to the material ground of the picture itself, which they map.

Making strange with color

Malevich was not a positivist (he always stuck to an antirationalist point of view that brought him, especially in his late, post-revolutionary texts, close to a mystical position). Even in the most "deductive" of his canvases, he always made sure that his squares were slightly skewed so that (by virtue of the *ostranenie*) one would notice their stark simplicity and read them as stubbornly "one" (both unique and whole) rather than identifying them as geometric figures. For what mattered most to him, as he kept repeating, was "intuition."

One of the surest routes to attain this nonverbal, nonarticulate mode of communication in painting was color, the sheer expanse of undivided planes of saturated pigment. Malevich's passion for

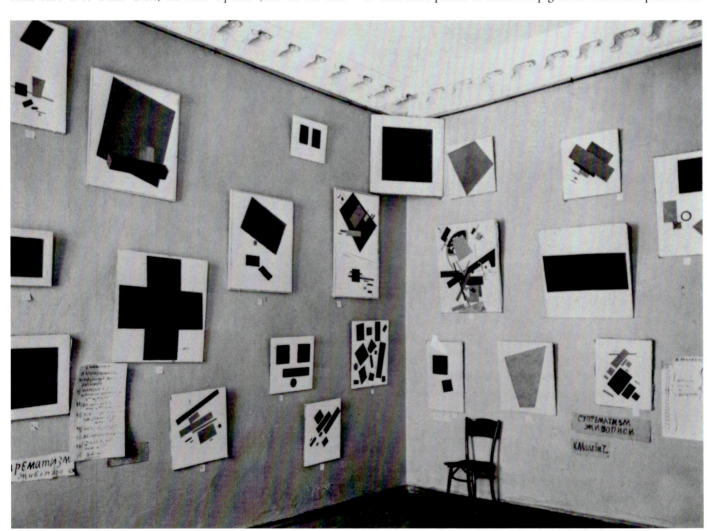

2 • A view of the "0.10" exhibition in Petrograd, 1915
Malevich's *Black Square* can be seen in the corner of the room above his other paintings.

▲ 1914, 1921b • 1942a, 1960b ■ 1958 ▲ 1908, 1913

color played a major role in his rapid evolution from Cubism to abstraction, as did the works of Matisse, also discovered in the Shchukin Collection. But despite his enthusiasm for the French master's *ostranenie* tactics of using arbitrary color, Malevich quickly came to the conclusion (via his apprenticeship in the "analytical" mode of thinking pertaining to Cubism) that color would never be "isolated" and perceived as such (that is, it would never reign "supreme") without first being freed from any determination of a subject matter other than its own radiance.

And this desire to explore "color" as such, to expose the "zero" of color, also led Malevich to take leave of the deductive structure. For next to the *Black Square* or the *Red Square* [3], which was exhibited under the ironic, *zaum* title of *Peasant Woman: Suprematism* (it is now subtitled *Painterly Realism of a Peasant Woman in Two Dimensions*), one could see many pictures on the walls of "0.10" in which rectangles of all sizes and of various colors floated on a white background. For a brief period, these paintings led to what Malevich would later call "aerial suprematism," works he would himself severely criticize for their return to illusionism and their quite direct allusion to a cosmic imagery as though one were viewing Earth from outer space [4].

It was the sixties American artist Donald Judd, one of the harshest critics of illusionism in painting, and always ready to point out how much of it still remained in the works of the pioneers of abstraction and their followers of the twenties and thirties, who was the first to reinscribe these agitated paintings into the theoretical framework of the Formalist (*ostranenie*) logic. Reviewing a Malevich retrospective exhibition in 1974, Judd noted that in these canvases colors do not "combine; they can only make a set of three or any two in the way that three bricks make a set." Those sets, writes Judd, "are not harmonic, do not make a further overall color or tone." In other words, the color relationships are not compositional. The allusion to bricks, to the "one thing next to the other" of Minimalism, is very much to the point. But colors are not random either: they assert their independence from the whole via their fragmentary groupings into clusters, preventing any perceptual organization of the shapes into a gestaltist order (and allowing for clashing, almost "kitsch" juxtapositions, such as red and pink).

After zero …

By 1917–18, as the ideological directions of the October Revolution were making increasing demands on the artists of the Russian avant-garde—the only artistic group to have given it support from the start—Malevich found it increasingly difficult to justify his pictorial activity ideologically. His own political inclinations, close to anarchism, which he saw as perfectly congruent with his aesthetics, were not of great help after the Bolsheviks' repression of an anarchist revolt at Kronstadt in 1918. His momentary farewell to painting constitutes one of the borderline experiences of twentieth-century art, the moment when the "zero" is almost tangible—there, on the canvas. The works in question are several pictures in which a

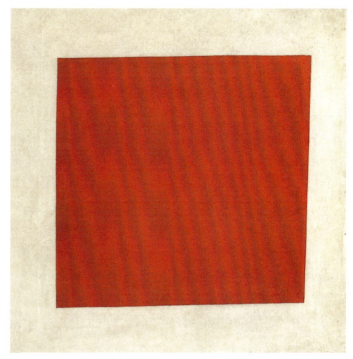

3 • Kazimir Malevich, *Red Square (Painterly Realism of a Peasant Woman in Two Dimensions)*, 1915
Oil on canvas, 53 × 53 (20⅞ × 20⅞)

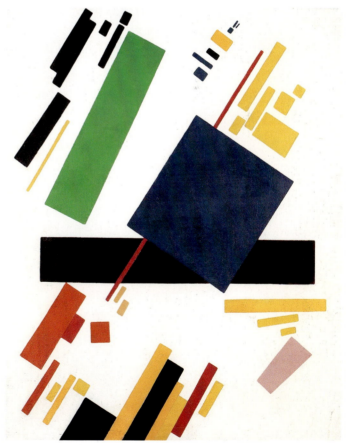

4 • Kazimir Malevich, *Suprematist Construction*, 1915–16
Oil on canvas, 88 × 70 (34⅝ × 27⅝)

"white" form (slightly off-white, to be more precise) glides, at the threshold of visibility, on the white expanse of the canvas [**5**]. Displaying almost nothing but the smallest differentiation of tone, and the sensual marks of the brush-stroke, sometimes these "white-on-white" pictures were even exhibited on a white ceiling, thus emphasizing their own potential dissolution, as white squares themselves, into the architectural space.

Malevich was enlisted in several cultural and agitprop tasks after the Revolution (from planning new museum collections to designing posters), but his most sustained activity was as a pedagogue. In 1919, having dislodged Chagall as head of the Popular Art Institute in Vitebsk, and having secured the help of the much younger El Lissitzky (1890–1941), he founded the Unovis school (the Russian acronym for "Affirmers of the New Art"). The pictorial production of his pupils, most of them in their teens, was derivative at best. How odd it is to imagine the unheated Unovis classrooms full of paintings of bouncing red squares, in the midst of a huge economic crisis, civil war, and famine! But it was there that Malevich began to develop, with his students, his conception of architecture, which he would actively pursue at the Institute for the Study of the Culture of Contemporary Art of Leningrad (or Ginkhuk), of which he was appointed director in 1922. As there was no question of actual building, architecture was approached as a language, much as Malevich had analyzed the constituents of painting: What would be the zero in architecture? Where would architecture go if it were devoid of function? The results of his inquiry, models of ideal cities and dwellings called *arkhitektoniki*, with their multiplication of cantilevers and their questioning of the classical opposition of post and lintel, were to have an immediate impact on the emerging International Style in architecture and town-planning (particularly after their publication, through El Lissitzky, in several European publications in the mid-twenties).

While abstract painting, *zaum* poetry, and Formalist criticism, now deemed bourgeois and elitist, increasingly became the target of political censorship in Soviet Russia, architectural research, even as utopian as that of Malevich and his followers, remained relatively free. But soon after the death of Lenin (in 1924) cultural repression began to close down on all spheres of cultural activity, and even Malevich's *arkhitektoniki* had to pay tribute to the heroic, neo-classical proportions demanded by Stalin's watchdogs. Malevich, still teaching (to a thinning student body) and devoting vast energy to writing (most of it unpublished at that time), started painting again in the late twenties. But because abstraction was now almost a political crime, he became engaged in the very strange activity of running through his own pictorial evolution in reverse, going back not only to Cubo-Futurism but also as far as Impressionism, yet consistently antedating this belated production as if it were from his youth. This manifest fraud, puzzling to the historians, is in keeping with the modernist creed of his quest for the zero: like Mondrian, Malevich thought that each art had to define its own essence by eliminating those conventions deemed unnecessary and, in this evolutionary march, each work of art was to be a step beyond the preceding one— which means that each was assigned a proper date on this progression. A flashback is always possible within this logic, but it would have been morally wrong to present something which could (and should) have been done in 1912 as dating from 1928. (Similarly, when around 1920 Mondrian was forced to paint flowers for economic reasons, he made sure to adorn these "commercial" works with his signature of around the turn of the century.)

The last works by Malevich, however, from the early thirties, are not antedated. Crude pastiches of Renaissance portraits in harsh colors, but often bearing a tiny Suprematist emblem (the geometric ornaments of a belt or a hat), these paintings are replete with irony. Unlike, say, a de Chirico, Malevich is not welcoming here the "return to order." But condemned to figuration and to a mimetic conception of painting against which he had fought all his life, he is "making strange" the very practice of portraiture by giving a sense of the historical distance denied by his censors between the epoch of genuine portrait-making and his own.　YAB

FURTHER READING
Troels Andersen, *Malevich* (Amsterdam: Stedelijk Museum, 1970)
Victor Erlich, *Russian Formalism* (New Haven and London: Yale University Press, 1981)
Paul Galvez, "Avance rapide," *Cahiers du Musée National d'Art Moderne*, no. 79, Spring 2002
Roman Jakobson, *My Futurist Years*, ed. Bengt Jangfeldt and Stephen Rudy (New York: Marsilio Publishers, 1997)
Gerald Janecek, *The Look of Russian Literature: Avant-Garde Visual Experiments, 1900–1930* (Princeton: Princeton University Press, 1984)
Anna Lawton (ed.), *Russian Futurism Through its Manifestoes 1912–1928* (Ithaca, N.Y. and London: Cornell University Press, 1988)
Kazimir Malevich, *Essays on Art*, ed. Troels Andersen, four volumes (Copenhagen: Borgen Verlag, 1968–78)
Krystyna Pomorska, *Russian Formalist Theory and Its Poetic Ambiance* (The Hague and Paris: Mouton, 1968)
Angelica Rudenstine (ed.), *Kazimir Malevich 1878–1935* (Washington, D.C.: National Gallery of Art, 1990)

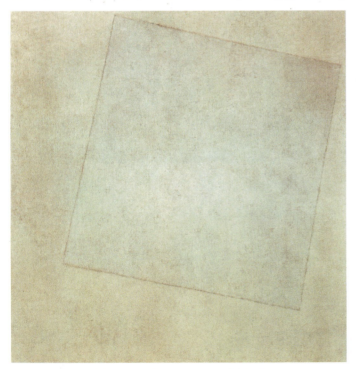

5 • Kazimir Malevich, *Suprematist Painting (White on White)*, 1918
Oil on canvas, 79.3 × 79.3 (31 × 31)

▲ 1926, 1928a, 1928b　　　　　　▲ 1934a　● 1913, 1917a, 1944a　■ 1909, 1919, 1924

1916 _a

In Zurich, the international movement of Dada is launched in a double reaction to the catastrophe of World War I and the provocations of Futurism and Expressionism.

ada encompassed a wide range of practices, politics, and places, so it could hardly be coherent even if it wanted to be, which it did not: most of its participants viewed any coherence, any order at all, with derision (legend has it that the word "Dada" was picked at random from a German–French dictionary). This anarchic assault on all artistic convention caught fire quickly. Despite its short life—by the early twenties it was either burned out or subsumed into Surrealism in France and ▲ Neue Sachlichkeit in Germany—it had no fewer than six major bases of operation: Zurich, New York, Paris, Berlin, Cologne, and Hanover, which were connected, intermittently, by ambitious impresarios (Tristan Tzara, for example), nomadic artists (such as ▲ Francis Picabia), and international journals (see box). Born in ● double reaction to the catastrophe of World War I and the provocations of Futurism and Expressionism, Dada took direct aim at bourgeois culture, which it blamed for the butchery of the war. In many ways, however, this culture was already dead for Dada, and Dada rose to dance on its grave (Hugo Ball, a principal figure in the Zurich group, once defined Dada as a cross between a "harlequinade" and a "requiem mass"). In short, the Dadaists pledged to

1 • Hugo Ball in his "Magical Bishop" costume, at the Cabaret Voltaire, Zurich, June 1916

2 • Marcel Janco, *Mask*, c. 1919
Paper, cardboard, string, gouache, and pastel, 45 × 22 × 5 (17¾ × 8⅝ × 2)

▲ 1924, 1925b, 1929, 1930b, 1931a ▲ 1916b, 1919 ● 1908, 1909

attack all norms, even incipient ones of their own ("Dada is Anti-Dada" was a favorite refrain); in Zurich, they did so through especially outlandish performances, exhibitions, and publications.

A farce of nothingness

The international group of poets, painters, and filmmakers drawn to neutral Switzerland before or during the war included the Germans Ball (1886–1927), Emmy Hennings (1885–1948), Richard Huelsenbeck (1892–1974), and Hans Richter (1888–1976), the Romanians Tzara (1896–1963) and Marcel Janco ▲ (1895–1984), the Alsatian Hans Arp, the Swiss Sophie Taeuber, and the Swede Viking Eggeling (1880–1925). Zurich was a principal refuge for other vanguards too: James Joyce lived there for a time, as did Vladimir Lenin, who lodged diagonally across the street from the Cabaret Voltaire that served as Dada headquarters. Named after the great French satirist of the eighteenth century (author of *Candide*, an attack on the idiocies of his own age), the Cabaret was founded on February 5, 1916, as a venue for a vaude-villian mockery of "the ideals of culture and of art." "That is our *Candide* against the times," Ball wrote in his extraordinary diary, *Flight Out of Time.* "People act as if nothing had happened, [as if] all this civilized carnage [were] a triumph." The Dadaists aimed to act out this crisis in a performative chaos of their own, one pledged "to draw attention, across the barriers of war and nation-alism, to the few independent spirits who live for other ideals" (Ball). Surrounded by Expressionist posters and primitivist pictures by Janco and Richter, these provocateurs recited contra-dictory manifestos (both Futurist and Expressionist), poems in French, German, and Russian (that is, in languages on different sides of the war), and quasi-African chants; they also contrived concerts with typewriters, kettledrums, rakes, and pot covers. "Total pandemonium" is how Arp described the Cabaret Voltaire in retrospect: "The people around us are shouting, laughing, and gesticulating. Our replies are sighs of love, volleys of hiccups, poems, moos, and miaowing of medieval Bruitists. Tzara is wiggling his behind like the belly of an Oriental dancer. Janco is playing an invisible violin and bowing and scraping. Madam Hennings, with a Madonna face, is doing the splits. Huelsenbeck is banging away nonstop on the great drum, with Ball accompanying him on the piano pale as a chalky ghost. We were given the honorary title of Nihilists."

Yet the Dadaists were not only nihilists. Although they acted out the dislocations of exile (the name "Tristan Tzara," the pseu-donym of Sami Rosenstock, suggests "sad in country"), they also formed a community of artists committed to internationalist poli-tics and universal languages (Richter and Eggeling hoped that abstract film might qualify as one). They could be affirmative as well as destructive in spirit, redemptive as well as regressive in posture; for Ball the term "Dada" held all these associations together: "In Romanian Dada means yes yes, in French a hobby horse. To Germans it is an indication of idiotic naiveté and of a

preoccupation with procreation and the baby carriage." Anarchic impulses were also mixed with mystical leanings, especially in the ▲ Dadaist relation to language. Like the Futurist Marinetti, Ball worked to release language from conventional syntax and seman-• tics into raw sound (the Hanover Dadaist Kurt Schwitters worked along similar lines). Yet the Dadaist interest in sound poetry diverged sharply from the Futurist embrace of nonrational expres-sion: in his "words-in-freedom" the militarist Marinetti worked to plunge language into a bodily matrix of the senses—to reforge it as force—while the pacifist Ball sought to empty language not only of conventional sense but also of the instrumental reason that had underwritten the mass carnage of the war. "A line of poetry is a chance to get rid of all the filth that clings to this accursed language," Ball wrote. "Every word that is spoken and sung here says at least this one thing: that this humiliated age has not succeeded in winning our respect." Even as Ball worked to shatter language, however, he also sought to recover the word as "logos," to transform language into so many "magical complex images."

The short life of the Cabaret Voltaire ended abruptly on June 23, 1916, with a legendary performance by Ball [1], recounted here in *Flight Out of Time:*

> *My legs were in a cylinder of shiny blue cardboard, which came up to my hips so that I looked like an obelisk. Over it I wore a huge coat collar cut out of cardboard, scarlet inside and gold outside.… I also wore a high, blue-and-white-striped witch doctor's hat.… I was carried onto the stage in the dark and began slowly and solemnly: "gadji beri bimba/ glandridi lauli lonni cadori/ gadjama bim beri glassala/ glandridi glassala tuffm i zimbrabim/ blassa galassasa tuffm i zimbrabim.…"… Then I noticed that my voice had no choice but to take on the ancient cadence of priestly lamentation, that style of liturgical singing that wails in all the Catholic churches of East and West.… For a moment it seemed as if there were a pale, bewildered face in my Cubist mask, that half-frightened, half-curious face of a ten-year-old boy, trembling and hanging avidly on the priest's words in the requiems and high masses in his home parish.… Bathed in sweat, I was carried down off the stage like a magical bishop.*

In the performance Ball is part shaman, part priest, but he is also a child once again entranced by ritual magic. This "playground for crazy emotions" witnessed other such performances with fantastic costumes and bizarre masks, often contrived for the occasion by Janco [2]; Sophie Taueber contributed theatrical props and dance pieces as well. "The motive power of these masks was irresistibly conveyed to us," Ball remarked of the masks, which he regarded as modern equivalents of those in ancient Greek and Japanese theater. "[They] simply demanded that their wearers start to move in a tragic-absurd dance."

In part, Ball saw Dada as an avant-garde rite of possession and exorcism. The Dadaist "suffers from the dissonances [of the world] to the point of self-disintegration.… [He] fights against the agony

and the death throes of this age." In effect, Ball regarded the Dadaist as a traumatic mime who assumes the dire conditions of war, revolt, and exile, and exacerbates them in the form of a buffoonish parody. "What we call Dada is a farce of nothingness in which all the higher questions are involved," he remarked less than two weeks before his Magical Bishop performance, "a gladiator's gesture, a play with shabby leftovers." Here Dada mimes dissonance and destruction in order to purge them somehow, or at least to transform such shock into a shield, an immunological antidote that retains a strong dose of fear and loathing. "The horror of our time, the paralyzing background of events, is made visible," Ball once commented of the Janco masks; and of the poetry of Huelsenbeck he had this to say: "The Gorgon's head of a boundless terror smiles out of the fantastic destruction."

Exhausted, Ball left Zurich soon after his performance (eventually to return to the Church), and Tzara took over as prime instigator of Zurich Dada. Tzara was the "natural antithesis of Ball," Richter once remarked, as dandyish in his stance of disgust as Ball was desperate in his acting out of trauma. His model as avant-garde impresario was Marinetti: Tzara not only stressed the Futurist aspects of Dada but also orchestrated Dada much as Marinetti
▲ had Futurism—with manifestos, a journal, even a gallery. In a self-contradictory development, Zurich Dada thus became less a chaotic mix of other styles than an artistic movement of its own. In the third issue of *Dada* (1918), Tzara published the "Dada Manifesto," which put Dada on the map of European avant-gardes;
• it also attracted Picabia from New York, and together he and Tzara prepared the Dadaist campaign in Paris that was to follow the war. When the war did end, so, effectively, did Zurich Dada, as refugees were free to move once again.

Sense and senselessness

"Dada is for the senseless," Arp once wrote, "which doesn't mean nonsense." This is an important distinction for Dadaist abstraction as practiced by Arp and Taeuber, the key artists of the second phase of Zurich Dada. While other Dadaists, such as Tzara and Picabia, claimed that Dada intends nothing (except perhaps nothingness), Arp and Taueber suggested that it can mean almost anything at all. "Dada is as senseless as nature," Arp continued; "Dada is for infinite sense and definite means." That is, it is as full of meaning, as infinite in sense, as nature is—or indeed as empty. Yet how can a work be at once replete and null, infinite and definite? Consider the many reliefs Arp produced in his Dada years (and after): constructed out of different pieces of painted wood bolted together, they are abstract compositions that are nonetheless suggestive of biomorphic forms (human, animal, plant) [3]. In this way, they are specific, almost referential (as his titles often suggest—a torso, a bird, etc.), even as they are also metamorphic, open in association.

Arp and Taeuber met in 1915 in Zurich, where Taeuber taught textile design at the School of Applied Arts. More exactly, they met

in November 1915 at the Tanner Gallery, where, along with two Dutch friends (Otto and Adya van Rees), Arp had a show of tapestries and collages. "These works are constructed with lines, surfaces, shapes, and colors," Arp wrote at the time, as if to underscore that they are resolutely abstract, not concerned either with
▲ the play of signification, as entertained in Cubist collages (which he did know), or with "the truth to materials," as proposed in early
• Constructivist experiments (which he did not). His abstractions have another aim: "They try to transcend the human and attain the infinite and eternal. They are a denial of human egotism." This anti-individualism became a central principle for Arp and Taeuber: first and last, they pledged their abstract work against the "egotism" that had caused the war.

This position guided Arp and Taeuber in several respects. First, it made them skeptical of easel painting, which was too individualistic in production and reception ("we regarded [it] as characteristic of a pretentious and conceited world"). Second, it led them to collaborate, especially on collaged and woven pieces, which were sometimes designated "duo," in a way that also challenged individual authorship [4]. Third, the stance against "egotism" inclined Arp and Taeuber to the grid (they were among the first to use it so directly). Implicit in the composition of

3 • Hans Arp, *Torso, Navel*, 1915
Wood, 66 × 43.2 × 10.2 (26 × 17 × 4)

Dada journals

The group of artists and poets who gravitated toward Zurich at the outbreak of World War I immediately started *Cabaret Voltaire* (1916), the journal through which Dada was able to spread throughout Europe and into North America. If art is understood by psychoanalysis as sublimatory—a way of rising above the animal instincts that form the underbelly of the psyche—Dada saw itself as desublimatory—scoffing at the spiritual ambitions of poetry and painting. In his short history of the movement, Richard Huelsenbeck wrote, "The German *dichter* [poet] is the typical dope…. He does not understand what a gigantic humbug the world has made of the 'spirit'."

By 1917, *Dada*, edited by Tristan Tzara, was also being published in Zurich. *Dadaco*, an anthology with Dada works of art, such as photomontages by George Grosz, soon followed. That the very word "*dada*" was provocative is heralded by an article in *Dadaco* which begins: "Was ist dada? Eine Kunst? Eine Philosophie? Eine Politick? Eine Feuerversicherung? Oder: Staatsreligion. Ist dada wirkliche Energie? Oder ist es Garnichts, d.h. alles?" (What is dada? An art? A philosophy? A politics? A fire insurance policy Or: Official religion? Is dada truly energy? Or is it nothing at all, i.e., everything?")

The Dada movement in the United States soon resulted in Man Ray's *Ridgefield Gazook*, published from 1915, as well as *New York Dada*, the periodical he produced with Marcel Duchamp. The international character of Dada journals is further illustrated by Kurt Schwitters's *Merz* in Hanover and Francis Picabia's *391*, the latter published out of Barcelona. But in France, *La Nouvelle Revue Française* resumed publication in 1919 (after having been suppressed during the war) by accusing the "new school" of nonsense symptomatized by the "indefinite repetition of the mystical syllables 'dada dadada dada da.'" The French novelist André Gide joined the debate with an article announcing: "The day the word Dada was found, there was nothing left to do. Everything written subsequently seemed to me a bit beside the point…. Nothing was up to it: DADA. These two syllables had accomplished that 'sonorous inanity,' an absolute of meaninglessness."

Indeed, in Gide's novel *The Counterfeiters* (1926), the villain Strouvilhou imagines what a Dada journal should be when he says, "If I edit a review, it will be in order to prick bladders—in order to demonetize fine feelings, and those promissory notes which go by the name of *words*." In the first issue, he announces (with the Duchamp collage *L.H.O.O.Q.* in mind), there will be "a reproduction of the *Mona Lisa*, with a pair of mustaches stuck on to her face." It is this linking of abstraction and nonsense that is associated, in Gide's narrative, with the emptying out of the sign's meaning: "If we manage our affairs well," says Strouvilhou, "I don't ask for more than two years before a future poet will think himself dishonored if anyone can understand a word of what he says. All sense, all meaning will be considered anti-poetical. Illogicality shall be our guiding star."

the collaged works and intrinsic to the support of the woven works, the grid is a given order that informs these works, again in an anti-autographic manner; the evocation of ornamental patterning here also puts artistic individuation into doubt. Finally, this position prompted them to experiment with quasi-automatist procedures. Already in 1914 Arp had produced small embroideries in wool, with geometric or curvilinear shapes oriented on the horizontal or the vertical. Like the woven works made by Taeuber a few years later, these works are not only repetitive in process but sometimes symmetrical in form; this too makes them appear almost authorless, as though they were elaborated by the medium or the pattern alone.

▲ Arp experimented with aleatory techniques too, as in his famous collages of 1916–17 that consist of rectangular pieces of paper "arranged according to the laws of chance." However, this phrase was a later addition to the titles (Arp attached it sometime
● after 1930, in the milieu of Surrealism), and chance is hardly the opposite of control in these works: individual elements and overall composition are calculated enough. This is also true of his quasi-automatist drawings of 1915–20, where initial marks in pencil often appear under or alongside the main figures in ink [**5**]. For Arp, chance could signal the individual as much as control did (for his collages he soon substituted a paper cutter for scissors, which "all too readily betrayed the life of the hand"), and he remained ambivalent about the aleatory.

An art of silence

For Arp and Taueber, abstraction was not only anti-individualist in spirit but also antisemantic in aim. "All these works were drawn from the simplest forms," Arp wrote; they are "realities, pure and independent, with no meaning." However, this "art of silence" (as he called it) is not simply negative; rather, it involves a deconstructive play with opposites, for the abstractions of Arp and Taeuber are not quite single or double in authorship, not quite preconceived or aleatory in process, and not quite ordered or random in composition, nor are they obviously aesthetic or utilitarian in orientation, or fine or applied as art. They possess just enough of one term to put the other in doubt—just enough order not to appear random, just enough aesthetic interest not to be taken as utilitarian, and so on. This neutral structure frustrates our usual model of meaning based on binaries, and points to another logic. Seen in this way, then, the "art of silence" of Arp and Taeuber is indeed against meaning and interpretation, but in a way that aims to open up both. "Once you are neither this nor that, then you are all things," Meister Eckhart, the medieval German theologian, once wrote. This thought was dear to Arp, and it might be taken as the motto of these abstractions in general.

■ Such a suspension of opposites is also at work in the Arp woodcuts of 1916–20 and the Taeuber objects of 1916–18. As in the embroideries, the shapes in the woodcuts are often repeated, and they, too, hesitate between the representational and the abstract:

▲ 1918 ● 1924, 1930b, 1931a ■ 1925c

4 • Hans Arp and Sophie Taeuber, *Untitled (Duo-Collage),* **1918**
Collage of papers, board, and silver leaf on paperboard, 82 × 62 (32⁵⁄₁₆ × 24⁷⁄₁₆)

5 • Hans Arp, *Dada*, c. 1920
Ink and pencil on paper, 26.7 × 20.8 (10½ × 8³⁄₁₆)

some recall patterns in ornament based on vases and flowers, while others resemble figures with crowns or collars such as kings or clergymen. On the one hand, then, these forms are entirely conventional—in fact so banal as to appear devoid of significance; whereas, on the other, they evoke emblems of political authority or suggest a religious meaning. Here the null–full tension in the Arp and Taeuber abstractions is most extreme: empty shapes that also connote auratic signs of power (crests, scepters), bathetic patterns that also suggest, as Arp says, "meditations, mandalas, signposts."

The Taeuber objects are like the Arp woodcuts elaborated in the round. They, too, are representational yet abstract, utilitarian yet aesthetic, even ritualistic (of the four extant objects, two are ▲ subtitled *Dada Bowl* and *Powder Box* and two are called *Amphora* and *Chalice*), crafted by hand yet all but unmarked (turned on the lathe, they are smooth in facture and uniform in paint), and so on. In short, these objects are also "neither this nor that," and in this ambiguity they not only oppose the traditional categories of sculpture, such as the figure and the monument, but also differ from the new models of object-making of the time, such as the readymade, the construction, and the fetish.

So why turn crowns into dingbats, as Arp does in his woodcuts, or chalices into thingamajigs, as Taeuber does in her objects? Why render empty of sense what otherwise seems replete with significance? Again, a core belief of Dada, especially in Zurich, was that the world war had exposed, once and for all, the utter corruption of bourgeois civilization, of its language in particular—a complete crisis in the symbolic order with ramifications that were at once political, social, religious, and artistic. As we have seen, the insistence on meaninglessness in Dada, on a voiding of sense in its art, writing, and performance, can be understood as an excessive acting-out, a bathetic exacerbation, of this general state of affairs. At the same time, this voiding was also a purging of a civilization become barbaric: "These years," Arp wrote in retrospect, "affected us like a purification, like spiritual exercises." This purification concerned language above all, visual as well as verbal, which was to be broken up and / or stripped down to a zero degree.

However, if meaning was to be voided in a first moment, it called out for renewal in a second moment, with the collapse of the old sense somehow troped as an opening to a new sense. Such is the stake of the doubleness in the Arp and Taeuber abstractions that oscillate between too much meaning and none at all. In his poetry in particular, Arp sometimes seems to reprise a mythical origin of language, like a Dadaist Adam rising from the ruins of the war to name the world anew. This scene recalls the explosion of signification at the dawn of man once imagined by Claude Lévi-Strauss. "Language can only have risen all at once," Lévi-Strauss writes in an essay on his fellow anthropologist, Marcel Mauss. "Things cannot have begun to signify gradually. In the wake of [this] transformation … a shift occurred from a stage when nothing had a meaning to a stage when everything had meaning." In this hypothetical moment, Lévi-Strauss argues, there is a surplus of signification, a non-fit between signifiers and signifieds,

such that a signifier might float free as "a simple form, or to be more accurate, a symbol in its pure state, therefore liable to take on any symbolic content whatever." Such, according to Lévi-Strauss, was the Polynesian term *mana* in the relevant writings of Mauss. "Dada" is a *mana* word too, and there are many *mana* forms in Arp and Taeuber, such as "the navel" in his reliefs or "the cloud" in his poetry or indeed any of her objects. HF

FURTHER READING

Jean Arp, *Arp on Arp: Poems, Essays, Memories*, ed. Marcel Jean, trans. Joachim Neugroschel (New York: Viking Press, 1972)
Hugo Ball, *Flight Out of Time: A Dada Diary* (1927), ed. John Elderfield, trans. Ann Raimes (New York: Viking Press, 1974)
Leah Dickerman (ed.), *Dada* (Washington: National Gallery of Art, 2005)
Richard Huelsenbeck, *Memoirs of a Dada Drummer*, ed. Hans J. Kleinschmidt, trans. Joachim Neugroschel (New York: Viking Press, 1974)
Ruth Hemus, *Dada's Women* (New Haven and London: Yale University Press, 2009)
Robert Motherwell (ed.), *The Dada Painters and Poets* (1951) (Cambridge, Mass.: Harvard University Press, 1989)
Hans Richter, *Dada: Art and Anti-Art* (London: Thames & Hudson, 1978)
Bibiana Obler, *Intimate Collaborations: Kandinsky and Münter, Arp and Taeuber* (New Haven and London: Yale University Press, 2014)

▲ 1925c

1910–1919

Paul Strand enters the pages of Alfred Stieglitz's magazine *Camera Work*: the American avant-garde forms itself around a complex relationship between photography and the other arts.

That Alfred Stieglitz (1864–1946) should have been portrayed by Francis Picabia in 1915 in the form of a camera [1] would have surprised no one in the world of avant-garde art, certainly not in New York, but not in Paris either. For by 1915, Stieglitz's magazine *Camera Work* (published from 1903) was famous on both sides of the Atlantic, and his gallery at 291 Fifth Avenue in Manhattan, having changed its name in 1908 from the Little Galleries of the Photo-Secession to simply 291, had mounted major exhibitions of Matisse (1908, 1910, and 1912), Picasso (1911, 1914, and 1915), Brancusi (1914), and Picabia (1915).

Nonetheless, several contradictions crisscross the "face" of Stieglitz's portrait. For one thing, the Dada spirit of the mechanomorphic form has nothing to do with Stieglitz's own aesthetic convictions; his belief in American values such as sincerity, honesty, and innocence clash as much as possible with Picabia's ironic rendering of the human subject as a machine. And as a continuation of this, Stieglitz's commitment to authenticity, taking the form, as it did, of truth to the nature of a given medium, had placed him at direct odds with the photographic practice of his day. The result was that from 1911, 291 no longer exhibited camera-based work (the one exception being Stieglitz's own exhibition in 1913 to coincide with the Armory Show). In Stieglitz's eyes, that is, modernism and photography had, distressingly, become antithetical.

It was only when the young Paul Strand (1890–1976) presented Stieglitz with the photographs he had made in 1916 that the elder man could see the vindication of his own position. For he viewed Strand's work as a demonstration that the values of modernism and those of "straight photography" *could* utterly fuse on the surface of a single print. Accordingly, Stieglitz decided to hold an exhibition of Strand's photographs at 291 and to revive *Camera Work*, which had been languishing since January 1915. In October 1916, he brought out issue number 48, and in June 1917 he ended the project with number 49/50. Both issues were intended as monuments to Strand and to a renewed sense of photography's having definitively joined an authentic modernism. With this assessment in place, Stieglitz ended his entrepreneurship on behalf of the avant-garde and redevoted himself to his own practice of photography.

The peculiar zigzag of this trajectory had begun in Berlin, where Stieglitz had enrolled as an engineering student in 1882. A course

1 • Francis Picabia, *Ici, c'est ici Stieglitz*, 1915
Pen and red ink on paper, 75.9 × 50.8 (29⅞ × 20)

in photochemistry introduced the young American to photography, a medium he took to immediately, although he had had no previous training in art. "I went to photography really a free soul," he later explained. "There was no short cut, no foolproof photographing—no 'art world' in photography. I started with the real A.B.C."

▲ 1914, 1916a, 1919

By 1889, Stieglitz had made *Sun Rays—Paula—Berlin* [2], a work that in its sharpness of detail was far away from the idiom that had settled over all aesthetically ambitious photography in the late nineteenth century and into the first decade of the twentieth. Called "Pictorialist," this photography had bet the future of the medium on aping the features of painting and was thus involved in various effects of blurring (soft focus, greased lenses) and even handwork ("drawing" on the negatives with gum bichromate) to manipulate the final image as much as possible.

Focusing instead on "the real A.B.C." of photography, *Sun Rays—Paula—Berlin* not only mobilizes a strict realism to separate itself from Pictorialism's simulation of "art," but also produces something of an inventory of the values and mechanisms inherent to the medium itself. One of these mechanisms is the brute fact of the photomechanical, by which light enters the camera through a shutter to make a permanent trace on the sensitive emulsion of the negative. Bodying forth this light as a sequence of rays falling across the field in a striated pattern of dark and light, *Sun Rays* also identifies the opened windows through which sunlight streams into the darkened room (or *camera*) with the camera's shutter.

None of this would be remarkably different from the various Impressionist attempts to present the light on which their technique depended as the very subject of a given painting were it not for the concatenation of images pictured inside the room itself. For there the photomechanical's relation to mechanical reproduction—to the multiple duplication and serialization of the image—is dramatized, as the young woman writing at the table bends her head toward a framed portrait (possibly of herself) that we identify as a photograph, since above her on the wall we see its exact duplicate flanked by two landscapes betraying their own identity as photographs in their similar condition as identical twins. And this fact of reproducibility set up inside the image of *Paula* rebounds, by implication, onto *Paula* itself, so that at some later point in the series it, too, could take up residence on that same wall. In this sense, *Paula* is a display of Chinese boxes, a demonstration of the reproducible as a potentially infinite series of the same.

Stieglitz forms the Photo-Secession

Nothing could be further from the values Stieglitz encountered in the photographic magazines and exhibitions occurring both in Europe and in the America to which he returned in 1890. Joining the New York Camera Club, Stieglitz had no choice but to take up arms *for* Pictorialism rather than against it, since it was only in the hands of certain of its practitioners (such as Clarence White ▲ [1871–1925] and Edward J. Steichen [1879–1973]) that photography was being taken seriously as a valid means of artistic expression. From 1897 Stieglitz began to edit *Camera Notes* as a forum for the Pictorialist group he supported against the vigorous opposition of the more conservative members of the New York Camera Club, which had recently merged with the Society of Amateur Photographers to form the Camera Club of New York,

The Armory Show

On February 15, 1913, an exhibition sponsored by the Association of American Painters and Sculptors opened at the armory quartering the 69th Regiment of the National Guard in New York City. Baptized "The Armory Show," the intention of its organizers was to bring the most advanced European art to the consciousness of American artists, who would be tested by showing alongside the work of their counterparts from across the Atlantic. The effort to find such work took the show's impresarios, Arthur B. Davies and Walt Kuhn, associates of the most noticeable wing of the American avant-garde—a group of realist painters called The Eight (Stieglitz's more radical 291 operation was known mostly to insiders)—all around Europe. For the developing international avant-garde exhibition circuit now included the "Sonderbund International" in Cologne, Roger Fry's "Second Post-Impressionist Exhibition" in London, as well as shows at The Hague, Amsterdam, Berlin, Munich, and Paris, where Gertrude Stein and other Americans-in-residence gave Davies and Kuhn access to dealers such as Daniel-Henry Kahnweiler and Ambroise Vollard, or artists like Constantin Brancusi, Marcel Duchamp, and Odilon Redon.

Outrage against the exhibition's 420 works, expressed by the press, mounted quickly during the month of the show's duration, bringing record crowds (a total of 88,000) to the Armory. Famous sneers at Brancusi's *Mlle Pogany* ("a hard-boiled egg balanced on a cube of sugar"), at Duchamp's *Nude Descending a Staircase* ("explosion in a shingle factory"), at Henri Matisse's *Blue Nude* ("leering effrontery") set part of the tone. But the other part was fixed by the leap in taste among American artists and collectors who experienced the assembled work as a revelation. Thus, while the newspaper headline in the *Sun* ironically signaled the exhibition's departure as good riddance— "Cubists Migrate, Thousands Mourn"—the success of the show, which had also toured Chicago and Boston, inaugurated a clamor for advanced art, which would now be hosted at department stores, art societies, and private galleries (between 1913 and 1918 there were almost 250 such exhibitions). Another immediate effect was the repeal of the fifteen percent import duty on art less than twenty years old, a legal battle led by lawyer and collector John Quinn. It was this that permitted European art to enter the States, but it also set the stage for the notorious customs case over the entry of Brancusi's *Bird in Space* in 1927, in which modernism's very status as art became a legal issue.

the magazine's sponsor. In 1902, on the pattern of other avant- ▲ garde "secessions," this group resigned from the Club and constituted itself as "The Photo-Secession," led by Stieglitz, who inaugurated *Camera Work* as its editorial arm in 1903 and, with the encouragement and assistance of Steichen, opened "The Little Galleries of the Photo-Secession" in 1905.

Soon, however, Stieglitz's natural antipathy to Pictorialist manipulation and his belief instead that photographic excellence must arise from a "straight" approach to the medium, opened a rift

▲ 1959d ▲ 1900a

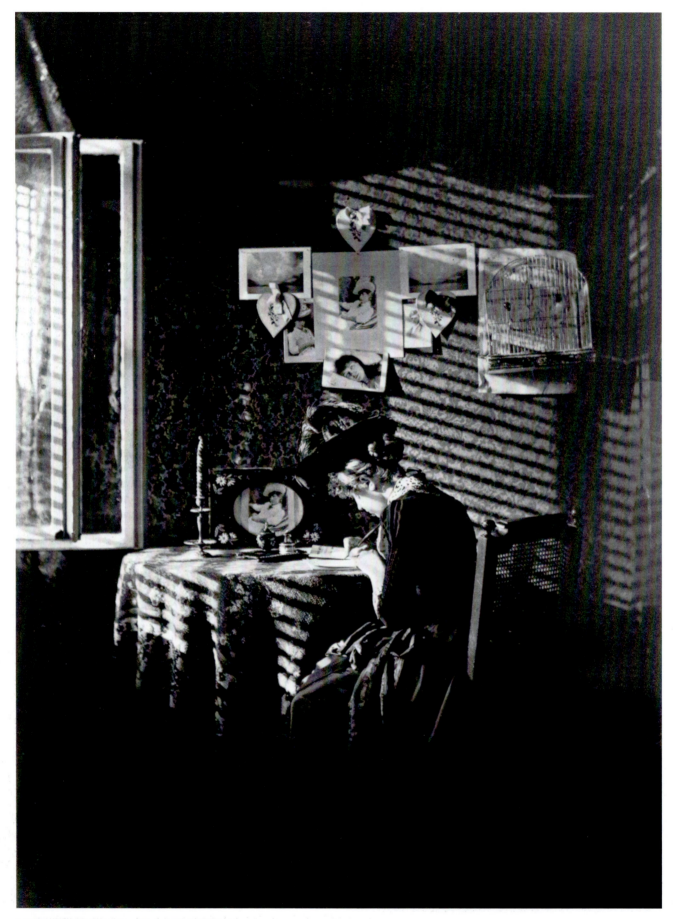

2 • Alfred Stieglitz, *Sun Rays—Paula—Berlin*, 1889
Silver-gelatin print, 22 × 16.2 (8⅝ × 6⅜)

between himself and his Photo-Secession confreres. Confessing to Steichen that he could not see enough strong work coming from photographic quarters to fill the gallery, Stieglitz relied on the younger man, by now installed in Paris, to supply the gallery with serious work, by which the two agreed that the choice must necessarily shift from photography to modernist painting and sculpture.

▲ Beginning with the Rodin drawings that Steichen picked out in 1908, the selections came to be increasingly influenced by far more adventurous tastes, whether they were those of Leo and Gertrude
• Stein or those of the American organizers of the 1913 Armory Show who had been scouring Europe for examples of the most advanced work. Thus Stieglitz's commitment to straight photography progressively synchronized itself with a belief in Cubism and African art rather than with the late Symbolist values of Pictorialism celebrated by and through Steichen's portrait of Rodin.

Indeed, nothing could offer a greater contrast than Steichen's *Rodin and The Thinker* [3] and Stieglitz's *The Steerage* [4]: the former, a willing sacrifice of detail to the dramatic conflation of silhouetted profiles (the sculptor's confronting the hunched contour of his own *Thinker*) against the blurred features of Rodin's *Victor Hugo*, which, godlike, constitutes the enigmatic background; the latter, a devastatingly sharp play of forms. Captured from the upper deck of an ocean liner, *The Steerage* peers down into the jumble of human forms separated visually from the parade of bourgeois passengers above it by the bright diagonal of a gangplank. The separation of classes could not, thus, be more forcefully maintained even while the photograph's even-handed mechanical viewing, which holds everything in the same focus, produces a redistribution of "wealth" over the surface of the image, such redistribution given a formal translation in the rhyming of ovals (the straw hats, the sunlit caps, the boat's funnels) over the surface of the print.

It would be this principle of rhyming, but now emptied of its social content and, almost, of any recognizable content whatsoever,

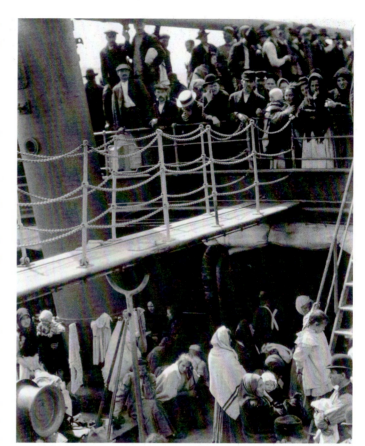

4 • Alfred Stieglitz, *The Steerage*, 1907
Photogravure, 33.5 × 26.5 (13¼ × 10⅜)

that Stieglitz would find in the work that Strand produced in the summer of 1916, after having experimented with Pictorialism for a number of years. Whether it was *Abstraction, Bowls* or *Abstraction, Porch Shadows, Twin Lakes, Connecticut* [5], Strand so controlled the play of light that a deep ambiguity settled over the image—as concave confused itself with convex, or vertical field with horizontal—without yielding anything of the relentless sharpness of the photographic as such. Indeed Strand's photographic "abstraction" did not seem to depend on pushing toward the unrecognizability of the objects photographed. The experience of being startled by a kind of hyper-vision—vision ratcheted into a focus beyond any normal type of seeing—that outdistanced the mere registration of this or that object could be found in Strand's presentation of lowly things such as *The White Fence* (1916), a line of pickets seen against a darkened yard.

The jolt delivered to Stieglitz by Strand's photography was reinforced by his growing sense of conviction that modernism itself was no longer the exclusive property of Europe. And, indeed, at the same moment when he encountered Strand's new work he had another revelation, in the form of the series of drawings by
▲ Georgia O'Keeffe (1887–1986) called *Lines and Spaces in Charcoal*, which had been passed to him by a friend, and which he exhibited in 1916 as well. The abstract watercolors that O'Keeffe went on to make in 1917, flooded as they were with a kind of pure luminosity, constituted the final exhibition at 291.

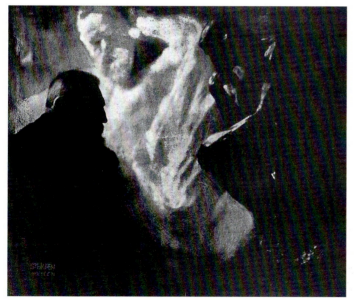

3 • Edward Steichen, *Rodin and The Thinker,* 1902
Gum-bichromate print

▲ 1900b • 1907

▲ 1927c

5 • Paul Strand, *Abstraction, Porch Shadows, Twin Lakes, Connecticut*, 1916
Silver-platinum print, 32.8 × 24.4 (12⅞ × 9⅝)

By 1918 Stieglitz had set off on a new phase of his life and his art. Living now with O'Keeffe and spending his summers with her at Lake George, New York, he turned with a new intensity to photography. In certain instances he seemed bent on outdoing Strand in the dazzling purity of a photographic kind of "hypervision." But in other parts of his work he returned to the kind of investigation he had opened in *Sun Rays—Paula—Berlin*, namely the naked answer to the question "What is a photograph?"

The abstraction of the cut

Coming most radically in the form of a series of cloud pictures that Stieglitz made between 1923 and 1931, called *Equivalents* [6], the answer to this question was now struck by the drive toward unity that one finds in many modernist responses to the same kind of ontological question—"What is _____?"—responses, when posed for the medium of painting, for instance, that take the form of the monochrome, the grid, the image placed serially, etc. Stieglitz's answer now focuses on the nature of the cut or the crop: the photograph is something necessarily cut away from a larger whole. In being punched out of the continuous fabric of the heavens, any *Equivalent* displays itself as a naked function of the cut, not simply because the sky is vast and the photograph is only a tiny part of it, but also because the sky is essentially not composed. Like Duchamp's
▲ readymades, these pictures do not attempt to discover fortuitous compositional relationships in an otherwise indifferent object; rather, the cut operates holistically on every part of the image at once, resonating within it the single message that it has been radically moved from one context to another through the single act of being cut away, dislocated, detached.

This detachment of cutting the image away from its ground (in this case, the sky) is then redoubled within the photograph as its resultant image produces a sense in us as viewers that we have been vertiginously cut away from our own "grounds." For the disorientation caused by the verticality of the clouds as they rise upward along the image in sharp slivers results in our not understanding what is up and what is down, or why this photograph that seems to be so much *of* the world should not contain the most primitive element of our relationship to that world, namely our sense of orientation, our rootedness to the Earth.

In unmooring, or ungrounding, these photographs, Stieglitz naturally enough omits any indication of Earth or horizon from the image. Thus, on a literal level, the *Equivalents* float free. But what they lose literally, they parody formally, since many of the images are strongly vectored (that is, given a sense of direction), light zones abruptly bordering dark ones, producing an axis, like the separation of light and dark achieved by the horizon line that organizes our own relation to the Earth. Yet this formal echo of our natural horizon is taken up in the work only to be denied by being transformed into the uninhabitable verticality of the clouds.

At this moment, then, the cut or crop became Stieglitz's way of emphasizing photography's absolute and essential transposition

6 • Alfred Stieglitz, *Equivalent*, c. 1927
Silver-gelatin print, 9.2 × 11.7 (3⅝ × 4⅝)

of reality; essential not because the photographic image is unlike reality in being flat, or black and white, or small, but because as a set of marks on paper traced by light, it is shown to have no more "natural" an orientation to the axial directions of the real world than do those marks in a book we know as writing. It is in this "equivalence" that "straight" photography and modernism effortlessly join hands. RK

FURTHER READING
Jonathan Green (ed.), *Camera Work: A Critical Anthology* (New York: Aperture, 1973)
Maria Morris Hambourg, *Paul Strand, Circa 1916* (New York: Metropolitan Museum of Art, 1998)
William Innes Homer, *Alfred Stieglitz and the American Avant-Garde* (Boston: N.Y. Graphic Society, 1977)
Dickran Tashjian, *Skyscraper Primitives: Dada and the American Avant-Garde, 1910–1925* (Middletown, Conn.: Wesleyan University Press, 1975)
Allan Trachtenberg, "From *Camera Work* to Social Work," *Reading American Photographs* (New York: Hill and Wang, 1989)
Jay Bochner, *An American Lens: Scenes from Alfred Stieglitz's New York Secession* (Cambridge, Mass.: MIT Press, 2005)
Malcolm Daniel, *Stieglitz, Steichen, Strand* (New Haven and London: Yale University Press, 2010)

▲ 1914

1917a

After two years of intense research, Piet Mondrian breaks through to abstraction and goes on to invent Neoplasticism.

When, in July 1914, Piet Mondrian returned to Holland for a family visit, his sojourn was caught up in the events of World War I, keeping him away from Paris for five long years. If he had originally moved to the French capital in early 1912 with one goal in mind, it was that of mastering Cubism. Unaware, however, of the movement's recent redirection in relation to its innovative use of collage, with all its consequences for the status of the representational sign, Mondrian wound the clock back to the summer of 1910. At that particular moment in Cubism's history, both Picasso and Braque, having found themselves on the verge of painting totally abstract grids, had recoiled. First reintroducing snippets of referentiality into their pictures (such as the tie and mustache in Picasso's *Portrait of Daniel-Henry Kahnweiler*, they soon added lettering, flush with the picture plane, that aimed to make everything else in the painting look three-dimensional by comparison, thus ensuring that the representational character of the picture be at least hinted at.

Reading this Analytical Cubism through the lens of fin de siècle Symbolism mixed with Theosophy (an occultist and syncretic doctrine that combined various Eastern and Western religions and philosophies, highly popular in Europe at the turn of the century), Mondrian quickly became aware that just what Picasso and Braque feared most (abstraction and flatness) was precisely what he was searching for, since that would accord with the category of "the universal" that was central to his own belief system. Adopting a frontal point of view, Mondrian found a way of translating his favorite motifs (first trees and then architecture—most notably, in 1914, blank walls uncovered by the demolition of adjacent buildings) into a more orthogonally rigorous version of the Cubist grid. Through this means, what he called an image's *particularity* is overcome and spatial illusion is replaced by "truth," by the opposition of vertical and horizontal that is the "immutable" essence of all things. The method is infallible, Mondrian thought at the time: everything can be reduced to a common denominator; every figure can be digitalized into a pattern of horizontal versus vertical units and thus disseminated across the surface; and all hierarchy (thus all centrality) can be abolished. The picture's function now becomes the revelation of the world's underlying structure, understood as a reservoir of binary oppositions; but further, and more

1 • Piet Mondrian, *Compositie 10 in Zwart Wit* (Composition No. 10 in Black and White), 1915
Oil on canvas, 85 × 108 (33½ × 42½)

important, it is also to show how these oppositions can neutralize one another into a timeless equilibrium.

It was at this juncture, in 1914, that Mondrian went back to Holland, where, unlike his isolated situation in France, he had a considerable following, for beginning in 1908 he had turned away from Dutch naturalism, embraced modernism, and immediately risen to the head of the local avant-garde. Joining his old Theosophist friends in his usual summer haunt—the artists' colony of Domburg—he attempted to apply his digitalizing technique to the motifs he had painted in various Postimpressionist styles—the small Gothic church, the sea, the piers—before having left for Paris. Only two paintings would result from this group of studies (one in 1915, *Composition No. 10 in Black and White* [1], better known by its nickname *Pier and Ocean*; the other, *Composition 1916*), but together they mark a sea change.

One of the most important factors in this shift was Mondrian's exposure to the philosophy of Hegel, which helped him break away from the inherently static character of digitalization and the neo-Platonic notion of essential truths to be disclosed behind a world of illusions. For if Hegel's Theory of Dialectics is grounded in opposi-

2 • Piet Mondrian, *Compositie in lijn* (Composition in Line), 1916/17
Oil on canvas, 108 × 108 (42½ × 42½)

tions, it does not seek their neutralization. On the contrary, it is a dynamic system moved by tensions, by contradiction. Mondrian's lifelong motto coined at that time—"each element is determined by its contrary"—stems directly from Hegel. The issue is no longer the translating (or, since it is a matter of establishing a set of arbitrary signs that will turn the real world into a form of code, a better term would be *transcoding*) of the visible world into a geometric pattern, but rather the enactment on canvas of the laws of dialectics that govern the world, visible or not.

Though both *Composition No. 10 in Black and White* and *Composition 1916* were based on drawings that had refined the digitalizing method, these canvases now forsook it, abandoning as well the overall symmetry that had resulted from the process (from now on symmetry would be banned from Mondrian's work). In the "plus/minus" drawings that led to the first of these two paintings, Mondrian explored the cruciform structure resulting from the vertical intrusion of the pier as seen from above into the horizontality of reflections on the sea. But rather than the cruciform itself, what we

see in the painting is its simultaneous gestation and dissolution—something perfectly caught by Theo van Doesburg (1883–1931) when he wrote about the work in a review that its "methodical construction embodies 'becoming' rather than 'being.'" And although almost immediately after completing it, Mondrian would judge *Composition 1916* severely for its too-strong emphasis on one direction in particular (the vertical), all references to the church facade have been suppressed in the work: it is no longer the spectacle of the world that is transcoded but the elements of the art of painting itself that are digitalized—line, color, plane, each reduced to a basic cipher. Though Mondrian would never entirely forgo his original spiritualist position, his art now became, and would remain, one of the most elaborate explorations of the materiality of painting itself, an analysis of its signifiers. This dialectical jump from extreme idealism to extreme materialism is a common feature in the evolution of many early pioneers of abstraction.

Mondrian's principle of reduction is that of maximal tension: a straight line is but a "tensed curve." The same argument goes for surfaces (the flatter, the tenser) and was soon to apply to color. That Mondrian would wait four more years (until 1920) before adopting the triad of the pure primaries (red, yellow, and blue, used alongside black, gray, and white) should not mask the fact that he already knew at this point that it was the inevitable consequence of his logic. He had first to purge himself entirely of the idea, derived from Goethe, of color as the matter that sullies the purity (read spirituality) of light—this was the last vestige of representation to go, perhaps because its mimetic character, coated in symbolism, was harder to detect. But this delay did not prevent Mondrian, when he started work on *Composition in Line* [2] in mid-1916, from taking the plunge into pure abstraction.

Once freed from any referential obligation, Mondrian's work evolved at breakneck speed. *Composition in Line*, finished in early 1917, radicalizes the dynamism of the two previous works, accentuating the tension between an originary randomness and a purported nonhierarchical order. But with it Mondrian realized that a major component of the pictorial language still remained somewhat passive in his work. For, though the figure itself, utterly dispersed by and absorbed within the grid, is now so thoroughly atomized that it is bound to remain a virtuality—each cluster of linear units competing for attention—the white ground behind these black or dark-gray lines is not yet fully "tensed." It is optically activated by the geometrical relations that virtually interconnect the discrete elements of the picture, but in itself it remains an empty space waiting to be filled with a figure—and this, Mondrian now understood, would stop only if the ground ceases to exist as ground. Which is to say that the opposition between figure and ground—the very condition of representation—had to be abolished if an aesthetic program of pure abstraction were to be fulfilled. It was to finding means of achieving this that Mondrian devoted the years from 1917 to 1920.

In a series of canvases immediately following *Composition in Line*, Mondrian eliminated all superimposition of planes. In the first of these paintings, lateral extension is conceived as an antidote to atmospheric illusion, but soon Mondrian realized that floating color planes, appearing as though they were going to glide sideways out of the picture, still presuppose the neutrality of the ground. Gradually aligning the colored rectangles, and, most importantly, ending up this series by dividing the interstitial space itself into rectangles of various shades of white, he thereby eliminated the very notion of passive interstice.

The final step in this rapid march toward the abolition of the ground as ground would be the modular grid, which Mondrian explored in nine canvases dating from 1918 and 1919. In using the proportions of the canvas as the basis of its division into regular units, Mondrian came to terms with a deductive structure that suppresses, in principle, any projection of an a priori image onto the surface. There is no difference between ground and nonground (or, to put it another way, the ground is the figure, the field is the image). The whole surface of the canvas has again become a grid, but this grid is no longer a Cubist scaffolding built up in empty space, since every zone of the canvas is now transformed into a commensurable rectangular unit.

This does not mean, however, that every unit is of equal weight: throughout this series of modular canvases, which comprises his first four so-called "diamond" paintings, Mondrian never abandoned an opposition between marked (through a greater thickness of the "contour," or through color) and unmarked units. This may come as a surprise were it not for Mondrian's Hegelianism: a dynamic tension must lie at the core of any work, which is what an even grid would automatically disallow. (It is precisely because the allover continuity of a regular grid annuls the pathos of tension that a painter such as Ad Reinhardt, and scores of Minimalist artists after him, had such a predilection for this form.) So in Mondrian's least compositional works, the poorly nicknamed *Checkerboard Composition with Dark Colors* and *Checkerboard Composition with Light Colors* [3], there is a sense of struggle between the "objective" data of the operating module and the "subjective" play of the color distribution. In order for the "universal" to manifest itself, a zest of "particularity" must still be factored in—at least for the time being.

These two paintings are the last of the kind. As soon as he finished them, in the spring of 1919, Mondrian returned to Paris, utterly confident that with his modular grids he had just discovered the ultimate answer to most pictorial problems facing artists in the wake of Cubism. But the atmosphere had changed in the French capital, as exemplified by Picasso's exhibition of neoclassical works. This surely helped Mondrian realize that the absolute "elimination of the particular" was a utopian dream, and thus that the solution of the modular grid, for all its radicality, was, if not a red herring, at least ahead of its time—something for the distant future perhaps, when conditions of perception would have changed, but something that no one would be able to grasp in the present situation. Furthermore, Mondrian began to realize that the modular grid did not accord with his own theories and beliefs: in that such grids are based on repetition (for Mondrian, there was

▲ 1917b, 1928a, 1937b ● 1913

▲ 1957b ● 1919

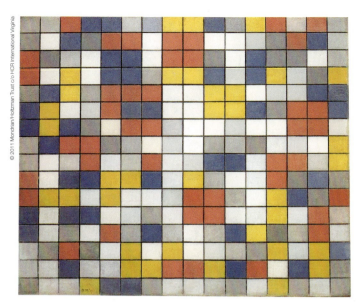

3 • Piet Mondrian, *Composition with Grid 9: Checkerboard Composition with Light Colors*, 1919
Oil on canvas, 86 × 106 (33⅞ × 41¾)

no difference between the repetitive rhythm of a machine and that of the seasons), and because reticulation (division into a network of squares engenders illusionistic optical effect (all illusions are feats of nature), he felt that they doubly contradicted his theoretical ban on the "natural."

The invention of Neoplasticism

By the end of 1920, Mondrian's mature style, which he called "Neoplasticism," was in place. Its invention was the result of an intense period of work during which Mondrian gradually eradicated modularity. The difficult goal he now set himself was to reintroduce composition without restoring the hierarchical opposition of figure and ground. The path he chose drew from the same logic that had given birth to his regular grids, but now in reverse. The new equilibrium would not be based on the promise of an equalization of all units but on their dissonance. Optical illusions would now be eliminated entirely, not only the effects of visual flicker induced by the clustering of black lines at the intersections of the grids but even, in the end, the very possibility of color contrasts: color planes cease to be adjacent and, from now on, they are more often than not displaced to the painting's periphery. There is no more opposition between figure and ground here than in the modular grids, but now each unit, clearly differentiated (it is at this point that the primary colors appear), aims at destroying the centrality of all others.

Composition with Yellow, Red, Black, Blue, and Gray [4], the first Neoplastic painting proper, demonstrates the efficiency of Mondrian's new method. Although the balancing logic of the painting had called for a large central square, we do not perceive it as such. In this pictorial language, with its hostility to the idea of the gestalt (or form understood as the separation of figure from its background), nothing, not even an easily recognized shape (rectangle, square)

placed on the axis of symmetry, must get the lion's share of attention. From now on, each Neoplastic painting would be a microcosmic model, a practico-theoretical object in which the destructive powers of dialectical thought are tested each time anew. *Each time anew* needs to be emphasized here, for unlike most painters in the tradition of geometrical abstract art, Mondrian never worked according to a formula—there is never anything predetermined in his compositions, each conceived, in dialectical fashion, as an improvement over its predecessor, and each geared toward the same goal: creating in itself a new kind of equilibrium, an equilibrium in tension, in which each element would be endowed with the maximal energy, and which he exposed in terms very similar to those used after the war by military strategists when advocating the theory of deterrence (Mutual Assured Destruction).

The years immediately following the advent of Neoplasticism would be Mondrian's most productive (one fifth of his Neoplastic output was painted from the end of 1920 to mid-1923). He did not work exactly in series, but he returned over and over to three compositional types that he would transform as he pressed on—the most minute change in one area necessitating a complete reformulation of the whole canvas, a fact made all the more patent by the drastic paring down of Mondrian's pictorial vocabulary, now limited to planes of primary colors and to elements of 'non-colors' (black lines, white planes and, albeit rarely, gray ones). Those three compositional types, very different from each other, were based on the idea that an element seemingly poised to dominate the canvas had to be undermined by the combined actions of all the other elements (these dominating features could be a large square or near-square in its central area, as in the first Neoplastic painting just discussed; or two lines bisecting the painting, also close to the central area; or a large "open" plane, colored or not, in one of its corners, limited on two of its sides by the edges of the canvas). And just as the radical limitation to his pictorial vocabulary was a direct consequence of his principle of "dynamic equilibrium" (a concept he would formulate only in the thirties), the number of elements present in one single work could also be reduced in order to augment each element's share of the tension. In the barest of all his works, *Lozenge Composition with Two Lines* of 1931 [5], two black lines of unequal width, one vertical and the other horizontal, traverse a square white surface placed on its tip, and cross not far from its lower left border. The work is so simple in appearance that the origin of its gripping tautness is hard to discern at first: the "crossing," contrary to what one is tempted to believe (precisely by the habits of perception that Mondrian's art never cease to combat), is *not* symmetrically disposed along an oblique axis that would divide the canvas into two parts mirroring each other. It is only *nearly* so. The four white planes are different—maximal difference in the case of the tiny triangle at lower left and the large pentagon that covers the largest expanse of the canvas, and minimal difference in the case of the two irregular quadrangles at both sides of the painting. This latter, almost imperceptible difference, as well as that of the width of the black

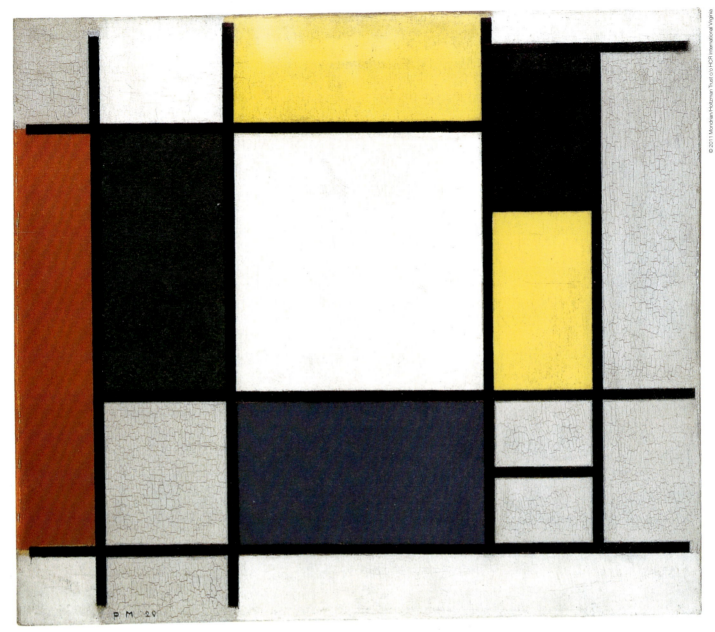

4 • Piet Mondrian, *Composition with Yellow, Red, Black, Blue, and Gray*, 1920
Oil on canvas, 51.5 × 61 (20¼ × 24)

bars, is what subliminally annuls the potentially static resolve of symmetry and sets the painting into motion. None of Mondrian's colleagues would have dared come so close to symmetry—in itself an absolute taboo in his art—because none would have been as confident that it could be simultaneously, or rather dialectically, courted and undermined.

"A surrogate of the whole"

A lot has been written on Mondrian's so-called "lozenge" paintings (there were sixteen of them spanning his whole career as an abstract painter, from 1918 to 1944; he himself called them *tableaux losangiques*, a clumsy French neologism he created, and they were often called "diamond" by art historians, although neither term is appropriate since they are actually square canvases positioned on one of their tips). The main point discussed in the literature is their paradoxical nature with regard to the opposition between extension and limitation. Though Mondrian continually stressed that his canvases were autonomous paintings, independent from the architectural setting that would eventually host them, each complete in itself as a microcosm, he seemed at first sight in these *losangiques* works to be advocating a virtual extension of the composition into the surrounding space—or, more precisely, implying that they were fragments of a whole, slivers of an invisible yet all-encompassing orthogonal grid that they would be revealing to us. That idea, noto- ▲ riously put forward by the painter Max Bill in the fifties and later by art historian Meyer Schapiro, seemed to be in accordance with the call for a unification of painting and architecture that was a crucial

▲ 1928a, 1937b, 1947a, 1959e, 1967c

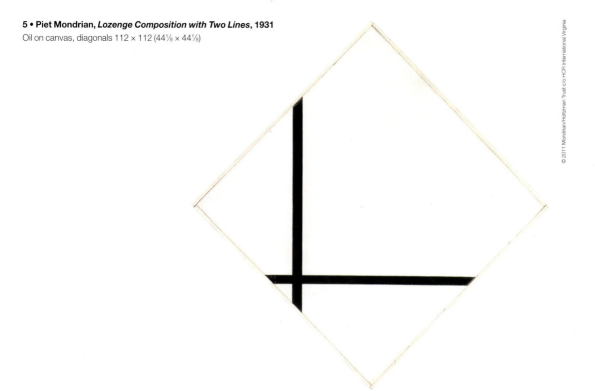

5 • Piet Mondrian, *Lozenge Composition with Two Lines*, 1931
Oil on canvas, diagonals 112 × 112 (44⅛ × 44⅛)

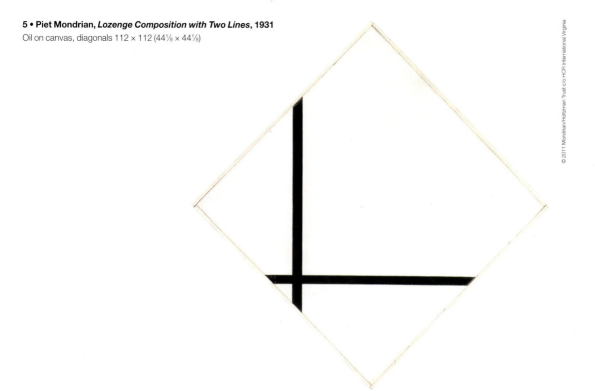

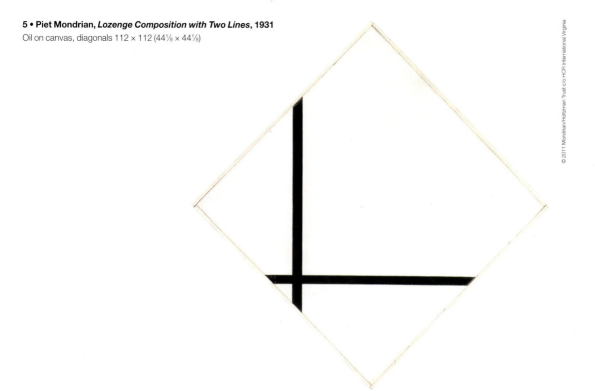

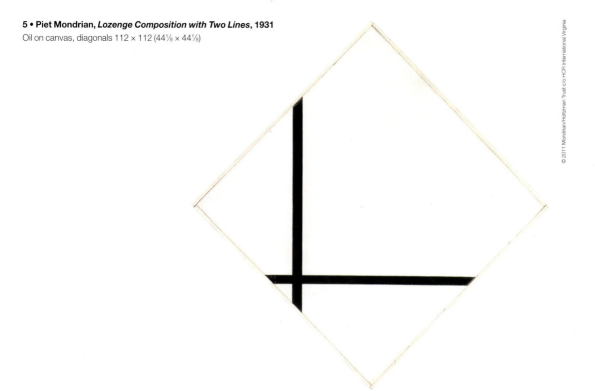

© 2011 Mondrian/Holtzman Trust c/o HCR International Virginia

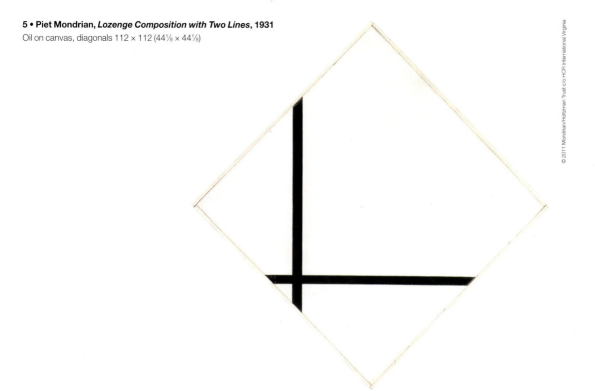

▲ rallying cry for the members of the De Stijl movement (of which Mondrian was a prominent member from 1917 to 1924), and with Mondrian's own utopia of a future dissolution of art into the environment. But no matter how seductive the matching of Mondrian's "*losangique*" format and his ideas about architecture might seem, the link is based on a double misunderstanding—of the works themselves and of the theory.

Contrary to what one might believe, Mondrian always insisted that the Neoplastic canvas was a closed totality, a "surrogate of the whole," as he loved to say, and thus necessarily contrasting with its (chaotic, natural, "undetermined") environment, wherever it would be placed—until, that is, modern architecture had evolved to the point when it could effortlessly integrate his art because it would share its general principles; but that point, he kept warning, was some way off in the future. The idea that his canvases, in underlining by themselves the "disharmony" of their surroundings, could function as a kind of accelerator in the progress of humankind toward its vision of an abstract built environment even precedes the formation of Neoplasticism (it first appears in 1917 in his writings); but as Mondrian devoted more and more thoughts to the issue of architecture throughout the twenties, this view gradually became a mantra, culminating in his 1927 essay "The Home—Street—City." In the present condition of architecture and urbanism, Mondrian stated, the best a Neoplastic artist can do is to adjust the interior space of his studio to the aesthetic rigor of his paintings, hoping that this homeopathic dose of Neoplasticism injected into the built environment would in time induce a transformation of the whole house (adjusting to the Neoplastic studio in the same manner as the studio had adjusted to the Neoplastic paintings it contained), then that the same process

would spread to the whole street, then to the city, then ... to the world at large. Mondrian firmly clung to his utopian belief in such a chain reaction, hence the considerable energy he devoted, from 1920 to his death, to the constant transformation of his working and living space into a "chromo-plastic environment" whose walls were covered with colored pieces of cardboard, their number, size, and position changing in sync with the evolution of his art. (This work in progress, particularly the studio/apartment Mondrian occupied from 1921 to 1936 at the 26 rue du Départ in Paris, became a staple of the European avant-garde, visited by countless artists on whom it had a profound impact—the most famous
▲ example being Alexander Calder, who credited his conversion to abstraction to such a visit in October 1930).

The utopia sounds naive today, but Mondrian himself knew full well that it was far-fetched, which is why he had a more immediate goal for his paintings, entrusting them with a role they had to perform even in the most hostile environment: their linear grids would not virtually extend into the architectural space, but each picture would nevertheless be endowed with an expansive force; it would "irradiate in space," and, in doing so, "correct" the ugliness around it; it would be a bundle of energy so powerful that it would visually control the room in which it was hung. YAB

FURTHER READING
Carel Blotkamp, *Mondrian: The Art of Destruction* (New York: Harry N. Abrams, 1994)
Yve-Alain Bois, "The De Stijl Idea," *Painting as Model* (Cambridge, Mass.: MIT Press, 1990)
Piet Mondrian, *The New Art—The New Life* (Boston: G. K. Hall & Co, 1986)
Yve-Alain Bois, Joop Joosten, and Angelica Rudenstine, *Piet Mondrian* (Washington, D.C.: National Gallery of Art, 1994)
Joop Joosten and Robert P. Welsh, *Piet Mondrian*, catalogue raisonné, 2 vols (New York: Harry N. Abrams, 1998)

▲ 1917b

▲ 1931b, 1955b

1917 b

In October 1917, the journal *De Stijl* is launched by Theo van Doesburg in the small Dutch town of Leiden. It appears monthly until 1922, after which publication is irregular. The last issue dates from 1932 as a posthumous homage to van Doesburg shortly after his death in a Swiss sanatorium.

There are three ways of defining De Stijl, and all three were used by Theo van Doesburg in a 1927 retrospective article on the movement: (1) as a *journal*, (2) as a *group* of artists assembled around this journal, and (3) as an *idea* shared by members of this group. The first definition is the most convenient, for it is derived from a definite corpus. It is undeniable that the journal is the most prominent incarnation of the movement: its reputation as the first ever periodical devoted to abstraction in art is well deserved. Furthermore, it was the major link between group members, who were geographically dispersed and, in some cases, never actually met. Yet the very eclecticism of the journal, its openness to all aspects of the European avant-garde, could lead one to doubt that De Stijl had any specific identity as a movement. According to this definition, everything that appeared in *De Stijl* is "De Stijl." But to rank the Dadaists Hugo Ball, Hans Arp, and Hans Richter, the Italian Futurist Gino Severini, the Russian Construc-▲tivist El Lissitzky, and the sculptor Constantin Brancusi among De Stijl's "main collaborators," as van Doesburg does in 1927, not to mention the inclusion of Aldo Camini and I. K. Bonset (that is, van Doesburg himself under a Futurist and a Dadaist guise), is to miss what constituted the *group*'s strength and unity.

Indeed, it is the second definition—De Stijl as a group—that is the most commonly accepted. It establishes a simple hierarchy, based on historical precedence, between a handful of Dutch founding fathers and a heteroclite detachment of cosmopolitan new recruits who joined at various times to fill the gaps left by defecting members. Generally speaking, the founding fathers are those who signed the *First Manifesto* of De Stijl, published in November 1918: • the painters Piet Mondrian and the Hungarian Vilmos Huszár, the architects Jan Wils and Robert van't Hoff, the Belgian sculptor Georges Vantongerloo, the poet Antony Kok, and of course van Doesburg, the *homme-orchestre*, the only real link between the group members and the mainspring of the movement. To those names, one must add those of the painter Bart van der Leck (who had already left De Stijl before the publication of this manifesto) and the architects Gerrit Rietveld and J. J. P. Oud (the former had not yet joined the group, although he had produced an unpainted version of the *Red and Blue Chair*, which—in its painted form— was to become the landmark of the movement; the latter never

signed any collective text). For their part, the new recruits, with the exception of the architect Cornelis van Eesteren, all pursued careers independently from De Stijl and were only briefly associated with the movement when it was already approaching the end of its course. For example, the American musician Georges Antheil; the creators of reliefs César Domela and Friedrich Vordemberge-Gildewart; the architect and sculptor Frederick Kiesler; and the industrial designer Werner Gräff. But despite its usefulness, this second definition turns out to be only slightly more precise than the first, based as it is on what seems to be a purely circumstantial criterion of inclusion. It cannot explain, for example, van der Leck's defection from the movement in its first year, or Wils's and van't Hoff's in the second, Oud's in the fourth, Huszár's and Vantongerloo's in the fifth, and finally Mondrian's in 1925.

There remains therefore the third definition, De Stijl as an *idea*: "It is from the De Stijl idea that the De Stijl movement gradually developed," wrote van Doesburg in his retrospective article. Although this definition seems the vaguest of the three, it turns out, by its conceptual nature (as opposed to the empirical character of the other two), to be the most restrictive. What follows is a brief presentation of this "idea."

The principle of De Stijl

De Stijl was a typically modernist movement, whose theory was grounded on those two ideological pillars of modernism: historicism and essentialism. Historicism because it conceived of its production as the logical culmination of the art of the past, and because it prophesized in quasi-Hegelian terms the inevitable dissolution of art into an all-encompassing sphere ("life" or "the environment"). Essentialism because the motor of this slow historical process was an *ontological quest*: each art was to "realize" its own "nature" by purging itself of everything that was not specific to it, by revealing its materials and codes, and in doing so by working toward the institution of a "universal plastic language." None of this was particularly original, although De Stijl's formulation of this modernist theory developed quite early on. The specificity of De Stijl lies elsewhere: in the idea that a *single generative principle* might apply to all the arts without compromising

▲ 1909, 1916a, 1920, 1921b, 1926, 1927b ● 1917a, 1944a

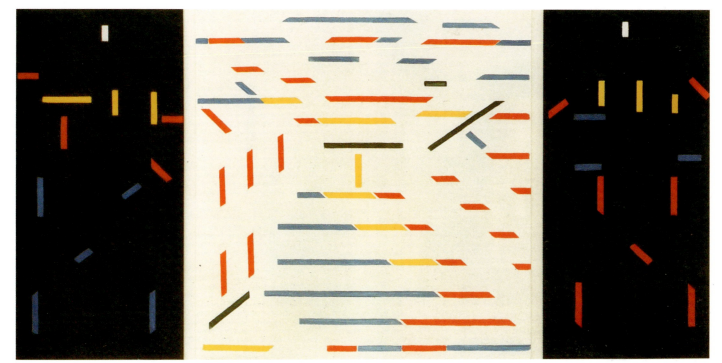

1 • **Bart van der Leck, *Composition 1916, No. 4 (Mine Triptych)*, 1916**
Oil on canvas, 110 × 220 (43⅞₆ × 86⅝)

their integrity, and moreover, that it is only on the basis of such a principle that the autonomy of each art can be secured.

Although this principle was never explicitly formulated by any of the movement's members, it involved two operations one could call *elementarization* and *integration*. Elementarization is the analysis of each practice into discrete components, and the reduction of these components to a few irreducible elements. Integration is the exhaustive articulation of those elements into a syntactically indivisible, nonhierarchical whole. The second operation rests upon a structural principle (like the phonemes of verbal language, the visual elements are meaningful only through their differences from one another). This principle is a totalizing one: no element is more important than any other, and none must escape integration. The mode of articulation stemming from this principle is not additive (as in Minimalism, for example) but exponential (hence De Stijl's rejection of repetition). A perfect example of elementarization-cum-integration is provided by the logo of De Stijl itself: as Michael White noted, the letters were "composed from disjointed blocks and avoided any previous typographic association."

This general principle rapidly displaced the ontological question—"What is the essence of painting / architecture?"—by prompting artists to consider the question of delimitation, of what distinguishes a work of art from its context. As a result, all of the De Stijl painters were interested in the frame and the polyptych format: *Composition 1916, No. 4* by van der Leck (known as the *Mine Triptych*) [1], for example. The logic of this shift goes something like this: as a constitutive element of every form of artistic practice, the limit (frame, boundary, edge, base) must itself be both *elementarized* and *integrated*; but its integration will remain incomplete as long as

the inside and the outside (which the limit articulates) lack a common denominator, that is, as long as the outside itself has not also been subject to the same treatment. Thus, De Stijl's environmental utopia, however naive it may seem today, was no mere ideological dream, but a corollary of the movement's general principle.

A system of oppositions

De Stijl was initially a congregation of painters, which architects later joined, and it was the painters who laid the foundation for De Stijl's "general principle." Although only Mondrian managed to fully translate this principle into practice, with the elaboration of his Neoplastic oeuvre from 1920 on, both van der Leck and Huszár contributed to its formulation. It is known that van der Leck was the first to *elementarize* color (Mondrian credited his own use of the primary colors to him), but he was never able to achieve the *integration* of all the elements of his canvases. As "abstract" as some of his paintings may seem, he never relinquished an illusionistic conception of space. The white ground behaves like a neutral zone, an empty container that exists before the inscription of forms. Thus it is not surprising that van der Leck left the movement in 1918 to "return" to figuration: once the other painters had solved the problem of the ground, van der Leck found that he no longer spoke the same language.

As for Huszár, a handful of compositions—among them, the 1917 cover design for the first issue of *De Stijl* [2] and a 1919 canvas entitled *Hammer and Saw* (the only painting ever to be reproduced in color in *De Stijl*)—reveal his one pictorial contribution to the movement, namely the *elementarization* of the ground, or rather of

2 • Vilmos Huszár, cover of *De Stijl*, vol. 1, no. 1, October 1917
Letterpress on paper, 26 × 19 (10¼ × 7½)

the figure–ground relationship, which he reduced to a binary opposition. Unfortunately, he stopped there and after a brief attempt at using the modular grid at the same time as Mondrian was exploring it (none of these works by Huszár survive), he went back to the illusionistic conception of space of Bart van der Leck that he had emulated earlier.

▲ Having assimilated the lessons of Cubism while in Paris in 1912–14, Mondrian was faster than the others to resolve the question of abstraction, thus he was able to devote all of his attention to the issue of *integration*. His first concern, after the choice for primary colors, was to unite figure and ground into an inseparable entity. Suffice it to say that he rid his pictorial vocabulary of the "neutral ground" only after he had used a modular grid in nine of his canvases (1918–19). Though this device allowed him to solve an essential opposition not considered by others in De Stijl—that of color/noncolor—he found it regressive because it was based on repetition and privileged only one type of relationship between the various parts of the painting (univocal engendering). Back in Paris by mid-1919, he spent the next year and a half ridding the canvas of
● the regular grid: the first truly Neoplastic painting dates from the end of 1920.

Van Doesburg, on the contrary, needed the grid throughout his life; for him it constituted a guarantee against the arbitrariness of the composition. Despite appearances and despite his formulations that sometimes bear "mathematical" pretensions, van Doesburg remained paralyzed by the question of abstraction: if a composition must be "abstract," it had to be "justified" by "mathematical" computations, its geometrical configuration had to be *motivated*. Before he arrived at the grid formula (through his work in decorative art, especially stained-glass windows), this obsession made him hesitate between the pictorial system of Huszár and that of van der Leck. Then it led him to a concern with the stylization of natural motifs (a portrait, a still life, a dancer, or even a cow). He even tried to apply this type of "explanation" to his grid compositions (as in the absurd presentation he made, in 1919, of his *Composition in Dissonance* as an *abstraction from* "a young woman in the artist's studio").

But this was a false trail, for if van Doesburg was seduced by the system of the grid, it was, in opposition to Mondrian, for its *projective* nature (his grids are generally nonmodular—that is, their planes are not modules whose proportion is generated by that of the canvas; they are applied *onto* the picture plane, whose material characteristics are of no importance). The projective, a priori nature of van Doesburg's grids throws some light on the famous quarrel about "Elementarism" (the extremely inappropriate word chosen by van Doesburg to label his introduction of the oblique into the formal vocabulary of Neoplasticism in 1925, as in his *Contra-composition XVI in dissonances*, for example) that led Mondrian to leave De Stijl. But if Mondrian rejected van Doesburg's "improvement," as the latter referred to it, it was not so much because it disregarded the formal rule of orthogonality (which he had broken in his own "lozenge" canvases) than because in a single stroke it destroyed the movement's efforts to achieve a total *integration* of all the elements of the painting. For as they glide over the surface of the canvas, van Doesburg's diagonals re-establish a distance between the imaginary moving surface they inhabit and the picture plane onto which they are applied, and we find ourselves once again before van der Leck's illusionist space. For an evolutionist like Mondrian, it was as if the clock had been turned back eight years. In short, van Doesburg's achievement in painting did not partake of the *general* principle of elementarization and integration that characterizes De Stijl. However, there are two areas in which he did work more efficiently toward the elaboration of this principle: that of the *interior* as art and that of *architecture*.

The importance given to the interior by the De Stijl artists stems both from their questioning of the limits of painting and from their distrust of the traditional notion of applied art. The common view of De Stijl as a movement that applied a formal solution to what is now referred to as "design" is erroneous: decorative art did not interest the De Stijl artists, with the temporary exception, in the case of van Doesburg and Huszár, of stained glass. If the arts were to remain faithful to the principle of De Stijl, then they could not simply be applied to each other, but would have to join together to

create an indivisible whole. The stakes were considerable, and almost all of the movement's internal quarrels resulted from a power struggle between painters and architects over this issue. The invention of the interior as a hybrid art form was not easy; as Nancy Troy has shown, it developed in two theoretical movements.

The interior as art form

The first movement: only when an art has defined the limits of its own field, when it has achieved the greatest possible degree of autonomy and discovered the artistic means specific to itself—that is, through a process of self-definition and differentiation from the other arts—will it discover what it has in common with another art form. This common denominator is what allows for the combination of the arts, for their integration. Thus the members of De Stijl thought that architecture and painting could go hand-in-hand because they share one basic element, that of planarity (of the wall and of the picture plane). Van der Leck is particularly eloquent on this score, but the idea is to be found as well in texts by Oud, Mondrian, and van Doesburg during the first year of *De Stijl*'s publication. From this first movement stems the totality of van der Leck's mostly unrealized interior coloristic projects, the first interiors of Huszár and van Doesburg, Mondrian's Paris studio and his *Projet de Salon pour Madame B..., à Dresde* of 1926. These works share a conception of architecture as static: each room is treated in isolation, as a sum of faces, a six-sided box, which is explicable by the fact that in each case the artist was working within the confines of an already existing architecture.

The second movement is the consequence of a collaborative enterprise turned sour, the first genuine collaboration between a De Stijl painter and architect—that is, van Doesburg and Oud's teamwork for the De Vonk vacation house of 1917 (at Noordwijkerhout), and later for the Spangen housing complex at Rotterdam (1918–21). If this collaboration resulted in creative divorce (Oud refusing the last coloristic projects of van Doesburg for Spangen), it is because, despite van Doesburg's attempt to integrate color into architecture (throughout each building, both inside and out, doors and windows are conceived according to a contrapuntal color sequence), the conventional massiveness of the architecture led the painter to plan his color scheme independently from the structure. This scheme was conceived in relation to the entire building, the wall no longer being the basic unit, and in opposition therefore to individual architectural elements. There is a paradox here: it was *precisely* because Oud's symmetrical, repetitive architecture was *absolutely* antithetical to the principle of De Stijl that van Doesburg was drawn to invent a type of *negative* integration based on the visual abolition of architecture by painting.

"Architecture joins together, binds—painting loosens, unbinds," van Doesburg wrote in 1918. Thus, the "Elementarist" oblique—which appears for the first time in a 1923 van Doesburg color study for a "University Hall" by van Eesteren [3]; again a year later in van Doesburg's design for a "flower room" in the Villa Mallet-Stevens in Hyères; and finally, on a grand scale, in the 1928 Café Aubette in Strasbourg—is each time launched as an attack against a preexisting architectural situation. While the oblique contradicted De Stijl's *integration* principle within the realm of painting, it fulfilled that principle in the new domain of the abstract interior. There, it is not "applied," rather, it is an element with a function (ironically, an antifunctionalist one), that of the camouflage of the building's horizontal/vertical skeleton (its "natural," anatomical aspect). Such camouflage was, for van Doesburg, absolutely necessary if the interior was to work as an abstract, nonhierarchical whole.

3 • Theo van Doesburg, *Project for a University in Amsterdam-Sud*, 1922
Pencil, gouache, and collage on card, 64 × 146 (25³⁄₁₆ × 57½)

4 • Vilmos Huszár and Gerrit Rietveld, *Spatial Color Composition for an Exhibition, Berlin*, 1923, from *L'Architecture vivante*, Autumn 1924

But the oblique was not the only solution to this new integrative task, as Huszár and Rietveld demonstrated in their extraordinary Berlin Pavilion of 1923 [**4**]: the articulation of architectural surfaces (walls, floor, ceiling) could itself be *elementarized* by using the corner as a visual agent of spatial continuity. In this interior, colored planes painted on the walls do not stop where the wall surfaces meet, but overlap, continue around the corner, creating a kind of spatial displacement and obliging the spectator to spin his body or gaze around. Not only had painting solved a purely architectural problem—circulation in space—but, given that the architectural space was not preexisting, this project of a pavilion marked the birth of De Stijl architecture proper.

De Stijl architecture

De Stijl's contribution to architecture is *quantitatively* far less important than what is generally believed: the two little houses Robert van't Hoff built in 1916 (before the foundation of the movement) are amiable and talented pastiches of Wright; Jan Wils's constructions flirt somewhat with Art Deco; as for Oud, his most interesting architectural work, executed after he had broken with van Doesburg, partakes much more of the Neue Sachlichkeit than of De Stijl (one could even say that its functionalism annuls whatever superficial features it might have of De Stijl's idiom). In fact, De Stijl's architectural contribution consists only of the projects exhibited by van Doesburg and van Eesteren in 1923 in the Galerie de l'Effort Moderne in Paris, directed by Léonce Rosenberg, and the work of Gerrit Rietveld. Regarding the former, an argument over attribution initiated by van Eesteren has confused the issue. Attribution here is the wrong question: what is essential is that there is a striking formal difference between the first project (an elegant *hôtel particulier* that anticipates the International Style by several years) and the last two (a *maison particulière* and a *maison d'artiste*). For the difference is the direct consequence of the intervention not of the painter (who worked on all three), but of *painting*: the model of the first project is white, the last two are polychrome. The starting-point of those last projects was indeed the possibility of conceiving simultaneously their coloristic and spatial articulation. And van Doesburg's inflated yet enigmatic claim that, in these projects, color becomes "construction material" is not simply rhetorical: it is color indeed that allowed the wall surface as such to be *elementarized*, culminating in the invention of a new architectural element—the indivisible unit of the *screen*. As van Doesburg demonstrates in the groundbreaking axonometric "analytical" drawings he made for the show [**5**], the screen combines two contradictory visual functions (in profile, it appears like a vanishing line; frontally,

5 • Theo van Doesburg, *Architectural Analysis Counter-Construction*, 1923
Print enhanced with gouache, 51.5 × 61 (20¼ × 24)

▲ 1925b

it is a plane that blocks spatial recession), and this contradiction promotes the visual interpenetration of volumes and the fluidity of their articulation. Thus, the desire to integrate painting and architecture, to establish a perfect coincidence between the basic elements of painting (the color planes) and architecture (the wall), led to a major architectural discovery—walls, floor, ceiling as surfaces without thickness, which can be duplicated or unfolded like screens and made to slide past one another in space.

Van Doesburg was not mistaken when he claimed that Rietveld's Schröder House (1924) was the only building to have realized the principles laid down in the last two projects for Rosenberg, with the proviso that the screen is used there in a much more extensive way, for Rietveld managed to *elementarize* that which had remained a *bête noire* for van Doesburg: the building's frame itself. The Rosenberg projects treat the frame from a constructive perspective (for which van Eesteren claims responsibility). That is, the frame is still treated as "natural," anatomical, motivated, and above all, functional. While the elementarization of the wall surface had led van Doesburg and van Eesteren to make intensive use of overhanging horizontal planes (the cantilever is one of the most distinctive formal features of the projects), Rietveld's invention was to subvert, most of the time by a minimal transformation, the opposition supporting/supported upon which every constructive frame is based. The Schröder House is full of inversions that pervert the functionalist ethic of modernist architecture, the most famous of which being the corner window that, once opened, violently disrupts the structural axis constituted by the intersection of two walls. Rietveld's furniture is based on the same model: in the famous *Red and Blue Chair* [6], for example, one of the vertical elements is both supporting (it bears the armrest) and supported (it hangs off the ground). Be it architecture or furniture, Rietveld understood his works as pieces of sculpture, as independent objects in charge of "separating, limiting and bringing into a human scale a part of unlimited space," as he wrote in 1957. This is in direct opposition to the texts on the interior in the early numbers of *De Stijl*, which focused on architecture as closure. With Rietveld, everything is deployed in such a way as to flatter our intellectual desire to dismantle his pieces of furniture or architecture into their component parts; but we would learn nothing from this operation (probably not even how to reassemble the parts), for the uniqueness of his work resides in the articulation of these elements, in their integration. YAB

FURTHER READING
Nancy Troy, *The De Stijl Environment* (Cambridge, Mass.: MIT Press, 1983)
Carel Blotkamp et al., *De Stijl: The Formative Years* (Cambridge, Mass.: MIT Press, 1986)
Michael White, *De Stijl and Dutch Modernism* (Manchester and New York: Manchester University Press, 2003)
Hans L. C. Jaffé (ed.), *De Stijl* (London: Thames & Hudson, 1970)
Gladys Fabre and Doris Wintgens Hötte (eds), *Van Doesburg and the International Avant-Garde* (London: Tate Publishing, 2009)

6 • Gerrit Rietveld, *Red and Blue Chair*, 1917–18
Painted wood, 86 × 64 × 68 (33⅞ × 25³⁄₁₆ × 26¾)

1918

Marcel Duchamp paints *Tu m'*: his last ever painting summarizes the departures undertaken in his work, such as the use of chance, the promotion of the readymade, and photography's status as an "index."

Marcel Duchamp had landed in New York in 1915 still awash in the celebrity of his *Nude Descending a Staircase No. 2* 1912, the most notorious painting of the 1913 ▲ Armory Show. Whether it was as "A Rude Descending a Staircase," or as "An Explosion in a Shingle Factory" (to echo the popular press), this Cubist picture, having set up a beachhead for avant-gardism in the New World, had secured a welcome for its author among the art patrons and collectors in and around Manhattan—figures such as Walter Arensberg, the Stettheimer sisters, and Katherine Dreier. It is not surprising, then, that Dreier should have asked Duchamp, in 1918, to make a long, friezelike painting to go over the bookcases in her library, something like the commission for decorative panels that Hamilton Easter Field had given to Picasso in 1910. What *is* surprising is that Duchamp should have accepted it.

For by the time of his arrival in America, Duchamp had abandoned working in oils; and the ambitious picture over which he was to begin laboring in 1915, *The Bride Stripped Bare by her Bachelors, Even* (also known as the *Large Glass*), was not, technically speaking, a painting [1]. Supported on trestles in the tiny apartment that Arensberg lent to Duchamp, it was in fact two very large panes of glass to which designs of a highly enigmatic kind were applied by a variety of curious means: dust that had settled on the work during months of inactivity was carefully "fixed" in certain places; or shapes of lead and stretches of wire were glued to its surface; or again, silvering was adhered in a given area and then carefully scratched away so as to leave a tracery of mirrored line. Although the execution was meticulous when actually carried out, Duchamp worked on it only sporadically—the piece was completed in 1923. Indeed, he spent as much time creating the conceptual climate for the work through the mass of notes he jotted down, some as early as 1911, others dating to 1915, which he later published collectively as *The Green Box* (1934).

The note labeled "Preface," and thus accorded some sort of authority over the various ideas generated for the *Large Glass*, is written as a strange syllogism. "Given," it starts, "[1] the waterfall, [2] the illuminating gas, we shall determine the conditions of the instantaneous State of Rest … of a succession of different facts …"; such "instantaneous State of Rest" being equivalent, it tells us in an appendix to the note, to "the expression extra-rapid." Now, if this "Preface" gives us any clues to what Duchamp thought he was doing *in the place* of painting, they are in the terms *instantaneous* (in French *instantané*—the word, if used as a noun, for snapshot) and *extra-rapid*. For in 1914 Duchamp had "published" a group of fifteen notes dealing with his ideas about art by placing the replicated scraps of paper in boxes normally containing photographic glass plates, the advanced technical capacities of which were indicated by the boxes' labels "extra-rapid" or "extra-rapid exposure."

If at first it might seem counterintuitive to think of *The Bride Stripped Bare* as a photograph—so imposing, intricate, and, to use Duchamp's own expression, "allegorical appearing" is it relative to the tiny scale and documentary straightforwardness of a snapshot—we have nonetheless to keep two things in mind. The first is the intense "realism" of the objects suspended within the glass, not only because of their sense of solidity but also because of the strong single-point perspective used to delineate them (and by implication, the space that contains them). The second is the impenetrability of the "allegory" itself, expressed on the one hand by the mechanical contraption housing the bachelors and, on the other, by the metallic shells and amorphous cloud of the bride.

You push the button …

In the years before Duchamp's "Notes" were published the only key to this mysterious narrative was the work's long but somehow noncommittal title, more a statement of fact—a bride is stripped by her (?) bachelors—than an explanation of meaning. Even after their publication, however, the mystery has not lifted but only burgeoned into more and more elaborate decipherings: "the stripping of the bride is an allegory of courtly love"; "the stripping is a kind of alchemical purification—base matter turning into spirit"; "the stripping is our access to the fourth dimension"; etc. As each of these explanations leads to no definitive "solution" but only back to the brute fact of the objects' sitting in the solidity of their "realistic" presentation, we encounter a feature of photography that connects the two aspects of the glass: its verism and its mute resistance to interpretation. For photographs do not bind their interpretive text into themselves the way paintings with their compositional protocols are

▲ 1914, 1916b

1 • Marcel Duchamp, *The Bride Stripped Bare by Her Bachelors, Even (The Large Glass)*, 1915–23
Oil, varnish, lead foil, lead wire, and dust on two sheets on glass panels, 276.9 × 175.9 (109¼ × 69¼)

able to do. Rather, stenciled directly off reality, the photograph is a manifestation of fact which often depends on an added text—such as the newspaper caption—for its explanation.

Addressing photography itself as a structural problem, in the ▲ early sixties the French critic and semiologist Roland Barthes called this basic feature of photography its condition of being "a message without a code." Barthes thereby contrasted the nature of the photographic sign with signs of different types: pictures or maps, say, or words. Insofar as words emerge from a background of systematized language with its own grammatical rules and its own lexical compendium, these particular signs belong to a highly coded system. Moreover, it is only from within that system that meaning attaches to them, since they neither look like the thing to which they refer (the way pictures do) nor are literally caused by it (the way footprints are), and so their relationship to meaning is purely arbitrary and thus conventional; and to mark their distinction from other types of signs, semiologists call them *symbols*.

Pictures, on the other hand, are given the name *icon*, since they relate to their referents not by convention but through the axis of resemblance. Nonetheless, they, too, are able to be composed or manipulated so as to incorporate coded meanings: national colors, for example, or the seating arrangement through which we recognize the Last Supper.

It is the last of the three types of sign, the *index*, that resists coding altogether, since it cannot be internally reorganized or rearranged. This is because the index is literally *caused* by its referent and thus has a blocklike connection to it: like the weather vane pushed into a certain direction by the wind, or the fever induced in the body by microbes, or the circles left on tables by cold glasses, or the patterns etched in the sand by the outgoing tide. Thus, if photography is a message without a code, this puts it in a class with footprints and medical symptoms, and distances it from the Sistine Chapel ceiling, no matter how resemblant (or iconic) a photograph might also be. The fact that it is a photochemically produced trace—the index of the object to which the light-sensitive medium was exposed—is what counts for the semiologist.

It seems also to have been what counted for Duchamp. For across the field of *The Bride Stripped Bare* the index finds multiple repetitions. Not only are the seven conical forms of the "sieves" (that part of the bachelor machine in which male desire is condensed) corporealized by fixing the amount of dust that fell on the glass over the course of several months (an index of time passing), but the nine "shots" (the rays of desire that actually penetrate into the bride's realm) are traces of where matches fired from a toy cannon hit the surface. Or again, the three "draft pistons" (openings in the cloudlike shape appended to the bride) are shapes obtained by suspending a square of fabric in front of an open window, thrice photographing its deformations caused by the wind, and then using the profiles registered on the resultant prints as stencils from which to transfer the shapes to the glass.

Procedurally, the execution of the "pistons" follows that of the *Three Standard Stoppages* [2], an earlier work Duchamp made by dropping three meter-long strings from the height of one meter onto a surface on which the entirely chance configuration of each was fixed, all three then being used to cut stencils that would serve as very curious "yardsticks" indeed, since each one has a different profile and results in a different length. To this artisanally wrought operation of chance, the "pistons" merely added the more mechanical intervention of the camera's shutter and the photographic print.

But the *Three Standard Stoppages* underscore the sense in which the index—the unique trace or precipitate of an event or, in this case, of a chance occurrence—in being "a message without a code," is resistant to language. For language depends on its signs (for example, its words) remaining stable over the many instances of their repetition. Even though a given context may reconfigure the connotation or even the *meaning* (or signified) of a word, its form (or signifier) must be the same for each iteration of it. This is even more nakedly true for units of measure—such as feet and inches—in which both signifier and signified must remain constant from one context to another. Duchamp's ironically non-"standard" yardstick, which changes its length from instance to instance, thus defies the coding that gives measurement its precision and its meaning.

A note from *The Green Box* explicitly connects the two systems—linguistic and numerical—by imagining what Duchamp calls "prime words": "Conditions of a language: the search for 'prime words' ('divisible' only by themselves and by unity)."

2 • Marcel Duchamp, *Three Standard Stoppages*, 1913–14
Thread, glue, and paint on glass panels in a wooden box, 28.2 × 129.2 × 22.7 (11⅛ × 50⅞ × 9)

▲ Introduction 3

The impossibility of the prime number's entering into numerical relations with the rest of the arithmetic system—being divisible by other numbers or dividing itself into them—is thus explicitly related to a kind of linguistic sign that resists the "combinatory function of language"—the rules that allow either a small set of sounds to be recombined into the huge set of words that make up a vocabulary, or that permit the combination of these words into infinite numbers of sentences. The "prime word" can be thought of, rather, as an index lodged inside the system of language, a marker of a specific event, as when a child is baptized with a proper name—which thus belongs uniquely to that child—or when I point my finger toward something and say "this," thus naming (but only for the specific instance of my pointing) a particular object: this book, this apple, this chair.

Panorama of the index

If we started out, then, by seeing the *Large Glass* through the model of the photograph, what we quickly begin to realize is that for Duchamp the photographic category is, in turn, folded into the far more generalized model of the index, which can be visual (snapshots, for instance, but also smoke, fingerprints, etc.) or verbal ("this," "here," "today"). Further, we also realize that the index implies not just a shift in the traditional type of sign employed by the visual artist (from iconic to indexical) but also a deep change in artistic procedure. For the index, insofar as it marks the trace of an event, can be the precipitate of a chance occurrence, as in the deformations recorded by the *Large Glass*'s "draft pistons." Indeed, Duchamp explicitly referred to the *Three Standard Stoppages* as "canned chance." But chance, of course, rules out the traditional artist's desire to compose his or her work, to prepare it step by step. And in abrogating composition, the use of chance also nullifies the idea of skill that had always been associated with the very definition of the artist. Embracing something far more like (and even more radical than) Kodak's photographic slogan "You push the button, we do the rest," Duchamp's use of chance both mechanizes the making of the work (the artist is like a camera, thus depersonalized) and deskills it (nothing, not even a camera, is needed).

The possibilities of Duchamp's recourse to chance were quickly seized on by others who were also interested in strategies for undoing the role of composition in the making of the work. One of
▲ these was Hans Arp, the Dada artist, who some time around 1915 began to make collages by tearing up pieces of paper and dropping
● them onto a waiting surface [3]. Another was Francis Picabia, who threw ink at a page to make a formless splotch which he called *The Blessed Virgin* (1920). In producing this blasphemous conjunction of meaningless sign and sacred formula, however, Picabia was going beyond Arp's procedural implementation of chance to participate in Duchamp's extension of it into the realm of meaning—or rather a short circuit in the field of meaning.

Another of Duchamp's notes from *The Green Box* pulls chance, photography, and linguistic emptiness all together. Called "Specifi-

3 • Hans Arp, *Collage of Squares Arranged According to the Laws of Chance*, 1916–17
Collage of colored papers, 48.6 × 34.6 (19⅛ × 13⅝)

cation for Readymades," it declares that the readymade will be whatever object the artist stumbles on at a moment he or she predetermines. Calling this a kind of rendezvous or encounter, the note compares it with a snapshot (the indexical recording of the event) but also says that it is "like a speech pronounced on no matter what occasion but at such and such an hour," which is to say, a linguistic event whose mechanized inappropriateness renders it meaningless.

If we have seen that Duchamp's notes often pull together various strands of the index's implications, this tendency to synthesize is nowhere more in evidence than in his valedictory painting made for Katherine Dreier. For *Tu m'* [4], a kind of résumé of Duchamp's post-Cubist production, is a panorama of the index in its many
▲ forms. Several of his readymades—the *Bicycle Wheel* (1913) and the *Hat Rack* (1916)—themselves the index or trace of the rendezvous through which Duchamp encountered them, are projected onto the canvas as cast shadows (another form of index). The *Three Standard Stoppages* appear both in depicted form and as a series of profiles traced from their stencils. The finicky representation of a pointing hand, its *index* finger extended toward the right side of the work as if to designate the hat rack with the gesture "this," opens onto the verbal form of the index that is finally invoked in the work's title: *Tu m'* ("You _____ [to] me").

4 • Marcel Duchamp, *Tu m'*, 1918
Oil and graphite on canvas, with bottle-washing brush, safety pins, nut and bolt, 69.9 × 311.8 (27½ × 122¾)

Just as *this* or *that* are indexical words connected with a referent only within the temporary context of a given act of pointing, so the personal pronouns *you* and *I* are similarly indexical, connecting to their referent in the shifting context of a given speech event. For it is only the one who says "I" who fills the pronoun at the moment of saying it, during which time his or her interlocutor is named as "you," although becoming "I" in turn, by taking up the other side of the conversation. It is because the signified of the personal pronouns shifts in this way—naming now one participant in a colloquy, now the other—that linguists have called these indexical kinds of words "shifters."

What does it mean, however, that in *Tu m'* Duchamp invokes the two sides of the colloquy at once, as though he were mixing up linguistic decorum by occupying both poles himself:

"You _____ [to] me"? Could this relate to yet another note from *The Green Box* which consists of a little sketch for the *Large Glass* with the feminine bride in the upper register labeled MAR (for *mariée*) and the masculine bachelors in the lower one labeled CEL (for *célibataires*). Put together, of course, these two syllables produce the "Marcel" by which Duchamp names himself, although strangely split and doubled as would be the case with *Tu m'*.

If the iconic mode of representation had significantly changed in the move from naturalism to modernist forms such as Cubism or Fauvism, and if the single-point perspective of the earlier system had been under attack by the destruction of perspective involved in modernism, nonetheless within iconic representation certain things remain constant. One of these is the assumption of a unified subject or viewer as the one who makes contact with the image.

5 • Marcel Duchamp and Man Ray, *Belle Haleine, Eau de Voilette* (Beautiful Breath, Veil Water), 1921
Perfume bottle with collage label inside oval violet cardboard box, 16.3 × 11.2 (6⅜ × 4⅜)

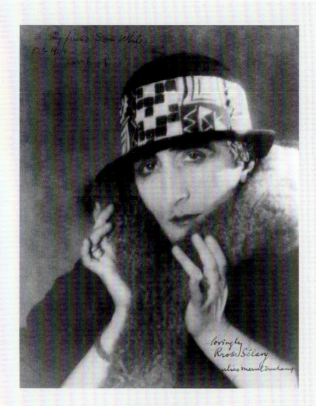

Rrose Sélavy

first idea that came to me was to take a Jewish name …
I didn't find a Jewish name that I especially liked, or that
tempted me, and suddenly I had an idea: why not change
sex? It was much simpler. So the name Rrose Sélavy came
from that …
Cabanne: *You went so far in your sex change as to have
yourself photographed dressed a a woman.*
Duchamp: *It was Man Ray who did the photograph …*

Having stopped work on the *Glass* in 1923, Duchamp
transferred his artistic enterprise to this new character and
had business cards printed up giving his name and profession
as "Rrose Sélavy, Precision Oculist." The works he went on to
make as "oculist" were machines with turning optical disks—
the *Rotary Demisphere* and the *Rotoreliefs*—as well as films,
such as *Anemic Cinema.*

There is a way to understand Rrose Sélavy's enterprise as
the undermining of the Kantian aesthetic system in which the
work of art opens onto a collective visual space acknowledging,
in effect, the simultaneity of points of view of all the spectators
who are gathered to see it, a multiplicity whose appreciation
for the work speaks with, as Kant would say, the universal voice.
On the contrary, Duchamp's "precision optics" were, like the
holes in the door of his installation *Etant données*, available to
only one viewer at a time. Organized as optical illusions, they
were clearly the solitary visual projection of the viewer placed
in the right vector to experience them. As the *Rotoreliefs*—a set
of printed cards—revolved like visual records on a phonograph
turntable, their designs of slightly skewed concentric circles spiral
to burgeon outward like a balloon inflating and then to reverse
themselves into an inward, sucking movement. Some appeared
like eyes or breasts, trembling in a phantom space; another
sported a goldfish that seemed to be swimming in a basin whose
plug had been pulled, so that the fish was being sucked down the
drain. In this sense, Duchamp's switch to Rrose and her activities
marks a turn from an interest in the mechanical (the Bachelor
Machine, the Chocolate Grinder) to a concern for the optical.

O ne of the sketches Duchamp drew for the *Large Glass*
and published in the *Green Box* shows the double field
of the work with the upper area labeled "MAR" (short for
mariée [bride]) and the lower one "CEL" (short for *célibataires*
[bachelors]). With this personal identification with the protago-
nists of the *Glass*, (MAR + CEL = Marcel) Duchamp thought
about assuming a feminine persona. As he told his interviewer,
Pierre Cabanne:

Cabanne: *Rrose Sélavy was born in 1920, I think.*
Duchamp: *In effect, I wanted to change my identity, and the*

Perspective had specifically located this viewer in its plotting of a
▲ precise vantage point. But both Cubism and Fauvism, by finding
other means to unify the pictorial space, also address themselves to
a unified human subject: the viewer / interpreter of the work.

The final implication of Duchamp's removal of his field of
operations from the iconic to the indexical sign becomes clear in
this context. For beyond its marking a break with "picturing" and a
rejection of "skill," beyond its displacement of meaning from
repeatable code to unique event, the index's aspect as shifter has
implications for the status of the subject, of the one who says "I,"
in this case Duchamp "himself." For as the subject of the vast
self-portrait assembled by *Tu m'*, Duchamp declares himself a
disjunctive, fractured subject, split axially into the two facing poles
of pronominal space, even as he would split himself sexually into
the two opposite poles of gender in the many photographic self-

portraits he would make while in drag and sign "Rrose Sélavy" [5].
Taking up Rimbaud's "je est un autre" ("I is an other"), Duchamp's
shattering of subjectivity was perhaps his most radical act. RK

FURTHER READING
Roland Barthes, "The Photographic Message" and "The Rhetoric of the Image,"
Image / Music / Text (New York: Hill and Wang, 1977)
Marcel Duchamp, *Salt Seller: The Writings of Marcel Duchamp (Marchand du Sel)*, eds Michel
Sanouillet and Elmer Peterson (New York: Oxford University Press, 1973)
Thierry de Duve, *Pictorial Nominalism: On Duchamp's Passage from Painting to the Readymade*,
trans. Dana Polan (Minneapolis: University of Minnesota Press, 1991)
Thierry de Duve (ed.), *The Definitively Unfinished Marcel Duchamp* (Cambridge, Mass.: MIT Press,
1991)
Rosalind Krauss, "Notes on the Index," *The Originality of the Avant-Garde and Other Modernist
Myths* (Cambridge, Mass.: MIT Press, 1985)
Robert Lebel, *Marcel Duchamp* (New York: Grove Press, 1959)
Francis M. Naumann and Hector Obalk (eds), *Affect t | Marcel.: The Selected Correspondence
of Marcel Duchamp* (London: Thames & Hudson, 2000)

▲ 1906, 1907, 1911, 1912, 1921a

1919

Pablo Picasso has his first solo exhibition in Paris in thirteen years: the onset of pastiche in his work coincides with a widespread antimodernist reaction.

When Wilhelm Uhde, the German collector and dealer of French avant-garde art, entered the Paul Rosenberg Gallery in 1919, he was stunned. Instead of the powerful style he had witnessed Picasso developing in the years leading ▲ up to the outbreak of World War I—first Analytical Cubism, a major example of which was Picasso's 1910 portrait of Uhde ● himself, then collage, and finally "Synthetic Cubism" (the form that collage took when rendered in oil paint on canvas)—Uhde was confronted with a strange mixture.

On the one hand there were neoclassical portraits, redolent of the manner of Ingres, Corot, late Renoir, indeed the whole panoply of nineteenth-century French artists influenced by the classical tradition, all the way from Greek and Roman antiquity up through the Renaissance and into the work of seventeenth-century French painters such as Poussin [1]. On the other hand there were Cubist still lifes, but now of a compromised form: impregnated with vistas of deep space, prettified by a decorative palette of pinks and cerulean blues. Uhde remembers:

> I found myself in the presence of a huge portrait in what is known as the Ingres manner; the conventionality, the sobriety of the attitude seemed studied, and it seemed to be repressing some pathetic secret.… What was the meaning of this and the other pictures I saw on that occasion? Were they but an interlude, a gesture—splendid but without significance …?

Wanting to see what he viewed as Picasso's self-betrayal as merely a parenthesis, the momentary flagging of his true creative energies, Uhde nonetheless had suspicions that the artist had capitulated to something more sinister, to the fear inspired by the xenophobia unleashed by French nationalism during the war, a hatred of everything foreign that had already manifested itself in a prewar cultural campaign in which Cubism was linked with the approaching enemy and affixed with the label "boche" ("kraut"). Accordingly, Uhde continues his speculations on the cause of what he has seen:

> Or was it that at this time when men were ruled by hate … [Picasso] felt that innumerable people were pointing their fingers at him, reproaching him with having strong German sympathies and accusing him of being secretly in connivance with the enemy?… Was he trying definitely to range himself on the French side, and did these pictures attest to the torment of his soul?

Among the many things that emerge from this scene, the two most obvious concern the enormity of the break that Uhde sensed in Picasso's art and, given this, his conviction that its explanation had to be found in a cause outside the inner logic of the work itself.

Uhde has since been joined by many historians in seeking this explanation, even though not all of them agree with him about the nature of this external cause. Yet for the ones who side with Uhde in looking to politics for an answer, that explanation is linked to the *rappel à l'ordre* (return to order), a widespread postwar reaction against what was seen as the avant-garde's promotion of anarchic and antihumanist expressive means and an embrace instead of a classicism worthy of the French ("Mediterranean") tradition.

Was Picasso, the avant-garde leader, now following in the wake of this massive "return," his ship unable to hold its own against the flood tide of historical reaction? To some scholars the actual date of Picasso's conversion makes the postwar *rappel à l'ordre* dubious as an explanation. For Picasso had already begun to embrace a classical style *during* the war, as, for example, in his 1915 portrait drawings of Max Jacob [2] and Ambroise Vollard. So, instead, these scholars look to the circumstances of Picasso's personal life. They cite his isolation, ▲ with close artistic allies like Braque and Apollinaire away at the front, and Eva Gouel, the companion of his prewar years, dying of cancer; they mention his growing restlessness with a Cubist style that had become increasingly formulaic and, in the hands of lesser followers, banal; they see his excitement at being swept up in the glamour of the Ballets Russes, with its eccentric personnel such as Sergei Diaghilev, its elegant ballerinas, and its glittering clientele; finally, they see his succumbing to the charms of Olga Koklova, the dancer in the corps of the Ballets Russes whom Picasso would marry in 1918 and whom he would allow to integrate him into that world of wealth and pleasure for which the avant-garde was just another form of *chic*.

But if these two explanations—one sociopolitical, the other biographical—are at odds with each other, they agree about looking for the reason for this change *outside* the limits of Picasso's actual work. In this they share a common understanding about the nature of causal explanation. As a consequence they are opposed to another

▲ 1911 ● 1912, 1921a

▲ 1911, 1912, 1921a

1 • Pablo Picasso, *Olga Picasso in an Armchair*, 1917 (detail)
Oil on canvas, 130 × 88.8 (51⅛ × 35)

position, which insists that the postwar manner can be logically deduced from Cubism itself and thus, like the growth of an organism, its genetic coding is entirely internal to it and more or less impervious to external factors. The principle that this side sees at work—internal to Cubism itself—is collage: the grafting of heterogeneous material onto the formerly homogeneous surface of the work of art. If collage could paste matchbooks and calling cards, wallpaper swatches, and newsprint onto the field of Cubism, they reason, why cannot this practice be extended to the grafting of a whole range of "extraneous" styles onto the unfolding oeuvre, so that Poussin will be redone in the manner of archaic Greek sculpture, or the realist compositions of the seventeenth-century painter Le Nain will be presented through the gay confetti of Seurat's pointillism? Ultimately, the defenders of

this position argue, there is no need to explain the change in Picasso, since nothing in fact changes; the collage principle remains the same—only the "extraneous" matter shifts a little.

Contextualists versus internalists

The radical division between these two camps of scholars brings us face to face with the issue of historical method. The contextual explanation sets itself against the theory of the internally determined growth of the creative individual, each position feeling the other is blind to certain facts. The contextualists, for example, see the other side as refusing to face up to the reactionary content unleashed by neoclassicism and the need to find the source of such

Sergei Diaghilev (1872–1929) and the Ballets Russes

In the late nineteenth century, German composer Richard Wagner theorized the achievement he hoped his operatic theatre would realize under the term *Gesamtkunstwerk*. This idea of a "total work of the arts" meant the coordination of all the senses—sound, spectacle, narrative—into a single continuity. The antimodernism of Wagner's position lay in its negation of the idea of a given work's obligation to reveal the boundaries of its own medium and to seek its own possibility of meaning within those boundaries. Wagner never achieved a true *Gesamtkunstwerk*, however; it was left to another form of musical theater and another impresario from another country to do so. During the first half of the twentieth century, Sergei Diaghilev, Russian director of the Ballets Russes, wove together the full range of avant-garde talent into a sumptuous fabric of visual spectacle: his composers ranged from Igor Stravinsky and Erik Satie to Darius Milhaud and Georges Auric; his choreographers were Massine and Nijinsky; his set and costume designers were Picasso, Georges Braque, and Fernand Léger, among others.

Writer Jean Cocteau describes the meeting he arranged in 1919 between Diaghilev and Picasso in order to convince the latter to collaborate on Cocteau's own ballet *Parade*:

I understood that there existed in Paris an artistic Right and an artistic Left, which were ignorant or disdainful of each other for no valid reasons and which it was perfectly possible to bring together. It was a question of converting Diaghilev to modern painting, and the modern painters, especially Picasso, to the sumptuous, decorative esthetic of the ballet: of coaxing the Cubists out of their isolation, persuading them to abandon their hermetic Montmartre folklore of pipes, packages of tobacco, guitars, and old newspapers ... the discovery of a middle-of-the-road solution attuned to the taste for luxury and pleasure, of the revived cult of French "clarity" that was springing up in Paris even before the war ... such was the history of Parade.

The "sumptuous, decorative aesthetic," to which Cocteau refers was a gorgeous Art Nouveau texture, as bejeweled and gilded as any Tiffany lamp or oriental interior. For *Parade*, Picasso and Satie were to defy the Ballets Russes's usual designer Léon Bakst's drive toward Orientalist splendor, substituting the ascetic drabness of Cubist sets and costumes and unleashing the sounds of typewriters and popular ditties on the appalled audience, which responded by hurling insults at the stage: "*métèques*," [half-breeds] and "*boches*" [krauts]. Cocteau, who prided himself on his fashionableness and his understanding of the high cultural taste for occasional slumming, had as his motto: "You have to know just how far you can go too far." But in *Parade* he and Diaghilev had apparently gone too far and the audience, along with the ballet's sponsors—the Comtesse de Chabrillon, the Comtesse de Chavigné, and the Comtesse de Beaumont—could not wait to tell them so.

Ballet companies now considered themselves heir to the ambitions of the artistic avant-garde. One in particular was the Ballets Suédois, whose director, Rolf de Maré, turned to Francis Picabia for the design of the set for *Relâche* (1924), a title that was itself a snub to its audience since it meant "performance canceled." Picabia's set consisted of over three hundred automobile headlights trained out toward the audience and turned on in unison at the end of one of the acts in a blinding, bedazzling, sadistic fury.

reaction; the internalists see themselves vindicated by the early date of Picasso's move, showing that it must be motivated by something native to his creative will and unproblematically continuous with his previous concerns with Cubism.

The positivist historians among us (or the positivist impulses within each of us) would like to cut the knot of this argument by coming up with a document that will solve the debate: a letter by Picasso, for example, or a statement in an interview in which he says what this change in style meant to him or what he intended by it. However, there rarely is such a thing in relation to Picasso (or to most other artists for that matter), and even in the few instances where it does exist, we *still* have to interpret it. In this case, for example, Picasso seems to have sided with the internalists when in response to the Swiss conductor Ernest Ansermet's question, put to him in Rome in 1917, about why he engaged simultaneously in two totally opposite styles (Cubism and neoclassicism), Picasso merely quipped: "Can't you see? The results are the same!"

But there are art historians who cannot accept this answer, seeming as it does to act out its own blindness to the difference between modernism and pastiche, or between authenticity and fraudulence. Modernist art, of which Cubism was a fundamental example, stakes its claim to authenticity on its progressive uncovering of the structural and material (and thus objectively demonstrable) realities of a given artistic medium; while pastiche—the flagrant imitation by one artist of the style of another—shrugs off this notion of an inner pictorial logic to be revealed, one that puts certain options out of bounds, and maintains instead that every option is open to the creative spirit. Thus Cubism and the pastiche of neoclassicism cannot be "the same," and we should rephrase our historical problem by asking what could have made Picasso, as early as 1915, imagine that they were?

At this point it is important to realize that a fight had already begun, just before the war, over the legacy of Cubism, which is to say, over the future that Cubism itself had made possible. On the one hand there were artists—such as Piet Mondrian, or Robert Delaunay, ▲ or František Kupka (or in Russia, Kazimir Malevich)—who believed that this legacy was pure abstraction, the next logical move after the ascetically reduced grid of the Analytical Cubism of 1911–12. • On the other, there were those, such as Marcel Duchamp and (briefly) Francis Picabia, who saw Cubism opening up to the mechanization of art in an obvious extension of collage into the readymade. Picabia's own development of Cubism in this latter direction took the form of what he called "mechanomorphs," industrial objects (such as spark plugs or turbine parts or cameras) coldly rendered by means of mechanical drawing and declared to be portraits (whether of the ■ photographer Alfred Stieglitz, the critic Marius de Zayas, or "a young American girl in a state of nudity" [3]). The date of most of this output, interestingly enough, was 1915, and it appeared in the magazine *291*, which Picasso would certainly have seen.

Now, if these two options were what the avant-garde saw as the logical next step of Cubism, they were not the possibilities that Picasso himself found acceptable as the fate of "his" brainchild. Always vociferously against abstraction, he was also opposed to any mechanization of seeing (as in, according to some, photography) or of making (as in the readymade).

Thus, if the precise onset of Picasso's embrace of classicism—1915—argues against the externalist notion of cause and for the idea of something internal to the work, that same date opens up an internalist explanation that, far from repressing the antimodernist, reactionary form of his pastiche, will explain both its continuousness with Cubism *and* its total break with it. For the summer of 1915 confronted Picasso with Cubism's own logical consequences in the form of Picabia's published, mechanomorphic portraits: mechanically drawn, coldly impersonal, readymade. But in styling his own rejection of such consequences as neoclassicism, Picasso embarked on a strange campaign of portraiture of his own, in which he began to churn out image after image, each startlingly like the other in pose, lighting, treatment, scale, and, in particular, the handling of line, which, bizarrely invariant and graphically insensitive, seemed to be produced more as an act of tracing than as a record of seeing [4].

It is possible, even preferable, then, to describe Picasso's neoclassicism with the exact same words as were used for Picabia's mechanomorphs: mechanically drawn, coldly impersonal, readymade. There is no reason why classicism might not be adopted as a strategy to rise above the industrial level of the mass-produced object, which the readymade extolled and in which abstract painting and sculpture participated in their own way by adopting the principle of

2 • Pablo Picasso, *Max Jacob*, 1915
Pencil on paper, 33 × 25 (13 × 9⅞)

▲ 1913, 1915, 1917a ● 1914, 1918 ■ 1916b

3 • Francis Picabia, *Portrait d'une jeune fille américaine dans l'état de nudité* (Portrait of a Young American Girl in the State of Nudity), 1915
Reproduced in *291*, nos 5/6, July/August 1915

model assuming, with greater or lesser sophistication, that cultural expression will be the effect of causes external to what the aesthetic sphere (erroneously) promotes as the "autonomy" of its own site of production. We have also seen the internalists cutting their model to the shape of an independent organism—whether that be the creative will of the artist or the coherent development of an artistic tradition.

The case we might call "Picasso-pastiche" suggests the usefulness of another model, one most clearly outlined by Freud in the psychoanalytic theories he was developing right at this moment. This model, which Freud called "reaction-formation," was meant to describe a curious transformation of repressed urges, a transformation that seemed to deny those low, libidinally charged impulses by substituting for them something that was their exact opposite: behavior that was "high," laudable, upright, proper. But this opposite, Freud points out, is in fact a way of continuing the prohibited behavior by smuggling it in under its cleaned-up, sublimated guise. The anal personality transforms the explosive urge toward dirtiness into the retentive features of obsessive thrift or conscientiousness; the infantile masturbator ends by being a compulsive hand-washer, whose gestures of stroking and rubbing carry on the earlier desires under a newly acceptable (albeit out-of-control) form. Further, says Freud, reaction-formation carries with it a "secondary gain." Not only is the subject able, furtively, to carry on his or her impulses, but now this behavior becomes socially commendable.

4 • Pablo Picasso, *Igor Stravinsky*, 1920
Lead pencil, charcoal, 61.5 × 48.2 (24¼ × 19)

serial production, for example, or by lowering the level of technical skill needed to execute the forms. But in Picasso's deployment of it the strategy backfires. For in his hands classicism ends by repeating those very same features of the position he despised, a position—we have to repeat—that was being claimed as continuous with Cubism, *inside* it as it were, rather than coming from the outside.

Other models of history

There is a naive belief that historical explanations are simply a record of the facts that the historian extracts from the archive. But facts need to be organized, analyzed, weighted, interrogated; and to do this all historians (consciously or not) have recourse to an underlying model that gives shape to the facts. We have seen the contextualists'

There are two advantages of using reaction-formation as a model for Picasso-pastiche. First, it explains the dialectical connection—which is to say, the togetherness in opposition—between Cubism and its neoclassical "other." Second, it produces a structure that helps to account for the shape of many other antimodernist practices throughout the century, including the *rappel à l'ordre* production, but also reactionary painting from Giorgio de Chirico to later Picabia. It shows, that is, the degree to which those antimodernisms are themselves conditioned by exactly those features in the modernist work they wish to repudiate and repress.

To the cases of de Chirico and Picabia (as well as that of *pittura metafisica*), one must add that of Juan Gris, Picasso's fellow Spaniard, who emigrated to Paris in 1906, encountered Picasso, and soon devoted himself to Cubism. His *Portrait of Picasso* (1912) manifests his understanding of the new style as a matter of imposing a geometric grid over a relatively realistic representation so as to splinter its contours and fragment its volumes. Instead of the orthogonal grid favored by Picasso and Braque, Gris adopted a diagonal one, which implied the receding lines of the perspective Cubism had abandoned.

5 • Juan Gris, *Newspaper and Fruit Dish*, 1916
Oil on canvas, 92 × 60 (36¼ × 23⅝)

▲ 1909, 1924 ● 1911

Rappel à l'ordre

The *rappel à l'ordre* issued a call for a return to the presumed classical roots of French art, in the course of which its proponents opened an attack on Cubism. The beginnings of this return are assigned various dates, a late one being the 1923 essay by Jean Cocteau "Le Rappel à l'Ordre," a much earlier one being *Après le Cubisme*, published in 1918 by the painter Amédée Ozenfant and the architect Charles-Édouard Jeanneret. But what all these calls to order have in common is the idea that the prewar period was defined by chaos, by a decadent sensuality that needed to be replaced by the purity of classical rationalism, and by the barbarization of French culture by German influences. In fact, Ozenfant and Jeanneret called on artists to focus on the golden section and other ideas of classical proportion, making it possible for there to be a "new Pythagoras." "Science and great Art have the common ideal of generalizing," they wrote. Arguing that if "The Greeks triumphed over the Barbarians" it was because they sought intellectual beauty beneath sensory beauty.

Two versions of this classicism are represented by these two tracts, however. The first, Purism, has a modern, streamlined look, and speaks the language of science and of general laws, such as proportion. It argues that the artist-designer should dedicate himself to industry, producing for it the generalized types associated with classical forms. The second has a reactionary, Old Master character and recycles the themes and genres of the neoclassical art it wishes to revive. The mother-and-child theme became a preferred one—taken up by former Cubists such as Gino Severini as well as modified ones such as Albert Gleizes—as did the tradition of the *commedia dell'arte*. Severini's clowns and harlequins, painted in the early twenties in the hard outlines and licked surfaces of the most academicized classicism, are determined examples of the latter.

The broken strokes of paint that Gris employs in his portrait reflects Analytical Cubism's own stippled surfaces, as does Gris's palette, which is limited to the muted colors of the painter's modeling and shading of volume. This stippled surface soon yielded to a far more enameled one paralleling metallic forms. The hardened surfaces of Gris's style during the teens echo Picabia's concern with the mechanomorph, the world seen as a collection of industrially wrought mechanical parts. And Gris's style gravitated to the industrially wrought aesthetic surface as well. In his *Newspaper and Fruit Dish* [5], textures such as wood-graining and reflected light are translated into the repetitive, mechanical language of commercial illustration. Gris himself thought of this hardened, aloof manner as a form of classicism, and it was in this way that Daniel-Henry Kahnweiler, the greatest contemporary interpreter of Cubism, also read his work. RK

FURTHER READING
Benjamin H. D. Buchloh, "Figures of Authority, Ciphers of Regression," *October*, no. 16, Spring 1981
Rosalind Krauss, *The Picasso Papers* (New York: Farrar, Straus & Giroux, 1998)
Kenneth Silver, *Esprit de Corps* (Princeton, N.J.: Princeton University Press, 1989)

1920–1929

1920

The Dada Fair is held in Berlin: the polarization of avant-garde culture and cultural traditions leads to a politicization of artistic practices and the emergence of photomontage as a new medium.

The Dada Fair held in June 1920 at Dr. Otto Burchard's gallery in Berlin was the first public appearance of the group of artists—diverse in both project and origin—who came to constitute the official Berlin Dada movement. The fact that the event was announced as a fair rather than as an exhibition signals that from the very outset its parody of the display of commodities, whether at the level of window design or of large commercial presentations, emphasized the Dadaists' intention to radically transform both the structure of exhibitions and the art objects within them [1].

Some of the central objects of the fair—specifically Hannah Höch's (1889–1978) *Cut with the Kitchen Knife through the Beer Belly of the Weimar Republic* [2], Raoul Hausmann's (1886–1971) *Tatlin at Home* (1920) and *Mechanical Head (Spirit of the Age)* [3], and the collaborative contributions of George Grosz (1893–1959) and John Heartfield (Helmut Herzfelde) (1891–1968)—indicate the diversity of strategies employed by the newly defined group. In contact with the work of both the Italian Futurists and the Soviet avant-garde, Berlin Dada situated itself at the intersection of a critical revision of traditional modernism, on the one hand, and a manifest embracing of the new synthesis of avant-garde art with technology on the other. But more specifically, Berlin Dada also stood in radical opposition to the local avant-garde, namely the hegemonic model of German Expressionism. It was Expressionism's ethos, with its universalizing humanitarian aims, and its practice, with its fervent attempt to fuse spirituality and abstraction, that came under scrutiny and devastating critique at the hands of the Dadaists.

Dada: distraction and destruction

Under the impact of World War I, in which Expressionism had played the fateful and ultimately failed role of trying to appeal to the supposedly universal terms of human existence, Dada explicitly positioned itself against this aspiration for artistic practice. This stance has erroneously appeared to many to be a form of nihilism, but what needs to be stressed instead is the positive nature of Dada's critique. Against Expressionism's effort to fuse the aesthetic and the spiritual, Dada constructed a model of antiaesthetics; against the attempt to claim universality for human experience by assimilating

1 • First International Dada Fair at Kunstsalon Dr. Otto Burchard, Berlin, June 1920

the aesthetic to the mystical, Dada emphasized extreme forms of political secularization of artistic practice.

Several of the Berlin Dada group rallied to the left, identifying with the aims of the Communist Party to the degree, in the cases of Heartfield and Grosz, of becoming members of the Party when it was founded in Germany in 1919. From that perspective it is important to recognize that Berlin Dada is an explicitly politicized avant-garde project previously unknown in the German context. However, this project's axis ranges from a critique of bourgeois concepts of high art to a model for activist propaganda and from embracing French examples of earlier proto-Dada practices—such as Duchamp's and Picabia's—to the systematic development of montage techniques intended to undermine the emerging mass-cultural power of the Weimar publication industry.

The simultaneity of objects, textures, printed matter, and surfaces to which Heartfield and Grosz relate in their initial work from 1918 (no longer extant) clearly has a precursor in Cubism. But this earliest photomontage work to come out of Berlin is explicitly conceived of as a mockery of Cubism's aestheticized, apolitical approach to the emerging power of mass-cultural imagery. In 1919, immediately following this parody of Picasso's

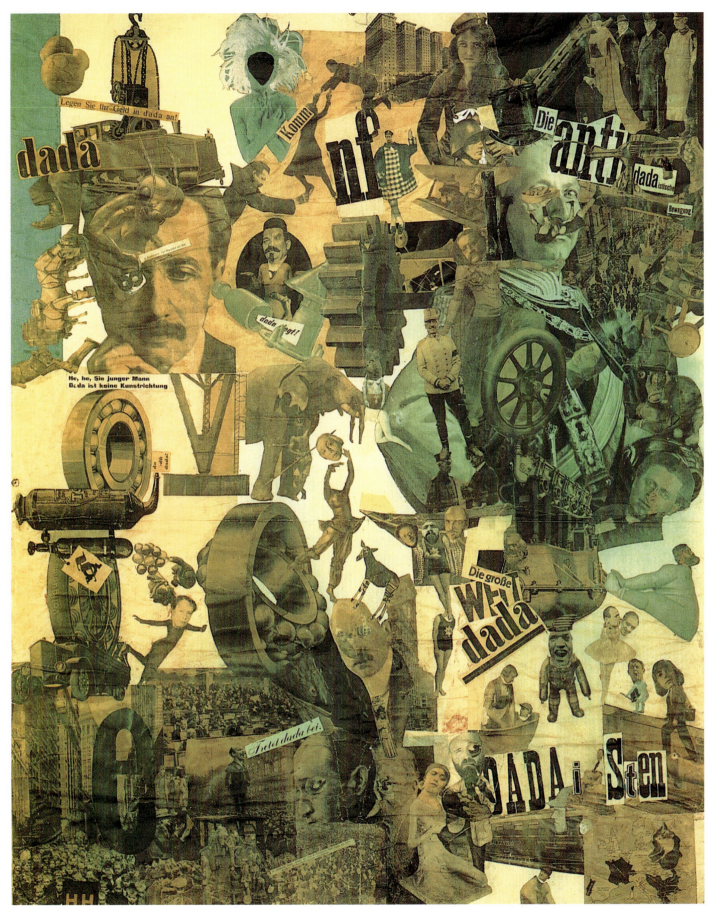

2 • Hannah Höch, *Cut with the Kitchen Knife through the Beer Belly of the Weimar Republic*, c. 1919
Collage, 114 × 89.8 (44⅞ × 35⅜)

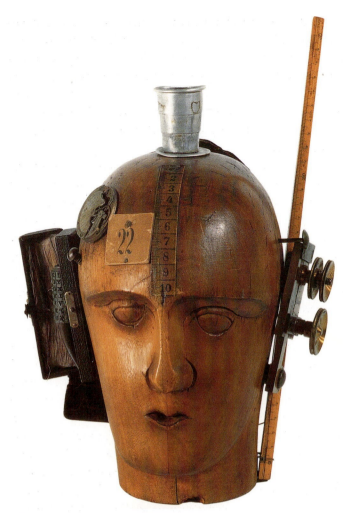

3 • Raoul Hausmann, *Mechanical Head (Spirit of The Age)*, c. 1920
Wood, leather, aluminum, brass, and board, 32.5 × 21 × 20 (12¾ × 8¼ × 7⅞)

form of collage, Heartfield, Hausmann, Höch, and Grosz—jointly and collaboratively—developed their first photomontage projects [**4**].

These were paralleled in the Soviet Union by the simultaneous development of photomontage by Gustav Klutsis and Aleksandr Rodchenko. Although both sides claim to have invented the medium, photomontage had been developed as early as the 1890s as a commercial technique for the design of advertising. In fact, in their first text on the montage, Hausmann and Höch refer to populist models for combining and transforming images as their inspiration, and identify the picture postcards soldiers sent home from the Front as the examples from which they took their cues.

One of the key works of 1919 is Höch's *Cut with the Kitchen Knife* … in which the full range of technical and strategic ambiguities that would form the project of photomontage is apparent. From an iconically rendered narrative to a purely structural deployment of textual material, the possibilities established in Höch's work would become the axis of a dialectic operation within photomontage itself. In *Cut with the Kitchen Knife* … the iconic narrative consists of a detailed inventory of key figures from the public world of the Weimar Republic. These move from political figures such as Friedrich Ebert, the Social Democratic President who had been responsible for the murders of members of the Spartakist Bund,

specifically Rosa Luxemburg (1870–1919) and Karl Liebknecht (1871–1919), at the hands of his Minister of the Interior, Gustav Noske (who is depicted by Heartfield in a later photomontage as well), to figures of the cultural world such as Albert Einstein, Käthe Kollwitz (1867–1945), and the dancer Niddy Impekoven. All of these are disseminated across the field of the work according to a nonhierarchical, noncompositional, and aleatory principle of distribution, mingled with a variety of textual fragments that often invoke the nonsensical syllables "da-da." According to Huelsenbeck's claim, "*dada*" was found by inserting a knife into the pages of a dictionary; other origin stories for the term "dada" have been given, for example by the Cabaret Voltaire Dadaists.

But whether in the context of the Weimar Republic or in that of the Soviet Union, what links Heartfield, Grosz, Höch, and Hausmann on the one hand, and Rodchenko and Klutsis on the other, is first of all, the discovery of the photographic permeation of the visual world as a result of the emergence of the mass-cultural distribution of photographic images. Secondly, both groups participate in a nonsemantic production of meaning intended to destroy visual and textual homogeneity, to emphasize the materiality of the signifier over a presumed universal legibility of either the textual or iconic signified, and to stress the rupture and discontinuity of temporal and spatial forms of experience. The critical impulse behind this alogical attack on the very fabric of legibility was the intention to dismantle the mythical representations promoted by the mass-cultural production of commodity imagery and advertising. Lastly, photomontage represents the shared desire to construct a new type of art object, one that is ephemeral, one that has no claim either to innate worth or transhistorical value, one that is instead located within the perspective of intervention and rupture. This defines the political dimension of the photomontage practitioners' decision to stage artistic practice within the very medium of mass-cultural representation rather than outside or in opposition to it, as was the

4 • George Grosz and John Heartfield, *Life and Activity in Universal City at 12.05 midday*, 1919
Photomontage, dimensions unknown

case in abstract art's attempt to retreat into the values specific to the mediums of painting or sculpture. These strategies link both groups' activities around 1919.

From photomontage to new narratives

As photomontage developed in Weimar Germany its range of options led its practitioners in various directions. In Hausmann's case the emphasis was increasingly textual with the verbal sign dismantled into graphic and phonetic fragments [5], whereas in Höch's work the focus on photographic imagery eventually displaced the structural separations that characterize the disjunction of textual elements. This was in favor of an increasingly homogeneous type of photomontage in which only two or three fragments are used to form peculiarly enigmatic figures.

John Heartfield, a third member of the original Berlin Dada group, quickly moved away from what he came to criticize as the "avant-gardist" dimension of the aestheticizing photomontage model, whose nonsensical or anomic qualities he rejected in favor of a new type of photomontage of communicative action. In this new form, photomontage was meant to reach an emerging working-class audience within what the Left hoped would become a proletarian public sphere. Those audiences are directly addressed through a strategy in which all former montage techniques are inverted: disjunction is replaced by narrative; the discontinuity of textures, surfaces, and materials is replaced by an artificially constructed homogeneity that is the result of Heartfield's careful airbrushing techniques; extreme forms of the fragmentation of language that isolated the grapheme or the phoneme are abandoned in favor of the insertion of captions whose function is to construct a revelation that will take a dialectical form. This type of commentary, which operates through the sudden juxtaposition of different types of historical and ▲ political information, is similar to what Bertolt Brecht subsequently developed in his own theatrical montage technique which, like Heartfield's work, was intended as an initiation to dialectics.

Heartfield's work also implicitly criticized early Berlin photomontage for having resulted in a set of singular objects that in the end possessed the status of traditional works of art just like any other individual work on paper or on canvas. Heartfield's attempt to create a work within the emerging proletarian public sphere, however, was specifically meant to alter the distribution form of photomontage by making it the vehicle of a printed medium and thus a mass-cultural tool.

The triggering moment in Heartfield's development was his encounter with Willi Münzenberg, who hired Heartfield to become the major designer of the *Arbeiter Illustrierte Zeitung*, the Communist Party organ founded in opposition to the old-style illustrated ▲ press. The *AIZ*, as it came to be called, specifically aimed to challenge the *Berliner Illustrierte Zeitung*, which had achieved a circulation ranging in the hundreds of thousands and could legitimately be called one of the first examples of mass media, serving as the model for subsequent magazines such as *Life* or *Paris Match*. The *AIZ* was thus conceived as a mass-cultural countertool.

Until his departure from Berlin after the Nazis' takeover of the government in 1933, Heartfield did most of his work for the *AIZ*, or as covers for books published by his brother Weiland Herzfelde and his Malik-Verlag publishing company. A typical example of his shift from the Berlin Dada photomontage aesthetic, as represented by Höch and Hausmann, would be Heartfield's *The Face of Fascism*, his cover illustration for *Italy in Chains*, published in 1928 by the Communist Party. Although juxtaposition, rupture, fracturing, and fragmentation are still operative here, they are so forged into a new coherence as to be able to serve different purposes altogether. Mussolini's head is fused with a skull that penetrates it from within and the vignettes that surround it work, on the right-hand side, to fuse images of victims of violence with the representation of dignitaries of the Pope and the Catholic Church and on the left, to fuse the top-hatted bourgeois capitalist with the armed Fascist street gangs. This technique of fusion was the alternative to what Heartfield criticized as the construction of

5 • Raoul Hausmann, *Off* and *fmsbw*, 1918
Two phonetic poem posters,
32.5 × 47.5 (12¾ × 18¾)

▲ Introduction 3 ▲ 1930a

DER SINN DES HITLERGRUSSES:

Motto: MILLIONEN STEHEN HINTER MIR!

Kleiner Mann bittet um große Gaben

6 • John Heartfield, *The Meaning of the Hitler Salute: Little Man Asks for Big Gifts. Motto: Millions Stand Behind Me!*, 1932
Photomontage, 38 × 27 (15 × 10⅝)

Asks for Big Gifts. Motto: Millions Stand Behind Me! [6], makes this point even more manifest in that Hitler is presented as a miniature figure standing in front of a huge, anonymous "fat cat" figure of a man passing a bundle of bank notes into the little man's raised arm and hand, thereby producing an ironic rereading of the "Hitler salute." Extremely simplified, grotesque, comical, and therefore all the more stunning, this form of argument was meant to clarify the otherwise inscrutable political and economic links that attracted big business to the leader of German fascism, seen as a counterforce and as a violent form of oppressing Socialist and Communist tendencies within the Weimar Republic. The assumption that *AIZ*, whose circulation at that time reached 350,000, would have a propagandistic effect turned out to be false since large numbers of the working class who had formerly voted Communist would vote for the Nazi Party in 1933, thereby dealing a final blow to the leftist aspirations of the Weimar Republic.

Unsurprisingly, Heartfield was one of the first artists to be prosecuted by the Gestapo after Hitler's rise to power. In 1933 he left for Prague, where his polemical, didactic, and propagandistic efforts against Hitler's regime were so widespread that Hitler intervened with the Czech government to order the closure of Heartfield's exhibitions in Prague.

From semiosis to communicative action

In the parallel evolution of photomontage within the Weimar and Soviet contexts, the changes that emerged around 1925 were aimed at transforming the original strategies. The techniques of alogical shock, of the nonsensical destruction of meaning, of the self-referential foregrounding of the graphic and phonetic dimension of language through an emphasis on fragmentation were now recast so as to be repositioned within the radical project of creating a proletarian public sphere. If by the mid-twenties a key cultural project of the avant-gardes was the transformation of audiences, this in turn required a return to the instrumentalized forms of language and image, where visual recognition and readability are paramount. The type of photomontage that Heartfield and Klutsis went on to produce now focused on the values of information and communication. The alogism, the shock, and the rupture of the previous work were discarded as so many bourgeois, avant-gardist jokes; its antiart position was seen as simply performing an act of shadow-boxing with the bourgeois public sphere and a model of culture that had long since been surpassed. The specific task that was now assigned to photomontage was no longer the destruction of painting and sculpture or culture as a separate, autonomous sphere; its task now was to provide mass audiences with images of didactic information and politicization.

One such example comes from a series of photomontages and posters Klutsis made between 1928 and 1930 [7], in which the metonymy of a raised hand is used as an emblem of political participation and a key image of the actual representation of the masses in the voting process. Substituting a part of the body for the whole,

mere nonsensical juxtapositions that generated rupture and shock but carried no political orientation, no countertruth, no moment of sudden revelation.

The fusion of opposites in Heartfield's work in 1928, five years before the rise of the Nazi Party, is particularly astonishing since it indicates the degree to which certain intellectuals were fully aware of the increasing threat to bourgeois institutions and democratic politics and were fully apprised of the need to locate cultural projects within strategies of opposition and resistance. This is even more evident in two of the images that Heartfield designed for the *AIZ* in 1932, portraying the Chairman of the German National Socialist Party, Adolf Hitler, a year before his election to become Chancellor in 1933. In each image, Hitler is depicted as a puppet, a hollow, artificial figure who executes the interests of capital. In the first, *Adolf—the Superman. Swallows Gold and Spouts Junk*, Hitler's body is shown in X-ray with a swastika in place of his heart, an Iron Cross instead of a liver, and his vertebrae made of gold coins, clearly framing the political argument that it was the German entrepreneurial class that was financing the Nazi Party in order to avert and eventually liquidate a proletarian revolution that had been initiated by the formation of the first Communist Party on German territory in 1919. The second, *The Meaning of the Hitler Salute: Little Man*

▲ 1937c

the hand clearly "stands for" the subject who raises it, just as the single hand, within the boundaries of which a multitude of other such hands can be seen, "stands for" the unity of purpose produced by a single representative who can speak for a massive electorate. Variations on the image with different textual inscriptions were used for several purposes: one for a call to participate in the election of the Soviets; in another version for an appeal to women to become active in the Soviets through their own vote. The metonymy of the hand as a sign of physical, perceptual, and political participation in the collective process is a central example of how photomontage's initial strategy of cropping and fragmentation had been transformed by this time.

With the means of photomontage, Heartfield and Klutsis therefore became the first members of the avant-garde to invoke propaganda as an artistic model. Almost all discussions of twentieth-century art have shunned this term, since it is seen as being in direct opposition to the modernist definition of the work of art. The term *propaganda* implies manipulation, politicization, and a pure instrumentality that heralds the destruction of subjectivity. Yet Heartfield's and Klutsis's practice intervened in the very institutions and forms of distribution that had heretofore defined what artistic practice can be. By contrast, they sought the

transformation of an aesthetic of the single object into one lodged in the mass-cultural distribution of the printed magazine, and a shift from the privileged spectator to the participatory masses then emerging through the industrial revolution of the Soviet Union or the changing industrial conditions in Weimar Germany. It was those aspirations that formed the actual structures and historical framework within which the formation of an aesthetic of a proletarian public sphere should be addressed. Propaganda as a counterform to the existing forms of ever-intensifying mass-cultural propaganda, namely advertising, clearly has to be recognized as a deliberate project undertaken by the Dada and Soviet avant-gardes to abolish the contradictions still maintained by the bourgeois vanguardist model of a pure, abstract opposition to the existing forms of mass culture. BB

FURTHER READING
Hanne Bergius, *Das Lachen Dadas (The Dada Laughter)* (Giessen: Anabas Verlag, 1989)
Hanne Bergius, *Montage und Metamechanik: Dada Berlin* (Berlin: Gebrüder Mann Verlag, 2000)
Brigid Doherty, "The Work of Art and the Problem of Politics in Berlin Dada," in Leah Dickerman (ed.), "Dada," special issue, *October*, no. 105, Summer 2003
Brigid Doherty, "We are all Neurasthenics, or the trauma of Dada Montage," *Critical Inquiry*, vol. 24, no. 1, Fall 1997
Leah Dickerman (ed.), *Dada* (Washington: National Gallery of Art, 2005)

1920–1929

7 • Gustav Klutsis, *Let us Fulfill the Plan of the Great Projects*, 1930
Lithograph poster, dimensions unknown

With *Three Musicians*, Pablo Picasso enlists the classicism of Nicolas Poussin in the development of Synthetic Cubism, the reigning style of postwar modernism.

Among the many formal inventions of Cubist collage was that of the figure–ground reversal: the visual snap of an advancing, uppermost plane that suddenly recedes into the background behind another plane before returning in an instant toward the top. This back-and-forth often created an oscillation between solid and void, as when the white sound-hole of Pablo Picasso's *Guitar, Sheet Music, and Glass* of 1912, sitting atop its underlying wallpaper ground, visually retreats to a position beneath the ground to produce the strong illusion of a hole burrowing into depth. The effect is even more apparent in his *Bottle of Vieux Marc* of the following year, where the silhouetted wine glass submerged behind *Le Journal* pushes upward to the newspaper's very level as a result of the decorative, toquelike shape of its liquid contents. This shuffling between above and below, with the ambiguous placement it creates, produces the visual effect of tonal modeling: the experience of a volume's convexity advancing and receding from protrusion above the surface to recession beneath it. The shimmer of figure–ground reversal thus stimulates an optical illusion that reproduces the very shading and shallow depth of the little canted facet-planes of Analytical Cubism, but by more economic means.

If collage had displaced Analytical Cubism to gain access to the simplified shapes of recognizable objects, Synthetic Cubism now displaces collage itself with even more simplified planes that adopt the patterns of product logos and the slick typographical look of modern advertising. Yet, in the formal operation of collage's figure–ground reversal, these simplified Synthetic planes are nevertheless able to sustain the pictorial effects of spatial analysis.

The return of the repressed

As though this premonition of depth were not enough to introduce an illusionistic space, the symmetry of the Cubist collages of 1912 and 1913—their central spine of bottles and violins flanked by silhouettes of guitars and glasses—suggested also the symmetrical form of classical compositions. Nicolas Poussin's *Et in Arcadia Ego* of 1637–8 is one celebrated example that demonstrates how such compositions were used in classical art to convey

not only the effect of pictorial space but also a sense of visual storytelling. The painting distributes two pairs of idealized shepherds on either side of a tomb in a three-part scene in an attempt to give the impression of a mythological narrative from antiquity. This tripartite structure became one of the building blocks of history painting, the tradition of pictorial representation as the telling of a succession of famous battles, coronations, oaths, and burials.

But in the late nineteenth and early twentieth centuries, the byword of the newly emergent modernism was an emphatic "No!" to such academic conventions, and its formal breakthroughs set forth from this rejection of narrative: Édouard Manet's spatial compression left no dramatic stage available; and Impressionism's flattening of the picture plane by its close-valued haze of color made landscape evanesce. All of these innovations were precedents for the way the Cubist grid reduced "narrative" to nothing more than a self-referential iteration of the material facts of the painting: its rectangular shape; its lateral spread; its literal flatness. Cubism thus carried on the silence enforced by early modernism. Carried it on, that is, until the Synthetic Cubism of the postwar period suddenly adopted the speech of classical compositions such as Poussin's.

Picasso's *Three Musicians* [1] not only follows *Et in Arcadia Ego*'s tripartite composition, it also produces its own illusion of space through the now familiar reversal of figure and ground. On the left, the Pierrot's white legs emerge as figure only to retreat under the protrusion of lap and tabletop to become the background to the table's advancing leg. The figures' arms reach forward to grasp their instruments (clarinet, guitar) as though they were the black borders on a printed card, advancing from the edge of a plane onto which another reading calls them back again. In the case of the Pierrot, this is the pattern of the indigo mask of the Harlequin (the central musician) attached to the Pierrot's lower face and torso to form an advancing figure that makes the white surplice of the Pierrot withdraw into a background. The complex figure of the indigo plane is visually joined to the vertical stripe bifurcating the habit of the monk on the right, as well as implicitly connecting with the leftmost angle below the Pierrot's legs to create both a figure and a ground floating above the planes

▲ 1912 ● 1911

1 • Pablo Picasso, *Three Musicians*, 1921
Oil on canvas, 200.7 × 222.9 (79 × 87¾)

of the musicians. But another surface surrounds both the indigo figure / ground and the trio of musicians; this is the brown backdrop of the actors' stage—an ambience that was challenged by the indigo's figure, which it now in turn challenges at every interstice between the forms (particularly the brown smudge covering the Harlequin's face immediately below his mask). The indigo figure flipping back and forth into its supporting ground performs this reversal constantly. With the decorative striations of their costumes, especially so of the quilted suit of the Harlequin, the nearly grey monochrome of Analytical Cubist painting has retreated behind the strong colors and symmetries of this postwar Cubism, now named Synthetic.

The entry of Poussinesque classicism into Cubist space was extended in this mid-twenties Synthetic turn by Picasso's frequent representations of the painter and model in the studio. Giving each participant in this narrative of aesthetic creation its own domain, the paintings divide into the familiar tripartite composition to display artist on one side, model on the other, with canvas at the center, as in *Painter and Model* of 1928 [**2**]. Not content with merely choreographing the triplet within the studio, Picasso also stages the act of representing, as the model's profile appears on the canvas surface as if her very shadow were being cast upon it—just as the shadow of one of the shepherds appears on the side of the tomb in *Et in Arcadia Ego*.

2 • Pablo Picasso, *Painter and Model*, 1928
Oil on canvas, 129.8 × 163 (51⅛ × 64¼)

But Picasso did not need to separate the participants in his narrative of the act of creation to represent artist, canvas, and model individually. In his earlier 1915 *Harlequin* [**3**], he overlaid the three in true Synthetic style, which he was then just beginning to develop. The painter represents himself as Harlequin in his diamond-patterned suit, his head superimposed on a geometric background that forms his arm and easel. Curvilinear shapes are cut out of this background to suggest the shape of the artist's palette, so the arm that grasps it catches the painter in his very "act." Representation continues in the white square on the right-hand side of the painting, suggesting a canvas onto which a pale shadow of the model is faintly cast. The three levels fluctuate between themselves so that now artist, now palette, now canvas is figure to the others' ground.

3 • Pablo Picasso, *Harlequin*, 1915
Oil on canvas, 183.5 × 105 (72¼ × 41⅜)

4 • Georges Braque, *The Gray Table*, 1930
Oil and sand on canvas, 145 × 76 (57⅛ × 69⅜)

5 • Juan Gris, *Harlequin with Guitar*, 1919
Oil on canvas, 116 × 89 (45⅝ × 35)

Unsurprisingly, Picasso's *Harlequin* solution provided the pattern for Georges Braque's own postwar Synthetic practice and throughout the twenties. Reprising the composition of a figure holding a lute or other stringed instrument that he had exploited in *The Portuguese*, Braque suggests the figure's body as a shadow, itself most often the surface of a table [**4**]. Against this shadow, the familiar elements of Cubist still life are supported: newspaper, guitar, fruit bowl. Juan Gris, too, took up this impacted version of artist / canvas / model in his *Harlequin with Guitar* of 1919 [**5**]. The Harlequin's guitar and shadow enact the same premonition of artist's palette as in Picasso's; canvas appears in the canted rectangle below the figure's right arm, and the model seems to cast her shadow in the profile of the figure's face. If the studio-of-the-artist might be a contracted form of narrative, it nonetheless prolongs the modernist determination to portray the operations of the medium itself: the work of creation; the limits of representation; the elements of the aesthetic medium.

As we have seen, the two compositional types that emerge in Picasso's postwar Synthetic Cubism either divide the canvas into thirds, as in *Three Musicians*, or superimpose the elements into the interlace of figure / ground, as in the *Harlequin*. In his own adoption of the Synthetic style, Fernand Léger made use of both solutions.

▲ 1911, 1912, 1919

Scenes from the life of Bohemia

Cubism was a constant restaging of still life. The familiar objects positioned on the café table by the Analytical style were resituated by the Synthetic variant to the artist's garret. This attic space was the shabby domain at the heart of "Bohemia," the mythic urban quarter where artists gathered alongside other unconventional types to flaunt the hardship of creation and their precarious existence on the social margins. Picasso placed several postwar still lifes in such a setting, with walls and ceiling sloping toward a dormer window that opens onto rooftops and sky. Ironwork balconies are rhymed with fretted wooden panels below tables to compress the space of the room—to void it.

The location of the still life inside a private room thus links early twentieth-century Cubism with the domestic interiors of seventeenth-century Dutch painting. Art historians have seen these sumptuous works as the proud display of middle-class wealth, with their owners commissioning painters to depict the valuable possessions they had amassed from around the world. The support for this luxuriant ostentation was the circulation of capital necessary to the development of the bourgeois individual, the prototype of the democratic subject. The artist's garret is thus the legatee of this idea of the free individual; and the myth of Bohemia—the land of aesthetic freedom—grew up around it.

In *Picasso and Truth*, T. J. Clark argues that World War I condemned Bohemia to death, bringing an end both to its restless creator and to the liberated individual subject who inhabited the garrets of la Bohème. Indeed, with Braque and Apollinaire stationed at the front in the early years of the war, Picasso's entourage had been emptied out of Paris. The latter's death in 1918 came as a severe blow to Picasso, who was later invited to make a sculptural monument in memory of his friend. His proposal got as far as sketches and several two-foot-high iron-rod maquettes he produced in 1928 with Julio González—"outline drawings in space," as Daniel-Henry Kahnweiler called them. The open lattice work of the proposed sculpture, with its contours of oval body and triangulated arms reaching forward to grasp the rectangle of a canvas, repeated elements of the 1915 *Harlequin*, itself a representation of the artist in the studio. In this way, the transparency and forms of this memorial to Apollinaire mourned also for the garrets of Paris and their Bohemian inhabitants.

The monument relates to an answer that art historians offer to the puzzle posed by the eclipse of early Analytical Cubism with the onset of the Synthetic period in Picasso's work. According to this explanation, Picasso is seen to have been impatient with the sycophants of Cubism, with their endless guitars on pedestal tables, fruit bowls, pipes, and tobacco pouches, leeching the stringency out of the style's power to shock. In his hands, however, Cubism had lost none of its ability to cause controversy. The monument committee rejected his designs as too abstract for a memorial and it remained unrealized for four decades. Had it been completed and installed as intended, it would at least have been able to commemorate another Parisian Bohemia, one teeming with cafés and nightclubs, studios and dancers, including the half-nude Josephine Baker, who was then mesmerizing audiences with her intoxicating and scandalous show.

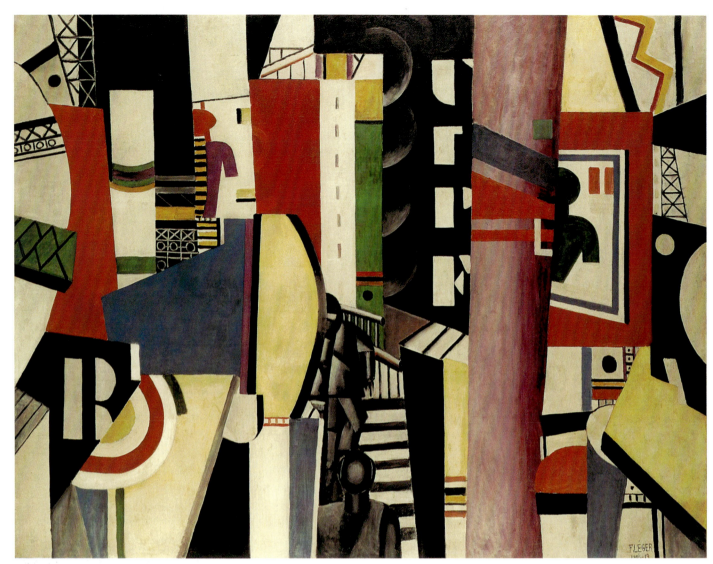

6 • Fernand Léger, *The City*, 1919
Oil on canvas, 231.1 × 298.4 (91 × 117½)

His explorations of the urban environment of Paris, as in *The City* of 1919 [6], converted billboards and street signs into the figure–ground oscillation, with stenciled lettering and the bifurcated auras of street lights producing both the staccato of urban confusion and the shallow depth of the Analytical Cubist canvas. But in his "Breakfast" paintings, he adopted the tripartite structure. Perhaps it was his preference for the full-blown forms ▲ of the classical nude that led to this choice, as in *Three Women (Le Grand Déjeuner)* of 1921, where each figure is declared as independent, removed from her ground by the sharp contrast between the contour of shoulder and forearm against the couch behind her. This particular painting also signals a story from classical antiquity that had been explored by painters and sculptors from at least the Renaissance, centuries before Cubism: the Three Graces. In visual depictions of this tale from Greek mythology, the three daughters of the god Zeus—said to represent beauty, charm, and joy—are displayed in the round and often nude. The subject allowed artists to present the naked female figure from several angles by

rotating the model's body 360° before the viewer. Léger's *Breakfast* enacts this theme with the right-hand nude in the frontal position, the left-hand model on her side, and the central figure displaying her back. Picasso himself adopted the motif of the Three Graces in his 1925 *Three Dancers*, giving yet one more instance of how the interweave of the *Harlequin*'s figure–ground reversal allows Synthetic Cubism to enter narrative and vice versa. Yet if the Three Graces open Cubism to the space of classical myth, they also open it onto another form of narrative altogether: that of time.

The story of the fourth dimension

The Analytical phase of Cubism has sometimes been referred to as "hermetic," so insular had the splintering of physical forms become that to distinguish forehead from face or chin from neck had become nigh impossible for untrained eyes. The supporters of Cubism felt it incumbent to explain this fractured style of representation as a collective response to the novelty of modern

▲ 1925a

experience, and to give it status by associating it with the latest achievements in science and geometry. To this end, in his 1911 essay "Cubism and Tradition," the painter Jean Metzinger reached for the innovation of the space–time continuum of the fourth dimension, which could work to narrativize Cubism, writing:

Already [the cubists] have uprooted the prejudice that commanded the painter to remain motionless in front of the object, at a fixed distance from it, and to catch on the canvas no more than a retinal photograph more or less modified by "personal feeling." They have allowed themselves to move around the object, in order to give, under the control of intelligence, a concrete representation of it, made up of several successive aspects. Formerly a picture took possession of space; now it reigns also in time. In painting, any daring is legitimate that tends to augment the picture's power as painting. To draw, in a portrait, the eyes full face, the nose in semi-profile, and to select the mouth so as to reveal its profile, might very well— provided the craftsman had some tact—prodigiously heighten the likeness and at the same time, at a crossroad in the history of art, show us the right road.

The technique of the "cubists" is clear and rational. These are painters aware of the miracle that is achieved when the surface of a picture produces Space.

When Gris made an Analytical Cubist portrait of his compatriot Picasso in 1912, he followed this formula, drawing "the eyes full face, the nose in semi-profile, and [selecting] the mouth so as to reveal its profile." His imposition of a diagonal, lattice-like grid over the whole surface enforces the experience within it of the little shimmer of canted facet-planes that tie this representation to Picasso's own painstaking work of perceptual analysis. But already as early as 1913 Gris had started to adopt the larger, more decorative forms of Synthetic Cubism, in a triplicate of violins [7] that seem—Three Graces style—to present the observer with two side views of the instrument flanking its front face and thus producing the by-then standard formula according to which the Cubists "have allowed themselves to move around the object, in order to give, under the control of intelligence, a concrete representation of it, made up of several successive aspects."

It was not Cubism, however, that fully embraced Metzinger's movement around the object so as to portray it as "made up of successive aspects" but Futurism. In the first two decades of the century, the philosopher and public intellectual Henri Bergson was a sensation in Paris with his lectures at the Collège de France, enthusiastically attended by scholars, artists, and old ladies alike. His major work *Matter and Memory*, which he had published in 1896, transformed the aesthetic ideas of the Futurist leader, Filippo Tommaso Marinetti, to reconsider space as a continuum of these very "aspects." Bergson's argument had insisted on the distinction between space and time by pointing out that space is measured in identical units each necessarily distinct from and

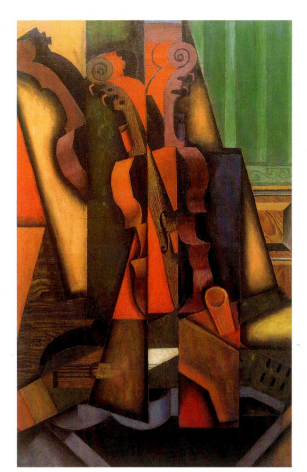

7 • Juan Gris, *Violin and Guitar*, 1913
Oil on canvas, 100 × 65.5 (39⅜ × 25¾)

outside the other (like the inches on a ruler); while time, he argued, is immutably fused within experience: the present retrospectively overlapped by the past and prospectively projected onto its future. The drive towards a representation of such fusion not only determined Giacomo Balla's repetition of continuous ▲ contours, but also led Umberto Boccioni to conceive a work such as *Development of a Bottle in Space* (1913) as a spiral revolving like a nautilus before a viewer to induce in that observer the experience of circling the object.

Yet the figure–ground reversal of Picasso's, Braque's, and Gris's greatest Synthetic works allowed the painting to maintain its obdurate frontality, the flicker of the illusionistically projecting and receding planes opening the minimal implication of a depth that no viewer could enter so as to "move around the object," and thereby grasp its "several successive aspects." No matter how Picasso and Braque were betrayed by their supposed followers, they always remained true to the formal logic that required a painting to remain parallel to and motionless before a viewer's eyes. RK

FURTHER READING
Clement Greenberg, "Collage," *Art and Culture: Critical Essays* (Boston: Beacon Press, 1961)
T. J. Clark, *Picasso and Truth: From Cubism to Guernica* (Princeton, N.J.: Princeton University Press, 2013)
Yve-Alain Bois (ed.), *Picasso Harlequin 1917–1937* (Milan: Skira, 2008)

▲ 1909

The members of the Moscow Institute of Artistic Culture define Constructivism as a logical practice responding to the demands of a new collective society.

On December 22, 1921, Varvara Stepanova (1894–1958) presented a paper entitled "On Constructivism" to her colleagues at the Inkhuk—the Moscow Institute of Artistic Culture, a state research institution founded in May 1920 under the auspices of the Department of Fine Arts (IZO) of the People's Commissariat of Enlightenment (Narkompros). It had been almost a year since the first director of the Institute, Wassily Kandinsky, had resigned, his psychology-based program being rejected as obsolete (if not plain counterrevolutionary) by a swarming group of newcomers marching behind Aleksandr Rodchenko (1891–1956).

As salaried employees of the state, the avant-garde artists and theoreticians who made up Stepanova's audience had to follow bureaucratic routine and keep a stenographic record of the animated discussion that followed the talk. From this we can discern that what was at stake that evening in December 1921 was less the retrospective account of Constructivism offered by Stepanova than the anxious question it prompted about the future: how will the Soviet artist justify his or her existence once he or she has voluntarily abandoned any artistic activity but is yet without the technical knowledge essential for industrial production? (Note the gender qualifiers here: there was perhaps no other artistic movement in the first half of the century where women exerted such a powerful role.)

The Marxist critic Boris Arvatov (1896–1940), soon to become one of the most vocal hard-liners of Productivism, aptly summed up the historical weight of the moment. The artist will not be of any use to industry until he acquires some education in a polytechnic institute, he remarked, but his work nevertheless has a function at the ideological level:

> It's Utopia, but we have to say it. And every time we say it we will be avoiding dogmatism and will not be shading our eyes and we'll be saying that this is real, and necessary, and nobody will reproach us for it. We have to explain the great thing that this doctrine [Constructivism] has brought. It's true that the situation is tragic, like any revolutionary situation. This is the situation of a man on a riverbank who needs to cross over to the other side. You have to lay a foundation and build a bridge. Then the historical role will be fulfilled.

At the end of 1921, the Constructivists were at a crossroads. Since the spring of that year, Lenin's New Economic Policy (NEP), characterized by a partial return to a free market, had been gradually replacing the centralized planning that had presided over Russia during the civil war, a system that had directly benefited members of the artistic avant-garde as a reward for their early and enthusiastic support of the Revolution. The Constructivists knew that the days of the Inkhuk as they had shaped it—as a place where they could freely conduct their "laboratory experiments"—were over, and they embraced the changes to come. The bridge mentioned by Arvatov (that between "art" and "production") had long been on everyone's mind (its necessity had already been advocated with great rhetorical flourish in the pages of *Iskusstvo Kommuny* [Art of the Commune], the official journal of IZO published from December 1918 to April 1919), but one could now feel a distinct acceleration. A month before Stepanova's talk, following a call by Osip Brik, a former member of Opoyaz, for them to transfer out of the jurisdiction of Narkompros into that of the Ministry of the Economy, the Inkhuk Constructivists had collectively decided to abandon "easelism" and to shift to "production." (The word "easelism" derives, of course, from "easel painting" but it was used to describe any kind of autonomous art object, including sculpture). Among the group, the most radical proponents of the Productivist program were even predicting the end of art altogether: Arvatov's bridge had to be built to reach the other side, but it would have to be destroyed as useless once this heaven had been attained. To a large extent, this remained wishful thinking, and the concerns that were vented during the December 1921 evening would eventually be proven to be well founded. But if the glee with which the Constructivists had endorsed their resignation as artists now rings of something like a manic denial, it certainly could not have looked in any way suicidal at the time. There was a logic to their self-immolation which constituted the climax of a whole year of experimentation.

"The first monument without a beard"

The birth of Constructivism came as a direct response to Vladimir Tatlin's model for the *Monument to the Third International*, often simply called his *Tower* [1]. Commissioned in early 1919, the

model was unveiled in Petrograd on November 8, 1920 (the third anniversary of the October Revolution), before being shipped to Moscow, where it was re-erected in the building hosting the VIIIth Congress of the Soviets at the very moment when Lenin's plan for the electrification of Russia was being debated. From the detailed pamphlet written by the critic and art historian Nikolai Punin and published on the occasion of the work's presentation, and from numerous declarations by the artist himself, we know that, while the model was a large wooden sculpture of between 18 and 21 feet high, the finished monument was to have been a huge metal-and-glass construction some 1,300 feet high—a third taller than the Eiffel Tower, at the time the tallest building in the world and a feat ▲ of engineering Tatlin had greatly admired during his trip to Paris before World War I. The most striking element of Tatlin's celebrated design was its tilted structure consisting of two dovetailing conical spirals and a complex web of oblique and vertical slats that framed four geometric glass volumes suspended on top of each other within its slanting core. Each of these volumes was supposed to be an independent building housing a different branch of the Comintern (the Soviet organization in charge of "spreading the revolution" to other countries), and each would rotate at a specific pace. The revolution of the lowest and largest volume, a cylinder destined to house the International's "legislative assemblies," was to take a year; that of the second volume, an oblique pyramid for

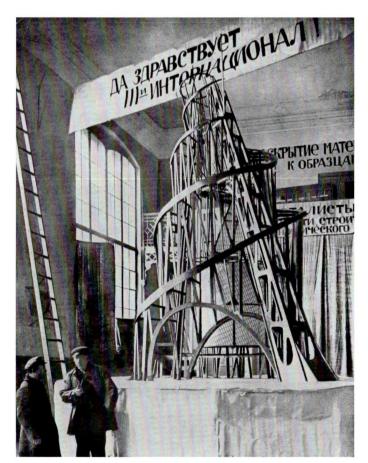

1 • **Vladimir Tatlin, First model of the** *Monument to the Third International* **in the former Academy of Arts, Petrograd, 1920.** Wood, height c. 548.6–640 (216–252)

Soviet institutions

As had been the case during the French Revolution in the eighteenth century, finding a name for a new institution, or renaming an old one, became highly charged political acts in revolutionary Russia, from the very first days of the February 1917 insurrection to Lenin's rise to power in October 1917 and well into the Stalinist era that followed his death in 1924. And the baptismal frenzy of the young Soviet state did not only affect official organizations, but also the many avant-garde groups that had multiplied in the teens, during the heyday of Cubo-Futurism. The absurdist monikers of these prerevolutionary groups (such as Knave of Diamonds, The Donkey's Tail, Tramway V) still smacked too much of the Symbolist past they had been intended to mock. A new linguistic form had to be devised to signify that a radically new era was beginning, and for both the Bolshevik power and that small fringe of the intelligentsia that immediately put itself at its service, the acronym became the prime signifier of such a *tabula rasa*. It was both economical and "poetically" unfamiliar.

The political nature of this linguistic device was established early with the coinage of Proletkult (for "Proletarian Culture") in 1906. Although this organization worried Lenin to the point that by 1909 he had excluded its leader Aleksandr Bogdanov from the Bolshevik party, it was only after the "ten days that shook the world" that it took real stride. But the new government countered its rise by founding an umbrella department, the Narkompros (for "People's Commissariat of Enlightenment"), headed by the liberal Anatoly Lunacharsky, whose domain encompassed cultural affairs, propaganda, and education, and under which all artistic groups—including the recently created Komfuts (for "Communist Futurists")—had to be subsumed. In January 1918, IZO, the visual arts section of Narkompros, was created and placed in Petrograd under the supervision of David Shterenberg, a well-traveled, francophile, eclectic modernist painter who did his best to satisfy the diverse tendencies of the Soviet avant-garde as well as reorganize all art museums of the USSR. His deputy in Moscow was Tatlin.

Among the many new institutions launched by Narkompros were the Svomas (for "Free State Studios"), founded in 1918 and replaced in 1920 by the Vkhutemas ("Higher State Artistic and Technical Workshops"), which can be characterized as the Soviet equivalents to the Bauhaus, the design school that had recently opened in Germany; the Inkhuk (for "Institute of Artistic Culture"), founded in Moscow in 1920 (its first director was Kandinsky, soon evicted by Rodchenko) and its pendant in Petrograd, the Ginkhuk, where Malevich took refuge after the close of his own school in Vitebsk, Unovis ("Affirmers of the New Art") in 1922. Even after the restoration of private business by the NEP in 1921, the government's hold on cultural affairs did not falter, neither did its penchant for acronyms: in 1922, the Inkhuk became part of the Rakhn ("Russian Academy of the Sciences of Art"), where it quickly lost its edge, and the AKhRR ("Association of Artists of Revolutionary Russia") began its steady ascent, which would end up ten years later in the brutal establishment of "Socialist Realism" as the official line in all the arts.

the executive branch, would have lasted a month; that of the next volume, a cylinder for the propaganda services, would have taken a day; and that of the uppermost volume, a small hemisphere added late in the elaboration of the project, would have presumably lasted an hour.

Tatlin and his friends (most notably Punin as his official spokesman) developed three lines of argument in favor of the actual construction of the monument on its projected, vast scale. First, as opposed to the eyesores erected in various places to commemorate the Revolution, it would definitively be "modern" (the poet Vladimir Mayakovsky celebrated the project as "the first monument without a beard"), which meant for Tatlin that it was in strict obedience to the principle of the "culture of materials" (that is, of "truth to materials") he had been developing in his sculptural ▲ reliefs of 1914–17. Second, it was to be an entirely functional, productivist object (Mayakovsky also called it "the first object of October"), surpassing, in yet another sense, the Eiffel Tower, whose principal use was as a radio antenna. Third, like all public monuments, it was conceived as a symbolic beacon: it spelled out "dynamism" as the ethos of the Revolution.

At the Inkhuk, the formation by Rodchenko and his friends of the Working Group of Objective Analysis, which precipitated Kandinsky's demise as director, had preceded by just a few weeks the unveiling of Tatlin's monument. Given the enormous attention that this project received in Moscow at the time, it is not surprising that the Working Group focused on the issues it raised. The fact that it was an experimental design unlikely ever to be built (although it was declared technically possible by a team of Soviet engineers) did not deter them—on the contrary, the very fact that a project could have such an impact was an encouragement to pursue "laboratory work." Bracketing for the moment the concern for production and functionality, the members of the Working Group concentrated on the model's two other aspects, its "truth to materials" (or *faktura*) and its symbolic dynamism (or *tectonics*), which were seen by Rodchenko and the others as being contradictory in Tatlin's project. They felt that at the material level, and contrary to Tatlin's argument, nothing justified the formal use of a spiral and the appeal to an age-old iconography. The *Monument* was a romantic affair, they argued, elaborated by a lone artist in the secrecy of his studio and with the traditional tools of his craft; its formal organization remained an indecipherable secret that reeked of "bourgeois individualism": it was not a construction but an authorial composition.

The construction / composition debate

But those terms were too loose and had to be properly defined: from January 1, 1921, to the end of April, the Working Group conducted a lengthy debate centering upon the very notions of construction and composition. Each participant had to demonstrate, by means of a pair of drawings, what they understood of these two opposing words. Except for the drawings of Nikolai Ladovsky (1881–1941) and Karl Ioganson (c. 1890–1929)—both proposing as "construction" what would be labeled much later a "deductive structure," that is, a formal division of the surface that is predicated by the material properties (shape, proportion, dimension) of that very surface—the resulting portfolio is somewhat disappointing. Either the opposition was confused by a change of technique (*sfumato* for composition, sharp edge for construction) or by the evocation of a change in medium (a sketch of a painting versus that of a sculpture); or, especially in the case of Vladimir Stenberg (1899–1982), construction was simply under-

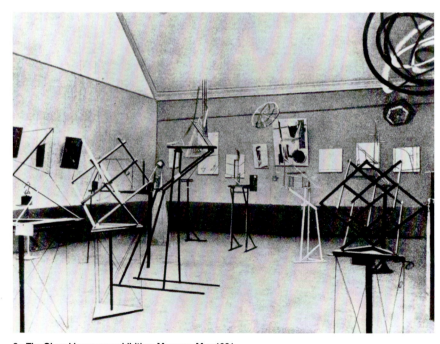

2 • The Obmokhu group exhibition, Moscow, May 1921
Karl Ioganson's *Study in Balance* can be seen on the extreme left.

▲ 1914

3 • Karl Ioganson, *Study in Balance*, c. 1921
Medium and dimensions unknown (destroyed)

stood as anything with a machine look. But the written statements and the many discussions that accompanied the production of these drawings are most enlightening. After much polemicizing, sometimes very harsh, a consensus was reached: construction was said to be based on a "scientific" mode or organization in which "no excess materials or elements" were involved. Or to put it in semiological terms, a construction was a "motivated" sign, that is, its arbitrariness is limited, its form and meaning being determined (motivated) by the relationship between its various materials (which is why it cannot borrow iconographical elements, for example), whereas a composition was "arbitrary."

This conclusion seems at first a rather meager result for four months of intense discussion, and the rhetoric of the debate was undoubtedly naive ("excess" = "waste" = "bourgeois epicure-anism" = "morally condemnable"), but it is nevertheless from this lengthy forum that Constructivism as a movement arose: the term itself emerged during the debate, and Rodchenko quickly monop-olized it, in March 1921, by forging with his closest allies the Working Group of Constructivists (it consisted of five sculptors or, rather, creators of "spatial constructions"—himself, Ioganson, Konstantin Medunetsky [1899–c. 1935], Vladimir Stenberg, and his brother Georgy [1900–33]—who were joined by Stepanova

and, from outside the Inkhuk, the cultural agitator Aleksei Gan [1889–1940]). Gan, who had just been expelled from Narkompros for his extremism, was immediately put in charge of writing a Constructivist program, and a lot of debating among the Group evolved around his obscure terminology. Gan's confused and polemical prose (his book *Constructivism* appeared in 1922) is of no great help in assessing the thinking of the Group, and it is most unfortunate that this peripheral figure should have been assigned the central position of spokesman (it would prove particularly damaging, much later, when Stalin's commissars were on a repressive rampage, but it would also long distort the view of historians of the movement). Much more to the point is the artistic activity of the other founding members in the immediate aftermath of the construction / composition debate.

One farewell to art

A key event is their participation in the second group show of Obmokhu (Society of Young Artists), in May 1921, which consisted mainly of "spatial constructions" [2]. Even though only two of these sculptures survive, this legendary exhibition is well documented. Neither the works of the Stenberg brothers, which

4 • Aleksandr Rodchenko, *Oval Hanging Construction No. 12,* **c. 1920**
Plywood, open construction partially painted with aluminum paint, and wire, 61 × 84 × 47 (24 × 35¹⁵⁄₁₆ × 18½)

resemble metallic bridges, nor the polychrome sculptures of Medunetsky (one of which was bought by Katherine Dreier at the "First Russian Exhibition" in Berlin in 1922, and is today at the Yale University Art Gallery in New Haven) abide by the strict definition of construction proposed during the debate. The first do not go beyond Tatlin's conception of the "truth to materials"; ▲ the second are clearly indebted to Malevich's painting. But Rodchenko's suspended sculptures and Ioganson's "Spatial Cross Series" testify to the major step accomplished in a very short time. Both series of works were conceived as demonstrations of a "scientific" (which meant at this time dialectic, materialist, Communist) method: there was no a priori conception (no borrowed image); every aspect of the work was determined by its material conditions.

In the case of Rodchenko's suspended sculptures, a single sheet of plywood coated with aluminum paint was cut out into concentric shapes (either a circle, a hexagon, a rectangle, or an ellipse—the latter being the only surviving example of the series [**4**]). These were then rotated in depth to create various three-dimensional geometric volumes: the sculpture could easily be folded back into its original planar condition, thereby laying bare the process of its production. Ioganson's works exhibited the same pedagogical directness. In one of them in particular [**3**], set on a triangular base and consisting of three rods maintained in space through the tension of a connecting string, Ioganson attempted to give a visual and measurable form to the "excess" that every construction should aim to eradicate: the string was longer than required, but this "excess," clamped at the end of the tense loop and hanging limp, also had a demonstrative function (to lower the three pointed rods and thus transform the sculpture, one had only to release more of the string's slack). In other words, in contrast with the bourgeois artist's studio secrets, the sculpture's "logical" mode of production and deductive structure were heralded as a means of opposing the fetishization of artistic inspiration.

The same could be said of the modular sculptures that Rodchenko realized soon after the Obmokhu exhibition (each of which is made of equal-sized woodblocks, the plan sometimes being equal to the elevation). The formal logic that presides over these works, once again a deductive structure, is close to that enacted by the ● Minimalists forty years later (Carl Andre would sing their praises when photographs of them appeared in the West). And it is not by chance either that such a logic should have had similar effects in both historical periods, no matter how dissimilar were the contexts of revolutionary Russia and late-fifties New York Bohemia as far as the status of painting was concerned. Carried to the extreme in this medium, the reductive direction upon which the Inkhuk Constructivist had embarked could only result in either the pure grid or the pure monochrome: within the parameters of abstraction, any other pictorial possibility would involve an opposition between figure and ground, thus giving rise to imaginary space, composition, ■ "excess." And just as Donald Judd would condemn painting for its incapacity to entirely shed illusionism, Rodchenko said farewell to this art after having shown his famous monochrome triptych at the

5 • Aleksandr Rodchenko, *Pure Red Color, Pure Yellow Color, Pure Blue Color*, 1921
Oil on canvas, 62.5 × 52.5 (24⅝ × 20⅝)

exhibition "5 × 5 = 25" in September 1921 [**5**]: "I reduced painting to its logical conclusion and exhibited three canvases: red, blue, and yellow," he later wrote. "I affirmed: It's all over. Basic colors. Every plane is a plane, and there is to be no more representation."

Rodchenko's iconoclastic gesture quickly became a legendary landmark (nicknamed "the last picture," it is described as a ▲ turning-point by Nikolai Tarabukin, a former Formalist critic who had become the most astute ideologue of the Inkhuk group, in his 1923 treatise *From the Easel to the Machine*): with it a page of history had been turned, a point of no return had been reached. Analysis was no longer the order of the day: there was now no other possible path than to "enter production." Stepanova's December 1921 paper was a memorial service. The elaboration of a Productivist platform would be the central preoccupation of Rodchenko and his friends during the early months of 1922.

The move to propaganda

But despite their enthusiasm and their willingness to "work in the factory," the Constructivists-turned-Productivists were to meet a depressing reality: in the New Economic Policy of Lenin they could no longer count on the blanket support of the state. To their great chagrin, their services were not welcome: they were either seen as an interfering nuisance by the new entrepreneurial cast of production managers, or derided as intellectual parasites by the workers. Stepanova and Liubov Popova successfully created a line

of textile designs that were mass produced (these constitute perhaps the only success story of the Productivist utopia, but it remains a minor achievement); Tatlin, too, managed to work in a factory, but he could not endure for long the task he was asked to perform (merely that of decorating objects), and none of the utilitarian objects he designed once he had returned to his studio was ever realized industrially (most notably a hideous stove destined to minimize the use of fuel; a bentwood chair that is, paradoxically, one of his most elegant sculptures; and a Leonardesque flying machine, a kind of winged bicycle that he called *Letatlin*, from the contraction of his name with the verb "*letat*," to fly). Division of labor, which the Constructivists, as good Marxists, had first chided as being conducive to alienated labor, but then paradoxically endorsed when Lenin had declared it essential to the reconstruction of Russia, had turned against them. Only Ioganson, who had been the most technically creative of the Constructivists (although he was, at most, in his very early twenties), managed to participate actively in the production of objects: he was hired as an inventor. In another context his talents would have thrived (his Obmokhu sculptures were similar to the tensile structures proposed by Kenneth Snelson and Buckminster Fuller in the late forties and early fifties, now called "tensegrity systems" and considered today a major step in the history of building technology). But no one was there at the time to recognize that for once the bridge called for by Arvatov had been crossed: all in all, the output of hard-core Productivism is pretty slim.

However, the new ethos devised in early 1922 bore important fruits: not in the production of everyday functional objects, but in the field of propaganda. If usefulness was the motto, and even if industry could not see a way to put artists to use, then they could at least be enlisted in advertising the Revolution (or even the objects produced, without their help, in state-owned factories). From the early twenties on, the creation of posters, theater sets, agitational stands, exhibition, and book designs became the chosen domain of ▲ the Constructivists, and with continuing success. As Tarabukin had predicted, their realizations in the ideological realm (that of imaging the Revolution) became their most important legacy. Rather than presiding over the production of objects, they had shaped the ideology of Production: they had found a niche, at last, within Soviet Russia's ever-intensifying division of labor. YAB

FURTHER READING
Richard Andrews and Milena Kalinovska (eds), *Art Into Life: Russian Constructivism 1914–1932* (Seattle: Henry Art Gallery, University of Washington; and New York: Rizzoli, 1990)
Maria Gough, "In the Laboratory of Constructivism: Karl Ioganson's Cold Structures," *October*, no. 84, Spring 1998
Selim Khan-Magomedov, *Rodchenko: The Complete Work*, ed. Vieri Quilici (Cambridge, Mass.: MIT Press, 1987)
Christina Lodder, *Russian Constructivism* (New Haven and London: Yale University Press, 1983)

▲ 1928b

1922

Hans Prinzhorn publishes *Artistry of the Mentally Ill*: the "art of the insane" is explored in the work of Paul Klee and Max Ernst.

In the first decades of the century, many modernists drew on "primitive" art, while some also mimicked the art of children (e.g., the Blaue Reiter Expressionists). By the early twenties a third interest—the art of the insane—completed the set of exotic models. Today, these three might strike us as odd, but for modernists like Paul Klee they were natural, even necessary guides in the search for "primal beginnings in art." This points to a persistent paradox of the modernist search: that expressive *immediacy* would be pursued through the *mediation* of artistic forms as complex as tribal objects and schizophrenic images.

The reassessment of the art of the insane followed that of primitive art. Either dismissed out of hand or viewed in diagnostic terms, such art was ready for reevaluation. Yet most modernists saw it only according to their own ends: as intrinsically expressive, boldly defiant of convention, or directly revelatory of the unconscious, which for the most part it was not. The Romantics had also viewed the primitive, the child, and the insane as figures of creative genius unfettered by civilization. But in the modernist version of this trio the medium shifted from the verbal (poetry) to the visual (painting and sculpture), and the recovery of the art of the insane was complicated by its denigration after Romanticism. For by the middle of the nineteenth century this art was viewed less as a model of poetic inspiration than as a sign of psycho-physical "degeneration." A key figure here is the Italian psychiatrist Cesare Lombroso, who, along with his Hungarian follower Max Nordau, spread this ideological notion to several discourses. Lombroso understood madness as a regression to a primitive stage of psycho-physical development—a model that prepared a phobic association of primitive, child, and insane, which persisted in the twentieth century alongside the idyllic association of the three as creative innocents. In *Genius and Madness* (1877), a study of 107 patients, half of whom drew or painted, Lombroso detected this degeneration in "absurd" and "obscene" forms of representation.

Schizophrenic masters

This discourse of degeneration continued through psychiatry into psychoanalysis as it emerged in the late nineteenth century; and the diagnostic reading of the art of the insane persisted too. Like his French predecessor Jean-Martin Charcot, Sigmund Freud extended this approach through reversal, as he looked for signs of neurosis or psychosis in the work of "sane" masters like Leonardo or Michelangelo. By the turn of the century, with the clinical work of the German Emil Kraepelin and the Swiss Eugen Bleuler, focus fell on schizophrenia, which was understood as a broken relation to the self, as manifested in a dissociation of thought or a loss of affect—in any case, in a disruption of subjectivity marked by a disruption of image-making. This diagnostic approach was challenged only gradually, first with *L'Art chez fous* (1907) by Marcel Réja, the pseudonym of the French psychiatrist Paul Meunier, who examined the art of the insane for insight into the nature of artistic activity per se, and then with *Artistry of the Mentally Ill: A Contribution to the Psychology and Psychopathology of Configuration* (1922) by Hans Prinzhorn, who pursued this line of inquiry in a way that was provocative to several modernists.

Significantly, Prinzhorn studied art history (at the University of Vienna) before he turned to psychiatry and eventually to psychoanalysis. This unique training led the Heidelberg Psychiatric Clinic to appoint him in 1918; there he studied and extended its collection of art to some 4,500 works by 435 patients, most of them schizophrenics, from various institutions. With 187 images from this collection, his book included a "theoretical part," ten case-studies of "schizophrenic masters," and a summary of "results and problems." It was thus very selective; it was also often contradictory. On the one hand, Prinzhorn aimed not to be diagnostic; he saw six "drives" active in schizophrenic representation, but present in all artistic composition as well. On the other hand, Prinzhorn did not seek to be aesthetic; indeed, he cautioned against any direct equation with "sane" art, and, even as he called his ten favorites "masters," he used the archaic term *Bildnerei* ("artistry" or "image- making") in his title, in contradistinction to *Kunst* or "art." Nevertheless, Prinzhorn did refer to van Gogh, Henri Rousseau, James Ensor, Erich Heckel, Oskar Kokoschka, Alfred Kubin (who studied the art of the insane), Emil Nolde, and Max Pechstein. And further connections were made first by modernists, then by enemies of modernism—most infamously in the 1937 Nazi exhibition "Entartete 'Kunst'" ("Degenerate 'Art'") which attacked modernists like Klee through this association with the mad [1].

Zwei „Heilige"!!

Die obere heißt „Die Heilige vom inneren Licht" und stammt von Paul Klee. Die untere stammt von einem Schizophrenen aus einer Irrenanstalt. Daß diese „Heilige Magdalena mit Kind" immer noch menschenähnlicher aussieht als das Machwerk von Paul Klee, das durchaus ernst genommen werden wollte, ist sehr aufschlußreich.

„Ethik der Geisteskrankheit."

„Der Besessenen wahnsinniges Reden ist die höhere Weltweisheit, da sie menschlich ist . . . Warum haben wir diese Einsicht gegenüber der Welt des freien Willens noch nicht gewonnen? Weil wir äußerlich die Herren des Wahnsinns sind, weil die Geisteskranken von uns vergewaltigt werden, und wir sie daran hindern, nach ihren ethischen Gesetzen zu leben . . . Jetzt müssen wir den toten Punkt in unserem Verhältnis zur Geisteskrankheit zu überwinden trachten."

Der Jude Wieland Herzfelde in „Die Aktion" 1914.

1 • Paul Klee, *The Saint of Inner Light*, 1921, juxtaposed with a work by an unknown schizophrenic, in the brochure for the Nazi exhibition "Degenerate 'Art'," 1937 (texts translated below)

2 • Paul Klee, *Room Perspective with Inhabitants*, 1921
Watercolor and oil drawing, 48.4 × 31.5 (19 × 12½)

Two "Saints"!!

The one above is called "The Saint of Inner Light" and is by Paul Klee.

The one below is by a schizophrenic from a lunatic asylum. That this "Saint Mary Magdalen and Child" nevertheless looks more human than Paul Klee's botched effort, which was intended to be taken entirely seriously, is highly revealing.

"Ethics of Mental Illness"

"The crazy talk of obsessives is the higher wisdom, for it is human…. Why have we yet to gain this insight into the world of the free will? Because, superficially, we are in command of insanity, because we do violence to the mentally ill and prevent them from living in accordance with their own ethical laws…. Now we must seek to overcome the blind spot in our relationship with mental illness."

The Jew Wieland Herzfelde in "Action" 1914.

As his allusions suggest, Prinzhorn was interested in Expressionist art; his art-historical and philosophical models also inclined him toward a psychology of expression. Hence the six "drives" that govern the "artistry of the mentally ill": drives toward expression, play, ornamental elaboration, patterned order, obsessive copying, and symbolic systems, the interaction of which was said to determine each image. But here, too, Prinzhorn risked contradiction. For drives toward expression and play suggest a subject open to the world in a way that the other drives do not; on the contrary, compulsive ornamenting, ordering, copying, and system-building suggest a subject in rigid defense against the world (whether internal or external), not in empathic engagement with it. Even as Prinzhorn posed the former drives as correctives to the latter, he came to admit this essential difference between artist and schizophrenic:

> The loneliest artist still remains in contact with reality…. The schizophrenic, on the other hand, is detached from humanity, and by definition is neither willing nor able to reestablish contact with it…. We sense in our pictures the complete autistic isolation

▲ 1908

and the gruesome solipsism which far exceeds the limits of psychopathic alienations, and believe that in it we have found the essence of schizophrenic configuration.

The modernists most engaged by the art of the insane were Klee, the German Dadaist-turned-Surrealist Max Ernst (1891–1976), ▲and Jean Dubuffet (1901–85), the French founder of *art brut*; all knew *Artistry of the Mentally Ill* well. Klee and Ernst often contrived fantastic systems that sometimes mixed forms of writing and drawing—what Kraepelin once disparaged as the "word and picture salad" of schizophrenic representation. They also often experimented with bodily distortions that evoke psychic disturbance more than formal play. Klee sometimes enlarged the eyes or heads of figures (a common trait in the art of children, too), or extended other features into ornamental patterns (a tendency of schizophrenic representation noted by Prinzhorn), as in the scrolled wreaths and wings of his *Angelus Novus*, a drawing owned ●by Walter Benjamin, for whom it was an allegorical angel of history-as-catastrophe. Even more disruptively, Klee sometimes repeated certain parts of the body (like the face) in other parts, as if to literalize a schizophrenic sense of self-dislocation; Dubuffet did much the same thing.

This apparent anxiety about body images could prompt a paradoxical treatment of boundaries in Klee and Ernst as in schizophrenic art. Sometimes boundaries are effaced, or exaggerated, and sometimes they are exaggerated to the point of effacement again—as if, in the attempt to underscore the lines between self and world necessary to a sense of autonomy, these distinctions were undone. Klee evokes a collapsing of figure and ground, a merging of subject and space, in *Room Perspective with Inhabitants* [2]. The anxiety about boundaries could also prompt a counter to this collapse—a paranoid vision of the world as estranged, and hostile in its estrangement. Ernst evokes this alienation in *The Master's Bedroom* [3], where both the odd occupants and the skewed space seem to gaze back at the artist-viewer in threat, as if a traumatic fantasy, long repressed, had suddenly returned to possess its "master."

In-between worlds

In 1920, in the midst of his involvement with the art of the insane, Klee wrote his famous "Creative Credo," which begins: "Art does not reproduce the visible; rather, it makes visible." This principle points to the special status of the primitive, the child, and the insane for Klee: as inhabitants of an "in-between world" that "exists between the worlds our senses perceive," they "all still have—or have rediscovered—the power to see." This power is visionary for Klee, and as early as 1912, in a review of the Blaue Reiter, he deemed it necessary to any "reform" of art. And yet, just as Prinzhorn wanted to see schizophrenic art as expressive, only to discover that it is often radically *in*expressive, that is, expressive only of withdrawal, so Klee wanted to see an innocence of vision there, only to discover an intensity that often bordered on terror—the terror of the subject lost in space, as in *Room*

3 • Max Ernst, *The Master's Bedroom*, c. 1920
Collage, gouache, and pencil over a page from a schoolbook, 16.3 × 22 (6⅜ × 8⅝)

▲ 1924, 1946, 1959c ● 1935

Perspective with Inhabitants, or of visible objects become viewing subjects, as in *The Master's Bedroom*.

▲ According to Oskar Schlemmer, his colleague at the Bauhaus school of art and design, Klee knew of the Heidelberg collection before Prinzhorn lectured near Stuttgart in July 1920; and according to another colleague, Lothar Schreyer, Klee identified with work represented in *Artistry of the Mentally Ill* upon its publication in 1922—and this at an institution, the Bauhaus, renowned for its rationalism. "You know this excellent piece of work by Prinzhorn, don't you?" Schreyer has Klee remark. "This is a fine Klee. So is this, and this one, too. Look at these religious paintings. There's a depth and power of expression that I never achieve in religious subjects. Really sublime art. Direct spiritual vision." When Klee simply illustrates "religious subjects," as in his "angels," "ghosts," and "seers," he often does not achieve this "power of expression." However, when he evokes "direct spiritual vision," he often approaches it—an expression that "makes visible." Yet precisely here Klee runs the risk of a primal vision that, far from innocent, is hallucinatory—the risk of an image that possesses the artist. This state, too "direct," too "sublime," is evoked in some schizophrenic representation, such as *Monstrance Figure* by Johann Knüpfer [4], one of the ten Prinzhorn "masters" whose work Klee would have known. A "monstrance" is a "making visible"; in the Roman Catholic Church it is an open or transparent vessel in which the Host is displayed for veneration. But this "monstrance figure" is monstrous—an image that, however obscure to us, appears too transparent to the "religious vision" of its schizophrenic maker, the intensity of which shines through untamed. Some Klees catch a glimmer of this same intensity, and it burns away his innocent idea of the art of the insane.

Ernst had no illusions about the innocence of schizophrenic representation; on the contrary, he exploited its disturbances for his own antifoundational ends—to disrupt "the principle of identity" in art and self alike. Even before World War I he had encountered the art of the insane during his studies at the University of Bonn (which included psychology); at one point, he planned a book on such images. "They profoundly moved the young man," Ernst wrote in his art-treatise-cum-auto-analysis *Beyond Painting* (1948). "Only later, however, was he to discover certain 'procedures' that helped him penetrate into this 'no man's land.'" Already in his early Dadaist collages made in Cologne, Ernst not only assumed a quasi-autistic persona, "Dadamax," but also imaged the body in quasi-schizophrenic guise as a disjunctive, dysfunctional machine. These estranged schematic images are more caustic than the ironic mechanomorphic portraits of
● fellow Dadaists Duchamp and Picabia, for they point to the narcissistic damage produced by the war (in which Ernst was wounded). In one collage based on a found printer's proof, *Self-Constructed Small Machine* [5], the body is a bizarre broken apparatus. On the left is a drum figure with numbered slots, on the right, a tripod personage, suggestive of a camera and a gun, as if the subject of military-industrial modernity were reduced to

4 • Johann Knüpfer, *Monstrance Figure*, 1903–10
Pencil and ink on writing paper, 20.9 × 16.4 (8¼ × 6½)

two functions: those of recording machine and killing machine. Below runs a confused account of this armored "anatomy," in German and in French, that conflates sex and scatology, as a child or a schizophrenic might. This "self-constructed small machine" is indeed reminiscent of a mechanical substitute for a damaged ego, as found in some schizophrenic representations, but it is a substitute that only debilitates this ego further. In his alienated self-portrait, then, Ernst evokes the *development* of the military-industrial subject as a *regression* to broken functions and disordered drives.

Traumatic fantasies

These early collages (which include, as in *The Master's Bedroom*, "overpaintings" on found representations from old schoolbooks)
▲ were crucial to the definition of the Surrealist image. They "introduced an entirely original scheme of visual structure," André Breton wrote when they were first shown in Paris in 1921, "yet at

5 • Max Ernst, *Self-Constructed Small Machine*, c. 1920
Stamp and pencil rubbings of printer's block with ink on paper, 46 × 30.5 (18⅛ × 12)

the same time [they] corresponded exactly to the intentions of Lautréamont and Rimbaud in poetry." Lautréamont was the nineteenth-century poet-hero of Surrealism whose enigmatic line— "beautiful as the chance encounter of a sewing machine and an umbrella on a dissecting table"—was adopted as its aesthetic motto. Already the French poet Pierre Reverdy had defined Surrealist poetics as "two realities, more or less distant, brought together." Now, with the example of the Ernst collages, Breton could also define Surrealist art as "the juxtaposition of two more or less disparate realities." Such juxtaposition is a principle of collage, but, as Ernst once remarked, "Ce n'est pas la colle qui fait le collage" (It's not the glue that makes the collage); other "procedures" might produce this catalytic effect as well. Key here is the connection between a disruption in representation and a disruption in subjectivity, and it is difficult to imagine this aesthetics of dis / connection without the model of schizophrenic art. Indeed, when Ernst moved to Paris in 1922 to join the Surrealists-to-be, he brought a copy of *Artistry of the Mentally Ill*—as a gift for Paul Éluard, who in the same year collaborated with Breton on a poetic simulation of madness titled *Immaculate Conception*.

Ernst connects disruptions of image and self in *Beyond Painting*. The book opens with a "vision of half-sleep" dated "from 5 to 7 years," in which little Max watches his roguish father make "joyously obscene" marks on a panel. This first encounter with painting is cast in terms of a "primal scene," which Freud defined as the fantasy of parental intercourse through which children tease out the riddle of their origins. Ernst uses this trope of the primal scene in the origin stories of all the procedures "beyond painting" that he introduced into the Surrealist repertoire—collage, *frottage* (an image produced through rubbing), *grattage* (an image produced through scraping), and so on. Through such procedures he sought to "desublimate" art—to open it up to psychosexual drives and disturbances. Again, his hallucinatory ideal seems underwritten by schizophrenic representation: "I was surprised," Ernst writes of these experiments, "by the sudden intensification of my visionary capacities and by the hallucinatory succession of contradictory images superimposed, one upon the other, with the persistence and rapidity characteristic of amorous memories."

In this way Ernst worked not only to deploy traumatic fantasy in art, but also to develop it as a general theory of aesthetic practice: "It is as a spectator that the author assists … at the birth of his work.… The role of the painter is to … *project that which sees itself in him*." Here again, with the primal scene in mind, Ernst positions the artist as both a participant inside and a voyeur outside the scene of his art, as both an active creator of his fantasy and a passive receiver of his image. The visual fascinations and sexual confusions of the primal scene govern not only his definition of collage—"the coupling of two realities, irreconcilable in appearance, upon a plane which apparently does not suit them"—but also his description of its purpose—to disturb "the principle of identity," to "abolish" the fiction of "the author" as unitary and sovereign. His provocative images effect this disruption formally more than thematically. For example, even as *The Master's Bedroom* alludes to a primal scene, it is in the formal dis / connection of the image—its contradictory scale, anxious perspective, mad juxtaposition (table, bed, cabinet, tree; whale, sheep, bear, fish, snake)—that traumatic fantasy is evoked, paranoid affect produced. Such are the "'procedures' that helped him penetrate this no man's land" of schizophrenic representation. HF

FURTHER READING

Max Ernst, *Beyond Painting* (New York: Wittenborn & Schultz, 1948)

Hal Foster, *Prosthetic Gods* (Cambridge, Mass.: MIT Press, 2004)

Sander L. Gilman, *Difference and Pathology: Stereotypes of Sexuality, Race, and Madness* (Ithaca, N.Y.: Cornell University Press, 1985)

Felix Klee, *Paul Klee: His Life and Work in Documents* (New York: George Braziller, 1962)

Hans Prinzhorn, *Artistry of the Mentally Ill*, trans. Eric von Brockdorff (New York: Springer-Verlag, 1972)

Werner Spies, *Max Ernst Collages: The Invention of the Surrealist Universe*, trans. John William Gabriel (New York: Harry N. Abrams, 1991)

1923

The Bauhaus, the most influential school of modernist art and design in the twentieth century, holds its first public exhibition in Weimar, Germany.

The Bauhaus was born with the Weimar Republic in 1919, and died with it at the hands of the Nazis in 1933. It developed out of the Arts and Crafts movement as the merger of the Weimar School of Arts and Crafts, begun in 1904 by the Belgian Art Nouveau artist-architect Henry van de Velde (1863–1957), and the Weimar Academy of Fine Arts, which seceded from the Bauhaus a year later in 1920. As the first director of the Bauhaus, the German architect Walter Gropius (1883–1969), wrote in 1923, "[John] Ruskin and [William] Morris in England, van de Velde in Belgium, [Joseph Maria] Olbrich, [Peter] Behrens and others in Germany, and, finally, the German Werkbund discovered the basis of a reunion between creative arts and the industrial world." But this "reunion" was the project of the Bauhaus much more than that of its Arts and Crafts and Art Nouveau antecedents; indeed, the eventual embrace of "the industrial world" signaled the effective end of these prior movements.

This embrace began in 1922–3. The Dutch De Stijl leader Theo van Doesburg had visited the school in 1921–2, and the Russian Constructivist El Lissitzky also came to Weimar in 1922 for the "Constructivist-Dadaist Congress" (organized by van Doesburg). But the turn toward industrial design was only clinched by the hiring of the Hungarian artist László Moholy-Nagy (1895–1946) as a teacher in 1923. In 1925, after a conservative change in the regional government of Weimar, the Bauhaus moved north to the industrial city of Dessau, where its involvement in industrial design deepened. In 1928 Gropius was replaced as director by the Swiss architect Hannes Meyer (1889–1954), a staunch Marxist under whom, ironically, the school achieved its only commercial success. Due to political problems, however, Meyer was replaced in 1930 by the German architect Ludwig Mies van der Rohe (1886–1969), who in 1932, after another conservative change in the regional government, moved the Bauhaus to Berlin. A year later, shortly after Hitler came to power, the Nazis shut it down. That the closure was among the first of the Nazi suppressions is testament to the force of the Bauhaus idea, which did not end there. Indeed, this idea spread with the emigration of teachers and students alike (Gropius, for example, was chairman of the architecture department at Harvard University from 1938 to 1952). Postwar reincarnations were attempted in the United States under Moholy-Nagy, as well as in Europe, and the Bauhaus continues to have a posthumous life throughout the West, not only in many art and architecture schools, but also in countless copies of its furniture and fixtures, appliances and accessories, typefaces and layouts.

Fundaments of material and form

On its founding, Gropius defined the Bauhaus as a "comprehensive system" with "the theoretical activity of an art academy combined with the practical activity of an arts and craft school." The Bauhaus idea was thus to unite the disciplines of fine and applied arts under that of building in a new *Gesamtkunstwerk* or "total work of the arts"—despite the fact that the school did not have a proper architecture department until 1927. Its initial curriculum consisted of two basic parts [1]. The first was instruction in craft workshops: sculpture, carpentry, metal, pottery, stained glass, mural painting, and weaving—the last headed by a rare female instructor, the gifted Gunta Stölzl (1897–1983). The second was instruction in artistic

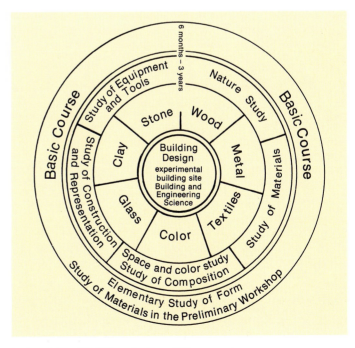

1 • Curriculum of the Weimar Bauhaus, 1923

"form problems": study of nature and materials; teaching in materials, tools, construction, and representation; and theory of space, color, and composition. "Workshop masters"—craftsmen—led the first instruction, while "form masters"—artists—led the second, although several of the latter also participated in the workshops. Despite attempts at equality, the workshop masters have remained obscure, while the form masters include such renowned twentieth-century artists as Wassily Kandinsky and Paul Klee.

In 1919 Gropius could afford only three appointments: the mystical Swiss painter Johannes Itten (1888–1967), who developed the first preliminary course required of all students; the German-American painter Lyonel Feininger (1871–1956), who developed a Cubist style with angular, quasi-Gothic lines [2]; and the German sculptor Gerhard Marcks (1889–1981), who became master of pottery. The next wave of recruits brought the best-known Bauhausians. Oskar Schlemmer (1888–1943), who arrived in late 1920, became master of sculpture and, after 1923, master of theater as well; he also did murals (several within the Bauhaus),

2 • Lyonel Feininger, *Cathedral of the Future*, 1919
Woodcut for the 1919 Program of the Bauhaus, dimensions unknown

for which his abstracted marionette figures in shallow geometric relief were well suited. Klee came in late 1920, too, followed by Kandinsky in early 1922. Although the Expressionist beginnings of the Bauhaus conflicted with its Constructivist leanings after the arrival of Moholy-Nagy, most of its artists were modernist in the sense that they all sought to reveal the fundamentals of materials, forms, and processes. It was this inquiry that drove the core curriculum of the Bauhaus—and all the later institutions that it inspired. This is true of the craft workshops as well: "We did not found our [weaving] workshop on a sentimental romanticism nor in protests against machine weaving," Stölzl remarked in retrospect. "Rather, we wanted to develop the greatest variety of fabrics by the simplest means, and thus to make it possible for the students to realize their own ideas."

The variety of this inquiry can be evoked through the courses offered by its most celebrated figures. Klee and Kandinsky taught a design course in tandem. Both had metaphysical tendencies, but they could also be analytical. For Klee, theory had to emerge from practice; "intuition joined to research" was the credo of his teaching as well as his art. He encouraged students to develop artistic techniques analogous to natural processes—to find "the becoming of forms," "the antecedents of the visible." Like Kandinsky, he began with the basics of point and line, which he saw as either active, passive, or neutral. Even as he valued affective variety in line (his famous definition of a drawing is "a line going for a walk"), he prized compositional harmony above all. So did Kandinsky, and in this regard both men took music as the paragon of abstract art (Klee was also a gifted violinist).

Like Klee, Kandinsky developed a psychology of pictorial elements, but his pedagogy was more dogmatic, in part because he was well established as artist and professor alike (he had set up the program for the Moscow Institute of Art and Culture—Inkhuk—in 1920). His teaching focused on the analytical aspects of drawing and the emotive effects of color. In the first course, Kandinsky required students to abstract from a given object: first to reduce a still life to a simple form, then to render this form in a drawing, and finally to mark the tensions in this drawing as the basis for an abstract composition. In the second course, Kandinsky taught a theory of color structured on such opposites as yellow and blue (he saw yellow as warm and expansive, blue as cold and recessive), with the idea that a visual language could be developed that was more immediate than any verbal communication. He posited a similar psychology of line (for instance, verticals as warm, horizontals as cold) and combined these notions of color and line in a general theory of composition. A questionnaire circulated by Kandinsky suggests its flavor: he asked fellow Bauhausians to fill in a blank triangle, square, and circle with the colors that each form elicited; his own (correct) answer was yellow, red, and blue respectively. For all its claim to system, then, his theory remained subjective, not to say arbitrary, as did the painting that evolved from it. Indeed, what both system and painting bespeak, more than an "inner necessity" of spirit or a universal law of composition, as he claimed,

▲ 1908, 1913, 1922, 1925c ● 1925c ▲ 1928b, 1929 ● 1908, 1913 ■ 1921b

is an anxiety about the arbitrariness of abstraction, and an attempt to reground it in apodictic meaning.

From craft to industry

The real battle of the Bauhaus occurred not in these design classes but in the *Vorkurs*, a six-month probationary course required of all new students. Its first instructor was Itten, who, influenced by Kandinsky before his arrival, also investigated the psychological effects of line and color, which Itten understood in almost mystical terms. Even as his students investigated natural materials and drew diagrams of Old Master paintings, they were asked to capture the spirit of these things. When Moholy-Nagy replaced Itten as head of the *Vorkurs* in 1923, everything seemed to change—except perhaps the ethical basis of the instruction. Where Itten had dressed like a monk and abhorred machines, Moholy-Nagy looked like an engineer and declared the machine "the spirit of this century." Out went the meditative exercises with natural materials and Old Masters; in came a Constructivist analysis of new media and industrial techniques. Self-taught, Moholy-Nagy was protean

▲ in his production. He made collages and photomontages, photographs and photograms (cameraless photographs in which various objects are placed on coated paper and exposed to light), metal constructions and "light-space modulators" [3] (kinetic constructions with lights), and so on. Whereas Itten had diagrammed masterpieces, legend has it that Moholy-Nagy once ordered geometric paintings from a sign factory—he literally phoned the order in. Yet in all these experiments Moholy-Nagy was fiercely analytical and logical, committed to understanding "the new culture of light." If the students had tired of the cultish behavior of Itten by the time of his resignation in October 1922, they were shocked by the rationalist rigor of Moholy-Nagy. But when he resigned in 1928, this rigor had become synonymous with the Bauhaus idea, and it was carried on by Josef Albers, his collaborator in the *Vorkurs* and fellow promoter

● of Bauhaus principles in the United States after World War II.

All histories of the Bauhaus remark on its pedagogical shift from preindustrial craft to industrial design. The first stance was manifested in the 1919 program written by Gropius to announce the school ("Architects, sculptors, painters, we must all return to the crafts!"); while the second is dated to 1923, when Gropius delivered a new position paper, "Art and Technology: A New Unity," at the first Bauhaus exhibition, which was intended to demonstrate the new approach. Specific studies only nuance the shift as a progression from an early medievalist notion of craft to a later industrialist idea of craft. The first was advanced immediately after World War I in order to escape the "dilletantism" of academic art, to reunite artistic disciplines and artisanal practices under the *Gesamtkunstwerk* of building, and so to reconnect not only artists to craftsmen but both of these groups to workers and the *Völk* (the people) as well. The second was advanced in the mid-twenties as a necessary preparation for the new artist-as-designer now that industrial production had recovered somewhat after the war.

3 • László Moholy-Nagy, *Light-Space Modulator*, 1930
Kinetic sculpture of steel, plastic, wood, and other materials with electric motor, 151 × 70 × 70 (59½ × 27½ × 27½)

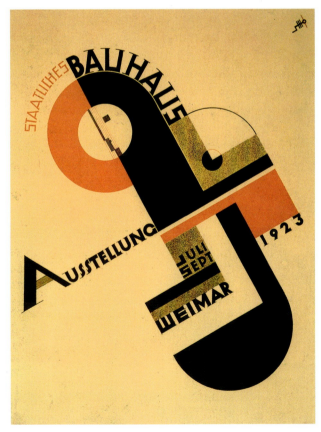

4 • Joost Schmidt, poster for the Bauhaus Exhibition, held in Weimar, July–September 1923

▲ 1929 ● 1947a

Evidence of this transformation is extensive. The original seal of the Bauhaus was an Expressionist stick figure with craft emblems under a wood frame designed by Karl Peter Röhl (1890–1969); in 1921 it was replaced by a confident Constructivist profile with Bauhaus lettering designed by Schlemmer. In 1919 the Bauhaus proclamation was illustrated with a Gothic-Cubist woodcut of "the cathedral of the future" by Feininger [2]; in 1923 the Bauhaus exhibition was announced by a rationalist lithograph poster by Joost Schmidt (1893–1948) that extended the Constructivist visage of Schlemmer into a figure that is at once human, machine, and architectural plan [4]. Until this time the emblematic building of the Bauhaus was an Arts and Crafts loghouse built in Berlin by Gropius and Adolf Meyer (1881–1929) for the timber merchant Adolf Sommerfeld; in 1923, for the Bauhaus exhibition, Georg Muche (1895–1987), who had arrived at the Bauhaus as much a mystic as Itten, modeled a steel-and-concrete "machine for living in." But the real mark of the pedagogical shift was the replacement of the mystical Itten and his core course based on meditative exercise with the technophilic Moholy-Nagy and his course based on structural analysis. The transformation was made institutional in 1925, when the Bauhaus moved to a modernist plant designed by Gropius in Dessau [5], and was renamed an "institute of design" replete with a new program, and established a limited company for trade and patents.

The transformation, then, is not in dispute; the question is how to understand it. Neither an overnight coup nor an orderly transition, the shift from "craft" to "industry" was driven by contradictory forces that preexisted the Bauhaus. (These forces ▲ were also active, for example, in the Deutscher Werkbund, an association of artists and industrialists founded by the architect Hermann Muthesius in 1907, in which Henry van de Velde argued for a craft basis for design, while Muthesius insisted on industrial prototypes.) Thus, more than a personal opposition, Itten and Moholy-Nagy registered a historical contradiction, as did the discrepancy between the early craft advocacy of Gropius and the technological commitment of his architecture, both early

and late (as in his great Fagus shoe factory of 1911). In principle, the Bauhaus was always socialist, but its socialism changed as this socioeconomic contradiction developed. In its first moment, even as the Bauhaus looked to past models like medieval guilds, it also proclaimed a future utopia of artist-craftsmen united under building. In its second moment, however, this futuristic alliance became one of fellow producers in industrial design. In a sense, its historical contradiction is captured in the very term "Bauhaus": even as it invokes modernist design for us today—rationalist architecture, tubular furniture, sans-serif typography, and so on—the name actually derives from the medieval *Bauhütte*, or lodge for masons.

Crisis and closure

"Originally the Bauhaus was founded with visions of the cathedral of socialism, and the workshops were established in the manner of the cathedral building lodges," Schlemmer wrote in November 1922. "Today we must think at best in terms of the house.... In the face of the economic plight, it is our task to become pioneers of simplicity." As Schlemmer sensed at the time, the two basic positions of the Bauhaus responded to two different Germanys: an anarchic country of 1919 that, torn by a lost war, an abdicated kaiser, and a failed revolution, was desperate to restore cultural community; and a fragile republic of 1923 that, wracked by inflation, was equally desperate to modernize industrially. Far from dead in 1919, the Art and Crafts movement was revived as a salve to the labor divisions and class conflicts exposed by the war. Such artist-architect associations as the Novembergruppe (named in honor of the failed November 1918 revolution in Germany) and the Arbeitsrat für Kunst (Workers' Council for Art) kept a "romantic anticapitalism" in the foreground of debate when the Bauhaus was founded. "For all its evils," Gropius, who belonged to both groups, wrote in 1919, "Bolshevism is probably the only way to create the preconditions for a new culture." What happened by 1923 to make him ditch his craft romanticism, propose a "new unity" of art and technology, advocate industrial design, and seek capitalist partnership?

More tactician than opportunist, Gropius had to struggle to keep the Bauhaus open through crisis and controversy, both internal and external. Before 1923, as inflation crippled the German economy (the Bauhaus student/teacher Herbert Bayer [1900–85] designed a one-million-mark note for general circulation in 1923), a craft program made perfect sense. By late 1923, however, the currency was reformed, and in early 1924 the Dawes loan plan from the United States began; German industry slowly recovered and soon boomed with foreign investments and new technologies. It was in this brief period of relative prosperity, which continued until the Wall Street Crash in 1929, that the Bauhaus shifted toward industrial design. The paradoxical position of Germany in between East and West helped its reorientation: the cultural experiments of Russian

5 • **Walter Gropius, the Bauhaus buildings, Dessau, c. 1925**

▲ 1929

6 • Marcel Breuer, *Slat Chair*, 1922
Pearwood

7 • Marianne Brandt and Hein Briedendiek, bedside lamp, 1928
Designed for Körting and Mathiesen

▲ Constructivism inspired great interest (witness again the repeated presence of El Lissitzky in Germany), but so did the industrial techniques of American Fordism (the autobiography of Henry Ford was a bestseller in Germany in 1923). In effect, the Bauhaus adapted the ideological look of the former to moderate the economic logic of the latter—but then what could it do after a failed revolution in a state controlled by capitalists? In any case, upon its move to Dessau, "masters" became "instructors," workshops centered on the experience of material became technical laboratories based on the principle of function, and training was soon divided into two types—work on building techniques and work on industrial prototypes. Practices like woodcarving, stained glass, and pottery were dropped, metal and carpentry shops were combined, and the print shop was given over to design (in which Bayer in particular excelled).

Nevertheless, actual interaction with industry was limited, though not as limited as in Russian Constructivism, which dealt with an industry starved of raw materials and suspended between ● rigid Communist and reformist capitalist policies. As of 1924 the Bauhaus had only twenty contracts with German firms, much of which was publicity work. This is not to deny the sheer brilliance of Bauhaus design or its great influence on subsequent production. Besides the famous fixtures of Moholy-Nagy and chairs of Marcel Breuer (1902–81) [6], the work of Marianne Brandt (1893–1983) is extraordinary in quality and variety; though best known for her tableware, her greatest successes were her lighting fixtures (with its wedge base and bell shade to focus light, her reading lamp [7] set the standard for decades to come, and she also innovated with other task lamps, as well as ceiling lights set in opaque globes and frosted glass). It is only to suggest that the new goal of industrial participation was no more realized than the old goal of craft rehabilitation. For both were responses to a historical problem that the Bauhaus alone could not solve: how to address the division of labor between artistic disciplines and artisanal practices on the one hand, and to adapt both of these to the capitalist modernization of Germany, which was intensive because it was tardy, on the other. The Nazis had a different solution, in which the polar forces that the Bauhaus attempted to moderate—the atavism toward a mythical Teutonic past and the acceleration toward a capitalist industrialist future—were forced together in a deadly compound. HF

FURTHER READING
Herbert Bayer et al., *Bauhaus 1919–1928* (New York: Museum of Modern Art, 1938)
Eva Forgács, *The Bauhaus Idea and Bauhaus Politics* (Budapest: Central European University Press, 1995)
Marcel Franciscono, *Walter Gropius and the Creation of the Bauhaus in Weimar* (Urbana: University of Illinois Press, 1971)
László Moholy-Nagy, *Painting, Photography, Film* (1927), trans. Janet Seligman Cambridge, Mass.: MIT Press, 1969)
Frank Whitford, *Bauhaus* (London and New York: Thames & Hudson, 1984)
Hans Wingler (ed.), *The Bauhaus: Weimar, Dessau, Berlin, Chicago* (Cambridge, Mass.: MIT Press, 1969)

▲ 1926, 1928b ● 1921b

1924

André Breton publishes the first issue of *La Révolution surréaliste*, establishing the terms of Surrealist aesthetics.

Developing as a young poet under the inauspicious conditions of World War I France, André Breton (1896–1966) was profoundly marked by two, mutually reinforcing phenomena. The first was his service as a medical orderly on a ward of shell-shock patients at the Val de Grâce Hospital in Paris; the second was his encounter with the sensibility of Dada in the person of Jacques Vaché, a permanent *révolté* and subscriber to the utter absurdity of life.

Breton's ardent acceptance of the ideas of psychoanalysis—the unconscious, the pleasure principle, the expressive power of the symptom and of dreams, castration anxiety, even the death drive—derived from his experience with profoundly disturbed trauma victims. And the very nature of their trauma—that something could happen for which there was no way to prepare ahead of time—fits, furthermore, into Vaché's absurdist views. The idea of life as a series of unpredictable and uncontrollable shocks was enacted by Breton and Vaché in a type of movie-going in which they entered and exited from screenings in rapid succession and without any regard for the program, thereby producing a random collage of visual and narrative experiences wholly out of their control. A few years later Breton would put this attitude of openness to whatever might happen—or *disponibilité*—to work poetically in *Les Champs magnétiques* (*Magnetic Fields*; 1920), which he wrote with Philippe Soupault as an exercise in stream-of-consciousness, and which he composed, in this sense, "automatically."

When it was time for Breton to separate himself from the Dada activities that had been mounted in Paris by the Romanian poet ▲ Tristan Tzara after the ending of the war and the Cabaret Voltaire Dadaists had been able to move from Zurich to France, he used the avant-garde form of the manifesto to set out the terms of what he was announcing as a new movement. "SURREALISM, *n.*," his definition ran, "Psychic automism in its pure state … Dictated by thought, in the absence of any control exercised by reason, exempt from any aesthetic or moral concern." And the two avenues the manifesto laid out for capturing the products of psychic automatism were (1) the kind of automatic writing *Magnetic Fields* had already explored and (2) the irrational narratives provided by dreams. Indeed, the new movement's very first act was to set up a central office in which to collect such narratives (offered by its young members) and to establish a magazine, *La Révolution surréaliste*, in which to publish them.

The interpretation of dreams

None of this was very promising, one might say, from the point of view of the visual arts, and indeed the magazine's first editor, Pierre Naville (who left the movement in 1927 to become Leon Trotsky's secretary), opened fire on the idea of any traffic with the fine arts or the refinements of style: "We have no taste," he wrote in the magazine's third issue (1925), "but distaste.… No one can still be in the dark about the fact that there isn't any *surrealist painting*. Neither pencil marks deposited by aleatory gestures, nor the image retracing dream figures.… But there are *spectacles*.… The street, the kiosques, cars, streetlamps bursting against the sky." And in accordance with his call for mass-cultural phenomena in place of "art," Naville illustrated the magazine mainly with photographs, many of them anonymous.

But Breton, who was an aesthete through and through—it was ▲ he who had brokered the sale of Pablo Picasso's *Les Demoiselles d'Avignon* to the fashion designer Jacques Doucet; it was he who had purchased heavily from Daniel-Henry Kahnweiler's wartime sequestered stock of Cubist paintings at government auctions in 1921 and 1922; it was he who was amassing an extraordinary collection of tribal art—struck back, taking the magazine away from Naville in late 1925. Thereupon he began publishing the serialized treatise "Surrealism and Painting," in which he laid claim to a variety of older artists as Surrealists-without-knowing-it ● (Picasso and Giorgio de Chirico [1]), a group of Dada figures as ■ threshold Surrealists (Max Ernst and Man Ray [1870–1976]), and a group of younger artists as burgeoning Surrealists (André Masson ◆ [1896–1987] and Joan Miró [1893–1983]).

Insisting that psychic automatism could indeed issue from brush or pencil, Breton welcomed the uncontrolled production of Masson's automatic drawings and dribbled sand paintings, Miró's dripped and spattered "dream pictures," Ernst's trancelike rubbings (or *frottages*). The transfer of collectively written "poems" that would "automatically" generate surprising imagery (called *exquisite corpse* after the first result: "the exquisite corpse drinks the

▲ 1916a ▲ 1907 ● 1909 ■ 1922, 1930b, 1931a ◆ 1930b, 1931b, 1942a, 1942b

new wine") to games of collective drawing seemed to him an obvious move. But at the same time Breton also insisted on the importance of the idea of the symptom or trace or index as giving unimpeachable evidence of what lies behind reality by registering a disturbance on its surface. In practice this meant that he continued Naville's reliance on photography, not only in subsequent issues of the magazine but in the pages of his three autobiographical "novels," the first of which, *Nadja*, was published in 1928.

From the automatic text to the photograph seems a great leap indeed. The first is irrational and chaotic, while the second is mechanical and organized according to the very world the unconscious strives to disrupt. Yet in Breton's survey in "Surrealism and Painting" both of these poles are represented: automatism by ▲ the liquid spills and mists of Miró's open color paintings or the meanders of Masson's automatic drawings; the photographic by Man Ray's silver prints, often reproduced in *La Révolution surréaliste*, or the veristic dream paintings by Ernst, such as *Two Children Menaced by a Nightingale* [2].

It is this stylistic schizophrenia that has made Surrealism so elusive for many art historians. On the one hand, an iconographic bias has exploited the movement's formal heterogeneity to push for a thematic reading of its output, gathering works under various categories. Some of these reflect psychoanalytic concerns, such as castration anxiety (which produces a fear of female genitalia and imagery cycling around the idea of the *vagina dentata*) and

1 • Giorgio de Chirico, *The Child's Brain*, 1914
Oil on canvas, 80 × 65 (31⅛ × 25⅛)

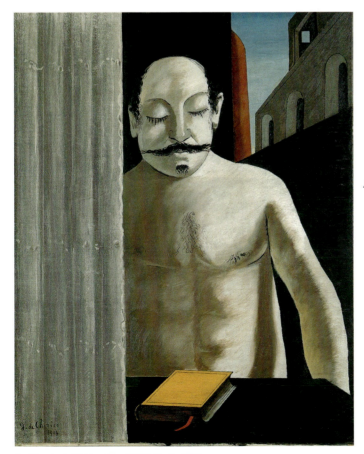

2 • Max Ernst, *Two Children Menaced by a Nightingale*, 1924
Oil on wood in original frame, 69.9 × 57.2 × 11.4 (27½ × 22½ × 4½)

fetishism; others relate to the searing experience of World War I, such as the disorienting wasteland of the trenches or the grotesque physiognomies of the wounded or a desire to regress toward a primitive state of humanity. On the other hand, a certain type of modernism wants to claim those parts of Surrealism's visual production that seem acceptably abstract—Miró and the half of Ernst that confines itself to *frottage*—while disencumbering itself of everything that seems retrograde and antimodernist because too suavely realistic—other parts of Ernst, late (and repetitious) ▲ de Chirico and René Magritte, and, after 1930, Salvador Dalí's photographically rendered dream pictures [3].

That Miró lends himself to this modernist tendency is easy enough to see. Having begun in the late teens in Barcelona as a Fauve-derived painter, and having subsequently absorbed the lessons of Cubism, he arrived in Paris in the early twenties and by 1923 was assimilated to the circle of poets and artists around Breton. The "dream paintings" he was making by 1925 were erotic recodings of Matisse's work from around 1911, in that fields of intense color were allowed to spread uninterruptedly over the surface, so disembodied was the drawing within them. If in Matisse's case drawing had been carried out by means of negative lines or "reserves" (as in *The Red Studio* [1911]), in Miró's it was now performed as a kind of calligraphy that converted all bodies to the transparency and weightlessness of the written sign. These waves of blue, in which space is devoid of limits and objects float like wisps of smoke, and in which bodies turn into question marks

▲ 1931b

▲ 1927a

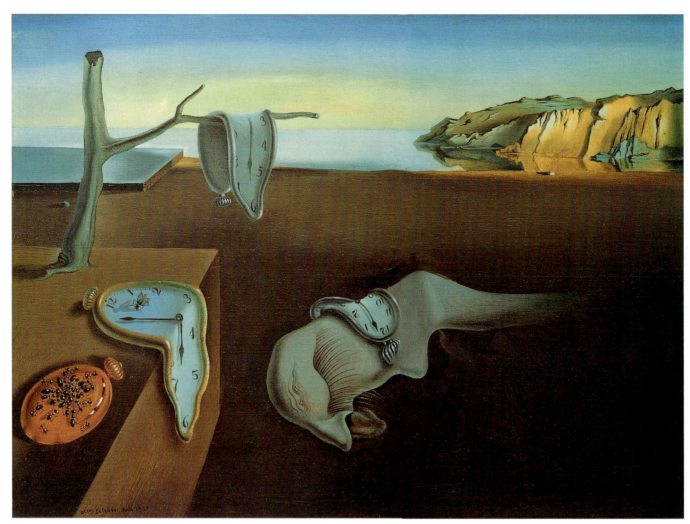

3 • Salvador Dalí, *The Persistence of Memory*, 1931
Oil on canvas, 24.1 × 33 (9½ × 13)

or signs for infinity—only the little red bar at the nexus of the figure eight indicating that the content of this graphic mark is the joining of two cells in erotic contact [**4**]—fit nicely with a modernist narrative of formal "progress."

But if the iconographic treatment of Surrealism seems insufficient, remaining blind as it does to something like the formal brilliance of Miró's art, the modernist account seems equally impoverished. It can neither produce a reading that would relate ▲ Miró to his colleagues in the movement—from Masson to Dalí to Surrealist photographers like Raoul Ubac (1910–85) and Hans Bellmer (1902–75)—nor can it address the structural issue of whether, on the level of the signifier (the form of expression), there is anything coherent in all the rich diversity of Surrealist activity.

The third alternative is to use the actual categories that Breton developed to theorize Surrealism and to mine them for their *structure*, thereby generating on the one hand a set of formal principles (the technique of *doubling* would be one of them) that can be permuted through a whole range of visual styles and, on the other, an understanding of the way such categories recode psychoanalytic or sociohistorical problems. As just one example we could take "objective chance," a variant on "psychic automatism" and a

vehicle of the end result that Breton aspired to as a Surrealist, namely, "the marvelous."

Breton describes objective chance as the crossing-point of two causal chains, the first subjective, interior to the human psyche, and the second objective, a function of real world events. In this conjunction, so seemingly unprepared for, it is discovered that on each side there was a kind of determinism at work. On the side of the real, the subject seems to have been expected, since what the world proffers at this moment is a "sign" specifically addressed to him or her. While on the side of the subject, there is an unconscious desire driving him or her unwittingly toward this sign, even constituting it as such, and allowing the sign to be deciphered after the fact.

The semiosis of Surrealism

While *Nadja* is constructed as a tissue of objective chance, the clearest illustration of how it works is presented at the beginning of another autobiographical novel, *L'Amour fou* (Mad Love; 1937). There Breton tells of going to the Marché aux Puces flea market in Paris and bringing home a wooden spoon with a little carved shoe projecting from the underside of its handle [**5**]. Not even liking this

4 • Joan Miró, *The Kiss*, 1924
Oil on canvas, 73 × 92 (28¾ × 36¼)

object, he nonetheless sets it on his desk whereupon it reminds
▲ him of another object he had fruitlessly asked Alberto Giacometti
to sculpt for him some time earlier. This object, an ashtray in the
shape of a glass slipper, had been meant to exorcise the nonsense
phrase that had been running through Breton's head like a persis-
tent tune: "*cendrier-Cendrillon*," or "Cinderella ashtray." Now
suddenly, he says, he begins to see the newly purchased spoon as a
series of nested slippers, each the representational double of the
preceding one (the bowl of the spoon as the front of the slipper, the
handle as the middle section, and the shoe beneath as the heel; then
the shoe itself as the front, the middle section, and the heel; and
then—imaginatively—*its* heel as containing another such slipper;
and so on). This structure in which an object is mirrored by
another, the double functioning as the representation of the first,
Breton understands semiotically—he sees it as constituting a sign.

In this, Breton is completely orthodox, since signs are always
pictured as ghostly doubles of the things they represent. More

5 • Man Ray, André Breton's slipper-spoon, 1934
Reproduced in Breton's *L'Amour fou* (1937)

▲ 1931a, 1959c

Surrealist journals

*L*a Révolution surréaliste, the journal that formed the backbone of the Surrealist movement, lasted ten years, from 1924 until, after issue no. 12, in 1929 it yielded to *Le Surréalisme au service de la révolution*, which in turn was outshone by the more lavish and aesthetically more ambitious *Minotaure*. The initial journal was riven by an internal debate between André Breton and the journal's first editor, Pierre Naville. Naville proudly modeled the cover of *LRS* on the nineteenth-century magazine of popular science *La Nature*, since the "positivist nature" of the latter stood for the status of the documentary material the Surrealist journal would publish—accounts of dreams, and answers to questionnaires around such problems as "Is suicide a solution?" In addition, Naville called the offices of the review the Surrealist "*centrale*," imitating the headquarters of Communist Party cells. A collage of three photographs of the members of the movement gathered in the *centrale* ornamented the first issue of *LRS* (December 1924). The place of photography was secured both inside the journal's covers and on its outside, since Naville was interested in anonymous, popular imagery and was programmatically hostile to art. But when Breton took over the editorship of the journal he began to publish his four-part text "Surrealism and Painting," in which the genesis of Surrealist visual production (in the work of Picasso) is shown to have yielded such contemporary practitioners as Miró, Arp, Ernst, and Masson.

The documentary focus of the journal was not abandoned altogether, however. Breton celebrated the "50th Anniversary of the Discovery of Hysteria" with the publication of photographs taken of Charcot's patients in the Salpetrière Asylum. The threshold between *LRS* and its successor *LSASDLR* was constructed by Breton's second manifesto of Surrealism, in which he exiled many of the original members of the movement, particularly those who had left the *centrale* to join with Georges Bataille and his radical journal *Documents*. Announcing on its cover that the areas of its concern would be ethnography, archaeology, and popular culture in addition to fine arts, *Documents* celebrated Bataille's own version of Naville's "distaste," in his exploration of the *informe* or formlessness.

importantly this condition of doubling is itself at the very beginning of language, as when a baby, repeating a sound—"ma-ma" or "pa-pa" or "ca-ca"—suddenly understands that the second sound, in redoubling the first, both reaches back to mark the initial one as a signifier (which is to say, not just a random sound but a meaningful utterance) and sets it up as a carrier of intentional meaning.

The slipper-spoon is, then, the world convulsed into a sign. But crucially this sign was not only addressed *to* Breton; it was willed *by* him through the power of his own unconscious desire. For he associated this sign-material with his unconscious thoughts, which, unknown to him, were driving him to assume the role of a prince setting out to seek his mate. What immediately follows is the story of Breton's encounter with the subject of this "mad love," an encounter all of the details of which he discovers, to his amazement, were "predicted" by an automatic poem he had written a decade earlier and which he is now unconsciously repeating in the present. Thus if the world's "sign" is structured through the condition of the double, the unconscious operates on the same principle. Freud had described this as the compulsion to repeat; in the sixties, French psychoanalyst Jacques Lacan would recode this semiotically by saying that the unconscious is structured like a language. Redoubling, then, is the formal condition of the unconscious drives.

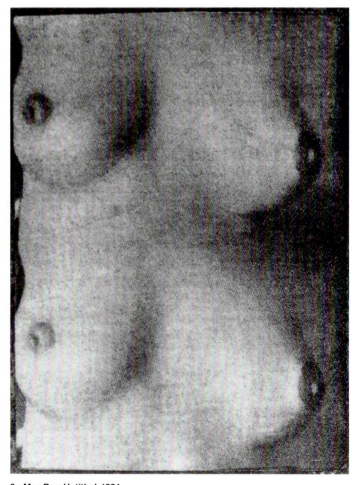

6 • Man Ray, *Untitled*, 1924
Published in *La Révolution surréaliste*

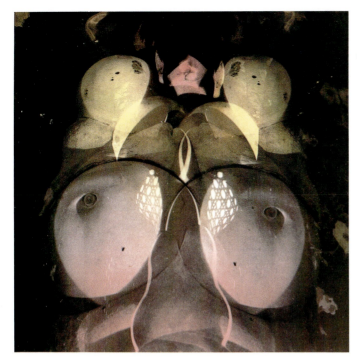

7 • Hans Bellmer, *La Poupée* (Doll), 1938

That photography is a function of doubling—not only does it "mirror" its object but, technically, its prints exist as multiples—made it a perfect vehicle for Surrealism, which exploited this aspect in its use of double exposures, sandwich printing, juxtapositions of negative and positive prints of the same image, and montaged doubles to produce this sense of the world redoubled as sign. The first issue of *La Révolution surréaliste* carried several photographs by Man Ray in which doubling was at work [6].

But doubling, as was pointed out, has a certain psychoanalytic content, one aspect of which Freud discusses in his essay "The Uncanny" (1919). Ghosts, the very stuff of uncanniness, are doubles of the living; and it is when live bodies are redoubled by lifeless ones—as in the case of automata or robots, or sometimes with dolls, or with people in states of seizure—that they take on the uncanniness of ghosts. That doubles should produce this condition is due, Freud explains, to the return of early states of dread. One of these derives from infantile feelings of omnipotence, in which the child believes itself able to project its control into the surrounding world only to find, however, these doubles of itself turning round to threaten and attack it. Another is castration anxiety, in which, similarly, the threat takes the form of one's phallic double. More generally, Freud says, anything that reminds us of our inner compulsion to repeat will strike us as uncanny.

That Hans Bellmer would build his early artistic practice entirely around a specially constructed doll, which he would arrange in various situations and then photograph, engages with this operation of the uncanny. Not only is the doll itself connected to this experience but Bellmer's treatment both exploits the sense of the way the doll's appearance to the viewer is dependent on either the operations of dream or on those of objective chance, and, by means of photomechanical doubling, projects the doll as the emblem of castration anxiety: tumescent female redoubled as male organ [7]. Uncanny doubling, although unrelated to the figure of the doll, was also exploited by the Belgian Surrealist René Magritte. Interestingly, Freud's description of the experience of the uncanny maps directly onto Breton's recipe for objective chance. "Involuntary repetition," Freud wrote, "surrounds with an uncanny atmosphere what would otherwise be innocent enough, and forces upon us the idea of something fateful and unescapable where otherwise we should have spoken of 'chance' only." And in relation to objective chance in *Nadja*, where Breton's attraction to Nadja herself is partly due to her being able to predict when these chance occurrences would take place, Freud recalls the tendency of his neurotic patients to have "presentiments" that "usually come true," a phenomenon he links to the recurrence of primitive omnipotence of thoughts. To the common example of objective chance occurring in most people's lives through "uncanny" repetitions of the same number (our birthday, our street address, and, say, our new friend's telephone number), Freud responds: "Unless a man is utterly hardened and proof against the lure of superstition he will be tempted to ascribe a secret meaning to this obstinate recurrence of a number, taking it, perhaps, as an indication of the span of life allotted to him."

Objective chance indeed provides a common ground between Surrealist photographic practice and Miró's "dream paintings," since, like the former, the latter are focused on the waves of color yielding up a sign of the dreamer's desire. Miró himself acknowledged as much in an extraordinary painting of this period in which, on a white ground, he deposited a splotch of intense cerulean blue. Over it, he wrote "this is the color of my dreams"; but in the upper left corner of the work, in much larger letters, he inscribed "Photo." Somewhere on the painting's material surface the chain of the real and the chain of the unconscious will meet. RK

FURTHER READING
Hal Foster, *Compulsive Beauty* (Cambridge, Mass.: MIT Press, 1993)
Roman Jakobson, "Why 'Mama' and 'Papa'" (1959), *Selected Writings* (The Hague: Mouton, 1962)
Rosalind Krauss and Jane Livingston, *L'Amour fou: Surrealism and Photography* (New York: Abbeville Press, 1986)
William Rubin, *Dada and Surrealist Art* (New York: Harry N. Abrams, 1968)
Sidra Stich (ed.), *Anxious Visions: Surrealist Art* (New York: Abbeville Press, 1990)

▲ 1925c

▲ 1927a

1925 a

While the Art Deco exhibition in Paris makes official the birth of modern kitsch, Le Corbusier's machine aesthetics becomes the bad dream of modernism and Aleksandr Rodchenko's Workers' Club advocates a new relationship between men and objects.

"As for this famous *Exposition*, it's probably not worth seeing it. They built such pavilions! Even from afar they are ugly and from close it's an horror." In the letters he wrote from Paris to his wife (the artist Varvara Stepanova), the Russian Constructivist Aleksandr Rodchenko did not mince his words about the Exposition Internationale des Arts Décoratifs of 1925—from which the label Art Deco derives. Siding with French workers who commented that the glitzy display of luxury goods was nothing short of immoral in such times of financial duress, the major exception for his utter contempt was Konstantin Melnikhov's Soviet Pavilion to which he had contributed the white, black, gray, and red color scheme: "Our pavilion will be the most beautiful for its newness," he beamed. Even if padded with national pride, Rodchenko's assessment of the fair was not unique. Calling the Exposition a "total failure," from both the social and the aesthetic point of view, the French critic Waldemar George singled out only five buildings that could "be properly called modern" at the Exposition: besides Melnikhov's pavilion, he named Gustave Perret's Théâtre, Robert Mallet-Stevens's Hall d'Entrée pour une Ambassade and Pavillon du Tourisme, and Le Corbusier's landmark manifesto, the Pavillon de l'Esprit Nouveau, named after the journal that the Swiss architect had been editing since 1920.

Department-store modernism

The project of the Exposition had been discussed since 1907 in French political circles—as the success of several international fairs, notably in Turin in 1902 and Milan in 1906, was quickly erasing the memory of the grand 1900 celebration in Paris. But it was the formidable participation of the Deutscher Werkbund at the 1910 Salon d'Automne in Paris, highlighting the thriving collaboration between designers and industry in Germany, that provided the definitive sting. French decorative art was in decline, a 1911 official report of the Société des Artistes Décorateurs asserted, its downfall clearly due to lack of imagination and servile dependence upon a glorious past, and it was soon to be smothered by foreign competition. An international contest, the report went on to say, would provide an incentive for the much needed reform of production, and it would force designers and industrialists alike to think about,

rather than deliberately dodge, the new conditions brought about by the fast-developing machine age; the traditional association between decorative arts and luxury would be dissipated; a veritable "democratization of art" would follow, and art would at last regain its "true social function," which it had lost since the Middle Ages. Planned for 1915, the fair was postponed several times (first because of the war, then because of the financial and political crises that resulted from it), and ended up opening a decade later. In the meantime, the control of the enterprise had passed from the professional designers' organizations to leaders of commerce, with the four major Parisian department stores at the helm. Each had their own lavish pavilion, all built on the same model—a symmetrical temple one entered through a monumental door to discover an interior space divided into overstuffed living rooms around a central hall.

Designers were not the only constituents to be defeated by the massive onslaught of commercial interests. The choice of the fair's site—in the same area as its 1900 predecessor at the center of Paris—signaled the failure of social reformers (among them several architects such as Le Corbusier) to persuade the French government that the fair should be conceived as a testing ground for the burning issue of mass housing in postwar France. Rather than staging an architectural competition for a model housing complex in a vacant area, something that could be inhabited after the close of the exhibition—a strategy favored by the Deutscher Werkbund in the twenties—the exhibition's committee decided to allow the construction of temporary pavilions as showcases for foreign products or those of French provinces and national guilds, and also of any private company able to afford the considerable rent.

The immense touristic success of the fair was in direct proportion to its artistic mediocrity. For the most part, its architecture consisted of streamlined or slightly geometrized versions of past styles, and nearly all the luxury objects it contained could have been designed a quarter of a century earlier. Indeed, while the innovative furniture proposed by De Stijl or the Bauhaus had been utterly banned, the only foreign products to be welcome (and widely imitated) were those issued by the Wiener Werkstätte, founded in 1903. Amazingly, many of the best designers we now associate with Art Deco (such as Eileen Gray or Pierre Chareau) either did not participate or contributed very traditional interiors. "In fact," as Nancy Troy suggests, "the exposition

▲ 1921b ● 1929 ▲ 1917b, 1923

as a whole might well be described as an attempt to link contemporary life in France with a lost or rapidly vanishing past. The long vistas bordered by manicured lawns separating symmetrically positioned buildings created a sense of stability and order that France had not yet recovered almost seven years after the end of World War I, and the unabashed opulence of the majority of pavilions was in manifest contrast to the financial situation in which the exposition had been planned." One should add that even though the majority of visitors were from the middle class, which accounted for only a little less than a third of the French population at the time, few would have been able to afford much of its content. The fair was a fantasy land, where one dreamed about the way the affluent live before rushing to the department stores nearby in search of cheaper imitations of the saucer, teapot, or side table one had fancied. The commercial strategy was that of *haute couture*, not surprisingly given the spectacular participation of major couturiers such as Paul Poiret, whose three pavilions were floating extravaganzas on the Seine.

Le Corbusier's machine age

The most vociferous critic of the Exposition was Le Corbusier. After a long bureaucratic struggle he had been allowed to build his Pavillon de l'Esprit Nouveau, at the periphery of the fair [1]. It consisted of two parts. The first, airy and drenched in light, was presented as a two-storey unit excerpted from the (nonbuilt) Immeubles-Villas, an apartment-cum-garden complex which he had conceived in 1922 and whose design he had been refining ever since; the second part was a windowless rotunda off the patio, devoted to the Swiss architect's ideas on urbanism, notably his scandalous plan for Paris, the Plan Voisin (named after the pavilion's main sponsor, the Voisin aeroplane and car manufacturer) in which he was proposing to raze the center of Paris, save a few important historical monuments, and replace its chaotic urban palimpsest with a vast green area interrupted by high-rise towers placed at regular intervals. The Plan Voisin was pure provocation, and it produced the expected reaction in the press, but while the dwelling section of the pavilion was less harshly criticized, it also had a very conspicuous polemical intent.

Since the beginning of World War I, Le Corbusier had lambasted architects and designers for their refusal to take into consideration the new conditions of production created by the machine, a denial made particularly conspicuous by the rapid evolution of mechanical processes in all industrialized nations as a result of the war effort. Even when new modes of construction were involved and new materials used, this had no bearing on the design's formal aspect, almost invariably conceived as a superficial mask hiding the architectonic structure, in whatever historical style was favored by the client. For Le Corbusier, Art Deco represented the triumph of such fraudulence. Not only was the claim of its designers (that their goal was an aestheticization of mass products) a lie, but even had it been true, its premises would still have been wrong. His Pavillon de l'Esprit Nouveau was intended above all to demonstrate that by the

sheer action of what he called "mechanical evolution" (a concept modeled after Darwin), industry was, by itself, able to engender a new kind of beauty: to tamper with it was a sure way to destroy it.

The pavilion was thus built using standard elements of the newest materials available, including the experimental wall paneling made of straw onto which concrete was projected. In the absence of any ornament, the modular regularity of the distribution of the vertical posts underscored the variations allowed by the structure (here a wall, there an opening) while, according to Le Corbusier, subliminally satisfying the visitor's "natural longing for order." But the most telling paean to industry was in the choice of furnishings that somewhat sparsely populated the pavilion: from the shelves and cabinets (industrial storage units labeled "*casiers standards*") to the chairs (notably, the famous Thonet bentwood café chairs, whose design dates from the nineteenth century) to the glass vases (laboratory glass vessels), most were objects already available in the marketplace and directly referring to public spheres of daily life, either work (office, laboratory), or leisure (cafés). In truth, some of these objects were slightly modified for the occasion—the Thonet chairs among them—but not in any way that would soften Le Corbusier's fundamental attack against his Art Deco colleagues reigning at the fair and their ideal of the bourgeois private home as an overall ensemble for which everything had to be custom made.

Le Corbusier's fascination with industrial standardization dates back to 1917, when he read Frederick W. Taylor's *Principles of Scientific Management*. In this book, published in 1911 and translated into French a year later, Taylor singles out efficiency in labor organization as the best way of maximizing profits and generating growth, even if it meant treating workers like machines. Henry Ford would soon follow suit (in 1913) with his invention of the assembly line, masterfully presenting this new form of slavery as a promise of more leisure time for the masses. Until the late twenties, with an amazing political naivety, Le Corbusier firmly believed that if industrial

1 • Le Corbusier, interior of the Pavillon de L'Esprit Nouveau, 1925
In the background is Fernand Léger's *The Baluster* next to a still life by Le Corbusier.

production were to be reformed according to Taylor's and Ford's principles, all the ills of postwar Europe would vanish by themselves. He saw modern architecture, situated at a midpoint between art (functionless) and industry, as an essential component of such a reform. And even though in his diatribes against decorative arts he had always insisted on the necessity to safeguard the autonomy of art—an autonomy consciously staged in his pavilion by the juxtaposition of a few modern paintings and sculptures and of an eclectic variety of objects whose use-value was highlighted—his theory and practice of painting rested for a good part on a fetishized notion of standardization. Indeed, his first homage to Taylorism appeared in *Après le cubisme* (1918) the book he wrote with Amédée Ozenfant to launch their pictorial movement, which they called Purism.

The taming of Cubism

Contrary to the claims made by Charles-Édouard Jeanneret (that is, Le Corbusier, who had not yet adopted his pseudonym) and Ozenfant in their tract, Purism is by no means a "post-Cubism." Rather, it consists of a mere academicization of Cubism which, paradoxically, was based on a complete misunderstanding of Braque and Picasso's enterprise. For the two Purist painters, Cubism was pure decoration— "if a cubist painting is beautiful," they write, "it is in the same way a carpet is beautiful." Although Cubism made ample use of geometrical forms, Ozenfant and Jeanneret claimed, it did so without recourse to any laws—its compositions were arbitrary, they were not controlled by any "standard." Braque and Picasso's extraordinary investigation of pictorial representation as indeed an arbitrary system of signs completely escaped the Purists, who saw in Cubism only an incompetent geometrization of reality that needed to be "corrected," just as the strictures of the assembly line prevented any erratic behavior on the part of workers.

This was not new by any means. As early as October 1912 a group of artists had organized the Salon de la Section d'Or (Golden Section) with the explicit program of presenting to the public a version of Cubism that would be tamed by "universal" principles of "geometric harmony" going back to classical Greece and well established in the tradition of French painting, from Poussin to Ingres to Cézanne and Seurat. Simultaneously, one of the participants—Raymond Duchamp-Villon—was presenting at the Salon d'Automne his facade of the Maison Cubiste, a project which is perhaps the seed of the Art Deco phenomenon. Conceived by André Mare, one of the most established designers in the future 1925 fair, and replete with works of Duchamp-Villon's co-exhibitors at the Section d'Or, such as his brothers Marcel Duchamp and Jacques Villon, but also Albert Gleizes and Jean Metzinger, the authors of *Du Cubisme* (1912) (a book long held as the theoretical basis of Cubism despite Picasso's and Braque's scorn), the decoration of the Maison Cubiste's three interior rooms is not particularly memorable. Its patent eclecticism was intended as the definitive blow against Art Nouveau design (deemed "international," which meant "German" at the time), and

it was successful at that, but only by espousing the nationalist tenet of a Louis-Philippe revival (not quite a return to the *ancien régime*, since it had developed under a bourgeois monarchy, this style was heralded as the last true French style). Duchamp-Villon's facade partook of this revivalist mode, and it revealed even more clearly that the modernism of the Maison Cubiste was only cosmetic: this decor was not much more of a pastiche of a nineteenth-century version of a seventeenth-century *hôtel particulier*'s facade, powdered with specks of angular faceting.

In the postwar context, the nationalistic current of this academic Cubism flourished under the aegis of what has been called the "return to order": the "righting" of Cubism was part of the reconstruction ideology, together with a renewed interest in France's *latinità* or a public policy favoring a surge in birthrate. Given his horrified response when discovering Picasso's first Ingres pastiches in 1915, which arguably mark the beginning of the "return to order," it might come as a surprise that Juan Gris would have so definitively joined its ranks. Yet even though Gris's prewar collages are no less feats of spatial ambiguity and plastic wit than those of his Spanish friend and mentor, his artistic creed reveals a latent rationalism that could not have been further from Picasso's attack against the tradition of mimetic representation: "Cézanne transforms a bottle into a cylinder," he wrote, and "I begin with a cylinder in order to create a bottle." In other words, geometry comes first: objects, to be included at all in the composition, have to fit an a priori grid.

Ozenfant's and Jeanneret's paintings follow the same logic (though their justification, unlike Gris's, was an appeal to Taylorist organization)—and it is not by chance that Le Corbusier included one of Gris's canvases in his Pavillon. Indeed, for all their paintings—inevitably still lifes [2], and most of them in a format determined by the golden section—Ozenfant and Jeanneret first established a grid of regulating lines ("*tracés régulateurs*") establishing the placement of "object-types" (supposedly the lucky survivors of "mechanical evolution"), often depicted both in plan

2 • Charles-Édouard Jeanneret (Le Corbusier), *Purist Still Life***, 1922**
Oil on canvas, 65 × 81 (25⅝ × 31⅞)

▲ 1911, 1912, 1921a ▲ 1919 ● 1919

3 • Fernand Léger, *Three Women (Le Grand Déjeuner)*, 1921
Oil on canvas, 183.5 × 251.5 (72¼ × 99)

and elevation and alluding directly to architectural forms (a carafe becoming a doric column, the neck of a bottle, a chimney). Volumes are reduced to simple prisms, with an occasional accentuation of the modeling all the more perceptible now that most objects are rendered by planes of color as flat as the background; orthogonals dominate; colors are never strident: the overall tone is one of tasteful, but somewhat vapid, restraint.

Another painter whose work was included in Le Corbusier's 1925 pavilion needs to be mentioned here, namely Fernand Léger—for although his work too was inflected by the "return to order" ideology, he was the only French artist who shared, and even exceeded, the architect's adulation for the machine. Although Léger had never emulated Picasso's art, he borrowed from Analytical Cubism one of its main strategies (using a single notational element for every object represented in a painting) in order to realize in 1913 his first ▲ mature works, a series of canvases entitled *Contrasts of Forms*. On the verge of abstraction, these paintings were conceived as accretions of tubular volumes of bright color whose metallic rotundity is signified by white highlights. When he was drafted to World War I's battlefield, Léger's mechanistic enthusiasm did not abate, almost inexplicably, given the horrors he witnessed and profusely sketched,

all due to the sheer force of modern armament. But he came back from the war with a blind desire to divest the machine of the destructive image it had in the eyes of his contemporaries. The tubular elements were gradually replaced by more recognizable segments of human anatomy [3]; the figures, almost all monochrome, schematically modeled, and striking poses that signify leisure, stood in more dramatic contrast to the colorful and dynamic background, most often cityscapes made of geometric shapes populated here and there by diagrammatic billboards.

The Baluster [4] is perhaps one of Léger's most legible canvases of the period, and, save for the brash color, stylistically the closest to the Purist aesthetic, which is undoubtedly why Le Corbusier chose it for his pavilion. As Carol Eliel notes, the central element can be read both as a baluster and a bottle; the red form that echoes it on the left, with its upended white circular opening, resembles the vents of factories or ocean liners illustrated in *L'Esprit Nouveau* and common in Léger's cityscapes of the period; the vertical edge of the book suggests a classical column; the "four verticals in the top half of the baluster, highlighted on a light ground, can be read as four smokestacks or grain silos, while the dashed horizontal form at the left edge of the canvas suggests the motions and movement of an assembly line as

▲ 1913

4 • Fernand Léger, *The Baluster*, 1925
Oil on canvas, 129.5 × 97.2 (51 × 38¼)

Black Deco

The association of negritude with abandon animated the artistic life of the Left Bank, particularly in the nightclub district, Montparnasse, where jazz filled the air with delicious dissonances, and frenzied music became the support for drunken dancing until late into the night. Floorshows such as those by Josephine Baker, who danced half-nude, underscored this relationship, which nonetheless soon gave way to a very different experience of black form. This could be called "Black Deco," or the aestheticized use of tribal shapes and motifs within the decorative arts. For the costumes and sets of the ballet *La Création du Monde* (1923), Fernand Léger exploited the strong silhouettes and repeated patterns of primitive sculpture. The entire panoply of Art Deco furniture and accessories followed this lead as silver patterns were combined with the sheen of ebony woods and leopard skins were juxtaposed with crocodile hides. Where this luxury trade led, artists soon followed and the influence of Black Deco on sculptors such as Constantin Brancusi and Jacques Lipchitz could be seen, as well as on designers like Le Corbusier and Jean Prouvé. For all these figures, Black Deco was a powerful cocktail mixing "primitive" Africa with machine-age America.

well as film sprockets." This last allusion is particularly significant, ▲ coming soon after Léger had finished his film *Ballet Mécanique* [5], which was, if not the very first, at least one of the most self-conscious attacks ever launched against narrative cinema. With its absurd repetition of found footage (a woman climbs a flight of steps twenty-three times), its kaleidoscopic multiplication of eyes, balls, hats, and other circular shapes within the same frame, its pulsatile celebration of linear motion, its decomposition and recomposition of bodies and faces, its dance of triangles, circles, and machine parts, *Ballet Mécanique* is Léger's most remarkable foray into abstraction. By contrast, and even though it was taken off the wall at the request of the government, the mural painting that he exhibited in Mallet-Stevens's Hall d'Entrée pour une Ambassade seems subdued.
● Inspired by De Stijl (in particular by van Doesburg's *Rhythm of a Russian Dance* of 1918), it belongs to a handful of works, all dating from 1924 to 1925, that Léger conceived as mural decoration—for him the only possible venue of pictorial abstraction.

Architecture or revolution / architecture as revolution

Had he been as distant from bourgeois culture as he thought he was, Léger might have reflected upon the very different proposal made by the Soviet entry at the Exposition, conceived as propaganda for the Soviet regime (which had just finally been recognized by the French government) and destined to prove that the Revolution was better equipped than the capitalist West to respond to the demands of postwar reconstruction. This entry consisted of two parts: Konstantin Melnikhov's Soviet Pavilion [6], and Rodchenko's Workers' Club built within that monument of 1900 kitsch, the Grand Palais.

Melnikhov's pavilion was by far the most daring building of the fair—Rodchenko was right on this point. In plan, it consisted of an oblong rectangle diagonally bisected by an exterior double staircase that functioned like a street one had walk through before entering any of the two enclosed triangular volumes on each of its sides. Triangles and ascending oblique lines were omnipresent

5 • Fernand Léger and Dudley Murphy, still from *Ballet Mécanique*, 1924

▲ 1925d ● 1917b

(even lending a new meaning to a traditional feature such as the slant roof). Melnikhov had created in architectural forms a homage to the "red wedge" of the Revolution that was as dynamic as El Lissitzky's famous 1918 poster *Beat the Whites with the Red Wedge*. The red, white, and gray colors of the exterior walls and interlocking (oblique) canopies above the staircase made a stark contrast with the transparency of the main glass facades; the deliberately unluxurious material (painted wood) and the elemental, almost ludic, mode of assembly, in record time, of all the parts, which were shipped from Moscow, was a clear jab at the massive pomp of most pavilions in the fair and their decorative skin of enameled tiles or marble.

Though less ebullient, Rodchenko's interior was no less a critique of capitalist luxury and, above all, of capitalism's veneration of the private sphere, for it was relentlessly marked as a collective space [7]. The workers' club was a recent invention of the nascent Soviet regime. In exporting this concept—and in making sure it would not escape notice by commissioning one of the most active Constructivist artists for its design—the new Socialist Republic wanted to demonstrate that the Soviet Revolution, far from being barbarian, had engendered a new culture, and that, in its care, the workers had access to leisure, unlike those in capitalist countries. Faithful to the

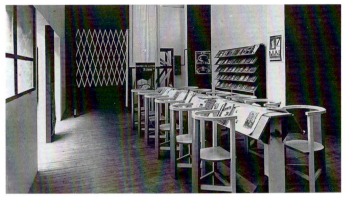

7 • Interior of Aleksandr Rodchenko's Workers' Club, built for the Exposition Internationale des Arts Décoratifs and installed in the Grand Palais, Paris, 1925

principles of his 1921 abstract sculptures, Rodchenko emphasized two aspects of his wood furniture (painted in the same colors as the Melnikhov building): the transparency of their mode of construction (without upholstery, all the joints were revealed) and their transformability. "Emphatically mobile," writes Leah Dickerman, "the Club's objects were to be adjustable by the user, both for convenience and for different functional requirements. The reading table had leaves that could be moved from an inclined position, for supporting reading matter, to a flat one, creating an expanded work surface; cylinders holding photographs allowed for a rotating display of many images in a small space; and the gaming surface of the chess table spun to the vertical to allow the players access to the built-in seats." The true star of this hymn to polyfunctionality was the collapsible orator rostrum / movie screen, with its lattice unfolding at will in all directions of space, and the care that Rodchenko devoted to its design reveals that he conceived of his club as a media space, in which workers would process information and act upon it.

The assembly-line disposition of the two rows of chairs around the Club's table was no less informed by Taylor's principles than was Le Corbusier's raiding of the marketplace for "standard objects" with which to furnish his pavilion, but Rodchenko did not share the architect's blind faith in the machine as a guarantee of mankind's future well-being. At the same time as his Club showed (*contra* Léger) that the future of abstraction was not necessarily in decoration, it proposed a new relationship between men and objects, in which we would no longer be consumers but coplayers in the chess game of life. While Le Corbusier's *Towards a New Architecture* ended with this alternative: "architecture or revolution," Rodchenko, true to his Constructivist program, articulated the slogan "architecture *as* revolution" with every square inch of his Club. Both dreams, the subsequent history of the century tells us, ended up as nightmares. YAB

FURTHER READING
Carol S. Eliel, "Purism in Paris, 1918–1925," *L'Esprit Nouveau: Purism in Paris, 1918–1925* (Los Angeles: Los Angeles County Museum of Art, 2001)
Leah Dickerman, "The Propagandizing of Things," *Aleksandr Rodchenko* (New York: Museum of Modern Art, 1998)
Christina Kiaer, "Rodchenko in Paris," *October*, no. 75, Winter 1996
Mary McLeod, "Architecture or Revolution: Taylorism, Technocracy, and Social Change," *Art Journal*, vol. 42, no. 2, Summer 1983
Nancy Troy, *Modernism and the Decorative Arts in France: Art Nouveau to Le Corbusier* (New Haven and London: Yale University Press, 1991)

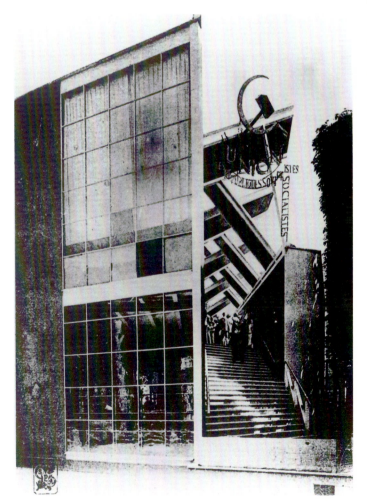

6 • Konstantin Melnikhov's Soviet Pavilion at the Exposition Internationale des Arts Décoratifs in Paris, 1925

▲ 1926, 1928a, 1928b ● 1921b

Curator Gustav F. Hartlaub organizes the first exhibition of Neue Sachlichkeit painting at the Kunsthalle, Mannheim: a variation of the international tendencies of the *rappel à l'ordre*, this new "magic realism" signals the end of Expressionism and Dada practices in Germany.

The short life of the Weimar Republic (1919–33) qualifies more than any other period in the twentieth century for Antonio Gramsci's diagnosis that "the crisis consists precisely in the fact that the old is dying and the new cannot be born. In this interregnum, a great variety of morbid symptoms appears." The first five years of the newly founded republic were marked by perpetual economic and political turmoil, by social disorganization and disillusion. Not until 1924 did a relative stabilization of the economy give an elementary (and illusionary) sense of solidity to the democratic culture of the Republic, only for it to be shattered again in 1929 with the world economic crisis, and to be decisively destroyed in 1933 with Germany's embrace of fascism and the rise of Hitler. Even during these "sober" years from 1924 to 1929, comprising the crucial period of Neue Sachlichkeit, most members of the cultural intelligentsia, if not the population at large, perceived themselves as being part of what literary historian Helmut Lethen has called an experimental existence "between two wars."

The term "Neue Sachlichkeit," somewhat inadequately translated as "New Objectivity" or "New Sobriety," was coined by Gustav Friedrich Hartlaub, the director of the Kunsthalle in Mannheim, when he announced a forthcoming exhibition of new figurative work by a group of German painters. Initially planned for 1923, the show eventually took place between June 14 and September 13, 1925, and included works by Max Beckmann (1884–1950), Otto Dix (1891–1969), George Grosz, Alexander Kanoldt (1881–1939), Carlo Mense (1886–1965), Kay H. Nebel (1888–1953), Georg Scholz (1890–1945), and Georg Schrimpf (1889–1938). In his announcement of the project, Hartlaub defined Neue Sachlichkeit somewhat lapidarily as work governed by the "loyalty to a positively tangible reality." He was not alone in discerning this new tendency toward realism in German painting. In the same year as "Neue Sachlichkeit" opened, critic and art historian Franz Roh published *Nach-Expressionismus: Magischer Realismus* (Post-Expressionism: Magic Realism), thereby providing his own label—magic realism— to describe the emerging style. (The success of the Mannheim exhibition meant that Hartlaub's term prevailed.)

From its very inception, Hartlaub, Roh, and other critics such as Paul Westheim recognized that Neue Sachlichkeit was deeply divided: the rift was identified, as Hartlaub wrote, by the opposi- tion between "the right wing of the neoclassicists like Picasso and the left wing of *veristic* painters like Beckmann, Grosz, Dix," that is, by the opposition between *Ingrismus* (named for the early nineteenth-century French painter Ingres) and *Verismus* (realism). These critics also recognized the extent to which the German artists' return to figuration (and its ostentatious departure from Expressionism and Dada) was due, at least in part, to their recent encounters with French and Italian antimodernist precedents. As early as 1919 Westheim had stated in his *Das Kunstblatt*: "Characteristic of Carlo Carrà's work … as indeed of a whole group of young artists, is an idiosyncratic, uncompromising realism (*verismo*), seeking a meticulous hard line which suppresses every trace of the individual artist's manner. In Germany, as is known, Grosz and Davringhausen are following a similar path." And in 1921 Westheim commented on the reverberations of Picasso's "Ingresque" style in Germany, addressing the topic again in September 1922 with a special issue of *Das Kunstblatt* that featured a questionnaire on the "New Realism."

From *manichino* to *machino*

The time and place of the Germans' encounter with *pittura metafisica* are firmly established, being, as is so often the case in the twentieth century, primarily in the pages of a journal. In this instance, it was the Italian publication *Valori plastici*, edited since 1918 by the critic and collector Mario Broglio. The third issue of the journal in 1919 was devoted in its entirety to the work of Giorgio de Chirico, Carlo Carrà, and Giorgio Morandi. It was admired at once by Max Ernst, George Grosz, Georg Schrimpf, and Heinrich Maria Davringhausen (1894–1970) in the Munich gallery and bookshop of Hans Goltz, *Valori plastici*'s German distributor. This encounter led not only to Max Ernst's instant publication of a *metafisica* portfolio of lithographs entitled *Fiat Modes, Pereat Ars* (1919), but also to the first exhibitions of Davringhausen in 1919 and Grosz in 1920 at Goltz's gallery.

The iconography of the metaphysical *manichino* (mannequin) would be dramatically recoded in the hands of the German Neue Sachlichkeit artists to become a *machino*. What had appeared in de Chirico as an allegory of painting's lost capacity to engender figu-

ration, reappeared now in Grosz's work as the "Republican Automaton," that peculiar hybrid between a tailor's dummy and the office robot in which the new identity of the *"civil servant,"* the white-collar authoritarian personality, appeared to be best captured [**1**]. Walter Benjamin's critique of *neusachlich* literature in the essay "Left Wing Melancholia" describes such types thus:

> These puppets heavy with sadness that will walk over corpses if necessary. With their rigid body armor, their slowly advancing movements, and the blindness of their actions, they embody the human fusion of insect and tank.

But even in its Neue Sachlichkeit adaptation, the *manichino/machino* morphology remains fluid, shifting easily from victor to victim. What is an authoritarian automaton in one image, becomes the industrially mechanized or armored body in the next. Or, after 1918, with six million soldiers returning from the war, in image after image we encounter the machinic body as the prosthetic body, the war cripple (as for example in the work of the Cologne Progressives group, like Heinrich Hoerle's *Cripple Portfolio* of 1920 or in Dix's *The War Cripples* [1920]).

The exclusion of photographers from Hartlaub's exhibition and from Roh's study (even though, four years later, Roh would publish the famous anthology of modernist photography *Foto-Auge*) indicates that the discoverers of a "new objectivity" wanted to see its truth-value established first of all with the traditional means of painting. Thus Hartlaub concluded his introduction to the exhibition by stating that:

> What we are showing is that art is still there … that it is alive, despite a cultural situation that seems hostile to the essence of art as other epochs have rarely been. Thus artists disillusioned, sobered, often resigned to the point of cynicism having nearly given up on themselves after a moment of unbounded, nearly apocalyptic hope—that artists in the midst of the catastrophe, have begun to ponder what is most immediate, certain, and durable: truth and craft.

That desperate desire for the objectivity of transhistorical truth could also be found in statements by other critics. Writing in *Der Cicerone* in 1923, Willi Wolfradt—once again opposing *Ingrismus* and *Verismus*—argued that both shared "the concept of clarity, the former in a more formal sense, and the latter in a more objective sense. In *Ingrismus* the definition of clarity is derived from antiquity, in *Verismus* it is derived from the machine. And while both might be incompatible worlds, in both worlds it is *objective truth that dominates.*" This opposition between the truth of craft and antiquity, on the one hand, and the truth of the machine on the other, originated, however, in a set of much more fundamental conflicts. First of all in the social schism between an enthusiastic embrace of industrial modernization along the lines of the much vaunted "Americanism" and "Fordism" (the source of endless fashions

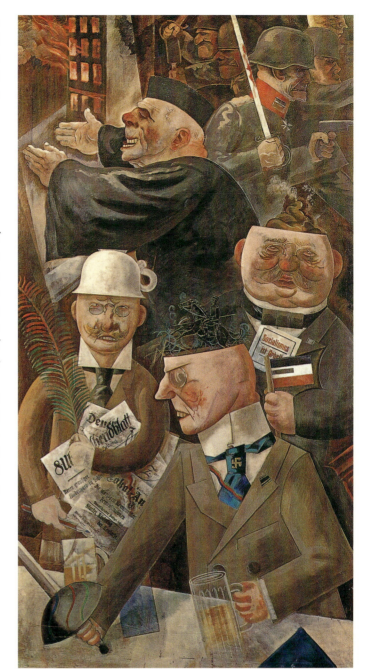

1 • George Grosz, *Pillars of Society*, 1926
Oil on canvas, 200 × 108 (78¾ × 42½)

and cults in Weimar Germany) and a violent and pessimistic reaction against these processes of industrial mechanization and rationalization. This reaction was primarily to be found among the increasingly unemployed and proletarianized middle class, leading to the rise of antimodernist and eventually ethnic and racist ideologies of "returns" to phantasms of pure origins and uncontaminated authenticity. Invoking German sociologist Ferdinand Tönnies's (1855–1936) famous distinction between *Gemeinschaft* (community) and *Gesellschaft* (society), the new ideologues of the conservative right promised a return to preindustrial belief systems, mythical forms of social organization, and artisanal production, thereby laying the foundations for the fascism of 1933.

This conflict was exacerbated by the opposition between bourgeois concepts of high art and the proletarian needs for a progressive emancipatory mass culture. Not only was the sphere of a supposedly autonomous high culture increasingly precarious (and therefore all the more fetishized), but all the earlier forms of social relations and popular culture had been replaced by a proto-totalitarian mass culture and media apparatus. Unlike the ▲ Soviet avant-garde, however, which was simultaneously undergoing a very similar transformation from a radical experimental modernist aesthetic to a systematic exploration of what a new postrevolutionary avant-garde culture in a developing proletarian public sphere might mean, the artists of the Neue Sachlichkeit did not face a similarly homogeneous revolutionary society. First of all, the Weimar Republic, as novelist Alfred Döblin (1878–1957) famously stated, came without an instruction manual, indicating that the new democratic culture of the "belated nation" had to be acquired through trial and error. Second, unlike the Soviet Union, the Weimar Republic after 1919—despite its revolutionary aspirations—had been structured as a class society, albeit one in which previously oppressed social strata suddenly found themselves with more economic and political power than they might have ever imagined under the previous regime of Kaiser Wilhelm. Thus Weimar, politically organized around the principles of social democracy, became the democracy not only of a newly empowered oligarchic bourgeoisie, but also of an economically powerless but rabid *petite bourgeoisie* and a proletariat that was perpetually oscillating between revolutionary radicalization and fascist *embourgeoisement*. Ernst Bloch, in his 1935 book *Erbschaft dieser Zeit* (Heritage of our Times), was the first to argue that Neue Sachlichkeit, rather than revealing a new face of the collective, actually camouflaged an evolved capitalism that had adopted socialist principles, such as a planned economy, collective housing, and an overall sense of equality, but without reneging the primacy of an economy of profit. These universally governing conditions of reification—according to Bloch—generated Neue Sachlichkeit's seduction as much as the vacuity of its representations.

From fragments to figures

The peculiar fact that Neue Sachlichkeit had both former Expressionists (Beckmann and Dix) and former Dadaists (Grosz and Schad) among its key members deserves attention. After all,
● Expressionism had been the moment in which the humanist and pacifist subject staged itself in a histrionics of finality, whereas the
■ Dada artists accelerated and celebrated the demise of bourgeois subjectivity in a grotesque travesty of cultural practices and pretenses. Thus, one might well ask what the motivations of these artists might have been to abandon either the Expressionist aspirations or the Dadaist derisions in favor of a peculiar hybrid of putative objectivity. These extreme ambiguities of transition are particularly evident in a number of key works around 1919–20, such as Beckmann's *The Night* [2], Dix's crucial paintings from the

same year such as *The War Cripples*, or Grosz's slightly later *Pillars of Society* from 1926 [1].

The Night is not only a classic example of Expressionism turning *neusachlich*, but even more so of the liberal inability (or refusal) to conduct an analysis of the political situation. Instead, it invokes and essentializes—in an act of humanist deflection—the universal catastrophe of the "human condition." While Beckmann's work had clearly acknowledged the tragic experiences of the failed German revolution of 1919, with its brutal murders of Marxist leaders Rosa Luxemburg and Karl Liebknecht among many others, this depiction of a cryptic scene of sado-masochistic mayhem positions the revolutionary worker (possibly a clandestine portrait of Lenin) on the same level of violent perpetration as the fascist *petit bourgeois*. Typically, Beckmann's humanist lament of universal bestiality fails to reflect on the painting's own heavily repressed but fully exposed indulgence in the sadistic scenes it pretends to reveal.

These ambiguities are keyed differently in Dix's most important paintings from the same moment, such as *The War Cripples*, *The Card Players*, and *Prager Strasse* (1920), or in Grosz's *Pillars of Society*. Here the subject is either depicted as the cripple, the physically annihilated victim of the imperialist war, or as the menacing impostor who inflicts the very conditions of physiological laceration and psychic trauma. Both the victor and the victim are mediated through similar iconographic, morphological, or formal devices of deformation, fragmentation, and literal bodily cuts. We witness therefore a dual dismissal in Neue Sachlichkeit's shift toward the fully closed contours and the fully modeled bodies. The first abandons Expressionist angularity, and its radiating ruptures in favor of the figure's newly enforced wholeness. The second literalizes the semiology of cuts and fragmentation from Dada photomontage and collage and redeploys these devices as surgical instruments: either, as in Dix, to lay bare the traumatized prosthetic body and the subject's threadbare existence; or, as in Grosz, to literally slice the lid from the heads of the representatives of the ruling powers of the state, the Church, and the military, revealing their skull's innermost recesses as stuffed with newspapers or grotesque steaming piles of feces. These travesties of the semiological radicality of Cubism articulate the simultaneous bankruptcy of the bourgeois subject as figuration, as much as they recognize that the proletarian subject can not yet be presented as the unified agent of a new history.

The Neue Sachlichkeit artists' inability to assume a position of class identity and agency became the third fundamental reason for the movement's internal rifts. It is not surprising then that they occupied the full spectrum of these contradictions. These ranged from the German adaptations of the Italian antimodernist *pittura* ▲ *metafisica* or the French *rappel à l'ordre* (such as Schrimpf, Mense, Kanoldt) to the radical extensions of Grosz's and John Heartfield's Dada aesthetic toward a new culture of the proletarian public sphere. Or they ranged from the cynical and melancholic attempts by the ex-Dadaist Christian Schad to pose as an Old Master of

▲ 1921b ● 1908 ■ 1916a, 1920 ▲ 1909, 1919

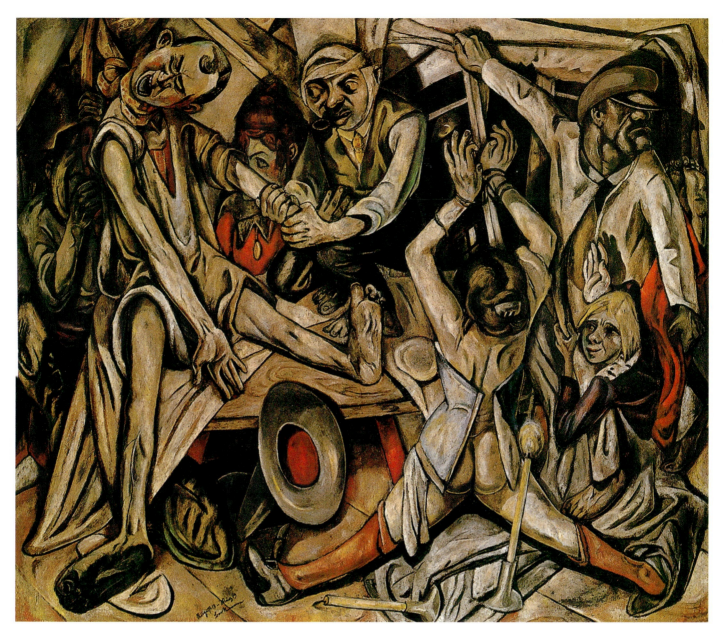

2 • Max Beckmann, _The Night_, 1918–19
Oil on canvas, 133 × 154 (52⅜ × 60⅝)

portrait painting (even if his portraits for the most part depicted bohemians and aristocrats situated at the margins of the newly established social hierarchy), to the printed typologies of the proletariat produced by Franz Wilhelm Seiwert (1894–1933) and Gerd Arntz (1900–88) in the context of the Cologne Progressives group (Seiwert, writing in the group's journal _A-Z_ suggested in 1928 that New Objectivity was neither new nor objective, but rather, the opposite of both). In 1928 Arntz would codesign the pictograms for Isotype, the collectively accessible sign language analyzing the current conditions of social, political, and economic relations in the publications of the radical Viennese sociologist Otto Neurath.

It appears then that these conflicts between high art and mass culture, those of class identity and social relations, were literally acted out in the opposition between a renewed emphasis on the artisanal foundations of artistic production on the one hand and a

commitment to the newly emerging apparatus of technical (that is, photographic) reproduction and mass cultural distribution on the other. Not surprisingly, the site where this battle was fought most actively was the portrait, seemingly one of the most venerable pictorial genres (even though it had been decisively ▲ deconstructed at the high moment of Analytical Cubism).

The "objective" portrait, the "human" subject

We find an enormously complex (and numerous) typology of portrait conceptions at the center of Neue Sachlichkeit. Starting with the post-Expressionist portraits of Beckmann, who remained committed throughout his entire oeuvre to the superannuated probing of the self, the artist seems to have been unable to relinquish not only the idea of a humanistically defined, self-motivated

▲ 1911

subjectivity, but also the conviction that his was a function to provide privileged forms of knowledge and insight. Schad's *Self-Portrait with Model* [3] brings these tropes of portraiture to a level of ostentatious self-consciousness where they become almost grotesque. In a cold confrontation, he depicts himself in the dress and pose of a Renaissance master (such as the transparent shirt in Bartolomeo Veneto's *Allegorical Portrait* [1507]). But the photographic realism in the depiction of his urbane physiognomy, and the mannered play on the fabric's transparency and the skin's opacity, manifestly contradict all claims to any historical continuity that either the genre and iconography of the self-portrait or the recitation of the most skillful traditions of painting could establish. His dubious female companion (as so often in Schad, she oscillates between prostitute and aristocratic bohemian, transvestite and *femme fatale*) is adorned in this instance with a sadistic cut to her face, undoubtedly inflicted by male property claims, clearly demarcating modernity.

At the other extreme of the spectrum of Neue Sachlichkeit portraiture one would find Dix's almost obsessive derision of the genre. Galvanizing his Expressionist legacy with the acid of caricature, Dix stripped his sitters of all pretenses and staged their subjecthood as either victim or prop of social construction. In his portrait of the journalist Sylvia von Harden [4], the attributes of the New Woman (bobbed hair, cigarette, highly fashionable flapper dress, and drink) are both celebrated and derided simultaneously, most manifestly in the gesticulation of the hypertrophic

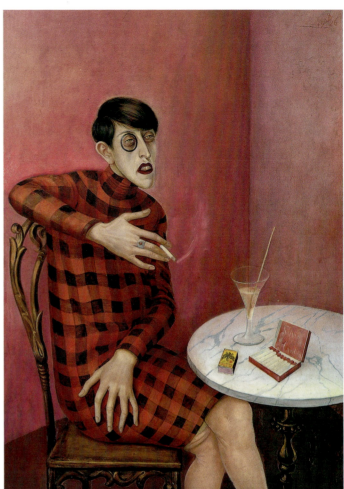

4 • Otto Dix, *Portrait of the Journalist Sylvia von Harden*, 1926
Mixed media on wood, 120 × 88 (47¼ × 34¾)

hands. This attitude of extreme ambiguity also governs one of the relatively rare portraits painted by George Grosz at the height of his Neue Sachlichkeit phase, the portrait of the writer and critic Max Hermann Neisse [5]. In distinction to Dix's caricaturesque hyperbole, Grosz by that time seems to have cooled his passion for caricature as modernism's countermodel, to which his friend, the historian of the medium Eduard Fuchs, had introduced him earlier in the decade. This intensified ambiguity, however, in which photography and caricature seem to recount their joint historical origins, could not be more appropriate to a quintessential *neusachlich* sitter like the critic Max Hermann Neisse, whose writings would soon thereafter shift from supporting Communist Party poets like Johannes R. Becher to championing the conservative Expressionist, and eventually fascist, Gottfried Benn.

Grosz, who had referred to himself as having "the character of an icepack" had been programmatic in his changing approach to the subject and its representation. Thus he wrote in an essay entitled "On some of my recent paintings" in *Das Kunstblatt* of 1921:

I am trying once again to draw a totally realistic picture of the world. If one makes an effort to develop a totally lucid and limpid style, one comes inevitably close to Carrà. Nevertheless

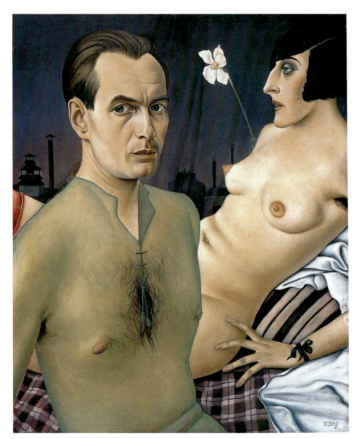

3 • Christian Schad, *Self-Portrait with Model*, 1927
Oil on canvas, 76 × 61.5 (29⅞ × 24¼)

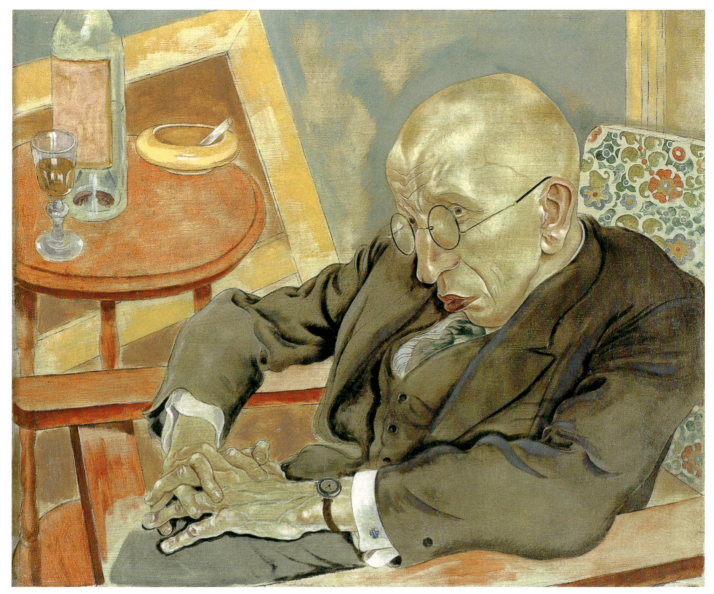

5 • George Grosz, *The Poet, Max Hermann Neisse*, 1927
Oil on canvas, 59.4 × 74 (23⅜ × 29⅛)

everything separates me from him, who wants to be appreciated in metaphysical terms and whose problematic is totally bourgeois.… Man in my paintings is no longer represented with a deep exploration of his confused psyche, but as a collectivist concept, almost mechanical. Individual destiny has no longer any importance whatsoever.

It has become evident, even if only fairly recently, that in the battle between photography and painting, between the machine and antiquity, the latter lost out. It is most certainly true on the territory of the portrait, where the true genius of Neue Sachlichkeit ▲ is August Sander, whose systematic archive of the multiplicity of possible social subject positions was recorded on the verge of the fascism that would annihilate them all. Here the photographic archive is infinitely more relevant to the history of the portrait than any of the above-mentioned painterly attempts to come to terms with the crisis of subjectivity in the twenties. Helmut Lethen has

called photography during that period "an instrument of definition," that has generated the "photographic physiognomies of Modernity in which the signatures of the individual have become assimilated to the conditions of technical reproduction." BB

FURTHER READING

Anton Kaes et al., *The Weimar Republic Sourcebook* (Berkeley and Los Angeles: University of California Press, 1994)

Helmut Lethen, *Cool Conduct: The Culture of Distance in Weimar Germany* (Berkeley: University of California, 2002)

Detlev Peukert, *The Weimar Republic* (New York: Hill and Wang, 1989)

Wieland Schmied, "L'histoire d'une influence: Pittura Metafisica et Nouvelle Objectivité," in Jean Clair (ed.), *Les Réalismes 1919–1939* (Paris: Musée National d'Art Moderne, 1981)

Wieland Schmied, "Neue Sachlichkeit and the Realism of the Twenties," in Catherine Lampert (ed.), *Neue Sachlichkeit and German Realism of the Twenties* (London: Hayward Gallery, 1978)

▲ 1929, 1935, 1968a

1925 c

Oskar Schlemmer publishes *The Theater of the Bauhaus*, presenting the mannequin and the automaton as models of the modern performer; other artists, especially women involved in Dada, explore the allegorical potential of the doll and the puppet.

1920–1929

Why were so many different artists in the teens and twenties—whether associated with Dada, Surrealism, or Neue Sachlichkeit, Futurism, Constructivism, or the Bauhaus—drawn to such figures as the doll and the puppet, the mannequin and the automaton? Rarely treated as art per se (for example, Paul Klee never exhibited the fifty hand puppets he made between 1916 and 1925 for his son), such toys and curiosities were so attractive, in large part, because they were so ambiguous. At once evoking prehistoric times (the earliest votive objects and effigies of the dead resemble dolls) and contemporary life (the modern subject as a construction to manipulate), these figures also possessed some of the outsider interest of folk art and some of the affective power of tribal art. At the same time, too, they were distinct from these other objects of modernist enthusiasm.

Philosophical toys

Some of the artists in question here were influenced by celebrated texts by Heinrich von Kleist, E. T. A. Hoffmann, Charles Baudelaire, Rainer Maria Rilke, and Sigmund Freud, who were also intrigued by dolls and puppets. In one influential essay, "On the Marionette Theater" (1810), Kleist presents the marionette as the very image of innocence: "Grace appears most purely in that human form which either has no consciousness or an infinite consciousness. That is, in the puppet or in the god." So, too, in "The Philosophy of Toys" (1853) Baudelaire ponders the paradox of an inert figure endowed with a special force, here from the vantage of the child, for whom the toy represents not only "the first concrete example of art" but also "the first metaphysical stirring." However, this stirring can turn aggressive, even sadistic, according to Baudelaire, as the child strives "to get at and see the soul" of the toy, shaking it, banging it, finally prying it open, only to be devastated by the discovery of its utter soullessness. "This moment marks the beginnings of stupor and melancholy," the poet concludes.

Rilke, too, sees the doll as a thing of intense ambivalence in his 1914 text "On the Wax Dolls of Lotte Pritzel" (Pritzel was a Munich maker of emaciated and erotic figurines for adults, well known to German artists involved in doll-making such as Emmy Hennings and Hans Bellmer). Initially, the doll attracts our deep sympathy as a special object, even an intimate friend, Rilke writes, but "we soon realized we could not make it into a thing or a person, and in such moments it became a stranger to us"; eventually it is "unmasked as the gruesome foreign body on which we squandered our purest affection." Finally, a few years later in "The Uncanny" (1919), Freud theorizes the ambivalence that such figures so often incite. Prompted in part by famous tales about automata by Hoffmann, Freud argues that these objects produce a confusion between the animate and the inanimate, the human and the inhuman, which we register as eerie or uncanny, because it suggests that what is most alien to us—like death—is sometimes evoked by what is most familiar—like a favorite doll.

In this manner, such figures as marionettes and automata came to represent near-opposite values: on the one hand, principles of rationality and causality championed by the Enlightenment and, on the other, experiences of the irrational and the marvelous explored by Romantics such as Hoffmann. These divergent associations persisted in the modernist period. In Futurism, Constructivism, and the Bauhaus, these figures often appear sleek, almost perfect, so many avatars of a new (super)human to come; while in Dada, Surrealism, and Neue Sachlichkeit, they are usually broken and fragmentary, as if thrown together out of discordant parts, in a bitter riposte to the technological ideals promoted by the former movements. In this case, even when produced from scratch, dolls, puppets, and the like sometimes appear as emblems of a private childhood or relics of a collective past, in which guises they can carry a sense of aura or, again, of uncanniness. (The possible connection here between the psychologically repressed and the socially outmoded was of special interest to the Surrealists, who searched for forgotten things redolent of such associations in flea markets and other marginal sites; Walter Benjamin was intrigued by old dolls for similar reasons.) In fact, even when posed as portents of a technological future, figures like marionettes and automata might signify ambiguously and ambivalently; it was in this era, after all, that "the robot" was invented in an updating of Frankenstein's monster as an industrial worker-machine that runs amok, turning murderously on its human creator. (The term was coined by the Czech playwright Karel Čapek, who developed this theme in his 1921 play *R.U.R. (Rossum's Universal Robots)*, while

▲ 1909, 1914, 1916a, 1920, 1921b, 1923, 1924, 1925b, 1931a ● 1924 ▲ Introduction 1 ● 1935

Fritz Lang offered its most charged embodiment in the vampish robot Maria, who inspires the working masses to a disastrous rebellion in his 1927 film *Metropolis*.)

Given these multiple guises, no one motive or meaning can be ascribed to the appearance of dolls and puppets in modernist art. However, we might see these figures as so many reflections on the changed status of object-relations in modern Europe of the teens and twenties, especially the relations of humans to machines and commodities during a period of intensive industrialization, international war, and frenetic consumerism. At both poles of production and consumption, this new political economy was often identified with the United States—with its Fordist procedures of industrial labor, on the one hand, and its new forms of mass entertainment, such as jazz and movies, on the other. Indeed, "Americanism" became the shorthand for the Second Industrial Revolution that swept through Europe at this time, bringing new means of transportation and reproduction in its wake (such as automobiles, airplanes, news photography, and fast-speed film), all of which underlay "the new vision" promulgated in turn by modernists like

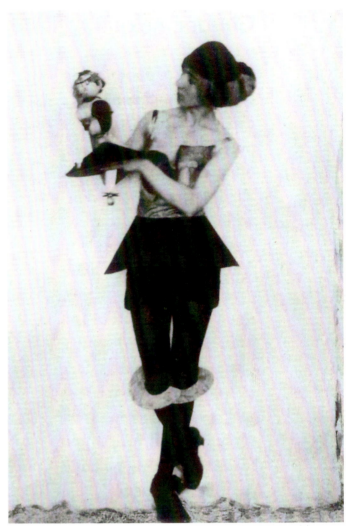

2 • Hannah Höch with doll, 1921
Photographer unknown

1 • Emmy Hennings with doll, 1917
Photographer unknown

László Moholy-Nagy. (It was for related reasons that some artists were also drawn to the photographic motion-studies of Eadweard Muybridge and Étienne-Jules Marey.) In this context, the automata and mannequins that appear in the various movements of the period take on an allegorical valence, as charged figures of horror or delight at the pervasive becoming-machine and becoming-commodity of the modern subject. Some artists mocked this condition, as Dadaists like Max Ernst did in his caustic portraits of humans as dysfunctional automata, while others thrilled to it, as Futurists like F. T. Marinetti did in his hyperbolic celebrations of the new prosthetic man raised to the superhuman status of machine-weapon.

Just as importantly, the dolls and puppets that also appear at this time point to a new performative dimension in artistic practice, which is especially pronounced in the work of women involved in Dada. In Zurich, Sophie Taeuber and Emmy Hennings, who made marionettes and puppets respectively, were brilliant stage-presences, while in Berlin Hannah Höch also interacted with dolls of her own making (importantly, all three were photographed with their creations as well [**1–3**]). For these women, such figures were vehicles of role-playing, of staging and testing models of femininity, of

3 • Sophie Taeuber with *Dada Head*, 1920
Photographer unknown

exploring female desire as well as feminine identity—an interest pressured by their association with prominent male Dadaists (Taeuber was married to Hans Arp, and Hennings to Hugo Ball, while Höch had a long affair with Raoul Hausmann). Of course, men might also use dolls to explore male desire, and some did so extravagantly: Oskar Kokoschka made a life-size doll, with which he would dine and travel publicly, while Bellmer photographed his manipulated *Poupées* in various scenes evocative of sadomasochistic fantasies. Meanwhile, others like Marcel Duchamp and Francis Picabia suggested less literal scenarios of erotic (dis)connection in their "bachelor machines"—scenarios that point to the possible effects of mechanization and commodification on modern sexuality. All of these concerns—the performative dimension of art, the doll and the puppet as primordial and charged examples of representation, the role of sexual difference in image-making, the possible connections between technology and sexuality—also have a bearing on contemporary art, which might underlie the renewed interest in such artists as Taueber, Hennings, and Höch in recent years.

Folk theater and psychoanalytic travesty

Emmy Hennings made puppets and drew dolls as part of her varied career as artist, poet, and performer [1]. Her dolls appear waifish, almost spectral, while her puppets are rough, like rag dolls, in keeping with the brash masks produced by Marcel Janco for performances at the Cabaret Voltaire in Zurich, where Hennings

was the star attraction. In her pre-Dada days she had worked as a chanteuse in Munich, where she met Lotte Pritzel, who influenced her later doll-making. Hennings performed with her creations occasionally, and identified with them always: photographed with her dolls, she also referred to them in her writing. "When man lives, acts, he is an automaton, a doll," Hennings once wrote, "yet how sensitive he is as a doll." As suggested here, her dolls and puppets seemed to represent a psychological split for Hennings—a doubling with special resonance for her life as artist and performer: "I sit there in front of my mirror and I can observe this doll. I know that I can double myself."

Little is known about the dolls produced by Hennings, and not much more about the ones made by Hannah Höch—though she did exhibit two at the famous Dada Fair in Berlin in 1920. Stitched together out of various pieces of fabric, with beads and buttons for eyes and breasts, and clumps of yarn for hair, these dolls appear deranged, closer to the art of the insane than to the toys of children; they might also anticipate the tribal figures that Höch reassembled in her provocative series of photomontages "From an Ethnographic Museum" (1929). Sitting on top of a wood case near the entrance of the Fair, the two dolls announced the Dada exhibition (which featured more notorious examples of costumed mannequins) as a site of play that was both transgressive and regressive, suggesting, as the dolls did, an uninhibited world of anger and play.

Like Hennings, Höch was photographed with her creations, and she, too, performed an ambiguous identification with them. In two photographs with another doll, Höch is posed in the guise of a seated mother holding her child and then of a dancer paired with her partner (her costume rhymes with that of the doll [2]). Suggested here are two themes developed in her greatest images of this period—themes that are dialectically related. On the one hand, Höch implies that the modern subject is hollowed out by mechanization and commodification; her famous collage *Cut with the Kitchen Knife Dada Through the Beer Belly of the Weimar Republic* (c. 1919) is a panorama of this transformation as visited on German subjects soon after the fall of the Kaiser, who appears here precisely as a broken doll, as do representatives of Weimar culture on the rise (for example, Hausmann pops up as a little robot dangling from the corrupted body of the Kaiser). On the other hand, Höch also presents this transformation as a liberation; the same collage is as much a joyous bursting-forth of the new order as it is a brutal autopsy of the old regime. Her photomontages of the early twenties featuring women are also dialectical in this way: they present "the new woman" of the era as subject to cultural stereotypes and manufactured desires imposed from without; at the same time, even as this woman is a construction, she is shown to possess an agency of her own—even the agency to transform her constructed image, as Höch does in these works.

Important though the making of puppets and the like was for Hennings and Höch, it was central to Sophie Taeuber, who was accomplished in the crafts (she taught for thirteen years at the Applied Arts and Crafts School in Zurich, supporting Arp as she

▲ 1924 ● 1918, 1919 ■ 1916a ▲ 1920

did so). For a 1918 staging of *The King Stag* by the eighteenth-century Venetian satirist Carlo Gozzi at the Théâtre Zurichois de Marionettes, Taeuber produced no less than seventeen painted marionettes out of wood and metal in geometric shapes (mostly cylinders and cones) that are sometimes repeated in the absurdist fashion of Dada (she added headdresses, fabric, pearls, and feathers to gender or otherwise distinguish some of the figures [**4**]). For this production, the Gozzi tale of court intrigue was radically transformed: relocated to the forest outside Burghölzli, the psychiatric hospital of the University of Zurich with which Carl Jung, a Freud apostate, was associated, the play became a spoof of psychoanalysis—of its claims to authority as well as its internecine battles then underway. For here, the king and his beloved are at the mercy of three characters named Freud Analytikus, Dr. Komplex (a representative of Jung), and the alluring Urlibido, all of whom struggle for control over the royals. It is not clear whom Taeuber and friends favored in the fight; though Zurich was the headquarters of Jungian analysis and her sister worked as a secretary to Jung, Dr. Komplex appears no less ridiculous than Freud Analytikus (both figures sport headdresses and skirts).

Like other Zurich Dadaists, Taeuber was interested in ritual. Trained by Rudolf von Laban, a great innovator in modern dance, she participated as both choreographer and dancer at the Cabaret Voltaire, and one extant photograph shows her dancing wildly in a Janco mask and an Arp costume, while another captures her with other dancers in Hopi Indian dress of her own design. This might suggest that Taeuber favored the Jungian universe of ritualistic regression (as did Ball), and her marionettes might indeed be read as Jungian archetypes. Yet, even when festooned, her figures are oddly blank, and the note of parody of depth psychology is difficult to miss, especially as the objects are puppets to be manipulated, and some are robotic in appearance (Max Ernst comes to mind here, especially his piston men in *The Hat Makes the Man* or *The Self-Constructed Small Machine* [both 1919]).

This impression is deepened by several *Dada Heads* that Taeuber made in the two years after *The King Stag* marionettes (only four survive). Turned on a lathe, two of these painted wood pieces present an ovoid head with a trapezoidal nose and a cylindrical neck set on a base made of two inverted cones, while the other two substitute slightly different geometries; all four are colored in decorative, almost proto-Art Deco patterns (one is tattooed "1920 Dada" [**3**]). As the curator Anne Umland has noted, these heads are "antimonumental and antimimetic," and they "take deft parodic aim at the historic characteristics of portrait busts." Two are subtitled *Portrait of Hans Arp*, but offer no indication of why they might be representations of Arp, so blank, so nonsubjective are they (Taeuber might have signed them "the woman who mistook her husband for a hat stand"). In this respect, the heads are close to another group of

4 • Sophie Taeuber, *Dr. Komplex*, 1918
Turned, painted wood, brass, and metal joints, 38.5 × 18.5 (15⅛ × 7¼)

5 • Sophie Taeuber and Hans Arp, *Untitled (Amphora)*, 1917
Turned, painted wood, height 30 (11¹³⁄₁₆), diameter 15.2 (5¹⁵⁄₁₆)

wood pieces Taeuber turned with Arp between 1916 and 1918 [5]. These pieces evoke domestic objects—they are subtitled "chalice," "*poudrier*," "bowl," and so on—but they too are resolutely neutral, a composite of negations—not aesthetic, not utilitarian, not figurative, not abstract, not freely invented, not readymade …

Paul Klee began his hand puppets after a June 1916 visit to Zurich, where he might have seen the first Taeuber marionettes; but his are much more expressive, made as they were for his young son Felix. The first eight of the fifty puppets (thirty survive) were produced for his ninth birthday; Klee resumed them after the war, with a second group added in 1919, and after Felix became a student at the Bauhaus in fall 1921, new figures were added every year for performances there until 1925. A former associate of the Blaue Reiter, Klee shared the interest of the Expressionists in folk art, an interest the puppets manifest: the first group is based on characters from the German version of Punch and Judy theater seen at fairs (the Klees knew them from the Auer Dult, a traditional Munich flea market). The hero is Kasperl, a vulgar but crafty soul who is usually aided by his wife Gretl and his friend Sepperl in endless battles with Death, the Devil, the Grandmother, the Policeman, and the Crocodile—battles from which Kasperl eventually emerges the victor. Of the first group made by Klee, only one puppet, Death, remains; with its white skull dominated by large black spots for eye sockets and a horizontal grid of clenched teeth, it is an impressive specter.

Bourgeois households often contained little Kasperl and Gretl theaters, and Felix staged his own shows at home, for which Klee also supplied the miniature sets (Felix later became a director of theater and opera). Over time, Klee added new characters to the stock types, some based on personal acquaintances (he included a self-portrait as well), others on public stereotypes (such as the German Nationalist, the Russian Peasant, the Bearded Frenchman). All the heads are worked in plaster, which is sometimes modeled with gauze, then painted; as with Kasperl and Gretl puppets at the fairs, the clothes are made of remnants (occasionally Klee was assisted in this task by an actual doll-maker, Sasha von Sinner). Like the other works at issue here, the hand puppets are not mimetic; in fact, some resemble the fantasmatic figures, often grotesque or ghostly, that appear in Klee's drawings and paintings. If anything, the puppets he made at the Bauhaus are more radical in their nonrepresentational use of odd materials and found objects (shells, nails, matchboxes, etc.), which might reflect his experiments in the Bauhaus *Vorkurs* at this time. *Electrical Spook* (1923) is the strangest of the group [6]: a sort of Bauhaus version of Death, its body is marked by a vertical stripe of red fabric, and its plaster neck supports a head that is a ceramic electrical socket. Is this what a folk spook looks like in a technological age—or does Klee suggest that modern technology possesses its own kind of uncanniness?

The transfiguration of the human form

Already master of the sculpture workshop at the Bauhaus, Oskar Schlemmer was named master of the theater workshop, too, in 1923. On the one hand, like Klee, he was interested in the stock types of folk theater: "The number of genuine stage costumes has stayed very small," Schlemmer writes in *The Theater of the Bauhaus* (1925), the fourth in the series of pedagogical Bauhaus Books. "They are the standardized costumes of the *commedia dell'arte*: Harlequin, Pierrot, Columbine, etc; and they have remained basic and authentic to this day." On the other hand, he was caught up in the technological turn—the new vision—that swept through the Bauhaus upon the arrival of Moholy-Nagy in 1923, which also marks *The Theater of the Bauhaus*. "The history of the theater is the history of the transfiguration of the human form," Schlemmer argues, in line with Moholy-Nagy, and "the new potentials of technology" have prompted "the boldest fantasies." In this respect, Schlemmer was most concerned to address what he saw as the key forces of the time—abstraction in art and mechanization in society—and to elaborate the new relations between man and space they set up. According to Schlemmer, the old illusionistic theater subordinated space to man, the stage set to the human drama, while the new abstract theater must reverse this hierarchy and relate man to space. The most direct way to do so was to render the human more architectonic in form, to make of man an "ambulant architecture," but Schlemmer advanced two other models in his own work that were somewhat more practical: the human form reconfigured either in geometric shapes in order to express certain laws of motion, which he calls "the technical organism" or "the automaton," or in functional terms in order to express certain laws of the body,

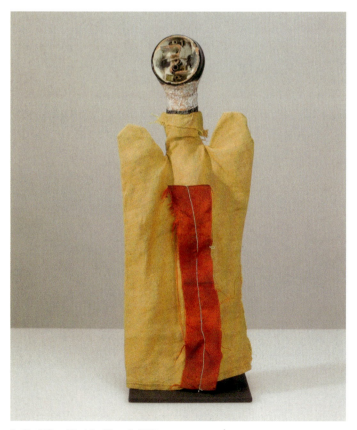

6 • Paul Klee, *Electrical Spook*, 1923
Ceramic electrical socket, metal, plaster, fabric, paint, and glaze, height 38 (15)

▲ 1922 ● 1923 ■ 1923

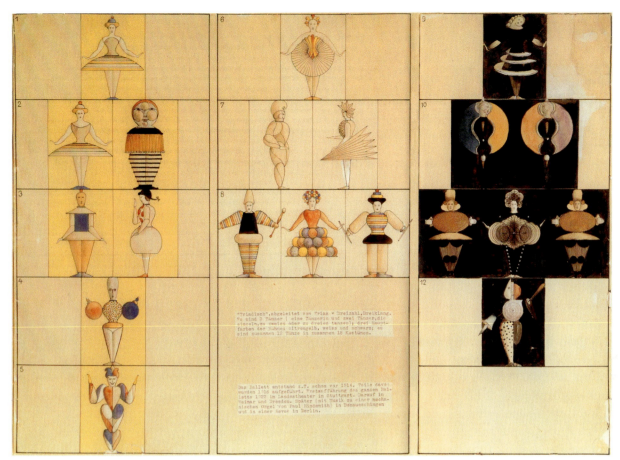

7 • Oskar Schlemmer, *Das Triadische Ballett, Figurenplan* (Figure-plan for *The Triadic Ballet*), 1924
Pencil, ink, watercolor, and gouache, 38.1 × 53.3 (15 × 21)

which he calls "the marionette." Led in this direction by his "endeavor to free man from his physical bondage," Schlemmer favored the automaton and the marionette in particular because they "permit any kind of movement." Here, then, like Kleist and Hoffmann (both of whom he cites), Schlemmer sees the figures of the marionette and the automaton as images of godly grace and uncanny power, not of mechanistic oppression—though it can be debated whether his performers suggest a new freedom in the end. (In this regard, his experiments diverge from the revolutionary theater of Vsevolod Meyerhold and others in the Soviet Union during the same period, who produced plays featuring anti-illusionistic sets by such artists as Liubov Popova, Varvara Stepanova, and Aleksandra Ekster; this kind of theater replaced the psychological realism of bourgeois drama with a "biomechanical" technique of acting that, in effect, adapted Taylorism to the stage.)

The Triadic Ballet was the most celebrated of Schlemmer productions at the Bauhaus [7]. Called "triadic" because it was performed in three parts by three dancers (two of whom were male), the ballet included twelve different dances performed in no less than eighteen different costumes, most constructed of padded cloth and stiff papier-mâché painted in metallic and other colors. A few of the *commedia dell'arte* characters prized by Schlemmer are still legible here, as are a few types of the classical ballet, but there are also updated clowns and jesters as well as a robotic knight.

Schlemmer describes the first part of the dance, set against a yellow backdrop, as a "gay burlesque," the second part, set on a rose stage, as "ceremonious and solemn," and the third part, set on a black stage, as "a mystical fantasy." The *Triadic Ballet* thus contains aspects of a folk theater, a variety show, and a medieval ritual, as if these disparate cultural forms—and the conflicted social forces they register—could be reconciled in a new template for performance in the machine age. "Let's not complain about mechanization, but rather let us delight in mathematics!" Schlemmer exhorts his contemporaries in the 1926 essay "The Mathematics of the Dance," where he sublimates mechanization "as a vehicle for a substance which is spiritual, abstract, metaphysical, and ultimately religious in nature." If *Electrical Spook* suggests how unlikely the combination of folk tradition and technological modernity is, *The Triadic Ballet* makes the very attempt at such reconciliation seem like "the boldest fantasy." HF

FURTHER READING
Leah Dickerman (ed.), *Dada* (Washington: National Gallery of Art, 2005)
Hal Foster, *Prosthetic Gods* (Cambridge, Mass.: MIT Press, 2004)
Ruth Hemus, *Dada's Women* (New Haven and London: Yale University Press, 2009)
Juliet Koss, *Modernism After Wagner* (Minneapolis: University of Minnesota Press, 2010)
Andreas Marti (ed.), *Paul Klee: Hand Puppets* (Bern: Zentrum Paul Klee, 2006)
Anne Umland and Adrian Sudhalter (eds), *Dada in the Collection of the Museum of Modern Art* (New York: Museum of Modern Art, 2008)

▲ 1913, 1921b

On May 3, a public screening of avant-garde cinema titled "The Absolute Film" is held in Berlin: on the program are experimental works by Hans Richter, Viking Eggeling, Walter Ruttmann, and Fernand Léger that continue the project of abstraction by filmic means.

One of the origins of abstract cinema was abstract painting; or, more precisely, one of its motives was to make this painting move, to animate its images somehow. Prompted by analogies to music already advanced by abstract painters such as Wassily Kandinsky and František Kupka, the pioneers of "absolute film," who included the Russian-Danish-Finnish Léopold Survage (1879–1968), the Swede Viking Eggeling, and the Germans Hans Richter (1888–1976) and Walter Ruttmann (1887–1941), often thought in terms of rhythm and counterpoint and in forms like fugue and symphony. In fact, the notion of "absolute film" was modeled on the idea of "absolute music" put forward by Richard Wagner in the mid-nineteenth century; long seen as the least referential of the arts, music was taken to be the paragon of a medium concerned first and foremost with its own expressive properties. In some respects, then, abstract film was born of a marriage between avant-garde painting and post-Wagnerian music, often drawing its visual forms from the former and its temporal rhythms from the latter, all in an attempt to avoid (its practitioners might say "transcend") both the referential restrictions of straight photography and the narrative conventions of popular cinema.

Rhythms in color and light

An early instance of this elaboration of abstraction, one that involved neither camera nor celluloid, is the 1913 project *Rhythme coloré* by Survage, who was based in Paris. It consists of more than one hundred drawings of nonobjective forms in lush watercolors on black backgrounds (most of the paper sheets are roughly 36 by 27 centimeters [approximately 14 by 10½ inches]). Meant to be seen in sequence, these shapes "sweep space," as Survage put it, and sometimes appear to extend beyond the frame of the paper, which we come to regard almost as a cinematic screen. As we shift from sheet to sheet, the forms mutate: sometimes straight, then curved; sometimes separate, then combined; sometimes as though in close-up, then in long shot [1]. Yet, even as *Rhythme coloré* mimics filmic representation in these ways, it presents no referent and provides no scale. We might imagine bodies and spaces that

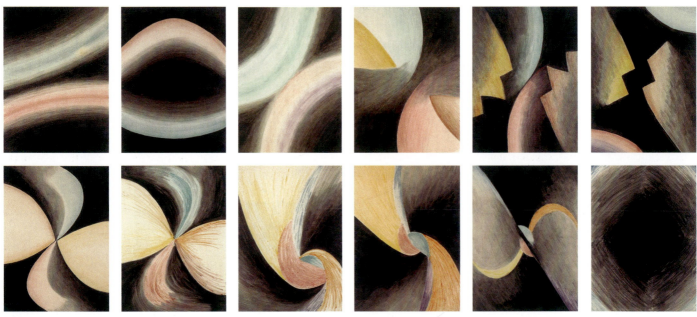

1 • Léopold Survage, *Rhythme coloré*, 1913
Watercolor and ink on paper on black paper-faced board, each 36 × 26.6 (14³⁄₁₆ × 10½)

▲ 1908, 1913

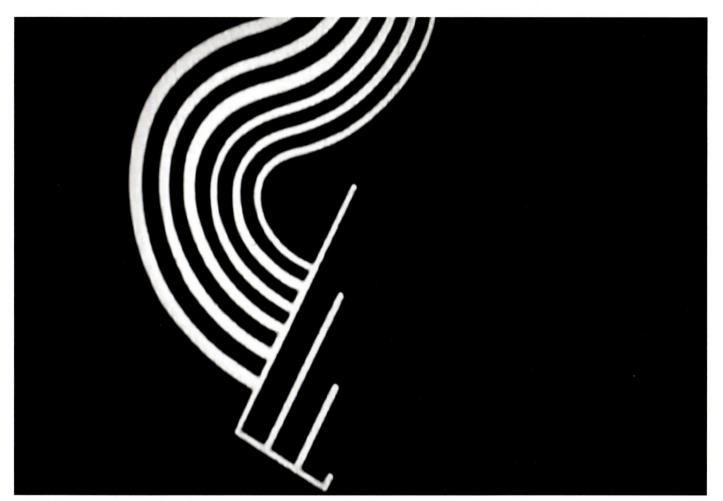

2 • Viking Eggeling, *Symphonie diagonale*, 1921–4
16mm film, black and white, silent, 7 minutes

are either tiny or vast—the movements of microscopic organisms, say, or the pathways of celestial light—but these remain projections in our minds. And it is projection in another sense that emerges as the subject here: luminous against the black backgrounds, the colored forms suggest prismatic light projected into darkness; that is, they suggest film at its most abstract—and perhaps at its most advanced (Survage here anticipates color film).

Survage planned to shoot his watercolors (he knew that many more would be needed to make a film of any length), and the French movie company Gaumont was interested for a time, but the outbreak of World War I dashed this project. However, his practice of "paper cinema" was soon developed by others. In Paris from 1911 to 1915, Eggeling came to know Survage, and he, too, produced abstract drawings, mostly in pencil on paper, which were also composed like separate shots in long sequences. Eggeling referred to these scrolls, most of which are horizontal in format, as "picture rolls"; some are as long as fifteen meters. By 1918, he was active in Zurich, where he quickly befriended Hans Richter, ▲ one of the ringleaders of Dada there; in 1919, as Dada waned in the Swiss city, the two men moved on to Berlin, where they worked for the next few years, both separately and together, at the Richter family home. "Here, in its highest perfection, was a level of visual

organization comparable to counterpoint in music," Richter wrote about his first viewing of a picture roll by Eggeling, "a kind of controlled freedom or emancipated discipline, a system within which chance could be given a comprehensible meaning. This was exactly what I was now ready for."

Eggeling was able to film only one scroll before his untimely death in May 1925, just sixteen days after "The Absolute Film" screening at the UFA Palast in Berlin. For *Symphonie diagonale* (1921–4), which was shown at this screening, he drew black lines on white paper so that, when filmed and projected, they would appear as white figures on a black ground: immediately this redoubles our basic experience of the light and dark of the cinema [2]. For each sequence, Eggeling began with a complete drawing, shot it, then masked part of it with tin foil, shot it again, and so on. At certain points, he alternated this process of subtraction with one of addition, unmasking the given drawing in increments, which he also then filmed; sometimes, too, he shot in a mirror so that his forms reappear but in inverted position. Throughout the film, white lines emerge, quickly combine into complex figures, then withdraw piece by piece, finally to disappear altogether, only to be replaced by other figures—and it all happens as though Eggeling has no part in the production. At times, the figures suggest musical

▲ 1916a, 1920, 1925c, 1926

3 • Hans Richter, *Rhythmus 21*, 1921
35mm film, black and white, silent, 3 minutes

and *Rhythmus 25* (1925). *Rhythmus 21* establishes the language for the other two: first singly and then in combination, white rectangles emerge from the black background, moving horizontally or vertically across the screen, sometimes expanding and advancing, sometimes contracting and receding [**3**]; intermittently, the rectangles switch to black and the background changes to white, but the basic pattern of rectangles in movement, transformation, and reversal remains constant. If Eggeling favored line and thus the pictorial aspect of abstract film, Richter privileged plane and thus the spatial dimension, and that dimension takes on depth as his planes advance and recede. Even more than Eggeling, then, Richter presents filmic abstraction as a perpetual diagramming of cinematic space. Yet in neither case is this diagramming bloodless; in fact, it has a kind of pulse that one might associate with the pumping of a heart (in the Eggeling) or the movement of sex (in the Richter)—as though the body were evacuated as a figure only to return precisely as a rhythm.

The rectangles of the *Rhythmus* films redouble the frame, and this reflexivity is central to their effect. Yet the films are not medium-specific in a reductive way; indeed, for Richter the forms are less important than the intervals between them. "I went on to take parts of the rectangular screen and move these *parts* together or against each other," he wrote of *Rhythmus 21.* "These rectangles are not *forms*, they are parts of movement.... [T]he relationship between the positions becomes the thing to be perceived, not the single or individual form. One doesn't see the form or object anymore but rather the relationship. In this way you see a kind of rhythm." It is this differential understanding of the fundamental elements of film that makes the *Rhythmus* pieces the quintessential examples of abstract cinema. Certainly it allowed Richter both to control his forms and to motivate their meanings: "A vertical line was made meaningful by the horizontal, a strong line grew stronger by a weak one, a defined one was clear against an undefined one, and so forth. All of these discoveries became meaningful in light of our belief that a precise polar interrelationship of opposites was the key to an order, and once we understood this order we knew we could control this new freedom."

An abstract medium for an abstract world

This ambition to define the basic components of film was close in spirit to the aim of the De Stijl movement with regards to painting and design, and indeed Richter and Eggeling were close to Theo van Doesburg, the leader of De Stijl, who visited them in Berlin for several weeks in late 1920, not long before *Rhythmus 21* was created and *Symphonie diagonale* was begun. In De Stijl, the analysis of a given art form was only the first step in the process; the next move, the key one, was to integrate this deconstructed medium with other forms in a new totality of the arts, an updated *Gesamtkunstwerk.* (A similar project animated *G: Material zur elementaren Gestaltung* [G: Materials for Elemental Form-Creation], a syncretic journal in equal parts Dadaist and Constructivist

notations or architectural diagrams, yet in the end *Symphonie diagonale* prompts even fewer associations than does *Rhythme coloré.* We are left with the impression not only of abstract forms but also of autonomous movement—these lines seem to beat with a life of their own.

Eggeling positioned his forms on the oblique—hence the diagonal of *Symphonie diagonale*—in a way that dynamizes the rectangle of the screen. This kind of counterpoint was essential to his work, as Richter was quick to see: "Eggeling tried to discover which 'expressions' a form would and could take under the various influences of 'opposites': little against big, light against dark, one against many, top against bottom, and so forth." This account is even more fitting for his own abstract films, of which Richter made three during this period: *Rhythmus 21* (1921), which was shown under its original title *Film ist Rhythmus* at the second showing of "The Absolute Film," a week after the first; *Rhythmus 23* (1923);

▲ 1917b ● 1928a ■ 1916a, 1920, 1921b, 1925c, 1926, 1928a

1920–1929

that Richter founded and edited from 1923 to 1926.) If abstract film drew on painting and music in its beginnings, it soon implicated architecture as well. "The space of the viewers of *Rhythmus 21* fuses with the space of the film," the film historian Philippe-Alain Michaud has argued. "They no longer watch the film as a theatrical representation, they optically live it. If film becomes architecture, the screen becomes the ultimate unit of architecture." This is an expanded concept of abstract cinema, one represented at "The Absolute Film" by the first piece in the sixty-minute program, a multimedia spectacle by the German Ludwig Hirschfeld-Mack (1893–1965), a member of the Bauhaus. In his *Tripartite Color Sonatina—Reflectory Color Plays* (1925), four people operated a device called a "color organ" that projected geometric shapes through optical filters and other devices onto a transparent screen, all to musical accompaniment. This *Lichtspiel*, or "light play," was in keeping with ideas put forward by László Moholy-Nagy in his ▲ *Malerei, Fotographie, Film* (1925), in which the Bauhaus master anticipated an eventual dematerialization of art—from abstract painting into "optical expression" as such—by means of new technologies of light.

This was one tendency within absolute cinema: not only to make abstract films but to extend this filmic abstraction into the world at large. Another tendency aimed at a similar goal but from the opposite direction, for it involved the filming of an industrial-capitalist world that was seen to be *already* abstract in its own ways. This approach was exemplified in "The Absolute Film" ▲ by *Ballet Mécanique* (1924) by Fernand Léger, who collaborated with the American filmmaker Dudley Murphy and the American composer George Antheil (the American artist Man Ray assisted too). *Ballet Mécanique* presents a panoply of cinematic devices—close-ups, dissolves, apertures, prisms, stop-motion shots, repeated sequences of new and found footage—but they appear as expressive elements in their own right, released from any narrative [4]. However, unlike most of his colleagues in abstract film, Léger did not eschew the human figure; on the contrary, he set people in delirious motion with objects, precisely in a "mechanical ballet" driven by a throbbing score featuring percussive pianos and wailing sirens. The film begins with a cartoon animation of Charlie Chaplin, the comic epitome of machine-age man, then shifts to a sequence of Katherine Murphy (wife of Dudley) on a swing; this sequence is repeated upside down; then, in a vertiginous move, the camera gets a turn on the swing. Soon all sorts of people and things are turning and gyrating—city-dwellers on amusement-park rides, pistons, wheels, and cogs in factories, and hats, shoes, wine bottles, and pots and pans on display. *Ballet Mécanique* thus becomes a dance of analogies between abstract geometries, mechanical parts, everyday commodities, and human features and limbs (we see repeated close-ups of Kiki de Montparnasse,

4 • Fernand Léger and Dudley Murphy, stills from *Ballet Mécanique*, 1924
35mm film, black and white, silent, 12 minutes

▲ 1929 ▲ 1925a

5 • Dziga Vertov, still from *Man with a Movie Camera*, 1929
35mm film, black and white, 68 minutes

a star of the Parisian demimonde, especially her lipstick mouth and mascara eyes, as well as a cancan of female legs detached from any body). Film is an excellent match for the modern world, Léger suggests, as both are defined by mechanistic motion, and film must tend to the abstract because this world does so; in fact, film might be the ideal medium for the machine age because it, too, is both industrial and commercial.

▲ Trained as an architectural draftsman, Léger was a pioneer of abstract painting, yet even his prewar canvases are built from elements that seem to derive from body parts or machine parts or both. And as his paintings developed after the war, he always insisted that they were "realist"—so many objective renderings of a modern life that was given over to industrial production and commercial consumption—and he paints his urban surround precisely as a panorama of fragmented mechanisms, products, people, and signs. In time, this environment informed his model of painting too: like a machine, his painting became a device of interrelated parts and, like a product, a matter of clean outlines, bright colors, and shiny surfaces. Léger was drawn, as was his
• colleague Le Corbusier, to the emblematic objects of capitalist industry, and the processes that govern these "object types" seem to govern his art as well; even his human figures appear to be

subjected to mechanization and commodification—in a word, to capitalist abstraction. It is this modeling of the human figure on the machine and commodity that sets up "the mechanical ballet" of his film.

In "The Spectacle," an essay published in 1924, the same year that *Ballet Mécanique* was produced, Léger describes a world where a new mobility of vision is dominant and "the shock of the surprise effect" rules, and he argues that the artist must not only "compete" with these conditions, but also "orchestrate" them: "We have found what we are competing with; we must renew the man-spectacle mechanically.... [T]hat vast spectacle is badly orchestrated; in fact, not orchestrated at all. The intensity of the street shatters our nerves and drives us crazy. Let's tackle the problem in all its scope. Let's organize the external spectacle." Here, the film historian Malcolm Turvey has argued, "just as Richter neither accepts nor rejects the rationalism of modernity, Léger neither repudiates nor embraces the fragmentation of perception in modernity." Rather, Léger represents the "surprise effect" of this spectacle—in part out of a delight in its vitality (even more than the forms in *Symphonie diagonale* and *Rythmus 21* do the objects in *Ballet Mécanique* seem to come alive), in part to absorb its "shock," and in part to push this spectacle further, with

▲ 1913, 1921a, 1925a ● 1925a

the hope that modern subjects might somehow pass through it to another kind of social order altogether (for Léger, this order would be a Communist one).

Léger was not alone in this project. For example, in 1927 Walter Ruttmann produced *Berlin: Symphony of a Great City*, a new kind of documentary that intercuts abstract images with photographic shots of everyday life in the industrial metropolis. (Ruttmann was represented in "The Absolute Film" by three abstract pieces, *Lichtspiel Opus I, II*, and *III*, in which, like Eggeling and Richter, he emphasizes musical rhythm, even as he deviates from them with shapes that are both colored and expressive.) Other filmmakers exploited the devices of abstract cinema, too, in a concerted effort not merely to represent modern life, but also to enact its mediated perspectives in ways that photography (let alone painting) could not do. Exemplary here is the Soviet director known as Dziga Vertov (David Abelevich Kaufman; 1896–1954), whose *Man with a Movie Camera* (1929) qualifies as a "city symphony" as well [5]. In fact, already by the moment of "The Absolute Film," Soviet filmmakers had seized the mantle of advanced cinema. By 1925, Sergei Eisenstein (1898–1948) had proposed his theory of montage as a system of "attractions", relieving film of any residual reliance on painting or music, a theory he put into practice in *Battleship Potemkin* of that same year, which was an international sensation. Within the avant-garde, too, abstract cinema was challenged by Dadaist and
▲ Surrealist films that, though hardly narrative in any conventional sense, were also far from abstract. (One of these productions, *Entr'acte*, a collaboration among the filmmaker René Clair, the
● artist Francis Picabia, and the composer Erik Satie, was the fifth, final, and somewhat incongruous entry in "The Absolute Film.")

In this respect, though "The Absolute Film" garnered great interest (it sold out the vast Palast theater on the Kurfürstendamm, the largest cinema in Germany at the time), it marked an end as much as a beginning. Again, Eggeling died very soon after the event; Richter went on to direct other kinds of films, both documentary and narrative; and Ruttmann soon rejected abstract cinema altogether. Other filmmakers, such as the German Oskar Fischinger (1900–67), carried on with abstract experiments, but most were soon compelled to adapt these means to the ends of advertising, Hollywood cinema, or both. (Ruttmann used abstract animation for a short film for automobile tires as early as 1922; he also later assisted Leni Riefenstahl on the greatest of all Nazi propaganda films, *The Triumph of Will* [1935]). For the most part, "absolute film," born of abstract painting circa 1913, was done in by the advent of synchronized sound circa 1929, which allowed film to be captured by an emergent studio system dedicated to narratives based on the theater or the novel. And the general suppression of modernist experimentation in the thirties, especially in Germany, dealt the death blow. However, like other avant-garde forms repressed at this time, abstract film returned in the postwar period, with the "structural film" and "expanded cinema" movements of the fifties and sixties, but that is another story. HF

▲ 1916a, 1920, 1924, 1927a, 1930b ● 1916b, 1919

FURTHER READING
Timothy Benton (ed.), *Hans Richter: Encounters* (Los Angeles: LACMA, 2013)
Leah Dickerman (ed.), *Inventing Abstraction, 1910–1925* (New York: Museum of Modern Art, 2012)
Fernand Léger, *Functions of Painting* (New York: Viking Press, 1973)
Standish D. Lawder (ed.), *The Cubist Cinema* (New York: New York University Press, 1975)
Hans Richter, *Dada: Art and Anti-Art* (London: Thames & Hudson, 1965)
Malcolm Turvey, *The Filming of Modern Life: European Avant-Garde Film of the 1920s* (Cambridge, Mass.: MIT Press, 2011)

1926

El Lissitzky's *Demonstration Room* and Kurt Schwitters's *Merzbau* are installed in Hanover, Germany: the architecture of the museum as archive and the allegory of modernist space as melancholia are dialectically conceived by the Constructivist and the Dadaist.

In July 1919 Kurt Schwitters (1887–1948) jettisoned both his formation as an academically trained landscape and portrait painter and his recent past as a member of the German Expressionist avant-garde by publicly declaring his discovery of a new type of picture-making. The name he gave this new project was "Merz," a syllable fragmented from a larger word, *Kommerz*, which he had accidentally found on a torn advertisement for the Hannover Kommerzbank when wandering round his native Hanover. It was on the grounds of that fragment that Schwitters developed an aesthetic both of collage and of phonetic, textual, and graphic segmentation that became one of the key contributions to German Dada.

In his initial practice of Merz, however, Schwitters maintained all the idioms of the Expressionist and Futurist aesthetic that had been so influential for the German avant-garde during the late teens. In early Merz works, such as *Welten Kreise* (1919), one can trace both the dynamic vectors and force-lines of Cubo-Futurism and the chromatic scheme of Expressionist painting. Yet what radically alters works from this period is Schwitters's insertion of found metallic, wooden, or other debris collected in the streets [1]. Morphologically and formally, one could even go so far as to sense a distant echo of Francis Picabia's mechanomorphic works in these paintings. Yet, as with all responses that Schwitters makes, in each instance, the legacy—whether of Expressionism, Cubism, Futurism, or Picabia's Dadaism—is transformed into what one could call a specific mode of "melancholic" response. In his reaction to the total transformation of painting into a technological object, or in his response to the assimilation of mechanomorphic forms to the shapes of the composition, or in his response to Expressionism's high-flown humanitarian ideals, Schwitters situates himself as an artist who returns to an allegorical reading of techno-scientific utopianism by countering it with a position of melancholic contemplation.

The debris in Schwitters's work was, quite logically, not accepted as a credible commitment to Dada practices; and already in early 1919, the leader of the Berlin Dada circle Richard Huelsenbeck had denounced Schwitters as "the Biedermeier" of German Dada (a reference to an early-nineteenth-century style in German art and life, and a term often used pejoratively to describe something as conventional or bourgeois), thereby calling attention to Schwitters's manifest concern for a continuation of painting as a space of

contemplative experience. As Schwitters himself never tired of saying, the technological objects, the found materials in his work, only functioned in order to conceive of a new type of *painting*. They were never theorized as readymades that would displace painting, or as morphologies that deny the validity of drawing, or as chromatic objects that dismantle the legacy of visual intensity in Expressionist art. In all instances, Schwitters's ultimate goal remained one of conceiving what he called a "painting for contemporary experience."

A similar change took place in Schwitters's drawings at this time. Here the Expressionist idiom of angular, jagged profiles was suddenly juxtaposed with the mechanized imprint of found office stamps that Schwitters had collected and now deployed as elements of mechanical drawing. Yet, as in the collages, the emphasis stays focused on the construction of an object that is primarily legible as

1 • Kurt Schwitters, *Merzbild Rossfett (Horse Fat)*, c. 1919
Assemblage, 20.4 × 17.4 (8 × 6⅞)

▲ 1916b, 1919 ● 1908, 1909, 1911, 1912, 1916a, 1921a ■ 1916a, 1920

poetic or pictorial, never reducing the compositional structure or the reading order to a fully homogenized, mechanically produced image such as in Picabia's mechanomorphic portraits. Rather, the drawings operate within the tension between manual inscription and technologically based textual production.

A corresponding ambiguity can be traced in Schwitters's practice of abstract sound poetry. This lifelong project began most notoriously with *An Anna Blume*, a masterpiece of German alogical verse in the tradition of early-twentieth-century writers such as Christian Morgenstern. But if, in its shrill and ludicrous exclamation and its florid homage, Schwitters's writing is first of all a Dada derision of both the bathos of Expressionism and the sentimentality of turn-of-the-century German writing, its position nonetheless remains ambiguous. For once again, rather than focusing on the linguistic self-referentiality that Russian Cubo-Futurist poetry forges in the context of a Formalist theorization of language, Schwitters's poetry positions itself in an ambivalent relationship to the most radical dismantling of narrative and representation. Similarly, it occupies the same position with regard to the dismemberment of the poetic texts that Dada figures such as Raoul Hausmann were producing at that same moment in Berlin as they foregrounded the grapheme over the phoneme, exclusively making the poem the subject of a totally nonlexical structure.

Schwitters's declaration from the outset that he had no political ambitions whatever, that he wanted his work to be situated within the tradition of painting, that his goals were utterly aesthetic and aimed at a new plastic formal order, set him at a further remove from Berlin Dada. Remaining in Hanover, with brief interruptions, and developing his own project, Schwitters soon became the center of a separate avant-garde scene, with friends and collaborators forming around him. The museum director Alexander Dorner, especially, became a crucial organizer and curator in bringing international avant-garde activities to the provincial city.

Schwitters and Lissitzky in collaboration

In 1925, Dorner invited the Russian Constructivist El Lissitzky to return to Germany to produce a major installation for the Landesgalerie Hannover (Lissitzky had studied architecture and engineering in Darmstadt from 1909 to 1914 and had stayed in Germany for long periods in the early twenties while collaborating on a number of projects). Schwitters first came into contact with Lissitzky and Russian Constructivism and Productivism in 1922, and the two artists became friends and collaborators. In 1923 Schwitters invited Lissitzky to become the designer and coeditor of issue 8/9 of his magazine *Merz* [2], published in April 1924 and called "Nasci" ("being born" or "becoming"), which was an explicitly programmatic alliance of Constructivist and Dadaist ideals. While in historical hindsight it seems unlikely that these two models would have provided the basis of fruitful exchange, it is precisely in the collaboration between Lissitzky and Schwitters at the moment of 1926 that the productivity of such an encounter can be most adequately traced.

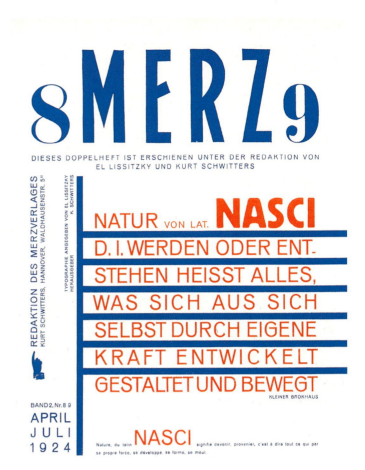

2 • El Lissitzky, cover design for Kurt Schwitters's *Merz*, no. 8/9, April–July 1924

By then both artists had been increasingly transforming their projects from pictorial or sculptural work into the investigation of architectural space. In his *Proun Room* for the Great Berlin Art Exhibition of 1923, for example, Lissitzky had transformed his ideas into three-dimensional form for the first time, designing the walls and ceilings with geometric shapes and reliefs [3]. An additional element was Dorner's intensifying attempt to theorize the new forms of display, the redesign of traditional museum spaces in favor of an adequate representation and display of avant-garde practices in painting and sculpture. Lissitzky had already designed a space for the 1926 International Exhibition in Dresden in which to show international, avant-garde, abstract art. For his first model, he rigorously emphasized walls on which the works would be hung by installing vertical wooden battens, spaced equidistant all across the display surfaces and painted white, gray, and black, and by placing the paintings on those surfaces. Ironically, the eventual master design of the 1926 Dresden exhibition was placed in the hands of the reactionary German architect Heinrich Tessenow, who would soon become known for his staunch advocacy of the return of architecture to an antimodernist regionalism.

It was Lissitzky's preliminary design for Dresden that made Dorner decide to invite the Russian to Hanover, and it was there that Lissitzky produced a second version of the cabinet for the display of abstract art, called the *Demonstration Room* [4]. During

▲ 1916b, 1919 ● 1915 ■ 1920 ◆ 1928b

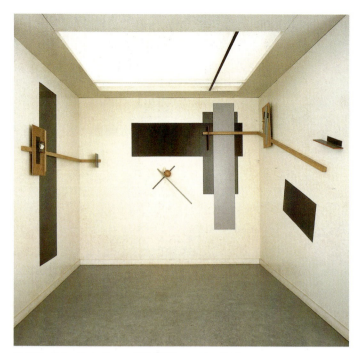

3 • El Lissitzky, *Proun Room*, 1923 (1965 reconstruction)
3,000 × 300 × 260 (1181½ × 118⅛ × 102⅜)

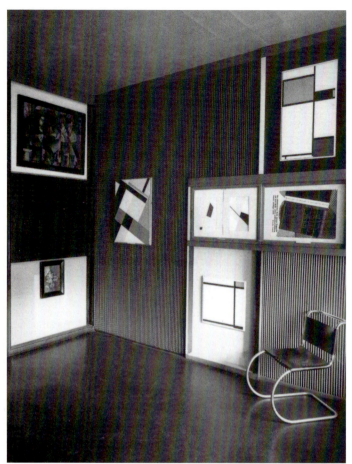

4 • El Lissitzky, *The Abstract Cabinet: Demonstration Room* in the Landesgalerie, Hanover, 1927–8 (1935 installation view)

this extended stay in Hanover, Schwitters and Lissitzky further developed their friendship. Schwitters had by now also moved away from painting and collage to his own first architectural project, which came to be known as the *Merzbau* [5]. Beginning in his studio on the ground floor of his own private house, he gradually transformed all aspects of the traditional cubic space of the domestic room into an increasingly distorted, multiperspectival spatial structure, installing wooden, painted reliefs and loading various objects and additional forms into the spaces created.

The opposition between the *Merzbau* and the *Demonstration Room* and the close bond between their two authors produce one of the most puzzling moments of mid-twenties German avant-garde history. Yet one bridge that links the two is their focus on the issue of tactility and bodily experience in relation to the work of art. For Lissitzky's project to accommodate avant-garde painting and sculpture within the museum now focused primarily on Dorner's call for a new participatory mode of reading and perceiving. Dorner's project was to reconceive the museum as a space of author/object/spectator collaboration mediated through an increased experience of tactility. In the installation that Lissitzky designed, with its emphasis on drawers and cabinets and shelves that the spectator could open and move, thereby being directly involved in the repositioning of him- or herself as a spectator or in the positioning of the object in a new relationship, tactility and tangibility were clearly elements of a radically altered mode of perceptual interaction, changing the contemplative space of the museum into an archive.

But what Dorner's vision had not anticipated was the specific contribution that Lissitzky was to introduce into the design of the *Demonstration Room*. The transformation of the exhibition space and its display devices and conventions led him to articulate the actual historical transformation of the institution of the museum,

as well as the actual status of the object displayed within it. The new situation moved the art work, that is, from being an object of cultic origins to one of pure exhibition-value, from being an object of transhistorical intelligibility to one of historical specificity, of the kind necessary to archival purposes. Those ideas about the need to transform the museum in terms of its functions, its audience, and its institutional definition had emerged in the Soviet Union as early as 1919, when artists discussed the reorientation of the aesthetic object from cult to exhibition and the transformation of viewing spaces from ones of ritual to ones of archival dimensions.

Apart from this shared interest in tactility, however, Schwitters's *Merzbau* inverted every single aspect of Lissitzky's approach, which we could call the rationalist transformation of the last residual ritualistic element in the display and reading of the work of art. In contrast, the *Merzbau*'s space was reconceived as specifically ritualistic, with the object and its display welded into an almost Wagnerian drive toward the condition of the *Gesamtkunstwerk*, in which all the senses, all perceptual elements, would be unified in an overall intensified form of visual, cognitive, and somatic—that is, physical—interaction with the objects, structures, and materials on display. Schwitters's attempt to construct a grotto, or a *Bau*, carried all the connotations that word has in German: from an animal burrow (the original ▲ meaning of *Bau*) to the famous Bauhaus declaration in which the medieval guilds of community and communality building cathedrals

▲ 1923

in a preindustrial society and the structure of the collective could be invoked. These sources came together in his perpetual insertions into the overall display of objects, textures, and materials that emphasize the somatic dimension of perception. Thus he brought the solicited residues of bodily secretions into the building (bottles of urine, for instance, or snippets of friends' hair), which he stored and inserted into the various layers of the structure. He thereby fabricated a manifestly nonrational, nonarchival, noninstitutional space, in which a certain regression into the totality of an unconscious architectural space was conceived, and called it *The Cathedral of Erotic Misery*.

Two extremes of avant-garde design

Schwitters's *Merzbau* and Lissitzky's *Demonstration Room* could therefore be theorized as the two extreme opposites of the possibilities of avant-garde design in the twenties. Clearly, compared with the ideology of the Bauhaus, neither Schwitters nor Lissitzky belongs to the utopianism of a Bauhaus spirit that was attempting at the same moment to transform everyday life and domestic architecture through a mode of rationalization and a form of democratized consumption. Specifically in the *Merzbau*, which would be continued throughout Schwitters's life (after the *Merzbau* in Hanover was destroyed by Allied bombing in 1943, Schwitters installed a second version in Norway, to where he had emigrated in 1937 after his work had appeared in the "Degenerate 'Art'" exhibition in Munich, and a third—the *Merzbarn*—near Ambleside in northern England, just before his death in 1948), the idea of a space of radical rationalization was refused on every single level. This project of instrumentalizing or rationalizing space was intended to reach right down to the most intimate sphere of everyday life, where function reigned supreme, as daily activities were submitted to planning, control, and the principle of greater efficiency. In the light of this, Schwitters's *Merzbau* proposed a space of total inefficiency, utter dysfunction, a complete refusal to subject spatial experience to rationality, transparency, and instrumentalization. By emphasizing the space as the ground, the grotto, and a home of a different kind, Schwitters created a secularized but at the same time ritualized space of bodily function, one of bodily retrieval outside and in opposition to a rigorously controlled public sphere.

Despite its appearance, Lissitzky's space is also dramatically different from the functional realm of Bauhaus design, specifically because of its theoretical accommodation of the radically transformed conditions of perception of the work of art. That is, Lissitzky's space is in a sense a program for the retheorization of the institution of the museum. If it has been misread as a dynamic display of abstract, avant-garde art, to which it supposedly lends support through its streamlined design, that false interpretation should be counteracted by emphasizing the degree to which Lissitzky saw the museum as being increasingly transformed into the mere institution of historicization and archival order. Thus, inasmuch as Lissitzky recognized that the cognitive and perceptual modes still embedded in easel painting were no longer to be rescued or redeemed by even the most advanced forms of abstraction, he had already subjected the avant-garde

5 • Kurt Schwitters, *The Hanover Merzbau: The Merz Column*, 1923
Mixed media, dimensions unknown (destroyed)

promise of abstraction to an internal critique. Looking at the display of the specimens of abstraction in the *Demonstration Room*, one can—with hindsight of course—recognize that even in the way these objects are displayed there is already a certain critical operation taking place. This is because Lissitzky's reliefs—wall structures, cabinets, drawers, movable panels—become the ultimate work of art, while the abstract paintings, in all their radicality, become mere illustrations of an aesthetic that had already been superseded. BB

FURTHER READING
Elizabeth Burns Gamard, *Kurt Schwitters' Merzbau* (Princeton: Princeton Architectural Press, 2000)
John Elderfield, *Kurt Schwitters* (London: Thames & Hudson, 1985)
Joan Ockman, "The road not taken: Alexander Dorner's way beyond art," in R. E. Somol (ed.), *Autonomy and Ideology: Positioning an Avant-Garde in America* (New York: The Monacelli Press, 1997)
Nancy Perloff and Brian Reed (eds), *Situating El Lissitzky: Issues and Debates* (Los Angeles: Getty Research Institute, 2003)
Henning Rischbieter (ed.), *Die Zwanziger Jahre in Hannover* (Hanover: Kunstverein Hannover, 1962)

▲ 1937a

1927 a

After working as a commercial artist in Brussels, René Magritte joins the Surrealist movement in Paris, where his art plays on the idioms of advertising and the ambiguities of language and representation.

While still in Brussels, René Magritte (1898–1967) operated a studio specializing in commercial art from a garage behind his house; thereafter in Paris he often turned to book design and advertising work to support himself. For some critics, his deadpan representational style was always distressingly close to that of commercial art, but his experience in this field might also account for his abiding interest in the relation between figurative and verbal forms of representation, and the interaction—often the interference—between these ways of evoking an object or suggesting an idea. It might also explain his later willingness to issue the most important of his paintings in multiple copies. His most famous painting, *The Treachery of Images* [1], in which the picture of a pipe is captioned "This is not a pipe" ("Ceci n'est pas une pipe"), was issued at least five times, once as a large sign. Another, *Dominion of Light* (1952), in which a darkened house illuminated by streetlamps stands in a night landscape but is seen against a daytime sky, was reproduced in sixteen oil and seven gouache versions (the first in 1949, the last in 1964). In 1965 he would plagiarize his own *The Great Family* (1963)—an image in which the silhouette of an object (in this case, a bird; in *The Seducer*, a ship) is "fleshed out" by the substance of its milieu (here, clouds; there, waves)—to produce *Skybird* for Sabena Airlines, with the understanding that it would be used for publicity campaigns.

The potential complementarity of fine and commercial arts depended on the nature of mass culture. Stimulated by advertising, desire for a commodity became a craving less for a unique object than for one of many copies. As Walter Benjamin argued in ▲"The Work of Art in the Age of Mechanical Reproduction" (1936), such desire aims to extract a sense of equivalence "even from a unique object by way of reproduction." Sucking the very idea of uniqueness and distance (or what Benjamin called "aura") out of lived experience, the culture of the commodity prepares simultaneously for the seductions of media imagery and the spectacle of an artist pirating his own work.

Everything in the Surrealist position, however, would seem to shun the prefabricated and the mass-produced. Everything would seem to be geared, instead, to the unrepeatable moment of shock in which the most banal object of everyday life would be reinfused ●with wonder and revelatory power—what André Breton called

"the marvelous" and theorized as "objective chance." As Surrealist artists lent themselves to jewelry design, department-store display, and Hollywood set design during the thirties and after the war, the commercialization of the movement struck a postwar generation of artists as a travesty of the Surrealist mission to transform reality in order to create a revolutionary consciousness. In 1962, on the occasion of Magritte's retrospective at Knokke-le-Zoute, Belgium, Marcel Mariën (1920–93), a second-generation Belgian Surrealist and editor of *Naked Lips*, circulated a leaflet to the magazine's subscribers titled "Big Reductions" and fraudulently signed "Magritte." At the top of the sheet a Belgian banknote was reproduced with Magritte's head montaged over that of King Leopold I. Below, Magritte is made to complain that his paintings are being used for sordid speculation, being bought like land, fur coats, or jewels. "I have decided to put an end to this shameful exploitation of mystery," the text goes on, "by bringing it within reach of every purse. Below will be found the necessary details [a mail-order form] which, I hope, will bring rich and poor together at the feet of genuine mystery. (The frame is not included in the price.)"

Repetition compulsion

It is possible to argue, however, that Magritte's fascination with and practice of the multiple was not a function of a slackening of his Surrealist "purity." Many of his earliest paintings are internally composed through recourse to the multiple. His 1928 portrait of Paul Nougé (1895–1967) doubles a single image of the Belgian poet, while *The Murderous Sky* [2] suspends the same bloody corpse of a bird four times against the background of a rocky cliff. Indeed, it could be said that what allows one to identify Magritte as a Surrealist is the sense that a form of doubling grips his work from the very start, infusing it with a version of just that Surrealist ▲practice of the double that was connected to the Freudian concept of the uncanny and the compulsion to repeat.

Freud had identified the feeling of uncanniness as a sense of the return of something archaic, and had analyzed the accompanying anxiety as related to the death drive's compulsion to repeat; the uncanny could thus be said to be a kind of eruption of the nonliving in the midst of life: a return of the living dead. It is this

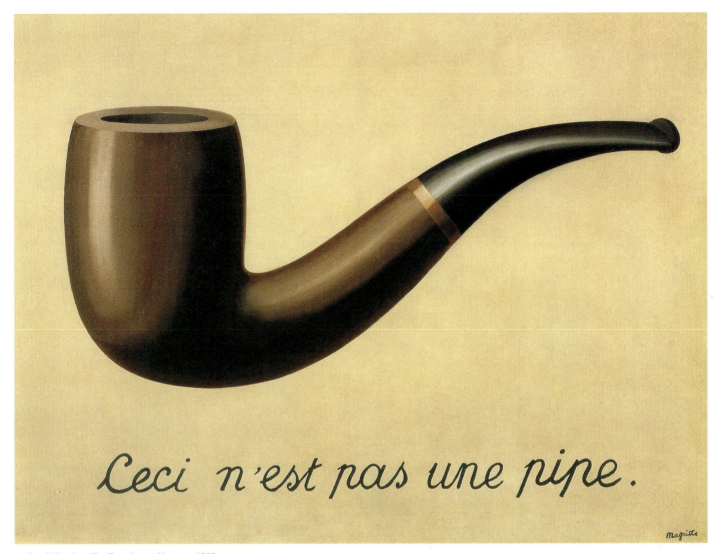

1 • René Magritte, *The Treachery of Images*, 1929
Oil on canvas, 60 × 81 (23½ × 31½)

character that suffuses Magrittean imagery such as the whole series related to *The Human Condition* [**3**], in which the painting shows a landscape against which is superimposed a painting of the same landscape, the edges of the nested representation nearly fusing with what must now be recognized as the "merely" representational status of the master image, formerly understood as transparently real. Thus the dead double (the representation) erupts among the living reality to threaten its solidity, to suck out its substance, like the vampires that return by means of mirrors.

Within the context of Surrealism, Roger Caillois had offered an alternative example for the spookiness of the living dead. With the case of animal mimicry, in which a dizzying perspective is offered by the praying mantis of death imitating life imitating death, there opens a vertiginous hall of mirrors that would come to be identified during the sixties with the term *simulacrum*. Like the dead animal "playing dead," the simulacrum offers a case of resemblance in which a crucial internal thread between similar things is cut: "life" in the example of the mantis; "the absence of sin" in the instance of post-Fall humanity (man was originally made in the image of God; after the Fall he no longer resembles Him). In the two examples just given, however, there is an ultimate court of appeal that will allow one to distinguish the living insect from its dead copy or the innocent from the sinner. The ultimate simulacral state, however, is where there is no way to differentiate copy from original, dead from living. This is a state of multiples *without originals*. Michel Foucault would invoke that state at the very end of "Ceci n'est pas une pipe," his 1968 essay on Magritte and the simulacral: "A day will come when, by means of similitude relayed indefinitely along the length of a series, the image itself, along with the name it bears, will lose its identity. Campbell, Campbell, Campbell, Campbell [a reference to Andy Warhol's soup cans]."

It was during the very period of the early sixties, when Magritte was appearing to his fellow artists in Belgium to have sold out to the enemy, that Foucault was developing a theory of literature positively based on the idea of the simulacrum (although in a way unrelated to Surrealism). One example of this work, his book *Death and the Labyrinth* (1963) dealing with the writer Raymond Roussel, was known to Magritte, himself interested in Roussel's

▲ 1930b ▲ 1971

2 • René Magritte, *The Murderous Sky*, 1927
Oil on canvas, 73 × 100 (28½ × 39)

procedures for draining the meaning out of words (like the dead sucking life out of the living). In 1966 Magritte's attention was also drawn to Foucault's recently published *The Order of Things*, the title of which coincided with the name of Magritte's own current exhibition. He and Foucault exchanged letters during 1966; Foucault's interest led him in 1968 to address Magritte's work directly.

Using Magritte's *The Treachery of Images* as his essay's object lesson, Foucault's analysis turned on (what in French is called) "the object-lesson" itself. This is the grammar-school session in which, say, a teacher draws a picture on the blackboard and underneath it writes its name. Such a combination of picture and name Foucault calls a *lieu commun*, a "commonplace," or in the literal sense of the page, a "common ground," referring to the convention we experience from our very first A.B.C. book ("A is for apple; B is for baby; C is for …") through to textbook explanations, dictionary entries, or scientific manuals of all kinds. It is a convention in which the channel of white space separating the domain of the illustration from the realm of the text in fact binds them together with all the
▲ powerful glue of what the philosopher Ludwig Wittgenstein would sometimes call a "language game" and at other times "a form of life."

The power of this convention is first that the fact of representation disappears within the object-lesson. Thus Foucault writes: "No matter that it is the material deposit, on a sheet of paper or a blackboard, of a little graphite or a thin dust of chalk. It does not 'aim' like an arrow or a pointer toward a particular [object] in the distance or elsewhere. It *is* [that object]." Second, the relationship encoded in the picture–caption couple is that of truth—between the image (as copy) and the model in the world to which it is transparent; for this reason, "the commonplace" serves as the basis for knowledge: "It is there," Foucault writes, referring to the channel linking image and caption, "on these few millimeters of white, the calm sand of the page, that are established all the relations of designation, nomination, description, classification."

Apparently challenging the banality of the commonplace, the modernist tradition of "the calligram" is only, Foucault argues,
▲ a covert attempt to reinforce it. When Guillaume Apollinaire writes a poem about rain in vertical lines of type that imitate rain, he assumes that he has collapsed the two-part structure of the commonplace into a higher order of synthesis in which *rain* (the word) disappears into its object made newly present on the page. Commenting that this transparency is futile, since to read the poem we have to disregard the image it forms, and to see the image we have to ignore the words, Foucault argues that the problematic of the calligram nonetheless serves as Magritte's point of departure, since what is happening in *The Treachery of Images* is a form of "unraveled calligram."

The work is calligrammatic in that the substance of the writing—"this is not a pipe"—and that of the image are so manifestly a matter of the same laborious hand (here the banality of Magritte's style of rendering serves this outcome). But this

▲ 1958 ▲ 1911, 1912

3 • René Magritte, *The Human Condition*, 1933
Oil on canvas, 100 × 81 (39⅜ × 31⅞)

calligram is unraveled because it ironically undoes both the tautological urgency of the picture-poem and the truth content of the object-lesson at one and the same time. Such undoing turns on the operation of the *this* in the work, which functions in at least three ways at once, finally producing a confusion that aborts its operation completely. Does *this* in "This is not a pipe" point to the word "pipe" and thus the nonresemblance between word and picture? Does it point to itself, the word *this*, and thus the nonresemblance between this form of language and representation? Does it point to the object-lesson as a whole, and thus the nonresemblance between it and the real-world model to which it is supposed to be transparent? All of these nonresemblances being true, what falls apart within this ironic maneuver is the "truth" that language tries to encode in what it takes to be the primal force of the indexical aspect of language crystallized in the term *this*.

Returning to the channel of white that binds object and caption, Foucault concludes that if "the calligram absorbed that interstice," Magritte's calligram-against-the-grain reopens "the trap the calligram had sprung on the thing it described. But in the act, the object itself escaped.… The trap shattered on emptiness: image and text fall each to its own side, of their own weight. No longer do they have a *common ground*." And if the object (the real-world model) disappears from the place of knowledge, as the guarantee of its truth-value lying behind it but always transparent to it, what is left is the simulacral condition, a world of multiples without originals.

The unraveled museum

Developing as a young poet in the forties within the orbit of Magritte and other Belgian Surrealists such as Paul Nougé, as well as Marcel Mariën and Christian Dotremont, Marcel Broodthaers initially shared the ambivalence toward Magritte expressed in "Big Reductions." But in the course of establishing his "Musée d'Art Moderne" after 1968, Broodthaers began to draw close to the idea of a simulacral operation of language, and Magritte, mediated by Foucault's text, became strategically important to him. Thus in "The Eagle from the Oligocene to the Present," the exhibition his "Musée d'Art Moderne, Département des Aigles" mounted in 1972 in Düsseldorf, he displayed hundreds of objects each accompanied by a label stating "This is not a work of art." Explaining this caption by saying that "This is not a work of art'" is a formula obtained by the contraction of a concept by Marcel Duchamp and an antithetical concept by Magritte, Broodthaers reproduced Duchamp's *Fountain* and Magritte's *The Treachery of Images* in the exhibition catalogue on facing pages and advised the reader to read Foucault's "Ceci n'est pas une pipe."

One way of understanding such a "contraction" is first, to see the object-lesson performed by Duchamp's readymade as pointing to the entire institutional context in which the work of art occurs, since it is that context that folds onto the ordinary object—urinal, curry comb, hat rack—to confer artistic status on it; and second, to feel the way that lesson is confounded by the multiple arrows of Magritte's "unraveled calligram"—pointing now to the label itself (as not being a work of art), now to the objects on display, many of which, like stuffed eagles or corks with eagles printed on them, are nonaesthetic in status (and thus not works of art), and now to the whole of the exhibition in its condition as "fictitious." For if Duchamp had wanted to expose the institution of the museum as conventional, Broodthaers is now displaying it as simulacral. RK

FURTHER READING
Thierry de Duve, "Echoes of the Readymade: Critique of Pure Modernism," *October*, no. 70, Fall 1994
Michel Foucault, "Ceci n'est pas une pipe," *Les Cahiers du Chemin* (1968), expanded as *Ceci n'est pas une pipe* (1973), and translated as "This Is Not a Pipe," trans. James Harkness (Berkeley: Quantum, 1983)
Denis Hollier, "The Word of God: 'I am dead'," *October*, no. 44, Spring 1988
David Sylvester and Sarah Whitfield, *René Magritte: Catalogue Raisonné*, five volumes (Houston: Menil Foundation; and London: Philip Wilson Publishers, 1992–7)

▲ Introduction 4, 1972a ● 1914

1927 ᵇ

Constantin Brancusi produces a stainless-steel cast of *The Newborn*: his sculpture unleashes a battle between models of high art and industrial production, brought to a head in the US trial over his *Bird in Space*.

D uring the four weeks in 1907 when Constantin Brancusi (1876–1957) was one of the fifty assistants working for France's most famous sculptor, Auguste Rodin, he would have been exposed to two, antithetical phenomena. First, as one of a contingent of "pointers"—operators of caliper-like devices used to transfer a sculptural idea from its plaster model to the marble block (often to make enlargements or reductions)—he would have seen the travesty of the aesthetic "original" wrought by a kind of assembly-line production. Second, as the talented graduate hired by Rodin fresh from the École des Beaux-Arts, he would have experienced the other side of the master's practice in which, as though by magic, Rodin caught the most ephemeral gestures of a troupe of Balinese dancers weaving before him, suggesting the delicacy of their movements out of simple rolls of clay.

This latter output, the very opposite of the former, contained the quintessence of what Walter Benjamin would call "aura," namely the uniqueness of something captured at a particular moment and in a particular place, this never-to-be-repeated quality resonating in the uniqueness of the medium, itself the result of a personalized touch. Relating this aura back to art's earliest sources in religious ritual, Benjamin pointed to the necessity that the cult object be an original in order to work its effect, for which substitutes or copies would be powerless. Secularization did nothing to diminish this importance of the aura-filled, aesthetic original, and from the Renaissance to Romanticism an ever higher premium was paid not only for the originality of a given artist's conception but also for the sense that the line or brush-stroke that delivered that idea was inimitable. Rodin's dancers, caught on the wing in a pinch of clay that bears the imprint of the master, could be said to be the supreme example of this desire. His marbles and bronzes in multiple copies, on the other hand, point instead to the type of art industry—with its traffic in replicas—that characterizes the decorative, rather than the fine, arts.

The birth of the world

Fleeing Rodin's studio after just one month, Brancusi adopted an approach to sculpture that could be said to be the exact opposite of this industrialization. For on the wood or stone he was able to salvage (being too poor then to buy his materials), he began to work without

1 • Constantin Brancusi, *Prometheus*, 1911
Marble, 13.8 × 17.8 × 13.7 (5⅜ × 7 × 5⅜)

the intermediary of the clay or plaster model, carving directly into the block instead. The aesthetic honesty of such "direct carving" operates on two levels. First, it responds to the specific nature of the material in which it is fashioned, involving none of the transfers from modeled clay to stone or plaster and bronze through which traditional sculpture was conceived. Second, the immediacy of this response resists replication, ruling out the production of the multiple.

The ethos of direct carving brought other associations, all of which were welcomed by Brancusi, who began increasingly to affect the bearing of a Romanian peasant, wearing a long beard, worker's smock, and sandals. The rural wood-carving traditions of his native land were a reinforcement to his antiestablishment position, supporting as they did the influence of African and other primitive sculpture evident in his work by 1914. That in succumbing to such an influence he was merely following the rest of the Parisian avant-garde, first in its enthusiasm for Paul Gauguin (who had initiated direct carving within this milieu) and then for a wider primitivism, was something Brancusi did not like to admit, so adamant was he

▲ 1900a ● 1935

▲ 1903, 1907

1920–1929

that he stood outside the historical drive of modernism, so focused was he on the presumed timelessness and universality of his work.

Indeed it is this search for the historically unmediated that seems to underlie the course of Brancusi's art as it pursued forms of increasing simplification and purity. The trajectory of a single idea, as it moves from a realistic child's torso, its head bent in a caress of shoulder and cheek (*The Supplicant II*, 1907), to the suddenly isolated head as simplified oval lying on its side (*Head of a Sleeping Child*, 1908), to a sphere whose teardroplike appendage produces neck and shoulder with breathtaking economy and barely breaks the spherical surface with a whisper of the facial features [1], to an egglike form creased longitudinally and beveled at one end [2] to suggest at one and the same time the ovum and its moment of splitting into multiple cells, to a prone, entirely featureless ovoid, demonstrates this rage for reduction. Many of Brancusi's admirers saw this as a kind of Platonism, as when Ezra Pound wrote an early appreciation of the works as the "master-keys to the world of form," typically viewing Brancusi's sculptural gift as a genius for releasing the eidetic form— the pure "idea"—from the physical matter of the initial block.

The high finishes that Brancusi applied to his works, beginning with the bronze version of *Prometheus* in 1911, in which meticulous (and arduous) hand polishing brings the surface to a mirrorlike shine, only reinforce this sense of perfection. Thus, when a polished bronze version of *Sculpture for the Blind*, now

titled *The Beginning of the World* [3], is set on an equally polished steel plate, the facing mirror surfaces concentrate the effect of the encapsulation of the "idea" behind its glittering surface.

The same finish was applied to Brancusi's *Bird in Space*, first rendered in sleek marble in 1923 and then in highly polished bronze in 1924 (to be repeated in bronze in 1927 [4], 1931, and 1941). This sculpture, delicately elongated and plumelike, is part bird's body, part outstretched wing, and part vision of the effortless rise into flight. In its condensation of gesture it seems to hark back to that aspect of Rodin's work that had not compromised its aura: those matchless dancers that had emanated from his fingers.

With this mention of Rodin, however, something quite contrary enters the discussion of Brancusi. For, like the master, this rustic "peasant" needed his own band of assistants to rub the marbles and bronzes into a perfect state of polish and, like Rodin, he was in the habit of issuing many of his pieces in small "editions"; furthermore, these gleaming objects with their slightly Africanized shapes and their mixture of svelte metallic contours and crenellated wooden bases, could easily slip over into a family resemblance with ▲ the most fashionable of decorative idioms, namely Art Deco, the twenties marriage of chrome and stainless steel, ebony and zebra skin, primitivism and industrialization. Far from being timeless and universal, Brancusi's work thus participates in the entirely historical phenomenon of stylistic change and, more "degradingly,"

2 • Constantin Brancusi, *The Newborn II*, 1927
Stainless steel 17.2 × 24.5 × 17 (6¾ × 9⅝ × 6¾)

3 • Constantin Brancusi, *The Beginning of the World*, 1924
Bronze, 17.8 × 28.5 × 17.6 (7 × 11¼ × 6⅞)

▲ 1925a

in the revolving door of style known as fashion—a version of the "art industry" even more compromised than Rodin's.

Nothing could betray this connection more directly than the commission Brancusi undertook for the Vicomte de Noailles, who wanted a large version of the *Bird in Space* for the garden of his opulent country house. Designed by the fashionable architect Robert Mallet-Stevens, the 1923 mansion is pure Art Deco, a mixture of concrete, glass, and chrome; Brancusi's 150-feet-tall sculpture, it was decided, should be executed in stainless steel. Jean Prouvé, an architect who had pioneered in this medium, took charge of the project, and the two men embarked on a trial cast of *The Newborn* [2] before attempting the monumental version of the other work.

The result of their trial is pure paradox: part platonic solid, part ball bearing. On the surface there is no difference between this 1927 cast and the 1923 bronze, except one is "silver" and the other is "gold." But that is just the point. By allowing his "idea" to be submitted to industrialization—by using a material developed for mass production, one whose gleam has nothing to do with aura and everything to do with multiplicity—Brancusi produced a retroactive critique of his own aesthetic posture. Not only are his surfaces compromised by being twinned with high-end decoration, but his deep involvement with serialization is itself a version of industrial method. As he set the restricted number of his themes on their paths toward ever greater formal reduction, he was working serially. And then, once his repertory of forms had been established (by 1923), he repeated these over and over, with minor variations, until his death in 1957.

At the same time as Brancusi was working with Prouvé, a commotion was stirring the art world on the other side of the Atlantic. ▲ When Edward Steichen tried to bring his recently purchased version of *Bird in Space* into New York for a large retrospective of Brancusi's work, US Customs officials classed the sculpture as a kitchen utensil, and thus as mass-produced, unoriginal, ready made, and requiring the payment of import duty, rather than as a work of art, which would have been duty free. Their decision was repeated a few weeks later when Marcel Duchamp entered the Port of New York with the large Brancusi he owned. Numerous protests, in which powerful American art collectors weighed in, were to no avail. The headline "Brancusi's Art Is Not Art, Federal Customs Men Rule" made front-page news in January 1927. It was not until these patrons, armed with prominent lawyers and art experts, took the case to trial in October 1927 that the decision was overturned, the courts admitting that something had changed in art to make Brancusi's work eligible for duty-free status. Accordingly, the judgment read:

> There has been developing a so-called new school of art, whose exponents attempt to portray abstract ideas rather than to imitate natural objects.... The object is made of harmonious and symmetrical lines and while some difficulty might be encountered in associating it with a bird, it is nevertheless pleasing to look at and highly ornamental, and as we hold under the evidence that it is the original production of a professional sculptor ... we sustain the protest and find that it is entitled to free entry.

4 • Constantin Brancusi, *Bird in Space*, 1927
Bronze, height 184.1 (72½), circumference 44.8 (17⅝)

Buying the arguments of the critics, collectors, and museum directors ranged on its behalf, the judge accepted the idea that Brancusi's work was redeemed by its abstraction and its formal purity. The philistines working in the Customs Office were thereby seen as beneath contempt. Yet history often has exquisite jokes up its sleeve, one of them being the strange relationship between this Romanian "peasant" purist and the father of the readymade. Brancusi first met Duchamp in Fernand Léger's presence, so the story goes, at an aeronautics fair in Paris in 1912. Marveling at a propeller on display, Duchamp asked his new friend if he could do any better. His own conviction that no

▲ 1916b, 1959d

artist could led him the following year to present *Bicycle Wheel* as the first readymade, while Brancusi's response, it could be argued, was not only the *Bird in Space*—part propeller, part Mallarméan suggestion—but the whole ambivalence of his work's development, one aspect of which the men at Customs unerringly grasped.

The links between Duchamp and Brancusi do not stop at this peculiar double helix in which the industrial readymade crosses with a notion of "art" as inviolate concept. The two are also connected via a shared ambiguity between pure and impure at the level of carnality, since Duchamp's marriage between the industrially impersonal and the erotic—his *Fountain*, *Female Fig Leaf*, the entire scenario of the *Large Glass*, etc.—is echoed in Brancusi's mystic union between the abstract and the libidinal. Nowhere is this more obvious than in *Princesse X* [**5**], which was censored from the 1920 Salon des Indépendants on the grounds of obscenity, the purity of the artist's reduction of female torso to the double ovoids of the breasts connected by the curving tube of the neck to the ovoid of the head being redescribed—by Picasso, among others—as simply phallic. Although Brancusi protested any such connection, he continued to photograph the work from the angle that underscored this association. And indeed the kinds of reductions to which he submitted the human body seemed inevitably to participate in the logic of the part object, in which the whole body, in being metonymically rendered by a purified fragment, increasingly takes on the character of a sexual organ. This is particularly true of Brancusi's series of elegantly simplified male torsos (1917–24), which come to be suspended between a phallic representation and the "elbow" of a plumbing connection.

It is possible to take this opening onto the sexual and to recode it in terms of an iconography of the self-creating (male) body. Here it becomes important that what is male in Brancusi's *Torso* is its overall phallic shape, since the lithe body itself, without a penis, is to all intents and purposes female. This bi-gendering, so prominent in *Princesse X*, is read by such an interpretive strategy as a fantasy of male primacy involving the circumvention of the female body in a dream of omnipotent self-regeneration, a regeneration that can then be carried into the whole of Brancusi's work, with the *Bird in Space* now seen as a version of the immortal phoenix, and the *Newborns* as a way of bypassing the female in an act of parthenogenesis.

This strategy marries the eroticism of Brancusi's sculpture with the modernist drive toward autonomy, so that biological self-creation becomes the "unconscious" analogue for the formal desire to make an object that is self-contained. This, however, is to cut the eroticism of Brancusi's sculptures off from the industrial logic that functions as their (very different) "unconscious." A final story of Brancusi's connection to Duchamp makes clear the strange workings of this logic.

The story begins with the 1924 death of John Quinn, one of Brancusi's most enthusiastic American collectors. To save Brancusi's prices from the catastrophe of having many works dumped on the market at one time, Duchamp stepped in and, with the novelist Henri-Pierre Roché, bought the twenty-nine pieces in Quinn's collection at the fire-sale price of $8,500 for the lot. If Duchamp had stopped making art for sale in the early twenties, he had nonetheless now acquired a huge body of work by another artist, from the sale of which he was able to live. Brancusi was thus a participant in Duchamp's playing at every role within the institutional structure of art, from artist to critic to museum director to publisher and now to dealer. In 1933 when asked if he thought painters should be less professional, Duchamp replied that they should be more so, but that among dealers a bit of amateurishness would be welcome. It was Duchamp who was the perfect amateur "dealer" with just one artist in his stable; and Brancusi was, apparently, perfectly content with this situation: the unconscious of art presented as pure commerce. RK

FURTHER READING
Friedrich Teja Bach, Margit Rowell, and Ann Temkin, *Brancusi* (Philadelphia: Philadelphia Museum of Art, 1995)
Anna Chave, *Constantin Brancusi: Shifting the Bases of Art* (New Haven and London: Yale University Press, 1994)
Sidney Geist, *Brancusi: A Study of the Sculpture* (New York: Grossman, 1968) and "Rodin/Brancusi," in Albert E. Elsen (ed.), *Rodin Rediscovered* (Washington, D.C.: National Gallery of Art, 1981)
Carola Giedion-Welcker, *Constantin Brancusi* (New York: George Braziller, 1959)
Rosalind Krauss, *Passages in Modern Sculpture* (New York: Viking Press, 1977)

5 • Constantin Brancusi, *Princesse X*, 1915–16
Polished bronze, 61.7 × 40.5 × 22.2 (24¼ × 16 × 8¾)

▲ 1914, 1918

1927c

Charles Sheeler is commissioned by Ford to document its new River Rouge plant: North American modernists develop a lyrical relation to the machine age, which Georgia O'Keeffe extends to the natural world.

When in *The Bridge* (1930) the American poet Hart Crane (1899–1932) saluted the Brooklyn Bridge as "harp and altar" on which to celebrate a new "myth to God," his encomium harked back to the ecstatic vision of his hero, nineteenth-century poet Walt Whitman. But for avant-gardists in New York the celebration of this feat of engineering, already under way in Cubist and Cubo-Futurist renderings of the bridge by John Marin (1870–1953) and Joseph Stella (1877–1946), might also have recalled the ironic defense made by Marcel Duchamp after his urinal ▲ *Fountain* was rejected by the Society of Independent Artists in 1917: that America's two greatest contributions to civilization were its plumbing and its bridges. This was as much compliment as insult.

• Even as Dadaists like Duchamp and Francis Picabia used the machine sarcastically, in a manner opposite to the lyrical exaltations of Crane, Stella, and other North American machine-age artists, they also believed that such icons of modernity as industrial machines, suspension bridges, and skyscrapers made the United States "the country of the art of the future" (Duchamp) and New York "the futurist, the cubist city." And these are indeed the icons, extended to the factory and the city, that became the staples of North American machine-age art. So when Morton Schamberg (1881–1918) titled a cluster of pipe joints *God* (1916), some in his milieu may have taken it less as a Dadaist satire on the religion of art than as a modern fetish of American practicality not unworthy of a little worship.

The machine as modernist shrine

The United States might have possessed the prized icons of modernity, but its artists lacked the privileged styles of modernism. As a result they felt at once benighted and belated in relation to European modernists, a condition that complicated the transatlantic travel of artists in the teens and twenties. (The ocean-liner, celebrated by ■ Le Corbusier as a model of functional design in his famous manifesto *Vers une architecture* [1923] and detailed by Charles Demuth [1883–1935] in *Paquebot "Paris"* [1921–2] and Charles Sheeler [1883–1965] in *Upper Deck* [1929], was the vehicle of this passage.) Discontent with the messy realism of their elder compatriots, some American artists voyaged to Europe to seek out modernist art, while others had already seen such work in New York at the controversial

1 • Marsden Hartley, *The Iron Cross*, 1915
Oil on canvas, 121 × 121 (47⅝ × 47⅝)

Armory Show in 1913 or in the various exhibitions at the 291 Gallery, ▲ run by Alfred Stieglitz, and the de Zayas and Modern galleries, run by Marius de Zayas. Indeed, the North American encounter with modernism occurred mostly in the States, where Duchamp, Picabia, and others had fled during World War I. At the time New York was the interim capital of the avant-garde, which gravitated to two salons above all: one around Stieglitz (which Picabia favored), the other • around the collectors Walter and Louise Arensberg (where Duchamp met Man Ray, the American who was soon to be central to both Dada and Surrealism). In these settings Americans like Marin, Stella, Arthur Dove, and Marsden Hartley (1877–1943), who had already adapted different modernist idioms [1], mixed with Europeans involved in Dada. And this milieu provided the contradictory mix that artists like Demuth and Sheeler attempted to resolve: a diagrammatic draftsmanship validated by Dada but stripped of its irony, and a lyrical semiabstraction developed in different ways by Dove, Hartley, Marin, and Stella. To this combination was

▲ 1914　　● 1916b, 1918, 1919　　■ 1925a　　　　　　　▲ 1916b　　● 1918, 1930b, 1931a

The diagram contains the following labels and dates:

1890 — JAPANESE PRINTS, Gauguin d. 1903 SYNTHETISM 1888 Pont-Aven, Paris, Cézanne Provence d. 1906, Van Gogh d. 1890, Seurat d. 1891 NEO-IMPRESSIONISM 1886 Paris — 1890

1895 — Redon Paris d. 1916, Rousseau Paris d. 1910 — 1895

1900 — 1900

1905 — NEAR-EASTERN ART, FAUVISM 1905 Paris, NEGRO SCULPTURE, CUBISM 1906-08 Paris — 1905

1910 — (ABSTRACT) EXPRESSIONISM 1911 Munich, FUTURISM 1910 Milan, MACHINE ESTHETIC, ORPHISM 1912 Paris, SUPREMATISM 1913 Moscow — 1910

1915 — Brancusi Paris, CONSTRUCTIVISM 1914 Moscow — 1915

(ABSTRACT) DADAISM Zurich Paris 1916 Cologne Berlin, PURISM 1918 Paris, DE STIJL and NEOPLASTICISM Leyden 1916 Berlin

1920 — BAUHAUS Weimar Dessau 1919 1925 — 1920

1925 — (ABSTRACT) SURREALISM 1924 Paris, MODERN ARCHITECTURE — 1925

1930 — 1930

1935 — NON-GEOMETRICAL ABSTRACT ART, GEOMETRICAL ABSTRACT ART — 1935

MoMA and Alfred H. Barr, Jr.

On November 7, 1929, only days after the Stock Market crash, the Museum of Modern Art opened a show of Postimpressionist masters (Cézanne, van Gogh, Gauguin) in six small rooms at 730 5th Avenue in New York. The brainchild of three collectors, Abby Aldrich Rockefeller (wife of John D. Jr.), Lillie P. Bliss (sister of the Secretary of the Interior), and Mary Quinn Sullivan, MoMA was inaugurated in the same period as the Whitney Museum of American Art (begun by Gertrude Vanderbilt Whitney in 1931), The Museum of Non-Objective Painting (the first incarnation of the Guggenheim Museum, opened by Solomon R. Guggenheim and Baroness Hilla Rebay von Ehrenweisen in 1939), and the Barnes Foundation (established by Albert C. Barnes near Philadelphia in 1922, though not opened to the public in his lifetime)—all cultural projects of rich Americans inspired in part by the 1913 Armory Show and such early advocates of modernist art as Alfred Stieglitz and Walter Arensberg. With A. Conger Goodyear as chairman of the board, the Modern pledged to exhibit "the great modern masters—American and European—from Cézanne to the present day" and "to establish a permanent public museum" of such work. (An agenda of design and education was also urged on the fledgling institution by the regents of the State University of New York.)

A persistent paradox of advanced art in the United States is located right here: its very reception often occurred within museum settings, and in this sense it was often already institutional. On the other hand, the museological field of

modern art was brand new, so much so that MoMA turned to a twenty-seven-year old professor of art from Wellesley College named Alfred H. Barr, Jr. (1902–81) as director. Barr had taught the first course on twentieth-century art in the United States in 1927; in the winter of 1927–8 in Europe he encountered such radical experiments in art, architecture, and design as De Stijl in Holland, Constructivism in the Soviet Union, and the Bauhaus in Germany. Barr seems to have absorbed and rejected these models in almost equal measure. He proposed a broad framework for MoMA with departments not only of painting and sculpture, prints and drawings, but also of commercial art, industrial art, design, film, and photography (which were more widely exhibited than many at the museum might think today). However, the trustees scaled this plan back on the grounds that it would confuse the public, and Barr seems to have acquiesced in large part.

A similar compromise was reached regarding exhibition display. Barr did away with the traditional decorative grouping of cluttered art works, but he was not nearly as experimental as El Lissitzky and others in Europe. Instead he practiced a well-spaced positioning of objects arranged by subject and style on open walls and floors. The effect was to create an aesthetic dimension that appeared both autonomous and historical: the works were "isolated," in his own words, with "no effort … made to suggest a period atmosphere"; at the same time they suggested an "almost perfect chronological sequence." For Barr style was the principal medium of meaning in modern art, and influence was its main motor. He was likely guided here by his Princeton professor, Charles Rufus Morey, who used a similar evolutionary scheme to narrate medieval art, but Barr made this system effectual for twentieth-century art in a way that was widely adopted by other institutions.

The first epitome of this MoMA museology was the 1936 show "Cubism and Abstract Art." On the one hand, Barr introduced a vast range of European avant-garde practices to an American audience—photographs, constructions, architectural models, posters, film stills, and furniture as well as paintings and sculptures. On the other hand, the signature element of the exhibition was the cover image of its scholarly catalogue, which consisted of a flowchart of the many avant-gardes first channeled into a few mainstream movements—Surrealism, Purism, Neoplasticism, Bauhaus, Constructivism—then further reduced to "Non-Geometrical Abstract Art" and "Geometrical Abstract Art."

By 1939, when MoMA moved to a new building on 53rd Street, it had begun to establish a proprietary right over these movements, and its history of style-influence was soon interpreted as a projection of future artmaking as well. Although the initial plan was to transfer or to sell works as they aged to other institutions, MoMA decided to keep its acquisitions, and in 1958 it opened a permanent installation of its collection. Barr was relieved of the directorship of the museum in 1943, but he retained a research position, and in 1947 he was reinstated as head of collections, in which position he remained until his retirement in 1967.

2 • Joseph Stella, *New York Interpreted: The Voice of the City*, 1920–2
Oil and tempera on canvas, four panels 224.8 × 137.2 (88½ × 54), central panel 252.1 × 137.2 (99¼ × 54)

added a photographic criterion of precision stipulated by Stieglitz
▲ and exemplified by Paul Strand. In fact, several of these young Americans, who came to be called "Precisionists," worked as photographers as well, and Sheeler collaborated with Strand on a short filmic celebration of New York called *Manahatta* in 1919.

Stylistically, Joseph Stella was more Cubo-Futurist than Precisionist, but no account of machine-age art can omit such works as his *New York Interpreted: The Voice of the City* [**2**], a painting of five panels, each over seven feet high, that evokes the city through massive scale, nighttime luster, and linear force. Here Stella conceives New York as a circuit of movement, with each panel devoted to a site of transportation. The two panels on the left are "The Port (The Harbor, The Battery)" and "The White Way I" (the great avenues of Manhattan as a modern Milky Way); on the right are "The White Way II" (a specific ode to Broadway) and "The Bridge" (as in Brooklyn Bridge, his favorite motif); and in the center, slightly higher than the other panels, is "The Skyscrapers (The Prow)," which evokes the island of Manhattan as a ship's prow, a mobile vessel of light in a sea of night. This is a pictorial version of the poetic trope of personification, used to excess by Hart Crane, in which a thing is addressed as a person. As the Expressionist Franz Marc had
● done with nature, Stella uses a Cubo-Futurist line to vitalize the city—to give it a "voice," to render it more than human. Like Crane, Stella saw New York as an "apotheosis" of "the new civilization," with the bridge as its "shrine," and his painting is a kind of modern altarpiece in which the city appears as a cathedral, with its skyscrapers, bridges, and avenues as so many columns, vaults, and naves.

■ In the Bauhaus, the machine was opposed to the Church; in *The Biography of Henry Adams* (1900), Adams contrasted the dynamo to the Virgin as emblems of very different epochs. Here, however, such opposites are fused. This is the wager that machine-age art makes: that a spiritual (or at least lyrical) subjectivity can be achieved not in opposition to the machine or the city (as the Expressionists had thought) but by means of them. This American image of the metropolis diverges from the European account of the German sociologist Georg Simmel, for whom urban shocks are parried by a "blasé" subject. Like Crane, Stella urges a "gusto" embrace of the city instead. But this embrace, which, again like Crane, Stella saw in sexual as well as religious terms, was impossible to sustain, as the overwrought nature of both *The Bridge* and *New York Interpreted* might suggest.

The task of the modern poet, Crane once wrote, is "to acclimatize" the machine—an ambiguous formulation that points to a persistent problem of machine-age art. Does it "technologize" traditional forms (as *The Bridge* does to the epic, or *New York Interpreted* does to the altarpiece), or does it "traditionalize" technological developments through such forms, which are thereby updated? At the 1912 Salon de la locomotion aérienne in Paris, Duchamp remarked to
▲ Brancusi: "Painting is over. Who'd do better than this propeller? Tell me, could you do that?" The Precisionists attempted to do so through a monumental style that combined a precision associated with photography with an abstraction derived from Cubism—ingredients that chastened and transformed one another. For example, the "Cubism" of Demuth and Sheeler is not "analytical" in the sense that the object is not fragmented. On the contrary, the planar projections of the ship vents in *Upper Deck* by Sheeler and the grain elevators in *My Egypt* by Demuth [**3**] solidify the object, simplify its structure, and define its contour, and so clarify rather than complicate our vision. At the same time, these images are hardly photographic. Forms are reduced and spaces flattened, shadows emboldened and tonalities transformed—more so in Demuth, who is more lyrical than Sheeler. Architecture, then, is not only a prime motif of this art; it also influenced its way of seeing. *Upper Deck*, Sheeler once remarked, was painted "much as the architect completes his plans before the work," with a thorough study of structure and a clear presentation of perspective.

On this matter of architecture the European–American exchange became deliriously circular. With its bridges and factories, industrial America was not just a giant readymade for Dadaists like Duchamp

and Picabia; it was also a polemical model of functional design for modernist architects like Walter Gropius and Le Corbusier. In the 1913 *Deutscher Werkbund Yearbook* Gropius published seven pages of photographs of American factories and grain elevators, one of which Le Corbusier retouched (to remove its nonmodernist details) in his Purist journal *L'Esprit Nouveau* in 1919 and again in *Vers une architecture*. Neither designer had visited the United States, but they needed this "Concrete Atlantis," as the architectural historian Reyner Banham called it, for its "factories and grain elevators were an available iconography, a language of forms, whereby promises could be made, adherence to the modernist credo could be asserted, and the way pointed to some kind of technological utopia." How better to argue for a functionalist architecture than to point to its "primitive" preexistence in utilitarian structures in the States? In this European allegory, industrial America was not only futuristic but also almost prehistoric. It was sometimes associated, through black culture, with exotic Africa, especially in France, where Le Corbusier participated in a "techno-primitive" cult of jazz, dancing, and boxing, and sometimes with ancient Egypt, especially in Germany, where Gropius made the connection to America via monumental architecture (for instance, the grain elevators as modern pyramids). The art historian Wilhelm Worringer pointed to this Egyptian association implicitly in *Abstraction and Empathy* in 1908, which Gropius knew in 1913, and explicitly in *Egyptian Art* in 1927, which borrowed an American illustration from Gropius. This association was also adopted in the same year by Demuth in *My Egypt*, an exemplary Precisionist painting of grain elevators in his native town of Lancaster, Pennsylvania (other Precisionists like Ralston Crawford [1906–78] painted the elevators in Buffalo favored by Gropius et al.). The title *My Egypt* might seem ironic, but the elevators are imaged proudly, viewed from below with geometric masses raked by precise spotlights. It is as if Demuth wanted to claim that these elevators are also monuments for the ages, even to suggest another myth of modernity, not one of mobility (as with so many other modernists) but one of monumentality. Yet there is a catch to this myth. For Worringer, ancient Egypt represented an "artistic will" to abstraction that expressed an anxious withdrawal from a chaotic world, and he saw a similar anxiety behind modernist abstraction. Might the monumentality of Precisionist work point to a related ambivalence about a machinic world so dynamic as to be disintegrative, to a related turn to compositions of stasis and stability, as if in defense against modern chaos? As Strand once remarked, "spiritual control over the machine" was the primary struggle of this generation of artists.

The Precisionists represented modern icons, but were these artists modern*ist*? They never broached pure abstraction; on the contrary, they used its simplifications to represent the world all the more precisely. It was for this reason that Precisionism was sometimes called "Cubist Realism." "It was Sheeler," de Zayas remarked, perhaps with Strand also in mind, "who proved that Cubism exists in nature and that photography can record it," and that painting based on photography, as often with Sheeler, might do so as well. This return to clarity and stability, this reconciliation of representation

3 • Charles Demuth, *My Egypt*, 1927
Oil on board, 90.8 × 76.2 (35¾ × 30)

and abstraction, aligns Precisionism with the mostly antimodernist "return to order" in much European art of the twenties. In fact it has more in common with the style known as Neue Sachlichkeit (New Objectivity) in Germany of the same time, yet without its critique of the military-industrial complex that produced World War I. Indeed, Precisionism was gung ho about capitalist modernity even after the Stock Market crash of 1929, and this aligns it more closely still with another ambiguous movement, the Purism of Le Corbusier and Amedée Ozenfant. This style also sought to rationalize art and to classicize the machine—to aestheticize not only machined products but a mechanistic way of seeing as well, which is to say that the Purists also valued the "precisionism" of mass production. In this regard both movements were poles apart from Russian Constructivism, for rather than transform art vis-à-vis industry, they worked to recoup industry as an image for art. Precisionism also resisted the aesthetic implications of mechanical reproduction, for rather than transform painting vis-à-vis photography, it worked to assimilate photography into painting—to use its apparent transparency to the object in order to render painting as immediate, as illusionistic, as possible. (The Precisionists were also called "the Immaculates"—immaculate as in "immaculate conception," pure, without stain.) Whereas other modernists foregrounded the medium of painting, Sheeler admitted "his effort … to eliminate the interception of the medium between the eyes of the spectator and the creation of the artist," to "set forth [the object] with the utmost clarity by means of craftsmanship so adequate as to be unobtrusive."

▲ 1923, 1925a ● 1925a ■ 1908

▲ 1919 ● 1925b ■ 1925a ◆ 1921b

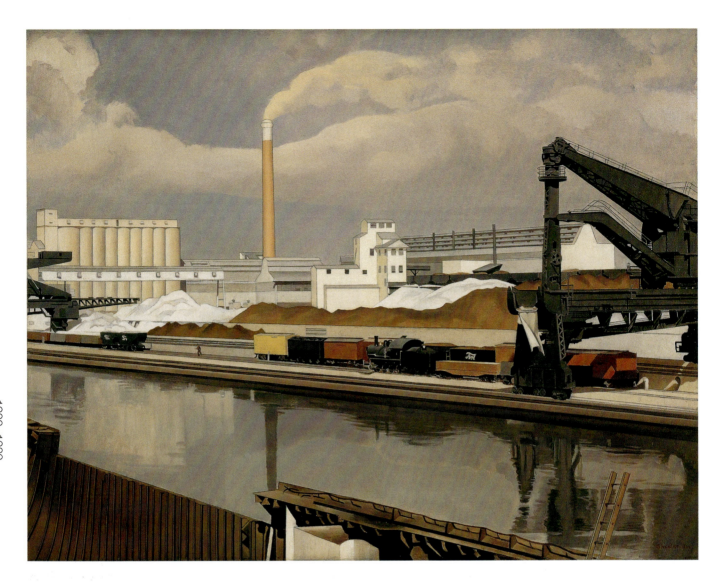

4 • Charles Sheeler,
American Landscape, 1931
Oil on canvas, 61 × 78.7 (24 × 31)

5 • Stuart Davis,
House and Street, 1931
Oil on canvas, 66 × 107.3 (26 × 42¼)

The epitome of this "capitalist illusionism" is the work done by Sheeler for the Ford Motor Company. By the mid-twenties Ford had outgrown its Highland Park factory where the Model T was assembled, so River Rouge was built ten miles from Detroit in order to produce the Model A. The largest industrial complex in the world, with twenty-three buildings, ninety-three miles of track, 53,000 machines, and 75,000 employees, it was a site of total automobile production, from the smelting of steel to the painting of cars. In 1927 Sheeler was commissioned to photograph the new factory. In six weeks he completed thirty-two official photographs, nine of which were published in magazines. (*Vanity Fair* printed one, *Criss-Crossed Conveyors*, with the caption "By Their Works Ye Shall Know Them," and referred to River Rouge as "an American altar of the God-Objective of Mass Production.") Sheeler showed some photographs as art works and used others for paintings, in which very few workers appear, and no drudgery, let alone exploitation, is shown. In short, he identified artistic perspective with techno-cratic surveillance, and he reconciled landscape composition with Taylorist and Fordist principles of work-management. In his compositions the fragmentation and reification of work and worker alike, which the Marxist critic György Lukács defined in 1923 as the prime effects of assembly-line production, are magically smoothed over. Sheeler even titled a few panoramas of River Rouge *Classic Landscape*, as if the plant were an idyll, and he continued to produce such paintings well into the worst years of the Depression.

The climax of this work is *American Landscape* [4], where land-scape is remapped as industrial production, America as the rationalization of labor, and nature as the transporting and processing of raw materials into Model As. In the foreground, at the start of production, is a vacant ladder, sign of the obsolescence of preindustrial man (the sole worker is a tiny figure on the tracks in the middle ground). In the background, at the end of production, stands a stack where smoke mixes with clouds. Here the world culminates in a factory, where it is a question no longer of the invasive machine in the "Edenic garden of America" (in the phrase of historian Leo Marx) but of the machine *as* this garden. This is the ideological effect of such machine-age art: it represents capitalist industry, but only to obscure its exploitation of labor behind an "occult mechanism"—a monumental structure, a beautiful image (this particular painting was purchased by a member of the Rockefeller family). Such art spiritualizes, monumentalizes, and naturalizes a historical moment as a "machine age": New York as glorious cathedral, grain elevators as Egyptian pyramids, a factory as a classical landscape.

Some artists did not subscribe to this monumentalist agenda. Although Stuart Davis (1894–1964) also evoked the urban life of the machine age, he did so through symbols of consumption rather than through icons of production. In a colorful style derived from
▲ Synthetic Cubism Davis painted the city as a street poster of jazzy rhythms, surfaces, and signs [5]. But he did so in a way that reclaims collage for painting and is neither disruptive of high art nor critical of mass culture. In effect, Davis displaced the machine, only to high-
• light the commodity in an artistic solution that foreshadows Pop art.

6 • Georgia O'Keeffe, *Black Iris III*, 1926
Oil on canvas, 91.4 × 75.9 (36 × 29⅞)

It was left to Georgia O'Keeffe to salvage the lyrical subjectivity that some artists hoped to wrest from the machine age, but in order to do so she abandoned images of production and consumption altogether. After a decade of intermittent paintings of New York, she turned away from the city, and eventually rediscovered, in the desert landscape of the American Southwest, a relation to objects and images that reasserted rather than overwhelmed the body [6]. A male fantasy of self-creation—of men "born without a mother" (Picabia)—hovers over machine-age art from the mechano-
▲ morphic portraits of the Dadaists to the production pastorals of the Precisionists. With her abstracted flowers and landscapes, O'Keeffe, an artist who appears without progenitors, recaptures self-creation for her own art of nature and troubles the male gendering of this fantasy as well. In doing so, she charts an alterna-tive identity for American artists, especially for women, one that departs from the machine age and its myths of modernity. HF

FURTHER READING
Reyner Banham, *A Concrete Atlantis: U.S. Industrial Building and European Modern Architecture 1900–1925* (Cambridge, Mass.: MIT Press, 1986)
Leo Marx, *The Machine in the Garden: Technology and the Pastoral Ideal in America* (New York: Oxford University Press, 1964)
Terry Smith, *Making the Modern: Industry, Art, and Design in America* (Chicago: University of Chicago Press, 1993)
Gail Stavitsky et al., *Precisionism in America: 1915–1941* (Montclair, N.J.: Montclair Art Museum, 1994)
Karen Tsujimoto, *Images of America: Precisionist Painting and Modern Photography* (Seattle: San Francisco Museum of Art / University of Washington Press, 1982)
Anne M. Wagner, *Three Artists (Three Women): Modernism and the Art of Hesse, Krasner, and O'Keeffe* (Berkeley: University of California Press, 1996)

▲ 1921a ● 1960c, 1964b ▲ 1916b

1928ₐ

The publication of "Unism in Painting" by Wladyslaw Stzreminski, followed in 1931 by a book on sculpture he coauthored with Katarzyna Kobro, *The Composition of Space*, marks the apogee of the internationalization of Constructivism.

"The Blockade of Russia is Coming to an End": such is the title of the editorial launching the first issue of *Veshch'/Gegenstand/Objet*, a short-lived trilingual "international journal of modern art" published in 1922 by two members of the Russian avant-garde living in Berlin at the time: the Constructivist artist ▲ El Lissitzky and the writer Ilya Ehrenburg (1891–1967). The end of the blockade imposed by Western nations at the outbreak of the October Revolution of 1917 was still only a wish when the manifesto was penned (*Veshch's* inaugural double issue is dated March–April), but this wish was granted a few weeks later. On April 16, 1922, angering most other Western countries forced to swallow its diplomatic coup and, sooner or later, to follow suit, Germany signed the Treaty of Rapello, recognizing the Soviet government in Moscow. Neither El Lissitzky nor Ehrenburg was a political pundit, but no particular expertise was needed to sense that the wall of isolation behind which Soviet Russia had been kept ever since 1917 was about to topple and that Germany, the great loser of World War I, would be the first country to lend a hand to this pariah of the international community.

Russians in Berlin

Unlike Ehrenburg, who had traveled throughout Europe for a few months (allegedly to study) before settling in Berlin in the fall of 1921, Lissitzky arrived there straight from Moscow via Warsaw on New Year's Eve, 1921. Ehrenburg was more of a fellow traveler than an ardent Bolshevik, whereas Lissitzky considered it his duty to propagate the new developments of Soviet art in the West. It has never been proven that the Russian artist had received an official mandate, but at the very least he had the tacit support of Anatoly Lunacharsky's Soviet ministry of culture and education (Narkom-
● pros, or People's Commissariat of Enlightenment) set up in 1917: he would be chosen to design the catalogue of the groundbreaking "Erste Russische Kunstausstellung" ("First Russian Art Exhibition") financed by the Soviet government and held at the van Diemen Galerie in October and November 1922 [1]. Both Ehrenburg and Lissitzky were immediately seduced by Berlin, then a formidable cultural and ideological melting-pot, vibrant with a multiplicity of pacifist and left-wing groups, some still hoping to revive the

1 • El Lissitzky, preliminary sketch for the cover of the catalogue of "Erste Russische Kunstausstellung," 1922
Tracing paper, gouache, Indian ink, graphite, 27 × 19 (10⅔ × 7½)

January 1919 uprising that had upset the city for a season before being brutally crushed with the assassinations of the Marxist leaders Karl Liebknecht and Rosa Luxemburg. In a matter of weeks the Russian artists established contacts with all the major players of the Berlin avant-garde, particularly with the highly politicized ▲ Berlin Dadaists but also with many artists from the countries artificially created by the Treaty of Versailles, which officialized the fall of the Austro-Hungarian Empire at the close of World War I.

▲ 1926 ● 1921b ▲ 1920

But the largest group of immigrants was the Russians—and, contrary to what one might expect, relatively few of them were faithful to the deposed Czarist regime (those who were White Russians, as they were called, preferred Paris); many had been disenchanted by Lenin's politics or had fled the terrible famine and the civil war of 1918 to 1921, but they still hoped that one day they could go back to their country and contribute to its development.

There was perhaps no form of artistic production that piqued the curiosity of the cosmopolitan intelligentsia gathered in Berlin more than that of the Russian avant-garde. Communications with the rest of Europe had ceased at the beginning of 1914; although some information had begun to filter in from 1920 on (notably through the first book on the topic ever published in the West, *Neue Kunst in Russland 1914–1919* (New Art in Russia 1914–1919), written by the young, Vienna-based Soviet journalist Konstantin Umansky), and this had fueled the already vast interest in "the new Russian art."

The editors of *Veshch'* were fully aware that the timing was perfect, as the first paragraph of "The Blockade of Russia is Coming to an End" testifies:

The appearance of Veshch' *is another sign that the exchange of practical knowledge, realizations, and "objects" between young Russian and West European artists has begun. Seven years of separate existence have shown that the common ground of artistic aims and undertakings that exists in various countries is not simply an effect of change, a dogma, or a passing fashion, but an inevitable accompaniment of the maturing of humanity. Art is today international, though retaining all its local symptoms and particularity. The founders of the new artistic community are strengthening ties between Russia, in the aftermath of the mighty Revolution, and the West, in its wretched postwar Black Monday frame of mind; in so doing they are bypassing all artistic distinctions whether psychological, economic, or racial.* Veshch' *is the meeting point of two adjacent lines of communication.*

The program that followed, forcefully laid out by Lissitzky in three parallel columns (one for each language: German, French, and Russian) punctuated by the repetition of the title of the journal in bold type, contained a condemnation of the "negative tactics of the Dadaists" (compared to those of the prewar Futurists) as well as those of the Russian Productivists:

▲ those of the Russian Productivists:

We have nothing in common with those poets who propose in verse that verse should no longer be written, or with those painters who use painting as a means of propaganda for the abandonment of painting. Primitive utilitarianism is far from being our doctrine. Veshch' *considers poetry, plastic form, theater as "objects" that cannot be dispensed with.*

This did not mean that *Veshch'* was advocating a return to art for art's sake, continued the editors: for them, "every organized work—whether it be a house, a poem, or a picture—is an "object" directed toward a particular end, which is calculated not to turn people away from life, but to summon them to make their contri-

bution toward life's organization." Thus *Veshch'* vowed to "investigate examples of industrial products, new inventions, the language of everyday speech and the language of newspapers, the gesture of sports, etc.—in short, everything that is suitable as material for the conscious creative artist of our times." The key words were "organization" and "construction": contrary to what the Productivists believed, art would abdicate its ideological power if it was entirely subsumed into industrial production, but both art and industrial production could function as a model for each other. What the latter has to gain from this interrelation remains vague in the editorial, but according to its authors the recent developments of artistic production provide a clear lesson: its strength derives in great part from the fact that it is a collective enterprise and that each work is conceived according to a plan, following certain rules defined by the material, and not the mere result of subjective inspiration.

Although *Veshch'* played a major role in publicizing the art of the Russian avant-garde, it should be noted that most of the contributions appeared in Russian (a major exception is Lissitzky's long overall review of "exhibitions in Russia," illustrated by an
▲ installation photograph of the 1921 Obmokhu show, published in German). The editors' dream was to act as an intermediary between East and West and in so doing give ammunition to their colleagues at home, who were already fearing that Lenin's New Economic Policy, drafted in 1921 and advocating the return of "bourgeois specialists," was going to seal their fate. To inform the Soviet avant-garde of projects similar to its own in various countries of Europe was to encourage its members to hold fast: they were not alone. Thus, among the mass of information printed in the first issue of *Veshch'* one reads an announcement for an international exhibition of "Progressive Art" to be held in Düsseldorf.

The editors of *Veshch'* took an active part in the "Congress of International Progressive Artists" that coincided with the Düsseldorf exhibition (May 29–31, 1922), during which they solidified
• their link with the Dutch movement De Stijl as well as with other groups working on similar premises in countries such as Romania, Switzerland, Sweden, and Germany [2]. With Hans Richter (an ex-Dadaist turned Constructivist filmmaker) and Theo van Doesburg, the mastermind behind De Stijl (who had just published his manifesto on "Monumental art" in the first issue of *Veshch'*), Lissitzky formed the "International Faction of Constructivists." In a "minority" statement conceived as a direct counterproposal to the humanist creed of the Congress's resolution, the three coauthors protested against the lack of definition of the term "progressive artist": "We define the progressive artist as one who fights and rejects the tyranny of the subjective in art, as one whose work is not based on lyrical arbitrariness, as one who accepts the new principles of artistic creation—the systematization of the means of expression to produce results that are universally comprehensible." Furthermore, they lambasted the corporatist ideology that fueled the Congress's ambition to create what they saw as "an international trade for the exhibition of painting." Against such a

▲ 1909, 1921b

▲ 1921b • 1917b

2 • El Lissitzky (fourth from right) and Theo van Doesburg (third from right) at the "Congress of International Progressive Artists" in Düsseldorf, 1922

"bourgeois colonial policy," they stated: "We reject the present conception of an exhibition: a warehouse stuffed with unrelated objects, all for sale. Today we stand between a society that does not need us and one that does not yet exist; the only purpose of exhibitions is to demonstrate what we wish to achieve (illustrated with plans, sketches, and models) or what we have already achieved." The definition of art that concludes this declaration confirms the constitution of a lingua franca of Constructivism: "Art is, in just the same way as science and technology, a method of organization which applies to the whole of life."

The "Erste Russische Kunstausstellung" at the van Diemen Galerie was not exactly a Constructivist exhibition—all trends of Russian art were represented, including the nascent "Socialist ▲ Realism"—but it provided the first occasion for an avid public to discover the prodigious activity of the Russian avant-garde in all media, from the Suprematist canvases of Malevich and his pupils to the theater design of Rodchenko's friends and the sculptures of Obmokhu, not to forget Lissitzky's own abstract paintings, which he called *prouns* (an acronym based on the Russian phrase "for the affirmation of the new"), and which made quite a sensation [4]. The exhibition was an immense success, with its Constructivist section receiving the lion's share of the press's attention. Lissitzky contributed in no small way to this triumph, taking an active part in all the public debates surrounding the exhibition and embarking on a lecture tour through several Dutch and German cities. His enthusiastic lecture on the "New Russian Art" still remains today one of the most lucid analyses of the development of the Russian avant-garde from 1910 to 1922.

The impact of the van Diemen show was immediate. Not only did commercial art galleries in Berlin (such as Der Sturm), till then clinging to Expressionism as a genuinely Germanic form of expression, rush to open their walls to the new avant-garde, but also there was the creation (or the conversion to Constructivism) of a myriad of avant-garde periodicals in Eastern European countries, all clearly indebted to the Russian model about which most of them were gathering information from correspondents in Berlin. Among many

others, these publications included *Zenit* in Zagreb (now in Croatia) and then Belgrade (now in Serbia), *Revue Devetsilu*, *Zivot*, and *Pasmo* in Prague, *Zwrotnica* and *Blok* in Warsaw, *Contimporanul* in Bucharest—not to speak of architectural journals such as *G: Material zur elementaren Gestaltung* (based in Berlin) and *ABC* (based in Basel), which Lissitzky helped launch. (A case in point was Lajos Kassák's *MA* [also the name of a group of artists and writers], which had began its publication in 1916 in Budapest and moved to Vienna during the repression that followed the aborted Hungarian proletarian republic: as soon as László Moholy-Nagy, who left Vienna for Berlin in November 1919, became its editor there, *MA* turned into one of the most ardent advocates of the Constructivist position.)

This is not to say that the artists grouped around these little magazines suddenly woke up from a long sleep when touched by the magic wand of Russian Constructivism—as a matter of fact, many had been trying for several years to revive an avant-garde culture that had been all but eliminated in their countries by the events of World War I—but for the most part their post-Cubist production lacked direction, which is exactly what their encounter with Russian ▲ art provided them with. Malevich's brilliant interpretation of Cubism had nourished a whole generation of Russian artists, even if they had come to reject his aesthetic position; without necessarily being aware of this, the young turks of this emerging "internationale" were fed a coherent narrative (from Cubism to Suprematism to Constructivism) that laid down the principles of action they most needed. Few of these new converts produced highly original works. A major exception is that of the Hungarian László Peri (1899–1967), whose paintings of various geometric shapes on shaped wood, canvas, or occasionally concrete slabs are particularly striking [3]. Another exception is constituted by the paintings of Wladyslaw Strzeminski (1893–1952) and the sculptures of his wife, Katarzyna Kobro (1898–1951), a partnership that was the main force behind the Polish avant-garde of the twenties and early thirties.

To call Kobro and Strzeminski "new converts" would actually be misleading: firstly, born respectively in Moscow and Minsk

3 • László Peri, *Three-Part Space Construction*, 1923
Painted concrete, part 1: 60 × 68 (23⅝ × 26¾); part 2: 55.5 × 70 (21⅞ × 27½); part 3: 58 × 68 (22¾ × 26¾)

4 • El Lissitzky, *Proun R.V.N.2*, 1923
Mixed media on canvas, 99 × 99 (39 × 39)

(Bielorussia, now Belarus), they had a direct knowledge of the Russian avant-garde, particularly of the art of Malevich with whom they had studied in the Svomas and later kept in close contact, often participating in artistic events held at Unovis, Malevich's school (where they most probably met Lissitzky); secondly, newly arrived in Poland in 1922, they did not share their fellow citizens' enthusiasm for the recent hardening of Constructivism into Productivism. The first major essay written by Strzeminski, "Notes on Russian Art," published in Kraków in 1922 shortly before

Lissitzky's lecture, should be read as its pendant. Offering a rigorous analysis of the art of Malevich, Strzeminski warns against any instrumentalization of art, a danger he sees as a major threat not only in the Productivist but already present in the Constructivist position. Adhering to the statement of the International Faction of Constructivists, according to which the work of art is an object whose construction has to obey a certain number of rules in order to evacuate the "tyranny of the subjective," he soon conceived of his task as that of articulating such rules.

▲ 1921b

Unism

By the end of the twenties, having rapidly ascended the ranks of the Polish avant-garde, Strzeminski proposed a full-blown theory, which he called Unism (published in 1928 as *Unizm w malarstwie* [Unism in Painting]) and which constitutes one of the most sophisticated discourses concerning abstract art. A brief summary of this theory is in order. In each medium, and differently in each medium, according to the theory of Unism, the artist must strive toward creating a "real" work of art (a work having a "real" existence, a work not relying upon any kind of transcendence). Any work of art whose formal configuration is not motivated by its physical condition (format, materials, and so on) is arbitrary, in the sense that the composition originates in an a priori vision conceived by the artist prior to its actual embodiment in matter, prior to the physical existence of the work. Such arbitrary compositions (which Strzeminski calls "baroque") are always enacting a drama (thesis, antithesis) whose resolution (synthesis) must convince. (Strzeminski was remarkably aware of the fact that the pictorial ordering we call composition, first theorized during the Italian Renaissance, had been borrowed from the art of rhetoric.) But, he continues, any "baroque" synthesis is necessarily a false solution because the problem it solves is grounded in metaphysical oppositions that are artificially superimposed upon matter (the figure–ground opposition, for example) and are, therefore, not "real." Any trace of dualism must be evacuated if one is to escape the idealism of composition so as to achieve a true construction (needless to say, Mondrian's dialectics was rejected by Strzeminski).

Pictorial flatness, formal deduction from the frame, and abolition of the figure–ground opposition are thus the three main conditions of Unism in painting. As soon as a shape is not motivated by the format of the canvas, it floats, creating a figure–ground dualism and thus entering the realm of the "baroque" (even if Malevich was praised for his *Black Square*, most of his overtly dynamic compositions were severely criticized).

Understandably, Strzeminski had a hard time putting his extremist theory into practice. His wish to suppress all contrasts, formulated as early as 1924, should have given rise to a monochromatic type of ▲ painting; yet this did not occur until 1932 (more than ten years after Rodchenko's *Red, Yellow, and Blue* triptych, and then for only a few canvases). But because he was keeping the monochrome at bay, Strzeminski had to find a means to "divide" the surface of his paintings, a means that would not be "arbitrary" and subjective. ● His invention, formulated in 1928—which would reappear in Frank Stella's black paintings of 1959, though without any awareness of this historical precedent—was the "deductive structure," to use the phrase coined by Michael Fried in 1965 with regard to Stella's work: the proportions of all of the canvas's formal divisions are determined by the ratio of its actual length and breadth.

In the extraordinary series of paintings deriving from this principle, the surface is divided in two or three planes (whose colors were supposed to be of equal intensity) and the negative–

5 • Wladyslaw Strzeminski, *Architectonic Composition 9c*, c. 1929
Oil on canvas, 96 × 60 (37¾ × 23⅝)

positive articulation suspends the figure–ground hierarchy [5]. The division is indeed proportional to the format of the painting, but the occasional use of curves, which would seem impossible in a deductivist structure (within an orthogonal format), shows that Strzeminski had to mellow his program and reintroduce a certain dose of "arbitrariness" for the sake of variety. This would lead to a major crisis which only emerged, paradoxically, after he had attempted with Kobro's help to transpose the theory of Unism into the domain of sculpture.

He began, faithful to the modernist notion of the specificity of each medium, by positing the radical difference between the pictorial and the sculptural object: the first has "natural limits" beyond which it cannot go (the actual dimensions of the canvas), the second does not have such luck and the "unity" it must establish is with the "totality of space." To achieve this, the sculptural object must not stand out as a figure in an empty background (it cannot be a monument) but must incorporate space as one of its materials.

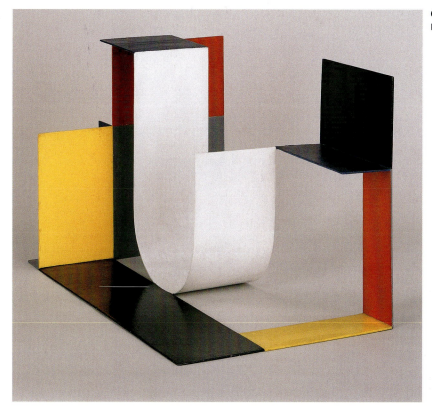

6 • Katarzyna Kobro, *Spatial Composition #4*, 1929
Painted steel, 40 × 64 × 40 (15¾ × 25⁹⁄₁₆ × 15¾)

In order not to be "a foreign body in space," it must "create the prolongation of space" that it materializes through its axes. Easier said than done—but Kobro was up to the task. The real inventiveness of Kobro's works after 1925, all made of intersecting planes, orthogonal or curved, lies in the two methods she employed to prevent her sculptures from being perceived as figures in space or rather as figures separated from space—two methods based on what could be called an extreme syntactic disjunctiveness. The first method was polychromy: the harsh contrast of primary colors makes the sculpture explode in three dimensions, preventing it from becoming a unified silhouette because each side of each plane is painted differently. The second method involved the temporal perception of the sculpture as the viewer turns around it, Kobro being particularly careful to make sure that it would look utterly different from each successive point of view and that no elevation could be inferred from any other. The combination of these two disjunctive methods is remarkably efficient in the works Kobro produced from 1929 to 1930, such as *Spatial Composition #4* [6], which, similar in that sense to Strzeminski's Unist canvases, could easily be misdated to 1960.

Strzeminski was rigorous enough to realize that, in positing the absence of any "natural limits" for the sculptural object, he had raised a major issue in his theory of painting. He asked himself: "If the division of the picture is determined by its dimensions, what then is the motivation of these particular dimensions?" The answer he provided created a vicious circle, while ignoring the Unist principle of the specificity of each medium: drawing from the "nature" of architecture, about which Strzeminski wrote that "the homogeneous rhythm of its movement must be a function of the dimensions of man," he established and proposed for every art a kind of ideal proportions (8/5). Demonstrating, despite himself, that it is impossible completely to eradicate the arbitrary in artistic production, Strzeminski reached back to a humanist ideal that Unism had precisely sought to destroy. The monochrome was his next way out, but by then the social metaphor that had been at the core of Strzeminski's enterprise—his conception of the non-hierarchical, "homogeneous" pictorial object in which all parts are equal and interdependent as a model for the society to come— was wearing thin. Condemning artistic redundancy, Strzeminski preferred to abort Unism rather than repeat himself. The rise of Hitler in Germany and of Stalin in Russia were the last straws that silenced his utopian impulse. He spent the final twenty years of his life teaching, drawing biomorphic landscapes as a hobby. He died a year after Kobro, in 1952, without having renounced the principles of Unism but with the full knowledge that they were just as idealist as anything against which he had struggled. YAB

FURTHER READING
Stephen Bann, *The Tradition of Constructivism* (London: Thames & Hudson, 1971)
Yve-Alain Bois, "Strzeminski and Kobro: In Search of Motivation," *Painting as Model* (Cambridge, Mass.: MIT Press, 1990)
El Lissitzky, "New Russian Art," in Sophie Lissitzky-Kuppers, *El Lissitzky: Life, Letters, Texts* (London: Thames & Hudson, 1968)
Krisztina Passuth, *Les avant-gardes de l'Europe centrale* (Paris: Flammarion, 1988)
Ryszard Stanislawski, *Constructivism in Poland* (Essen: Folkwang Museum; and Otterlo: Kröller-Müller Museum, 1973)
Manfredo Tafuri, *The Sphere and the Labyrinth: Avant-Garde and Architecture from Piranesi to the 1970s* (Cambridge, Mass.: MIT Press, 1987)

1928 b

The publication of *Die neue Typographie* by Jan Tschichold confirms the impact of the Soviet avant-garde's production on book design and advertising in capitalist Western European countries, and ratifies the emergence of an international style.

1920–1929

When Jan Tschichold's (1902–74) *Die neue Typographie* (The New Typography) appeared in June 1928, published by the very official press of the German printing trade union, its reception was far less dramatic than expected (though the book sold very well and was quickly out of print). Far less, in any case, than that of its immediate antecedent, the special issue of the journal *Typographische Mitteilungen* published on the same topic and by the same organ only three years earlier, which had generated much debate in the journal. Entitled *elementare typographie* and edited by the young Tschichold (then aged twenty-three), this special issue rocked the traditional world of German book design, in which he had been trained, by introducing it to the typographical works and theories of El Lissitzky and László Moholy-Nagy, and to a host of illustrations by Kurt Schwitters, Herbert Bayer, Max Burchartz, and other members of the "International Constructivist" avant-garde, not to mention Tschichold's own virulent manifesto and his introduction seeking to place the new trend he was advocating into historical context. That was in 1925, just as the Bauhaus was relocating to Dessau, but things were then going very fast in Weimar Germany. Reading *Die neue Typographie* in 1928, without foresight of the fate of the "new typography" in Nazi Germany just a few years later (it would be denounced as "degenerate"), one could easily imagine that Tschichold had won his battle.

The book, in itself, is an extraordinary achievement, and one would have a hard time finding its equivalent in other artistic fields. Copiously illustrated, designed according to the very "laws" it posits, it proposes at once a historical account of the birth of new typography, a defense and illustration of its essential principles (with a claim to their universality that, in effect, contradicts their historical grounding), and a do-it-yourself manual. To illustrate the very specific rules that Tschichold establishes for the design of logos, business letterheads, envelopes (with or without windows), postcards, business cards, posters, newspapers, illustrated magazines, books, and many other items, each treated in a separate section and in excruciating detail, the book opposes many examples of good and bad modern layouts, on the grounds that "merely to copy the external shapes of the new typography would be to create a new formalism as bad as the old." The strategy is not

entirely new (a decade earlier Theo van Doesburg had used it in his journal *De Stijl*, where he opposed a jazzy grid composition by Vilmos Huszár to a lifeless "uncomposed" grid of the same size), but Tschichold is relentless. He even provides several makeovers of traditional or ersatz-modern designs (a poster for the continuing education classes offered by the city of Munich, an advertisement for a local newspaper), the "before" and "after" versions neatly juxtaposed in sharp contrast.

In fact, one could arguably say that nothing was entirely new in *Die neue Typographie*. That is, it is an extremely lucid synthesis, well organized and well argued, of principles that had been put forward and acted upon, from around 1922, by all the artists Tschichold had already singled out in *elementare typographie*. He is scrupulously honest about his debt, quoting several manifestos preceding his own, amply illustrating the work of his peers, and even discreetly managing, without ruffling feathers, to restore some credit where credit is due, notably when reattributing to Man Ray the invention of the "photogram" (abstract cameraless photography) that Moholy-Nagy had claimed to himself, a "theft" that permanently damaged the Hungarian artist's relationship with El Lissitzky.

In order to summarize the axioms of the "new typography" laid down by Tschichold, a little history is in order, following his own procedure: after a brief introduction that is a typical modernist paean to the machine age, including a quasi-mandatory belief in the social progress this age will bring to a collective humanity, the first three chapters of *Die neue Typographie* are devoted to a historical account. "The old typography (1440–1914)" is dealt with first, followed by a chapter on "the new art," and, finally, by a detailed chronicle of the advent of the "new typography" proper.

As to be expected, the "old typography" is very severely treated, with a particular hostility toward the historicism of what Tschichold disdainfully labels the "book-artists" of the nineteenth century, who took advantage of the new technical advances of lithography, photography, and photolithography to clutter their designs with a profusion of ornaments. The movements reacting against this abundant production are briefly described—namely William Morris's Arts and Craft, the *Jugendstil*, and even the renewed, simplified Biedermeier that came out of their ashes—but each are discarded as ill-suited to the modern world. Morris is

1 • F. T. Marinetti, page from *Les Mots en liberté futuriste*, 1919

ridiculed for his unequivocal rejection of the machine; the *Jugendstil* is criticized for its naive fascination for natural motifs and its indifference to the materiality of the typographic medium upon which it imposed these motifs; and the neo-Biedermeier style, praised for its self-restraint (particularly that of Peter ▲ Behrens, the architect in whose office Walter Gropius apprenticed), is condemned for its allegiance to the age-old precept of symmetry. However, both *Jugendstil* and neo-Biedermeier are commended for their adoption of roman characters instead of the Fraktur alphabet, commonly used in Germany since the Renaissance but almost illegible for any non-native German speaker. Cleverly, furtively, Tschichold has laid out the grounds for principles he would articulate later in the book (in favor of mechanization; against the a priori imposition of any form—floral letter-design, symmetry—onto the medium of typographic design; against nationalism).

The narrative of modernism given in the chapter on "the new art" is by now fairly banal—from Manet and Cézanne to abstract art and the photography of the twenties (about which Tschichold ● would design a book he coauthored with Franz Roh the following year). For the time, however, it was remarkably well-informed, especially in its treatment of Dada and of Russian Constructivism. Even more informative, as expected, is the chapter devoted to the "new typography." With characteristic aplomb, Tschichold credits ■ the Italian poet F. T. Marinetti, the founder of Futurism, "for providing the curtain-raiser for the change-over from ornamental to functional typography." Quoting at length Marinetti's 1913 typographic manifesto included in his celebrated book *Les Mots en liberté futuriste* of 1919 [1], Tschichold reproduces one of its plates famously conceived like a musical score, albeit a nonlinear one, the

size and orientation of the letters giving indication to the volume and pitch a voice is to obtain when reading the poem out loud: "For the first time typography here becomes a functional expression of its content." Curiously, Tschichold refrains from criticizing Marinetti's pictorialism (especially the representational function of the printed character when it pretends to be the graphic transcription of industrial and urban noise); it is rather to Dadaist typography that he addresses this reproach, taking for example an invitation designed by Tristan Tzara for the "Soirée du coeur à Barbe," a Dada event held in Paris in July 1923. Rather brief on Berlin Dada (Grosz, Heartfield, and Huelsenbeck are mentioned, ▲ but Raoul Hausmann's phonetic poems are not), he salutes Schwitters, notably for his "Theses on Typography" published in ● the special issue of *Merz* devoted to "Typoreklame" in the spring of 1924 (a double spread of which is later reproduced in Tschichold's book, devoted to an advertisement for Pelikan [2], the ink-producer for whom El Lissitzky would soon produce one of his best photograms, also reproduced). Tschichold expedites the Bauhaus in one sentence (all the more surprising since the production of its participants, not only Moholy-Nagy [3] and Bayer but also Joost Schmidt, figures abundantly in the book), and is done ■ with his praise of van Doesburg and *De Stijl* with just one paragraph, before concluding with the work of El Lissitzky, clearly cast as the major hero of this story (more of his works are reproduced in the book than that of any other artist or designer).

The impulse of the Soviet avant-garde

Indeed, throughout *Die neue Typographie*, the Russian artist's arrival in Germany at the end of 1921 and his tireless activity there for the next three years is implicitly presented as the main cause for the radical turn modern German typography took at that time. True, later on Tschichold would always trace his own discovery of "the new typography" to his visit to the Bauhaus for its famous ◆ summer 1923 exhibition, but then he had only just completed his

2 • Kurt Schwitters, advertisement for Pelikan Ink, *Merz*, no. 11, 1924

3 • László Moholy-Nagy, *Bauhausbucher 14: Von Material zu Architektur*, 1929
Book cover

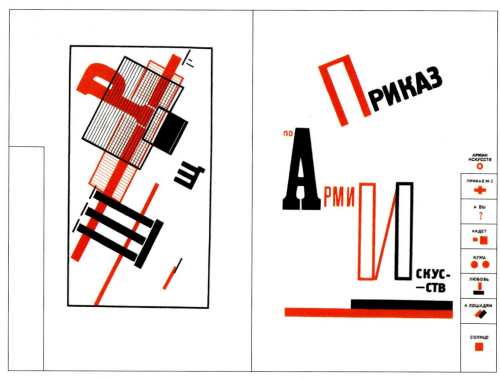

4 • El Lissitzky, "The Art Army," double-page spread from Vladimir Mayakovsky's *For the Voice*, 1922

apprenticeship in traditional design: though still rather timid, the innovations of Weimar's Bauhaus—prior to Moholy-Nagy's and his student Bayer's conversion to the Constructivist vernacular—must have felt to the young Tschichold like thunderous battle cries. Introduced to El Lissitzky's work shortly thereafter, notably to the layout of his journal *Veshch'/Gegenstand/Objet* (1922–3), and even more to that of Vladimir Mayakovsky's book of poems entitled *For the Voice*, which he long held an unsurpassable masterpiece [4], Tschichold would immediately become a champion of Soviet avant-garde design, praising not only El Lissitzky's work but also that of Aleksandr Rodchenko, particularly this artist's own version ▲ of a Mayakovsky book of poems, *About This* (1923), saluted as the first volume solely illustrated with photomontages.

Tschichold's assessment of El Lissitzky's eminent role is undoubtedly correct. The abrupt transformation of Schwitters's typography in the immediate aftermath of his encounter with the Russian artist is patent, and the same could be said of Moholy-Nagy's and van Doesburg's: a tell-tale sign, each of them immediately adopts the thick black lines and emphatic contrasts that characterize the layout of *Veshch'* (Schwitters in *Merz*, the no. 8/9 issue of which, entitled *Nasci*, he actually coauthored with El Lissitzky in the spring of 1924 [5]; Moholy-Nagy in his "typo-photo scenario" called *Dynamic of the Metropolis*, included in his 1925 Bauhaus book *Malerei, Fotografie, Film* [Painting, Photography, Film]; and van Doesburg in his design for *Mecano*, the Dada periodical he had launched under the pseudonym I. K. Bonset). Of course, if these artists were immediately seduced by the El Lissitzky model, it is because it corresponded to what they were themselves trying to formulate in their own work but each had difficulty doing: Schwitters because he could not easily abandon the random

collage-effect of Dadaist typography; Moholy-Nagy, because despite his recent enthusiasm for geometric abstraction and the machine age, he had not yet freed his typographic production from the expressionist tradition it had been following; and van Doesburg because, aside from the Dadaist layouts he had been emulating in *Mecano*, the only other resource he had at his disposal was the ▲ Neoplastic grid, which, strangely enough, he had never known how to adapt to typographic purposes, but which by then he found too static anyway (on this score, El Lissitzky and Schwitters proved him wrong with the inside pages of *Nasci*, where various photographic fragments are linked by black or gray lines on an open white field animated by the asymmetric distribution of masses).

El Lissitzky was one of the most articulate artists of his generation (his famous "Lecture on Russian Art," which he delivered in many German cities throughout 1922, as well as in Holland, remained for long the best account, and most intelligent analysis, of early Soviet art). He was also an ardent pedagogue, "always using his unerring pencil to demonstrate any idea put forward by him," to quote his future wife and first biographer, Sophie Lissitzky-Küppers. Needless to say, his precepts, already reverberated by the manifestos of Schwitters and Moholy-Nagy, are directly echoed in "the principles of the new typography" that comprise the second quarter of Tschichold's book.

Form from function

The first of these principles, clearly partaking of the optimistic Taylorism of the period, are those pertaining to *rationalization, mechanization,* and *standardization.* "Modern man has to absorb every day a mass of printed matter" that surpasses in quantity

▲ 1921b, 1935

▲ 1917b

anything he has been accustomed to, and whose reading thus requires a radical change of speed. In turn, this necessary acceleration at the level of reception requires of the printed matter itself that it be more efficiently (quickly) readable and more visually startling in order to stand out from the universal grayness of the printed world and to compete with other visual stimuli (the case is made without any scruple with regard to advertisement). "The new book demands the new writer. Ink-pots and goose-quills are dead," El Lissitzky had written in his manifesto "Topography of Typography," first published in *Merz* no. 4 (July 1923) and reprinted in full by Tschichold. There is nothing unexpected in this prolegomenon: the hymn to technology conceived as a "kind of second nature," in the words of Tschichold, is plain Constructivist parlance ("both technology and nature use the same laws of economy, precision, minimum friction, and so on"). Yet, because he was trained as a printer, Tschichold is more exacting than his peers in his demands from the new techniques: he can fully appreciate the limits imposed on artists like El Lissitzky and others by the traditional tools of the typesetter, and even more forcefully than them urge the printing trade to develop machines able to cope with their desire for a fully fledged "typophoto," in which text and images would be not only visually but also technologically equivalent.

The second principle is that of *motivation*, and here, with the help of El Lisstizky's ethos, imported from the debates that had inflamed the Soviet avant-garde a few years before, Tschichold is able to put his finger on an obstacle in the road of functional typography. Until then motivation in typography, following Ferdinand de Saussure's famous opposition between motivated signs (like figurative painting) and arbitrary ones (like words) had been understood in terms of mimetic representation. Yet, since typographic signs like letters are arbitrary, the only things they can "imitate" in themselves, through their size or orientation, are some properties of the sounds they transcribe; they can also, through their graphic disposition on the page, diagrammatically imitate the shape of an object. (The first case is that of Marinetti's *mots en liberté*, whose graphic signs—such as GRAAAACQ—are conceived as the rendering of street noises through an implicit code according to which LARGE and **bold** translates louder than small and *italics*; the second case is that of *calligrammes*, an age-old tradition revived in the early teens by the French poet Guillaume Apollinaire, and not particularly attuned to the demands of "speed-reading"). The Russian Futurists, particularly Velemir Khlebnikov and Aleksei Kruchenikh, and many Dadaists (Haussmann above all), were all dreaming of freeing language from the servitude of imitation, to celebrate "language as such" by creating pure sound poetry (sounds that would not refer to anything in particular except themselves and would form a new language—which they often thought of as "universal" since it did not depend on any national idiom). But this only suppressed one layer of mimetic motivation: the sounds themselves were not imitating anything, but the letters transcribing them on the page were still conceived as their graphic representation—and vice versa, in the more frequent case when the writing

5 • El Lissitzky, double-page spread from *Nasci*, *Merz*, no. 8/9, April–July 1924

▲ 1912

was first and its vocal enactment second. In fact, Kruchenikh and Khlebnikov's 1913 manifesto "The Letter as Such" even resorts to the dubious discipline of graphology in order to justify their oddly anti-machine-age production of handwritten books: since "a word written in one handwriting or set in one typeface is not at all similar to the same word in another written form," it should be written by the poet himself so that his "handwriting, idiosyncratically influenced by mood, conveys this mood to the reader independently of the words."

With Tschichold, "motivation" leaves the realm of mimesis to enter that of teleology: something is motivated not because it resembles anything else but because its shape is determined by its purpose. A turning point is El Lisstizky's design of Mayakovsky's *For the Voice*, already mentioned: contrary to what is often thought about this little typographical jewel, it is not the opening pages of each poem, conceived as *calligrammes*, that honor the fact it is destined to be read out loud (as its title indicates), but the thumb index helping the reader to quickly locate the poem he or she wants to find. "The New Typography is distinguished from the old by the fact that its first objective is to develop its visible form out of the function of the text.... The function of printed text is communication, emphasis (word value), and the logical sequence of the contents," writes Tschichold, who adds: "The typographer must take the greatest care to study how his work is read and ought to be read. It is true that we usually read from top left to bottom right [in the West]—but that is not a law." That the function of the text should determine its printed form explains the aversion of the "new typographer" to symmetrical designs: symmetry is an a priori form, applied at the ready without the slightest consideration for the nature of the text. Furthermore (and this is obviously said with advertisement in mind), because of its persistent domination, anything that departs from it will catch the eye. "The New Typography so designs text matter that the eye is led from one word and one group of words to the next ... through the use of different type-sizes, weights, placing in relation to space, color, etc." There is something shamelessly authoritarian in the productions of the "new typography": it tells your gaze where to go (no wonder that the domains it rapidly conquered were political propaganda and publicity).

The third principle posited by Tschichold—a typically modernist one—is that of *medium-specificity*: to be functional and rational, typography had to be cleansed of all extraneous importations, the most egregious of them being gratuitous decoration (taking his cue from the field of architecture, in which modernist discourse had by then matured into a canon, Tschichold invoked an 1898 essay by Adolf Loos against ornament). Of course, what could be deemed essential to typography was particularly hard to pin down at a moment when the technology was in rapid transformation. But technical conditions were not the only parameters involved: just as El Lissitzky had taken pride in the fact that in order to compose *For the Voice* he had only used the traditional materials he could find in the typesetter's shop, Tschichold mentioned that the typographical character he used for his own book was only the best that was at his disposal at the time—ergo, materials are less important than how they are used. Furthermore, the materiality of the typographic medium consists for the most part in elements that had been repressed in the "old typography" (just like, say, the planarity of painting was repressed in pre-modernist painting). A case in point is this rule: "The New Typography uses the effectiveness of the former 'background' [note the quotation marks] quite deliberately, and considers the blank white spaces on the paper as formal elements just as much as the areas of black type." At first glance this seems a mere echo of the fight against the figure/ground hierarchy that had played such an important role in the pictorial field ever since Cézanne and Seurat (and was most exactly articulated in the works of the De Stijl members around 1918 and, at the very moment Tschichold's book was being published, in that of ▲ the Polish Constructivist painter—and typographer—Wladyslaw Strzeminski). But pictorial modernism was no more than a welcome ally on that score: the principle that in printed matters "blanks" are as significant as words had already long ago been formulated within the field of language and by extension book design, notably by the French poet Stéphane Mallarmé in the preface of his *Coup de dés* (1897), undoubtedly the first masterpiece of modern typography (and to which Marinetti—reluctantly—and Apollinaire—lovingly—were both clearly indebted).

A type for modernity

Among the "unnecessary conventions" that the modernist creed embraced by Tschichold was poised to lambast was the use of serifs in printed characters. Tschichold went as far to claim that sans-serif characters were the only ones corresponding to the speed of modern life (speed of production as well as of reception) and thus should be used *exclusively*—except, he admits, in case of parody. Tschichold was not alone in his passionate defense of sans serif—Moholy-Nagy and Bayer at the Bauhaus had been among its most ardent promoters [6]—and in retrospect the prevalence of sans-serif characters in functional typography at the time seems a direct response to the omnipresence of Fraktur (a character that is all serifs, one could say) in the German printed world, the work of typographers of other countries happily taking their cues from their German colleagues without having to enter a painful debate about national identity.

Another specifically German feature that played a role in the ideological formation of functional typography is the particular circumstance of the German written language according to which all nouns have to be capitalized. Even though Jakob Grimm had already campaigned against it in the nineteenth century (and had requested that, as in English and other languages using the Roman alphabet, capitals be used only for proper names and at the beginning of sentences), the first sustained attack against this custom—still in practice today—was the 1920 book *Sprache und Schrift* (Speech and Writing), authored by the engineer Walter

6 • Herbert Bayer, exhibition poster for "Kandinsky Jubiläums-Austellung zum 60. Geburtstag," 1926

Porstmann (1886–1959), one of Tschichold's heros in that he devised the DIN standardization of paper format on which we are still dependent today (among other things the A4 size is a direct product of it).

The urge to standardize, which occupies a large portion of Tschichold's précis, takes hold of the second, practical part of his book—the part that probably accounts for its immediate success. Abandoning the grandstanding of the previous chapters, Tschichold reveals himself the utmost pragmatist. Standardized formats and proportions are discussed for every single kind of typographic item figuring on his long list, generously replete with successful examples authored by him or his peers and countless words of advice to the neophyte typographer (including which mistake to avoid and how), a bibliography, and a list of suppliers—even the personal address of all the practitioners whose works are reproduced (one wonders how many readers wrote to El Lissitzky, and if those putative letters reached him in Moscow). There perhaps lies the really original aspect of Tschichold's book: in being among other things a handbook, it signals that it has nothing to do with Utopia, that it belongs to the real world. Of course, the vague quasi-socialist claims made here and there are not mere smokescreens—it was possible then to believe that the shape of a book could help change the world!—even though, as Robin Kinross notes, they were mocked in a review published in *bauhaus*, the journal of the school whose directorship had just shifted to the Marxist architect Hannes Meyer. But just as Gropius, Meyer's predecessor, had been keen to underline that the Bauhaus products could all be mechanically produced (and had widely publicized the school's few successes at that), Tschichold wanted to make sure that the industry got his message, no matter if the nod toward capitalism and consumerism that his emphasis on advertisement efficiency represented contradicted his stated political views.

Unlike all the artists he celebrates in his book, Tschichold was a professional typographer (that is, he had no other activity), and as such he was far better equipped than his peers to find flaws in his own precepts. Unlike Bayer, for example, he never went as far as suppressing *all* capitals (Bayer stuck to his dogma all his life, which made all his texts difficult to read, contrary to what he seriously believed, since it suppresses the marker of a sentence's beginning); and as soon as 1935, Tschichold had no qualms using serif characters for the cover of his *Typographische Gestaltung*, as if to prove that one could create a modern design using old types (much better in any case, he warns in this book, than when sans-serif characters are badly used). By the late thirties, the tradition in which Tschichold had been steeped in his teens caught up with him. Exiled in Switzerland after Hitler's rise to power, he gradually relinquished all the principles he had so eloquently defended. By the time he left for England to become designer-in-chief for Penguin Books, he was one of the strongest opponents of the "new typography," and many of his book covers developed an eerie family resemblance with some of those he had been lambasting in *Die neue Typogra-▲ phie*. When Max Bill charged him with treason, in 1946, he went as far as equating the creed of modernist typographers, including his former self, as "not so very far from the delusion of 'order' that ruled the Third Reich." A page, sadly, had been turned. YAB

FURTHER READING
Herbert Spencer, *Pioneers of Modern Typography,* revised edition (Cambridge, Mass: MIT Press, 2004)
Sophie Lissitzky-Küppers, *El Lissitzky: Life-Letters-Texts* (London: Thames & Hudson, 1968)
Ruari McLean, *Jan Tschichold: Typographer* (Boston: David R. Godine, 1975)
Christopher Burke, *Active Literature: Jan Tschichold and New Typography* (London: Hyphen Press, 2007)
Richard Kostelanetz (ed.), *Moholy-Nagy* (London: Allen Lane, 1971)
Arthur A. Cohen, *Herbert Bayer: The Complete Work* (Cambridge, Mass: MIT Press, 1984)

▲ 1937b, 1959e, 1967c

1929

The "Film und Foto" exhibition, organized by the Deutscher Werkbund and held in Stuttgart from May 18 to July 7, displays a spectrum of international photographic practices and debates: the exhibition demarcates a climax in twentieth-century photography and marks the emergence of a new critical theory and historiography of the medium.

1920–1929

Partially motivated by the impact of World War I, the visual culture of Weimar Germany had increasingly focused on the photographic and the filmic image in all its variations: some authors have argued that this was in order to turn away from the traditional models of cultural production that still prevailed in France, England, and Italy even in the late twenties. Organized by Gustav Stotz (assisted by the architect Bernhard Pankok, the typographic designer Jan Tschichold, and others) on behalf of the Deutscher Werkbund (founded in 1907 to reconnect industry, artisanal, and artistic production), "Film und Foto" [1] displayed a tremendous diversity of international photographic practices. More than 200 photographers showed 1,200 photographs, and each national section had its individual curator. Edward Weston and Edward Steichen served for the United States section, which included works by Weston himself, his son Brett Weston, Charles Sheeler [2], and Imogen Cunningham; Christian Zervos presented Eugène Atget and Man Ray for France; Dutch designer and typographer Piet Zwart was in charge of the Dutch and Belgian section; El Lissitzky selected the work to represent the Soviet Union; while László Moholy-Nagy and Stotz curated the German section, with works by, among others, Aenne Mosbacher [3], Aenne Biermann [4], Erhard Dorner, and Willi Ruge. Moholy-Nagy also conceived and designed the first room introducing the history and techniques of photography, and in a third, his own separate exhibition space, he displayed the principles and materials of his *Malerei, Photographie, Film* (Painting, Photography, Film) published as a Bauhaus book in 1925.

Not surprisingly, it was at this point that the professional identities of the new photographers, as suppliers of images of daily life, of political activities, of current events, of tourism, of fashion and consumption, were formed. By contrast, the artistic and functional "identities" of photography became increasingly fractured. It is important to recognize that "Film und Foto" succeeded because it summarized all of these tendencies of photography in the twenties. First of all, since the rise of the illustrated magazines, photography had emerged as the new medium of political and historical information (rivaled only by the weekly newsreels), integral to the formation of Weimar culture. As contributors to illustrated weeklies in Germany such as the *Berliner Illustrierte Zeitung* (*BIZ*) or the Ullstein *UHU*, which were the precursors of *Paris Match* in France and *Life* in the US, photographers opened up immensely important new information resources. Secondly, photography had achieved a central role in the design, development, and expansion of the advertising and fashion industries, aimed at the new lower-middle-class of (often female) white-collar workers in Berlin and other large industrialized urban centers. Thirdly, a new, antithetical model emerged—a type of counterformation to paid photojournalism, photographic advertisement, and product propaganda.

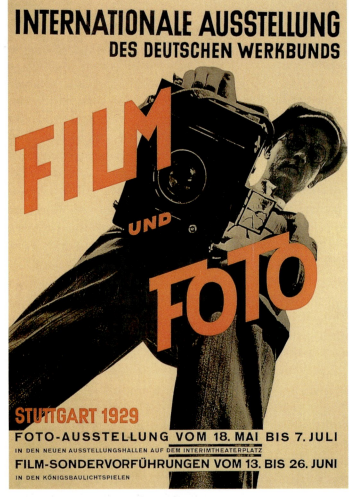

1 • Unknown designer, *Film und Foto*, 1929
Poster, lithograph on paper, 84.1 × 58.4 (33⅛ × 23)

▲ 1916b, 1927c, 1959d ● 1924, 1930b, 1931a, 1935 ■ 1926, 1928a, 1928b ◆ 1923, 1947a ▲ 1930a

2 • Charles Sheeler, *Pennsylvania Barn*, c. 1915
Silver-gelatin print, 19.1 × 23.9 (7½ × 9⅜)

Product propaganda and the proletarian public sphere

This model was developed as the result of attempts to abolish the professional specialization of ideological image production, and to make the tools of photography directly available to the working class. Organized to a considerable degree by the German Communist Party, the Workers' Photography Movement enabled the anonymous worker to participate in the emergent process of political and cultural self-representation. It organized its educational and agitational functions in the Workers' Photography Clubs and in Willi Münzenberg's journal *Der Arbeiter Fotograf,* published from 1926 onward. "Photography as a weapon" became the slogan that was coined in opposition to photography's increasing importance in the indoctrination of the mass public sphere with the ideologies of total consumption and the commercialization of the visual language of everyday life. Appropriately then, the "Film und Foto" exhibition expanded photography's traditional artistic parameters by including photojournalism, advertisement and amateur photography, as well as the political photomontage work of John Heartfield, yet it was primarily defined by the aesthetic contrast between Moholy-Nagy's concept of "New Vision" photography and Albert Renger-Patzsch's (1897–1966) project of "photographic photography," the technically masterful images of Neue Sachlichkeit. Moholy-Nagy and

Renger-Patzsch had first pronounced their oppositional views of the "new" medium and the specificity of its aesthetic conventions in 1927, in the first issue of the new magazine *Das Deutsche Lichtbild* (The German Photograph). While Moholy-Nagy had prioritized the technical, optical and chemical dimensions in order to foreground photography's experimental and constructive qualities, Renger-Patzsch had insisted on its almost ontological realism: "In photography one should surely proceed from the essence of the object and one should try to represent it with photographic means alone, regardless of whether it is a human being, landscape, architecture, or something else" [5]. And later Renger-Patzsch stated that "the secret of good photography is that it can obtain artistic qualities just like a work of art, through its realism. Therefore let us leave art to the artists, and let us attempt to create photography with the means of photography, that can hold its own because of its photographic qualities, without having to borrow from art."

Moholy-Nagy's self-reflexive deployment of the medium, featuring photograms, superimpositions, the scientific devices of macrophotography and X-rays, as well as the cinematic devices of rapidly alternating close-up and long-distance shots, was matched by his emphasis on the diversity of photographic procedures, be they chemical, optical, or technical. He foregrounded cameraless photography as one of his "inventions." Even though

3 • Aenne Mosbacher, *Koralle*, 1928

4 • Aenne Biermann, *Aschenschale*, c. 1928

the photogram had been deployed shortly before by artists such
▲ as Christian Schad and Man Ray (and cameraless photography
of course had been known since the times of Anna Atkins and
William Fox Talbot in the nineteenth century), it was Moholy-
Nagy who now redefined the photogram practically, theoretically,
and philosophically. Associating the photogram not only with a
perfectly aperspectival space, he also saw it as the concrete embod-
iment of his project to use "light instead of pigment," to articulate

"space through light," and to provide photographic evidence of
a "time–space continuum."

All of these strategies originated in an optimism about the
medium that considered camera vision as a powerful expansion of
natural eyesight, even its technical prosthesis. Moholy-Nagy had
stated in *Malerei, Photographie, Film* that "the photographic appa-
ratus can complement our optical instruments, the eyes, and even
make them perfect. This principle has already been deployed during
scientific experiments of motion studies (striding, jumping and
galloping) as well as in images of zoological, botanical and mineral-
ogical forms (microscopic enlargements).… This becomes equally
evident in the so-called mistaken, but all the more astonishing
photographic images, taken from a bird's-eye or worm's-eye perspec-
tive, or from below or from a tilted angle that surprise us all the more
today." [6] Clearly, Moholy-Nagy's experimental book and his display
▲ at "Film und Foto" inspired Walter Benjamin to write in 1931 (in his
crucial review of some of the above-mentioned photography books,
entitled "A Short History of Photography") that "it is a different
nature that speaks to the camera than that speaking to the eye."

Naturalizing technology

The modernist abolition of central perspectival space in Cubist
painting had led to a form of photography that aestheticized
modernity's angularity and spatial discontinuities. Pictorial over-
views of the landscape or the figure were displaced by the
diagrammatic and the detail. In their compulsion to assimilate all
forms of experience into the governing principles of technocratic
order, photographers discovered that even the principles of
modernist construction were ontologically prefigured in the
natural orders of plants and petrifications. These photographic
comparisons between natural and technological structures led
to the discovery of the work of Karl Blossfeldt (1865–1932) and to
the publication in 1928 of his collection of photographs, *Urformen
der Kunst* (Prototypes of Art), which came to be seen as precursors
to the photography of Neue Sachlichkeit.

Blossfeldt, initially trained as a sculptor, had been working as an
instructor of drawing and mold casting at the Institute for Higher
Education in Arts and Crafts (*Kunstgewerbeschule*) in Berlin since
1898. Increasingly he used photographs rather than plaster casts
of plants as the models from which students were to learn the
fundamental skills of naturalist drawing and functionalist design
(in the traditions established by architect, teacher, and theorist
Gottfried Semper and by Theodor Haeckel in the mid-nineteenth
century). His first photographs of plants were published in 1896
and, maintaining the exact or similar technical tools, standards,
and photographic principles for the next thirty years, Blossfeldt
produced an enormous archive of glass plates recording the extreme
differentiations of individual plant formations [7], intending them
to be used primarily as teaching supplements in his drawing classes.
It was not until 1928, when the art dealer Karl Nierendorf initi-
ated the publication of *Urformen der Kunst* with Ernst Wasmuth

▲ 1918, 1925b, 1930b, 1931a

▲ 1935

5 • Albert Renger-Patzsch, *Natterkopf*, 1925

in Berlin, that Blossfeldt was discovered as the great pioneering photographer of the emerging aesthetic of Neue Sachlichkeit; Moholy-Nagy thus included him in the entrance room of the "Film und Foto" exhibition the following year.

Making macroscopic detail and scientific series the epistemic structures of photographic observation, Blossfeldt developed the format of a photographic typology that would reverberate all the way into the sixties in the work of Bernd and Hilla Becher. At the time of Neue Sachlichkeit in the twenties, Blossfeldt's photographs were celebrated as evidence that modernist technical construction and the identity of function and ornament had a foundation in nature. More importantly, Blossfeldt's magical imagery of plant details responded to the desire to reconcile the fragmented experience of time and space under the conditions of industrialized labor with an ontological experience of natural rhythms and evolution. If the visual contemplation of the machine could serve to eventually ban its menacing and alienating presence by naturalizing it using photographic means, then the detailed detection of a serially and structurally produced nature would comfort the spectator in the discovery of the profound unity of manmade and natural orders and structures. Franz Roh, the critic who would publish the crucial book *Foto-Auge* (Photo-Eye) in 1929 to accompany the "Film und Foto" exhibition, had already stated in an essay on post-Expressionist art in 1927 that "while expression had been detected until recently in the movement of life, we now discover the power of expression already in the stillness of being itself, while listening carefully to the *ursounds* of a mere entity that has come fully into being." Walter Benjamin in his essay in 1931 associated Blossfeldt with Atget's sobriety and singled out his photographs not only as early examples of photography's emancipation from Pictorialism, but also as evidence of its privileged access to the optical unconscious.

From now on, nature would be assimilated into technology, and technology had to be naturalized, or as Thomas Mann famously wrote in his review of Renger-Patzsch's 1928 book *Die Welt ist schön* (The World is Beautiful): "But what if now that psychic experience falls prey to the technological, the technological itself becomes soulful?" Renger-Patzsch's book, decorated with an emblem that combines the structures of an agave cactus with that of a telegraph mast, in a perplexing claim to correspondence, was initially meant to be called *Die Dinge* (The Things). It was Carl Georg Heise, the author of the preface, and the curator who had given Renger-Patzsch his first museum exhibition in 1927, who suggested the more emphatic title, involuntarily signaling to its critics the essentially affirmative character of Neue Sachlichkeit.

Walter Benjamin's response was the most devastating, identifying the problems of Renger-Patzsch's Neue Sachlichkeit photography more lucidly than anybody, when he stated: "What is creative in photography is its submission to fashion, and, not surprisingly, its motto is 'The World is Beautiful.' In that title, a tendency reveals itself that can position the montage of a soup can in cosmic space, but it cannot grasp any of the most elementary human contexts. Even in its most oneiric subjects, it still initiates more of the object's saleability rather than its cognition. Since the true visage of this type of photography is advertisement, (de-) construction would of course be its rightful counterpart."

The serial subject

But the photography of Neue Sachlichkeit was of course determined by a larger spectrum of contradictory promises and social interests, and its definition as a new type of "technological vision" lent itself in an ideal fashion to all of these tasks. First of all, the photographic aesthetic of Weimar articulated an anti-Expressionist restraint that began in Weimar Germany around 1925 as a response to the general political and economic stabilization of the period. Secondly, as a technologically formed aesthetic, it was part of a larger process of modernization in which the photographic practices themselves adjusted to a rapidly changing social environment, that is, the creation of a mass public sphere and rapidly advancing forms of industrialization.

Traditional German aesthetic thought, grounded in the subject's dialectical relationship to nature, was shifting to an aesthetic in which the primacy of nature would be displaced by the desire to associate the work of the artist with the advancement of industry and technology. And lastly, and most importantly perhaps, only photography, with its capacity to select, stage, and present objects as utterly authentic, could provide the images for a process of total commodification: only photography, with its intrinsically fetishistic structure, could record the impact of commodity fetishism on the subject's daily experience (which would become the project of Surrealism more than that of Neue Sachlichkeit). As Herbert Molderings has poignantly observed, the photographers of the Neue Sachlichkeit discovered their aesthetic project only "when it became evident that the serial principle and the intensification of repetition defined industrial production in general. Henceforth the rhythm of standardization and the ornamental accumulation of eternally identical objects would determine all the images of the new photographer."

▲ 1968a

▲ 1924, 1931a

6 • László Moholy-Nagy, *Berlin*, 1928

7 • Karl Blossfeldt, *Impatiens Glandulifera; Balsamine, Springkraut*, 1927
Silver salts print, dimensions unknown

▲ Paradoxically, August Sander (1867–1964), undoubtedly the greatest photographer of Neue Sachlichkeit, and one of the outstanding figures in the history of photography, was not included in the "Film und Foto" exhibition. Sander, who had been running a portrait studio since the beginning of the first decade of the twentieth century, had emphasized all along that photography had to be purged of its Pictorialist kitsch in favor of what he called "exact photography." In the early twenties, Sander had initiated a long-term project which attempted to construct an exhaustive documentation, entitled *Menschen des 20. Jahrhunderts* (Citizens of the Twentieth Century). His project—not unlike that of Atget's

● disappearing Paris—resulted in an archive of tens of thousands of negatives (large parts of which were destroyed first by the Nazi government and subsequently by Allied bombs). Sander envisaged the eventual publication as consisting of forty-five portfolios of twelve images each that would represent and classify members of Weimar society according to their professional and class identities.

The ends of an archive

When a preliminary selection from the work was published in 1929, under the title *Antlitz der Zeit* (Face of Our Time), with an introduction by the novelist Alfred Döblin, it became instantly evident that Sander's was neither an ordinary portrait project nor a photographic enterprise that could be summoned for the

aesthetics of Neue Sachlichkeit. Once again, it was Walter Benjamin's acumen that situated Sander's project in the most poignant historical context. Calling it an "atlas in physiognomic exercise," or a training manual (an *Übungsatlas*), Benjamin positioned Sander's *Antlitz der Zeit* in an astonishing, but historically precise comparison to the new (anti)portraits of the photographic and filmic culture of the Soviet Union. In both instances, Benjamin argued, the need for a new portrait form was articulated, one in which not only would a new social class find its proper representation (as in Soviet film), but one in which concern for a scientific understanding of social collectivity would displace the bourgeois subject's false claims for autonomy.

Sander was closely affiliated with the Cologne Progressives group, whose engagement in formulating a radically different conception of the subject and of a new proletarian public sphere had led them to an increased interest in social typology. One of the group's founders, Cologne artist Franz Wilhelm Seiwert had published a series of typological woodcuts called *Sieben Antlitze der Zeit* (Seven Portraits of our Time) in 1921, inspiring Sander's title.

While historians of photography have wondered why Sander's *Antlitz der Zeit* was confiscated and destroyed by the Nazi government in 1934, the answer seems relatively clear. First of all, Sander's project of a scientific typology of the social collective deconstructed the traditional safeguard of the singular bourgeois portrait. It replaced it with a collectivist photographic archive, unacceptable to an emerging totalitarian regime that was based on the destruction of the political identity of class and collectivity. Secondly, Sander's *Übungsatlas* delivered the last glance at an extraordinarily differentiated society, and the asynchronous diversity of the subject positions that Germany's first liberal democracy had allowed for. With the destruction of Sander's book and its photographic plates, the fascists attempted not only to eradicate the memory of that democracy, but—most significantly of all—to liquidate any possibility of a photographic analysis of social relations and their impact on the formation of the subject right from the very beginning. BB

FURTHER READING
George Baker, "August Sander: Photography between Narrativity and Stasis," *October*, no. 76, Spring 1996
Ute Eskildsen and Jan-Christopher Horak (eds), *Film und Foto der Zwanziger Jahre* (Stuttgart: Verlag Gerd Hatje, 1979)
Heinz Fuchs, "Die Dinge, die Sachen, die Welt der Technik," *Fotografie 1919–1979 Made in Germany* (Frankfurt: Umschau, 1979)
Gert Mattenklott, "Karl Blossfeldt: Fotografischer Naturalismus um 1900 und 1930," *Karl Blossfeldt* (Munich: Schirmer/Mosel, 1994)
Herbert Molderings, "Überlegungen zur Fotografie der Neuen Sachlichkeit und des Bauhauses," in Molderings, Keller, and Ranke (eds), *Beitraege zur Geschichte und Aesthetik der Fotografie* (Giessen: Anabas Verlag, 1979)
Karl Steinorth (ed.), *Internationale Ausstellung des Deutschen Werkbundes "Film und Foto, 1929"* (Stuttgart: Deutsche Verlags-Anstalt, 1979)

▲ 1935 ● 1935

1930–1939

1930 a

The introduction of mass consumer and fashion magazines in twenties and thirties Weimar Germany generates new frameworks for the production and distribution of photographic imagery and helps foster the emergence of a group of important women photographers.

It is no accident that an astonishingly large number of women were among the key photographers of European and American photographic culture in the twenties and thirties. The famous question posed by Linda Nochlin in an essay in 1972 entitled "Why have there been no great women artists?" would have to be reversed for this period with the question being "Why were there so many great women photographers in the twenties and thirties?" In introducing the work of some of these photographers, and in order to explain this phenomenon, numerous and contradictory factors have to be considered. Generally speaking, one could argue that photography provided access to a technical and scientific apparatus of image production that displaced, once and for all, the exclusionist patriarchal rule that had declared exceptional manual skill, if not virtuosity, to be the single valid criterion of art. Photography—the techno-scientific reorganization of images—was causally intertwined with a general reformulation of the concepts of male sublimation that lay at the root of artistic identity. This is evident, for example, in the paradigm shift occurring in the work of Florence Henri (1893–1982) after she had taken courses with ▲ László Moholy-Nagy at the Bauhaus in Dessau in 1927 (as well as with Wassily Kandinsky and Paul Klee).

Recognizing that photography had become the central instrument of image production within the industrialization of everyday life, Henri adopted the principles and practices of Moholy-Nagy's "New Vision" photography. Returning to Paris in 1928, she wrote to her friend Lou Scheper:

Paris makes an incredibly old fashioned impression after the Bauhaus. I am no longer under its spell.... I am photographing.... I am fed up with painting and getting nowhere, and I have got an incredible number of ideas for photography.

The tensions and tendencies embodied in the photography of Weimar women became apparent in a comparison of self-portraits by two of the most important protagonists of photography in the twenties. Germaine Krull's (1897–1985) *Self-Portrait with Ikarette* from 1925 [1] constructs the photographer's image within a complex amalgam of tropes of modernity: firstly, the fragmentation of the body and the metonymic foregrounding of the indexical hands that self-reflexively perform the act of photographic recording; secondly, the superimposition, if not the substitution, of the camera for the photographer's physiognomy, causes the photographer's eye and the optical device (the camera's viewfinder) to collapse in a mechanomorphic symbiosis. And lastly, the tropes of the emancipated "New Woman," in which the display of the technical apparatus is matched by an equally ostentatious display of the cigarette—offers yet another universal emblem of independence.

By contrast, Lotte Jacobi's (1896–1990) *Self-Portrait* of c. 1930 [2] emerges not only from a dramatic painterly chiaroscuro, but also from a far more traditional concept of the portrait and the photograph. The probing introspection with which Jacobi faces the camera seems to be driven by both *desires* for and *doubts* about the very feasibility of portraiture and the credibility of that genre, in which the representation of the subject had been anchored for centuries. In Jacobi's portrait the protagonist is not yet the camera itself, but is, rather, an artistic subject, albeit a struggling and desperate one. And yet, Jacobi's attempt to maintain a hierarchical relation between the subject and a (presumably subservient) technological apparatus is uncannily contested by the camera's glistening eye with its typographic inscription emerging from the dark of the studio space, and even more so by the ostentatiously lit remote-control cable that links machine and maker like an umbilical cord.

The "New Woman" as photographer

More concrete explanations for the increased numbers of women photographers can be found in the historical transformations of professional and educational institutions. Until the turn of the century, the traditional route to photographic education had been to work as an apprentice in the studio of a professional photographer (as did Jacobi, for example, who learned the profession in the workshop of her father and grandfather). Yet two institutions in Wilhelminian Germany offered photographic education within the curriculum when most of the traditional beaux-arts academies still barred female students. The first was the Institute for Photographic Education of the Lette Verein (founded in 1890 for the professional education of female photographers, it had begun with thirteen students and had 337 by 1919). The second major institution was the Teaching Institute for Photography (*Lehr- und*

▲ 1923, 1929

1 • Germaine Krull, *Self-Portrait with Ikarette*, 1925
Silver-gelatin print, 20 × 15.1 (7⅞ × 6)

2 • Lotte Jacobi, *Self-Portrait*, Berlin, c. 1930
Silver print, 32.1 × 25.1 (12⅝ × 9⅞)

Versuchsanstalt für Photographie), founded in Munich in 1900, which admitted women as of 1905; Krull, for example, studied with the American Pictorialist Frank Eugene Smith, who taught at the Munich Institute from 1907 to 1913. Nevertheless, it was not until 1921 that women could become full members of the German Professional Guild of Photographers. By the mid-twenties, photography was introduced in most German arts and crafts schools as a new medium within the curriculum of the applied arts. It had become more and more evident that the rapidly expanding need for advertisement and graphic design would benefit immensely from an increase in technical and artistic competence in photography. Thus, as of 1925 the Munich Institute for example, replaced its Pictorialist faculty and appointed younger photographers who ▲ were familiar with the aesthetics of "New Objectivity." Other private institutions, such as the Reimann Schule appointed the young "New Vision" photographer Lucia Moholy to its faculty, where she remained from 1930 to 1933. The Bauhaus made its first faculty appointment in photography only under the directorship of Hannes Meyer, who nominated Walter Peterhans in 1929 to direct the new photographic curriculum that was aligned with the courses for advertising and design. Until 1933, when the Bauhaus was closed by the Nazi government, eleven women had successfully completed the photography class, among them several

who went on to find considerable professional recognition, such as Ellen Auerbach (1906–2004), Grete Stern (1904–99), Elsa Franke (1910–1981) and Irena Blühova (1904–91) (not to mention those who—like Henri—had studied with Moholy-Nagy).

But of equal, if not greater importance, were the newly arising professional opportunities offered to women. Statistics from 1925 record that 11.5 million women were professionals (35.8 percent of the total working population), making up the majority of low-level workers at the conveyor belts of industrial mass production, of white-collar workers in offices, and of sales personnel in department stores and retail industries. The social role model of the "New Woman" not only provided access to forms of emancipated experience. It also constructed women as producers and consumers and as objects within the overall process of the industrialization of new desires. Photographic mass culture generated and responded to these new behavioral forms and needs.

The new culture of illustrated magazines first emerged in Berlin (there were 200 registered magazines devoted to women, fashion, and domestic culture alone), ranging from Ullstein's conservative middle-class *BIZ*, the *Berliner Illustrierte Zeitung* (circulation 1.7 million copies), to a counterpublication for the working class, ▲ Willi Münzenberg's *AIZ*, the *Arbeiter Illustrierte Zeitung*, sometimes reaching a print run of 350,000. Their equivalents in

▲ 1925b, 1929

▲ 1920

3 • Ringl + Pit (Ellen Auerbach and Grete Stern), *Fragment of a Bride*, 1930
Silver print, 16.5 × 22 (6⅛ × 8⅝)

details with the highest exactitude, for example, to dramatize the play of light and shadow, and to exaggerate the transparency or the reflexivity of the surfaces of seduction), and second, to suspend the object in a condition of extreme fragmentation and spatial isolation so that it became the irresistible commodity fetish.

Travel photography was a third type of image production that women photographers developed in Europe in the prewar period (for example, Lotte Rosenberg-Errell's book *Kleine Reise zu Schwarzen Menschen* [Short Visit to Black People], published in 1931). Yet the genre of travel reportage became even more important after 1933 and in the immediate postwar period, more often than not as the result of exile. As with the previous genres, the motivations that defined and sustained it were manifold, ranging from the new medium's engagement in amateur—and professional—anthropology and ethnography to the instigation of new forms of mass and global tourism, or originating in the political desire to report on people's progress under radically changed historical and sociopolitical circumstances.

This stance is best exemplified in Jacobi's extensive documentation of the newly developing social relations in the Asian states of the Soviet Union, the formerly theocratic Islamic nations of Uzbekistan and Tajikistan that had been recently secularized. Travel photography would also fulfill the opposite need, that is, to document the urgent need for political change under conditions of political repression, as recorded in Germaine Krull's projects in Africa and Asia, or in Gisèle Freund's (1912–2000) work produced during her emigration to Argentina, and in Mexico in the fifties, when, as a suspected leftist, she was barred from entering the United States.

Travel photography in the guise of social documentary or political reporting would inevitably deteriorate in the postwar period, even in the hands of the greatest photographers (e.g., Henri Cartier-Bresson). Photographers could no longer match the excess of exotic visuality (the result of an increased access to geopolitical and ethnic diversities in the process of an expanding global tourism for which these photographers often served as unwitting pioneers) with the level of analysis necessary to grasp the political and economic links between the hunger for photographic images in the urban centers and the profoundly different conditions of experience that governed colonized and postcolonial societies. All too often, therefore, postwar travel photography served the continuously intensifying spectacle of exoticization and "othering," which found a first
▲ epochal climax in Edward Steichen's "The Family of Man" exhibition at the Museum of Modern Art in New York in 1955.

Paris—for which many of the Weimar photographers supplied images—ranged from Lucien Vogel's liberal *VU* and Florent Fels's *VOILA* to the left-wing *Regards* (where Lisette Model's first photographs were published.)

These were soon followed by the American *Life* (whose first issue in 1936 had a cover photograph by Margaret Bourke White) and *Picture Post,* and the equivalent propaganda magazine in the Soviet Union, *USSR in Construction.* These photographic magazines would radically alter the image world of the bourgeois public sphere, either by constructing the earliest cohesive and totalizing forms of the new societies of spectacle and consumption, or by attempting to transform that sphere according to the needs of a newly emerging industrial proletariat and *its* public sphere.

The primary tasks of the illustrated magazines were achieved via four photographic genres. The first, visual reportage and photojournalism, had to simplify the complex narratives of history and politics by reducing them to a merely specular apprehension (the work of Alfred Eisenstaedt, Erich Salomon, or Felix Man, for example). The second, advertising photography, had to accelerate cycles of artificial actuality and immediate obsolescence. As product propaganda, photography had to modernize the objects and architectural spaces of everyday life according to the laws of an emerging consumer culture, while fashion photography had to initiate, sustain, and control the construction of new identities (such as the "New Woman").

The photographic work of Ringl + Pit (Ellen Auerbach and Grete Stern) is of exceptional significance in Weimar advertising photography. In images such as *Fragment of a Bride* [3] or *Polski Monopol* (1930), the two former Bauhaus students implemented the functions of advertising photography while simultaneously putting them on display with a supremely ironical self-reflexivity (unlike
▲ Albert Renger-Patzsch, their major rival in the field of Neue Sachlichkeit advertising photography). Both images concretize the two most important functions of the photograph as advertising: first, to serve as a deictic tool of ostentatious presentation (to render

Three portrait positions

Lastly, and perhaps most importantly in the history of Weimar photography, we encounter the portrait in its most differentiated and dialectical forms. While still serving as *the* economic foundation of the photographic studio (the Berlin *Yellow Pages* for 1931 lists 600 photographic studios, of which at least 100 were owned and directed by women), the portrait also became the site where photography in

▲ 1929

▲ 1959d

4 • Gisèle Freund, *Demonstration in Frankfurt*, 1932

the thirties worked through its most profound contradictions. These ranged from the iterative production and distribution of images of the star, the new public persona whose function it was to compensate for the loss of subjective experience in the masses, to the contemplation of the precarious status—if not the final demise—of the representation of the bourgeois subject. The photograph's essential duality as both an exact indexical record and an artificial simulacrum (its most extreme form being the montage of photographs) lent itself to both the ideology of a physiognomically anchored identity and to the conception of subjectivity as pure construction.

At one extreme we find Erna Lendvai-Dircksen (1883–1962). Admitted as one of the first women members of the German Guild of Photographers in 1924, she ran one of the most successful portrait studios in Berlin. Lendvai-Dircksen claimed that a subject's identity was grounded in ethnicity and race, homeland and religion, and that therefore the portrait could best map that identity by tracing the physiognomy of the sitter as accurately as only photography would allow. In her lecture in 1933, "On German Photography," she polemicized against the "internationalist dissolution of the photograph by New Objectivity" and promised that her project would "save the German and the Germanic people's faces" and would follow the "inner obligation to participate in the restoration of the decaying German physiognomy." Not surprisingly, Lendvai-Dircksen not only became an ardent fascist herself in 1933, but her work would soon be published and distributed by the Nazi rulers as the photographic corroboration of their racist ideologies.

We find the dialectical opposite in portrait photographs by Freund and Jacobi, Annelise Kretschmer (1903–87), and in Helmar Lerski's

(1871–1956) project *Köpfe des Alltags* (Everyday Heads), published in 1931. In 1932 Freund had still been attempting to construct the image of the new proletarian and collective subject in her photographs of mass demonstrations [4] and Jacobi had produced portraits of the Communist candidate Ernst Thälmann for the cover of *AIZ* in a desperate attempt to prevent the Nazi Party from coming to power in the fatal elections of 1933. In these images—as in the photographs by

▲ Aleksandr Rodchenko and the Soviet avant-garde photographers working at that time—the subject is anonymous, and ostentatiously presented as constructed by class, social relations, and professional identities. In some of the most radical work of the time, the subject is constituted in the process of labor itself, as in the extraordinary series of images of street workers, taken by Ella Bergmann-Michel between 1928 and 1932 from a bird's-eye view, in which the ground of labor (the grid of cubic basalt blocks making up a street) and the laboring figure itself are fused in an inseparable unity.

We find, however, a third model of Weimar portrait photography in the extraordinary portraits that Krull and Freund produced in the late twenties in Germany and when exiled in France in the thirties, and in particular in the work of Jacobi, one of the greatest portraitists of the twentieth century, during her years in Berlin and New York. These images are defined by an innate sense of the subject's fragility, its historically determined transitional status. Their almost exhaustive account of the intellectuals and artists of the interwar period (such as Krull's portrait of Walter Benjamin in 1926) reminds us of Nadar's astonishing pantheon of portraits of the Republican intellectuals and artists in France after 1848. These images seem to hold on to the last moment of European subjectivity before the concept of

▲ 1935

the subject and its social reality were annihilated by the joint onslaughts of fascist politics and engulfment by the image technologies of mass culture.

The subject in exile

As evident in her numerous portraits of actors of the period, for example *Lotte Lenya Weill* [5], Jacobi already seems to have recognized that the modern specular subject of the "star" would be constituted at the very intersection of fashion design, makeup, lighting techniques, and iterative distribution, in outright opposition to the traditional conception of unique subjectivity, that assumed "naturally" available markers of distinction (by class privilege) and the inevitable emanation of individual psychic presence. Photographs now appeared to be uniquely qualified to record images of that new type of constructed subjectivity. But Jacobi and Freund—like their ▲ great Viennese colleague Lisette Model— would also record subjectivity as suspended, in transition between Weimar culture and exile.

Freund had been a member of the Communist Student Organization at the University of Frankfurt, where she had been working on her doctoral dissertation under the tutelage of Karl Mannheim, Norbert Elias, and Theodor Adorno. Forced to emigrate to Paris in 1933, she saved her manuscript and subsequently completed it at the Sorbonne in Paris in 1936, where it was published in 1937 as the first social history of photography under the title *La Photographie en France au XIXème Siècle.*

Jacobi emigrated to New York in 1935. While stark chiaroscuro had been a hallmark of her portraits throughout the twenties, signifying dramatic specular modernity with its attributes of theatricality, fashion, and film (such as the portrait of the actor *Francis Lederer* or *Russian Dancer* in 1929), it acquired a distinctly melancholic dimension after her arrival in the United States. Jacobi's portraits recorded the danger of the historical moment and the tragic experiences of her sitters (the portraits of Erich Reiss, Karen Horney, and Max Reinhardt, for example) who found themselves not only biographically and professionally suspended in the geopolitical chasm of exile, but equally, as did Jacobi herself, in the historical shift from the radical bourgeois public sphere of Weimar culture to that of the culture industry of the United States.

While Jacobi's melancholic chiaroscuro attempted to rescue the subject's contemplative dimension, Freund's decision to employ color photography from 1938 onward (the portraits of James Joyce and of French interwar intellectual and artistic "celebrities," for example) situated the portrait within an altogether different set of relations, signaling the inevitable shift toward the spectacularization of subjectivity. Freund's color photographs seem involuntarily intertwined with the imminent influx of American technicolor movies and with the full-color advertisements of the *Saturday Evening Post* or *Life* magazine whose chromatic "naturalism" would simulate immediacy, presence, and life, promising unlimited access to the universe of dead objects that consumer culture was soon to foist on its postwar subjects.

5 • Lotte Jacobi, *Portrait of Lotte Lenya Weill, c.* 1928
Silver print, 27.6 × 35.6 (10⅞ × 14)

It is particularly important to trace the development of the Weimar photographers after their emigration either to France (as was the case with Freund and Krull), to the United States (as was the case with Jacobi, Auerbach, and many others), or to Argentina (as in the case of Grete Stern). Bereft not only of their language and culture, but also of the progressive social and political contexts from within which they had emerged (for instance, the context of the Weimar avant-garde—such as the Bauhaus—the emergence of an emancipatory feminist consciousness evident in the radical enactment of the rights of the "New Woman," and the horizon of an actually existing socialist politics), they now found themselves confronted with totally different definitions of the social functions of photography. On the one hand was an outright and intensified commercialism in the rapidly accelerating consumer culture of the United States where "photography as a weapon" was more thoroughly discredited and censored than one might be able to recollect at this point. On the other hand was a general cultural backlash and a return to the patriarchal supremacy of painting as the centrally governing practice of visual culture (as in Abstract Expressionism), against which photography, shunted from its position at the radical forefront of Weimar culture, could now be relegated to its earlier role as the minor "sister art." BB

FURTHER READING
Ellen Auerbach, *Berlin, Tel Aviv, London, New York* (Munich and New York: Prestel Verlag, 1998)
Marion Beckers and Elisabeth Moortgat, *Atelier Lotte Jacobi: Berlin—New York* (Berlin: Nicolai Verlag, 1997)
Christian Caujolle (ed.), *Gisèle Freund: Photographer* (New York: Harry N. Abrams, 1985)
Ute Eskildsen (ed.), *Fotografieren hiess teilnehmen: Fotografinnen der Weimarer Republik* (Essen: Museum Folkwang; and Düsseldorf: Richter Verlag, 1994)
Naomi Rosenblum, *A History of Women's Photographers* (New York: Abbeville Press, 1994)
Kim Sichel, *Germaine Krull: Photographer of Modernity* (Cambridge, Mass.: MIT Press, 1999)
Kelly Wise, *Lotte Jacobi* (Danbury: Addison House, 1978)

▲ 1959d

1930–1939

1930b

Georges Bataille reviews *L'Art primitif* in *Documents*, making apparent a rift within the avant-garde's relation to primitivism and a deep split within Surrealism.

By the time Georges Bataille (1897–1962)—philosopher, librarian, pornographer, critic, and editor of the dissident Surrealist magazine *Documents* (whom André Breton called Surrealism's "enemy from within")—decided to address the recently published *L'Art primitif* (Primitive Art) by French psychologist Georges Luquet, "primitivism" was no longer just the private enthusiasm of the avant-garde. In Paris especially, "primitivism" had emerged as spectacle—both at the level of high culture, as in the opera *The Creation of the World* (1923), with tribal costuming and sets by Fernand Léger and music by Darius Milhaud, and (given that the tribal could be updated in the contemporary imagination to include anything "African") at the lower end of the scale, as in the nightclub performances of Josephine Baker and in the eruption of jazz in Montparnasse bars and clubs. The newfound chic of "primitivism" also meant that tribal motifs were now a part of the world of expensive ornament, with the Art Deco palette of chrome and plastic expanded to accommodate a taste for ivory, ebony, and zebra skin.

Further, "primitivism," a term that encompassed both paleolithic and tribal art, was now understood in terms of the development of the human species ontogenetically as well as ethnically. It was the category through which to address the birth of art itself, whether in the caves at the dawn of human creativity or in the modern nursery at the onset of every child's urge to draw. This is why "primitivism" was now the province of psychologists as well as aestheticians (in his 1928 *Foundations of Art*, the French painter Amédée Ozenfant tried to operate as both). No longer a state of degeneracy or deviance, the "primitive" was not now restricted to psychiatry but had also become the concern of developmental psychology. It was "Exhibit A" in the study of the evolution of human cognitive thought.

Bringing things down

In his review of *L'Art primitif*, Bataille summarized Luquet's developmental schema. Motor enthusiasm drives both contemporary child and earliest caveman to produce a random scrawl on paper or wall; empowered by the need to find "form" in the world, the scribbler starts to "recognize" the shapes of objects within this marking; recognition leads to the intention to produce such shapes at will and a primitive mimetic drive thus begins, first conveying natural objects in a schematic way, finally (at the end of the process) rendering them in a realistic manner.

But Bataille did not agree with Luquet. According to him, it was not Narcissus bending over a pool of water who was to be found in the caves 25,000 years ago but the Minotaur, a raging beast patrolling the dark, vertiginous space of the labyrinth. The child begins to mark, Bataille argues, not out of constructive impulses but from the joy of destruction, the pleasure of dirtying. Far from disappearing, this destructive drive continues into the representational phase, and as it does so it is consistently turned against the draftsman himself as a form of self-mutilation; for, Bataille points out, in the paleolithic caves the human effigy is consistently defaced and deformed, even while animal depictions become more and more assured. Auto-mutilation, the drive toward lowering or debasing the human form, is, then, at the core of art; it is not the law of form (or gestalt) that reveals what took place at art's beginnings but rather the sway of what Bataille calls the *informe*, the "formless."

"Informe," Bataille's little text on formlessness, appeared early on in the short life of *Documents*. It was part of the "Dictionary" written collectively by members of the *Documents* group over the two-year span of the magazine. Reflexive in nature, the text addressed the very definitions of words. A dictionary, it argued, should give words *jobs* rather than meanings, with the job of the word "formless" being that of undoing the whole system of meaning, itself a matter of form or classification. By declassifying, *formless* would also "de-class" or bring things down in the world (*déclasser*). It would break the back of resemblance—in which a categorical ideal or model is copied, the one always capable of being distinguished from the other—so necessary to the possibility of gathering things together in classes: "To assert that the universe does not resemble anything and is merely formless," Bataille concludes, "amounts to saying that the universe is something like a spider or spit."

The license to shock

Bankrolled by the art dealer Georges Wildenstein, *Documents* was supposed to have been an art magazine. But from the first issue the rubric "Fine Arts" was joined on its cover by those of "Doctrines,"

"Archaeology," and "Ethnography" (a fifth section, "Variétés," promising texts on popular culture, replaced "Doctrines" from issue five). In counterdistinction to the aestheticized ethnography that gripped the Surrealist movement by the end of the twenties, the *Documents* notion of the tribal was violently antiaesthetic. The premises of the ethnographers who published in the magazine—Marcel Griaule, Michel Leiris, Paul Rivet, Georges-Henri Rivière, André Schaeffner—were antimuseum; they believed that tribal material was meaningless when taken out of context and that, far from being a matter of arresting visual forms, such material concerned a pattern of ritual and daily experience (Griaule wrote on "spitting" as a form of hygiene) that could not be frozen into the world of the vitrine and the gallery.

In adding "spit" to the catalogue of their concerns, the ethnographers could be seen as announcing an affinity with Surrealism's own defiant posture, its decision to carry a "license to shock." Indeed, with many former members of the movement having ▲ abandoned André Breton for the *Documents* circle—the painter ● André Masson, the poet Robert Desnos, the photographer Jacques-André Boiffard, to name three—Bataille's group was itself an alternative form of Surrealism, which the historian James Clifford has called "ethnographic surrealism." Like the Surrealists with their practice of automatic writing, and like the psychoanalyst in his use of free association, the *Documents* ethnographers demanded that everything should be allowed to surface. Their investigations, scientific in nature, should operate according to the law of no exclusions; they should concern everything in a culture from its highest to its lowest expressions; everything—"even the most formless"—should enter the world of ethnographic classification.

It is exactly at this point, the French critic Denis Hollier has argued, that a rift opens within *Documents* itself. For if its ethnographers thought of themselves as being shocking by attending equally to low and to high, their very act of attention strips the low of its power to shock. This is because theirs is precisely the work of *classification*, submitting "even the most formless" to the work of resemblance. Yet for Bataille, as we have seen, the "formless" resembles nothing. Lower than low, totally without example, and thus "impossible," it is that which declassifies. Bataille's concept of formless thus parts company with that of the ethnographers. "On the one hand," writes Hollier, "the law of 'no exception'; on the other, that of an absolute exception, of that which is unique but without properties."

Although he was an ethnographer, the writer Michel Leiris was closer to Bataille in many respects than to Marcel Griaule. His *Phantom Africa* (1934), the account of his participation in Griaule's 1933 expedition from Dakar to Djibouti (to study the Dogon people), was as much an exercise in personal introspection—dreams, fantasies—as it was objective reportage. Leiris was ■ also close to artists such as Joan Miró and Alberto Giacometti, writing the very first account of the latter's work for a review in *Documents*. Drawing these artists into Bataille's orbit, this connec-

tion (documented in Miró's 1927 painting *Michel [Leiris], Bataille, et moi*) was to prove fateful for both.

Taking Miró at his word when he claimed in 1927 that he wanted to "assassinate" painting, Leiris switched the discourse on ▲ Miró's dream pictures from Surrealist to formless. Accordingly, in his 1929 essay in *Documents*, he spoke of these works as being "not so much painted as dirtied," their calligrammatic drawing recoded in his eyes as graffiti. They are, he wrote, "troubling like destroyed buildings, tantalizing like faded walls on which generations of poster-hangers, allied over centuries of drizzle, have inscribed mysterious poems, long smears taking louche shapes, uncertain like alluvial deposits."

"Like a spider or spit"

When Bataille also addressed Miró's art in *Documents*, in 1930, he spoke of it as *informe*. And indeed, during the two years of Miró's entry into this orbit his rage against painting took the guise of making little constructions of objects picked out of garbage cans, or of working on collages with nails projecting from them [1]. Writing of the few canvases that Miró produced, which the artist termed "antipainting," Bataille related: "the decomposition was pushed to the point where nothing remained but some formless blotches on the cover (or, if you prefer, on the gravestone) of

1 • Joan Miró, *Relief Construction*, Montroig, August–November 1930
Wood and metal, 91.1 × 70.2 × 16.2 (35⅞ × 27⅝ × 6⅜)

2 • Alberto Giacometti, *Suspended Ball*, 1930–1 (1965 reconstruction)
Plaster and metal, 61 × 36 × 33.5 (24 × 14⅛ × 13¼)

Carl Einstein (1885–1940)

Carl Einstein is best remembered today for being the first author to have discussed African sculptures in aesthetic terms rather than as ethnographic artifacts, in his profusely illustrated and groundbreaking *Negerplastik* (Negro Sculpture) of 1915, which was widely circulated among avant-garde artists of the day. He is also credited with writing the first extensive survey of twentieth-century art—in 1926, when only a quarter of the century in question had passed! But that is just the tip of a large iceberg. An accomplished writer whose modernist novel *Bebuquin* was celebrated in many avant-garde journals soon after its publication in 1912, Einstein was also a cultural critic whose positions were often akin to that of the Frankfurt School, particularly of its most famous members Theodor Adorno and Walter Benjamin. Reacting against the traditional formalism of his professor Heinrich Wölfflin, he proposed early on an interpretation of Cubism that, resolutely opposed to its then current apology as an art of synthesis and ideation, stressed instead its heterogeneous nature and its discontinuity. Soon after his arrival in Paris in 1928, he became one of the founders and major contributors of *Documents*, and sided with Georges Bataille in the elaboration of a view of Surrealism that radically dissented from André Breton's official line. A lifelong anarchist militant, he enlisted in the Spanish Civil War in 1936 and returned to France at the victory of General Franco, where he was arrested and interned by the French government until he committed suicide to escape Nazi persecutions.

painting's box of tricks." But one cannot kill off art *and* remain an artist; by 1930–1, Miró, who had practically stopped working, had to choose. His decision was to return to painting, but in a corrosive style that carried over a *Documents* sensibility in its attack on the human body and on "good form."

Giacometti's case is even more telling in regard to the issue of primitivism, since, as a developing sculptor, his attraction to the work of Brancusi led him at first to the kind of aestheticizing primitivism that Bataille and the *Documents* ethnographers abhorred. But through Masson and Leiris he, too, entered the pages of the magazine and soon thereafter into the sensibility of the formless. The first direction this took was an attraction to the theme of the praying mantis, itself an important incarnation of the attack on form. His most achieved production of formlessness was, however, the sculpture called *Suspended Ball*, which, ironically, caused great excitement among the Surrealists when it was first exhibited in 1930 [**2**].

There, two caged forms—a recumbent wedge and a cloven ball hung, pendulum-like, from a strut at the cage's top—seem to make contact, as the ball appears to swing, caressingly, over the crescent shape below. This contact seems manifestly sexual since the forms are so genital in appearance. But the deep ambiguity that descends on them makes their gender identification a matter of constant indecision. Vulvalike, the wedge is also coded male, like the phallic knife that slices across the heroine's eye in Salvador Dalí and Luis Buñuel's film *Un Chien d'Andalou* (Andalusian Dog; 1929). Masculine in its active role, the ball's cleft also pronounces it as feminine. And the continual crisscross of this play of identification, itself imitating the metronomic swing of the structure's pendulum, results in just that act of declassifying that Bataille had termed the job of formlessness. The "impossible" condition that emerges in *Suspended Ball* is Hollier's "absolute exception," or what Roland Barthes would call, referring to a similar crossing of gender identifications in Bataille's pornographic novel *The Story of the Eye*, a "round phallicism."

The important lesson that *Suspended Ball* delivers is that the formless is not simply mess or slime. Its cancellation of boundaries is more structural than that since it involves a voiding of categories. Such a voiding is operational, active, like the swing of Giacometti's pendulum, or like the lowering from vertical to horizontal that Bataille invokes in his "Dictionary" definition when he says that the formless will "knock form off its pedestal and bring it down in

the world." Another example of such a lowering or cancellation of the difference between these spatial coordinates is the labyrinthine space of caves, where the axes of reason and of architecture no longer apply. It is from this that Bataille's love of the cave's denizen, the Minotaur, derives. Giacometti's decision in 1930 to orient his sculpture to the horizontal, making it out of nothing but what had formerly been the mere base of sculpture, emerged from this thought of the formless. The breakthrough in the history of modernist sculpture represented by a work like *No More Play* (1933), however, would be understood only in the sixties with a ▲ movement such as Earthworks.

That formlessness results from a blurring of categories, rather than from a literal clouding of shape, is once more apparent in two works reproduced in the magazine *Minotaure* (named by Bataille but controlled for the most part by Breton) in the early thirties. One of these, made as a frontispiece for the magazine, displays the Minotaur photographically, with Man Ray lighting his model so as to produce a headless torso whose arms and chest now double as the horns and brow of a bull [3]. Thus collapsing human and animal into a single "impossible" category, the seeming headlessness of the human model further implies the downward pull that goes with a loss of form. The other work, from *Minotaure*'s first issue, is also a photograph, again produced with a great precision that nonetheless yields up categorical blur. This is Brassaï's *Nude* [4], in which the female body is transgressively shot so as to project itself unmistakably as phallic, once more collapsing gender distinctions in the manner of *Suspended Ball*.

Minotaure was the site of a sequence of photoconceptual works made in a partnership between Salvador Dalí and Brassaï, all of which circle around the formless. *The Phenomenon of Ecstasy* [5], even while organizing the units of the images into a grid (that is, into the structure that announces form's drive toward order and logic), exploits the idea of a fall from vertical to horizontal and a (hysterical) collapse of upper organs (mouth, ear) onto lower ones (vagina, anus). *Involuntary Sculptures* (1933) displays the tiny results of unconscious, masturbatory gestures: bus tickets obsessively rolled in one's pockets, erasers or crusts of bread distractedly kneaded, etc. In the third work, Dalí discusses Hector Guimard's Art Nouveau metro entrances, photographed by Brassaï to demonstrate the presence within these forms of the silhouette of the praying mantis.

An embodiment of formlessness as fascinating as the Minotaur itself, the praying mantis received its most brilliant theorization from the pen of Roger Caillois, an ally of Bataille's, who wrote on the creature in the fifth issue of *Minotaure* (1934). Here formlessness moves through the channel of animal mimicry, in which insects camouflage themselves in a form of identification with their surrounding space. In the case of the mantis this takes the guise of "playing dead" as, stock still, it turns itself into a blade of grass. Although blending with the background produces its own type of categorical cancellation, as the difference between figure and ground or that between the interior and the exterior of the

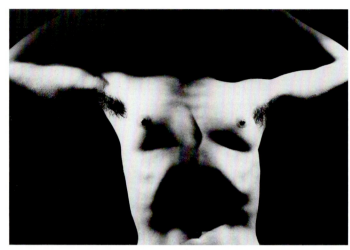

3 • Man Ray, *Minotaur*, 1934
Silver-gelatin print

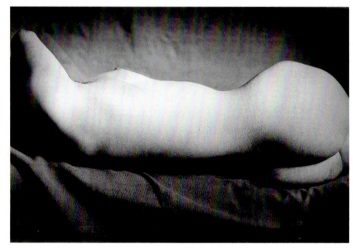

4 • Brassaï, *Nude*, 1933
Silver-gelatin print

organism seems to be erased, the mantis's "playing dead" ratchets this up yet another notch on the scale of the "impossible." For the mantis, often decapitated in its fights with others, is an insect that carries on its living duties regardless—hunting, laying eggs, building nests. Dead, it plays at life. But since among its activities when alive was the defense of playing dead, it is assumed that a dead mantis would do this, too. Thus dead, it plays at life playing at death.

The cancellation of resemblance produces the impossible instance of death playing dead. In another, later lexicon this would ▲ be called the *simulacrum*; Bataille called it the formless. RK

FURTHER READING
Dawn Ades (ed.), *Dada and Surrealism Reviewed* (London: Hayward Gallery, 1978)
Roland Barthes, "The Metaphor of the Eye," *Critical Essays* (Evanston: Northwestern University Press, 1972)
Yve-Alain Bois and Rosalind Krauss, *Formless: A User's Guide* (New York: Zone Books, 1997)
Roger Caillois, "La mante réligieuse," *Minotaure*, no. 5 (1934), translated in *October*, no. 44, Spring 1988
Dawn Ades and Simon Baker, *Undercover Surrealism: Georges Bataille and Documents* (Cambridge, Mass.: MIT Press, 2006)

▲ 1967a, 1970

▲ Introduction 4, 1977a, 1980

5 • Salvador Dalí, *The Phenomenon of Ecstasy*, 1933
Photomontage, dimensions unknown

Alberto Giacometti, Salvador Dalí, and André Breton publish texts on "the object of symbolic function" in the magazine *Le Surréalisme au service de la révolution*: Surrealism extends its aesthetic of fetishism and fantasy into the realm of object-making.

▲
•

Two challenges to traditional sculpture came in the form of the tribal artifact, as used by primitivist artists, and the everyday commodity, as used in the Duchampian ready-made. Although they are obviously different, each object seemed to possess or play on a kind of fetishistic power. The tribal artifact evoked the fetish as a ritual object, with a special life or cultic force of its own, while the readymade evoked the fetish as commercial product, the commodity fetish. According to the classic analysis of Karl Marx, capitalist production leads us to forget that commodities are made by human labor, and so we tend to endow these things with an autonomous life or power, to fetishize them in this sense as well. Part of the attraction of the tribal artifact was its very difference from a capitalist economy of commodity exchange, while part of the provocation of the readymade was its implicit demonstration that, despite its often transcendental pretenses, modern art was bound to this same economy—that like any other product it was made primarily for display and sale. With the advent of the Surrealist object, this partial typology of modernist object-making may be extended, for it involves a third kind of fetish, the sexual fetish, and part of its effect was also due to its juxtaposition of different economies of the object.

Ambivalent objects

Consider an object already cited in this book, the little slipper-spoon
■ found by André Breton in a Paris flea market. In his 1937 novel *L'Amour fou* (Mad Love), the object reminds Breton of a phrase, "Cinderella ashtray," that represents his desire for love—no doubt because of its conjoining of a spoon, a classic Surrealist emblem of woman, with a slipper, a classic sexual fetish. But this wooden spoon, Breton tells us in *L'Amour fou*, was also an object of "peasant fabrication," a crafted thing made for personal use that was outmoded, literally pushed to the flea market, by the industrial production of mass goods. Thus its service as a sign of a repressed wish or desire may be related to its status as a vestige of a displaced social formation or economic mode. That is, the Surrealist concern with "the uncanny" in subjective life, with familiar images, objects, or events made strange by repression, may be connected to the Marxist concern with "the nonsynchronous" in historical life—with

the uneven development of social relations and productive modes. The very force of Surrealist objects like the slipper-spoon may depend on this connection between subjective and social histories.

"What prepares these products to receive the investment of psychic energy characteristic of their use by Surrealism," the American critic Fredric Jameson has argued, "is precisely the half-sketched, uneffaced mark of human labor, of the human gestures, on them; they are still frozen gesture, not yet completely separated from subjectivity, and remain therefore potentially as mysterious and expressive as the human body itself." Here Jameson elaborates on an insight of the German critic Walter Benjamin, who, in his essay "Surrealism: The Last Snapshot of the European Intelligentsia" (1929), celebrated the Surrealists as "the first to perceive the revolutionary energies in the 'outmoded,' in the first iron construction, the first factory buildings, the earliest photos, the objects that have begun to be extinct." To recover such "wish-symbols of the previous century" was, for Benjamin, to redeem these "ruins of the bourgeoisie" as talismans of "dialectical thinking" or "historical awakening." This "profane illumination" was sometimes sparked by the way that a particular object might set different economies of the object into contradiction.

The first Surrealist object proposed by Breton, in his essay "Introduction to the Discourse on the Paucity of Reality" (1924), was also seen in a flea market, but only in a dream. This object was a fantastic book, with pages made of black cloth and a wooden spine carved in the form of a gnome—a remainder from an even more exotic time than that of the slipper-spoon. In this early essay, Breton stressed the *unreality* of the Surrealist object, its challenge to "creatures and things of 'reason'" and use, a definition that he likely extrapolated from a reading of the readymade. But soon Breton shifted to stress the *reality* of the Surrealist object as a sign of desire, which points to an important difference from the readymade. For though the readymade is a found object, it is rarely outmoded and never uncanny in the Surrealist sense; and though it may pun sexually, it is not invested with psychic energy in the same sense either. On the contrary, Duchamp aimed at "visual indifference," even "complete anaesthesia," in the readymade, which, unlike the Surrealist object, is "separated from subjectivity" in order that it might challenge this deepest of bourgeois beliefs about the subjective origin of all art.

▲ 1903, 1907 ● 1914 ■ 1924

Nonetheless, the Surrealist object derived from the Duchampian readymade, just as the Surrealist image derived from the Dadaist collage. Indeed, this development was an inaugural act of Surrealism, defined in the first issue of its first magazine *La Révolution surréaliste* (1924) as "any discovery that changes the nature or the destination of an object or a phenomenon." This transformation is best traced in the work of the American photographer and painter Man Ray, whose *Enigma of Isidore Ducasse* (1920), a photograph of an object said to be a sewing machine, blanketed with burlap and bound in rope, accompanied this definition in the magazine. (Ducasse, known as Lautréamont, was a nineteenth-century poet-hero of the Surrealists, who took his line—"beautiful as the chance encounter of a sewing machine and an umbrella on a dissecting table"—as an aesthetic motto.) In his days as a New York Dadaist, Man Ray produced and / or photographed several readymades, some pure, some "assisted"; respective examples of each kind are a simple eggbeater titled *Man* and its counterpart, two hemispherical reflectors divided by a glass pane pinched by six laundry pins, titled *Woman* (both 1918). The sexual puns are intended here, and they point to a transitional work titled *Gift* [1] made during his first Paris show in December 1921 (Man Ray lived in Paris until 1940). On a whim, accompanied by the composer Erik Satie, he purchased a flatiron used on coal stoves, glued a row of fourteen tacks to its bottom (most replicas show nails), and added the object to the exhibition. The sadistic charge, only implicit in the eggbeater and

pins of *Man* and *Woman*, is explicit here, as the tacks turn the readymade iron into a proto-Surrealist object. "You can tear a dress to ribbons with it," Man Ray once remarked of this work, as if to acknowledge that its sadism was directed at women. "I did it once, and asked a beautiful eighteen-year-old colored girl to wear it as she danced," he added, in a way that suggests how racial fetishism can compound sexual fetishism (as it often does in his work). "Her body showed through as she danced around; it was like a bronze in movement. It was really beautiful." But if *Gift* were only sadistic, it would not be as effective as it is; what makes it so is its ambivalence, which is twofold. In terms of its address to the viewer, the object is aggressive, but it is designated a gift; as such it literalizes the ambivalence of any present—as both an offering made and a debt incurred—an ambivalence detailed by the French anthropologist Marcel Mauss in his *Essai sur le don* (Essay on the Gift) of 1925. So, too, *Gift* is ambiguous in terms of function (most irons smooth and press; this one gouges and tears) and in terms of gender (most irons are associated with female labor; this one has penile tacks). Placed in contradiction, these aims turn the iron into the artistic equivalent of a symptom or, more exactly, of a fetish, which Freud defined as an object in which conflicted desires converge.

Objects mobile and mute

The Surrealists were among the first modernists to study Freud closely, but they also developed parallel insights, and it is not clear how much they knew of texts such as his 1927 essay on fetishism. For Freud the fetish is a substitute for the penis that the mother lacks. This lack is said to horrify the little boy who discovers it (the ambiguous case of the little girl is scanted), for it threatens him with this "castration" too, and so he turns to penile surrogates, that is, to fetishes, to maintain his fantasy of bodily wholeness, of phallic power. Thus fetishism is a practice of ambivalence in which the male subject both recognizes and disavows castration or any such traumatic loss. This ambivalence may split the subject, to be sure, but it may also split the fetish into an ambivalent object—both "memorial" to castration and "protection" against it. This is why, according to Freud, the fetish often registers both "hostility" and "affection," and why, apart from all the sexual desire displaced onto it, it is such a fraught thing.

The Surrealists were intrigued by this scenario, which they put into play in images and objects alike. For example, Surrealist photographs of nudes often oscillate between fragmentary parts and fetishistic wholes, in which the female body appears castrated and castrative one moment, only to appear integral and phallic the next. But castration anxiety and fetishistic defense are most focused in Surrealist objects—those by Alberto Giacometti above all others. It is as though some of his objects aim to suspend the castration that defines sexual difference in Freudian theory, or at least to render sexual reference ambiguous (as in *Suspended Ball*); Others seem to disavow this castration fetishistically (such as the two *Disagreeable Objects* [1930–1]), while still others appear to

1 • Man Ray, *Gift*, 1921
Iron, nails, 17 × 10 × 11 (6⅝ × 3⅞ × 4⅜)

▲ 1918, 1924, 1930b

▲ Introduction 1, 1930b ● 1930b

punish its female representative sadistically (such as the insectoid *Woman with Her Throat Cut* [1932]), with "horror at the mutilated creature or triumphant contempt for her" (Freud). At least for a few years Giacometti was able to turn the psychic ambivalence in fetishism into a symbolic ambiguity in object-making.

For the December 1931 issue of *Le Surréalisme au service de la révolution*, Giacometti sketched seven objects under the rubric *objets mobiles and muets*. This is a strange designation: it evokes things uncannily alive, mobile with desire but mute with repression. At least five of the objects were subsequently executed, while the other two evoke scenarios of sex and / or sacrifice also characteristic of Giacometti. In the drawing, a hand nearly touches the phallic form, as if to test the taboo against touching the desired thing (whether this be a totem animal, a sexual object, or an art work), that is, as if to point to the complementary relation between desire and prohibition, transgression and law, that structures the ambivalence of these works. Giacometti titled this object "disagreeable," as he did another one, also pictured in the drawing,

in which the phallic form is cut by a plane; but it is difficult not to hear the word "agreeable" here as well. For both objects are at once "agreeable" as fetishes and "disagreeable" as shapes that nonetheless evoke castration. In its executed form, the first *Disagreeable Object* seems almost animate, an embryonic body with eyes, an object that suggests its own series of ambivalent associations (penis, feces, baby …) analyzed elsewhere by Freud in terms of objects of feared loss. And recognition of castration does appear to be inscribed here in the form of the spikes: "hostility" for the fetish is indeed mixed with "affection."

This mixing of the agreeable and the disagreeable, the fetishistic and the castrative, is also at work in the most famous Surrealist object of all, the fur-lined teacup, saucer, and spoon made by the young German-Swiss Surrealist Meret Oppenheim (1913–85) in 1936. Such objects have stories—they are the precipitates of charged narratives—and the story here is this: one day at the Café de Flore in Paris, Oppenheim happened to show Picasso her design for a bracelet lined with fur, to which he replied that anything,

2 • The Galerie Charles Ratton, Paris, at the time of the "Exposition surréaliste d'objets," in May 1936

▲ Introduction 1

"even this cup and saucer," could be so covered (it is telling that by the mid-thirties such objects had already become not merely a genre of art but a style of jewelry). When Breton invited Oppenheim to exhibit in the 1936 "Exposition surréaliste d'objets" at the Galerie Charles Ratton [2], she bought a tea set at a department store and lined each object (including a spoon for good measure) with the fur of a Chinese gazelle. Breton then titled the work *Déjeuner en fourrure* (*Luncheon in Fur*), a fitting homage to the painting by Édouard Manet *Déjeuner sur l'herbe* (Luncheon on the Grass) of 1862–3, as well as to the novel by Leopold von Sacher-Masoch *Venus in Furs* (1870; it was Sacher-Masoch who lent his name to the term "masochism"). For *Déjeuner en fourrure* is a still life-cum-nude, a witty disturbance of teatime propriety through a smutty allusion to female genitalia that plays ambivalently on oral eroticism as well. It also sends up the Freudian fetish, mocks it through excess, as if to fling its masculinist bias in the face of the male viewer. One senses the joy of power reversed in this well-played joke, a Venus in Furs who delights in her sadistic ploy. But the sadistic position, Freud tells us, can quickly turn into its masochistic double, and this reversal is suggested by another fetish contrived by Oppenheim in 1936, *Ma gouvernante—My Nurse—Mein Kindermädchen* [3] (her title implies that fetishism is not specific to gender or language). In his 1927 essay, Freud uses the bound feet of aristocratic women in old China as an example of the mixing of contempt and reverence in the fetish. Here Oppenheim offers us bound white high heels, a classic fetish in any case, turned over and cuffed in twine, an apparent trophy-testimonial of the sadism of men and the masochism of women. But this woman has garnished these heels with tassels and served them up on a silver platter, as if to subvert the sadistic position through sheer delight in the masochistic one; and indeed, in the sadomasochistic contract, the masochist is the person in control.

Lost objects

By 1936 the fetish had begun to be a cliché in the hands of Surrealists who seemed to script objects after Freud. Salvador Dalí in particular was chastised by Breton for "the voluntary incorporation" of psychoanalytic interpretation into art in a way that weakened its effect. For Breton this scripting immobilized desire rather than motivated ambivalence, and yet he sought such a fixing, too. For he also held that every desire has a distinctive object, which chance would deliver as punctually as it had his slipper-spoon in the flea market. But the French psychoanalyst Jacques Lacan, who was a young associate of the Surrealists, has shown this idea of satisfied desire to be wishful thinking. In his account, need (the need of the infant, say, for maternal milk) can be satisfied, but desire (the desire of the infant, say, for the absent breast) cannot be satisfied, for its object is precisely lost (desire would not arise otherwise) and can only be re-created in fantasy. On the one hand, then, as Freud remarked, "the finding of a [sexual] object is in fact a refinding of it." On the other hand, as

3 • Meret Oppenheim, *Ma gouvernante—My Nurse—Mein Kindermädchen*, 1936
Metal, paper, shoes, and string, 14 × 21 × 33 (5½ × 8¼ × 13)

Lacan suggested, this refinding is forever a seeking: the object cannot be regained because it is phantasmatic, and desire cannot be satisfied because it is defined in lack. From this perspective, the Surrealist object is impossible in a way that most Surrealists never grasped, for they continued to insist on its discovery—on an object adequate to desire.

This confusion also comes into focus in the flea-market episode of the slipper-spoon, where Breton recounts how Giacometti made *Invisible Object* (*Hands Holding the Void*), otherwise known as *Feminine Personage* [4]. This figure was born of a romantic crisis, Breton tells us, and Giacometti had trouble with the hands, the head, and, implicitly, the breasts, which he resolved only when he discovered a strange helmet-mask at the market. For Breton this is a textbook case of a perfect match between desire and object. But in fact *Invisible Object* evokes the opposite condition, the *impossibility* of the lost object regained. With its cupped hands and blank stare, this feminine personage shapes "the invisible object" in its very absence; such is the eerie pathos of this alienated supplicant. In this way the Surrealist object is not only a fetish that covers

▲ 1924

4 • Alberto Giacometti, *Invisible Object (Hands Holding the Void)*, 1934
Bronze, 153 × 32 × 29 (60⅝ × 12⅝ × 11⅜)

5 • Joseph Cornell, *Soap Bubble Set*, 1947–8
Construction, 32.4 × 47.3 × 7.6 (12¾ × 18⅝ × 3)

up a lack; it is also a figure of this lack, an analogue of the lost object keyed to the maternal breast, as the invisible object is keyed here. We arrive, then, at this paradoxical formula of the found object in Surrealism: a lost object, it is never recovered but forever sought; always a substitute, it drives on its own search.

Faced with this difficulty, Giacometti turned back from traumatic fantasy to mimetic representation as the source of his art: "I worked with the model all day from 1935 to 1940." Yet, charged by fetishistic ambivalence, his Surrealist objects of the early thirties remain the high point of this practice. Too often in other hands these tableaux of "mobile and mute objects" became tabulations of inert and talky things. For example, in the same issue of *Le Surréalisme au service de la révolution* Dalí presented a tabulation of Surrealist objects that attempts to be absurd (he lists objects as "transubstantiated," "projected," "wrapped," and so on), to derange any order of things. But a "table" remains beneath such tabulations to arrange them, just as a table remains to support the "chance encounter of a sewing machine and the umbrella" in the line from Lautréamont. Often this table is one of display—many Surrealist objects appear in boxes or vitrines—and this display is not so alien to modes of exhibition in a gallery or indeed in a store. The objects in the celebrated 1936 show of Surrealist objects have circled back in this way to a setting like a flea market: these once-strange fetishes have once again become bric-à-brac for sale.

The Surrealist theater of fantasy was developed most effectively by the American Joseph Cornell (1903–72). Modeled on old dovecotes, slot machines, and the like, his boxes adapt the cage and gameboard models of Giacometti, and they often mix the uncanny and the outmoded in Surrealist fashion. But even as these "philosophical toys" create an aesthetics of wonder—dream spaces where sand and stars, or soap bubbles and moon maps, seem to touch [5]—they amuse more than amaze. So too, even as they deal with loss, they smooth it over nostalgically more than activate it traumatically. Thus, however disparate his objects, Cornell allows subjectivity to cohere through the medium of memory. And although desire courses through some of his boxes (several are titled "hotel," and a few are posted with glamorous stars), in other boxes this desire often seems solitary and onanistic, and sometimes disconnected and dead (several are titled "museum," and a few hold stuffed birds). Here the Surrealist object arrives at another destination—not a display where disagreeable objects have become agreeable knickknacks, but a reliquary where the subject haunts its desire like a ghost. HF

FURTHER READING
Walter Benjamin, "Surrealism: The Last Snapshot of the European Intelligentsia" (1929), *Reflections*, trans. Edmund Jephcott (New York: Harcourt Brace Jovanovich, 1978)
André Breton, *Mad Love* (1937), trans. Mary Ann Caws (Lincoln, N.E.: University of Nebraska-Lincoln, 1987)
Hal Foster, *Compulsive Beauty* (Cambridge, Mass.: MIT Press, 1993)
Rosalind Krauss, *The Optical Unconscious* (Cambridge, Mass.: MIT Press, 1993)
Rosalind Krauss and Jane Livingston, *L'Amour fou: Surrealism and Photography* (New York: Abbeville Press, 1987)

▲ 1959c

1931 b

As Joan Miró reaffirms his vow to "assassinate painting" and Alexander Calder's delicate mobiles are replaced by the stolid stabiles, European painting and sculpture display a new sensibility that reflects Georges Bataille's concept of the "formless."

In "Surrealism and Painting," his magisterial four-part survey of the art fundamental to the Surrealist project, published in *La Révolution surréaliste* between 1926 and 1928, André Breton acknowledged the centrality of both Pablo Picasso and Joan Miró for the cultural presence of the movement. For Breton, Miró was both the naive, childlike artist (spattering; nursery images; finger painting) and, at the same time, the consummate formalist, "giving himself up utterly to painting, and to painting alone." "Painting and painting alone" acknowledges the transparent blue veils of the Mirós of the mid-twenties, often called "dream paintings"—their evanescent backgrounds a spontaneity of spills and liquid washes, their drawing the finest of webs, so as not to interrupt the luminous atmosphere with graphic compartments that would dam the flow. This desire to avoid the interruptive contours of solid figures led Miró to "draw" on his canvases in spidery writing. As with the *calligramme*, invented by Guillaume Apollinaire, the task of "reading" these pictures disrupts and buries that of "seeing."

By 1927, calligrammatic paintings had moved to the center of Miró's work, as he wrote phrases or poems over the translucent grounds: *Étoiles en des sexes d'escargots* (Stars in the shape of snails' sexual organs); *Le Corps de ma brune* (My brunette's body); *Un oiseau poursuit une abeille et la baisse* (A bird chases a bee and kisses it). The term "dream painting" derives from a raw-canvas work with a blue splotch near its center, under which, in calligrammatic fashion, is written *ceci est la couleur de mes rêves* ("this is the color of my dreams") [1].

The product of a Catalan painter fascinated by the landscape of northern Spain, Miró's earliest paintings are haunted by the presence of a horizon line separating field from sky. It is not surprising, then, that in his later drive to acknowledge the surface and structure of painting formally, Miró would bisect the canvas in such works as *Catalan Peasant* [2], not only producing the cross-axial arrangement of a Catalan figure transecting a horizon line, but also making the cruciform armature a reference to the oblong

1 • Joan Miró, *Photo – ceci est la couleur de mes rêves*, Montroig, July–September 1925
Oil on canvas, 96.5 × 129.5 (38 × 51)

▲ 1924 ● 1912

frame of the picture (a schematized version of the Cubist grid). In an untitled painting of 1925, the entirely blue wash of the ground thickens slightly to indicate the same presence of the "horizon"—but the only "figure" against this azure ground is a tiny white dot in the upper left corner, like a star appearing against a midnight sky.

These and other "dream paintings" from the twenties are indeed marked by a luminous, dreamlike quality, and a light, seemingly automatic spontaneity that suggests that what the works provide is a transparent "window" onto the sleeping unconscious. *The Birth of the World* of 1925 [3], for example, can be likened to the freely made
▲ dripped whorls of Jackson Pollock in the late forties, abstract and monumental yet incandescent; while the canvas's spontaneous runs of color testifying to the rapidity of its execution resemble those of Abstract Expressionist painters such as Arshile Gorky and
● Willem de Kooning working at the same time. But by this point, in the forties, Miró's "dream paintings" had become methodical, deliberate, even if they remained "childlike." The very name *Constellations*, for a series in the early part of the decade, reminds the viewer of the earlier nocturnal skies, even though the playful shapes of the constellations are opaque, with eyes that seem to challenge the viewer. (These motifs presage Miró's later work, in which the misty surfaces are punctuated by colorful cartoon characters surrounded by the familiar language of stars and exclamation points.)

Between the delicate luminosity of the "dream paintings" and the formal clarity of the *Constellations* came a series of works that Miró created after he had proclaimed his desire to "assassinate painting," an abrupt and surprising determination he made first in 1927 and repeated in a 1929 letter to his friend Michel Leiris, and then again, forcefully, in an interview with Madrid journalist Francesco Melgar in 1931. As visually seductive as the "dream paintings" are, the collages that followed, such as *Head of Georges Auric* of 1929 and *Rope and People I* from 1935 [4], assault the eye. Incorporating coarse sandpaper and aggressively twisted rope, they repudiate the delicacy of the twenties. The corrosive tactility of sandpaper is far from the nocturnal atmosphere of the blue paintings; in addition, the violence associated with the heavy rope disrupts the luminous "dream," both disturbances tolling a death knell to the *visual* at the heart of painting. Declaring them "anti-paintings," Miró acknowledged the way the new collages tore apart the formal coordination of figure and frame through which his "dream paintings" had enacted their allegiance to pictorial structure. The first thing he disavowed in his letter to Leiris was color: "The charm and music of colors [are] the final stage of degeneration," he wrote, adding, "This is hardly painting, but I don't give a damn." In his 1931 interview, he explained, "I was painting with an absolute contempt for painting.… I was feeling aggressive but at the same time I was feeling superior … I felt contempt for my oeuvre."

2 • Joan Miró, *Head of a Catalan Peasant I*, Montroig, Summer–Autumn 1924
Oil on canvas, 146 × 114.2 (57½ × 45)

3 • Joan Miró, *The Birth of the World*, Montroig, late Summer–Autumn 1925
Oil on canvas, 250.8 × 200 (98¾ × 78¾)

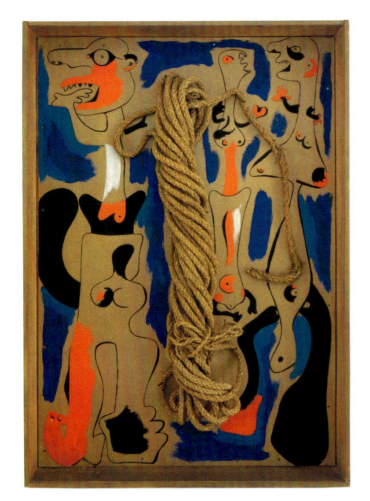

4 • Joan Miró, *Rope and People I*, Barcelona, March 27, 1935
Oil on cardboard mounted on wood, with coil of rope, 104.7 × 74.6 (41¼ × 29⅜)

Down in the world

Miró's transformation from dream to antipaintings coincided with his defection from the Surrealist orbit to join the group gathered around Georges Bataille, the editor of the avant-garde journal *Documents* and the man Breton resented as Surrealism's "enemy from within." This enemy not only lured away some of the most important members of Breton's coterie (Artaud, Masson, Soupault, Limbour, Leiris, and Miró himself), but also produced the pornographic work that was as far as possible from Breton's notion of "convulsive beauty": the novel *L'Histoire de l'oeil* (The Story of the Eye), published in 1928, which Roland Barthes characterized as producing a "round phallicism," thus standing as a pornographic book that trades in the impossible cancellation of the difference between man and woman.

It was Bataille who coined the term *l'informe*, a concept developed in *Documents* that celebrated the blurring of distinctions, such as the visual differentiation of figure from ground, inside from outside, or anatomical differences: male from female; head from toe; hand from foot—the very differences on which formal or semantic order depends. He added that his concept was about not only declassifying, but also declassing: "knocking things off their pedestals," as he put it, "and bringing them down in the world."

"Down in the world" certainly characterizes the Mirós that Bataille reproduced in *Documents* for his 1930 article on the artist. The works he chose replace the formal clarity of the early "dream paintings" with the newer "antipaintings," one of them a flaccid face in profile surrounded by graffiti-like scrawls from 1930, another a sexually explicit couple of the same year. In familiar fashion, Bataille celebrated the antipaintings as so many wreathes placed "on the gravestones of painting's box of tricks."

Shortly after Bataille's essay on his work, Miró began a series of drawings depicting shapeless creatures with enormous toes sprouting from their sides. More specific than the general concept *l'informe*, the prominence of the toes seems to acknowledge Bataille's essay "The Big Toe," published in *Documents* in 1929. Bataille begins by counterintuitively claiming that "the big toe is the most *human* part of the human body." This, he explains, is because the toe has stopped being prehensile, like the toes of gorillas or apes, such that, instead of clinging to vines so as to swing over the Earth, its newfound rigidity allows the human biped "to raise himself straight up in the air," hence giving "a firm foundation" to the erectness of the human form. The big toe is thus a hinge between rising and grounding, its lowered condition being *not* only its dirtiness but its deformation by corns and bunions. The foot is therefore abased, disgusting. But it is also seductive, a sexual fetish. Bataille ends the essay with "A return to reality … means that one is seduced in a base manner, without transpositions and to the point of screaming, opening his eyes wide: opening them wide, then, before a big toe."

In his 1972 essay "Outcomes of the Text," Barthes weaves the counterlogic of formlessness into the rest of Bataille's attack on classification, which is so insistently at work in "The Big Toe." The human body's meaning depends on the anatomical oppositions not only between man and woman or head and toe, but also mouth and anus (Barthes takes advantage of the fact that in French, *sens* translates as both "meaning" and "direction"). "Where does the body begin?", Bataille opens his little article "Mouth." Man has a prow, he wrote, like a ship organized along the horizontal axis that separates masthead from stern, or the human body along the axis of mouth to anus. Barthes cautions the reader against understanding Bataille's arguments as psychoanalytical (collapsing the aggressiveness of the toe into a mere fetish). Psychoanalysis gives *meaning* to the human anatomy: the body organized according to erogenous or libidinal zones whose *meaning* produces infantile development; Bataille's insistence on the *low* works against these classifications, as when a tennis player "wrong foots" his opponent by hitting the ball behind him (the French term is *déjouer*).

Miró's new association with the *Documents* group thus makes it unsurprising that he would fill a sketchbook in the mid-thirties with figures sporting monstrous toes, as well as producing the sexually explicit *Woman in Revolt* of 1938, conceived as if in demonstration of Bataille's disruption of the *meaning* of the human anatomy. The woman's leg extends directly from her belly and feminine sexual organ only to terminate in the toe rendered as an enormous phallus.

▲ 1930b ● Introduction 3

5 • Alexander Calder, *Mercury Fountain*, 1937
Steel rod, sheet steel surfaced with pitch, mercury, height 259 (102)

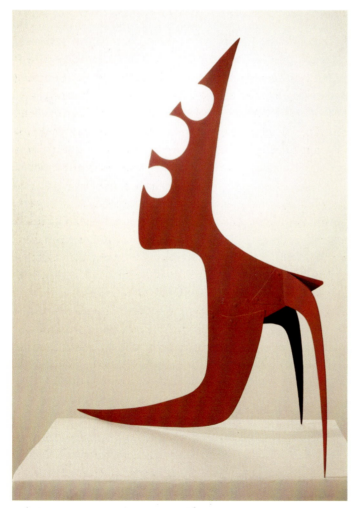

6 • Alexander Calder, *Portrait of the Artist as a Young Man*, c. 1945
Painted sheet metal, 88.9 × 68.6 × 29.2 (35 × 27 × 11½)

Toward the formless in sculpture

Miró was joined in this descent toward the low and *l'informe* by his friend the American sculptor Alexander Calder, whose work of the twenties was similarly playful and intuitive (he wrought a miniature group of animals and jugglers out of twisted wire), but also weightlessly transparent, as though the bronze cast or wooden block of traditional sculpture would weigh his invention down. The airborne cascades of floating color developed in the works of the early thirties, received enthusiastically as "mobiles," thus linked hands with the "dream paintings" in a seemingly light-▲ spirited parallel. Further, the mobiles' affinity with El Lissitzky's *Proun* paintings, in which polygonal shapes buoyantly hover above a gridded ground, indicates Calder's drive to make the waves of his weblike struts imply a set of organized, even if virtual, volumes.

But Calder was soon to "assassinate" his own joyous inventions when, in *Mercury Fountain* of 1937 [5], poisonous metal sluiced over the channels of his sculpture's recumbent armature in a defiant response to the murderous, fascist war in Spain. It was the Spanish government that had asked Calder to contribute this work for the International Exhibition in Paris, to build a fountain in
● which mercury flowed, rather than water, since the Republicans wanted to highlight their stand against Franco's siege of the Almaden region of Spain, which supplied more than sixty percent of the world's mercury. These mercury mines served as a symbol of the country's national pride. *Mercury Fountain*, Calder's first major commission, and a popular attraction at the exposition, was installed near Picasso's *Guernica*, laying before the Picasso as if paying homage to its shriek of protest. On the floor above, Miró added his own recent change of tone to the triumvirate's response to the ominous politics of thirties Europe with his mural-sized *The Reaper* (also known as *The Catalan Peasant in Revolt*).

The new solidity of *Mercury Fountain* issued into the large-scale public monuments Calder then went on to fashion. Brushing aside the mobile visual vocabulary, these hulking behemoths—more like dinosaurs or giant reptiles—acquired the name "stabiles" (courtesy of Hans Arp) [6]. Whereas his mobiles had addressed the intimacy of the home, in which they floated (even in cheap unauthorized reproductions) over dining table or crib, the trans-formation to the stabile's ponderous immobility might be seen as an anxious withdrawal from privacy in an imperative to gather civic populations around the symbolic fora of city hall or public space. Perched on civic plazas or city squares, these unex-pected, incongruous orange forms received an enthusiastic reception from the public. One, *La Grande Vitesse*, became a municipal logo, embossed on official stationery and—even stranger—on urban garbage trucks in Grand Rapids, Michigan, whose population took this exact pride in their stabile [7].

Perhaps the positive popular reception of the stabiles was in part because of their apparent celebration of heavy industrial produc-tion, their planes and phalanges bolted together like architectural beams or the struts of bridges. To contemporary critical sensibilities,

▲ 1926, 1955b ● 1937a, 1937c

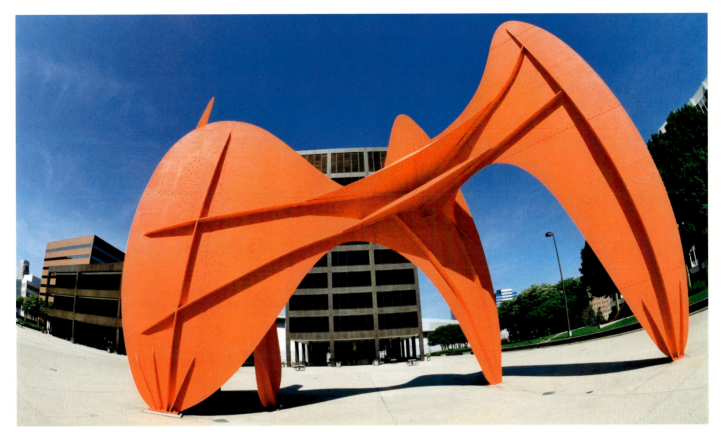

7 • Alexander Calder, *La Grande Vitesse*, 1969
Painted steel plate, width 1676.4 (660)

however, this heaviness is exactly what rendered them reactionary, since earlier, Cubist constructed sculpture had evolved a style of open, suggestive forms through which space could circulate. Evolving out of this collage-based vocabulary, Julio González fashioned iron constructions in the thirties, which he dubbed "drawing in space." It was David Smith who revised the stolid opacity of the stabiles with the luminous surfaces of his monumental series of *Cubis*—stainless steel corrosively polished to shimmer in the sun. Thinking of the *Cubis*, Constructivism, and Bauhaus design, Clement Greenberg celebrated the new sculptures' rejection of opacity, and welcomed the way new technology, with its use of transparent Lucite and its open steel armatures, released forms into what he called "the continuity and neutrality of a space which light alone inflects, without regard to the laws of gravity." In this, Greenberg saw abstract sculpture adopting a form of opticality that "brings anti-illusionism full circle." Now, he concluded, "instead of the illusion of things, we are offered the illusion of modalities: namely that matter is incorporeal, weightless, and exists only optically like a mirage."

A screaming fall

In the parallel being drawn here between Miró's and Calder's evolution in the thirties, one might think of the stabiles as something fallen, expressively inert—the buoyant mobiles fixated on the ground. If the mobiles' transparency and color had addressed the erectness of the human body, with the plane of the eyes riding atop the upright skeleton, this relates more to the analysis of Sigmund Freud than of Bataille. In *Civilization and its Discontents*, published in 1930, Freud addresses the decisive moment when humans stood up, their newfound erectness liberating their perceptual organs, such as their eyes, from the horizontality of the animal, whose heightened olfactory sense is a function of its orientation to the ground as it paws and sniffs after its partner. Through the distance it entails between subject and object, this newly autonomous visual sense, Freud argues, suddenly frees man to experience Beauty. The separation of the subject from his prey institutes a distance that overcomes the libidinal imperative of the sexual organ, elevating the body, sublimating the subject's senses. Indeed, for Freud, the very possibility of Beauty is a function of the human's upright liberation from the ground. Miró's luminous "dream paintings" and Calder's diaphanous mobiles had addressed the human subject's elevation, securing this *visual* experience, this transcendence of the grounded viewer. Their "antipaintings" and stabiles, however, reflected a new interest, following Bataille's formlessness, in degradation and abasement.

Nothing captures the attack on painting's commitment to *form* better than Bataille's essay "Rotten Sun," written for the 1930 issue of *Documents* in homage to Picasso. Like the argument of "The Big Toe," Bataille's little text stresses the question of elevation by calling the sun the "most abstract object." Its abstraction derives, he wrote, from the impossibility of staring at the sun directly. Such

▲ 1912　● 1945　■ 1914, 1921b, 1923

fixation, he adds, causes madness, "because it is no longer production that appears in light, but *refuse* or combustion, adequately expressed by the horror emanating from a brilliant arc lamp. In practice," Bataille continues, "the scrutinized sun can be identified with a mental ejaculation, foam on the lips, and an epileptic crisis." He goes further in another essay, "The Pineal Eye," in which he wants to project the body, "drunk with the sun" into a "sickening despair of vertigo." Further, the presence of the pineal eye's fascination with the sun manifests itself through a violent eruption that would decapitate the body itself. As Bataille conceives it, "the sun has been mythologically expressed by a man slashing his own throat, as well as by an anthropomorphic being *deprived of a head.*" He associates the vertiginous, decapitated body with Icarus, whose "aspiration towards ascent only led to his 'screaming fall.'"

Bataille's readers could hardly imagine a Picasso who would traffic in an epileptic "foam on the lips." Equally, for us today, thinking about Picasso as we do, it is puzzling to conceive his work through the image of the body's transformation of "itself into a vertiginous fall in celestial space, accompanied by a horrible cry,"

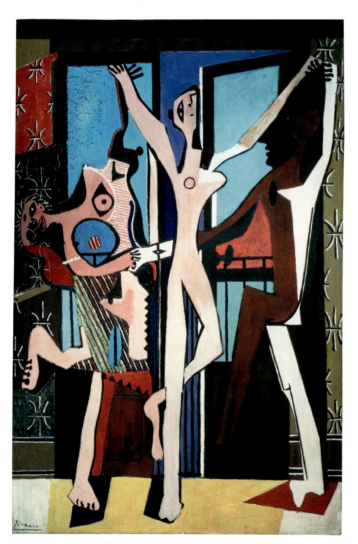

7 • Pablo Picasso, *The Three Dancers*, 1925
Oil on canvas, 215.3 × 142.2 (84^{13}/$_{16}$ × 56)

as Bataille put it. But in two paintings from 1929, *The Swimmer* and *Nude Standing by the Sea*, Picasso does indeed portray the vertiginous body in a vortex as—practically headless—it spins from high to low. "Rotten Sun" was illustrated by neither of these, but, instead, by the great 1925 painting *The Three Dancers* [8]. Bataille's choice of the work to accompany his text is especially suggestive. The leftmost dancer appears daemonic, a Maenad, as the terrible grimace on her face, atop a body collapsing towards the ground, echoes the gaping hole in her chest as if signaling an eruption—indeed, as if projecting *outside the self* a part of oneself. Nothing could accord more aptly with "projecting outside the self a part of oneself" than automutilation: biting off a finger (as in one psychiatric case that Bataille cites) or cutting off an ear (as in the notorious instance of Vincent van Gogh). In both of these cases, the practice of staring directly at the sun was diagnosed as a symptom of an incurable madness. Bataille links this madness to a stupefaction in the viewer by the sun's dazzling elevation, as of that of a god, to which men are driven to offer a sacrifice. This spirit of sacrifice, Bataille writes, "of which the automutilation of madmen is only the most absurd and terrible example [then demands] the rupture of personal homogeneity."

In the thirties, the very moment of "Rotten Sun," Picasso turned from Cubism to an imitation of Old Master art, with drawings celebrating Ingres and paintings modeled on Velázquez or Delacroix. It is not surprising that Bataille would dismiss as "academic" such a return to classicism, with its implication of balance and its move in direct opposition to the madness and vertigo of the "rotten sun." Indeed, Bataille is aware not only of the received ideas that his treatment of Picasso violates, but also of the dangers of applying his own theoretical categories to works to art: "It would be ridiculous," he warns, "to try to determine the precise equivalents for such movements in an activity as complex as painting." Nonetheless, Picasso's work seems to stand for what Bataille understands as the dominant spirit of the art of his time. He ends "Rotten Sun" by perversely exulting: "In contemporary painting, however, the search *for* that which most ruptures elevation, and *for* a blinding brilliance, has a share in the elaboration or in the decomposition of forms, though strictly speaking this is only noticeable in the paintings of Picasso." RK

FURTHER READING
Roland Barthes, "The Metaphor of the Eye," *Critical Essays* (Evanston: Northwestern University Press, 1972)
Georges Bataille, *Visions of Excess*, trans. Allen Stoekl (Minneapolis: University of Minnesota Press, 1985)
Yve-Alain Bois and Rosalind Krauss, *Formless: A User's Guide* (New York: Zone Books, 1997)
Hal Foster, *Compulsive Beauty* (Cambridge, Mass.: MIT Press, 1993)
Dawn Ades and Simon Baker, *Undercover Surrealism: Georges Bataille and Documents* (Cambridge, Mass.: MIT Press, 2006)
Rosalind Krauss, *Passages in Modern Sculpture* (New York: Viking Press, 1977; reprint, Cambridge, Mass.: MIT Press, 1981)

1933

Scandal breaks out over the portrait of Lenin by Diego Rivera in the murals for the Rockefeller Center: the Mexican mural movement produces public political mural work in various American locations and establishes a precedent for political avant-garde art in the United States.

The Mexican mural movement was a state-sponsored, ideologically driven avant-garde of the twenties and thirties whose primary goal was to reclaim and re-create a Mexican identity based on Mexico's precolonial past. Diego Maria Rivera (1886–1957), David Alfaro Siqueiros (1896–1974), and José Clemente Orozco (1883–1949) exerted an enormous influence not only in their native Mexico but also internationally, especially in the United States.

The movement emerged at the end of the Agrarian Revolution of 1910–20, which pitted peasants, intellectuals, and artists against dictator Porfirio Díaz and the big landowners and foreign investors he supported. After ten years of civil war, the inauguration in 1920 of President Alvaro Obregón, a former revolutionary leader, reformist, and art lover, ushered in a period of hope and optimism. This Mexican renaissance was greatly assisted by the philosophical idealism of the Minister of Education, José Vasconcelos, who believed passionately that public art could be a vital component in his mission to educate and enthuse the public and garner support for the new government. It was Vasconcelos who initiated the government's mural program, making him, in a very real sense, the founder of the movement. Vasconcelos and the postrevolutionary government hoped that by collaborating with artists on cultural reforms, the Mexican people would be empowered to participate in the development of the nation and the creation of a new national, cultural and intellectual identity. Vasconcelos and most of the artists involved in the mural movement believed that this could be best achieved by drawing on their shared heritage rather than on the colonial past which had divided them.

Artists thrilled to the challenge of creating a new national art and cultural identity, and many returned to, or visited, Mexico to take part. One of the first was French-born part-Mexican Jean Charlot (1898–1979), who explained how the choice of style and subject all had social and political significance for Mexican artists:

Divergent points of view in aesthetic matters contribute substantially to the pulling apart of Mexico's social classes. The Indian preserves and practices pre-Hispanic art. The middle class preserves and practices a European art qualified by the pre-Hispanic or Indian. The so-called aristocratic class claims its art to be pure European.... When native and middle class share one criterion where art is concerned, we shall be culturally redeemed, and national art, one of the solid bases of national consciousness, will become a fact.

Vasconcelos did not stipulate any particular style or subject matter, but most of the muralists adopted a mode of nationalist social realism, which drew on pre-Hispanic art forms and featured Mexican heroes and people. A respect for native traditions and popular history informed their art, as did an exploration of their Indian background. This did not, however, preclude an engagement with European modernism, for the new generation wanted to create a new, national art that was at once independent, socially committed, populist, and avant-garde. The quest also involved being able to communicate these revolutionary ideals to a largely illiterate audience in order to carry them along.

Important precursors of the mural movement included the painters Francisco Goitía (1882–1960) and Saturnino Herrán (1887–1918), who early in the century were beginning to develop a specifically Mexican art through their powerful, often tragic, scenes of the indigenous Indian population and events in Mexican history. The satirical caricatures and often harsh propagandist images for newspapers and prints of engraver José Guadalupe Posada (1852–1913) were a major influence on many of the future muralists, including Rivera and Orozco, for their style and content and their existence as a genuinely popular art form [1]. Another important figure was the artist Dr. Atl (Gerardo Murillo Cornado, 1875–1964). As a teacher at the Academy of San Carlos, he inflamed his students with his revolutionary ideals, his anticolonialism, and his fervent belief in the necessity of creating a national, modern art in Mexico that incorporated the "spiritual" qualities of Renaissance frescoes.

To these Mexican influences were added those of the Italian Renaissance and an awareness of Cubism, Futurism, Expressionism, Postimpressionism, Surrealism, the neoclassicism then ▲ sweeping through Europe, and the ideas of Marx and Lenin. Rivera, for instance, spent the years of the revolution in Europe, mostly in Paris, absorbing the various avant-garde developments. Siqueiros met up with Rivera in Paris in 1919: they discussed the revolution, modern art and the need to transform Mexican art with a social art movement.

▲ 1903, 1906, 1907, 1908, 1909, 1911, 1912, 1919, 1924, 1931b, 1934a

In 1920, Vasconcelos, then Rector of the University of Mexico, suggested to Rivera that he go to Italy to study the art of the Renaissance, hoping that this might provide the genesis of an art suitable for postrevolutionary Mexico. Rivera spent the next seventeen months studying the work of Giotto, Uccello, Mantegna, Piero della Francesca, and Michelangelo, among others. The epic scale of Italian Renaissance religious art and its power to educate and awe illiterate masses was to be an important example for those who would shortly become the Mexican muralists.

Vasconcelos's mural program was launched in 1921, and at his request, Rivera returned to Mexico to take part. In the same year, Siqueiros published his "Manifesto to the Artists of America" in the sole issue of *Vida Americana*. In it he proclaimed that they should "create a monumental and heroic art, a human and public art, with the direct and living example of our great masters and the extraordinary cultures of pre-Hispanic America." Early in 1922, Rivera began work on his first mural commission at the Amphitheater Bolivar of the National Preparatory School in Mexico City and joined the Communist Party. In September, Siqueiros returned to Mexico, joined the Communist Party, and with the support of Orozco, he and Rivera helped found the Union of Technical Workers, Painters, and Sculptors. In 1923, Siqueiros and Orozco received their first mural commissions, also for the National Preparatory School [1].

Under the auspices of the new Union, Siqueiros formulated a new manifesto which outlined the revolutionary ideology of the fledgling mural movement. Signed by a majority of the mural artists, it was published in 1924. Echoing the language of the Soviet ▲ Constructivists, "A Declaration of Social, Political, and Aesthetic Principles" proclaimed:

> We repudiate so-called easel painting … because it is aristocratic, and we praise monumental art in all its forms, because it is public property … art must no longer be the expression of individual satisfaction which it is today, but should aim to become a fighting, educative art for all.

This manifesto crystallized the principles of the mural movement and helped define it as a public, ideologically driven, didactic art. Although broadly speaking, the muralists worked in a figurative social realist style, this did not prevent them from developing highly individualistic forms of expression. By the mid-twenties, "The Big Three" had developed their distinctive revolutionary styles and subject matter.

Rivera created figure- and event-packed compositions dealing with both traditional and modern subject matter intended to inspire a sense of pride in his audience's Mexican heritage and proclaim a better future through socialism. He worked in a flat, decorative style with simplified forms, using both stylized figures as well as realistic, identifiable characters to tell his stories. His most ambitious project was *History of Mexico* for the Palacio Nacional in Mexico City, begun in 1929 and left unfinished at his death [2]. In two parts, "From the Pre-Hispanic Civilization to the Conquest" and "From the Conquest to the Future," he told the tale of Mexico's

1 • José Clemente Orozco, *The Trench*, 1926
Fresco, National Preparatory School, Mexico City

history beginning with the fall of Teotihuacán (around AD 900) and ending with Karl Marx leading the way to an ideal future.

Throughout his career, Siqueiros experimented with a variety of techniques and materials in his bold, turbulent, dynamic murals. His work has strongly Surrealist elements, using multiple perspectives, distortion, vibrant colors, and a mixture of realism and fantasy to express the raw power of the workers' universal struggle [3]. For his part, Orozco chose to convey the horrible human suffering of the downtrodden in a heartfelt, and often harrowing Expressionistic social realism, as seen in his murals for the National Preparatory School.

The Mexican muralists in the United States

The work of the three, particularly Rivera, was also beginning to attract attention from across the border. From the mid-twenties on, their work began to be featured in newspapers and the art press, and artists and intellectuals began to make the journey to Mexico to see them at work. They also began to be exhibited in New York, and in 1929 *The Frescoes of Diego Rivera* by Ernestine Evans was published, the first book on his work in English.

This attention soon led to commissions for all three in the United States, which brought their work to an even greater audience. Orozco painted frescoes at the New School for Social Research in New York from 1930–1, at Dartmouth College in Hanover, New Hampshire from 1932–4, where he also taught the techniques of

2 • Diego Rivera, *History of Mexico: From the Conquest to the Future*, 1929–35

Fresco, south wall, National Palace, Mexico City

3 • David Alfaro Siqueiros, *Portrait of the Bourgeoisie*, 1939–40

Pyroxaline on cement, Mexican Electricians' Syndicate, Mexico City

fresco painting, and at Pomona College in Claremont, California in 1939. In 1932, Siqueiros accepted an invitation to teach at the Chouinard School of Art in Los Angeles and while there completed murals for the school and the Plaza Art Center. In 1935–6 he opened an experimental workshop in New York. Announcing it as "a laboratory of modern techniques," he taught the use of innovative materials, tools, and techniques, such as throwing, dripping, and spraying. Significantly, the future Abstract Expressionist ▲ painter Jackson Pollock was a member of the workshop.

While Orozco and Siqueiros made an impact through their work and teaching, it was Rivera's work in the United States that was most noticed. In 1930 and 1931 he had exhibitions in San Francisco and Detroit and executed murals for the California Stock Exchange and the California School of Fine Arts, also receiving a commission to paint murals for the Detroit Institute of Arts. More spectacularly, in December 1931 Rivera was given the second ● retrospective in the new Museum of Modern Art in New York (the first, earlier in the year, had been devoted to Matisse). The exhibition was a critical and popular success, with record attendance figures: almost 57,000 people were exposed to his Mexican-themed work and introduced to the new subject he was exploring—the modern industrial landscape of twentieth-century North America.

Rivera also turned his gaze onto the contemporary American scene in his murals for Detroit (*Detroit Industry*, 1932–3). The introduction of American themes and social commentary in his work provided an important catalyst for American Regionalists such as Thomas Hart Benton (1889–1975), and social realists, such as Ben Shahn (1898–1969). As Benton commented later:

I saw in the Mexican effort a profound and much-needed redirection of art towards its ancient humanistic functions. The Mexican concern with publicly significant meanings and with the pageant of Mexican national life corresponded perfectly with what I had in mind for art in the United States. I also looked with envy on the opportunities given Mexican painters for public mural work.

In October of 1932 Rivera, Catalan muralist José María Sert (1876–1945) and the English artist Frank Brangwyn (1867–1956) were commissioned by the Rockefeller family to produce nine murals for the lobby of the RCA Building in the Rockefeller Center in New York. The oil family was one of the richest in the world, and John D. Rockefeller, Jr. was seen by many as the ultimate manifestation of American capitalism. Rockefeller's wife, Abby Aldrich Rockefeller was one of the founders of the Museum of Modern Art and they were already collectors of Rivera's work, having bought his sketchbook of the 1928 May Day parade in Moscow in 1931.

The title of Rivera's mural was *Man at the Crossroads Looking with Hope and High Vision to the Choosing of a Better Future* and he began work on it in March 1933 [4]. Some time in April the unmistakable head of Lenin appeared in the mural, leading to criticism in the press, such as the headline in the *World Telegraph*: "Rivera Perpetrates Scenes of Communist Activity for RCA Walls—and Rockefeller, Jr. Foots the Bill."

While the Rockefellers were aware of Rivera's politics, and not unduly concerned about them, this new twist and the negative publicity it was receiving placed them in an untenable position, jeopardizing the relationship with their partners in the Rockefeller Center venture. Nelson Rockefeller, son of the family and Rivera's principal contact and liaison, wrote to the artist:

Viewing the progress of your thrilling mural, I noticed that in the most recent portion of the painting you had included a portrait of Lenin.

This piece is beautifully painted, but it seems to me that his portrait appearing in this mural might very easily offend a great many people… As much as I dislike to do so I am afraid we must ask you to substitute the face of some man where Lenin's head now appears.

Rivera had literally painted himself into a corner—he was acutely aware of accusations from the Communist Party that he had sold out by working for the archcapitalist in the first place, and that he had become a figurehead for his assistants, who threatened to strike if he yielded to the request. After careful consideration, and with the aid of Shahn, then one of his assistants, Rivera replied that Lenin must stay, but as a compromise he would add some American heroes to the composition. He added, prophetically, "rather than mutilate the conception I should prefer the physical destruction of the composition in its entirety."

A few days later, on May 9, Rivera was dismissed, paid in full, and escorted from the premises. The "Battle of Rockefeller Center" was on: the mural was covered up, and the national and international press covered the story and the political protests that accompanied the forced stoppage. On February 10 and 11, 1934, the mural was destroyed. The scandal and the publicity made Rivera the most famous muralist in the Americas and a hero to left-wing artists in the United States who, after the Depression and the rise of fascism in Europe, had tried to distance themselves from the perceived decadence of Europe and European abstraction. They aspired to a native American art that addressed the plight of the common man and those aspects that defined America and differentiated it from Europe.

As American artists during the thirties searched for a unique "American" art that was not based on French models, they looked to the Mexican muralists, whose creation of an epic national style that was not antimodern provided a powerful model. As American artist Mitchell Siporin (1910–76), put it: "Through the lessons of our Mexican teachers, we have been made aware of the scope and fullness of the 'soul' of our own environment. We have been made aware of the application of modernism toward a socially moving epic art of our time and place."

Another American artist who was profoundly moved by the Mexicans and what they had achieved was George Biddle (1885–1973). In May 1933 he wrote to President Franklin D. Roosevelt suggesting that he initiate a government-sponsored mural program in the United States:

▲ 1949a, 1960b ● 1927c

4 • Photograph of Diego Rivera's unfinished RCA Building mural, taken by Lucienne Bloch just before all work was stopped in May 1933

The Mexican artists have produced the greatest national school of mural painting since the Italian Renaissance. Diego Rivera tells me that it was only possible because Obregon allowed Mexican artists to work to plumber's wages in order to express on the walls of the government buildings the social ideals of the Mexican revolution.

The younger artists of America are conscious as they never have been of the social revolution that our country and civilization are going through; and they would be eager to express these ideals in a permanent art form if they were given the government's cooperation. They would be contributing to and expressing in living monuments the social ideals that you are struggling to achieve.

Aware of the "Battle of Rockefeller Center," Roosevelt commented that he did not want "a lot of young enthusiasts painting Lenin's head on the Justice Building," but he took the suggestion on board ▲ and the New Deal's cultural support programs were born.

After their time in the United States, "The Big Three" continued to work in Latin America, attracting numerous followers. They left behind a powerful example of a type of public, national avant-garde art that could be at once critical, satirical, inspirational, and celebratory. Its genuine popularity with critics, patrons, and collectors as well as with the people marked a convergence of tastes • not seen again in the United States until the advent of Pop art.

The sheer size and bravado of the Mexicans' murals were also influential for American artists such as Ben Shahn, as was their creation of a popular figurative art with social content. While the Mexican muralists' influence on artists of the thirties was profound, their influence can also be detected in the work of later generations of ▲ artists producing political issue-driven art, and they can also be seen as prefiguring later movements negotiating issues of identity, such as the community mural movement of the late sixties and seventies in the United States and Latin America and the more recent urban community mural movement in postcolonial Africa. AD

FURTHER READING

Alejandro Anreus, *Orozco in Gringoland: The Years in New York* (Albuquerque: University of New Mexico Press, 2001)

Jacqueline Barnitz, *Twentieth-Century Art of Latin America* (Austin, Texas: University of Texas Press, 2001)

Linda Downs, *Diego Rivera: A Retrospective* (New York and London: Founders Society, Detroit Institute of Arts in association with W. W. Norton & Company, 1986)

Desmond Rochfort, *Mexican Muralists* (London: Laurence King Publishing, 1993)

Antonio Rodriguez, *A History of Mexican Mural Painting* (London: Thames & Hudson, 1969)

▲ 1936 ● 1960c, 1964b ▲ 1993c

1934 a

At the First All Union Congress of Writers, Andrei Zhdanov lays down the doctrine of Soviet Socialist Realism.

Soviet Socialist Realism emerged as a historically and geopolitically specific variant of the universally prevailing antimodernist tendencies of the late twenties and thirties: the *rappel à l'ordre* in France, Neue Sachlichkeit in Germany, Nazi painting in the Third Reich, Fascist neoclassicism in Mussolini's ▲ Italy, and the various forms of social realism in the United States. The terror regime of Joseph Stalin (1879–1953) not only provided the ideological and political framework, but also the pragmatic demands, for extraordinary propagandistic efforts by the ideological state apparatus. Accordingly, Stalin's hagiographers even credited him with having invented the term "Socialist Realism," claiming that during a secret meeting of writers in Maksim Gorky's (1868–1936) flat on October 26, 1932, Stalin supposedly stated the following:

> If the artist is going to depict life correctly, he cannot fail to observe and point out what is leading towards Socialism. So this will be Socialist art. It will be Socialist Realism.

The first documented *public* usage of the term "Socialist Realism," however, had already appeared in an article in the *Literaturnaya Gazeta* (Literary Gazette), for May 25, 1932, defining it—in the tautological language typical of ideology—as an art of "honesty, truthfulness, and as revolutionary in the representation of the proletarian revolution."

Andrei Zhdanov (1896–1948), Stalin's chief cultural commissar and Secretary of the Central Committee of the Communist Party, gave a programmatic definition of Socialist Realism at the First All Union Congress of Writers in August 1934. Quoting Stalin's (in)famous exhortation that artists and writers should become "the engineers of human souls," Zhdanov (and Stalin) actually echoed the theory of the prerevolutionary aesthetician Aleksandr Bogdanov, who had spoken of literature as a practice that should "organize workers and the oppressed in the struggle for the final destruction of all kinds of exploitation."

Zhdanov's normative aesthetics was paradoxical, requesting that Socialist Realism should engage in "revolutionary romanticism," but also that it should also stand with "both feet on the ground of real life and its materialist foundation." It stated that artists should "depict reality in its revolutionary development" but that they should also educate the worker in the utopian spirit of Communism. From January to March 1936—the year of the show trials and of the final elimination of the last remnants of modernism in the Soviet Union—Zhdanov published a series of articles in the Party's newspaper *Pravda* (The Truth) which denounced formalism in all of the arts. These publications, acquiring the status of prescriptions and prohibitions, introduced the period known as the *zhdanovschchina*, not only establishing the Party's total control of culture, but also the hegemony of Socialist Realism as the exclusive and official culture of authoritarian State Socialism.

Socialist Realism attempted to fuse the legacies of agitprop and ▲ the documentary projects of the twenties with heroicizing narratives that now—in the era of an intensely centralized Party control and its correlative ideology of authoritarian populism—had to be delivered in the manner of premodernist, nineteenth-century genre painting. This emphasis on narrative and figurative representation not only ● conflicted profoundly with the already existing practices of the Soviet avant-garde, from the Constructivists to the artists of the *proletkult* and the LEF group (all of whose practices would soon be eliminated), but it proved to be incompatible even with the crucial legacies of nineteenth-century modernism. While the art of Jacques-Louis David and Eugène Delacroix, or of Honoré Daumier, François Millet, Gustave Courbet, and Adolph Menzel, would be celebrated either as art of revolutionary fervor or as art of the people, Impressionism ■ and Postimpressionism—notably the work of Paul Cézanne—now became the subject of endless debates, since they threatened Socialist Realism's fraudulent iconography and its false stylistic homogeneity. The notion of painting as a self-reflexive critical project had to be dismantled: Socialist Realism was to enforce the most banal forms of illusionistic depiction, foregrounding its purely mimetic functions and artisanal skills while claiming access to painting's putative transhistorical monumentality.

Reflection as a process

Georgy Plekhanov (1856–1918), one of the founders of Russian Marxism, was among the first to criticize the Impressionists, juxtaposing their work with that of a group of Russian nineteenth-century artists who were now presented as the really autochthonous predecessors of Socialist Realism, namely the Peredvizhniki ("Wanderers"

▲ 1919, 1925b, 1927c, 1936, 1937a ▲ 1920 ● 1921b ■ 1906

or "Itinerants"). This group had been founded in 1870 to break away from the St. Petersburg Academy, to diversify patronage by organizing traveling exhibitions throughout Russia (and by charging entrance fees), and to provide a realistic—sometimes politically critical—picture of Russia. On the occasion of the forty-seventh exhibition of the Wanderers in 1922, they published a declaration which reads like an early definition of the tasks of Socialist Realism:

> We want to reflect with documentary truthfulness in genre, portrait, and landscape the life of contemporary Russia and the full range of its diverse ethnicities and their lives deeply devoted to labor…. While remaining faithful to Realistic painting, we want to seek those devices that are closest to the masses of people … to help the masses, in formally finished works of painting, become aware of and remember the great historic process taking place.

Vladimir I. Lenin (1870–1924) and Leon Trotsky (1879–1940), but most importantly Joseph Stalin, disliked modernism intensely, in particular its recent Soviet avant-garde incarnations, and all three men favored the Peredvizhniki. Lenin's *Materialism and Empirico-Criticism* argued against the prevailing nineteenth-century theories of perception (by implication, against Impressionism and Postimpressionism) by stating that optical sensations were not—as the Russian followers of Austrian physiologist Ernst Mach (including Aleksandr Bogdanov [1873–1928] and, in his early writings, the aesthetic theorist Anatoly Lunacharsky) had suggested—real elements within the experience of the world, but rather that they were mere *reflections* of the real things.

Thus Lenin [1] referred back to German socialist Friedrich Engels's (1820–95) famous statement that "copies, photographs, images are mirror reflections of things." Yet Lenin defined *reflection* as no longer a mere mirror-image but rather as a *process* by which consciousness actively appropriates and transforms the world; this condition of *praxis* would now become the criterion of philosophical truth. Consequently, a *Theory of Reflection* emerges as one of the foundational theoretical programs of Socialist Realism, developed most notably in the early thirties during the Moscow sojourn of György Lukács, the Hungarian-German philosopher who was Marxism's foremost literary theoretician at the time.

Among painters, Impressionism remained a subject of continuous discussion. As late as 1939, Aleksandr Gerasimov (1881–1963) and his artistic colleagues in power (such as Boris Ioganson [1893–1973] and Igor Grabar [1871–1960]) could still call for the "all-sided illumination of Impressionism which was a very great contribution to the treasury of art." But less than ten years later, he would be among those condemning Impressionism in favor of a highly finished painterly style. As Matthew Cullerne Bown argues:

> The Impressionist concentration on light, color and freedom of brushmark were all viewed negatively as tending towards the dissolution of solid, academically modelled forms in painting … (Impressionism) was felt to be antagonistic to Socialist Realist painting which was intent on revealing the essences of

1 • Moïsei Nappelbaum, *Photograph of V. I. Lenin*, 1918
Vintage silver-gelatin print

events from the point of view of the party, the working class and the "laws" of historical development.

From the mid-twenties onward, it became increasingly evident that the Constructivist avant-garde had failed to produce a culture for the new industrial and rural proletarian masses. There continued to be fervent debates about the renewed or remaining functions of painting in this historical moment, ranging from calls for the return to representational traditionalism and narratives in the manner of the Peredvizhniki (such as the emerging program of AKhRR) to the more complex models incorporating revolutionary poster design and the cinematic forms of montage and temporality, such as the paintings of the OST (the Society of Easel Painters.) Anatoly Lunacharsky, whom Lenin had reluctantly appointed in 1917 as the first head of Narkompros (People's Commissariat for Enlightenment), initially remained loyal to the avant-garde artists whom he had championed and endowed with institutional power. But now, presumably under Party pressure, he too argued for an urgent revival of narrative and figuration in painting, stating in a speech on May 9, 1923, entitled "Art and the Working Class" that "the main thing is to conquer the aversion to subject matter." Not surprisingly, in 1925 Lunacharsky claimed the Peredvizhniki as the equally true historical predecessors of a populist Socialist art of the present, and he reintroduced one of their key concepts, the *kartina*—the Russian for "picture"—into artistic debates. However, the term would now define not only the obligatory pictorial *narrative* (preferably a

dramatic scene that "realism" had to enact on the stage of painting) but also more specifically the cheap mass reproduction and distribution of that image in the tradition of the *lubki* woodcuts. In a speech of that year, Lunacharsky explicitly associated the concept of the *kartina* with the needs of the proletariat: "The proletariat needs the *kartina*. The *kartina* is understood as a social act."

▲ Thus, AKhRR (the Association of Artists of Revolutionary Russia), the group that considered itself to be the legitimate heir of the Peredvizhniki, laid the foundations of Socialist Realism, claiming that its members isolated "ideological content as the sign of the truthfulness of a work of art." AKhRR was officially founded at a meeting on March 1, 1922, and Yevgeny Katsman (1890–1976), one of the founders—ironically the brother-in-law of Kazimir Malevich—initially defined their project as "heroic realism."

Two major figures of Soviet Socialist Realism

By the end of 1925, AKhRR's membership numbered about one thousand artists, between them representing a broad range of the painterly positions that would soon define Socialist Realism: from the neoclassical academicism of Katsman and the sharp-focus photographic realism of Isaak Izraelevich Brodsky (1884–1939) to the more painterly approaches of the Moscow artists Ioganson, Gerasimov [2], and Il'ya Mashkov (1881–1944). To others, though, it was evident that the task of constructing representations for a newly industrialized society could not be achieved by the deployment of those conventional painting practices that suggested that reality and its objects were merely emerging from the unchanging, originary forces of nature. Rather, the new society required a new type of painting, if any, in which contradictory social relations and their transformation could be articulated. Thus, the critique of the AKhRR painters was already formulated by the late twenties, most vociferously by the exiled German theoretician Alfred Kurella, who had become director of the Fine Arts Division (IZO) at Narkompros:

> If one hears the definition of art voiced by AKhRR, and if one sees their works (especially the paintings by Brodski, Jakolev, Kacman, et al.) one cannot help but ask the question: why don't they just take photographs?… The artists of AKhRR have totally forgotten the difference between painting and photography.… In our century of artistic photography the purely documentary side of art is bound to perish.

Partially in opposition to the reactionary ideas of AKhRR, the OST was formed in 1924, counting among its members Aleksandr Deineka (1899–1969), Yury Pimenov (1903–77), Kilment Redko (1881–1948), David Shterenberg (1881–1948; its chairman), and Aleksandr Tyshler (1898–1980). Some of these painters were former students of the avant-garde institutes Inkhuk and
● Vkhutemas that had become the center of discussions between the Constructivists, the Productivists, and the Stankovists, that is, those painters who now closed ranks to maintain painting as a space of relative autonomy from either agitprop propaganda (such

2 • Aleksandr Gerasimov, *Lenin on the Tribune*, 1929
Oil on canvas, 288 × 177 (113 × 70)

as photomontage and poster projects) or the production of utilitarian objects as advocated by the Productivists.

The central figure of OST—and undoubtedly the most important artist of the historical chapter of Socialist Realism—Aleksandr Deineka attempted to fuse the legacies of the Soviet poster and film culture with the traditions of easel painting, emphasizing that temporality had to become an integral element of painting if it was to attempt to articulate the historico-political processes of change and dialectical transformation. Conceiving a model of painterly montage, Deineka wanted to translate the dynamics of revolution and industrialization into a painterly and compositional dynamics by using rapidly altering spatial perspectives, cinematic points of view and shifting modes of painterly execution.

Both AKhRR artists and OST artists (along with members of other groups) contributed to an exhibition organized in 1928, celebrating the tenth anniversary of the Red Army (which had by now become the most important patron of portraits of its own heroic warriors and scenes of its victories). Deineka's painting *The Defense of Petrograd* was widely praised by the critics, partly because it opposed not only the model of nineteenth-century war paintings that served as the point of departure for most AKhRR painters, but also the photonaturalism of paintings such as Brodsky's *The Session of the Revolutionary War Council* (1928) and *Lenin in the Smolny Palace* [4]. Deineka's painting, by contrast, depicted the civil war not as a heroic episode of the past but as a process of collective transformation

1930–1939

3 • Aleksandr Deineka, *Building New Factories*, 1926
Oil on canvas, 209 × 200 (82 × 79)

continuing in the present. As the critic Chvojnik stated in his review of the exhibition, "The simplicity of the painting's well-articulated rhythm gives a clear account of the endless stream and indefatigable will of the revolutionary proletariat." Deineka's compositional conception followed a pictorial principle that Ferdinand Hodler had developed earlier, in the first decade, with correlating positive figures and negative ground in a frieze of almost temporally structured alternating shapes passing across the surface of the painting. While Deineka's peculiar and masterly synthesis of Soviet modernism and a more traditional definition of public and monumental mural painting could be called one of the most successful projects inside the perimeters of Socialist Realism, his work also bears clear resemblances to the dilemma of Neue Sachlichkeit in Germany, which had equally attempted to fuse the reality of new industrial technologies with the apparent obsolescence of pictorial means and subject matter. His painting *Building New Factories* [3] embodies all these contradictions. While Deineka equates the new industrial architecture with the modular picture grid, he repositions the latter within receding perspectival space. And in the construction of the figures, he gives us the most detailed modeling of the female bodies, yet their faces follow the rules of typecasting the anonymous Socialist subject.

The second major figure of Socialist Realism—and in many ways Deineka's opposite—was Isaak Brodsky, who had joined AKhRR in 1923. His work and his biography exemplify the contradictions that governed the politics and the aesthetics of Socialist Realism. Brodsky

had met Lunacharsky in Petrograd in the company of Maksim Gorky in late 1917 or early 1918, and Lunacharsky had endorsed him in a letter to Lenin: "From an ethical and political point of view the artist Brodsky merits complete trust." Before Stalin's final consolidation of power, however, Brodsky was subjected to severe criticism within the Association by the younger generation of artists and was excluded from AKhRR at its conference in May 1928 for his "extreme photonaturalism"—his *Brodskyism*, as the edict of exclusion called his sharp-focus neoclassical realism.

But the calls of the early plan years for a new, revolutionary, nonacademically based proletarian art that had denied the continuing validity of the realist easel picture, were soon to be extinguished. Brodsky reemerged, to become Stalin's favorite artist and a personal friend of Marshal Voroshilov, Stalin's commissar for defence. In 1934 he was appointed as rector of the Leningrad Academy of Art, where he enforced a return to the strictest rules of traditional academic art education, subsequently becoming the first artist to be awarded the Order of Lenin. Apparently Brodsky met Stalin on at least one occasion in 1933, when—in the company of Gerasimov and Katsman—Stalin advocated that they should paint "pictures that were comprehensible to the masses, and portraits that did not require you to guess who was portrayed."

One of Brodsky's most successful paintings—among his industrious production of portraits of Soviet heroes in oil and lithographs—was *Lenin in the Smolny Palace* [4]. Although it was

▲ 1925b

manifestly the result of a photographic projection after a photograph by Moïsei Nappelbaum, Brodsky nevertheless tried to disavow his photomechanical sources. In fact, he claimed to have produced this astonishing likeness from a number of sketches of Lenin that he made at the Third Comintern Congress; Brodsky even staged photographs that showed him producing these preparatory sketches. Thus, Leah Dickerman convincingly argues that:

The simultaneous dependence on and masking of photography that lies at the heart of socialist realist practice offer a structure of ambivalence. On the one hand, socialist realism's use of (and even more its insistent fidelity to) a photographic source speaks of desire for the photographic. On the other, the erasure of the image's mechanical origins speaks of fear of the photographic.

Brodsky's portrait of Marshal Voroshilov [5], one of the most avid patrons of Socialist Realism, is a masterpiece of naturalizing ideology. It situates the chief of the most powerful military state apparatus, the Red Army, in a perfect fusion of peaceful leisure and the most detailed nature of a Russian landscape. That naturalist account, however, results from the concealed technical apparatus of photographic reproduction.

While the last major retrospective of "Artists of the Russian Federation over Fifteen Years" could still include a significant segment of works by the Soviet avant-garde when first exhibited at the Russian Museum in Leningrad in 1932, that proportion had already had to be excised in favor of Socialist Realism when the exhibition traveled to Moscow in June 1933. Ossip Beskin, editor of *Iskusstvo* (Art)—the Union's newly founded official

4 • Isaak Brodsky, *Lenin in the Smolny Palace*, 1930
Oil on canvas, 190 × 287 (74¾ × 113)

5 • Isaak Brodsky, *The People's Commissar for Defense, Marshal of the Soviet Union, K. E. Voroshilov, out skiing*, 1937
Oil on canvas, 210 × 365 (83 × 144)

journal (all other magazines having been abolished)—announced the final battle against the avant-garde with the publication of his book *Formalism in Painting* (1932).

This battle against modernism would culminate in the total liquidation of Soviet avant-garde culture during 1932 and 1933. A decree from the Central Committee of the Communist Party abolished all independent artistic groupings and established a nationwide Union of Soviet Artists, the *orgkomitet*. MOSSKh, the Moscow section of this envisaged union, was formed in 1932 and became the leading organization in the country, displacing or absorbing all the other groups (AKhRR, OST, OMKh, RAPHk, etc.).

Aleksandr Gerasimov had now emerged as the third key figure of Socialist Realism. He typically moved from one powerful position to the next, regardless of the fact that the political situation in general had become increasingly unmanageable for most intellectuals and artists after 1936. Thus, Gerasimov came to be elected chair of MOSSKh, and in a speech in 1939 he defined Socialist Realism as "an art realist in form and socialist in content," an art that would celebrate the construction of Socialism and heroicize those who toiled on its behalf. Fashioning himself as a man of the Russian people, he enjoyed the company and support of the party elite, devoting much of his energy to official commissions of portraits of Lenin, Stalin, and Voroshilov, executed in a glazed style that imbued the faces of authoritarian state socialism with a double sheen: that of an affirmation of their authenticity through photographic presence and that of a transposition to their heroic status within a timeless past of neoclassicism.

While Socialist Realism would continue to be constantly embattled from 1934 to the beginning of the Kruschev thaw in 1953 and onward, it was basically defined by the following key concepts:

1. *Narodnost'* (*narod* meaning "people," "nation"). Coined by the former member of the World of Art group, the Symbolist painter Aleksandr Benua (1870–1960), *narodnost'* insisted on the relationship of art to the *people*. Initially conceived as a multicultural model, which yet allowed for the specificity of each ethnic group within the newly formed Union, it became a monolithic and ethnocentric norm to produce a chauvinist Soviet (that is, a fictitious Russian) culture. *Narodnost'* required that painting should first appeal to popular sentiments and ideas, but the concept also addressed the artist's task to document the current work of the population, to communicate with the working masses and to recognize and dignify the structures of their daily lives. The concept of *narodnost'* also served to support a Soviet version of a return to tradition. The theorists of Socialist Realism—just like their French and Italian counterparts of the *rappel à l'ordre*—embraced the art of classical Greece, of the Italian Renaissance, and of the Dutch and Flemish Old Masters of genre painting. Nikolai Bukharin, for example, argued that artists should "combine the spirit of the Renaissance with the huge ideological baggage of our age of Socialist revolution." Ivan Gronsky, the editor of *Novy Mir* (The New World), stated in 1933 that "Socialist Realism is Rubens, Rembrandt, and Repin put to serve the working class."

2. *Klassovost'* insisted that Socialist Realism should clearly articulate the class consciousness of the artist as much as that of the depicted subjects, a consciousness that had been heightened during the Cultural Revolution.

3. *Partiynost'* required that representations and their artistic execution should publicly confirm that the Communist Party had the leading role in all aspects of Soviet life. The concept was first defined in Lenin's essay "Party Literature and Party Propaganda" (1905).

4. *Ideynost'* demanded the introduction of new forms as central to the work of art. These new forms and attitudes had to be approved by the Party. The concept also aimed to make evident that every Socialist Realist work of art would enact the project of Socialism and articulate the glorious future promised by Stalin and the Party.

5. *Tipichnost'* requested that portraits and figure painting should depict typical characters in typical circumstances as heroes and heroines, drawn from recognizable and familiar circumstances. As Cullerne Bown states, "*tipichnost'* was a double-edged sword in Socialist Realism: on the one hand it helped the creation of accessible and eloquent works of social art, on the other it was a pretext to criticize (as 'untypical') paintings which failed to present a rosy enough image of the Soviet reality."

Gerasimov's staying power exceeded that of all his colleagues. Thus, when the USSR Academy of Arts was created on August 5, 1947, as the Party's institution of total control, Gerasimov rose to yet another position of supreme power to become the Academy's first president. In this role, Gerasimov would be traveling through the Soviet satellite states—East Germany, Hungary, Poland, and Czechoslovakia—to inspect the successful enforcement of the Socialist Realist programs in the art academies of those countries. His decrees now defined the tasks of Socialist Realism with an ever-increasing authoritarian animus and antimodernist aggression:

> To fight formalism, naturalism, and other manifestations of contemporary bourgeois decadent art, lack of ideology and political commitment in creative work, falsely scientific and idealistic theories in the area of aesthetics. BB

FURTHER READING

Matthew Cullerne Bown, *Socialist Realist Painting* (London and New Haven: Yale University Press, 1998)

Leah Dickerman, "Camera Obscura: Socialist Realism in the Shadow of Photography," *October*, no. 93, Summer 2000

David Elliott (ed.), *Engineers of the Human Soul: Soviet Socialist Realist Painting 1930s–1960s* (Oxford: Museum of Modern Art, 1992)

Hans Guenther (ed.), *The Culture of the Stalin Period* (New York and London: St. Martin's Press, 1990)

Thomas Lahusen and Evgeny Dobrenko (eds), *Socialist Realism without Shores* (Durham, N.C. and London: Duke University Press, 1997)

Brandon Taylor, "Photo Power: Painting and Iconicity in the First Five Year Plan," in Dawn Ades and Tim Benton (eds), *Art and Power: Europe Under the Dictators 1939–1945* (London: Thames & Hudson, 1995)

Andrei Zhdanov, "Speech to the Congress of Soviet Writers" (1934), translated and reprinted in Charles Harrison and Paul Wood (eds), *Art in Theory 1900–1990* (Oxford and Cambridge, Mass.: Blackwell, 1992)

▲ 1919

1934 b

In "The Sculptor's Aims," Henry Moore articulates a British aesthetic of direct carving in sculpture that mediates between figuration and abstraction, between Surrealism and Constructivism.

W hat counted as a tradition was never as well established in sculpture as in painting, so when the academic modeling of ideal figures based on (neo)classical precedents had lost all validity by the turn of the century, it was not clear what could replace it as a basic way of working. In Britain matters were complicated by the fact that modernist responses to this sculptural decay on the Continent were not yet well known in this early period: some news of the fragmented figures of Auguste Rodin had crossed the Channel, but little report of the semiabstract carving practiced by Constantin Brancusi, let alone of the radically different models of the object, the construction, and the ready-made, proposed by Picasso, Tatlin, and Duchamp.

Nonetheless, before World War I, the British group of artists known as the Vorticists had already rejected the humanist tradition of academic art as "flat and insipid" (as the critic T. E. Hulme put it), and they looked primarily to Jacob Epstein to show the way in this new sculptural wilderness. Born to Polish Orthodox Jews in the United States, Epstein had moved to London in 1905 after three years of study in Paris. Although trained in the traditional modeling of the figure, he immediately looked for alternative models in the carved forms of preclassical and primitive arts at the British Museum, the Louvre, and elsewhere—especially ancient Greek, Egyptian, Assyrian, and American. The influence of these sources was already apparent in his first major commission in London, in 1908—a set of huge nudes bluntly carved in stone to represent different stages of human life for the new building of the British Medical Association on the Strand. Despite the time-honored theme of the male nude, these archaistic giants provoked great controversy, which is some indication of British conservatism in art at the time. Yet this furor was nothing compared with the one that greeted his next major work, *The Tomb of Oscar Wilde* in the Père Lachaise cemetery in Paris [1], which remains startling to this day. In high relief Epstein carved out of a great block of limestone an entity that can only be called alien—an implacable sphinx that is equal parts Mayan god and Assyrian winged bull (based on such a figure in the British Museum, it was likely inspired by Wilde's poem "The Sphinx"). Frozen in horizontal flight, this strange angel guards the great Irish writer who had been exiled to an early death for his homosexuality ("for his mourners will be outcast men," the

1 • Jacob Epstein, *The Tomb of Oscar Wilde*, 1912
Père Lachaise cemetery, Paris

inscription on the tomb reads in part, "and outcasts always mourn"). But the tomb, too, needed guarding, for the genitals of the sphinx were soon smashed—a gesture in which aesthetic and sexual reaction seem to have converged.

Where all energy is concentrated

Drawn into the Vorticist circle in the years prior to World War I, Epstein moved away from allusions to the primitive, which his close friend Hulme could not abide, toward a different evocation of the primordial—of modern man as atavistic, aggressively mechanistic, even murderous. His long-lost *Rock Drill* [2], a large

2 • Jacob Epstein, *Rock Drill*, 1913–15 (1973 reconstruction)
Polyester resin, metal, and wood, 205 × 141.5 (80¾ × 55¾)

3 • Henri Gaudier-Brzeska, *Red Stone Dancer*, c. 1913
Red Mansfield stone, 43.2 × 22.9 × 22.9 (17 × 9 × 9)

conjunction of plaster creature and actual drill, is even more alien than his angel for Wilde, and without the redemption nominally promised by the latter. With a head that is half helmet and half snout, this machine-man with slatted ribs captures the Vorticist ethos of a "new ego" (as Vorticist leader Wyndham Lewis put it), hardened against the shocks of the modern world, more effectively than any other work. "Here is the armed, sinister figure of today and tomorrow," Epstein remarked in retrospect, after he had turned away from this kind of work. "No humanity, only the terrible Frankenstein's monster we have made ourselves into." This monster is not sterile, however, as it carries its amorphous progeny within its exposed midsection, as if to literalize the male fantasy of reproduction without women. This fantasy is common enough among modernists, but here this creation seems to occur outside of humanity altogether. (The opposite number of this belligerent
▲ robot is the supplicant *The Invisible Object* of Alberto Giacometti.)

Epstein produced nothing again so radical in its antihumanism as *Rock Drill*, and it was, in fact, his compressed fragments of carved figures in stone that were more influential on other Vorticists like Henri Gaudier-Brzeska, as well as on subsequent sculptors like Henry Moore (1898–1986) and Barbara Hepworth (1903–75). In Paris during the winter of 1912–13 Epstein had met Brancusi and befriended the Italian Amedeo Modigliani (1884–1920); perhaps this confirmation of direct carving furthered the practice in Britain. In any case, even as Epstein turned back to modeling after the war, Gaudier-Brzeska took up carving prior to it.

Although only twenty-four in 1914, this son of a French carpenter helped Lewis and Ezra Pound shape the Vorticist journal *Blast*. (Gaudier-Brzeska carved his *Hieratic Head of Ezra Pound* in the same year—the title captures this fierce evocation of Pound as high priest of modernist English poetry—and Pound published a book on Gaudier-Brzeska in 1916 that kept his work alive for Moore, Hepworth, and others.) "At the heart of the whirlpool … where all energy is concentrated" is how Lewis defined "the vortex" in *Blast*, and Gaudier-Brzeska took this concentration of energy in the compression of mass as his goal. To achieve such vitalistic density he often interlocked forms in a way that partook of both Cubist and African models. Thus Gaudier-Brzeska gave his *Red Stone Dancer* [3]
● a savage *contrapposto* à la Matisse's *The Blue Nude*; at the same time its schematic signs—inscribed triangles for a face, ellipses for a hand (or is it a breast?)—possess some of the semiotic ambiguity
■ of Picasso's work of this time. Yet *Red Stone Dancer* also manifests a tension peculiar to Gaudier-Brzeska—a tension between an expressive kind of vitalism and an antinatural notion of abstraction that Hulme had elaborated from the 1908 thesis *Abstraction and Empathy*
◆ by the German art historian Wilhelm Worringer. Sometimes Gaudier-Brzeska was able to turn this tension to his advantage: for example, the interlocked forms of his carved plaster *Bird Swallowing a Fish* (1914) literalize a Vorticist conception of nature as eat-or-be-eaten. However dark, this vitalism appealed to Moore and Hepworth more than the mechanicity of other Vorticist work, for it retained nature as a primary reference for sculptural practice.

▲ 1931a ● 1903 ■ 1912 ◆ 1908

Like some Futurists, some Vorticists were swallowed by the very war that they welcomed as "a great remedy": Gaudier-Brzeska was killed on the front in 1915 aged twenty-three, Hulme in 1917 (with an unfinished book on Epstein left behind). "Vorticism was not so much the harbinger of a new order as a symptom of the terminal disease of the old," Lewis later wrote. "The brave new world was a mirage—a snare and a delusion." Sculptors like Moore and Hepworth who were formed in the twenties turned away from the antihumanist swagger of the Vorticists (only, as we will see, to move toward a humanist sentimentality of their own). They were also less defensive regarding modernist developments on the Continent: whereas the Vorticists had a rivalrous relationship with Cubism and Futurism, the next generation advanced through a negotiation of such different avant-gardes as Surrealism and Constructivism. At the same time, Moore and Hepworth did not abandon the prewar principles of Gaudier-Brzeska and Epstein: in opposition to the academic tradition, they, too, looked to preclassical and primitive sources for "a world view" of sculpture (as Moore remarked in 1930), and in the process renewed the commitment to direct carving as an almost ethical value. Finally, like Gaudier-Brzeska and Epstein, Moore and Hepworth were initially outsiders to the British art establishment—Moore as the son of a Yorkshire miner; Hepworth, who was also from northern England, as a woman as well.

An intense life of its own

In his early carvings of the twenties Moore all but replicated prehistoric models in wood and stone—a small rounded horse, a smooth schematic head, a mother-and-child ensemble reminis-
cent of a fertility figure, and so on. By 1930 semiabstract figures predominated, both maternal and recumbent ones. Hepworth worked with these sympathetic types as well—all in stark contrast to the mechanistic Frankensteins and fragments of Vorticism. In opposition to relief (which Epstein sometimes still practiced), these carvers insisted on "the full three-dimensional realization" of sculpture in the round. To this end they also began to bore through the figure, and to rotate it around this hollow core, in order to make the sculpture whole through this very hole, as it were, with a fluent reciprocity of inside and outside that invited an almost tactile viewing of the finished work.

The next step was to extend this abstracted body, even to break it up in unequal parts on an elongated base. These parts were made to cohere as a kind of landscape (which could also reverse into landscape as a sort of body), as in Moore's *Four-Piece Composition: Reclining Figure* [4]. Or they came together as a kind of mother–child ensemble (that might also evoke a sort of landscape), as in Hepworth's *Large and Small Form* [5]. Her *Pictorial Biography* illustrates this piece opposite a photograph of Hepworth with one of her infant triplets on her knees in a composition that the sculpture seems to reproduce abstractly. This arrangement intimates that her biomorphic forms intend a psychological condition or emotional relationship in a way that points in turn to the influence of Surrealism, and Hepworth did acknowledge the impact of Hans Arp on her work, especially "the way Arp had fused landscape with the body."

Moore also touched on this influence in a 1934 publication by Unit One, a group of British artists that, according to its leader, the painter Paul Nash (1889–1946), had "two definite objects": "the pursuit of form," as in abstract art, and "the attempt to trace

4 • Henry Moore, *Four-Piece Composition: Reclining Figure*, 1934
Cumberland alabaster, length 51 (20⅛)

▲ 1909

▲ 1916a

5 • Barbara Hepworth, *Large and Small Form*, 1934
Alabaster, 23 × 37 × 18 (9 × 14 × 7)

the 'psyche,'" as in Surrealism. In this short text (now known as "The Sculptor's Aims"), Moore articulates his aesthetic of direct carving in five points. First, there is *truth to material*: "the sculptor works direct" so that "the material can take its part in the shaping of an idea"; thus, for example, the very graining of the wood in the diminutive *Figure* (1931) seems to guide the sweep of its shoulders, neck, head, and hair (or cape). Second, *full three-dimensional realization*: here Moore champions sculpture in the round for its "dynamic tension between parts" and multiple "points of view," as in *Four-Piece Composition*. Third, *observation of natural objects*: different "principles of form and rhythm" are to be drawn from such things as pebbles, bones, trees, and shells. Fourth, *vision and expression*: here, in keeping with the plan of Unit One, Moore urges sculptors to attend to both "abstract qualities of design" and "the psychological human element." And, finally, *vitality*: the ultimate goal of sculpture is "an intense life of its own, independent of the object it may represent."

Despite its confidence, this program points to a basic tension in Moore, as well as in Hepworth: both were ambivalent about total abstraction, at least until this time. They were almost too ready to find a trace of the figure in their materials, as if it were somehow immanent in the wood or the stone, latent in its grains or veins, its curves or cracks. Thus projected in the material, this liminal figure grounds the sculpture in turn, keeps it away from the very abstraction that it otherwise appears to embrace. Sometimes Moore and

Hepworth even inscribed partial profiles on the surface (as in *Four-Piece Composition*), as if to pull the sculpture back into a semifigurative reading.

Hepworth overcame this ambivalence more fully than did Moore, especially as she became involved with Ben Nicholson (they married in 1932), who had just moved from post-Cubist paintings to the geometric reliefs in white for which he is best known. "The experience," Hepworth later remarked, "helped to release all my energies for an exploration of free sculptural form." This move into abstraction deepened about the time that her triplets were born (in October 1934). At this point Hepworth became "absorbed in the relationships in space, in size and texture and weight, as well as in the tension between the forms." In this tension she hoped "to discover some absolute essence in sculptural terms"—an "absolute essence" that nonetheless had to convey "the quality of human relationships." This last condition is telling, for even as her sculpture became abstract, often geometrically so, it remained implicitly figurative in the very relationality of its forms. In this way, the figure was not canceled so much as elevated to the general; it was made to appear universal through abstraction, not despite it.

This is key to this British aesthetic, and central to its great acclaim (at least in the Anglo-American context). For in effect this sculpture served as a kind of compromise, as an aesthetic resolution to troublesome tensions. In the first instance these tensions were technical: Moore and Hepworth advocated direct carving in

▲ 1937b

opposition to the traditional practice of modeling and casting, yet all the natural references and maternal allusions made this carving seem like molding—on the analogy of erosion or gestation—and so pointed to an undoing of this old opposition in technique. In a related way, Moore and Hepworth eased the tension between the opacity of the sculptural material and the clarity of the sculptural idea, for the second seemed to arise naturally from the first in the kind of transformation that modern aesthetics had long privileged. Finally, they also appeared to overcome the more recent opposition between sculpture-as-fragment (associated with Rodin) and sculpture-as-totality (associated with Brancusi).

At the same time, Moore and Hepworth managed stylistic contradictions. With others in the Unit One milieu, they worked to reconcile Surrealist and Constructivist tendencies—"the psychological element" and "abstract principles" (Moore). This reconciliation was prepared by the watering-down of Surrealism on its crossing of the Channel, and by the reducing of Constructivism to abstract
▲ design in the *Circle* group around Naum Gabo. But Moore and Hepworth also contributed to this blurring of the two movements.
● For example, for Russian Constructivists "truth to materials" meant a treatment of industrial materials in a way that might render the constructive process of art not only physically transparent but also socially relevant. For Moore and Hepworth, on the other hand, it was a means to allow the traditional materials of sculpture to guide its semifigurative working. The ideological service of this work was to humanize abstraction, and to keep it within the realm of art. It provided a similar service vis-à-vis Surrealism. Although the British art critic Adrian Stokes related this sculpture to the aggres-
■ sive drives foregrounded in the psychoanalysis of Melanie Klein, the "psychological human element" in Moore and Hepworth was too nonspecific to be very disruptive, much less perverse. In effect they offered a Surrealism without the uncanny, in which natural analogies were favored over psychological provocations.

A world view of sculpture

There was further conciliation offered in this work. As suggested above, rather than overthrow the figure, as in the construction and the readymade, Moore and Hepworth tended to generalize it through abstraction. In this way, the old regime of art persisted in the very appearance of the new, which again is part of the great appeal of this work—and part of its ideological service too. As the British art critic Charles Harrison has argued, Moore and Hepworth worked to generalize "sculpture" as "an innate category of experience—the response to 'significant form,' wherever it might be found," in bones or stones, bodies or landscapes ("significant form" was the phrase of the early-twentieth-century British formalist critic Clive Bell). Perhaps, as Harrison suggests, this "all-inclusiveness of sculpture" was "a radical and progressive idea" in Britain at the time, but it was still achieved through a softening of aesthetic differences and political edges. Clearly this "universali-

zation" of sculpture was also a "rehumanization" of art, undertaken in reaction against the "dehumanization" preached by the Vorticists and made all too real in World War I. But just as clearly this rehumanization was no cure for "the terminal disease of the old" (Lewis). As Harrison has also suggested, it was a liberal response to what was already a crisis in liberalism—a liberalism about to be overwhelmed by various fascisms and another world war.

In large part this sculpture appears so human, almost natural, even universal, through its confection of modern and primitive allusions. In a short text from 1930 (now known as "A View of Sculpture"), Moore intimated that this primordial effect is, paradoxically, a mediated one:

The world has been producing sculpture for at least some thirty thousand years. Through modern development of communication much of this we now know and the few sculptors of a hundred years or so of Greece no longer blot our eyes to the sculptural achievements of the rest of mankind. Paleolithic and Neolithic sculpture, Sumerian, Babylonian and Egyptian, Early Greek, Chinese, Etruscan, Indian, Mayan, Mexican and Peruvian, Romanesque, Byzantine and Gothic, Negro, South Sea Island and North American Indian sculpture; actual examples of photographs of all are available, giving us a world view of sculpture never previously possible.

This statement anticipates the notion advanced by André
▲ Malraux a few years later of a *musée imaginaire* of world art. This idea of a "museum without walls" was founded equally on the empire of the West (its appropriation of cultural artifacts from around the world) and the empire of photography (its ability to turn these disparate artifacts into similar examples of "style"). In their own way, Moore and Hepworth produced a kind of *sculpture imaginaire*, "a world view of sculpture" elaborated into a practice of modern sculpture. Why was this "world view of sculpture" so attractive at the time? To what needs did it respond? And how did it come to count as a primary kind of modern sculpture (alongside
● the abstract design of Gabo and company)? Greatly acclaimed in the forties and fifties, this sculpture was later punished for its very success, as advanced artists in the sixties scorned its recipe of
■ Surrealism and Constructivism and turned to the models that it seemed to occlude: the readymades of Duchamp and the constructions of Rodchenko. And still today, after its great inflation and equally great deflation, it is difficult to see this sculpture clearly. HF

FURTHER READING
Charles Harrison, *English Art and Modernism 1900–1939* (New Haven and London: Yale University Press, 1981)
Barbara Hepworth, *A Pictorial Autobiography* (London: Tate Gallery, 1970)
Alex Potts, *The Sculptural Imagination: Figurative, Modernist, Minimalist* (New Haven and London: Yale University Press, 2000)
Ezra Pound, *Gaudier-Brzeska: A Memoir* (1916) (New York: New Directions, 1961)
Herbert Read, *Henry Moore: A Study of His Life and Work* (London: Thames & Hudson, 1965)
David Thistlewood (ed.), *Barbara Hepworth Reconsidered* (Liverpool: Tate Gallery, 1996)

1930–1939

▲ 1937b ● 1914, 1921b ■ 1966b, 1994a ▲ 1935 ● 1962c ■ 1914, 1921b

1935

Walter Benjamin drafts "The Work of Art in the Age of Mechanical Reproduction," André Malraux initiates "The Museum without Walls," and Marcel Duchamp begins the *Boîte-en-Valise*: the impact of mechanical reproduction, surfacing into art through photography, is felt within aesthetic theory, art history, and art practice.

In 1931 Walter Benjamin wrote "A Short History of Photography," in which, as a critic and theorist increasingly shaped by Marxist thought, he analyzed the medium's relationship to social class. Sharing something of a historical berth with the nineteenth-century novel, photography began (in the 1840s and 1850s) by participating in the heyday of bourgeois culture, so Benjamin related. An amateur pastime, it commemorated the frank exchange of intimacy between friends, as its early practitioners—writers or painters—made each other's portraits, images whose long exposure time (around five minutes) imposed a kind of open gaze and physiognomic authenticity.

By the end of the century, the commercialization that had rapidly overtaken photography had overtaken the class that supported it as well. The clarity and strength with which the new lenses and emulsions had initially captured the captains of industry had yielded to an uncertainty that expressed itself in the hothouse settings for middle-class portraits with their aspirations toward "art"—the sitter posed amid the flowers of a winter garden, or greenhouse, dappled in light and shade. This was the bourgeoisie losing its proprietorship as a class, wrote Benjamin, and the only authentic way to photograph what had happened to it within the urban setting that housed it was to show its class extinction. This is what Eugène Atget did when, in image after image, he shot the streets of Paris emptied of people, as though one were at "the scene of a crime."

The face of time

Photography's reinvention of "portraiture" awaited the twenties, so Benjamin argued. Here bourgeois individualism gave way to the kind of depersonalization that belongs to a different structure of society: a more collective one, as in the masses of faces passionately rendered in the films of Russian director Sergei Eisenstein; or a more anonymous one, as in Aleksandr Rodchenko's *Woman at the Telephone* [1]; or a more sociologized one, as in the social "types" catalogued by the ▲ German photographer August Sander in the late twenties, in his *Antlitz der Zeit* (1929) for instance, and early thirties [2, 3].

Returning four years later to the problem of photography and film in his essay "The Work of Art in the Age of Mechanical Reproduction," Benjamin exchanged the earlier analysis based on class for

1 • **Aleksandr Rodchenko,** *Woman at the Telephone*, **1928**
Silver-gelatin print, 39.5 × 29.2 (15½ × 11½)

one now grounded in modes of production. The use-value of a work, he reasoned, cannot be separated from the conditions under which it is produced. Within primitive societies these conditions inevitably involve hand fabrication, whether by craft procedures or by a simple transfer of magical properties to an object through the touch of shaman or priest. This "cult-value," often operating out of sight of the community, depends on the authenticity of the sacred object, the healing or other properties of which will not inhere in mere replicas or reproductions. The culture of engraved copies of original works of art that begins to develop in the Renaissance adds "exhibition-value" to cult-value and clearly imposes a new use on

▲ 1929

2 • August Sander, *Farming Couple*, c. 1932
Silver-gelatin print, 26 × 18.2 (10¼ × 7⅛)

which, as Benjamin pointed out, "substitutes a plurality of copies for a unique existence." If such an existence could be characterized as tied to the place and time of its origin and thus psychologically distant from its viewer, the mechanical reproduction vaults over that distance. It satisfies "the urge to get hold of an object at very close range by way of its likeness." Mechanical reproduction thus develops a corresponding psychological drive, with its own way of seeing: "To pry an object from its shell, to destroy its aura, is the mark of a perception whose 'sense of the universal equality of things' has increased to such a degree that it extracts it even from a unique object by means of reproduction." Thus a serialization of production (base) begins to effect a serialization of vision, which drives in turn a taste for serialization in the work of art itself (super-structure). Going from the mode of production to the "use-value," Benjamin now writes: "To an ever greater degree the work of art reproduced becomes the work of art designed for reproducibility." The number of artists whose work has been "designed for repro-ducibility" either unconsciously or consciously (from Duchamp to ▲ Warhol and beyond) bears out Benjamin's prediction that the change in the mode of production would sweep all aesthetic values before it. "Earlier much futile thought had been devoted to the question of whether photography is an art," he wrote. "The primary

3 • August Sander, *Gentleman Farmer and Wife*, 1924
Silver-gelatin print, 26 × 18.3 (10¼ × 7¼)

the art object, one involving its propaganda impact as its image circulates through papal or diplomatic channels. But this form of the copy makes a clear distinction between itself and the artistic original whose status *as original* is undiminished. Benjamin terms this status the work's "aura," by which he means its untransferable uniqueness. The handcraft that produces the etched copy partici-pates in the mode of production of the original; both bear the touch of their maker.

With industrialization, conditions of production radically change, as a matrix or "die" is now fashioned from which to mass-produce objects. Mass production entered the world of the image initially via lithography, which, though hand-drawn, is mechani-cally printed. But photography soon took over as mechanical reproduction through and through. Hand work does not inter-vene in taking the picture nor in its printing and, in line with other industrial forms, its matrix—the negative—is not its "original" since it does not fully resemble the finished image. Rather the photograph is a multiple *without* an original. "From a photo-graphic negative," as Benjamin wrote, "one can make any number of prints; to ask for the 'authentic' print makes no sense."

Authenticity and the aura connected to the original are thus *structurally* removed from the mechanically produced object,

▲ 1914, 1918, 1960c, 1962d, 1964b, 1966a

question—whether the very invention of photography had not transformed the entire nature of art—was not raised."

The off-the-wall museum

In 1935 Walter Benjamin was not the only one raising "the primary question" with regard to photography. The French novelist and left-wing political figure André Malraux (1901–76) also saw the medium as transforming "the entire nature of art," but with conclusions diametrically opposed to those of his German counterpart. Where they agreed was on the fact that the photograph wrenched the original away from the site for which it was made and relocated it in an entirely new place, closer to its viewer and reorganized for a new set of uses. They also agreed that this extraction somehow denatures the original works, since in the process of being folded into the photograph that reproduces such works, "they have," as Malraux argued, "lost their properties as *objects*." But where the two men disagreed was in the interpretation of this loss, since for Malraux, "by the same token, they have gained something: the utmost significance as to *style* that they can possibly acquire."

This stylization enabled by photography was a function of the kinds of close-ups and eccentric camera angles that began to be linked in the twenties to what was called the photographic "new vision." Photography's capacity for massive disruptions of original scale (tiny cylinder seals enlarged to become the same visual size as monumental bas-reliefs, for instance), its ability to use strange camera angles or theatrical lighting to effect stunning reinventions (with ancient Sumerian terracotta figures thereby emerging as the cousins of twentieth-century sculptures by Joan Miró), and its possibilities for wresting a dramatically framed fragment from a larger work by means of cutting or cropping: all of this surgically intervenes in the aesthetic unity of the original to enable new and startling grafts. The conclusion Malraux draws from this is a salute to the medium that makes it possible: "Classical aesthetics proceeded from the part to the whole; ours, often proceeding from the whole to the fragment, finds a precious ally in photographic reproduction."

Photography, then, is the great leveler, the means of submitting objects from every period and every place to a kind of stylistic homogeneity, so that they take on the features of "our aesthetics." And the payoff of this procedure is a compendium of total information about the world's art that is made possible by the new tool. This compendium, the art book, is what Malraux began to call "the museum without walls" [4]. The original French for this—the

▲ 1929

"*musée imaginaire*" (the imaginary museum)—brings out the antimateriality of the operation, its drive to reduce the physicality of the object to the virtuality of the image, a drive that will only be reinforced later in the century when the imaginary museum *really* reaches for global coverage and its virtual home will not be the art book but the internet.

If for Malraux the value of the art book is that it democratizes the experience of art by bringing it into the lives of vastly more people than the elitist museums had done (a value that is exponentially increased by the web, in the eyes of enthusiasts of the "information superhighway"), this was not its primary function. Rather, it was that, by means of its concatenation of photographic reproductions, the book recodes works of art from "objects" into "meanings"—as he had said, the works gain "the utmost *significance* as to style that they can possibly acquire." The art book is a semiotic machine, then; and the photograph is what gives it leverage. For the photograph is the great facilitator of *comparison*, of moving past the contemplation of a work in isolation to the *differential* experi-▲ence of it, its meaning emerging—as linguist Ferdinand de Saussure had assured us it would—in relation to what it is *not*.

One of Malraux's very first texts, a 1922 preface to an exhibition catalogue, already presents this notion of art as a vast semiotic system, a multiple chorus of meaning. In it Malraux had written: "We can feel only by comparison. He who knows *Andromaque* or *Phèdre* will gain a better idea of the French genius by reading *A Midsummer Night's Dream* than by reading all the other tragedies by Racine. The Greek genius will be better understood by comparing a Greek statue to an Egyptian or Asiatic one than by acquaintance with a hundred Greek statues."

Malraux, at the age of twenty, did not stumble by himself onto this conception of the aesthetic as comparative and therefore as fundamentally semiotic. Apprenticed to the art dealer Daniel-Henry Kahnweiler, Malraux was indoctrinated into an experience of the visual arts that was informed by both German art history and Cubist aesthetics, which is to say a way of seeing that had dispensed with the idea of form as beauty in favor of a conception of it as "linguistic." Classical art, as an aesthetic absolute for Western taste, had instituted beauty as the ideal of artistic practice and experience. In the late nineteenth century the Swiss art historian •Heinrich Wölfflin had relativized this absolute by arguing that Classicism can only be "read" within a comparative system through which it can be contrasted with the Baroque. Setting up a group of formal vectors through which to make such comparative readings—the tactile versus the optical, the planar versus the recessive, closed form versus open form—Wölfflin transmuted form into the condition of the linguistic sign: oppositive, relative, and negative. Form no longer had value in itself, but only within a system, and in contrast to another set of forms. The aesthetic component was no longer beautiful; it was significant.

Kahnweiler's connection to this early, structuralizing art history in Germany influenced his own understanding of Cubism. ■For Picasso's dealer saw the Cubist exploitation of African art, for

example, as a breakthrough to the production of forms that would ▲function as signs. Malraux took this dictum, and never forgot it. Art produces signs that can be read comparatively. Comparison decentralizes and dehierarchizes art, for the comparison works on the juxtaposition of systems—*all* systems: east versus west, high versus low, courtly versus popular, north versus south. And photography, by fragmenting and isolating the signifying elements from within a work's complexity, is the ultimate aid to this reading.

If the massive study that finally emerged from Malraux's contemplation of this problem was called *The Voices of Silence* (1951), this was because the "texts"—which he called "fictions"— that such readings can produce would release a new power from the mute work of art. It is this transformation into a system of meaning that makes up for what reproduction takes away, leaving no room for regret that these figures have lost "both their original significance as objects and their function (religious or other); we see them," he declared, "only as works of art and they bring home to us only their makers' talent."

Benjamin had said "That which withers in the age of mechanical reproduction is the aura of the work of art"; Malraux was insisting on retaining a notion of aura no matter how transformed. The "fiction" created by the art book transmits what he calls "the spirit of art." And it is this spirit that reproduction liberates to tell its story, no matter how silently: "Thus it is that, thanks to the rather specious unity imposed by photographic reproduction on a multiplicity of objects, ranging from the statue to the bas-relief, from bas-reliefs to seal-impressions, and from these to the plaques of the nomads, a 'Babylonian style' seems to emerge as a real entity, not a mere classification—as something resembling, rather, the life-story of a great creator."

The "original" copy

Dates seem to have their own center of gravity: 1935 was not just the moment for both Benjamin and Malraux to contemplate art's fate at the hands of reproduction, it was also the year when Duchamp began to create his own museum without walls, although whether it was to tell "the life-story of a great creator" (Duchamp himself) or not is, as always with Duchamp, held hostage to the artist's extreme sense of irony. The *Boîte-en-valise* [5] was begun in 1935 as a massive retrospective of Duchamp's work to date carried out through sixty-nine ●reproductions, including tiny replicas of several of the readymades. Miniaturizing the museum exhibition to the size of a carrying case, this "art book" unmistakably strikes up a family resemblance to a salesman's sample case. It is thus that Malraux's eloquent "voices of silence" are rescored for advertising jingles and the "spirit of art" is retooled in the light of the commodity.

Yet nothing is simple with Duchamp. Over the course of the next five years he painstakingly produced his reproductions by the labor-intensive method of collotype printing, in which color is applied by hand with the use of stencils, on average thirty such for each proof. Executing them himself, these became *coloriages originaux* (original

5 • Marcel Duchamp, *Boîte-en-valise*, 1935–41 (1941 version)
Assemblage, dimensions variable

colorings-in), which issued into the extreme aesthetic mutation of authorized "original" copies (some of them even signed and notarized) of original works, some of which (the readymades) were themselves unredeemably multiples. In this endless perspective of facing mirrors, original and reproduction thus continue to change places, with Duchamp now defying Benjamin's dicta by returning to the authenticating touch of the artist, and now thumbing his nose at Malraux's "great creator" by shackling this spirit to the compulsive performance of serialized repetition.

Summarizing the effect of the *Boîte*, David Joselit has written that it may appear to be about shoring up "Duchamp's artistic identity through a coherent summary of his oeuvre, but as an elaborate performance of compulsive repetition—the same form of repetition that Freud associated with the unconscious instinctual drive of death *and* Eros—Duchamp represented a self that is alternately organic and inorganic, masculine and feminine. The act of copying both *constitutes and destroys* the self…. He had found himself—*readymade*." RK

FURTHER READING
Walter Benjamin, *Illuminations* (New York: Schocken Books, 1969) and *One Way Street* (London: New Left Books, 1979)
Ecke Bonk, *Marcel Duchamp: The Box in a Valise* (New York: Rizzoli; and London: Thames & Hudson, 1989)
David Joselit, *Infinite Regress: Marcel Duchamp 1910–1941* (Cambridge, Mass.: MIT Press, 1998)
André Malraux, *Museum without Walls*, trans. Stuart Gilbert and Francis Price (New York: Doubleday, 1967) and *The Voices of Silence*, trans. Stuart Gilbert (Princeton: Princeton University Press, 1978)

1936

As part of Franklin D. Roosevelt's New Deal, Walker Evans, Dorothea Lange, and other photographers are commissioned to document rural America in the grip of the Great Depression.

Two unforgettable films by the American documentary film-maker Pare Lorentz (1905–92)—*The Plow That Broke the Plains* (1936) and *The River* (1937)—emerged from the many produced by the Information Division of the Farm Securities Administration (FSA), a US government agency established in 1936 as part of President Franklin D. Roosevelt's New Deal. Both films were documentaries of the crisis conditions of rural America in the grip of the Great Depression, the first depicting the Oklahoma Dust Bowl, the second, the catastrophic flooding of the Mississippi River system.

Beyond merely documenting the plight of the victims of these natural disasters, however, Lorentz was intent on achieving at least two other things: to articulate the human cause of these events in the persistent misuse of the land by its owners, and to propagandize for specific government programs to address this situation, such as the Tennessee Valley Authority (TVA) and its projects for building dams along the Mississippi River system. And for this latter goal to be effective, Lorentz needed to seize the imagination of the public, first, by acquainting the citizens of a huge country with parts of it they had never seen before or known much about; and, second, by giving his factual film the emotional drive of a fictional narrative. Only in this way could he overcome the characterization emanating from parts of the US Congress that Roosevelt's programs were a form of the "socialism" that many Americans dreaded, while at the same time countering this demonization by advocating a version of that very same socialism (that is, the centralization of authority necessary to the TVA, or the use of farm cooperatives in order to restructure the prospects of the tenant farmer).

To amber waves of grain …

On the eve of moving into the FSA to head its Historical Section, Roy Emerson Stryker (1893–1975), had long meetings with the sociologist Robert Lynd to refine his own sense of mission with regard to documentary. He emerged from these sessions with the idea of coordinating the Section's efforts by preparing "shooting scripts" that he would issue to the team of photographers working under him. An early version of part of such a script goes:

HOME IN THE EVENING

Photographs showing the various ways that different income groups spend their evenings, for example:
Informal clothes
Listening to the radio
Bridge
More precise dress
Guests

The static character of this "script" obviously sets it apart from the grand flow of cinematic narrative, which can control its own temporal momentum, moving in a few dramatic seconds, for instance, from droplets melting from branches in the Wisconsin springtime to the vast sweep of the Mississippi reaching the Delta, as Lorentz did in *The River*. And indeed, Stryker's idea of how to collate the results of the images that his photographers would amass over the nine years of their collective efforts (consisting of more than 100,000 prints) was not a sequential narrative but a spatial container: an encyclopedic file or archive, organized, by categories and subcategories and subdivisions of these.

The immediate use to which the FSA photographs were put was the supply of visual information to the public, whether through the government's own books and exhibitions or, more effectively, through the mass media, in such newly founded illustrated weeklies as *Life* (begun in 1936) or *Look* (begun in 1937). For Stryker, the FSA material was, however, substantially different from the photojournalism on which these magazines thrived, since he viewed news photography as "dramatic, all subject and action"; while on the other hand, he said, "Ours shows what's in [the] back of the action." Against the news photo's subject and verb, Stryker characterized the FSA work as adjective and adverb.

This is probably as good a characterization as any of Dorothea Lange's *Migrant Mother* [1], the photograph that perhaps more than any other came to stand for the emotional appeal, effectiveness, and memory-searing quality of the FSA's work. For there is no action connected with this image, unless its sitter's staring into an utterly uncertain future could be called action. And as for the adjective and adverb connection, in its shuttling back and forth between the universal—the reading it invites of a timeless "human

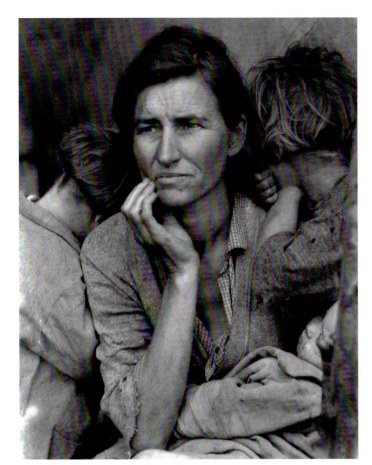

1 • Dorothea Lange, *Migrant Mother*, 1936

dignity" emerging from within a situation of despair—and the particularity of the woman the camera captures, this image constitutes an example of the kind of "humanitarian realism" that Stryker supported. Indeed, Lange's picture, which came to be called "Madonna of the Migrants," sets up certain echoes with religious paintings, whether these be the seventeenth-century Italian painter Caravaggio's projection of the mother of Christ into the lowliest of Roman peasant women, or a work like Rosso Fiorentino's *Dead Christ* (1525–6) which, like Lange's image, wedges the figure of the Man of Sorrows between two flanking angels.

The redemptive tenor suggested for Lange's work by such comparisons is not out of keeping with an overall concern of the survey. As a contemporary of Stryker's wrote: "You could feel the Depression deepen but you could not look out of the window and see it. Men who lost their jobs dropped out of sight. They were quiet, and you had to know just when and where to find them." Stryker saw the mission of his survey, with its search for the details of rural life and small-town poverty, as a project "to find them." And he gloried in the photographs of an entire range of human types, the faces of whom, he felt, proclaimed the will and the ability to survive the utmost hardship. As Stryker would later say: "The faces to me were the most significant part of the file."

But if Stryker read a message of survival and redemption in the photographs, others have seen them as globally projecting an entirely different message. The historian Alan Trachtenberg has

Works Progress Administration

From the time between Franklin Delano Roosevelt's inauguration as President of the United States in January 1933 and the summer of 1935, the federal government ran a series of work-relief projects in an attempt to aid the vast numbers of unemployed created by the Great Depression. At the urging of Henry Hopkins, the director of the Civil Works Administration, a small allocation was made to artists through the Public Works of Art Project. Typical of the early phase of federal relief, this program was both short-lived (its funding ran out after four months) and the target of political controversy. In New York, those lucky enough to be signed onto it spent their time cleaning and repairing the city's statues and monuments; with its demise they were forced back onto the relief rolls.

By the summer of 1935 Hopkins had managed to persuade Roosevelt to set up the Works Progress Administration, a mammoth program of work-relief that would "take America off the dole and put it back to work." As Hopkins expressed it: "Those who are forced to accept charity, no matter how unwillingly, are first pitied, then disdained." During its six years, the WPA employed an average of 2,100,000 workers and spent $2 billion. Its nearly quarter of a million projects ranged from raking leaves to building airfields. As he had in the Civil Works Administration, Hopkins made sure that money would be channeled to artists. Accordingly, over this same period five percent of WPA funds ($46 million) and two percent of its employees (38,000) were allotted to the creative and performing arts. For the visual arts this meant the Federal Arts Project, directed by Holger Cahill, in addition to which there was a Federal Music Project, Theater Project, and Writers' Project.

In New York City, about 1,000 artists joined the FAP payroll in its first four months. The guidelines that required painters to be divided up between the mural and easel divisions also mandated a screening procedure according to which artists would be classified as "unskilled, intermediate, skilled, or professional," with their payscale regulated by these grades. Traditionalists and modernists competed fiercely for administrative power and control of this and other processes. Although the traditionalists were dominant for the most part, a small group of abstract artists led by Burgoyne Diller and Harry Holtzman—disciples of Piet Mondrian—were able to gain enough power to assign murals to young abstract painters such as Arshile Gorky, Stuart Davis, Byron Browne, Jan Matulka, and Ilya Bolotowsky.

The effect of the Federal Arts Project was an overwhelming one of bringing artists together in a new way: artists not only helped each other get around bureaucratic rules, but also the WPA offices to which they went to get their checks and their assignments became meeting places along with the bars and coffee houses of the Village. No longer obliged to work at part-time jobs, these full-time artists now saw themselves as a single community.

written, for example: "If there is a great overarching theme of the FSA file, it is surely the end of rural America and its displacement by a commercial, urban culture with its marketplace relationships. Automobiles, movies, telephone poles, billboards, canned food, ready-made clothing: these familiar icons from the file bespeak a vast upheaval … a profound breach in the relation of American society to its "nature" and to the production of sustenance from the land."

In this reading, in which the file's images of trains sliding past grain silos can be seen as representations of the machine as the agent of the further impoverishment of the dispossessed, or the repeated pictures of billboards announce the replacement of handmade signs by printed ones, an important shift away from the human face is announced. And in such a shift, Stryker's disagreement with the most famous of his photographers can be felt. For Walker Evans (1903–75) had a predilection for just those building facades and posters that projected a land emptied of its "human" content that Stryker resisted [2].

The FSA style

Joining Stryker's project in 1935, when the FSA was still called the Resettlement Administration, Walker Evans worked for Stryker for eighteen months. Their differences were expressed as the split between Evans's demand for a "pure record" and Stryker's desire for pictures that would promote social or political change, a desire that led the decidedly nonsurvey photographer Ansel Adams (1902–84) to complain to Stryker: "What you've got are not photographers. They're a bunch of sociologists with cameras." Indeed, Evans was careful to separate himself from real documentary, a term he did not want applied to his work, saying: "The term should be *documentary style*. You see, a document has use, whereas art is really useless. Therefore art is never a document, although it can adopt that style."

Contained within Evans's seemingly paradoxical statement—that documentary could be just another "style," albeit the style in which photography "as such" is essentialized—is a whole aesthetic that developed around the medium in the thirties, slowly building into the postwar years and fully blossoming in the sixties to become the official stance of such arbiters of photographic taste and photographic history as the Museum of Modern Art's Department of Photography. Although the museum was an enthusiastic supporter of Evans's work, the documentary photographer who came to be seen as the most perfect representative of photography's essence was a Frenchman working in the opening decades of the century, Eugène Atget (1856–1927).

Like Evans's work, Atget's documentary pictures were commissioned in the context of various surveys: by the Library of the City of Paris, by French antiquarian societies, by builders' guilds, and so forth. But like Evans again, Atget's work made strong connections to aesthetic sensibilities that went beyond the sociological to lodge firmly in the tastes of contemporary art. Pictures like Evans's *Penny Picture Display, Savannah* [3], with its rows of contact sheets pressed against a shop window made synonymous with the surface of the print itself, the window's lettering—STUDIO—as compressive a

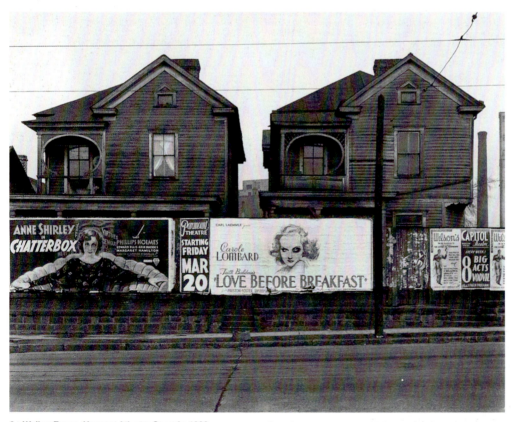

2 • Walker Evans, *Houses. Atlanta, Georgia*, 1936
Silver-gelatin print

▲ 1959d

3 • Walker Evans, *Penny Picture Display, Savannah*, 1936
Silver-gelatin print

But if the Museum of Modern Art was determined to do so, it was because the very idea of a photographic "author" had, by the sixties and seventies, come to be projected through Evans's formula of "documentary style," now proclaimed as the essence of photographic *art*. To understand this we have to hold two (contradictory) notions in our head at once: the idea of the total transparency of the documentary photograph to its real world referent, or content, a content with which it does not interfere in any way; and the idea of style as the registration of the artist's own temperament, his or her vision, his or her shaping consciousness. Yet we also have to consider that there is a plane on which these two contradictions can be resolved. This is that of the camera itself, or rather the plate-glass surface on which, in a reflex camera, the image on the lens is mirrored for the photographer's view; it is there that the picture is previsualized on its way to leaving the real world from which it is "peeled" to enter the other, flattened reality of the "image." It is this difference between the world of matter and the world of the image that the photographer sees in the reflex camera's mirror, a difference that gives to that photographer an ironic distance, a "second degree" relation to reality that he or she can register in the results themselves. And it is this registration, be it ever so subtle, that enters the work as style.

Evans's style is built from just this second degree. The roadside billboard held absolutely parallel to the picture surface so that only

force as anything in Cubist collage, were seen as self-reflexively modernist rather than documentary. And if such a self-referential stance could be found in Evans, this same position was just as easy to spot in Atget. His facades of Parisian cafés come across as brilliant modernist exercises, photographed as they are head on, in such a way that the reflection of Atget's own body standing next to his shrouded stand-camera is deposited on the doorway's window at just the point at which the café-owner's curious face pierces the same mirrorlike surface from within to perch, magically, atop the cameraman's body, collapsing the space both before and behind the image's surface onto a single, flat plane [4].

Indeed, Atget was adopted by every variety of modernist sensibility from the twenties on. His "found" montages of shop-window reflection were Surrealist for the Surrealists; his flea-market "accumulations" were images of the serial life of the commodity for the German Neue Sachlichkeit; his limpid French gardens were sublime landscapes for the American styles that developed out of Precisionism as a form of "straight photography" that included Paul Strand, Edward Weston (1886–1958), and the Ansel Adams who had accused Stryker of sociologism. In fact, there were so many different "Atgets" to be found among the eight thousand negatives he left that it might be hard to focus all of these into the kind of oeuvre that we associate with a specific author—with its coherence reflecting the organic unity of a single person and the focused intentionality of an individual consciousness.

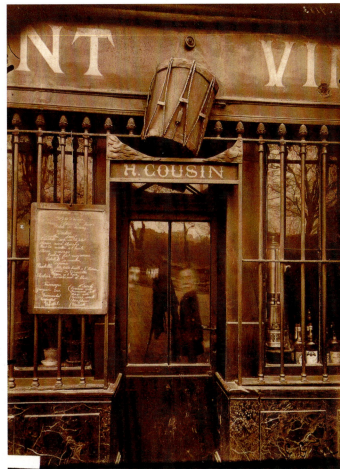

4 • Eugène Atget, *Café "Au Tambour," Quai de la Tournelle*, 1908
Silver-gelatin print (sepia-toned)

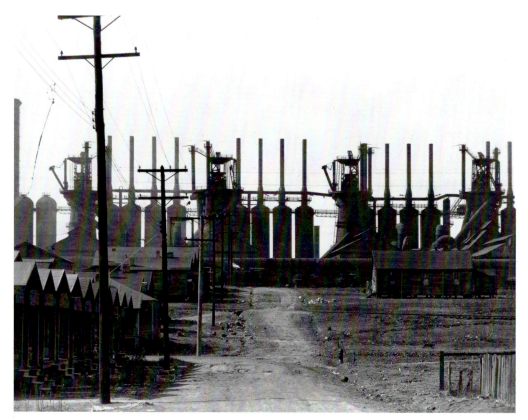

a tiny bit of landscape peeps out from behind its edges, pits the billboard's own illusionistic rendering of a house interior against the camera's now flattened data of the real world so that the collapse between the two produces a sense of reality and illusion ▲ switching sides, with reality itself become simulacral. Or in his deadpan, twinned house facades, flattened by the stark lighting that seems to render them into drawings of themselves, the sense of their existence as "duplicates" or mere copies not only repeats this simulacral sensibility but ties it to the very duplicative and serial nature of photography as well. This frontality and flattening so consistent within Evans finally renders even the steel mills and workers' housing of a company town into merely a "picture" of themselves, unreal and uncanny [5].

But if these are features of Evans's *style*—personal, unmistakable, original—they are also dispersed throughout the full range of the FSA's photographic material. They are to be found, for instance, in the rhythmic, blank facades of Arthur Rothstein's photographs of sharecroppers' shanties, their hapless boarding etched into elegant patterns by light, or in the parallel rows of magazines in John Vachon's *Newsstand*, with their ranged repetitions of the same covers. Indeed, if Alan Trachtenberg called attention to such a displacement of the natural by the mechanical as the "overarching theme" of the FSA file, it was not to make Walker Evans the file's "author." But neither was it to make Stryker that "author," as some scholars are now doing. Instead it was an attempt to scatter authorship as such, making the survey's reach and the camera's machinic specificity intersect at a certain moment in historical time.

The death of the author

This depersonalization of the very idea of the author is, as we would imagine, at work in a certain branch of the critical assessment of Atget's work as well. If the Museum of Modern Art's desire to unify the vastness of his production around a single, authorial intention coincided, historically, with the sudden emergence in the mid-sixties of photography as a rarefied, collectible type of work of art, it also coincided with structuralism's proclamation of "the death of the author." The institution of the "author-function" or the "author-effect" in the place of an originary subject, the dispersion of such a subject into the labyrinth of a textual space whose myriad, already-written, already-heard voices any purported author merely quotes—all of this views authorship as nothing but an effect of the space of a multiplicity of archives or, ▲ as Michel Foucault put it, of discourses. For the structuralist critic, then, Atget "himself" is simply an author-effect, the fractured source of which is the multiplicity of the many archives for which he worked. RK

FURTHER READING
James Agee and Walker Evans, *Let Us Now Praise Famous Men* (Boston: Houghton Mifflin, 1941)
Lawrence W. Levine and Alan Trachtenberg, *Documenting America, 1935–1943* (Berkeley and Los Angeles: University of California Press, 1988)
Maria Morris Hambourg et al., *Walker Evans* (Princeton: Princeton University Press, 2004)
Molly Nesbit, *Atget's Seven Albums* (New Haven and London: Yale University Press, 1992)
John Szarkowski, *Atget* (New York: Museum of Modern Art, 2000)
Roy E. Stryker and Nancy Wood, *In This Proud Land: America 1935–1943 As Seen in the FSA Photographs* (Greenwich, Conn.: New York Graphic Society, 1973)

▲ 1977a, 1980 ▲ 1971, 1977a, 1980, 1997, 2009b, 2010b

1937 a

The European powers contest one another in national pavilions of art, trade, and propaganda at the International Exhibition in Paris, while the Nazis open the "Degenerate 'Art'" exhibition, a vast condemnation of modernist art, in Munich.

On July 19, 1937, "Degenerate 'Art'" opened in the Nazi homeground of Munich, a day after Hitler inaugurated the "Great German Art" exhibition in the massive new House of German Art across the street. The Nazis intended the two shows as complementary demonstrations of racial types and political motives in art. The first was intended to expose the degeneration of modernist art as intrinsically Jewish and Bolshevik; the second, to display the purity of German art as self-evidently Aryan and National Socialist (ironically, only six of the 112 artists in "Degenerate 'Art'" were Jews). According to Minister of Propaganda Joseph Goebbels, degenerate art "insults German feeling, or destroys or confuses natural form, or simply reveals an absence of adequate manual and artistic skill."

Nazi art was presented as its antithesis: archnationalist in subject, it exalted "German feeling," and archtraditionalist in style, it armored "natural form" in neoclassical cladding, as in the pumped-up figures of its foremost sculptors Arno Breker (1900–91) and Josef Thorak (1889–1952). To a great extent, then, Nazi aesthetics projected a paranoid image of modernist art, and reacted against this image in its own art. To this end, it abjected the art of "primitives," children, ▲ and the insane, the primary affiliations used to condemn modernist art in "Degenerate 'Art'," which also charged this art with "disrespect" for religion, femininity, and the military [1].

The two exhibitions were not complementary, however, in attendance: "Degenerate 'Art'" attracted five times as many visitors

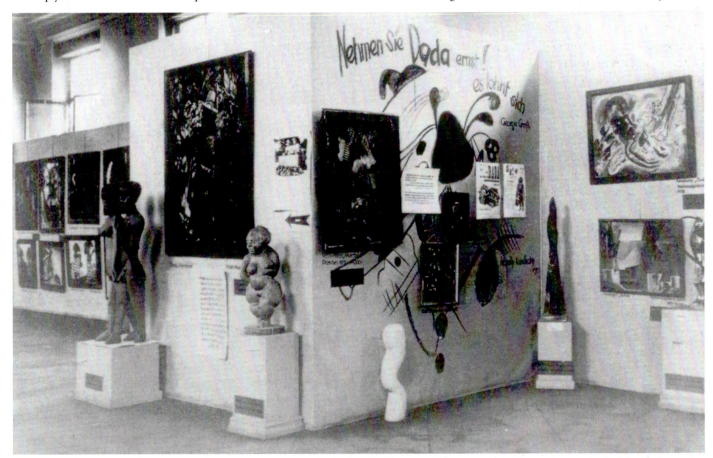

1 • Room 3 of the "Degenerate 'Art'" exhibition, 1937, Munich
Showing the projection along the south wall, including the Dada wall

▲ 1903, 1922

as "Great German Art"—two million in Munich alone, nearly another million in its tour of thirteen other cities in Germany and Austria over the next three years. It remains the most visited show of modernist art ever. This is a highly ambiguous statistic: if the work was so repulsive, why did it attract so many? Is scorn born of resentment the most "popular" response to modernist art? Were there alternative, even subversive, kinds of spectatorship, one that secretly appreciated the art on view (there is some evidence of this)? The show was only one event among many other anti-modernist exhibitions, anti-Semitic films, book burnings, and so on. Moreover, "Degenerate 'Art'" displayed just 650 of the 16,000 modernist works confiscated from thirty-two public art museums in 1937 alone, most of which were burned, "lost," or sold for cash—a provenance with which collections around the world are still coming to terms. However infamous, then, the exhibition was only a single episode in a long war on modernist culture, a total purge of progressive institutions. In 1933 the Nazis shut down the
▲ Bauhaus; in 1935 Hitler ordered the eradication of modernist art altogether; in 1936 Goebbels banned non-Nazi art criticism; and so on. Such is the cultural penetration of a totalitarian state, and the political importance of antimodernism to the Nazi regime.

Body politics

For the Russian art historian Igor Golomstock, several principles governed the art policies of totalitarian regimes of the interwar
● period (he includes Stalinist Soviet Union and Fascist Italy equally): art was treated as an ideological weapon; the state assumed a monopoly over cultural institutions; the most conservative art movement was made official; and all other styles were condemned. There are exceptions to these rules, particularly the last two, especially under Mussolini. Modernism was anathema in many ways, but not always because it was antitraditional or antibourgeois. At first Mussolini embraced Futurism for its ideology of destruction, and all these regimes sought to replace old affiliations of culture and class with new identifications with leader, party, and state. However, no regime could tolerate modernist deformations of the body. Thus the Nazis condemned Expressionism, even though it was "German," more violently than abstraction, which they deemed "Bolshevik"—much to the chagrin of the Expressionist Emil Nolde, a Nazi Party member who was well represented in "Degenerate 'Art'." In general, modernist art was dangerous because it privileged the individual in terms of original vision, singular style, personal redemption, and so on. Even more than its deformations, this "subjectivism" ran counter to the corporate imperative of totalitarian regimes—the need to bind the masses psychically and almost physically to the leader, party, and state [2]. In this scheme the individual body could only figure the body politic, and it was often imaged as phobically intact, even phallically aggressive, as in *Readiness* by Breker [3], an allegorical figure of Nazi militarism.

On the one hand, each totalitarian culture had to represent its political regime with its specific symbols—the Teutonic swastika

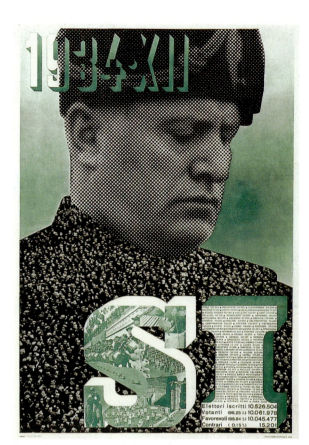

2 • **Xanti Schawinsky,** *1934—Year XII of the Fascist Era*, 1934
Letterpress poster, 95.7 × 71.8 (37⅝ × 28¼)

recovered by Hitler for his Nazi flag, or the ancient *fasces* of Roman lawmakers (an ax projecting from a bundle of rods bound with a red strap) recovered by the Italian Fascists for their party logo. On the other hand, it had to represent this regime as *non*specific, suprahistorical, even transcendental: thus the general use of a monumental neoclassicism. (Another highly ambiguous phenomenon is that other governments, not considered totalitarian, have also resorted to this idiom for similar reasons.) In this reversion to neoclassicism, Golomstock notes, the old hierarchy of academic genres was revived and recast. The royal portrait became the portrait of the party leader, and retained its "tendency to deify." The history painting became the "historico-revolutionary theme," and retained its tendency to mythify, with leaders, party martyrs (if Nazi or Fascist) or worker-heroes (if Stalinist) depicted as "creators of history." Genre painting became renderings of labor either as a "fierce struggle or a joyful festival." And landscape painting was treated "either as an image of the Fatherland … or as an arena of social transformations—the so-called 'industrial landscape.'" The "historico-revolutionary" paintings were especially burdened, for they had another contradiction to face as well: the story of the nation had to be told, but its greatest epoch only began with the totalitarian regime. In this restrictive scenario, the best heroes, that is to say the safest ones, were either allegorical or dead or both. This mode of allegory and cult of death pervaded totalitarian architecture too.

However, the term "totalitarian" obscures as much as it illuminates. Politically, it elides the fundamental fact that Nazism and

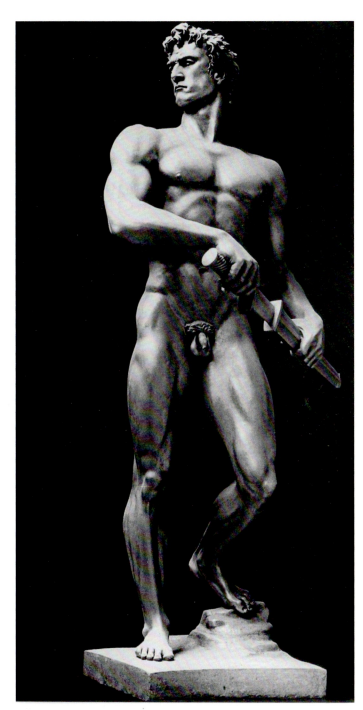

3 • Arno Breker, *Readiness*, Berlin, 1939
Bronze, height 320 (126)

The intensity of antimodernism also varied from regime to regime. Mussolini allowed some modernist forms (from Futurist art to Rationalist architecture) to coexist, indeed to combine, with some reactionary forms. In this way, as the American critic Jeffrey Schnapp has suggested, Fascism used "aesthetic overproduction" to cover for its ideological instability. And although Stalin suppressed Constructivism, he also employed some of its leaders, such as ▲ Aleksandr Rodchenko and El Lissitzky. (The recent argument, advanced by the Russian critic Boris Groys, that Stalin was the epitome of the Constructivist engineer of culture is reductive, indeed antimodernist in its own right.) The antimodernism of the Nazis was most thorough, but they too compounded atavistic forms of ritual (for instance, the party rallies at the Nuremberg Zeppenfeld designed by Albert Speer [1905–81]) with advanced forms of media (for instance, *Triumph of the Will*, the 1935 film by Leni Riefenstahl [1902–2003] of the 1934 party rally, the Nazi "Birth of a Nation"). In different ways, then, all three regimes mixed the modernist and the reactionary. Even when they were attracted to modernism for its transgression of bourgeois culture, they were repelled by its alienation of the masses; and even though they were eager to exploit the manipulative effects of media spectacle, they were reluctant to sacrifice the communal bases of archaic culture.

Some of these conflicts and contradictions surfaced at the International Exhibition in Paris, which opened in May 1937 under the government of Léon Blum, a Popular Front alliance of Socialists and Communists against fascism. With several art shows (both traditional and modern) and many national pavilions, the vast site extended from the Hôtel des Invalides across the Seine to the Trocadéro, with the Eiffel Tower (emblem of past exhibitions) at its center. Some pavilions featured displays of art and trade, others foregrounded photomontage narratives of nation; still others combined the two kinds of exhibit. Although intended as an international fair pledged to peace (replete with a Peace Tower at its north end), the International Exhibition was dominated by a cultural war that soon became an actual military one. Indeed, the Spanish Civil War, which • further pressured the confrontations here, was already under way.

The central confrontation occurred on the right bank of the Seine just above the Pont d'Iena [**4**]. There the Soviet pavilion, designed by Boris Iofan (1891–1976), a primary architect of Stalinist monoliths, faced the German pavilion, designed by Albert Speer, the chief architect to Hitlerian hubris. (In the continuum between culture and war at issue here, this master-builder of the Nazis became minister of armaments during World War II.) In his memoir *Inside the Third Reich* (1970), Speer revealed that a secret sketch of the Soviet pavilion influenced his own design: "A sculpted pair of figures thirty-three [meters] tall, on a high platform, were striding triumphantly towards the German Pavilion. I therefore designed a cubic mass, also elevated on stout pillars, which seemed to be checking this onslaught, while from the cornice of my tower an eagle with a swastika in its claws looked down on the Russian sculptures. I received a gold medal for the building; so did my Soviet colleague."

Fascism (which are hardly identical) struggled bitterly against Communism. On the artistic front alone, the neoclassicisms of the three regimes were as different as the nationalist myths that they served. The Nazis contrived a massive neoclassicism in order to posit an Aryan Germany as the warrior-heir to ancient Greece, while the Fascists produced a sleek neoclassicism in order to present a Fascist Italy as the modern revival of ancient Rome. The kitschy academicism of the Soviet Union was different still: not bound up with antique origin myths, its "Socialist Realism" was focused on present ideology—in the words of culture commissar Andrei ▲ Zhdanov, "to educate workers in the spirit of Communism."

▲ 1934a

▲ 1921b, 1926, 1928a, 1928b • 1937c

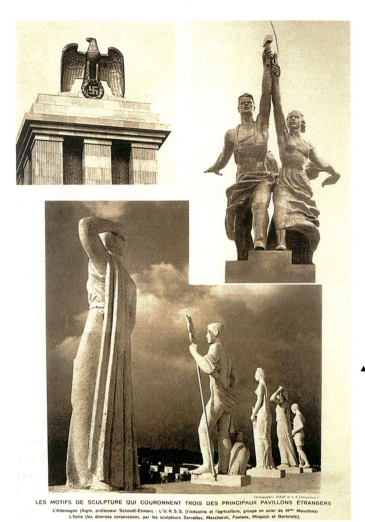

4 • Details of the Nazi (top left), Soviet (top right), and Italian (bottom) pavilions at the International Exhibition in Paris, 1937

As Speer suggests, the two pavilions were seen as equal instances of effective propaganda, but the similarity ends there. The Soviet structure served as a kinetic pedestal that thrust the steel-clad *Industrial Worker and Collective Farm Girl* sculpted by Vera Mukhina (1889–1953) forward, as if into world-historical prominence; they are sculptural embodiments of the proletariat as new heroes of history. No one could mistake this ensemble for the *Monument to the Third International* (1920) proposed by the

▲ Russian Constructivist Vladimir Tatlin: these allegorical figures represented the Soviet Union of Stalin, specifically his brutal Five-Year Plans to industrialize production and to collectivize agriculture. But, like the *Monument*, the Soviet pavilion did ascend dynamically, here to the union of hammer and sickle, Communist emblems of factory and farm. And as Speer also suggests, this advance was indeed arrested by the German pavilion, an oppressive temple to imperial power that announced a very different notion of nation and history; to note only the obvious, it culminated in emblems of party, not figures of labor.

Although its steel construction may seem modern, this pavilion was clad with German limestone, not to mention the swastika tiles in gold and red recessed between its piers. And although its stripped facade may also seem modern, this only "purified" the classical reference of the columns and the entablature. In fact, the pavilion was a typological pastiche in the guise of a pure monument, for even as its tower alluded to a classical temple, its exhibition hall alluded to a medieval church, in whose "apse" stood a model of the mausolean House of German Art designed by Paul Troost (1878–1934), the recently deceased predecessor to Speer as chief Nazi architect—an appropriate "altarpiece" in this architecture of death. For what is at stake in these historical allusions is the hubristic ambition to subsume history, indeed to transcend it. And this ambition was programmatic. Speer and Hitler, a failed artist and amateur architect in his own right, devised a "ruin theory" of architecture, whereby Nazi structures (such as the gargantuan Great Hall conceived by Speer for the new Berlin ordained by Hitler) would be built to last *beyond* the millennium of the Thousand-Year Reich—to subject all posterity to a sublime awe before its glorious ruins. Already "dead" in its neoclassicism, this aesthetic thus sought to dominate time posthumously—to turn time into a spectacle of domination. Perhaps this

▲ is what Walter Benjamin had in mind at the close of his famous essay on the new "mankind" fashioned by such spectacles: "its self-alienation has reached such a degree that it can experience its own destruction as an aesthetic pleasure of the first order."

A modernist retort

Within this war of pavilions there was also a battle of figures. Expunged from most modernist art for the first two decades of the century, the human figure returned with a vengeance in the

● *rappel à l'ordre* (return to order) of the twenties and thirties—not only in reactionary art but also in antidemocratic politics, in which, again, identification with the body of leader, party, and state became imperative. Such figures as the Soviet Worker and Farm Girl were hardly realist: they were allegorical types not only of comradeship but of equality in Communist labor. No less allegorical, the *Monumental Groups* by Thorak that flanked the German pavilion stressed the opposite: these trios of one nude man and two nude women insisted on sexual difference. This insistence accorded with the strict divisions in Nazi society as a whole, but one senses a psychic import here too, as if the phallic body-ego of the Nazi masculine ideal required a "feminine" other against whom to aggress—an other represented in different ways by Jews, Bolsheviks, homosexuals, gypsies, and so on.

The Italian figures across the Seine were different again. These robed representations of various corporations were intended to connect the Fascist state to ancient Rome (the same association was advanced within the Italian pavilion). But rather than enliven the past, they petrified the present, and turned this mythical history of Italy into a kitschy kind of costume ball. Different still were the two photographs of two women (the change in medium is significant) that stood out from the photomontage displays

■ at the Spanish pavilion, which was under the control of the

5 • Pablo Picasso, *Guernica*, 1937
Oil on canvas, 349 × 777 (137⅜ × 305⅞)

Republican Popular Front government. The woman on the left, wrapped in the traditional costume of Salamanca, stands mute and grim, as if burdened by her status as a folklorish fetish, while the woman on the right strides toward us in a militia uniform, larger than life, with her mouth open in song or shout. The metaphor here is one of metamorphosis: the militant butterfly of Republican resistance bursts from the cocoon of Nationalist tradition, as her caption states: "Freeing herself from her wrapping of superstition and misery, from the immemorial slave is born THE WOMAN, capable of taking an active part in the development of the future." Unlike the Fascist figures, she sheds the past in the name of a liberated future; yet, unlike the Soviet figures, she does so with a photographic specificity that makes her fight real.

And it was real. In February 1936, the Popular Front won elections in Spain; in July, General Francisco Franco led an army revolt; and three years of civil war ensued between his Nationalists (mostly army, Church, and industrialists) and the Republicans (mostly Socialists, Communists, anarchists, and liberals, supported by Basques and Catalans). Hitler and Mussolini aided the Nationalists actively, while Stalin supported the Republicans weakly. This, then, was the battleground behind the militant woman in the pavilion—a pavilion that connected democratic resistance and modernist art at several levels. The building, a Corbusian structure designed by Josep Lluis Sert (1902–83), was modernist, as were its principal contents, two protest-paintings made on behalf of the Republican cause: *The Catalan Peasant in Revolt* by Miró and *Guernica* by Picasso, the centerpiece of the exhibit [5].

On April 26, 1937, the German Condor Legion had bombed the Basque town of Guernica. Picasso, who had become the symbolic director of the Prado Museum in Madrid a year before, painted ▲ *Guernica* in six weeks, with motifs and forms drawn from his

hybrid Cubist-Surrealist work of the period. The huge painting shows four women in terror: one falls from a house in flames; two others flee distorted by fear; the fourth cradles her dead child and screams. A dismembered soldier lies on the ground, while a horse cries out in agony and a bull stares us in the eye. These animals attest to the bestiality of the bombing, but in this world turned upside down they also possess a humanity that seems stripped from the humans here. Picasso holds all this debris together by a pyramidal massing of figures and a muted range of blacks, whites, and grays. But his genius is to transform his own modernist inventions of Cubist fragmentation and Surrealist distortion into an expression of outrage: this is modernist art in the service of political actuality. A response to the Nazi bombing, a riposte to the Nationalist accusation that the Republicans had defiled "the artistic treasures" of Spain, *Guernica* also defies the mythical histories of totalitarian regimes, and rebuts the reactionary beliefs that political art can only be social realist and that modernist art can never be public. Here modernism is reconciled with referentiality, responsibility, and resistance. "Did you do that?" a Nazi officer asked Picasso in front of *Guernica*. "No," Picasso is said to have replied, "you did." HF

FURTHER READING
Dawn Ades and Tim Benton (eds), *Art and Power: Europe Under the Dictators 1939–1945* (London: Thames & Hudson, 1995)
Stephanie Barron (ed.), *"Degenerate Art": The Fate of the Avant-Garde in Nazi Germany* (Los Angeles: Los Angeles County Museum of Art, 1991)
Igor Golomstock, *Totalitarian Art* (London: Icon, 1990)
Boris Groys, *The Total Art of Stalinism*, trans. Charles Rougle (Princeton: Princeton University Press, 1992)
Eric Michaud, *The Cult of Art in Nazi Germany*, trans. Janet Lloyd (Palo Alto: Stanford University Press, 2004)
Jeffrey Schnapp, *Staging Fascism* (Palo Alto: Stanford University Press, 1996)

▲ 1937c

Naum Gabo, Ben Nicholson, and Leslie Martin publish *Circle* in London, solidifying the institutionalization of geometric abstraction.

Circle: International Survey of Constructive Art, edited by the Russian sculptor Naum Gabo (1890–1977) and the British painter Ben Nicholson (1894–1982) and architect Leslie Martin (1908–2000) and published to coincide with the exhibition "Constructive Art" at the London Gallery in July 1937, is an extraordinary document. It can be read in two opposed ways: as the last gasp of the utopianism that characterized the historical avant-gardes of the twenties or as the first step into what could be called their cooptation and institutionalized devolution. The content and composition of this volume—intended as a journal but produced, in the end, as a hefty one-time almanac—are worth examining in detail.

The design is resolutely inconspicuous, with its traditional grouping of plates off-text and its conventional typography. This clear demarcation between text and image echoes the strict adherence, in the organization of the volume, to the beaux-arts division of artistic practices by medium: the first three sections are devoted to painting, sculpture, and architecture respectively, and illustrated with an emphasis on historical continuity within each discipline, blending the works of the first generation of pioneers of "constructive art" with those of current (mostly British) artists and architects.

Only the fourth and last section, entitled "Art and Life," conveys the sense of open interdisciplinarity that had been the lingua franca of the small avant-garde publications that *Circle* was emulating or to which it was responding, though the paucity of illustrations in this section seems to indicate that the editors deemed it was less important than the first three. It consists of texts on unconnected topics: on art education (by ex-Bauhaus director Walter Gropius); on choreography (by Ballets Russes star Leonide Massine); on "Light painting" (by László Moholy-Nagy, who had been living London since 1935 but was to be appointed director of the New Bauhaus in Chicago within weeks after the publication of *Circle*); on typography (by Jan Tschichold, then still an ardent partisan of El Lissitzky's Constructivist book design but very soon to become one of the most powerful proponents, as typography director of Penguin Books, of a return to neoclassicism in this field); on "biotechnics" (by the Czech architect Karel Honzik, who proposed under such a title a fairly innocuous comparison between the geometric forms encountered in nature and the structural principles of architectural functionalism—a pale imitation of Karl Blossfeldt's successful *Urformen der Kunst,* whose first English edition dates from 1929); and, finally, on "the death of the monument" (by the American historian Lewis Mumford). If no attempt was made to stress a common denominator between the various contributions to this pot-pourri section, it is perhaps because *Circle's* editors felt that the task had already been performed by the brief unsigned editorial and by Gabo's lengthy essay, "The Constructive Idea in Art," at the beginning of the volume.

Given the dangers looming on the political horizon—made clear by the competitive stand-off between the Soviet and German pavilions at the 1937 Universal Exhibition, which had just opened in Paris when *Circle* appeared—the book's unsigned editorial seems, with hindsight, amazingly naive in its utter optimism. "A new cultural unity is slowly emerging out of the fundamental changes which are taking place in our present-day civilization," begins the short text. *Circle* is not a manifesto, we are told: its goal is to help the information circulate among practitioners of "the constructive trend in the art of today" who are working simultaneously in several countries, and to bypass all "dependence upon private enterprise" in order to directly reach the public. The editorial concludes with this sentence: "We hope to make clear a common basis and to demonstrate, not only the relationship of one work to the other but of this form of art to the whole social order." Gabo's essay, which immediately follows, sings the same tune. Acknowledging that *Circle's* efforts come after a century of revolutions that "have spared nothing in the edifice of culture which had been built up by the past ages," Gabo nevertheless affirms: "However long and however deep this process may go in its material destruction, it cannot deprive us any more of our optimism about the final outcome, since we see that in the realm of ideas we are now entering on the period of reconstruction."

"Social order," "period of reconstruction": the language is that of the "return to order" that had blossomed in the aftermath of World War I, particularly in its modernist version as advocated by Le Corbusier in *L'Esprit Nouveau.* As if to underline this heritage, *Circle* contains the architect's intervention in a famous public symposium, at the Maison de la Culture in Paris, under the aegis of the Communist Party ("The Quarrel with Realism"), where he is as rhapsodic as ever in his praise of the Machine, a stance echoed in Leslie Martin's "The State of Transition" in the volume's architectural section. And, just as Le Corbusier's Purism was a reaction against the

analytic "excesses" of Cubism, Gabo sees the task of the "constructive" artist as that of building anew upon the *tabula rasa* created by the Cubist "revolutionary explosion." For him, the critical function of avant-garde art (Dada is specifically targeted) is a thing of the past:

> *The logic of life does not tolerate permanent revolutions.… The Constructive idea does not expect from Art the performance of critical functions even when they are directed against the negative side of life. What is the use of showing us what is bad without revealing what is good?*

Finally, like Le Corbusier before him in *Après le cubisme* of 1918, Gabo draws upon a parallelism between art and science in order to buttress his position. "We can find efficient support for our optimism in those two domains of our culture where the revolution has been the most thorough, namely, in Science and in Art." Critical of a cliché of the literature on Cubism according to which this new art represented an "illustration" of Einstein's Theory of Relativity, Gabo warns against any pseudomorphic analogies between the productions of art and those of science (curiously, the sole scientist who contributed to *Circle*, J. D. Bernal, precisely fell into that trap in his essay "Art and the Scientist"). Art and science are not to be directly linked, but they partake of a common "vision of the world," of a common search for "universal laws." The main difference between Gabo's stand and that of Le Corbusier on this matter concerns the style which they respectively consider as best suited to the task of expressing these "universal laws." Both Le Corbusier and Gabo argue for a new humanism that would be coded in geometric forms, but while the former demands

anthropomorphism in art, Gabo conceives of geometric abstraction as the "cornerstone" of his program: "[The Constructive idea] has revealed an universal law that the elements of a visual art such as lines, colours, shapes, possess their own forces of expression independent of any association with the external aspects of the world [and] that their life and their action are self-conditioned psychological phenomena rooted in human nature."

The vagueness of this program is nowhere more apparent than in the choice of contemporary paintings and sculptures reproduced in *Circle*. Besides the anthology of works by early pioneers, mentioned above (Arp, Brancusi, Braque, Mondrian, Duchamp, El Lissitzky, Gabo, Gris, Léger, Kandinsky, Klee, Malevich, Medunetsky, Moholy-Nagy, Pevsner, Picasso, Taeuber-Arp, and Tatlin), *Circle* offers an eclectic panorama of the current production of a second generation of abstract artists, all working within the parameters set by their predecessors. As in the case of *Cercle et Carré* and of *Abstraction-Création*, which appeared in Paris in 1930 and 1932 and which, like *Circle*, were used as platforms to organize exhibitions, most of the recent art reproduced by Gabo and his acolytes represents a middle-brow, academicized version of geometric abstraction that has no programmatic characteristic other than that of being "non-objective," to use the vocabulary of the period.

The paintings are quite diverse—the post-Malevichean compositions of the German Friedrich Vordemberge-Gildewart (1899–1962) have little to do with the ovoids of the Swiss Hans Erni (1909–2015); the jazzy, interlocking volumes of the British John Piper (1903–92) bear no resemblance to the calm opposition, in Ben Nicholson's white reliefs, of square and circle [1], nor to the floating shapes of the

French Jean Hélion (1904–87) [2]. However, they are all figurative (in the sense that the duality of figure and ground is nowhere called into question, and that in each of them several figures are set upon a neutral background). Furthermore, they all seem based on the assumption that achieving a state of equilibrium between competing figures is what is requested from art, if art is indeed to express the kind of "universal law" called forth by Gabo. The recipe sometimes makes for elegant compositions, but it can also yield facile, decorative work. Heralded by *Circle* as evidence of a transnational "new cultural unity," this post-Cubist style, in which the main formal decision consists of a balancing act, was indeed fast becoming an international style, the rapidity of its spread being largely due to the fact that, with it, abstraction had lost its edge.

The section devoted to contemporary sculpture, though less eclectic in choice of works, had similar problems. Except for Alexander Calder's mobiles, the majority of the works presented are carved (in wood or marble) and presented on pedestals, Barbara Hepworth and Henry Moore having no qualms about that very traditional concept of the "monument" lambasted by Lewis Mumford in his contribution to the volume. The most telling position with regard to this issue is perhaps that of Gabo, whose essay, "Sculpture: Carving and Construction in Space" represents an about-face. While he reproduces some of his early works such as the *Kinetic Sculpture* of 1920, it is to denigrate them as experiments ("more an explanation of the idea of a kinetic sculpture than a kinetic sculpture itself"); while he nearly appropriates the theory of his ex-rival Tatlin, according to which each form has to be determined according to the properties of its material, he ends up advocating the notion of "absolute" form (absolute, thus not contingent upon its material); he repeats the plea of his 1920 "Realist Manifesto" for the constitution of space as a sculptural material, yet he defends the opposite possibility of the translation of his virtual volumes of the preceding years, done in Plexiglas, into massive stone carvings. His text ends with an apology for sculpture as the most efficient symbol of power—he praises this art for having given the "masses of Egypt confidence and certainty in the truth and the omnipotence of their King of Kings, the Sun"—that could have been written by Aristide Maillol or Arno Breker. Predictably, most of Gabo's subsequent work was miniature models of monuments. As Benjamin Buchloh noted, when Gabo finally realized one of these models on a large scale (the sculpture placed in front of the Bijenkorf in Rotterdam, completed in 1957), the "discrepancy between the structural and material elements," most conspicuous in "its bronze-wire network faking tension and structural function," would spectacularly betray Tatlin's legacy.

"Constructive" art versus Constructivism

In fact, Gabo is not a Constructivist (even if he labels his art "constructive"), though he successfully persuaded generations of art historians that he was a legitimate spokesman for the movement (including Alfred Barr, who legitimated the claim). He conceives of sculpture as the embodiment of a rational idea that could appeal directly to the mind of the spectator and be read as an image of consciousness: through material transparency (Plexiglas) of formal simplicity (symmetry, parabola), one would have access to the central core of the sculpture out of which volumes and surfaces project. This fundamentally figurative conception of sculpture is a far cry from the Constructivism of Rodchenko and the Obmokhu group, whom he opposed, as much as it is from that of Katarzyna Kobro, whose antimonumental stance constitutes the best rebuttal of Gabo's position (as well as a critique of most modernist sculpture).

There are two other serious differences between the Constructivist program and that of *Circle*. The first is that there is almost no trace of the political realm in the English publication. Reading Gabo's admonition that the Constructive idea should not compel "art to an immediate construction of material values in life," one could even say that it is resolutely apolitical. The immense question of new modes of production and distribution of art, so fervently discussed by the Soviet avant-garde, is completely ignored in the pages of *Circle*, where the only allusion to the life of works once they leave the artist's studio is a meek reference to the evils of "dependence upon private enterprise," mentioned above—a clear indication that the journal's editors, probably with the Art Deco phenomenon in mind, feared that their art would become mere decoration for bourgeois homes.

The second major difference between a "constructive" and a Constructivist art concerns the issue of composition. For the Constructivists, the traditional order of composition was what had to be destroyed—because both the subjective arbitrariness of the aesthetic choices it elicited, and the age-old conventions of its formal devices (balance, hierarchy), were for them ciphers of the authoritarian social order of the Czarist regime and had no place

2 • Jean Hélion, *Equilibre*, 1933
Oil on canvas, 81 × 100 (31⅞ × 39⅜)

▲ 1931b, 1934b ● 1955b ■ 1914, 1921b ◆ 1900b, 1937a

▲ 1921b ● 1928a ■ 1925a

in a revolutionary society. They went to great lengths to find ways in which one could motivate the organization of a work of art according to the properties of its material and the process in use: it is this motivated, "objective" organization (as opposed to the subjective, arbitrary composition) that they called a construction. Had
▲ Gabo participated in the 1921 debate at the Inkhuk (Moscow) at which such issues were discussed, he would undoubtedly have found himself a member of the losing minority.

In his defense, however, one should recall that by 1937 the strict opposition cast between composition and construction by Rodchenko and his peers was entirely forgotten. Furthermore, outside of Russia the very possibility of a noncompositional art had very few proponents (and the most articulate of them,
● Wladyslaw Strzeminski, was little known in the West, although reproductions of his works regularly appeared in *Abstraction-Création*). Yet, one emerging trend should have appealed to the *Circle* editors, especially to Gabo, given his recurrent fantasy about
■ a convergence of interests between art and science: Max Bill's Concrete Art, which had just been launched in Zurich (either *Circle* did not know about it, which is rather improbable, since Bill was very well connected, or they deliberately censored it.)

The term "Concrete Art" is not Bill's own but Theo van
◆ Doesburg's. Better known for his steering of the De Stijl movement, the Dutch artist, then based in Paris, had in 1930 published a small journal called *Art Concret* (it had only one issue), around which he intended to found a new artists' group. In its pages, he advocated an art that would be programmed entirely by mathematic calculations before it was realized ("We reject artistic handwriting," he wrote, adding: "Painting which is done in the manner of Jack the Ripper can interest only detectives, criminologists, psychologists and psychiatrists.") The publication had no effect whatsoever and the group never coalesced, in great part because van Doesburg died only a few months later in a Swiss sanatorium. Bill, however, had been enormously impressed, as much as by van Doesburg's manifestos as by his *Arithmetic Drawing*, a variation on the black, gray, and white *Arithmetic Composition* [3], in which the "Russian doll" logic of a figure within a figure transforms a simple *opposition*—between a black square placed on its tip within a white square that is four times as large—into a deductive structure that exactly determines the placement of each element. Bill's art would never achieve the stark simplicity of van Doesburg's late canvas—one could say that he never could dispense with "good taste," ruining his very idea of a programmed, a priori art by his purely subjective introjection of aesthetic factors that could not be quantified, such as color.

Yet theoretically at least, Bill's conception could have provided a way out for abstract artists who did not feel compelled by the post-Cubist, compositional model provided by *Circle*. Or they could have turned to Mondrian, and many thought they actually did, but at the cost of a gross misunderstanding due, in part, to his benevolent contribution to *Circle* and other publications of the sort. Had anyone then attentively read "Plastic Art and Pure Plastic Art,"

3 • Theo van Doesburg, *Arithmetic Composition*, 1930
Oil on canvas, 101 × 101 (39¾ × 39¾)

▲ the long essay by Mondrian that accompanies the reproduction of his recent paintings in *Circle*, one would have been struck by this statement: "Neo-Plastic is as destructive as it is constructive," and one might have realized that his ultimate goal was to destroy all figures, a goal diametrically opposed to that of the artists supported by *Circle*. But no one paid attention, and figurative abstract art became a cottage industry of the cultural elite—notably in the United States, where for a decade it filled the Museum of Non-Objective Painting (later called the Guggenheim Museum) and Albert Eugene Gallatin's Museum of Living Art, as well as the exhibitions of the American Abstract Artists Association, giving abstraction a bad name until Abstract Expressionism—whose participants loathed the AAA—would cast it aside. YAB

FURTHER READING
J. Leslie Martin, Ben Nicholson, and Naum Gabo (eds), *Circle* (1937; reprint London: Faber and Faber, 1971)
Benjamin H. D. Buchloh, "Cold War Constructivism," in Serge Guilbaut (ed.), *Reconstructing Modernism* (Cambridge, Mass.: MIT Press, 1990)
Jeremy Lewinson (ed.), *Circle: Constructive Art in Britain 1934–40* (Cambridge: Kettle's Yard Gallery, 1982)

▲ 1921b ● 1928a ■ 1959e, 1967c ◆ 1917b, 1928a ▲ 1913, 1917a, 1944a

1937 c

Pablo Picasso unveils *Guernica* in the Spanish Republican pavilion of the International Exhibition in Paris.

Very few works of art of the twentieth century—if any—have acquired the status of Pablo Picasso's *Guernica*, painted in five weeks between May 10 and June 15 in 1937, before being installed as the artist's contribution to the Spanish Republican pavilion at the International Exhibition in Paris, the full title of which was the "Exposition Internationale des Arts et Techniques dans la Vie Moderne." The reasons for the painting's universal and continuing attraction are not immediately evident, especially since several of the most important critical responses, from Anthony Blunt in 1937, to Max Raphael and Clement Greenberg in the forties and fifties to Carlo Ginzburg in the nineties, have identified the painting's failure to communicate. Or as Luis Buñuel, Picasso's compatriot and surrealist director confessed in his autobiography: "I can't stand *Guernica*. Everything about it makes me uncomfortable—the grandiloquent technique as well as the way it politicizes art."

The painting's mythical status thus seems to have originated in a spectrum of unresolved ambiguities. First there is the question of style and historical form: Shall we associate the work with late Cubism or high Surrealism, or could it possibly partake in both? Then there is the painting's ambivalent execution: Does its grisaille mimic press photographs and newsprint, or does it induce mnemonic mourning? And finally there is the undecidable genre: Is it a stage set or theater curtain (like Picasso's curtain for *Parade* in 1917), a decorative architectural mural, an agitprop montage billboard, or even—as the Catalan critic Lluis Permanyer called it in 1937—a cinematographic screen? T. W. Adorno responded to *Guernica*'s multiple irresolutions by figuring them as theoretical premises: "Modernism's refusal to communicate is a necessary but not a sufficient condition of ideology-free art. Such art also requires vitality of expression—a kind of expression that is tensed so as to articulate the tacit posture of art works.... As with Picasso's *Guernica*, it eventually takes on the unambiguously sharp contours of social protest."

In the first week of January 1937 Picasso received a delegation of Spanish Republican government officials, led by the photomontage artist Josep Renau accompanied by Josep Lluis Sert, the Catalan disciple of Le Corbusier and architect of the Spanish pavilion at the Paris exhibition. The delegation commissioned Picasso to contribute a mural painting for the pavilion. Francis Frascina has suggested that Picasso's conversations with his friends Paul Éluard and Dora Maar, engaging him since 1936 in debates concerning the Spanish Civil War, the Popular Front, and the role of images and poetry within Leftist and Surrealist agitation, had already prepared the ground for *Guernica*. One immediate result of the encounter with the delegation was Picasso's decision to publically support the Republican cause by etching the two plates of *Dreams and Lies of Franco* (*Songes et Mensonges de Franco*) on January 8–9 (with the second plate reworked and completed in June) to benefit the Spanish Refugee Relief campaign [1]. Picasso's first overtly political statement delivered a grotesque derision of Franco and fused two types of popular imagery: the *alleluias*, the archaic religious prints of Spanish Catholicism, and the *comics*, the contemporary narrative and iconic strips of challenged American literacy which had fascinated him since childhood.

The pavilion

The construction of the Spanish pavilion began on February 27, and it would finally open its doors on July 12, 1937, after a seven-week delay. Sert had designed the pavilion for the new Spanish Republic in manifest opposition to the totalitarian neoclassical buildings for the German Nazi state by Albert Speer and the Soviet Union by Boris Iofan. Conceived as a transparent modernist structure of readymade technological elements (such as moveable Celotex and concrete wall units), the pavilions featured a patio and stairs that were simultaneously reminiscent of a classical Mediterranean villa. A tall pole sculpture by Alberto Sanchez, a former baker and trade-union activist, was placed at the pavilion's entrance. Morphing between bone and branch, it was topped by a red flower reading simultaneously as a red star, and carried the euphoric inscription "El Pueblo Espagnol Tiene un Camino que Conduzca a una Estrella" (The Spanish people has taken a path leading to a star).

Both the inside and outside walls of the pavilion featured Renau's large photomontages celebrating the Spanish Republic and its achievements [2]: the *misiones pedagogicas*, the new literacy and educational programs, and the recently constructed factories,

▲ 1937a ● 1921a, 1924 ▲ 1937a

1 • Pablo Picasso, *Dreams and Lies of Franco*, (top) Plate I, January 8, 1937, Paris and (bottom) Plate II, January 8–9 and June 7, 1937, Paris
Etching, aquatint, and engraving on copper (state V), Plate I: 17 × 42.2 (6¹¹⁄₁₆ × 16⅝); Plate II: 18 × 42.2 (7 × 16⅝)

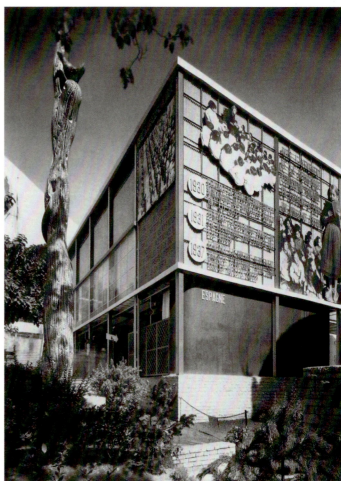

2 • Josep Renau, photomurals on the exterior of the Spanish Republican pavilion at the International Exhibition in Paris, 1937

schools, and hospitals. The photomurals also documented the Republic's defense against the fascist military assaults organized by the Falange, the landowners, and the Church that had ignited the Civil War in 1936. Furthermore, works by Joan Miró (*The Catalan Peasant in Revolt,* a mural painted on Celotex tiles) and Julio González's bronze sculpture *La Montserrat* were on display. Picasso's mural was to be placed on the back wall of the large patio where documentary movies and newsreels were projected, across ▲ from Alexander Calder's *Mercury Fountain* (an astonishing structure that resurrected an ancient model of Mozarabic architectural splendor [**3**]). Undoubtedly, Picasso had familiarized himself with site and architectural model before starting work. And as late as April 18 and 19—as more than a dozen sketches confirm—he was still trying to develop his initial idea to paint a seemingly timeless variation of the artist in the studio (which would have linked his mural to Velázquez's *Las Meninas*).

A week later, on April 26, 1937, as plotted by Franco and his fascist generals, the small Basque town of Guernica was bombed by Italian and German warplanes (the infamous Condor Legion), constituting the first aerial saturation bombing of a European civilian population in the twentieth century (extensive aerial bomb attacks had been inflicted before by the European colonial powers on populations in Africa and India). With the exception of the conservative newspapers (who either ignored the bombing or blamed it on the Republicans), international newspapers reported extensively on the barbaric acts of the fascist alliance and the destruction of Guernica. Picasso used images from *Ce Soir* (edited at the time by his friend, the Surrealist writer Louis Aragon) for his first six sketches for the painting on May 1. In these studies, Picasso abandoned his initial project of the studio allegory, mobilizing instead an iconography that combined Mediterranean and Spanish and mythical and religious images that had preoccupied the artist since the twenties: the Crucifixion and the Corrida, the Minotaur, the bull and the horse, motifs that the artist had fully developed in his extraordinary aquatint *Minotauromachy* in 1935 [**4**]. The first sketch of May 1 also featured a woman holding a light (equally cited from the print), and in the third sketch another screaming female figure and a fallen soldier were added. By the end of May 1, in sketch no. 6, Picasso had basically laid out the painting's structure, and on May 8, he produced another eleven sketches, approaching the painting's final composition in sketch no. 15. Three days later he transferred the preparatory studies onto a monumental canvas measuring more than 11 feet high by 25 feet wide (3.51 m × 7.82 m), installed in the

▲ 1931b

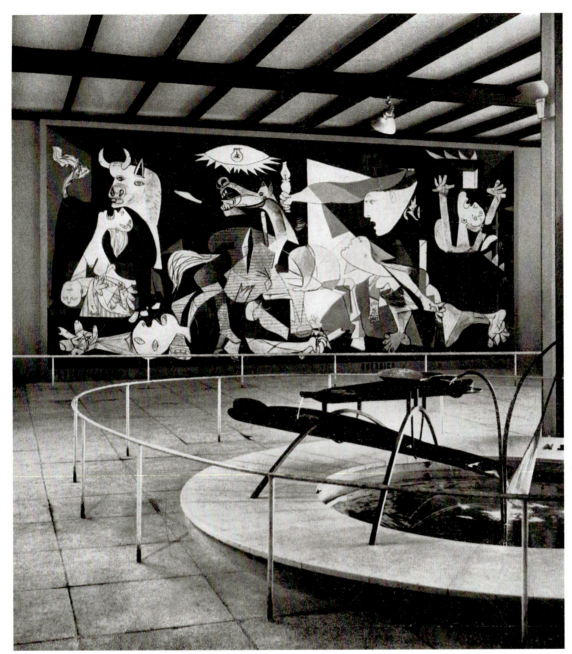

3 • Installation view of *Guernica*, as installed in the Spanish Republican pavilion, behind Alexander Calder's *Mercury Fountain*

vast studio on rue des Grands Augustins, which had been acquired by the Spanish government especially for this occasion. The extensive sketching and the size of the canvas clearly signaled Picasso's resolution to transfigure the mural commission with a monument commemorating the tragedy of the Spanish Civil War.

A sequence of photographs recorded by the artist Dora Maar, Picasso's lover at the time, allows us to track the minute and meaningful changes performed throughout *Guernica*'s production. In these changes, as Sidra Stich and Francis Frascina have argued, Picasso responded to the ongoing political debates of the moment. Thus, when the artist drew a large round sun above the wounded horse and added a sheaf of wheat to the fist of the prostrate soldier held up in the manner of the Communist salute (May 13, state 11), only to remove these symbols in the next phase, and to replace the

sun with a prosaic lamp and lightbulb, the artist's increasing doubts about the conflicts between the anarcho-syndicalist and the Communist factions in Spain were formulated. But Maar's "newsreel" photographs also recorded Picasso's artistic doubts, as when he added at one point large segments of wallpaper to the painting to make it appear as a gigantic Cubist collage, only to remove these remnants of a lost formal radicality in the next phase in order to homogenize the painting's photographic simulation and grisaille textuality. Maar's last photograph was taken on June 4 and about a week later the painting was delivered to the pavilion. Apparently, Picasso told Sert: "I don't know when I will finish it. Maybe never. You had better come and take it whenever you need it."

The preparatory drawings and an extensive collection of Maar's photographs were published by Christian Zervos, the editor of

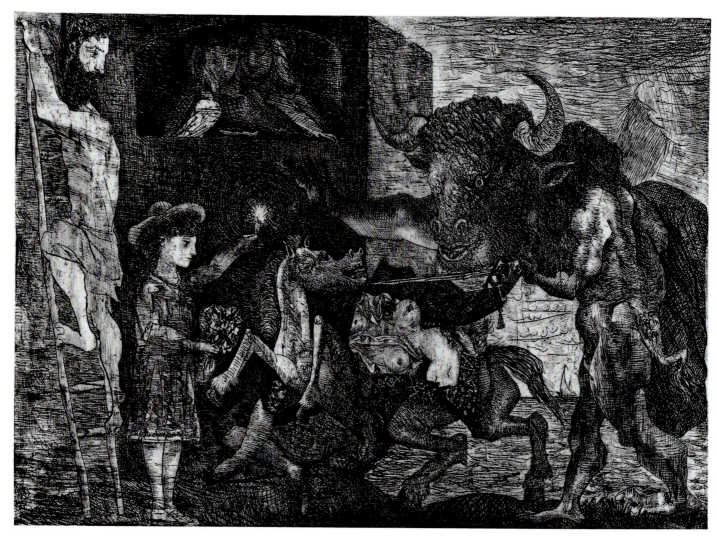

4 • Pablo Picasso, *Minotauromachy*, 1935
Etching and engraving, plate: 49.6 × 69.6 (19½ × 27⅜)

Picasso's *catalogue raisonné*, in two issues of Zervos's magazine *Cahiers d'art* devoted in part or entirely to *Guernica*. In issue no. 12 (Summer 1937) and the special issue no. 13 (November 1937), essays by Jean Cassou, Michel Leiris, the Spanish poet Jose Bergamin, and Zervos himself were published. Cassou initiated the painting's irresistible rise to a mythic status of an essentially Spanish art by comparing it to Goya:

> *Goya is brought back to life as Picasso. But at the same time Picasso has been reborn as Picasso. It had been the immense ambition of his genius to keep himself forever apart, denying his own being, making himself live and carry on outside of his own realm—like a ghost frenzied to see his vacant home, his lost body. The home has been found again, both body and soul. Everything that calls itself Goya, that calls itself Spain has been reintegrated. Picasso has been reunited with his homeland.*

After the closure of the Spanish pavilion, the painting embarked on an international journey through European countries and was exhibited to support the Spanish Republic and to bring the barbaric acts of Franco's fascism to international attention. During the summer of 1938, Roland Penrose and the Belgian Surrealist E. L. T. Mesens and a committee including Virginia Woolf, Douglas Cooper, and E. M. Forster, sponsored its exhibition at the New Burlington Galleries in London before it continued to the Whitechapel Art Gallery in the east end of the city. As an involuntary irony of history, the painting arrived on the day of the infamous Munich Agreement, September 30. Herbert Read had to respond to Anthony Blunt's second attack on the painting (in his essay "Picasso defrocked") by mobilizing the equation between Goya and Picasso once more:

> *It is not sufficient to compare the Picasso of this painting with the Goya of the* Desastres. *Goya too was a great artist, and a great humanist; but his reactions were individualistic—his instruments irony, satire, ridicule. Picasso is more universal: his symbols are banal, like the symbols of Homer, Dante, Cervantes. For it is only when the commonplace is inspired with the intensest passion that a great work of art, transcending all schools and categories, is born and being born lives immortally.*

1930–1939



Shortly after the tragic end of the Civil War on March 28, 1939, Picasso decided that *Guernica* should be shipped to the United States, declaring that the painting should not return to Spain until a democratic government had displaced Franco's regime. The painting arrived in New York aboard the *Normandie* on May 1, 1939, exactly one month after the United States had recognized Franco's government. After its initial presentation at the Dudensing Gallery in New York, it toured the United States (being shown at the Fogg Museum at Harvard, in Los Angeles, and in Chicago, among other sites), and it was finally installed on the walls of the Museum of Modern Art in New York, where it would remain for forty-two years. Inevitably, once on display at the foremost museum of modernism, all specific references to the Spanish Civil War would disappear and the formalist and aestheticizing readings would take over. Thus, ▲ already in 1946, Alfred H. Barr, Jr., director of the Museum, wrote:

The composition is clearly divided in half, and the halves are cut by diagonals which together form an obvious, gable shaped triangle starting with the hand at the left, the foot at the right , and culminating at the top of the lamp in the center—a triangle which suggests the pedimental composition of a Greek temple.

But the commentaries by artists and critics in New York—many at that time still being on the political left—differed dramatically from those formalist responses. Thus, Elizabeth McCausland, one of the foremost critics of her time, who had already seen the painting during its installation at the Spanish pavilion, argued strongly for sustaining the painting's political interpretations after it had arrived in New York:

The result is a canvas of amazing complexity, imbued with aesthetic ideas and concepts from Cubism, Abstractionism, neoclassicism and the psychological period. But all these attributes are only means to an end. Picasso has used the skill and dexterity of his method to convey a message.… He wants to cry out in horror and anguish against the invasion and destruction of the Spain of his love. He wants to protest with his art against the betrayal accomplished by Franco and his fascist allies.

But not all political voices were equally convinced of *Guernica*'s success as a work of political protest. The Marxist art historian and critic Max Raphael, who had emigrated from Berlin via Paris to New York, where he would encounter *Guernica* at the Museum of Modern Art, formulated a response that was comparable to Blunt's initial skepticism since he underlined the painting's (and modernism's) general constitutive dilemma to address proletarian audiences and claim public speech, yet to deliver its appeals in structures that would inevitably appear as cryptic if not esoteric: "This is a contrived painting and hence arbitrary and finite. This accounts for the fact that the masses—and the anti fascist masses most particularly—were perplexed by it and quickly lost interest. The literati only praised it in their turgid fashion."

While the painting's impact would become evident in the works of many American artists of the thirties and forties, for example ▲ Arshile Gorky (who participated in a roundtable discussion about the painting at its first American showing at the Dudensing Gallery), or Willem de Kooning, *Guernica*'s imprint was particularly deep ● for Jackson Pollock, as Lee Krasner's account testifies: "Picasso's *Guernica* floored me. When I saw it first at the Dudensing Gallery, I rushed out, walked about the block three times before coming back to look at it. And then later I used to go to the Modern every day to see it." Pollock's drawings produced at that time while undergoing treatment with his psychoanalyst Dr. Henderson resonated for years with *Guernica*'s impact, culminating in the quotation of mythical animal hybrids in paintings such as *Pasiphae*—the Minotaur's mother—or *The She Wolf* (both 1943), an iconography Pollock finally abandoned with the billboard-size mural for Peggy Guggenheim in 1943, generally perceived to be his breakthrough painting.

Animal icons: the Minotaur and Micky Mouse

Picasso's citations of the seemingly transhistorical imagery of mythical animals fractured the responses to *Guernica* from the start. Some considered the bull to be the embodiment of Franco's fascism; others read it as the image of the Spanish people. The confusion between the Minotaur (previously a cipher of Picasso's proclaimed supernatural male identity, as in the numerous images preceding the *Minotauromachy* aquatint) and the bull on the one hand and the horse on the other made it almost impossible not to read the depiction of the animals as opposing forces, male and female, fascist and Republican, victor and victim. Even when Picasso finally and exceptionally assented to interpret *Guernica*'s iconography in his conversation with Jerome Seckler for New York's leftist magazine *The New Masses* in March 1945, he not only reiterated the conflicts constitutive of modernist political art in general, but also intensified the painting's interpretive ambiguities:

The bull there represents brutality, the horse the people.… Yes, there I used symbolism, but not in the others.… The bull is not fascism but it is brutality and darkness. My work is not symbolic. Only the Guernica *mural is symbolic. But in the case of the mural that is allegorical.… There is no deliberate sense of propaganda in my painting … except in* Guernica. *In that there is a deliberate appeal to people, a deliberate sense of propaganda.*

Thus, one could argue that the painting's communicative deficiency originated in the ambiguity of the animal imagery, as much as in the work's ambiguity of genre, suspended between mural painting and photomontage, as Romy Golan has argued:

Picasso was able to address the tension between aura and exhibition value that underlay the Paris 1937 World's Fair. By devising a hybrid, an alloy, a Minotaur—not half man and half bull but half painting and half photomural, half allegory in the

old sense and half that of montage—Picasso struck at the heart of the aesthetic and ideological vicissitudes of the thirties.

Rather than analyzing and historicizing fascism, Picasso insisted on mythifying the elements of violence and war, endowing the painting with a humanist universalism that would guarantee its artistic fame in the future. This becomes all the more palpable when we compare the animal imagery used by John Heartfield to support the Spanish Republic in a 1936 photomontage that appeared in *Volks-Illustrierte*, the renamed *Arbeiter Illustrierte Zeitung* that had moved from Berlin to Prague after the Nazis came to power, and was used as a cover for Ilya Ehrenburg's antifascist book *No Pasaran* [5]. In distinct contrast to Picasso, Heartfield made the very impulse to transfigure historical reality into a timeless representation of a fabled animal itself part of his critical derision. His animal image is historically concretized when he literally

situates the "Condors" (as the Nazi pilots had named themselves, after all) politically and ideologically by endowing the heads and breasts of these birds with Spanish and German fascist kepis and badges, but also by singling out only one precise element of their animal "essence," the vultures' penchant to attend imminent death, as in this case when the "Condors" were bringing about the destruction of Republican Spain.

Picasso's preoccupation with the Minotaur and hybridized anthropomorphic and mythical zoomorphic figures emerges at the same moment as Walt Disney's Mickey Mouse (with his first movie appearance in *Steamboat Willie* in 1928) and Donald Duck (the figure's first movie was appropriately entitled *Don Donald* in 1937), the perfect American counterfigures to an apparently never-ending European preoccupation with Greek and Roman myths as the continent's cultural foundations. Therefore the increasing intertwinement of myth and rationality, and the various historical,

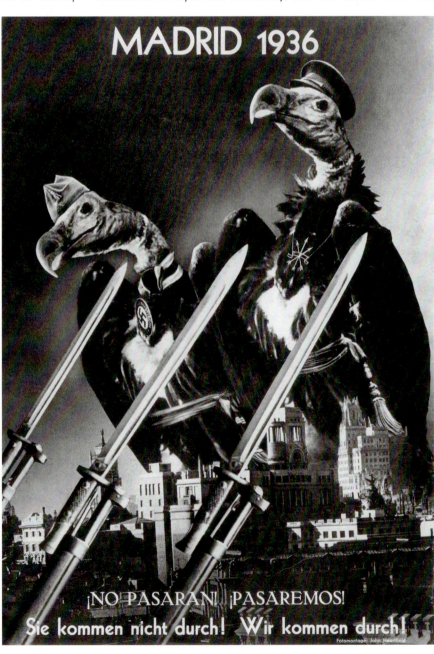

5 • John Heartfield, *Madrid 1936*, from *Volks-Illustrierte* (VI, Prague), no.15, November 25, 1936

▲ 1920

6 • Roy Lichtenstein, *Donald Duck*, **1958**
Ink on paper, 50.8 × 66 (20 × 26)

psycho-social, and political/ideological pressures on the patriarchal bourgeois subject found dialectically opposed articulations in both spheres. On one hand, certain factions of the so-called avant-garde, still operative in Paris, resorted to the mobilization of images derived from the supposedly transhistorical myths of Mediterranean culture to articulate the crisis of subjectivity. Thus Picasso's interest in the human/animal hybrids deploys the classical mythical imagery (in Freud's wake) to articulate the newly discovered permeation of conscious rationality by the violent forces of the unconscious. Yet it simultaneously formulated the anxieties over the imminent demise of the bourgeois Cartesian subject, once having been supposedly controlled by reason and self-determination, or it might even respond already at that moment to the confrontation with the emerging aegis of fascism. Picasso's animalistic iconography therefore oscillated between a Surrealist critique of obsolete models of humanist subject formations and a contemplation of proto-fascist celebrations of irrationality. Both Frascina and Ginzburg have recently suggested ▲ that *Guernica* incorporated elements from Georges Bataille's new political encoding of the ancient Minotaur and the acephalic figure as an explicit rejection of idealism. Bataille supposedly associated these monstrous hybrids with the experiential conditions of the proletarian masses and proposed these images as counterfigures to the "asexuated and noble heads of the bourgeoisie, which we will cut." But Ginzburg also alerts us to understand that "Bataille's attitude towards fascism was deeply ambiguous. He was fascinated by its aesthetic of violence, by its excesses. But he also insisted on several occasions that fascism had to be fought on its own battleground, in the sphere of mass emotions."

Meanwhile, on the other side of the Atlantic a new desubjectivization was propagated by the emerging mass-cultural formations. The comics were one among many textual and iconic innovations to provide the image regime and behavioral rules of the dissolution of social and subjective experience. Not surpris-

ingly, the critical interpretation of these phenomena would be constantly shifting as well. This is evident in the debates about Mickey Mouse and Donald Duck by some of the figures' earlier admirers and most trenchant critics such as T. W. Adorno, Walter ▲ Benjamin, and Sergei Eisenstein—a dialectical condition equally illuminated by the noteworthy detail that Paul Dessau, one of Weimar's most important composers and collaborators with Bertolt Brecht, who had early on composed for Disney films in Berlin (1926–8), wrote his first dodecaphonic piano concerto entitled *Guernica* after seeing the mural at the Spanish pavilion in 1937.

Thus a complex historical undercurrent linked the antibourgeois, antirationalist and antihumanist image of the Minotaur with the proletarian counteridentification in the mass cultural imagery of Mickey Mouse and Donald Duck. Both shifted between a subversion of bourgeois patriarchy and a fascisization of the dismantled individual in mass-cultural subjection. As Miriam Hansen has argued in her brilliant essay on the subject:

> *The problem was compounded with the more acute insight that these capacities, indeed the very concept of experience, were being held hostage by a bourgeois humanist culture that had tied them to the perpetuation of social privilege, to aestheticism, escapism, and hypocrisy.… The decline of experience is troped into an opportunity to abolish it altogether; the "new barbarism" of experiential poverty appears as the proletarian alternative to a moribund bourgeois culture.*

It is this intertwinement of mythical icons and its grisaille of technological rationality that *Guernica* would introduce to a newly emerging iconography of a dismantled subject in American painting. *Guernica*'s initially celebratory echos in Amer-
● ican painting of the forties, as in the works of Gorky, de Kooning, and Pollock, tried to sustain painting's privileged access to the presumably mythical depths of the unconscious as the site of a more elevated and deeper definition of subjecthood. Yet slowly and steadily these would be replaced by an acceptance of precisely those mass-cultural transformations of subjectivity that would eventually surface in Roy Lichtenstein's citations of Mickey Mouse and Donald Duck when he articulates opposition against the humanist
■ legacies of the New York School at the end of the fifties [6].　BB

FURTHER READING
Herschel B. Chipp, *Picasso's Guernica: History, Transformations, Meaning*
(Berkeley and Los Angeles: University of California Press, 1988)
Francis Frascina, "Picasso, Surrealism and Politics in 1937," in Silvano Levy (ed.), *Surrealism: Surrealist Visuality* (New York: New York University Press, 1997)
Carlo Ginzburg, "The Sword and the Lightbulb: A Reading of *Guernica*," in Michael S. Roth and Charles G. Salas (eds), *Disturbing Remains: Memory, History, and Crisis in the Twentieth Century* (Los Angeles: Getty Research Institute, 2001)
Romy Golan, *Muralnomads: The Paradox of Wall Painting Europe 1927–1957* (New Haven and London: Yale University Press, 2009)
Jutta Held, "How do the political effects of pictures come about? The case of Picasso's *Guernica*," *Oxford Art Journal*, vol. 11, no. 1, 1988, pp. 38–9
Gijs van Hensbergen, *Guernica: The Biography of a Twentieth-Century Icon* (London and New York: Bloomsbury, 2004)
Sidra Stich, "Picasso's Art and Politics in 1936," *Arts Magazine,* vol. 58, October 1983, pp. 113–18

▲ 1930b, 1931b　　　　　▲ 1935　　● 1942a, 1947b, 1949a　■ 1960c

1940–1944

1942a

The depoliticization of the American avant-garde reaches the point of no return when Clement Greenberg and the editors of *Partisan Review* bid farewell to Marxism.

In July 1942, an "Inquiry on Dialectic Materialism" appeared in the second issue of the international journal *Dyn*, founded and edited in Mexico from 1942–4 by the Austrian artist Wolfgang Paalen (1907–59). It consisted of a set of three questions that Paalen had sent to two dozen "distinguished scholars and writers," and of the answers (not everyone replied). The questions were: (1) Is Dialectic Materialism (the philosophy of Marx and Engels) "the science of a veritable 'dialectic' process"?; (2) Is the dialectic method elaborated by Hegel itself scientific (independently of its appropriation by Marxism), and if so, "does science owe important discoveries to this method"?; and (3) Are the laws established by Hegel in his *Logic*, laws which form the ground of his dialectic method, universally valid and useful?

Breton's spiteful silence

The addressees—a complete list of whom was provided—had been chosen both because they had not yet, or not recently enough, expressed their view on the matter and for their lack of direct involvement in "practical politics." Half of them responded. ▲ The most conspicuous among those who did *not* was André Breton, the founder of Surrealism, until then a fervent and efficient supporter of Paalen's art. The artist had been one of the scenographers of the famous "Exposition Internationale du Surréalisme" ● in Paris in January–February 1938, and in June of the same year Breton had prefaced an exhibition of his *fumages*, paintings realized by quickly grazing a smoking candle over a freshly prepared surface, and then editing the results—as always when the Surrealist conception of automatism is involved [1].

Had he answered, Breton would have disagreed with the majority of the respondents, who answered "No" to all three questions. Breton's admiration for Marx and Hegel never diminished, and Stalin's regime, of which he had been one of the harshest critics ever since the beginning of the Moscow trials in 1936, was for him doubly criminal in that its barbaric acts were committed in the name of dialectical materialism. But Breton's silence was motivated by spite: in the first issue of *Dyn*, published in April 1942 and which he had received in New York, where he had been living for less than a year, he had stumbled upon his protégé's treason, that is, Paalen's short but abrasive "Farewell to Surrealism." "In 1942, after all the

1 • Wolfgang Paalen, *Ciel de Pieuvre*, 1938
Fumage and oil on canvas, 97 × 130 (38¼ × 51⅛)

bloody failures of Dialectic Materialism and the progressive disintegration of all isms," Paalen claimed, one could no longer turn a blind eye to Surrealism's summary endorsement of certain of Marx's and Hegel's "too simplistic conceptions." Similarly discarding the movement's adherence to Freud's axiomatic principles concerning the fundamental role of unconscious desires in all human conduct, particularly the creative act, Paalen advocated greater familiarity with "the conquests and methods" of physical sciences on the part of artists, but dismissed allegiance to any one system of thought as dogmatic and constricting.

Breton did reply to Paalen, albeit indirectly, in the "Prolegomena to a Third Manifesto of Surrealism or Else," which appeared in June 1942 in the first issue of *VVV: Poetry, Plastic Arts, Anthropology, Sociology, Psychology,* a new Surrealist journal that he had launched in New York in 1940 (though the official editor was the sculptor David Hare [1917–91]). Reaffirming the spirit of rebellion that had always animated Surrealism, Breton rejected blind faith in any theoretical system, and, alluding to both Marxism and psychoanalysis, directly echoing Paalen's essay, he underlined how easily an "instrument of liberation" can be transformed into an "instrument of oppression," noting in passing that even science and mathematics are not immune to such a fate. Neither is Surrealism, implied Breton when denouncing what he called "a certain

▲ 1924 ● 1942b

Surrealist conformity," by which he meant the academicization of Surrealist practices in the American art world and their commercialization in the fashion and movie industries. (This seems to have been when Breton coined the anagram "Avida Dollars" to disparage Salvador Dalí, who epitomized this trend in his mind). The oddest pique, illustrating Breton's point that "man might not be the center of the universe," was reserved for the anthropomorphic (and thus nonmaterialist) conception of the animal kingdom manifested by an "exceptional" (materialist) thinker whose hand "had presided over some of the greatest events of our time," when speaking to him four years before, in Mexico, about the "natural" devotion of his dog. The brilliant thinker in question was Leon Trotsky, who, as a political refugee, Breton felt he could not publicly name—if anything, however, the strange allusion rightly points to the centrality of Trotsky (whose assassination by Stalin in 1940 had deeply affected Breton) for anyone concerned with the role of culture at this dire moment of history.

The American Artists' Congress

The Russian leader was certainly on the mind of several respondents to *Dyn's* inquiry who were actively involved, as editors or regular contributors, with the anti-Stalinist, New York–based literary journal *Partisan Review*, founded in 1934. These included Meyer Schapiro, Dwight Macdonald (1906–82), Philip Rahv (1908–73), and Clement Greenberg—the latter offering at least some explanation for his triple negative answers and adding that he "wished he could say yes." Most of them had espoused radical politics in the early thirties, as had the artists whom their journal was beginning to celebrate (soon to become the heroes of Abstract Expressionism, these had formed several unions and leftist organizations during their tenure at the WPA). When in the summer of 1935 Moscow had initiated the strategy of the Popular Front, intended to create an international alliance of intellectuals against fascism, these young men had volunteered their help and even embraced, momentarily, the cause of a "proletarian" art and culture, whereas Breton had been quick to detect the Stalinist trap, and immediately responded with a violent attack on the cultural politics of the USSR and a defense of artistic freedom.

A highlight of their growing involvement had been the first meeting of the American Artists' Congress, held in New York in February 1936, at which Schapiro read his paper, "The Social Bases of Art," where he harshly criticized the individualism of the modern (abstract) artist as political escapism that pandered to a new class of wealthy, dilettante patrons. (In the same breath, Stuart Davis, one of the organizers of the Congress, definitively broke with his longtime friend Arshile Gorky for his refusal to join in.)

The three show trials held in Moscow between August 1936 and March 1938 made the first serious dent in this youthful enthusiasm (though certain individuals, such as Davis, stubbornly stayed the course for several more years). Schapiro recanted his earlier antiformalist sermon in "The Nature of Abstract Art," a brilliant review of Alfred H. Barr, Jr.'s exhibition "Cubism and Abstract Art" at the Museum of Modern Art. (The review appeared in the short-lived journal *Marxist Quarterly* in January 1937.) Abstract art, Schapiro now claimed, was interacting with its historical context no less than any other art form, and was thus perfectly able to play an active role in it. Meanwhile *Partisan Review*, which had merged with a journal published by the Communist Party at the time of the first American Artists' Congress, had suspended publication in October 1936, to reappear only in December 1937, this time with a position closely allied to that of Trotsky whom a "commission of inquiry" chaired by John Dewey in April of that year had declared innocent of the crimes of which Stalin had accused him.

As early as July 1937, the editors of the future reincarnation of *Partisan Review* had courted Trotsky, then exiled in Mexico, hoping to obtain his contribution. Although appreciating their devotion, Trotsky delayed his decision until he had received some issues of the journal. His verdict was devastating: writing to Macdonald in January 1938, he snarled that for all their intelligence and education, the editors of *Partisan Review* basically had "nothing to say." Instead of "searching for themes that would not hurt anyone," the journal should follow the example of the artistic avant-garde movements ("naturalism, symbolism, futurism, cubism, expressionism and so on") which had always advanced their position by using the shock tactics of polemic and scandal. Trotsky's reluctance had not lessened two months later when he sent a letter to Rahv, but his insistence that the journal should keep an "eclectic" openness in aesthetic matters and support any "young and promising artistic movement" that came along indicates that for him cultural policy had become an important element in his struggle against Stalin. Trotsky finally gave in: the decisive factor was André Breton's arrival in Mexico in May 1938, of which Trotsky immediately informed the journal, even recommending the French poet as a contributor! (Ironically, it was Meyer Schapiro who had been instructed by Trotsky's secretary to send the Russian exile any of Breton's writing that he could find in New York.)

Breton had been in Mexico for less than a month and was in almost daily contact with him when Trotsky wrote an open letter dated June 17 to the editors of *Partisan Review*, published in its August–September 1938 issue as "Art and Politics." Its conclusion was particularly energizing: "Art, like science, not only does not seek orders, but by its very essence, cannot tolerate them.… Art can become a strong ally of revolution only insofar as it remains faithful to itself." The principal result of Breton's visit, however, was the manifesto "Towards a Free Revolutionary Art" calling for the formation of an International Federation of Independent Revolutionary Art, which he coauthored with Trotsky. The name of Diego Rivera replaced Trotsky's as cosignatory of the text when it was published worldwide, including in *Partisan Review* during the late fall of 1938 (even though Rivera, in whose house Trotsky was then living, had not taken the slightest part in its writing), because the Russian thought the manifesto would have more weight—especially as it condemned any enslavement of art by political forces—if

it came from two creators, especially if they were from different persuasions. Just in case people had any doubt about his stance, Trotsky sent for publication in the following issue of *Partisan Review* a letter congratulating Breton—who by then had long since returned to Paris—on having joined forces with Rivera, and once again affirming that "the struggle for revolutionary ideas in art must begin with the struggle for artistic *truth*, not in terms of any single school, but in terms of *the immutable faith of the artist in his own inner self.*"

The manifesto itself remains one of the most extraordinary documents of the period, notably for its appeal to both Marx and Freud, thus anticipating the Freudo-Marxism of Herbert Marcuse thirty years later. Its immediate effect on the art world was great. Greenberg quipped—in 1961, in a retrospective essay about the thirties—that "some day it will have to be told how 'anti-Stalinism,' which started out more or less as 'Trotskyism,' turned into 'art for art's sake,' and thereby cleared the way, heroically, for what was to come." In his first major essay, "Avant-Garde and Kitsch," published in *Partisan Review* in the fall of 1939, his analysis of the role of modernist art as a Trojan horse in a bourgeois society, and as the last rampart against barbarity, owes a lot to Breton and Trotsky's tract. For left-wing artists who had militated in Communist-infiltrated organization and had then been devastated by the Moscow trials, this signaled the end of a desiccating paralysis: not only was it all right not to follow the party line, but one did not have to think about one's art as primarily a mere instrument of the Revolution—Trotsky himself was saying so. Furthermore, despite his refusal to endorse any ▲ aesthetic program officially, Trotsky was singling out not only Mexican muralism (unsurprisingly, given the long history of political commitment by its artists) but also Surrealism!

By the time Stalin and Hitler signed a pact of nonaggression (August 23, 1939) and Soviet Russia invaded Finland (November 1939), any idea of a Popular Front had lost all credibility. Even Stuart Davis, who had long behaved like a Communist Party henchman, could no longer kid himself. He publicly resigned from the American Artists' Congress (the Popular Front's institutional voice in the US art scene), as did Schapiro, with Mark ● Rothko, Adolph Gottlieb, and many other young artists in his wake. Meanwhile, in March 1939, Rivera's wife, Frida Kahlo (1907–54), had attended the exhibition "Mexique" organized and prefaced by Breton (obviously nostalgic about his recent trip to that country) at the exclusive Parisian art gallery Renou & Colle. There she met Paalen and invited him to come to Mexico: not even waiting for the outbreak of war, which many predicted though hoping for a miracle, he arrived in Mexico City via New York, where he stayed a few months, in September 1939. Two years later, the beginner American artist Robert Motherwell (1915–91) had joined Paalen, having gone from New York to Mexico with the Chilean Roberto Matta (1911–2002), another of Breton's young recruits. He remained in Mexico further to perfect his Surrealist education under Paalen's guidance.

The Surrealists regroup in New York

The outbreak of the war and the influx of immigrants from Europe radically changed the situation of Surrealism in New York. The vociferous attacks against the movement as "escapist" had more or less died down (except from the discredited Stalinist wing), and its presence on the literary and artistic scene, as well as its attraction for young American artists, had grown at a spectacular pace. The first Surrealist painters to emigrate had been Kurt Seligmann (1900–62), Yves Tanguy (1900–55), and Matta, in November 1939. A few months later, they helped prepare the escape from occupied France of those who had not been prescient (or fortunate) enough to leave before, most notably rallying American support for the Emergency Rescue Committee that Varian Fry, an editor and classicist from New York, had courageously set up in Marseilles without help from (and even in defiance of) the US government. The Committee first secured André Masson's and Breton's exit (they finally arrived in New York in May 1941, after a stressful stay in Martinique, which was administered by the collaborationist French government), then ▲ that of Max Ernst, who finally rejoined his friends in July.

This regrouping of the Surrealist troops in New York could only further stimulate the interest of a young generation of artists already aroused by a series of lectures on the movement delivered, at Schapiro's invitation, by Matta's and Paalen's friend, the painter Gordon Onslow Ford (1912–2003) at the New School of Social Research in January–February 1941. An exhibition of Surrealist art, curated by Howard Putzel, accompanied the lecture series, which ● was attended by Motherwell and Gorky, but also Jackson Pollock, William Baziotes (1912–63), and Gerome Kamrowski (1914–2004), the latter three convening in Kamrowski's studio, quite possibly immediately after one of Ford's talks, and pouring oil and enamel on a "collective painting" [2]. Galleries and museums were playing their part too. A month after their immigration to the United States, Tanguy was offered a one-man show at the Pierre Matisse Gallery,

2 • Collective painting by Baziotes, Kamrowski, and Pollock, 1940–1
Oil and enamel on canvas, 48.9 × 64.8 (19¼ × 25½)

3 • André Masson, *Paysage Iroquois*, 1941
Indian ink on paper, 21 × 38 (8¼ × 15)

where he would exhibit again in 1942 and 1943, and Seligmann at Nierendorf's (where he would show again in 1941, before moving to another gallery). Paalen's April 1940 exhibition at the Julien Levy Gallery, which quickly became something of an official gallery of Surrealist art, was immediately followed by Matta's, his work being shown together with Walt Disney's sketches for *Pinocchio*! Masson's retrospective opened at the Baltimore Museum of Art in October 1941, and in the following month the Museum of Modern Art presented a large retrospective of Miró (who had refused to leave Europe) in tandem with one of Dalí's art, though by then his Surrealist credentials had vanished, thanks to his profascist pronouncements. Ernst, too, was celebrated, not only through exhibitions but also by the special issue devoted to his work by the Surrealist-friendly journal *View*, directed by Charles Henri Ford. The culmination of this public exposure took place in the fall

▲ of 1942, soon after the arrival of Marcel Duchamp in New York. In "First Papers of Surrealism," scenographed by Duchamp, young American artists such as Baziotes, Hare, and Motherwell were invited for the first time to show their work side by side with veterans of the movement such as Seligmann, Masson [**3**], Ernst, and Tanguy (not to mention Matta); its opening was followed a week later,

• on October 20, 1942, by that of Peggy Guggenheim's gallery, "Art of This Century," where her important collection of Surrealist art was presented in a curved space specially designed by Frederick Kiesler.

Despite all this activity, however, there was a certain *ennui* around the Surrealist movement as a whole. At least, Breton felt it, though he would have been the last to admit it: the art presented by the younger generation was clearly derivative, showing a particular fondness for the imaginary landscapes of Tanguy and the "automatic" gesturality of Masson, and these old-timers, in turn, were mainly resting on their laurels. The only exception was Matta, who in 1937, then a twenty-six-year-old student of architecture, had been the youngest recruit of the Surrealist movement and hailed by Breton as its bright new hope. By 1940, he had learned how to translate, in large and colorful paintings, his drawings of bio/mechanomorphic creatures floating in fantastic sci-fi decors that had seduced Breton [**4**]. The

clash between a rational, perspectival space and the oneiric irrationality of the figures that populate it had been at the core of much
▲ Surrealist painting, and Matta was not fundamentally departing from this model. But he was leaving aside the finicky *trompe-l'oeil* technique upon which the riveting effect of Tanguy's or Dalí's art mostly depended. In freeing his painting from the constraints of this academic studio practice and in welcoming sweeping gestures and automatism within the highly controlled stage of his cosmic landscapes, he had, almost despite himself, been led to a dramatic change of scale which struck his young American colleagues. Furthermore, his energy seemed boundless, his missionary zeal remarkably efficient. Soon after the "First Papers of Surrealism" exhibition, he set up a workshop where for a few months he "taught" pictorial automatism to Baziotes, Motherwell, Pollock, and a few others.

Breton had always been an authoritarian leader unwilling to share his power. He was wary of Matta's growing ascendancy in the New York art world, feeling that, despite Matta's allegiance and his orthodox discourse on the marvelous and the necessity of elaborating new myths (principles which Breton's "Prolegomena" had recently reaffirmed), these were not what was attracting Matta's young devotees. If Breton did not watch out, a new school, over which he would have no control whatsoever, was going to emerge from the ashes of Surrealism. Coincidentally, Breton stumbled upon the work of Armenian-born Arshile Gorky (1904–48)—whom he met in the winter of 1943–4 while Gorky was working on his formidable *The Liver is the Cock's Comb* [**5**]—and decided to champion his art.

Gorky's Surrealism becomes Abstract Expressionism

Paradoxically, however, Matta had been determinant in Gorky's development. Until around 1942–3, "among the painters in New York, Gorky stood out for years as the masterly apprentice," writes Meyer Schapiro. Until 1938 he was learning the language of Picasso, then he switched his attention to Miró. "In Matta," pursues

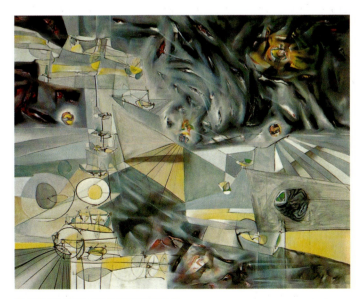

4 • Roberto Matta, *Years of Fear*, 1941–2
Oil on canvas, 111.7 × 142.2 (44 × 56)

▲ 1914, 1918, 1936, 1942b, 1966a • 1942b ▲ 1924, 1931b

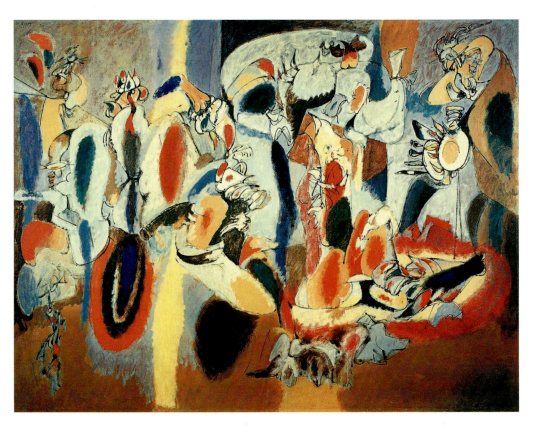

5 • Arshile Gorky, *The Liver is the Cock's Comb*, 1944
Oil on canvas, 186 × 249 (73¼ × 98)

Schapiro, "[Gorky] found for the first time a painter whose language, once mastered, he could use as freely himself. From Matta came the idea of the canvas as a field of prodigious excitement, unloosed energies, bright red and yellows opposed to cold greys, a new futurism of the organic as well as of mechanical forces. Gorky could draw his own conclusions from Matta's art without waiting for the inventor." [6] Liberated from copying by this "younger brother" who, among other things, encouraged him to paint more thinly (until then his canvases had been crusted with heavy impasto), Gorky took flight.

Without discarding all the lessons of his long schooling, he added all the marks of an exuberant gesturality, including multiple run-offs of paint, to what he had learned from Picasso (dissociation of form and contour), Miró (biomorphic figures), Kandinsky (saturated color), Matisse (transparency of the paint layer, which allows for an active role of the underlayers), Matta (sci-fi landscape, amoebic decor), and even Duchamp (whose *Large Glass* he greatly admired). Until his suicide in 1948, he produced at top speed works that could only be called Surrealist because Breton acclaimed them, but which Pollock, ▲ Newman, and other Abstract Expressionist painters immediately regarded as the seed of their own movement.

Always a loner, Gorky had been flattered by Breton's praise, and he flattered the French poet in return by letting him give titles to his canvases, but he steadfastly refused to play the part of a faithful member of the Surrealist group. In 1947, like Picasso before him, when Breton's demands became too pressing, he bade him farewell. Unlike Paalen's departure five years earlier, however, Gorky's defection signaled the end of Surrealism. YAB

FURTHER READING

T. J. Clark, "More on the Differences between Comrade Greenberg and Ourselves," in Serge Guilbaut, Benjamin H. D. Buchloh, and David Solkin (eds), *Modernism and Modernity* (Halifax: The Press of the Nova Scotia College of Art and Design, 1983)

Serge Guilbaut, *How New York Stole the Idea of Modern Art: Abstract Expressionism, Freedom, and the Cold War* (Chicago and London: University of Chicago Press, 1983)

Martica Sawin, *Surrealism in Exile and the Beginning of the New York School* (Cambridge, Mass.: MIT Press, 1995)

Meyer Schapiro, "Arshile Gorky" (1957), *Modern Art: 19th and 20th Century, Selected Papers, Vol. 2* (New York: George Braziller, 1978)

Dickran Tashjian, *A Boatload of Madmen: Surrealism and the American Avant-Garde 1920–1950* (London and New York: Thames & Hudson, 1995)

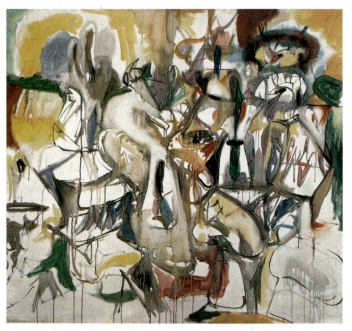

6 • Arshile Gorky, *How My Mother's Embroidered Apron Unfolds in My Life*, 1944
Oil on canvas, 101.6 × 114.3 (40 × 45)

▲ 1947b, 1949a, 1951

1940–1944

1942b

As World War II forces many Surrealists to emigrate from France to the United States, two shows in New York reflect on this condition of exile in different ways.

In 1929 the Surrealists published a map of the world in the Belgian journal *Variétés* [1]. It shows just two capitals, Paris and Constantinople, and redistributes land mass according to the artistic sympathies of the group. As the homes of the more "fantastic" tribal art favored by the Surrealists, Alaska and Oceania (the South Pacific) are vast, while Africa, the home of the more "formal" art already

▲ exploited by the Cubists and the Expressionists, is shrunken. Political affiliations also play a major role: Russia remains large, while the United States does not exist, and Germany and Austria have subsumed Europe entirely—though not yet ominously. Now flash forward nine years to 1938, to the first "International Exhibition of Surrealism" in Paris, only months after the Nazi condemnation of

● modernist art, the "Degenerate 'Art'" show, had opened in Munich. Among the works in Paris was a Surrealist object by Marcel Jean (1900–93) titled *Horoscope* [2], a dressmaker's dummy with plaster ornaments for its base and arms and a watch inset at its headless top. Jean painted the dummy a glossy blue, on which appears a gold-and-gray figure that is gradually disclosed to be both a map (some continents encircle the hips of the dummy) and a skeleton (we can make out its ribs). The two works convey the different moods of the two moments: the 1929 map bespeaks an imaginative appropriation of the world that wittily rewrites it according to Surrealist interests, while the 1937 horoscope-hourglass forecasts a deathly world, with its time running out. The first shows a Surrealism on the creative march; the second suggests a Surrealism that, however international, is on the political run.

The exhibition as "exquisite corpse"

By the thirties the exhibition had become a principal form of Surrealist activity. It could articulate political protest, as it did in "The Truth about the Colonies," a small counterexhibition to the official jingoistic Colonial Exhibition held in Paris in 1931; or it could announce an aesthetic shift, as it did in the "Surrealist Exhibi-

■ tion of Objects" at Galerie Charles Ratton in Paris in 1936, which showed radically diverse things—tribal art, Picasso constructions, mathematical objects, as well as such Surrealist objects as Meret

◆ Oppenheim's famous *Fur-Lined Teacup* (*Déjeuner en fourrure*). The exhibition could also promote the international acculturation

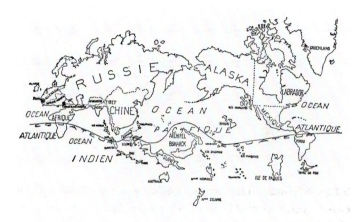

1 • The World in the Time of the Surrealists, first published in *Variétés*, 1929
Offset, printed in black, page size 24 × 17 (9½ × 6¾)

of Surrealism, as in the "International Surrealist Exhibition" at the New Burlington Galleries in London in the summer of 1936, and in "Fantastic Art, Dada, Surrealism" curated by Alfred H. Barr, Jr. at the Museum of Modern Art in December of the same year.

The objects in these shows were often bizarre, but the installations remained rather conventional. This changed dramatically with the "International Exhibition of Surrealism" in Paris in 1938, for here the narrative quality of the typical Surrealist object was extended into the actual space of the exhibition. No precedents existed for this sort of show: it was opposed to the rationalist displays proposed by various Constructivists in the twenties, such as

▲ the Demonstration Room of El Lissitzky, but it was also distinct from the anarchistic manifestations of the Dadaists, such as the

● 1920 Berlin Dada Fair. At the same time, to the extent that the Surrealist exhibition proposed an active, participatory viewer, it was closer in spirit to these other avant-gardist experiments than to any traditional form of exhibition with its passive, contemplative spectatorship. It should come as no surprise that, along with

■ André Breton and Paul Eluard, the "*générateur-arbitre*"(producer-referee) of the show was none other than Marcel Duchamp, already the veteran of several exhibition controversies and recently

◆ the curator of his own miniature museum, the *Boîte-en-valise*. "All exhibitions of painting and sculpture make me ill," Duchamp wrote his patron Jacques Doucet in 1925, two years after he seemed

2 • **Marcel Jean,** *Horoscope,* 1937
Painted dressmaker's dummy, plaster, and watch, height 71.1 (28)

to withdraw from all forms of artmaking. "And I'd rather not be involved in them." Apparently this inhibition did not extend to the orchestration of such events.

The first "International Exhibition of Surrealism"—and it was international, with sixty artists from fourteen countries—opened on January 17, 1938, at the Galerie Beaux-Arts. Owned by Georges Wildenstein, who also published the magazine *Beaux-Arts,* this upscale gallery was located in the rue du Faubourg Saint-Honoré, a high-bourgeois venue that led to charges that the Surrealists had sold out, politically as well as economically. Yet Duchamp did all he could to refashion its elegant eighteenth-century interior into a dim urban underground that undercut its high-art ambience. (Moreover, as if to underscore the commercialism of the context, he hung graphic work on revolving doors redolent of department stores.) The exhibition appeared to be a deranged narrative along the lines of the Surrealist game "exquisite corpse," in which different players drew different parts of a figure or wrote different parts of a sentence, each unbeknownst to the other; but in fact its layout was quite calculated. As soon as one stepped indoors, one seemed to be outdoors again, for in the lobby stood *Rainy Taxi* by Salvador Dalí, an old cab entwined with vines, drenched by rain, and occupied by two mannequins—a driver with a shark's head and dark goggles, and a female passenger covered with live Burgundian snails, a kind of "Birth of Venus" as Lady of the Night.

Already at this point Dalí played to a degraded notion of "Surrealism"—*Rainy Taxi* was so popular that it was re-created for the 1939 World's Fair in New York—and he was soon purged from the Surrealist ranks as much for his blatant commercialism (Breton renamed him, anagrammatically, "Avida Dollars") as for his outrageous expression of Nazi sympathies.

The theme of prostitution continued in the passageway that led from the lobby to the two galleries; it was decorated as a "Rue Surréaliste" with street signs (mostly fictitious, such as "Rue de la Transfusion de Sang") and sixteen female mannequins bizarrely dressed (or undressed) by Dalí, Miró, Ernst, Masson, Tanguy, Man Ray, and others. (Typically, Duchamp cross-dressed his mannequin with shirt, coat, tie, and hat, but no pants.) This passageway, which again confused interior and exterior, opened onto the main space, which combined other versions of indoors and outdoors. On the floor were dead leaves, moss and dirt, a small pond encircled by reeds and ferns, and, in each corner, a double bed with silk sheets. *Horoscope* stood at the foot of one bed, while various Surrealist pictures, such as *The Death of Ophelia* by Masson, hung on the walls. In short, the gallery was made up as a dream space, one with its own contrived logic. It was very dark: Duchamp had wanted the paintings on the walls to be illuminated by the approach of viewers, as in a peep show; when this could not be rigged, Man Ray, in his capacity as "master of lighting," handed out flashlights during the opening, with much the same effect of semi-lewd peering. (Duchamp would return ▲ to this positioning of the spectator in his diorama *Etant donnés.*) Attached to the ceiling were "1,200" coal bags, emptied of coal (due to insurance precautions) but dirty with dust nonetheless, while in the center of the floor stood a charcoal brazier [**3**]. (Almost thirty • years later Andy Warhol "would play with a Pop, postindustrial version of these sacks—helium-filled pillows that he let float as "silver clouds" through a gallery show.) Here was another conflation of spaces—of industrial work and artistic entertainment—further complicated, with the coal sacks on the ceiling, by an inversion of up and down. To top off this mélange of signifiers of art and prostitution, commerce and industry, Dalí hired a dancer, Hélène Vanel, to perform a simulation of hysteria titled "The Unconsummated Act"; and by some accounts, insane-asylum laughter and German military music were also piped into the galleries.

This last note must have struck a grim chord, for during the week of the opening Nazi bombs fell on Barcelona and Valencia. Perhaps the political frame of the Spanish Civil War made the changed social status of Surrealism all the more obvious. For many of the Surrealist gestures in the show were almost conventional by the late thirties: once a figure of the uncanny, the mannequin had ■ become a Surrealist cliché, difficult to distinguish from its use in fashion, which had adopted such Surrealist devices as the dreamlike invocation of desire, sometimes with the assistance of the Surrealists. At the same time, Surrealism was embraced by high society, which was out in full force and evening dress for the opening of the 1938 show: once provocative politically, Surrealism had become chic in an *outré* sort of way. Yet had the Surrealists

▲ 1966a ● 1960c, 1962d, 1964b ■ 1924, 1925c, 1930b, 1931a

3 • Marcel Duchamp, *1,200 Coal Bags Suspended from the Ceiling Over a Stove*, 1938
Environment for the "International Exhibition of Surrealism," Galerie Beaux-Arts, Paris

moral depravity and mental illness in a large display of pilloried works. The Surrealist show also mocked this fiercely ideological use of museum display. (Might Duchamp have sought to echo—that is, to exacerbate—this riotous installation in his own?)

The exhibition as labyrinth

A year later, with the fall of France to the Nazis in 1939, the condition of the Surrealists changed utterly—from international expansion to escape and emigration, mostly to the country that did not exist on their 1929 map, the United States. In New York, along with such ▲ magazines as *VVV* (guided by Breton) and *View* (edited by the American poet Charles Henri Ford), the exhibition remained a primary medium of Surrealist activity, and it now had the additional function of a banding-together of exiles. A pair of near-simultaneous exhibitions in New York in 1942—"Art of This Century" and "First Papers of Surrealism"—dramatized these changed circumstances.

simply withdrawn from the street to the salon, from political engagement to artistic spectacle (as some have charged)? Or did the 1938 show not disrupt accepted oppositions of interior and exterior, private and public, subjective and social? Perhaps the two developments are not mutually exclusive.

In any case, as Man Ray once remarked, the installation did "destroy that clinical atmosphere that reigned in the most modern of exhibition spaces," and here again we must place it in the context of its moment, for the year 1937 witnessed two very different models of museum display. On the one hand, there was a quasi-objective ideal of display put forward by the state-sponsored exhibition of ▲ museology at the 1937 International Exhibition in Paris, in which the proper techniques of "judgment, presentation, and protection of patrimony" were laid out ("noiseless rooms, evenly distributed lighting, studied floor and ceilings, appropriately sober surfaces, standardized labels, effusive wall text about the artists and works"), all designed to reassure viewers that "the exhibition space was neutral, the work of art autonomous, aesthetic appreciation disinterested." Obviously the Surrealist show flew in the face of this putatively scientific program. On the other hand, there was the opening just five months before of the twin Nazi demonstrations in Munich: the "Great German Art" exhibition, which laid out the reactionary aesthetic of Nazi kitsch, and the "Degenerate 'Art'" • show, which equated modernist art (including Surrealism) with

▲ 1937a, 1937c ● 1937a

▲ 1942a, 1968b

4 • Installation view of the Surrealist Gallery designed by Frederick Kiesler in "Art of This Century," New York, 1942

One thing had not changed, however: the embrace of socialites, such as the American Peggy Guggenheim, an heir to a copper-mining fortune, who had left Europe with her husband Max Ernst on July 14, 1941. To exhibit her collection of modernist art amassed in Europe, Guggenheim opened a gallery-museum called "Art of This Century" on October 20, 1942, in two converted tailor shops at 28–30 West 57th Street. The architect was Frederick ▲ Kiesler (1890–1965), a young associate of the De Stijl group, once active in Vienna but now resident in New York, who was already known for his avant-garde theater designs (in 1929 he had designed the first theater in United States specifically for film, the Film Guild Cinema on West 8th Street). Kiesler divided "Art of This Century" into four spaces: one for temporary shows and three for fixed exhibitions of the collection, each of which was styled after the art on display. With blue walls and turquoise floor decided by Guggenheim, the Abstract Gallery suspended its unframed paintings on wires that ran from ceiling to floor in giant vs both parallel and perpendicular to the walls. The Kinetic Gallery displayed several • paintings by Paul Klee on a conveyor belt, while another device ■ showed the *Boîte-en-valise*, one work at a time, through a peephole. More unusual still was the Surrealist Gallery [4]. Here Kiesler called for bowed walls made of gum-wood, from which he projected Surrealist paintings supported by batlike struts at different angles; meanwhile his biomorphic chairs doubled as sculpture stands. Like Duchamp before him, Kiesler wanted to control the lighting—to illuminate one side at a time for two minutes each, to have the gallery pulse "like your blood."

This last ambition aligns Kiesler with the Surrealist vision of an "intrauterine" architecture that Dalí, Tristan Tzara, and Roberto Matta had proposed in articles of the thirties, and Kiesler elaborated in his "Endless House" project of 1950. Here is Tzara ◆ on such architecture in 1933, from the magazine *Minotaure*: "When it is understood that comfort resides in the half-light of the soft tactile depths of the one and only possible hygiene, that of prenatal desire, then circular, spherical, and irregular houses will be built again, which man kept from cave to cradle and to tomb in his vision of an intrauterine life, and which the aesthetics of castration,

called modern, ignore." And here is Matta (who once worked for ▲ Le Corbusier) in 1938, also from *Minotaure*: "We must have walls like wet sheets that get out of shape and fit our psychological fears." Kiesler designed out of a similar fantasy of return to a primordial space of creation: in his Surrealist Gallery he sought to "dissolve the barrier and artificial duality of 'vision' and 'reality', 'image' and 'environment'… [where] there are no frames or borders between art, space, life. In eliminating the frame, the spectator recognizes his act of seeing, or receiving, as a participation in the creative process no less essential and direct than the artist's own." In effect Kiesler wanted to disguise the mediation of the gallery in order to simulate the immediacy of psychic space—hence the removal of conventional supports like frames, partitions, and bases.

The American critic T. J. Demos has interpreted this "fusional installation design" as "a response to the anomie of exile"—more specifically, as an attempt to move away from the old Surrealist exploration of the uncanny (in German *Unheimlich* or unhome-like) toward a new Surrealist myth of "a habitable and conceivable world" (as Breton described it at the time). Duchamp, in his own 1942 installation of Surrealist art, "First Papers of Surrealism," which opened a week before "Art of This Century," projected a different kind of world again—more alien than uncanny but certainly not homelike. "[The Surrealists] had a lot of confidence in the ideas I could bring them," Duchamp later remarked to Pierre Cabanne, "ideas which weren't anti-Surrealist, but which weren't always Surrealist, either." "First Papers of Surrealism" was a benefit exhibition for war prisoners, sponsored by the Coordinating Council of French Relief Societies at the Whitelaw Reid Mansion (451 Madison Avenue). The designer Elsa Schiaparelli asked Duchamp to install the exhibition and, along with Breton and Ernst, he chose works by roughly fifty artists—mostly old Surrealist • warriors, but also some new American associates, such as Joseph ■ Cornell, Kay Sage, David Hare, William Baziotes, and Robert Motherwell. The title, "First Papers," refers to application forms for US citizenship, and it could be read either as an optimistic statement of a new life or a bitter mockery of all official identification at the height of World War II. Also ambiguous was the most celebrated gesture of the show—the tangle of string a mile in length that Duchamp wound all around the main gallery in a way that not only obscured the paintings but also obstructed entry to the space [5].

Duchamp had used string before: only three meters' worth in ◆ his 1913 experiment in "canned chance," *Three Standard Stoppages*, and different lengths in his 1918 *Sculpture for Traveling*, made up of strips of shower caps of various colors attached by string and stretched to the four corners of his studio at 33 West 67th Street. This work, which Duchamp took with him on a 1918 sojourn to Buenos Aires, bespeaks both a sense of displacement (in the traveling of the title) and a strategy of occupation (in the installation of the piece). The string in "First Papers" exacerbates the displacement, and turns the occupation into its near-opposite—obstruction—for again the tangle impeded access to the gallery. Several readings were offered of this tangle: for some witnesses

5 • Marcel Duchamp, *Sixteen Miles of String*, at "First Papers of Surrealism," 1942
Vintage silver-gelatin print, 19.4 × 25.4 (7⅝ × 10)

(like Sidney Janis and Arturo Schwartz), it was a figure of the difficulty of all modernist art; for others (like Marcel Jean), it was a trope of age like a cobweb, though whether this age was one of veneration or decay was not clear. Still others dismissed the entire show as a tedious tangle. Certainly the installation played on the Surrealist fascination with the labyrinth as a figure of the unconscious (with the man-beast Minotaur at its center), a figure that it seemed to transform into an allegory of contemporary history, or rather of a breach in this history marked by war and exile, a breach that distanced the Surrealist art on display, almost literally, from the present. From this angle, the exhibited artists were posed as contemporary Ariadnes with little hope of finding their way out of the maze. If such an allegorical account appears dubious, we can simply state that the string obscured both pictorial and architectural spaces in a way that at once underscored and interrupted the given frames of painting and gallery alike. In any case, it was a negative, almost nihilistic gesture, but typically Duchamp presented it as playful, for he asked a group of children to play ball in the gallery for the duration of the opening. Nonetheless, the installation was hardly the "fun house space" that John Cage recalled of "Art of This Century."

While Kiesler wanted to do away with frames in order to render Surrealist art somehow immediate, Duchamp worked to elaborate frames excessively into a literal maze, as if to resist the institutional acculturation of this art. This difference has led T. J. Demos to see Surrealism-in-exile as torn between a search for a "compensatory home," as represented by Kiesler, and an acceptance of a profound homelessness, as represented by Duchamp. This seems right; however, circumstances changed again with the end of the war. In 1947 the two friends collaborated on the design of yet another "International Exhibition of Surrealism," now back in Paris. Their installation returned to the model of a deranged narrative used in the 1938 exhibition in Paris: the viewer had to pass through a series of tests in a sequence of spaces before looking at the works

Peggy Guggenheim (1898–1979)

Peggy Guggenheim was one of the greatest collectors and most passionate supporters of avant-garde art in the twentieth century. When she died, her collection included works by Kandinsky, Klee, Picabia, Braque, Gris, Severini, Balla, van Doesburg, Mondrian, Miró, Ernst, de Chirico, Tanguy, Dalí, Magritte, Pollock, Motherwell, Gorky, and Brauner. She also collected sculpture: by Brancusi, Calder, Lipchitz, Laurens, Pevsner, Giacometti, Moore, and Arp. In 1920, she moved from the United States to Paris, where the minor Surrealist painter Laurence Vail (whom she would marry) introduced her to a bohemian world that included Marcel Duchamp, Man Ray, Anaïs Nin, Max Ernst, and Samuel Beckett.

Her collecting began as a function of the first gallery she opened, in London in 1938 (modestly called Guggenheim Jeune), with Duchamp as her adviser. The opening exhibition was of the drawings of Jean Cocteau, and succeeding exhibitions featured Tanguy, Kandinsky, Arp, and Brancusi. After a year she decided to open a museum of modern art in London and convinced Herbert Read to be the museum's first director. By 1940 she had entered on a campaign to "buy a picture a day," and as the war worsened she worried about where to store her collection. The Louvre in Paris turned the works down as "not worth saving," but finally she found a château near Vichy with barns large enough to house them all. With her collection in storage for the war, Guggenheim went to Marseilles, where she contributed money to the effort to arrange passage out of Europe for a group of intellectuals and artists. She eventually left in 1942 in a plane that also carried Ernst and her two children from her abortive marriage to Vail.

In New York, she married Ernst and set to work on her new gallery, "Art of This Century." The gallery arranged the first solo exhibitions of some of the major figures of the developing school of Abstract Expressionism: Pollock in 1943, Baziotes in 1944, Rothko in 1945, and Clyfford Still in 1946. Believing Pollock to be "the greatest painter since Picasso," she arranged a contract to give him $150 a month. Lee Krasner later said:

"Art of This Century" was of the utmost importance as the first place where the New York School could be seen.… Her Gallery was the foundation, it's where it all started to happen.

on display. Here, then, the trope was neither a compensatory home nor an indefinite homelessness but a rite of return, and the narrative was one of ritual reincorporation. But at this point Surrealism had little left but such rituals, and few new initiates to go through them. In the postwar period it would dissolve into other movements altogether; it would disappear from the map. HF

FURTHER READING
Bruce Altshuler, *The Avant-Garde in Exhibition: New Art in the Twentieth Century* (New York: Harry N. Abrams, 1994)
T. J. Demos, "Duchamp's Labyrinth: 'First Papers of Surrealism'," *October*, no. 97, Summer 2001
Lewis Kachur, *Displaying the Marvelous: Marcel Duchamp, Salvador Dalí, and Surrealist Exhibition Installations* (Cambridge, Mass.: MIT Press, 2001)
Martica Sawin, *Surrealism in Exile: The Beginning of the New York School* (Cambridge, Mass.: MIT Press, 1994)

1943

James A. Porter's *Modern Negro Art*, the first scholarly study of African-American art, is published in New York as the Harlem Renaissance promotes race awareness and heritage.

Called the "father of African-American art history," James A. Porter (1905–70) was not only a distinguished art historian but also a successful painter in his own right. His groundbreaking survey *Modern Negro Art* (1943) was the result of ten years of collecting and collating documents about the history of African-American art, from its inception to the early forties. This seminal work made visible many little-known artists, especially Porter's contemporaries associated with the Harlem Renaissance, the African-American social, literary, and artistic movement that had been gathering force since the end of World War I.

The early flowering of the Harlem Renaissance

Although its spiritual home was in Harlem, New York, the Harlem Renaissance's ideas and ideals helped it blossom into a trans-national movement. Several factors led to its flowering as it promoted and celebrated the black experience in a variety of art forms. One was the "Great Migration" between the two world wars, during which more than two million black Americans migrated to northern urban centers from the rural South. This was mainly because life in the South became increasingly difficult and dangerous after the passing of the racist and segregationist "Jim Crow" laws (so called after a black minstrel show character) and the growth of the white supremacist Ku Klux Klan. This mass migration in pursuit of a new life in the more liberal North led to a growing black urban population that included academics, intellectuals, and artists, many of whom settled in Harlem.

Earlier in the century, many black people were calling for better conditions, ranging from Booker T. Washington's (1856–1915) philosophy that unskilled black Americans should focus on economic advancement to the radical activism of Harlem-based Jamaican Marcus Garvey (1887–1940) and his Universal Negro Improvement Association (UNIA), formed in 1914. Garvey's world-wide movement was both ennobling—encouraging black people everywhere to consider themselves, and to take pride in themselves, as Africans—and separatist. Believing that the rift between black communities and their white oppressors was too great, he advocated a "back to Africa" agenda, a campaign to repatriate colonial blacks and African-Americans in order to "uplift the race."

The Pan-Africanist philosophy of African-American civil rights activist and author W. E. B. Du Bois (1868–1963), who helped to create the National Association for the Advancement of Colored People in 1909, was articulated early in the century. It emphasized the shared African heritage of black Americans, which was furthered by the birth in the twenties of the literary and ideological movement known as Negritude. Created by French-speaking African and Caribbean poets, it sustained interest in the black civilizations of Africa and promoted the idea of the beauty of the race and the concept of unity between Africa's descendants.

Such thinking encouraged racial pride, a sense of nationhood and international solidarity among those of African descent. Du Bois's ideas, however, were the most important for the Harlem Renaissance: unlike Washington and Garvey, he believed that African-Americans could achieve full economic, civil, and political parity with white Americans in America. He was also passionate in his view that art, the greatest achievement of civilized man, could play a conciliatory role, and that supporting and empowering black artists would enable them to make valid and important contributions to American society as a whole.

Other factors that nurtured the Harlem Renaissance included ▲the European modernists' interest in "primitive" African art and their appreciation of African-American dance and music, particularly spirituals and jazz—encompassing both folk and avant-garde art from the New World. Black American intellectuals, such as philosopher Alain Locke (1886–1954) realized that this fashion for all things African and African-American could, and should, be capitalized on to work for social change.

Sociopolitical, economic, ideological, cultural, and aesthetic concerns all informed the search to define the "New Negro" and to encourage a cultural renewal that acknowledged the black American's African ancestry, life and history in America, and transformation into a modern urban persona. The New Negro Movement epitomized this need: as sociologist Charles S. Johnson (1893–1956) commented in 1925: "A new type of Negro is evolving—a city Negro." This new black urbanite required a new identity that would leave behind that of ex-slave.

Sculptor Meta Vaux Warrick Fuller (1877–1968) is acknowledged as one of the most important precursors of the Harlem

▲ 1903, 1906, 1907

1 • Meta Warrick Fuller, *The Awakening of Ethiopia*, 1914
Bronze, 170.2 × 40.6 × 50.8 (67 × 16 × 20)

Van Der Zee (1886–1983), Harlem's premier chronicler of the years 1920 to 1940, provided some of the most enduring, iconic images of the era [2]. In helping to create the image of the New Negro, styling and retouching the photographs to create uplifting images of black Americans, Van Der Zee produced photographs of Harlem's residents that capture the optimism, style, pride, and sophistication associated with this new urban identity.

The leaders of the New Negro Movement—black and white American philosophers, sociologists, critics, gallery owners, and patrons—believed that through culture, rather than politics, they could achieve their shared goal of equal rights and freedoms for black Americans. They reasoned that increased exposure through black arts and literature would help mainstream society see black Americans and their experience as *part of*, rather than *apart from*, the American experience.

They also thought that black American culture could, and should, be appreciated for more than just dance and music: the academics turned to those in the arts and letters to help them. The most responsive was Locke; he wanted to found a "Negro School of Art" in Harlem to increase black Americans' visibility and awareness of their African heritage and history. Some of his thinking was informed by his experiences in Berlin during the early days of German Expressionism, when he absorbed the idealistic belief that through art the world could be made a better place. This coalesced with Du Bois's introduction and advancement of the concept of a "talented

Renaissance. She took classes at the Pennsylvania Museum School of Industrial Art before going for several years to Paris, where she studied with Auguste Rodin. After her return to the United States in 1903 her work was exhibited regularly on the East Coast, where it came to the attention of the spokesmen for the Harlem Renaissance, who were drawn to her aesthetic based on the example of African sculpture and her use of black African and American subject matter.

Fuller was inspired by Du Bois's Pan-Africanist philosophy, which is evident in her best-known work, *The Awakening of Ethiopia* [1]. Drawing on an Egyptian sculptural tradition, the bronze figure of a woman awakening from a deep sleep could be read as a call to her fellow African-Americans for a rebirth of black culture after centuries of slavery and repression. Her use of black subject matter and of explicit links between Africa and black America provided a potent example for Locke and his followers as they tried to formulate an aesthetic for the New Negro.

The New Negro

The twenties were a time of optimism, pride, and excitement for African-Americans who hoped that their time for a respectable place in American society had finally arrived. Photographer James

2 • James Van Der Zee, *Family Portrait*, 1926

tenth"—the creation of an educated black elite whose mission it would be to better the lives of the less fortunate of their race.

White fascination with black America had been growing since around 1917, with the production of a number of plays and musicals featuring black themes and actors. While some were wary of this new interest, most leaders of the Harlem Renaissance saw it as the perfect opportunity to launch their black arts movement. In March 1921, Johnson organized a literary gala to celebrate young black writers at Manhattan's Civic Club, hosted by Locke with Du Bois as principal speaker, and attended by 110 literati, both black and white. Johnson's plan worked: Paul Kellogg, the white editor of *Survey Graphic*, a magazine of social and cultural issues, pitched to him the idea of a special issue dedicated to the black artists who had just been presented. The result was the March 1925 issue, "Harlem: Mecca of the New Negro," edited by Locke, which opened with a mission statement:

> The Survey *is seeking out month by month and year by year to follow the subtle traces of race growth and interaction through the shifting outline of social organization and by the flickering light of individual achievement.… If the* Survey *reads the signs aright, such a dramatic flowering of a new racespirit is taking place close at home among American Negroes, and the stage of that new episode is Harlem.*

It featured social essays, poetry, and fiction by and about the Harlem Renaissance and was illustrated throughout by German-born artist Winold Reiss (1886–1953). His dignified and realistic black-and-white pastel portraits included both Harlem personalities and ordinary residents—teachers, lawyers, schoolchildren, and Boy Scouts. Also included were Reiss's striking black-and-white Art Deco graphics of Harlem life, portraying an exciting, vibrant, modern city. The people and the work of the Harlem Renaissance were thus introduced to a largely white literary audience via the most popular issue in the magazine's history, selling out two printings.

Its success led to an expanded book version, published later in the same year by Albert and Charles Boni. *The New Negro: An Interpretation* was a 446-page anthology of essays, short fiction, poetry, and illustrations, edited and with contributions by Locke. In a manifesto-like form, he showcased new work and called for a celebration of black history and culture, imploring artists to rediscover and appreciate their African heritage and equally to reference and build on those traditions—such as folklore, blues, spirituals, and jazz—specific to their lives as African-Americans. The book was illustrated with color pastels by Weiss, stylish caricatures by New York-based Mexican Miguel Covarrubias (1904–57) and black-and-white Egyptian-style geometric woodcuts by African-American Aaron Douglas (1899–1979).

Although Reiss rarely features in discussions of the Harlem Renaissance, he was an influential figure: his worldwide studies of native populations, which respected and drew on their folk traditions, were an important example, as were his modernist graphic images. Thus, he was an important conduit for introducing many modernist European tendencies into American culture. Douglas, whom Locke would soon be calling a "pioneering Africanist," moved to Harlem (where he studied under Reiss) in 1924. Reiss encouraged him to move away from his strictly realist practice and to develop a style that respected his African ancestral heritage, his experience as an African-American, and modernist developments in art. He soon created an original modern black art in which the New Negro is an Art Deco silhouette. The American Precisionists' sharp angles and exuberance for the industrial landscape were harnessed toward his goal of expressing black pride and history [3]. His work quickly came to the attention of the Harlem Renaissance writers and he illustrated many of their books. Together with his illustrations in numerous magazines, this soon brought about his position as the Renaissance's "official" artist.

Individual and organizational support

With the publication of *The New Negro*, Locke became the main strategist and theoretician of the Harlem Renaissance, serving as mentor or, as he put it, "philosophical midwife," to many of its writers and artists. Existing support structures such as the National Association for the Advancement of Colored People (NAACP)

3 • Aaron Douglas, *The Creation*, 1935
Oil on masonite, 121.9 × 91.4 (48 × 36)

founded in 1909 to work for equal rights, and the Urban League, founded in 1910 to help new arrivals adjust to city life, championed the movement through their magazines: *The Crisis* (NAACP), edited by Du Bois and *Opportunity* (Urban League), edited by Johnson.

Further support and exposure came from wealthy white real-estate developer and philanthropist William Harmon (1862–1928). In 1926, achievement awards for African-Americans' contributions in music, the visual arts, literature, industry, education, race relations, and science were established under the auspices of the Harmon Foundation, which was a major patron of Harlem Renaissance artists: its annual national competition for black artists, the accompanying show and touring exhibition introduced their work to a national audience.

Artists from around the country responded enthusiastically to the Harlem Renaissance leaders' call to develop a visual vocabulary for black America. Writing to Langston Hughes in December 1925, Douglas expressed his thoughts on the matter:

> *Our problem is to conceive, develop, establish an art era.… Let's bare our arms and plunge them deep deep through the laughter, through pain, through sorrow, through hope, through disappointment, into the very depths of the souls of our people and drag forth material crude, rough neglected. Then let's sing it, dance it, write it, paint it.… Let's create something transcendentally material, mystically objective, Earthy. Spiritually earthy. Dynamic.*

The challenge was accepted and a number of different black representational possibilities were explored. A prominent strain explored by Fuller, Douglas, and others engaged heavily with the artists' African ancestry, while artists such as Archibald J. Motley (1891–1980) and Palmer C. Hayden (1893–1973) turned their attention to black folklore, history, and the minutiae of everyday life. Whether accessing a distant mythical past or nostalgia for a more recent rural past or celebrating progress and modernity, all the work of the Harlem Renaissance is involved in race consciousness and cultural identity for African-Americans.

The legacy of the first decade of the Harlem Renaissance included nationalism, primitivism, and atavism. The animated African mask in African-American Lois Mailou Jones's (1905–98) *Les Fétiches* [4], painted while she was in Paris, presents these ideas seen through a Surrealist lens. She seems both to acknowledge the Surrealists' fetishizing of the "dehumanizing" mask and to reclaim it as part of her legacy, bringing it to life as a valid ingredient in the search to define a modern black identity.

The thirties

The Stock Market crash of October 23, 1929, brought the "roaring twenties" to an end and ushered in the Great Depression. This tempered much of the idealism and optimism of the early Harlem Renaissance; in many, it strengthened their sense of racial pride and social responsibility. As private support dried up, artists turned to the Public Works of Art Project and the Federal Art

4 • Lois Mailou Jones, *Les Fétiches*, 1939
Oil on canvas, 78.7 × 67.3 (31 × 26½)

Project of the Works Progress Administration (WPA), which were organized in 1933 to employ artists at craftsmen's wages to decorate public property. Artists were assigned to either easel painting or mural painting; the subject matter was all aspects of the American scene and although no specific approach was stipulated, most were working in a social realist style at the time.

A considerable number of Harlem Renaissance artists were among those who received support from the WPA. Douglas, for example, painted a mural series, *Aspects of Negro Life*, for the WPA in 1934. Mounted in the 135th Street branch of the New York Public Library (now the Schomburg Center for Research in Black Culture), it brought Douglas's work to a larger audience, its monumental scale and epic quality furthering the Harlem Renaissance mission of promoting race awareness and pride and making a profound impression on the next generation of Harlem-based artists, among them Jacob Lawrence (1917–2000).

Lawrence moved to Harlem with his family during the thirties. He studied at the Harlem Art Center and spent many hours at the Schomburg Center absorbing Douglas's work and researching the struggles of the heroes of the black community. He soon developed his distinctive colorful, stylized figurative style and his central concern with the social issues and historical events effecting black Americans. Much of Lawrence's work of the late thirties was in series format, chronicling the lives of black heroes such as Toussaint Louverture (c. 1743–1803) (who was born into slavery, became a military leader and revolutionary, and established Haiti as the first

▲ 1903, 1906, 1907 ● 1924, 1930b, 1931a ▲ 1936

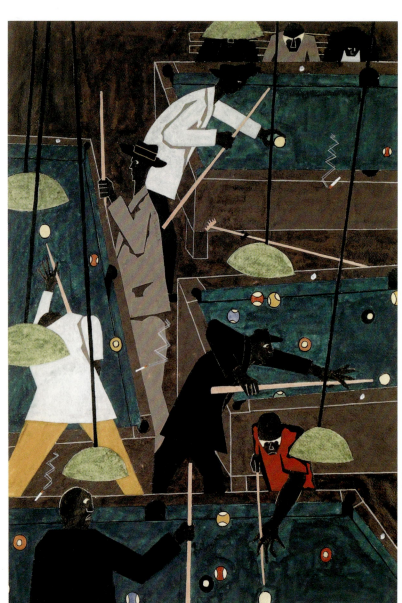

black Western republic) and the abolitionists Frederick Douglass, Harriet Tubman, and John Brown. His best-known work, painted while working in the easel division of the WPA, is *The Migration of the American Negro* (1940–1). This landmark narrative series of sixty small paintings captures the struggles of the "Great Migration" earlier in the century. The work was a critical success: part of it was published in the November 1941 issue of *Fortune* magazine, bringing Lawrence's work to a national audience. This early recognition led to numerous exhibitions, major museum purchases, and prizes, such as the one he won for *Pool Parlor* [5] in the "Artists for Victory" exhibition held at the Metropolitan Museum of Art in New York in 1942.

Norman W. Lewis (1909–79) was another young artist who began painting during the thirties in Harlem, where he absorbed Locke's ideas. *The Lady in the Yellow Hat* [6], an early work in an abstracted figurative mode, reflects this influence as well as that of social realism, but it also points to the future, for Lewis soon began to question the

effectiveness of Locke's theories, abandoning realistic imagery to ▲ become the only African-American Abstract Expressionist.

Lewis was not alone in questioning the Harlem Renaissance ethos. James A. Porter, who encouraged black artists to pursue personal expression rather than a separatist agenda, took Locke to task in 1937 in the pages of *Art Front* for advancing what he saw as Locke's "defeatist philosophy of the Segregationist." In *Modern Negro Art*, he made his stance clear, discussing African-American artists' work not only in relation to black culture but also in the contexts of both American art history and the history of modern art.

The end of an era

After the horrors of World War II, many African-American artists felt that race-oriented, isolationist ideologies were no longer desirable or appropriate. One such artist was Romare Bearden (1912–88) who, while using black content or Africanesque symbols

▲ 1947a

6 • Norman W. Lewis, *The Lady in the Yellow Hat*, 1936
Oil on burlap, 92.7 × 66 (36½ × 26)

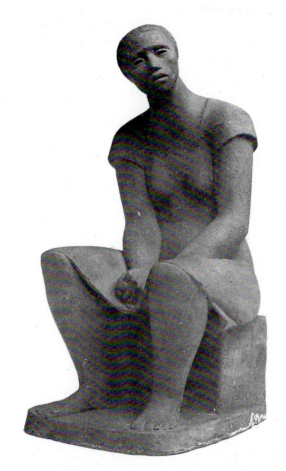

7 • Elizabeth Catlett, *Tired*, 1946
Terracotta, 39.4 × 15.2 × 19.1 (15½ × 6 × 7½)

in his work, always strove to project something about the universal condition. In 1946 he wrote:

> It would be highly artificial for the Negro artist to attempt a resurrection of African culture in America. The period between the generations is much too great, and whatever creations the Negro has fashioned in this country have been in relation to his American environment.… Modigliani, Picasso, Epstein and other modern artists studied African sculpture to reinforce their own design concepts. This would be perfectly appropriate for any Negro artist who cared to do the same … the true artist feels that there is only one art—and it belongs to all mankind.

Elizabeth Catlett's (1915–2012) *Tired* of the same year shows an exhausted African-American woman worn out from the struggle but with the inner strength to carry on [7]. American born, but a Mexican citizen, Catlett always used the black figure as a symbol of racial and cultural pride. Her words echo the ideals championed by the Harlem Renaissance:

> Art should come from the people and be for the people. Art for now must develop from a necessity within my people. It must answer a question, or wake somebody up, or give a shove in the right direction—our liberation.

The innovative energy of the Harlem Renaissance declined with World War II, although the careers and ideas of its practitioners did not. The issues that Locke and Porter raised—what constitutes a black aesthetic; whether one should be a 'black artist' who creates black art or an American artist who is black—were not resolved during the Harlem Renaissance: rather, they continue to inform ▲artmaking and criticism whenever issues of identity arise. AD

FURTHER READING

M. S. Campbell et al., *Harlem Renaissance: Art of Black America* (New York: Studio Museum in Harlem and Harry N. Abrams, 1987)

David C. Driskell, *Two Centuries of Black American Art* (New York: Alfred A. Knopf and Los Angeles County Museum of Art, 1976)

Alain Locke (ed.), *The New Negro: An Interpretation* (first published 1925; New York: Atheneum, 1968)

Guy C. McElroy, Richard J. Powell, and Sharon F. Patton, *African-American Artists 1880–1987: Selections from the Evans-Tibbs Collection* (Washington, D.C.: Smithsonian Institution Traveling Exhibition Service, 1989)

James A. Porter, *Modern Negro Art* (first published 1943; Washington, D.C.: Howard University Press, 1992)

Joanna Skipworth (ed.), *Rhapsodies in Black: Art of the Harlem Renaissance* (London: Hayward Gallery, 1997)

▲ 1907

▲ 1993c

1944 a

Piet Mondrian dies, leaving unfinished *Victory Boogie Woogie*, a work that exemplifies his conception of painting as a destructive enterprise.

Piet Mondrian died in New York on February 1, 1944. Shortly thereafter his executor and heir—the young painter Harry Holtzman, who had helped organize Mondrian's immigration to the United States—opened his studio, left untouched, to the public. The threadbare yet extraordinarily dynamic space, with its white walls transformed into screens of optical flickers by the many rectangles of pure colors that were pinned onto them, and its makeshift all-white furniture designed by Mondrian from wooden crates (again, adorned with colored rectangles), were already well known to several visitors. But very few had previously seen the unfinished *Victory Boogie Woogie* [1], even though the painter had worked on it since June 1942. It escaped none of these onlookers that there was a direct continuity between the pulsating surfaces of the walls and the staccato beat of Mondrian's last "lozangique" painting, as he called his series of square canvases rotated through forty-five degrees to stand on one corner (most commonly labeled his "diamond paintings").

This continuity was particularly enforced by the fact that not only had the black lines of classic Neoplasticism entirely vanished from the exceptionally large picture hovering on the easel, but so had *any* kind of line. One could speak only of "alignments" of tiny rectangles of color, most of them pieces of paper somewhat clumsily glued onto the canvas. But even these alignments are clearly on the verge of collapsing: they can be read only subliminally, inferred rather than seen, in most areas of the composition. Thus, to the visitors, the major difference between the walls and the painting must have seemed one of scale. Entering the box-car studio and being pulled toward *Victory Boogie Woogie* at the very end of this long pristine space, one must have had the exhilarating feeling of walking into a painting.

But for those who had seen this ultimate canvas before Mondrian's death, their posthumous encounter with it was a horrifying shock—in fact, among the small circle of Mondrian's acquaintances who had witnessed the painter struggling over it during the last eighteen months of his life, many shared dealer and writer Sidney Janis's verdict: it was now a ruined masterpiece.

Mondrian had several times brought the painting to a conclusion (in a photograph dating from the winter of 1942–3, one can see him putting the "finishing" brush-stroke to it). But each time

he had undone what he had achieved and, to the stupefaction of his friends, had started anew. He most certainly knew that his own end was coming, and his lifelong teleological bent had led him to assume that, if this painting were to be his swan song, it had to go further than anything he had done before. He was not interested in producing just one more painting in the electrifying style of his New York period. When a friend asked him why he kept repainting *Victory Boogie Woogie*, instead of making several pictures from the different solutions that had been superimposed on this same canvas, Mondrian replied: "I don't want pictures. I just want to find things out." During the week of January 17–23, 1944, three days before entering the hospital to be treated for his fatal pneumonia, he had "unfinished" his masterwork one more time, covering its painted surface with a myriad tiny bits of colored tape and paper—to the great sorrow of Janis et al.

But negative criticism is often more perceptive than unconditional praise. The admirers of Mondrian's classic Neoplasticism saw only destruction in this collage of the eleventh hour. In many ways they were right, and they would have been surprised to hear Mondrian agree, and agree with glee. For destruction was precisely what he had endlessly sought during the long gestation of *Victory Boogie Woogie*. The "finished" state that Janis and others had seen in his studio before the last frantic, week-long campaign was just not "destructive" enough for Mondrian: witnessing the panic of his most ardent supporters, he would have finally declared victory.

In fact, destruction had been at the very core of Mondrian's program all along. Since, right from his very first texts, he had written about the destruction of form, of the "particular," of individuality, his New York admirers should not have been so dismayed. They were not entirely at fault, however, for Mondrian had sent ambiguous signals with regard to his utopian dream of the "dissolution of art into the environment" (which he understood as a possibility for the "far distant future"): even though as early as 1922 he had determined that painting was the only vehicle within which his aesthetic principles could be truly tested by experiment, he had not gone out of his way to dissuade his early defenders from praising his art for its usefulness as a blueprint for modern architecture. By 1944, notwithstanding Mondrian's ever more aggressive statements about the fundamental role of negativity in his work

▲ 1917a

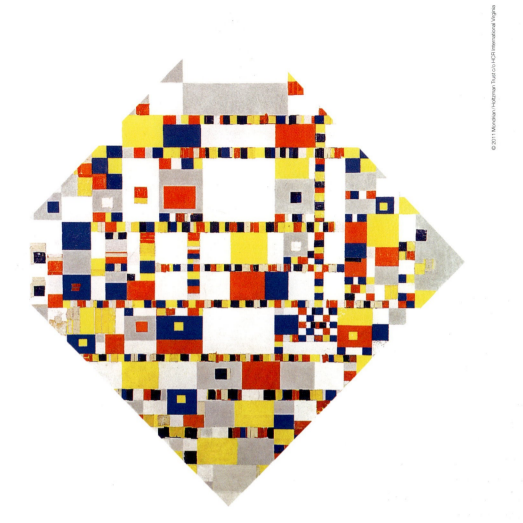

1 • Piet Mondrian, *VICTORY BOOGIE WOOGIE*, 1942–4 (unfinished)
Oil and paper on canvas, 126 × 126 (49⅝ × 49⅝), vertical axis 178.4 (70¼)

(such as "I think the destructive element is too much neglected in art"), it had become a cliché to think of him as the champion of a "constructive" aesthetic (already in 1937 Naum Gabo had been utterly baffled by Mondrian's refusal of this label.

It was in the thirties that Mondrian understood that he was not getting his message across. The posthumous publication, in the last issue of *De Stijl* (in January 1932), of fragments of Theo van Doesburg's diary must have been a severe blow. There, Mondrian's former friend compared his work to the classical painting of the seventeenth-century French artist Nicolas Poussin. At that time, indeed, through a very long process of trial and error, Mondrian's dialectical system of composition had reached a peak, a perfect pitch where nothing could go wrong. The "negation" of one element by the other had led his paintings to be absolutely decentralized (thus achieving the destruction of the "particular" he was looking for), but they were also flawlessly balanced. Mondrian celebrated this climax in a series of eight paintings, from 1930 to 1932, all based on the same general organization. Yet such a self-satisfied rehashing (unique in his production, contrary to what one might think) soon gave way to the realization that he was "stuck."

Never indulgent with himself, he came to the conclusion that if he had indeed reached a serene equilibrium in his compositions, this was at a terrible cost, since it hardly conveyed the sense of dynamic evolution, of everlasting perfectibility in art and life, that was so essential to his dialectical thinking. Courageously (at the age of sixty), he concluded that, in order to better enact the destruction he had always been advocating, he had above all to shatter the language of painting itself, including his own. One by one, the elements of Neoplasticism, which he had conceived as the culmination of all the art of the past, were annihilated as entities.

The first thing to be "dissolved," as he said, was the plane. To this effect, Mondrian reintroduced a feature that he had banned from his painting since 1919 and that would utterly undermine the "classical" look of his works—that is, repetition. If until then he had conceived of repetition only as a natural (and therefore prohibited) phenomenon, it now became a favorite weapon in his struggle against identity: he multiplied the lines delimiting and linking the planes together so that "rhythm alone emerges, leaving the planes [themselves] as 'nothing.'" Lines, which had been a secondary element in "classical" Neoplasticism, thus became the most active element, the main destructive agent, and their sheer multiplication ensured not

▲ 1937b ● 1917b

only that planes lost their "individuality" (as one cannot securely grasp a plane with multiple contours), but also that the same "depersonalization" would happen to the lines themselves.

Aesthetic sabotage

Mondrian's first attempt at such a radicalization of his pictorial program was *Composition B* of 1932 [**2**], based on the same compositional schema as the climactic series of the previous two years. With this work he inaugurated what he called his "double line"— two parallel black lines and their white interstice, itself perceived as a line. But while in this canvas the white gap of the double line is narrow (it is of the same thickness as the intersecting—"single"— black line), it will soon widen and (as Mondrian would write, bemused, to a friend) "head toward the plane." And where there is no fundamental difference between lines and planes, since the line has given up its subordinate position, should there not be colored lines as well? Though Mondrian answered this question in the affirmative as early as 1933 (with the "diamond" composition of that year, *Composition with Yellow Lines*, now in the Gemeentemuseum in The Hague, which bears only four "lines / planes" on a white background), it would not be until after his arrival in New York, in October 1940, that he would fully explore this possibility.

In the three years following *Composition B*, Mondrian continued to use the classical type of 1930–2 as a solid platform on which to test the sabotage of his past pictorial language. In the only two paintings completed in 1934 (one of them destroyed as "degenerate" by the Nazis), he doubled *all* the lines; in 1935, he tripled the horizontal axis of *Composition (No. I) Gris-Rouge* (Chicago Art Institute) and quadrupled that of *Composition (No. II) Bleu-Jaune* (Hirshhorn Museum, Washington, D.C.); in *Composition (No. III) with Red, Yellow and Blue* (Tate Modern, London) of the same year, this horizontal division is a "double line" whose white interstice has become wider than two of the "planes" in the picture; in the last painting of the series, *Composition with Yellow* (1936, Philadelphia Museum of Art), it is no longer really a question of double lines: instead we find a "plurality" of lines that bisect the canvas.

Mondrian's next move, during the second half of the thirties, was to transform this "plurality" of lines (ever more numerous) into a sheer scansion, an irregular pulsation of the whole surface of the canvas. Two unexpected changes resulted from this gradual filling-in of his paintings (which had once been so bare as to contain only two black lines on a white ground, as in the *Lozenge Composition with Two Black Lines* of 1931), and in both cases we witness Mondrian transgressing a taboo of his Neoplastic system: first, effects of superimposition, banned since 1917, begin to re-appear (effects that Mondrian then accentuated by varying the width of his black lines); second, one notices a return of the optical flickering caused by multiple linear intersections (something he had carefully avoided since 1919). It is as if the fear of illusionism that had engendered these past proscriptions was now far less an issue than that of making sure that nothing ever remains stable. To the

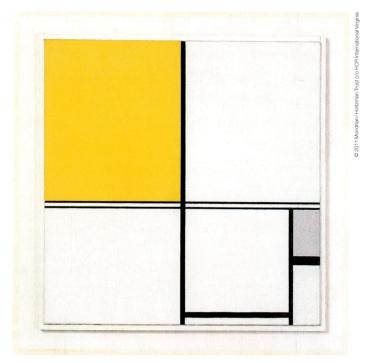

2 • Piet Mondrian, *COMPOSITION B, with Double Line and Yellow and Gray*, 1932
Oil on canvas, 50 × 50 (19⅝ × 19⅝)

variable thickness of the lines, to their multiplication and the discomforting retinal afterimage it creates, Mondrian then added a partial interruption of certain lines, which thereby cease to bisect the surface—rather, they interact to define fictive planes of a fugitive existence, forming and dissolving before our very eyes.

Mondrian's work was evolving at a rapid rate, his compositions becoming ever more complex, when, after a short interlude in Britain, he left Europe for America (he had fled Paris in 1938, mistakenly thinking that the French capital would be bombed by the Nazis—instead a bomb fell yards away from his London studio). There, after a few weeks of adjustment in New York, he took it upon himself to revise all the canvases he had brought with him (indeed all but four of the works completed in New York were begun in Europe). The myth of Mondrian's suddenly marveling at the Manhattan skyline at night is greatly exaggerated, since the changes in his art that occurred in America were more a direct consequence of an internal development than anything else. Yet there is no doubt that the urban vitality of New York (and specially the most recent jazz music that he suddenly discovered) hit Mondrian full in the face. He felt rejuvenated by the city; for the first time in his life he was acclaimed as a master and his advice was sought (it is thanks to his interest in Jackson Pollock's *Stenographic Picture* of 1942, for example, that Peggy Guggenheim gave this work a second look and ended up taking the American painter into her stable).

The first canvases to be reworked belong to a series of vertical compositions that Mondrian had initiated in Paris (in 1936), characterized by an "empty" bay in the center. In *Composition No. 9* [**3**], we can clearly isolate all the features of his late European period (superimposition of bisecting lines, moderate flicker effect [on the right], unequal length of black lines that determine fictively

▲ 1949a, 1960b ● 1942b

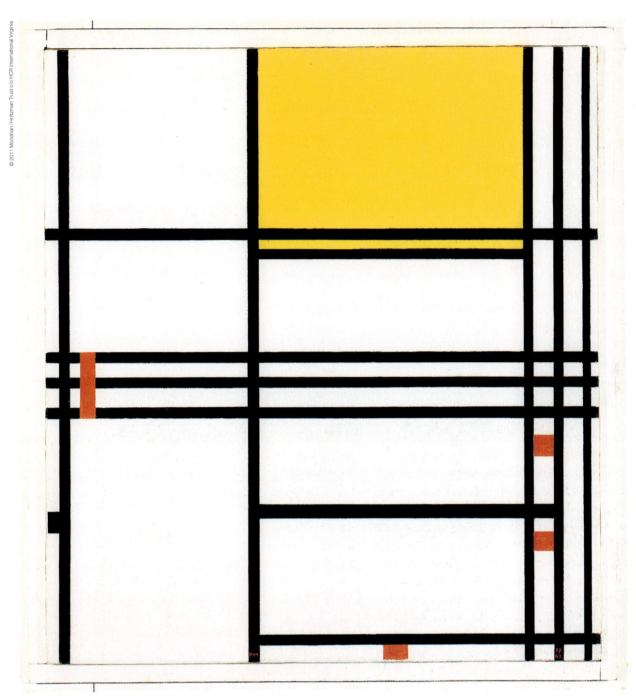

3 • Piet Mondrian, *Composition No. 9 with Yellow and Red*, 1938–42
Oil on canvas, 79.7 × 74 (31⅜ × 29¼)

overlapping rectangles of uncertain identity). To this vocabulary, Mondrian has added tiny dashes of color that seem to be unbounded by any restriction—one of them even crossing the stack of horizontal bars (in another canvas of the same batch, a red block cuts through a yellow plane, bringing the first color juxtaposition since 1917 into his art). Those dashes multiply and elongate in *Place de la Concorde* (1938–43), a picture titled in homage to the city in which Mondrian had started working on it, just as in the cases of *Trafalgar Square* (1939–43) and *New York* (1941–2). In this last painting, bisecting colored lines (briefly tried in 1933) reappear along with the dashes. The next step, with *New York City*, was the total elimination of black.

This work evolved from a series of paintings, once again initiated in Europe, where the sheer number of black lines crossing the canvas formed a grid, irregular, to be sure, but as optically active as that of the first two modular "diamond" paintings of 1918 and 1919. Mondrian had accepted the retinal afterimage as an inevitable by-product of the beat of lines scanning his canvases—but he was nevertheless wary of this. In *New York City*, he arrived at a solution to bypass this illusion, and he found it by pushing his enterprise of destruction of the language of painting further. During the early thirties, the plane as shape (the rectangle) had been "dissolved" by the multiple crossing of lines; then, in the late thirties, the identity of the line itself had been

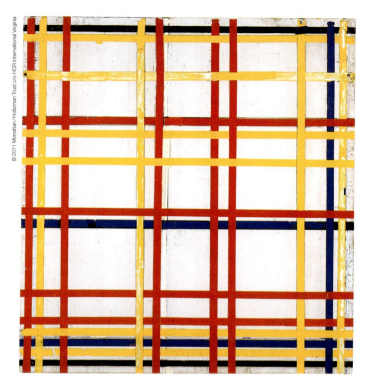

4 • Piet Mondrian, *New York City I*, **1941 (unfinished)**
Oil and painted paper strips on canvas, 119 × 115 (46⅞ × 45¼)

that had become chords of three colors—this vibrant painting is devoid of the type of material weave he had created in *New York City*. In that canvas an unexpected effect of simultaneous contrast (illusionistic apparition of complementary colors) had resulted from the multiple crossing of colored lines; in *Broadway Boogie Woogie*, he had tried not to correct this effect but to give it a form by marking each crossing of the predominantly yellow lines as a square of a different color, thus furthering the atomization of these lines. But the integrity of the ground had returned in full force.

This is probably what troubled him as well in the "finished" state of *Victory Boogie Woogie*, and why he furiously appended all the bits of colored paper one can see pasted onto it today, ending up with a collage where the relative position of all elements, woven in thickness in a shallow cut of actual (not illusionary) space, is in a perpetual state of flux—where the ground has become a ghost whose only possible existence, a fleeting one, is that of appearing *above* the figure. YAB

FURTHER READING
Yve-Alain Bois, "Piet Mondrian, *New York City,*" *Painting as Model* (Cambridge, Mass.: MIT Press, 1990)
Yve-Alain Bois, Joop Joosten, and Angelica Rudenstine, *Piet Mondrian* (Washington, D.C.: National Gallery of Art, 1994)
Harry Cooper, "Mondrian, Hegel, Boogie," *October*, no. 84, Spring 1998
Harry Cooper and Ron Spronk, *Mondrian: The Transatlantic Paintings* (New Haven and London: Yale University Press, 2001)
Joop Joosten and Robert P. Welsh, *Piet Mondrian*, catalogue raisonné, 2 vols (New York: Harry N. Abrams, 1998)

abolished with the accelerated pulse of repetition, but what had remained untouched during this battle fought against the fundamentals was the ground on which lines and plane rest. It was now the negation of the ground as a geometric and physical entity to which Mondrian aspired. Thus *New York City* was conceived as a weave of colored lines that one can never reconfigure into independent virtual planes (as a red, a yellow, and a blue web) since no line of any given color behaves in a constant fashion (a red line will be above a blue one at an extremity and under at the other). But this deliberate loss of geometric identity is based on the physical unevenness of the ground: the painting is ostensibly layered, Mondrian having carefully imitated, via impasto and emphatic brush-strokes, the above-and-underneath of the braid that he had created with colored tapes while drafting the composition, as can be witnessed in the other canvases of the same series that were left unfinished [4].

The logic behind this new turn was typical of Mondrian's reduction of all phenomena to their foundational dialectic: illusionism is what happens when the ground is being optically hollowed out, but if the ground did not exist as such to begin with, if there were no geometrically continuous surface, nothing of the sort would be possible. Yet it is probably only with his penultimate work that Mondrian fully grasped this particular point. Hailed as a masterpiece (and acquired by the Museum of Modern Art when it was exhibited, freshly painted, in 1943), *Broadway Boogie Woogie* was deemed a failure by Mondrian. "There is too much of the old in it," he would say. For although no previous picture of his had so efficiently captured the syncopated rhythm that he loved so much in jazz—with its colored lines divided into long beats of yellow (the base) and short beats of red, gray, and blue, and its rare larger planes

1944 b

At the outbreak of World War II, the "Old Masters" of modern art—Matisse, Picasso, Braque, and Bonnard—consider their refusal to flee occupied France as an act of resistance against barbarity: discovered at the Liberation, the style they had developed during the war years presents a challenge to the new generation of artists.

In 1950, the Grand Prize for Painting at the Venice Biennale was awarded to Henri Matisse (better late than never: he was 81). He had more works included in the show than any other artist that year. Not only had the French government selected him for its pavilion (along with Pierre Bonnard, Maurice Utrillo, and Jacques Villon), but his paintings easily dominated the historical exhibition devoted to Fauvism (including, besides Matisse, works by Braque, Derain, van Dongen, Dufy, Marquet, and Vlaminck). Matisse's presence at the 1950 Biennale amounted to a mini-retrospective, with twelve paintings in the Fauvism show and twenty-three in the French pavilion, which also included three sculptures and six drawings. With hindsight, it seems that the dice had been somewhat loaded, as though the Biennale's organizers had worried that it could be their jury's last chance to crown the modern Old Master, or old modern master. (In fact there would have been two more opportunities: Matisse did not die until the end of 1954.) As was often the case with Matisse's several postwar retrospective exhibitions, a deliberate emphasis was put both on the artist's early work and on his most recent work (done during or immediately after the war), which he was eager to present to the public. Altogether there were at least twenty-two paintings dating from 1896 to 1917 and seven from 1940 to 1948, while only six paintings covered the intervening period.

Bridging the hiatus

This time, however, Matisse hardly had to pull any strings for his strategy of "early/late and nothing in between" to be adopted: for reasons entirely different from his own assessment of his forte, the postwar strategy of the Biennale (which had closed in 1942 and reopened in 1948) was devoted to bridging the postwar present and the pre-Fascist past. The obvious goal was to erase memories of the twenties and thirties as a bad dream, and to atone for the hypernationalism (and growing antimodernism) of the Mussolini years. Nothing was better for this purpose than a latter-day version of "Sleeping Beauty." Matisse's evolution provided the perfect prop for the manufacture of such a collective amnesia, since it paralleled almost perfectly the life of the Biennale: the only times he had sent works to Venice were in 1920 and in 1928 during his

1 • Henri Matisse, *Still Life with Magnolia*, 1941
Oil on canvas, 74 × 101 (29⅛ × 39¾)

so-called 1917 to 1930 "Nice period"; that is, when Matisse himself had turned his back on the modernism of his youth and was participating in his own way in the conservative backlash called the "return to order," a reactionary trend that the Biennale was backing with all its institutional might. However, as soon as Matisse rekindled in his work the flame of his avant-gardism of the pre-World War I years—this happened in 1931 to 1933, while he was working on the large "decoration" of *The Dance* for the Barnes Foundation in Philadelphia—he was no longer welcome in Venice, and he no longer cared to send works either. But the reopening of the Biennale after World War II was carefully designed as the turning of a new page, and Matisse, who had gone through his own *aggiornamento* in the interim years, was delighted to take part in this healing event. The message it allowed him to convey to a large audience—that in his recent art he had not only gone back to the roots of his aesthetic innovation but that new shoots had sprung from these roots—was remarkably in sympathy with the politics of reconstruction common to all Europe in the immediate postwar period, an ideological program for which the Venice Biennale was the most conspicuous flagship in the sphere of artistic consumption.

It was at Matisse's request that the Musée National d'Art Moderne in Paris sent to Venice *Still Life with Magnolia* of 1941 [1]

▲ 1919

2 • Henri Matisse, *Large Red Interior*, 1948
Oil on canvas, 146 × 97 (57½ × 38¼)

▲ *Magnolia* and the 1910 *Music*, or the 1913 *Blue Window*—these are all purely frontal arrangements of figures floating in a field of saturated color. Yet if what distinguishes the second batch of work from the first is tenuous—the unpainted white areas that surround the objects even as these figures are traced in heavy black contours; the light of the blank canvas that shows through the brushwork—the new air of freedom these conspicuous marks of spontaneity lend to the late paintings is the direct result of a philosophy of art that Matisse had began to develop around 1935.

The word that Matisse chose to characterize his new approach was "unconscious." This was perhaps infelicitous since his notion of the unconscious had little to do with the Freudian concept and its underpinning of repressed desires. Matisse's "unconscious" was more of a "reflex," as he also said at times. In practical terms, to "rely upon one's unconscious" meant for him to adopt a two-tier working process, a technique that he initially developed in drawing. He would first patiently "take possession of his model" and learn from it everything he needed to know through what he called an "analytical study" (more often than not realized in charcoal, and with many *pentimenti*); then, only when he felt that this cumulative storing of information had reached saturation, there would be the explosive relief of the line drawing, or rather drawings, done almost as if in a trance and without any possibility of correction, his hand guided by sheer instinct, just like the acrobat or the high-wire artist who will fall if he starts thinking about what he is currently doing and its dangers. By 1941 Matisse had fully mastered this dual temporality in the graphic realm (he was understandably proud of his accomplishment and started to compile a facsimile album of drawings illustrating his method, published in 1943 under the title *Thèmes et Variations*), but he was not certain of how to implement it in painting. *Still Life with Magnolia*, one of the canvases he worked on most intensely, represents the turning-point. On the one hand, there are countless preparatory drawings for this painting (which is unusual for him); on the other hand, he erased it several times to start it each time anew until he could paint it without thinking. While the mood of this work is ominous, its frontal address to the viewer no less petrifying than that of *Music* (and, like this early painting, which
● was in part a response to Picasso's *Les Demoiselles d'Avignon*, no less recalling Freud's myth of Medusa's head), the technique Matisse employed there is responsible for the striking openness of all the Vence interiors. All appear to have been done in a matter of hours—and they were, if one considers only their final state; however, an unknown quantity of solvent had been used in effacing their previous incarnations, day after day. With this Penelopean process, Matisse had invented a new kind of pictorial automatism through which he felt that his lifelong goal of annihilating the gap between conception and realization could be achieved.

Matisse was seventy-nine when he painted *Large Red Interior*. Soon afterward he was definitively confined to bed. This was when he turned to another language of fusion, his paper cutouts [3]. This medium was not new in Matisse's repertoire—he had already used paper cutouts when working on the Barnes *Dance* in 1931 to 1933,

and *Large Red Interior* of 1948 [2], two works it had recently acquired. *Large Red Interior* is the painter's last major canvas and one could even call it his pictorial testament: it both concludes the great series of *interiors* realized in Vence after the war, of which four others were also presented in Venice, and it inevitably recalls the *Red Studio* of 1912 in that, like this recapitulative landmark of Matisse's early career, it represents among other things some of the artist's own creations tacked on the wall amidst an ocean of pulsatile red (a large brush-and-ink drawing of 1948 and *The Pineapple*, yet another canvas of the Vence series). *Still Life with Magnolia*, similarly bathed in red, remained Matisse's favorite painting until he had completed the Vence series: it is the first important canvas done in what could be called his "old-age style," just as *Large Red Interior*, seven years later, would be the last.

The close link between the *Red Studio* and *Large Red Interior* is not merely thematic. In purely formal terms, there is no fundamental difference between Matisse's "early" mature style
▲ (that is, post-*Le Bonheur de vivre* but prior to the Nice period) and the "old-age" style just mentioned. There are more similarities than differences, to take another example, between *Still Life with*

3 • Henri Matisse, *La Gerbe* (The Sheaf), 1953
Model for ceramic picture, cutout gouache, 2.9 × 3.4 (1⅛ × 1⅜)

then intermittently throughout the thirties for various decorative projects; his first major paper cutout opus, the album *Jazz*, was realized during the war, while he was temporarily bedridden (it was published in silkscreen form in 1947)—yet it is only during the last five years of his life that he had almost exclusive recourse to this means. It was particularly suitable, as was another medium he employed at the time (ceramic tiles), for working on large-scale decorative projects such as his Chapel of the Rosary in Vence, which was inaugurated in 1951. Like pictorial automatism, the paper cutouts represented a solution to a dilemma Matisse had sought to solve since the beginning of his career, this time not the split between conception and realization, but an effect of such a split, "the eternal conflict between [his] drawing and [his] color," about which he repeatedly complained and which the coloristic outburst of Fauvism—in particular *Le Bonheur de vivre*—had been intended to address. By "drawing directly into color," Matisse was able to maximize two sources of energy he had been employing with mastery for decades: the modulation of the intervals of white ground that animates his line drawings, and the electrifying saturation of his color.

"Old-age" style of modernist masters

Although Matisse's career provides the best example of the "old-age" style phenomenon among modernist masters, his case is not unique. Another artist similarly celebrated by the Venice Biennale, this time in 1948, was Georges Braque (perhaps as a substitute for Picasso, whose political allegiance to the Communist Party, trumpeted shortly after the Liberation, compounded by his staunch opposition to General Franco's fascist Spanish government, made him an unlikely laureate). Pierre Bonnard would not have been an absurd choice either. The particulars are different each time, but the core issue remains the same: the art of those painters who had already become famous before World War I and who had long been venerated as pioneers of modern art betrays an unexpected renewal after World War II; younger artists

emerging around 1945 had to cope with the fact that their heroes, of whom they had entirely lost sight for several years, were not only still alive but were also producing amazing new work.

Picasso was the most significant stumbling-block for the new generation (Pollock often lamented that the Spanish artist had invented everything, and he began to feel free from the senior artist's spell only after he had come up with the drip technique in 1947). There is no massive change between Picasso's pre- and postwar style (or rather multiplicity of styles) until the mid-sixties. But despite this surprising stylistic continuity in an oeuvre marked by discontinuities of all kinds, Picasso's work of the late forties and fifties is colored by a general approach that is antithetical to the structuralist method, based on the oppositional nature of pictorial signs, that he had elaborated during the heyday of Cubism. It is not by chance that this later mode, which could be termed "phenomenological" (in that it presupposes a kind of empathy by which the artist attempts to know his model as if from within) is most efficiently deployed in works that are in direct but posthumous dialogue with Matisse, the perennial rival he finally felt free to honor. In the two series of paintings Picasso made with his old friend, who had just died, explicitly in mind—the *Women of Algiers* of 1955 [**4**], and the *Studio at "La Californie"* of 1955—the model that Picasso strives to know from within is as much the represented motif (Delacroix's courtesans in one case; the kitsch Art Nouveau/neo-rococo mirror-filled space of his new studio in Cannes in the other) as it is Matisse's art (the odalisques that Picasso claimed had been bequeathed to him, and the airiness of the Vence interiors). This was not the first time that Picasso had expressly launched a pictorial colloquy with a dead master, for he had explored Grünewald's *Crucifixion* in the early thirties; Poussin's *The Triumph of Pan* during the Liberation of Paris; and Cranach, Courbet, and El Greco in the late forties and early fifties. In Matisse, however, he was mourning a contemporary rather than playfully toying with a distant past. This endowed these works with

4 • Pablo Picasso, *Women of Algiers* (version H), 1955
Oil on canvas, 130.2 × 162.3 (51¼ × 63⅞)

▲ 1906 ● 1911, 1912, 1921a

▲ 1949a, 1960b ● Introduction 3, 1907, 1911, 1912, 1921a

5 • Georges Braque, *The Billiard Table*, 1944
Oil on canvas, 130.5 × 95.5 (51⅜ × 37⅝)

an unusual gravity that he retained for the subsequent series in which he investigated the Western tradition of painting (forty-five canvases directly based on Velázquez's *Las Meninas* in 1957; twenty-seven canvases and around two hundred works in various media after Manet's *Le Déjeuner sur l'herbe* in 1959 to 1962). With Matisse's death, Picasso's world had received a blow that never quite healed. Musing on his own mortality, he would spend the rest of his long life arguing, more and more desperately, that painting as he had known it was still a game worth playing, but by the early sixties the phenomenon of the neo-avant-garde had clearly shifted the paradigm of expectations and young artists no longer deemed him relevant.

Braque's remarkable series of interiors revealed in Venice (including the first he painted, *The Billiard Table* [**5**]) bears signs of a liberation whose mechanism is not dissimilar from that experienced by Picasso in his "Matissean" paintings of 1955 to 1956, even if the cause is entirely different. Just as for the canvases of 1919 to 1921 (done when Braque was recovering in seclusion from the wound he had received at the front, and for once did not feel Picasso breathing down his neck) these late works magnify the artist's extraordinary technical know-how, the whole culinary aspect of painting of which he was a master without equal but that he had always tended to devalue under the peer-pressure of his sarcastic alter ego. In itself, the composition of these interior scenes is nothing but standard, one could even say academicized, Cubism, involving disjunction between color and form, multiple points of view, transparency, decomposition of the object into planes, etc., but their unusually large size underscores the materiality of the mixture of paint and sand Braque used to signify their obdurate reality as objects. Late in life, Braque was often praised for having restored a French tradition of still life that went back to Chardin in the eighteenth century, but if his interiors of the forties made an enormous impact, it is because in them he had unexpectedly switched from the intimate scale of the easel painting to the public scale of the mural.

One does not find a similar shift in scale in late Bonnard. In his *Studio with Mimosas* [**6**], there is nothing that was not already present in his work from the mid-thirties onward (the subtle chromatic interplay of accumulated paint layers of various colors—a stylistic feature emulated by Mark Rothko in his mature work; the zoom effect by which Bonnard crops the visual field and propels the beholder into the luminous thicket of things). Furthermore, the size of his canvases did not augment in the postwar period. What did, though, is the looseness of his brush-strokes. Outlines became ever less defined, as if perceived in a haze, and this general diffusion of form further reverberated Bonnard's coloristic high pitch, transforming the domestic world he had been depicting for decades into a full-blown oneiric space.

Léger's postwar work, by contrast, constitutes a retreat. While he was in America during the war, Léger had explored the possibility of an isotropic pictorial space with his series of *Divers* and *Acrobats*: jumping from all sides, their floating figures move in defiance of gravity. Theoretically, these canvases could be hung in four different positions—this was Léger's hypothetical claim at least, although he undermined it by applying a sole signature in one elected corner. Léger's many versions of his *Divers* and *Acrobats* all convey a sense of directionlessness akin to that of Joan Miró's *Constellations* of 1940 to 1941, and although this debt is rarely acknowledged, the 1944 exhibition of Léger's works in New York might have played no less significant a role in the elaboration of Pollock's concept of the allover than Miró's 1945 show at the Pierre Matisse Gallery. However, while Miró retained this resolutely open-ended sense of indirection in his art for years to come, Léger opted for the heroic-monumental genre. Even though he had been one of the few modernist painters to think seriously, as early as the mid-twenties, about what would much later be coined (by Clement Greenberg) the "crisis of the easel painting," even though he had clearly stated that this medium as such was doomed to wither and that the survival of painting was predicated upon its ability to fuse with other media (including architecture) and develop a new sense of scale, he was himself bound by his ideological allegiance. Léger joined the Communist Party shortly after Picasso, but while the Spanish painter fluctuated between cynical endorsement of Stalinist politics through minor propaganda work (for example, his assembly-line production of dove "peace" designs) and utter indifference to the Party line, Léger believed in the credo and wished to "educate the masses" through his art. As a result, his postwar art, while still having recourse to all the stylistic devices he had developed since the early thirties (thick contours enclosing the figures; schematic modeling by degradation of black superimposed on flat planes of pure colors), becomes increasingly stiff. His figures end up mimicking, without the harsh rudeness and convincing naivety one finds in the work of an Aleksandr Deineka, for example, the postures found in Soviet "Socialist Realist" painting. Unlike that of Matisse, Picasso, Braque, or Bonnard, Léger's art did not grow in the postwar Reconstruction period—which nevertheless did not prevent him from being a force with which the coming generation had to reckon.

▲ 1960a

▲ 1913, 1925a ● 1960b ■ 1934a

6 • Pierre Bonnard, *Studio with Mimosas*, 1939–46
Oil on canvas, 126 × 126 (49⅝ × 49⅝)

7 • Giorgio Morandi, *Still Life*, c. 1946
Oil on canvas, 28.7 × 39.4 (11⅜ × 15½)

A new generation comes into its own

Léger was passed over by the Venice Biennale. Having celebrated several figurative Old Masters of the School of Paris, the Biennale moved to Surrealism, another movement that had been deliberately ignored during the Fascist years (in 1954 Max Ernst received ▲ the Grand Prize for painting, and Hans Arp for sculpture), then, finally, it moved to the new generation—which meant at that time, for this old institution not particularly attuned to the most recent developments in art, postwar abstraction (Mark Tobey [1890–1976] and Eduardo Chillida [1924–2002] in 1958, Hans ● Hartung [1904–1989] and Jean Fautrier [1898–1964] in 1960).

But the attribution of Grand Prizes to international masters was not sufficient as a means for the Biennale to attend to its political campaign of redemptive amnesia: it also needed to address the troubled Italian context. The most daring move was its celebration ▲ in 1950 of "The Signers of the First Futurist Manifesto": in what amounted to a total travesty of history, it entirely omitted Marinetti, who as the uncontested leader of Futurism, had not only written the said manifesto but had also been the most famous official "bard" of Mussolini's regime. That his reluctant colleagues had not been reluctant enough—and had basically gone along with Marinetti's antics—was in no way addressed.

Not all of the Biennale's revisionist attempts were as ill-conceived or hypocritical. In 1948, two years before it tried to absolve Futurism of its past political crimes, it paid homage to *pittura metafisica* in a ● group show featuring Carlo Carrà, Giorgio de Chirico, and Giorgio Morandi (1890–1964). The exhibition failed to convince many critics that de Chirico's late work was anything but a total renunciation of his early stance (which had been so important for the birth of Surrealism), and Carrà's dimly lit star did not get any brighter either, but Morandi, a secluded man, until then barely known outside Italy, was suddenly put on the map. This outburst of recognition did not change anything for him—neither in his art, whose very strict parameters had been established since the early twenties, nor in his monastic life. For years until he died, Morandi painted similar compositions: mainly small still-life arrangements of several empty vessels (bottles, glass, cups, vases) seen slightly from above and disposed frontally on a barren plane (the table is never more than a horizon line) and against a no-less-barren wall [**7**]; the whole always in tonal color schemes (he became of master of gray) and in sharp light (either zenithal and thus without shadows, or oblique, with accentuated shadows reminiscent of de Chirico's first manner). Morandi's art is one of reticence, of whisper—it is at odds with the buoyant claims of the many avant-garde movements that succeeded one another at growing pace during the twentieth-century. Like ■ Ad Reinhardt in his abstract "black," "ultimate" paintings, Morandi opted for what one would be tempted to call a minor mode—if this term did not necessarily carry negative connotations—a mode in which pathos and the agonistic rhetoric of high contrasts are abolished and where the work requires a long contemplation before it can begin to take hold. Unsurprisingly, beholders were slow to grasp Morandi's quiet stance—but, in the end, the hermit of Bologna did more to convince younger artists that the game of painting was still worth playing than did Picasso in his postwar grandstanding. YAB

FURTHER READING
Lawrence Alloway, *The Venice Biennale 1895–1968: From Salon to Goldfish Bowl* (New York: New York Graphic Society, 1968)
Yve-Alain Bois, *Matisse and Picasso* (Paris: Flammarion, 1998)
John Golding et al., *Braque: The Late Works* (New Haven and London: Yale University Press, 1997)
Nicholas Serota (ed.), *Fernand Léger: The Later Years* (Munich: Prestel Verlag, 1987)
Leo Steinberg, "The Algerian Women and Picasso At Large," *Other Criteria: Confrontations with Twentieth-Century Art* (London, Oxford, and New York: Oxford University Press, 1972) and "Picasso's Endgame," *October*, no. 74, Fall 1995
Sarah Whitfield and John Elderfield, *Bonnard* (London: Tate Gallery; and New York: Museum of Modern Art, 1998)

▲ 1913, 1916a, 1918, 1922, 1924, 1925c ● 1946 ▲ 1909 ● 1909, 1924 ■ 1957b

roundtable

Art at mid-century

HF: First, let's address a few of the important narratives of prewar art that emerge in the postwar period, and clarify our historical differences from them. Second, we might take up the problem of antimodernism, and why this was long a difficult topic to discuss adequately. And third, we should grapple with the question of World War II as a caesura, and how different histories of twentieth-century art negotiate this break, either marking it as definitive, denying it in the interest of continuity, or bridging it in the name of reconstruction. No doubt we will stray from this itinerary—but let's begin with the account of prewar modernism developed by
▲ Alfred H. Barr, Jr., the first director of the Museum of Modern Art.

YAB: One thing that strikes us now is the difference between Barr's enthusiastic encounter with the Russian avant-garde on his trip to the Soviet Union in 1927–8 and the way Russian Constructivism was later melted down at MoMA to a production of abstract paintings and sculptures. Even if Barr was specifically searching for painters and sculptors on his visit ("I must find more painters," he noted in his diary after a visit to Rodchenko, who told him he had stopped painting in 1922), he was impressed by all the work done by Constructivist artists in what we could call the realm of
● propaganda or the "ideological front" (theater design, film sets, typography, exhibition design, etc.). Even if he was critical of the antiart concept of "factography" in the end, he spent a considerable amount of time with its theoretician, the writer Sergei Tretyakov, trying to understand it. Barr admired the "brilliant" Konstantin
■ Umansky, who "at the age of 19" had written the book *Neue Kunst in Russland* (it long remained the only synthetic study of Soviet art), and he was particularly struck by Umansky's comment that "a proletarian style was emerging from the wall newspaper with its combined text, poster, and photomontage": "an interesting and acute suggestion," Barr noted. In short, he was extremely curious about the transformations made in the aesthetic realm by the Soviet avant-garde, trying to gauge their consequences for the future. But then he seems to have "forgotten" all this almost as soon as he left Russia: he couldn't take it into consideration in the history of modern art he was constructing.

HF: Yet there are residues of his encounter with art in relation to industrial production in his interest in *design*, though that interest was
◆ mostly read through the Bauhaus, which Barr also visited—that is,

through a more capitalist-friendly version of art into production…. When does he do his flowchart of modernist movements?

BB: 1936.

HF: Right, for his "Cubism and Abstract Art" show of that year.

YAB: And his Bauhaus show comes soon after, in 1938.

BB: I wouldn't dismiss his interest in the Bauhaus simply as the capitalist version of the art-into-production project. I think it indicates a more complex comprehension of the transformation of avant-garde practices in the twenties toward production, architecture, and design, and utilitarian definitions of art in general that are very significant for Barr's position. And it is accompanied
▲ by an equally strong interest in the legacy of Dada, which was another set of operations that opened up the traditional model of art in a radical way. All of these positions are present in his 1936 account. The question is: How do these extraordinary historical chapters get edited out in the reception of MoMA's exhibitions and in the work of the first generation of American artists and critics after Barr?

HF: Of course there are other chapters, other movements, in his chart, yet they are also streamlined: they are all made to flow into successors according to a historicist model of consecutive influence and formal progress, and this sets up
● the further editing of modernism that occurs down the line with Clement Greenberg and others. Granted, it is a pedagogical chart, an introductory one, and the lines are more complicated, not to say convoluted, than we usually recall …

RK: Yet Barr does present a basic kind of bifurcation into, on the one hand, mechanicist models of form and, on the other, organicist models. And he emphasizes the organicist because he feels that
■ the most important phenomenon at the time is Surrealism. He wants to welcome Surrealism into the family of modernist forms.

HF: But those impulses are still formalized into "geometrical" and "nongeometrical" abstraction. True, the mechanicist is a force in the geometrical lineage, but it is removed from industrial production, indeed from social, economic, and political context altogether. Similarly, the organicist is a dimension of the nongeometrical lineage, but it is detached from the body and

▲ 1927c　　● 1921b, 1928b　　■ 1928a　　◆ 1923　　　　　　　　　　▲ 1916a, 1920, 1925c　　● 1960b　　■ 1924, 1930b, 1931a

the drives, from all psychoanalytic associations. Barr has these terms in play, but in a formal sense only.

BB: The teleology of his view of modernist art would also have to be associated with the overall teleology of American liberal democracy in which the actual integration of artistic practices into the sphere of everyday life is not at issue. What is at issue is their institutional containment, not their practical deployment and realization—neither the politics of Dada and Surrealism nor the politics of
▲ Constructivism and Productivism.

HF: This also speaks to the unique situation in the United States in which the initial encounter with the avant-garde is quickly followed by its partial institutionalization. There is the Armory Show in 1913, of course—the legendary shock of the first encounter—the Alfred
● Stieglitz circle in the teens, the New York Dada salons, and several gallery shows—but then there follows the Museum of Modern Art in 1929, "Art of This Century" in 1942, and so on, in which the reception of modernism all but occurs within the setting of the museum.

YAB: And the reception of the avant-garde in these museums, until very late, was only in regard to Europe. That was the complaint of many American artists: "They show the most advanced European art, and they don't even look at us." For the museums the source had to be from far away; it had to be Europe: that was the land, grand and strange, where these bizarre new objects were produced, and their foreignness is what allowed American museums to present them favorably and give them form institutionally. It's a new kind of exoticism, in a way.

HF: So what happens to Surrealism in this story, if it's so important to the first generation of abstract artists in the United States? It is very present in the form of exiled artists in New York during the war. We should talk a little about how it gets assimilated or occluded.

■ **RK**: In 1940 Clement Greenberg writes "Towards a Newer Laocoon" in which he attacks Surrealism, among other things, for being narrative, and Lessing's *Laocoön* becomes a kind of master model (though it was published in 1766!) of how to separate the visual and spatial arts from the verbal and temporal arts in modernism. For Greenberg the literary is temporal, Surrealism is literary, and so it must be condemned as impure.

HF: It is improper to visual art, and so not a modernist art, in his sense, at all. I never quite understood how "Towards a Newer Laocoon" could follow so closely on his "Avant-Garde and Kitsch" essay (1939), with its framing of the avant-garde still in terms of a social struggle in a historical field. In one year he seems to go from an almost dialectical account of the avant-garde to a rather static analysis of the decorum of the arts.

BB: The story of the elision of Surrealism in early accounts of Abstract Expressionism is more complicated than the resistance of Greenberg alone. Take the rejection of Surrealism by Barnett
◆ Newman: it's clearly a process of a programmatic disidentification after an initial embrace. The embrace had to do with the radicality of automatist procedures of mark-making and even, possibly, with

psychoanalytic models of the unconscious. Then, in the transition from the moment of Surrealist reception to the moment of the
▲ constitution of an Abstract Expressionist identity, Surrealism had to be rejected. This rejection was not a rejection of psychoanalysis—

YAB: —on the part of Newman it was.

BB: Nor did it mean the rejection of automatism. It was driven by a need to redefine aesthetic identity within the parameters of a new historical moment, and that entailed, for Newman too, a realization that the Surrealist indulgence in the unconscious was no longer valid after the trauma of World War II and the Holocaust. That is one rift, a major chasm, whether explicitly or only latently expressed. Another is the realization that this historical situation needed redefinition, not only in geopolitical terms or in terms of a new national identity, but also in terms that were specifically *tragic*. That's why Serge Guilbaut's account of the ideological functions of Abstract Expressionism and T. J. Clark's view of it as an art of middle-class vulgarity don't work for me: they don't understand the radicality of the point of departure of those artists.[1] There was a sense of loss, of destruction, of utter inaccessibility to prewar
● culture that rivals Theodor Adorno's in its decisiveness—though, of course, it couldn't be articulated in his terms at the time. The fundamental difference between the postwar aesthetics of Adorno and of Greenberg might be defined as follows. On the one hand, Adorno was a Marxist philosopher and an avant-garde composer-musician formed in the most differentiated culture of the European bourgeoisie who witnessed the actual destruction by the Nazis not only of his own context but of European bourgeois culture at large. On the other hand, Greenberg was a member of a New York
■ Trotskyite circle around the journal *Partisan Review*, which was then aspiring to lay the foundation of a new democratic culture in the United States; the historical condition of the Holocaust and World War I could not be easily integrated into his progressivist model of the future.

YAB: Paradoxically, the difference between European and American perspectives was deepened by the presence of many Surrealists in New York—André Breton above all, but also Salvador Dalí, Max Ernst, André Masson, Roberto Matta, Kurt Seligmann, Yves Tanguy, among others. Suddenly people who had been constructed at the level of myth were just *there*, and they didn't correspond to the legends. Some of them were living comfortable lives (Ernst was married to Peggy Guggenheim), and had a steady market. One shouldn't underestimate the shock of young admirers,
◆ such as Jackson Pollock and Arshile Gorky, who had worked in the Works Progress Administration, on seeing how little their heroes resembled *artistes maudits* or *enfants terribles*.

HF: Of course, the sense of the tragic and the traumatic could not be the basis of an affirmative story of modernism, a story of renewed continuity of the sort that Greenberg and others wanted to tell, and that institutions in this period of reconstruction needed to be told. So that dimension had to be occluded. The same goes for aspects of modernism contaminated by fascism—like late Futurism—or, especially in the McCarthy period, implicated

▲ 1916a, 1920, 1921b, 1924, 1925c, 1928a, 1928b, 1930b, 1931a ● 1916b, 1942b ■ 1960b ◆ 1951 ▲ 1947b ● Introduction 2 ■ 1942a ◆ 1936, 1942a, 1949a, 1960b

in Communism. Hence, in part, the blind eye turned to most
▲ Russian Constructivism and some German Dada.

BB: Absolutely.

YAB: There is one mantra that Newman repeats in his early essays: "After the monstrosity of the war, what do we do? What is there to paint? We have to start all over again." You never find this discourse in Greenberg—as if the trauma didn't exist.

HF: This might be too speculative, but I wonder if it reappears in displaced form in the discourse about Abstract Expressionism, with a traumatic sense of the war and the Holocaust sublimated and subjectivized in the reception of such work in terms of the Sublime. The experience of "the abyss" or "the void" in a Pollock, a Newman, a Rothko, or a Gottlieb might register this kind of historical sublime, but writ small—in fact small enough so that the viewer can feel the traumatic frisson but also recoup it, even be empowered by it, along the lines of the Sublime as classically understood by Kant or Burke. Perhaps there is a trace of this recouping in the response that the viewer of the late-modernist work is supposed to have: the epiphanic bolt of insight, the sudden sense of transcendence, what Michael Fried later famously called "grace."

RK: Shedding the dross of one's own body becomes the figure of transcending—

HF: —the historical in general—

RK: —and the physical as well.

BB: And recent history in particular. That was one of the precarious questions being asked by intellectuals in the forties around *Partisan Review*: "Are you confronting the Holocaust? Are you making it the key topic of every moment of your daily thinking? Or are you turning away from it in order to make a new culture?" If you read *Partisan Review* from that time it is amazing how the two positions appear side by side from issue to issue: Hannah Arendt in 1946 speaking about the concentration camps, for example, and Clement Greenberg two years later speaking about the rise of a pure modernism. Either you confront that history or you don't. And if you don't, it's easier to claim access to a new identity-formation in relation to American liberal-democratic culture: that lies at the foundation of the new painting in New York as well, and it's one of the bases of American formalism as well. I'm not polemicizing; I'm trying to describe the etiology of that compulsion to purify, to disidentify with that historical body.

YAB: There were several attempts from the early fifties to the mid-sixties to speak about Jewishness, art, and their relationship to the trauma of the Holocaust, but every time the issue is raised it is hushed up: people don't want to hear about it. Two of the critics at issue here write seriously about this—Greenberg in "Self-Hatred and Jewish Chauvinism: Some Reflections on 'Positive Jewishness'" (in *Commentary* in November 1950) and Harold Rosenberg in "Is There a Jewish Art?" (in the same magazine in July 1966)—but only once each, I believe, and mostly to explain

the silence. They try to theorize the post-traumatic silence with regard to the Holocaust on the part of artists.

HF: The early sixties is also the moment when New York intellectuals break apart over "the banality of evil" thesis developed by Arendt in her *New Yorker* coverage of the Eichmann trial in Jerusalem. (I've always wondered about the connection to another
▲ provocative "banality" at this time, that of Pop art, and the outraged response to its emergence by some of the same intellectuals—as if Pop also threatened the value of profundity, or whatever the opposite of banality is, in culture, morality, and politics.) After *Eichmann in Jerusalem* the traumatic silence gives way to a torrent of enraged speech. But, to return to that silence for a moment, one can imagine how oppressive it was for artists and writers to be asked, all but compelled, to think about the tragic and the traumatic in this way. One can understand the impulse to turn away, to begin again—even though that impulse is oppressive in its own way too, of course.

● **BB**: The figure of Meyer Schapiro should be brought into the conversation in this regard. There's another dimension here—Hal
■ just alluded to it—it's the dismantling of the Left. This is also the moment—to return to the comment about the shift in Greenberg from "Avant-Garde and Kitsch" in 1939 to "Towards a Newer Laocoon" in 1940—when the Marxist tradition is all but liquidated, sometimes auto-liquidated, self-exorcised.

HF: What's the famous line in Greenberg looking back on the thirties from the early fifties? "Some day it will have to be told how 'anti-Stalinism,' which started out more or less as 'Trotskyism,' turned into 'art for art's sake,' and thereby cleared the way, heroically, for what was to come."

RK: "Eliotic Trotskyism," T. J. Clark called it once.

YAB: The first traumatic event for the American Left was, of course, the Moscow show trials in 1936. And the Hitler–Stalin pact in 1939 was the last straw.

HF: Right. And Greenberg can't believe that some artists stick to the Party line. He later says of Pollock: "He was a damned Stalinist from start to finish." However misguided that position might have been, it also points to some resistance, political not only aesthetic, to Greenberg's reading of their art.

YAB: We have discussed what American artists faced immediately after the war, but not what French artists did. What was their situation? How different was it? There was the same trauma …

BB: There was more: after all it was European culture that had been ruined in the war, and a central European nation state whose fascist takeover had wrought that destruction—a nation state that, like its ally Italy, had once represented the highest achievements of European humanism.

◆ **YAB**: The case of Jean Fautrier, an artist who was always suppressed in the States, is interesting in this regard. No one paid attention when he exhibited in New York in 1952, '56, and '57

▲ 1920, 1921b, 1925c ▲ 1960c, 1964b ● Introduction 2 ■ 1942a ◆ 1946

(the last of these shows at Sidney Janis's), even though he was an abstract artist—not even Greenberg. But he has become more prominent lately, perhaps in part because we now recognize that he was one of the first avant-garde artists to take into account the trauma of the war and the Holocaust. It started during the war with his "Otages" paintings, but their exhibition in Paris in the immediate postwar moment was a great bomb. His attempt was immediately transformed by Jean Dubuffet, and also taken in a different direction

▲ by Lucio Fontana, so the "repression" of his work is not only an American phenomenon—it just took a different form in Europe, that of sanitization. It's always puzzled me that Fautrier's attempt to take the trauma into consideration disappeared so quickly.

BB: There is an even more deliberate desire to disavow the trauma, at least on the part of the next generation. If you look at Fontana, Piero Manzoni, and especially Yves Klein, you see the most important efforts in art to define European reconstruction culture. Perhaps paradoxically, the link—and it is particularly important for Fontana and Klein—that connects all these practices is spectacularization. At that moment two major theoreticians of postwar European aesthetics emerge: one is Adorno, and the

● other is Guy Debord. They represent the polarity through which an aesthetics of traumatization and the impossibility of renewing modernist continuity is articulated. That polarity reflects on the legacy of the Holocaust on the one hand and, on the other, on the apparatus of spectacle that will inevitably take over even the last remnants of opposition and exemption, resistance and subversion, that the avant-garde had previously claimed for itself. And that's where Fontana and Klein position themselves from the very beginning, even more so than Pollock—within the registers of spectacle culture.

HF: Some previous practices speak to both necessities. For example, the primordial and the primitive, the child and the insane, are old modernist interests, to be sure, but they return with special

■ force in the immediate postwar period with *art brut* and Cobra. Perhaps they provided a way at once to register the trauma of the Holocaust and to disavow it. To seek radical beginnings registers the horror of the past, but it is also an escapist flight from recent history—perhaps the Abstract Expressionist motto of "the First Man" functioned in a similar way.

BB: To dehistoricize the trauma. Also in play here is the sudden interest in sites like Lascaux: prehistoric caves in lieu of contemporary camps.

HF: Yes. But also evident there is an attempt to counter, perhaps even to recover, a primordialism that the Nazis had contaminated. It's not simply an either/or: either represent or disavow the trauma. There are aesthetic constructs that are almost compromise-formations—that acknowledge historical reality but in a bracketed, abstracted, or otherwise dehistoricized way. Again, the point is to describe these moves, to understand them, not to pathologize them.

BB: In addition to the first two complexes—namely, the trauma of World War II and the Holocaust and the destruction of the

American Left and Left culture at large—a third question confronts the New York School in its formative stages: how does the mass-cultural sphere reemerge, and how should the avant-garde relate to that sphere? After all, that had been one of the central questions of the twenties that had affected the constitution of all avant-garde practices. Paradoxically, in the postwar moment, as the mass-cultural sphere in its American version reemerges with even greater power than in the twenties, the avant-garde withdraws into a mode of total denial of its existence: it adopts a completely entrenched, hermetic model of modernist refusal. It takes at least ten years,

▲ with the rise of Jasper Johns and proto-Pop art, before the mass-cultural sphere reenters artistic awareness explicitly.

● **HF**: There is also the Independent Group in Britain slightly earlier. But, yes, before then, there is this talk of "we unhappy few" against the world. And yet at the same time Pollock appears in—

YAB: *Vogue*.

HF: Yes, in 1951 his drip paintings are used as backdrops to fashion pictures by Cecil Beaton, but also, earlier, in *Life*, in the famous article that serves as the heading for our "1949" Pollock

■ entry: "Is he the greatest living painter in the United States?"

BB: That's not a confrontation; that's an erosion, and an indication that the isolation is delusory, or that the claim to it is delusory.

HF: Yes. Modernist refusal gets "mediated" at that point, literally: it begins to be circulated on a mass level as a bohemian pose. The Situationists see this problem clearly by the late fifties.

BB: And the disavowal of psychoanalysis—

YAB: —occurs at the same time that it's taken up in Hollywood.

HF: Dalí doing the dream-sequence sets for Hitchcock's *Spellbound* in 1945.

BB: More important is that it's being institutionalized at a mass level in the United States. That's when psychoanalysis is raised to its highest level of everyday, pragmatic practice.

HF: But it's only a particular version of psychoanalysis—ego

◆ psychology—that gets taken up, and which Jacques Lacan, a young associate of the Surrealists (of Dalí's in fact!), always railed against.

YAB: Its Jungian version also gets taken up, earlier even with Pollock. It all becomes a common kind of do-it-yourself psychotherapy around that time.

HF: So again it's not a case of outright repression. One can understand why these discourses are shirked: their terms get corrupted, their appropriation renders them invalid.

YAB: They become consumables: you consume this or that brand of psychoanalysis the same way you consume this or that fridge.

BB: As Walter Benjamin said, "Neurosis is the equivalent of the commodity on the psychic level."

▲ 1959a ● 1957a ■ 1946, 1949b, 1957a

▲ 1958, 1962d ● 1949b, 1956 ■ 1949a ◆ Introduction 1

roundtable

RK: Can we understand the success of Greenberg's story, then, partly in relation to a collective need to repress this tragic or traumatic past? His brief for abstract painting succeeds in that partial repression, and therefore that painting performs a kind of social function.

HF: There is that connection, but we have to make it more indirectly. In a sense what we see as a process of repression they saw as a process of conservation. On the one hand, abstract painting is one of the great avant-garde ruptures; on the other hand, it is also, as "modernist painting," committed to the centrality of painting and the maintenance of its traditions. It serves to bracket or to suspend other avant-garde breaks, to keep other avant-garde paradigms to one side, at least in the States—I mean
▲ the paradigms that the German critic Peter Bürger,[2] the author of the third narrative that we want to discuss here, underscores: readymades and constructed sculptures, collages and photomontages. Historical memory is displaced and concentrated onto the memory of one medium, advanced painting, which then provides the basis for a historical continuity that cannot be maintained otherwise—not in art and not in history in general. There is also a displacement of political revolution onto formal innovation. That's implicit in the Greenberg remark I cited about looking back on the thirties from the fifties. Fried also states as much in a retrospective passage in "Three American Painters: Noland, Olitski, Stella" in 1965.[3]

YAB: What is also striking is that Greenberg never takes into consideration the political claims of the artists themselves. For
● example, Mondrian saw his work as a blueprint for a future socialist society—hard to believe though this might seem. In a manuscript that appeared only posthumously, *The New Art—The New Life: The Culture of Pure Relationships*, he directly appropriated a passage from a political pamphlet by his friend the anarcho-syndicalist militant Arthur Lehning. Lehning was, among other things, the editor of an extraordinary journal called *1:10* that appeared in 1927–8, which, besides offering the first serious analysis of the Stalinization of the Soviet Union, published texts not only by Mondrian, Kurt Schwitters, and László Moholy-Nagy but also Walter Benjamin, Ernst Bloch, and Alexander Berkman (an old ally of Emma Goldman). It is this type of information, this kind of link, that is obliterated in Greenberg's view of modernism.
■ The same thing happens with his treatment of Newman. Newman recognized the role Greenberg played in his sudden rise to fame in the late fifties, but he still disliked the critic's interpretation of his work because it failed to address its anarchistic implications. I'm not saying that Mondrian and Newman were right about their own painting, only that Greenberg was oblivious to these aspects of it.

HF: At the same time he was far and away the best contemporary critic of their aesthetic ambitions.

BB: Greenberg does address those ambitions, in their continuity with past painting too, but as far as Newman is concerned this continuity also had to be ruptured. For him it's not Newman and Mondrian; it's Newman versus Mondrian. Newman claims a radical

break with Mondrian: both his pictorial concepts and his utopian visions are invalidated, no longer possible.

HF: According to Newman.

BB: According to Greenberg too.

YAB: But not for the same reasons. It took Newman a long time to see why he was so different from Mondrian. Until the mid-sixties he repeated all the clichés of the Mondrian literature—that his work was not really abstract but grounded in nature, or that it was
▲ decorative design, etc. His young Minimalist admirers (Donald Judd in particular) provided him with a new critical vocabulary (that's when he begins to speak in terms of the "wholeness" or his paintings as opposed to the "part-to-part" aesthetic of Mondrian), but in the end he coins his criticism of Mondrian in political terms: the Dutch painter was not an anarchist, though he might sometimes have felt he was—he was too Hegelian, too totalistic in his ideas not only about painting but also about the state. Newman, who had always professed anarchistic positions (he prefaced the memoirs of Kropotkin) felt that Mondrian's utopianism was the exact opposite of his stance. Greenberg never addresses that: he never says that Mondrian's and Newman's suggest two totally different world views.

HF: But other artists of the time did not claim such a definitive caesura. Or if they did so, it was out of an Oedipal struggle—especially with Picasso, of course—in which a break at one level is staged in order to forge a connection at another level, a kind of trumping that is both psychological and stylistic. Political differences were usually overwhelmed by such aesthetic positioning.

YAB: Pollock's involved there.

● **HF**: And Gorky, de Kooning, and others. So the story of continuity, troubled or not, opportunistic or not, makes some sense. Again, it also makes great sense institutionally: the postwar period saw enormous growth in museums and universities, and there was a powerful demand for a narrative of recovery and reclamation. The Greenbergian version in particular is also a story, a technique, that could be reproduced, and it was, extensively—it was a great discursive success, curatorially and pedagogically. In a way its success parallels that of the modern discipline of art history when its German founders like Erwin Panofsky flee Hitler for Britain and the States: it, too, gets streamlined and simplified into a technique—primarily that of iconography—which is then circulated and passed down to subsequent generations.

BB: I would twist that, and say again that this narrative of modernism also has the specific *telos* of postwar American liberal democracy. It wants to implement, in response to the catastrophe of the bourgeois nation states of Europe, a different kind of access to education, a different kind of egalitarianism in aesthetic experience. I would not reduce it all to reconstruction ideology; I think there is a more complicated *telos*, with other political implications, in the institutionalization of the discourse of modernism. That, too, is part of avant-garde culture in New York

▲ Introduction 1, 1960a ● 1913, 1917a, 1944a ■ 1951

▲ 1965 ● 1942a, 1947b, 1959c

at the time, and certainly part of Greenberg's project as well. And, as you say, though his omissions are disastrous, he deals with the artists that he selects, American and European, more profoundly and more precisely than anyone else does. He is the one who, in a sense, redeems the modernist legacy for postwar memory.

YAB: It becomes clear now how he was able to do so. Greenberg pretended to a kind of ideological neutrality; this allowed him to make his positivist turn of seeming simply to describe the art. And this turn freed him from the pathos of existentialist critics like Rosenberg. Everything was discarded: an ex-Marxist, Greenberg could present himself as objective—as objective as an engineer or a scientist. So he became the pure empiricist who only describes. And he did it perfectly well …

HF: Let's move on to a third important model of prewar art, the one
▲ proposed by Peter Bürger in *Theory of the Avant-Garde*. Bürger makes two opposed claims: on the one hand, that a modernist autonomy of art was achieved in the late nineteenth century (earlier than in the Greenbergian narrative), and, on the other hand, that this aesthetic autonomy was attacked by "the historical avant-gardes" in the early twentieth century, both in forms of art (for example, the Dadaist assault on painting and sculpture) and in institutions of art (for example, the Futurist assault on the museums). Bürger goes on to construct a story about the tragic failure of this avant-garde and its farcical repetition in the postwar period, a project he dismisses as a "neo-avant-garde," as a recuperation of the historical critique of autonomous art as a new form of art.

BB: There are two things to add immediately: Bürger is a German *literary* historian, and he published that book in 1974. Even for this relatively early date it is very schematic; and yet, as you said before, he does realert us to those legacies that American formalists like Greenberg and Fried as well as European writers in their wake had disallowed or disavowed—Dada culture in all of its forms, Surrealism, Russian Constructivism and Soviet Productivism. Bürger was not the only one to do this; he wrote in a post-1968 moment that brought all of those practices back into view. In a sense he sums up this work.

HF: And as you pointed out once, he obscures one of his own conditions of possibility—contemporary artists like Marcel
● Broodthaers and Hans Haacke, who commented not only on the historical avant-garde but also on the neo-avant-garde—on the limits of this neo-avant-garde as well, the very limits that Bürger castigates so strongly.

BB: Yes, he concludes a process that was in the works for ten years or so in both scholarly and artistic practice.

YAB: And in exhibitions too.

BB: Bürger also failed to understand how those historical avant-garde models had differed tremendously from one another; this point was discussed extensively by his critics, at least in Germany when his text was first published. Of course these differences were both theoretical and political. For example, while Freudo-Marxism was constitutive of Surrealism, Dadaism had departed from rather different theoretical positions, ranging from mysticism to the beginnings of structural linguistics to Leninism in Berlin Dada. There was also an anarchistic, even nihilistic quality in Dadaism, which was not at all present in Russian Constructivism, let alone in Soviet Productivism. And while a reorientation toward collectivity was foundational to the Russian and Soviet avant-garde, it was
▲ not the kind of collectivity that De Stijl proposed in Holland. And so on. One should challenge Bürger's model on these points, and ask what exact features of the various avant-garde models he was bringing back into view at that time. One aspect that was *not* brought back by Bürger is the way that the bourgeois public sphere was not only contested by the historical avant-garde but also eroded and / or displaced by the rise of mass-cultural spheres—in Weimar Germany, in Italy both prior and during Fascism, and then under the totalitarian regimes of Germany and the Soviet Union.

HF: As important as the Bürger text is, it is schematic not only about the different avant-gardes, but also in its opposition of "the institution of art" and "life practice," of "art" and "reality." To begin with, the institution of art is radically different in different countries, and sometimes in different cities—think of the diverse contexts of Dada alone around World War I: Zurich, a neutral but tempestuous site; Berlin, in political revolt; Cologne, occupied; Hanover, an enclave; Paris, vectored by different political forces, artistic movements, antimodernist sentiments; New York, distant from these troubles, a scene of salon and exhibition scandals more than anything else.

YAB: What is also strange is that Bürger never alludes to the invention of the art market at the time of the historical avant-garde or to its enormous growth at the time of the neo-avant-garde.
● The auction consortium "Peau de l'Ours" was the first time that modern art made a profit, and this had an enormous impact. And yet it's as though the market doesn't exist for Bürger. In Germany too the art market was already very developed before WWI, with Herwarth Walden's der Sturm and other galleries …

HF: That's in part what I mean: the opposition of "autonomous art" and "life practice," if it can be posited historically at all, is already breaking down at the time of the historical avant-garde because of economic forces.

YAB: Yes. In a funny way Bürger treats the problem of the avant-garde in a historical vacuum.

BB: This oversight is especially surprising coming from a member of the 1968 generation for whom the problem of art's rapidly increasing commodification had become such a key question.

HF: What about a related question—the "mediation" of the historical avant-garde, the fact that it sometimes emerged in the very space of mass-media forms like the newspaper?
■ One example is given in our "1909" entry on Futurism: Marinetti publishes "The First Manifesto of Futurism" in *Le Figaro*. Another

▲ Introduction 2, 1960a ● 1971, 1972a, 1972b ▲ 1917b ● 1914 ■ 1909

▲ occurs in 1925 in the context of the "Arts décoratifs" exhibition at the World Fair in Paris

YAB: Yes: the transformation of the avant-garde into design, into luxury goods—Cubism turned into Art Deco tables.

HF: It happens fast—in that case in ten years or so—and it happens again and again.

YAB: And it completely saturates the perception of what modernism is. Here it's fascinating to look at Italy under Fascism where you have luxurious villas for Fascist leaders decorated with Cubist paintings, Eileen Gray tables, and so on.

HF: That too is not part of the Bürger account—or any other familiar one, for that matter. Also, on the one side his opposition of institution of art and life practice tends to occlude the various projects to *transform* the institution of art or to construct a new one altogether, as in the Russian Constructivist attempt to found different kinds of schools, different modes of making and exhibiting, production and distribution, to make a proletarian cultural or indeed public sphere. On the other side Bürger seems very romantic about life practice. This is a criticism that Jürgen Habermas makes too: What does it mean to break apart the putative autonomy of art under conditions of mass media and culture?

BB: As of the present day we know: it means the regime of total desublimation.

YAB: A good test case is the "Congress of International Progressive Artists" held in Düsseldorf in May 1922—that gives us a range of positions. The one that ends up as the most Leftist, most avant-gardist, is made up of such different figures as Hans Richter, El Lissitzky, and Theo van Doesburg—a German Dadaist, a Russian artist connected to both Suprematism and Constructivism, ■ and the Dutch head of De Stijl. They protest that the others in the Congress don't have a definition of what a new and progressive art is: "All you want to do," they say, "is to federate your movements so as to build up an art market." There's an amazingly clear analysis of the avant-garde, especially from Lissitzky, in its own historical moment: a recognition of its imminent failure and dispersal if the project is not carried beyond what I would call a "guild" mode.

HF: Isn't there, hidden in your example, another side of this failure, another side of the condition of mass media and culture, which is to say the possibility, for the first time, of a real internationalism of the avant-garde? And isn't there also a utopian dimension there, not only in individual projects but in the collective coming-together of such diverse figures at events like the Congress, which was not immediately commodified then and should not be forgotten now? How can we restore those dimensions to that moment of international meetings, exhibitions, manifestos, and so on? There were enormous hopes for modernism. We might see it now as just another ruse of history, but it wasn't all delusion.

BB: It depended on the programmatic theorization of what a real culture of the proletarian public sphere might become at the time,

and the Congress addressed the possibilities of its realization. One necessary condition for artistic practice was to live up to the aspirations of post-nation-state identities—identities that are not only defined by proletarian class and collectivity but also understood in terms of a subjectivity that could be constructed outside the parameters of the nation state. That's the reason why internationalism at that moment could be political and proletarian as well as aesthetic and avant-garde.

HF: One might have thought that World War I would have dashed the hope of such internationalism, as even most socialist parties submitted to nationalist imperatives, but it didn't: internationalism revived, and thrived, in the twenties. And in part it did so on account of the war, in reaction against it.

YAB: The case of Berlin in the early twenties is relevant here, especially after the end of the blockade isolating Russia, which was immediately followed by the arrival of many Russian artists and writers of all persuasions (not that many belonged to the old guard linked to the Czarist regime, as these tended to go to Paris). Members of the Hungarian avant-garde also came to Berlin fleeing the military coup that had ended a Soviet-like republic after just a few months in 1919. So in those years Berlin became a kind of platform of internationalism. The German intellectuals (and Berlin Dada in particular) were the most forceful: "We don't want to be caught in that horrible nationalistic butchery again." There was also still the hope, on the part of Russian pro-Soviet artists and writers (such as Lissitzky, who arrived in Germany in 1922), that they could export new means for the production and reception of art and culture. In fact one of the things that Bürger does not discuss is the will, on the part of many avant-garde practitioners in the late teens and twenties, to produce new kinds of distribution for their art—all their journals, for example, are also "art projects" in a way. The proliferation of those little magazines is very different from the immersion in mass media of Futurism, with Marinetti publishing his manifesto in *Le Figaro*. On the other hand, one might argue that, because those journals were not mass-produced, there was already a sort of retrenchment—but that was due to a lack of means as much as anything else.

HF: There's another possibility here, though one very dependent on particular political conditions, and that is the example of John Heartfield, who published some of his most critical photomontages as covers of mass worker magazines like the illustrated weekly ▲ *Arbeiter Illustrierte Zeitung* with circulations in the hundreds of thousands. But you're right: there is a real divide between the micro media of the journal and the mass media of the newspaper; there are some attempts, however, to cut across the gap, and not to be satisfied with either side.

BB: Marinetti simply accepted the given media apparatus as an institution that could not be contested. That is what happens again in a later moment, closer to our own time. But there is an interim moment when other distribution forms are conceived and alternative public spheres, whether proletarian or simply avant-gardist, are claimed. And sometimes they are acted upon, and

eventually asserted as actually existing—for example, the imaging
▲ of a proletarian public sphere in Heartfield's work—but then the
whole space collapses.

YAB: There are also moments of great aberration—like
Mayakovsky's books of poems *150,000,000* being printed in
editions of five thousand by the Soviet State Publishing House
in 1920 (Lenin was furious about that, and severely criticized
Lunacharsky, the minister of culture and education, for what
he considered a stupid mistake). Or Naum Gabo's "Realist
Manifesto"—it was also printed in great numbers because the
Soviet authorities thought he was a realist painter!

HF: One thing that Bürger does do is to put into play critical and
philosophical texts, mostly from the Frankfurt School, that are
roughly of the same period as these modernisms. He has enough
historical distance to juxtapose writings about the avant-garde
and mass culture by Benjamin and Adorno with actual practices
of the artists; in fact one of his important theses is the shared
historicity of the concepts at work in such texts and works alike.
In this textbook we have attempted similar moves. Frequently
these are connections not of causal influence so much as of
discursive affinity: epistemological fields that different artists and
intellectuals share, often without knowing it.

RK: Like the role of the index in Duchamp or of the uncanny in
● Surrealism. That conceptual clarity allows for a kind of critical
archaeology of artistic practice.

YAB: And it also allows for phenomena that fall outside the usual
histories of modern art to be discussed.

HF: The question I wanted to ask is different: now that we can
look back at what we have written about the prewar period, what
are our own occlusions? (Our exclusions might be clear enough.)
What other kinds of connections have we failed to see in this
historical field?

BB: My first statement in this register of self-critique would be
that we too, like everyone else in our field, have not managed to
address what has emerged as one of the key questions about the
century: the apparatus of mass culture in the totalitarian public
sphere (that's a contradiction in terms and meant to be). With its
annihilating antimodernisms, that apparatus precipitated the great
hiatus in avant-garde culture from 1933 to 1945 in Western Europe
(in many countries, some voluntarily, some as the victims of
occupation). How might it be understood now as an anticipation
of the eventual breakdown of the boundaries of avant-garde
culture and the mass-cultural public sphere in the postwar period?
The boundaries between those spheres were much more porous,
damaged, indeed destroyed in the period 1933 to 1945 than we
have long assumed, and we believed, also for far too long, that the
reconstruction of those boundaries in postwar neo-avant-garde
culture could actually hold up. What we see now is that they didn't
hold up, that they haven't for a long time.

RK: Can you give me an example?

HF: Maybe I can. Part of the story of the triumphal renewal of
modernist art after the war was its radical separation from unsavory
politics: if it was to represent liberal democracy, freedom of
expression, and so on, any contamination of this sort had to be
corrected. (Obviously this was overdetermined: the presentation
▲ of Abstract Expressionism as the epitome of the liberal spirit,
for example, was made in the face of a prior attack from the
McCarthyite Right, which associated abstraction with
● Communism.) In any case the connections between Futurism and
Fascism, say, had to be obscured; or, to choose a case that strikes
closer to home for some of us, the connections between Russian
Constructivism and Stalinism. Now obviously these are occlusions
that have prompted very reactive counterreadings in our own time,
almost antimodernist readings—for example, that Constructivism
■ somehow leads to Stalinism, that the Constructivist paragon of
the artist as engineer of a new proletarian cult is actually embodied
in Stalin. But those arguments are simply reactions against a
reaction, and so are doubly reductive, and they don't get at the
ways not only that some modernists lined up on the far Right but
also that some modernisms were bound up, paradoxically, with
antimodern positions—were "reactionary modernisms" in that
sense. This imbrication has become historically available now in a
way that it wasn't for people who had to purify modernism of any
such political taint or tie, either to fascism or to Communism.

YAB: There was a separation of modernism from totalitarianism,
but there was also a purification of modernism from the avant-
garde, so to speak, from the movements we've discussed—Dada,
Constructivism, and so on. The avant-garde became a side dish
to the great feast of modernism from Picasso and Matisse through
Mondrian to Newman.

BB: But those are your artists!

YAB: Yes, but I also see how they were used to push the avant-
garde into an ornamental role in the epic of modernism.

HF: At least we have put some of those stories back into play
together: the story of modernism with that of the avant-garde,
and both with that of antimodernism—not with adequate depth,
to be sure, but at least it is sketched.

YAB: Do we want to discuss here the second argument of Bürger,
the failure of the historical avant-garde (he never puts any quotation
marks around "failure"). What was this failure exactly? The failure
to transform the world? As Hal says, that's a little harsh on the part
of Mr. Bürger.

BB: Let alone the failure of the postwar neo-avant-garde.

YAB: It's bizarre from a Marxist critic. What did he expect?

HF: That might be a hangover from 1968 too.

BB: That's right, and he's German.

HF: Well, that explains it all.

BB: It's a traditional German task to give grades to history. The

▲ Introduction 2, 1920 ● 1918, 1924, 1930b, 1931a, 1935, 1942b ▲ 1947b, 1949a ● 1909 ■ 1921b

Constructivist side of the historical avant-garde is one part of the story; another part is the Surrealist side, and I want to return to it for a moment. In Surrealism a post-nation-state identity was put forward on the basis of radically emancipatory psychoanalytic models of subject-formation. These contested national identity as violently as a politically class-bound model of subject-formation did in the context of the Soviet avant-garde. It's not clear that Bürger treated that dimension, in his conception of the Surrealist subject, either, or whether William Rubin did, when, as chief curator at the Museum of Modern Art, he mounted his show of Dada and Surrealism in 1968. How did Surrealism come back then? We said that these exhibitions predate Bürger's text, and the Bürger–Rubin axis is an interesting one to consider in that light. Did the reception of Surrealism at that time recover its full historical scope, or did it come back already as a highly confined and fetishized historical construct in the form of particular images and objects?

HF: And another question: how was its model of the unconscious treated? Was it seen, in keeping with the sixties, in affirmative ▲ terms, à la Herbert Marcuse or Norman O. Brown, as a liberatory unconscious, an Eros-unconscious, an unconscious, moreover, that unlike in Marcuse and Brown was too often thought of in terms of a body that is private and not collective?

RK: In Rubin's hands Surrealism came back as painting and sculpture, not in terms of photography and texts. Twenty years later, when I did my show of Surrealist photography with Jane Livingston, "L'Amour fou: Surrealism and Photography" (1985), it was a historical and theoretical project, and it developed in resistance to the repression of that part of Surrealist history.

YAB: In reexamining the issue you redefined the way we look at Surrealism, because, as Benjamin said, what Rubin attempted to do—which is strange coming from him—was to rescue Surrealism …

RK: To rescue it as painting and sculpture. Whereas what interested me was how important photography was, and how Surrealism was disseminated through its magazines …

YAB: If Rubin had been more open to that, he would have had an easier case to make, because he couldn't find a lot of ammunition in Surrealism for the grand narrative of modernist painting. He had Miró, Masson, Matta

HF: Yes, Surrealism was still seen in Bretonian terms as a story of a liberatory desire with painting conceived as its primary vehicle of expression. What the "L'Amour fou" show did was to move ● the conversation away from Breton toward Georges Bataille, and from painting to photography, and to see Surrealism more as an attack on form, indeed as the disintegration of the very notion of form-giving mediums, which was pursued further in your exhibition "L'Informe" (1996). A very different understanding of psychoanalysis also emerged here: that the Surrealist unconscious had a dark side, not simply in relation to desire, which is not only liberatory but also bound up with lack, but also in relation to the

drives, drives that can be destructive, even deadly, as with the death drive. Perhaps the sixties reading was inflected by the Marcusean discourse of Eros; by the eighties, things looked different, and this difference speaks to the different politics of the two moments, one marked by revolts of many sorts, the ▲ other by despair about Reaganite reaction and AIDS deaths.

BB: Perhaps we should also ask what Rubin's approach to Dada was—for Dada was also included in his exhibition and its catalogue, "Dada, Surrealism, and Their Legacies." Not to belabor the point, but he did the same thing to the Dada legacy that he did to Surrealism: it became a constellation of astonishing objects and assemblages. Dada was not the photomontages of John ● Heartfield, for example; typically, Heartfield didn't even appear in either the show or the book.

HF: Rubin saw Dada in part through the prism of the objects and assemblages that emerged in the Rauschenberg–Johns moment. There was also the precedent of William Seitz's MoMA show "The Art of Assemblage" (1961), which favored Duchamp, Schwitters, Joseph Cornell, Rauschenberg …

RK: We have to realize too that Rubin was in constant dialogue with Greenberg, trying to convince him that he, Rubin, was not on the wrong track, and that within Surrealism and even Dada there were worthy modernist practices. He was pleading with Greenberg—

BB: And with Barr too, no?

YAB: I want to add two things to this discussion of Dada and Surrealism. Rubin also made his show in response to a wave of neo-Surrealist work in New York—early Oldenburgs, for example, ■ his soft objects, which Rubin saw in relation to Yves Tanguy, say. That's how Rubin thought—in terms of those kinds of juxtapositions. And he always disagreed with Greenberg on Pop; Rubin supported it. And so if he could justify his interest in this new work by finding historical precedents in Surrealism, well, that was one strategy.

BB: Magritte via Johns, for example.

YAB: Yes. My other point about the rereading of Dada and Surrealism in this period concerns the exhibition mounted by Dawn Ades and David Sylvester in London.

HF: That's ten years later, though—1978.

YAB: Yes, but it was the first time there was a show of material entirely based on journals. It was very intelligently organized in relation to what they thought was the crucial medium of those movements (again, the journals were not mass circulation).

RK: One thing that I discovered as I began to work on "L'Amour fou" is that nobody had read the articles in those magazines, ◆ for example in *Minotaure*. There was all this very interesting material, and it wasn't being taken into account.

BB: In light of that legacy we've just discussed, it's all the more astonishing that the reconstitution of an American avant-garde was

so programmatically defined in terms of nation-state identity. Both political internationalism and avant-garde internationalism were totally reversed in the constitution of a New York avant-garde. Its very names are foundational: the New York School, American art, and so on.

YAB: "The Triumph of American Painting."

BB: Yes, the sheer triumphalism of the discourse—I don't blame it on the artists.

HF: Some embraced it.

YAB: But others were not happy with it at all. Newman again was absolutely opposed, for example.

HF: But might some of this triumphalism be compensatory, that is to say, wish-fulfilling? I mean there was an enormous sense of inferiority among American artists around World War II vis-à-vis ▲ European art—in Gorky, in early Pollock …

BB: I've always disliked that argument because I think American modernism was fairly sophisticated even then.

YAB: And the inferiority complex mostly disappeared when the ● Surrealists arrived in New York and were demystified.

HF: But in an earlier moment it was still active, and Pollock and company didn't have the earlier American modernism—of Stieglitz and his circle—to draw on as a resource.

BB: Why is that edited out or forgotten? By Greenberg and other critics, and by us too, again and again, generation after generation? We all tend to say American modernist art begins with Pollock. I would find the argument of the inferiority complex more generative as an idea if I could understand what it originated in, and why it resorted to a nation-state identity.

RK: But early on there were already international connections. For example, the Museum of Modern Art founded an international council in 1953; early on they decided to make a concerted incursion into European art. When this council revved up, its effect was to promote the idea of an imperial cultural modernism that went with the Marshall Plan.

YAB: But that started even before, and at first outside of MoMA—in the State Department immediately after the war. The first major exhibition of this program was called "Advancing American Art," and it was shown at the Met in October 1946 before splitting into two groups of works, one small exhibit traveling to Cuba and Latin America, the other, larger one going to Paris and other European capitals such as Prague. It contained works by the first generation of American modernists—the Stieglitz group was well represented—but it was on the whole a mixed bag (Thomas Hart Benton, Ben Shahn, etc.). It was a rather successful diplomatic coup in Europe, though its reception in the States was very controversial, with angry congressmen protesting against the use of taxpayers' money. The State Department program continued its activity until 1956, when

it was abruptly terminated after protests against "communist-inspired art." It was at this point that MoMA's International Council began to really roll.

BB: That's a nice arc: to go from the dream of a proletarian cultural sphere to avant-garde internationalism, and from there to the State Department and International Council of the Museum of Modern Art!

1 See Serge Guilbaut, *How New York Stole the Idea of Modern Art: Abstract Expressionism, Freedom, and the Cold War* (Chicago and London: University of Chicago Press, 1983) and T. J. Clark, *Farewell to an Idea* (New Haven and London: Yale University Press, 1999), respectively.

2 Peter Bürger, *Theory of the Avant-Garde* (1974), trans. Michael Shaw (Minneapolis: University of Minnesota Press, 1984).

3 "This would amount to nothing less than the establishment of a perpetual revolution—perpetual because bent on unceasing radical criticism of itself. It is no wonder such an ideal has not been realized in the realm of politics, but it seems to me that the development of modernist painting over the past century has led to a situation that may be described in these terms." (Michael Fried, *Art and Objecthood* [Chicago: University of Chicago Press, 1998], p. 218.)

▲ 1942a ● 1942a, 1942b

roundtable

glossary

CAPITALS indicate other glossary terms

affirmative culture

The concept of an affirmative culture was initially coined by the philosopher Herbert Marcuse in his essay "On the Affirmative Character of Culture," where he argued that cultural production inherently supported existing political, economical, and ideological power structures by the very fact of its innately legitimizing character. This means that cultural production not only provides presumably compelling evidence of social and subjective autonomy to any given political system, but also prohibits contestation and change since it corroborates the *status quo* as valid and productive by its very existence; or as T. W. Adorno once said, "culture by the mere fact of its existence prohibits the sociopolitical change that it promises." Artists since the sixties in particular have attempted to overcome Marcuse's pessimistic totalization (represented best by Andy Warhol's universal affirmation), and have responded by developing a variety of specific critiques and contestations. And in fact it could be argued that the momentary successes of artistic practices such as institutional critique of the seventies, feminist interventions of the eighties, and gay activism of the nineties have proven that forms of cultural opposition can raise public and political consciousness successfully. This does not imply, however, that the continuously expanding arsenal of instant recuperation that transforms cultural opposition into mere market—and museum—goods does not pose a permanent challenge to artists and requires a perpetual change of strategies.

Alexandrianism

The avant-garde assumed different positions in its lifetime: opposed to academic art, engaged in political critique, turned inward toward its given materials, or outward toward mass culture, and so on. Yet common to all these positions was the imperative of *advance*—"to keep culture *moving*," as Clement Greenberg put it in "Avant-Garde and KITSCH" (1939), "in the midst of ideological confusion and violence" (note the date of the essay, on the brink of World War II). Paradoxically, in a society in transformation or turmoil when the "verities" of tradition are thrown into question, "a motionless *Alexandrianism*" can take over cultural practice: "an academicism in which the really important issues are left untouched because they involve controversy, and in which creative activity dwindles to virtuosity in the small details of form, all larger questions being decided by the precedents of the old masters." According to Greenberg, the avant-garde first emerged in the middle of the nineteenth century to challenge this stalled state of affairs; but such Alexandrianism is hardly a one-time event. The illusion of great movement that conceals the reality of oppressive stasis might well be the rule more than the exception in capitalist society; and if this is the case—if the problem of Alexandrianism has not disappeared—then perhaps the need for an avant-garde has not either.

alogism

This term, coined by Kazimir Malevich around 1913–14, refers to a body of works that he realized at the same time as he was transforming the idiom of Synthetic Cubism into his own particular brand of abstraction, Suprematism, which came to light in 1915. By superposing onto his alogic canvases unrelated figures, represented as they would be in an illustrated dictionary and sharply contrasting in terms of scale, that could not possibly belong to the same scene, Malevich sought to create the pictorial equivalent of the "transrational" (or ZAUM) poetry of his friends Aleksei Kruchenikh and Velemir Khlebnikov.

alterity

Etymologically, "alterity" is the condition of "otherness," a longtime goal of many modernists (note the statement of the young French poet Arthur Rimbaud in 1871: "Je est un autre"). Often this otherness was projected onto faraway cultures; the most famous instance is Paul Gauguin, who traveled to Tahiti in search of a new way not only to make art but to live life. But it could also be sought in places closer to home—in native traditions, folk art, peasant culture, and so on. Sometimes, too, this alterity was seen to exist even more intimately, if no less strangely, in the unconscious—the otherness of obscure dreams and vague desires explored by Surrealists like Max Ernst above all. In short, many modernists pursued alterity for its disruptive potential, but it never had a fixed location. In the wake of feminist theory and postcolonial discourse, the term has taken on a renewed valence, wherein alterity is privileged as a position of radical critique of the dominant culture—of what it cannot think or address or permit at all—more than as a place of romantic escape from it.

anomie / anomic

This term, first defined by Émile Durkheim in 1894, has been generally deployed in social history and theory in order to describe particular historical formations of social deregulation, periods in which the fundamental contracts of social ethics that had traditionally regulated the interaction among subjects, and between subjects and the state, have been canceled. In the present time, typical examples of the expansion of social anomie could be found in the overall attitudes of capitalist neo-liberalism that has systematically dismantled fundamental social institutions such as education, healthcare, and the elementary political processes of participation and representation (e.g., unionization). Transferred into aesthetic and art-historical debates, the term anomic identifies the working conditions of cultural producers for whom utopian avant-garde aspirations, or even the desire for a minimum of sociopolitical relevance, have become extinct. The absence of a sociopolitical dimension within artistic production inevitably leads to anomic conditions in culture at large (e.g., Jeff Koons, Matthew Barney) where the neo-liberal principles of speculation and investment opportunities driven by the promise of profit maximization govern the politics of artists, collectors, and institutions alike. Culture under the conditions of anomie acquires at best the features of a SIMULACRUM of legitimation and prestige, and at worst those of a closed-circuit system of specialized investment expertise.

aporia / aporetic

Originating in philosophy and rhetorics, the terms aporia and aporetic describe what seems to be an almost inextricably necessary condition of the work of art: that it generates intrinsically unresolvable structures of paradoxical contradiction. For example, to be at once representational yet self-referential; to claim autonomy status while being totally subjected to ideological interests; or to claim freedom from instrumentalization, yet be determined by mass-cultural frameworks and massive economic interests—these are just some of the more obvious cases of artistic aporias in the present. More subtle aporetic structures would be the claims of the aesthetic to be universally legible, yet to be always confined to privileged situations of reading and reception. Aporetic is also the work's desire to expand its audiences to disseminate critical reflection, only to end up in the mass-cultural formations of a voraciously recuperative spectacle culture. Thus one could argue that the aporetic has become in fact *one* of the fundamental rhetorical TROPES of the aesthetic at this moment. It remains unclear whether it is reactive, in the sense that that every work of art has to face unresolvable contradictions, or whether it is proactive in the sense that it is precisely the function of the work of art to subvert and implode fixities and certainties in the behavioral and perceptual structures of everyday life by confronting them with an incessant barrage of unresolvable contradictions.

art autre

Meaning "a different art," or, more literally, "an art that is other," this expression was launched in 1952 by the French critic Michel Tapié to group together the art of Jean Dubuffet, Jean Fautrier, and Wols (who had died in 1951), as well as that of their imitators and of an eclectic compendium of Abstract Expressionist and neo-Surrealist artists, under a single banner. Tapié soon replaced it, and with more lasting success, with the phrase *art informel* (although Dubuffet and Fautrier reviled that just as much as *art autre*). SEE ART INFORMEL

art informel

When in 1962 French writer Jean Paulhan published his book *L'Art informel*, the phrase, coined by Michel Tapié a decade earlier, had not gained much in clarity. By then it designated a post-Cubist pictorial (or eventually sculptural) mode in which the figures, abstract or not, were not readily legible but would gradually emerge from a tangle of gestures or accumulation of matter before the consciousness of the spectator. Most of the painters satisfied with this label were also to be called TACHISTES.

atavism

From the Latin for "great-grandparent," "atavism" signifies the tendency to resemble, in a given trait, an ancestor more than a parent. In the nineteenth century, largely under the influence of racialist biology, "atavism" took on a pathological shading, whereby such resemblance was taken to suggest a reversion to a diseased state that had passed into remission for a generation or two. Used in this way, the term connoted a regression to a primitive or

degenerate condition, ambiguously physical, psychological, or both, and this negative connotation still echoes in its use in art criticism and cultural discourse today.

avatar
While originally denoting a Hindu deity, the term "avatar" is now most commonly associated with graphical representations of surrogate identities in online games and chatrooms. What is most significant about an avatar in the context of contemporary art is that like the surrogate actors in video games, which are also known as avatars, these artist-built characters have no essential ties to an existing person or identity per se. Instead, they are remote-controlled surrogates who, like their virtual cousins in the game world, may travel to places or articulate meanings that would be inaccessible to any flesh-and-blood individual. In other words, avatars "free" artists from "having" to exhibit a particular identity, thus allowing them to propose forms of selfhood, or subjectivity, that may be collective, imaginary, or utopian.

biographism
With the eclipse of modernism in the seventies, the formal logic of abstract art began to fade, making way for a new conviction that the meaning of avant-garde works was to be found in the artist's life, for which the art objects could be seen to serve as an emblem. This was the same period during which biographism came under fierce attack, as in Roland Barthes's essay "The Death of the Author" (1968) and Michel Foucault's truculent "What matter who's speaking?" ("What is an author?"[1969]). Following Freud's *Leonardo da Vinci* and a *Memory of his Childhood* (1910), art historians and critics searched within the biographical information for a symptomatic detail that would "unlock" the work. Picasso's habit of signing his paintings and drawings not only with his name but with the precise dates and even hours of their execution lent credibility to this belief. Jaume Sabartés, Picasso's secretary, predicted that once this trail of clues was followed, "We would discover in his works his spiritual vicissitudes, the blows of fate, the satisfactions and annoyances, his joys and delight, the pain suffered on a certain day or at a certain time of a given year."

calligramme / calligram / calligrammatic
In 1918, Guillaume Apollinaire published a volume of his *calligrammes*, composed while he was sequestered in the trenches during World War I. *Calligrammes* are poems fashioned so that the words take the shape of the object named by the poem. One example is "Il pleut" (It is raining), with the letters descending in vertical channels to imitate rain; another is "The necktie and the pocket watch," with both objects represented by the words of the poem. The similar combination of language and image, as in Cubist collages or the paintings of Jasper Johns and Ed Ruscha, are therefore designated "calligrammatic."

Concrete poetry
As a historical term, Concrete poetry identifies the postwar resurrection and academicization of the linguistic and poetical experiments of the radical avant-gardes of the teens and twenties that had been conducted in the context of Russian Futurism, and the practices of international Dadaism in Berlin, Zurich, Hanover, and Paris. If the Dada painters and poets (such as Hugo Ball and Raoul Hausmann) were engaged in a radical opposition to traditional painterly and poetical languages (e.g., Berlin sound poetry as a travesty of the German cult of the poet Rainer Maria Rilke or of German Expressionism), the Russian and Soviet sound poets (e.g., the ZAUM poetry of Velemir Khlebnikov) developed a theoretical understanding of poetical processes and functions that would correspond to the new theoretical analysis of linguistic functions in Russian and Soviet Formalism. The Concrete poets of the postwar period typically emerged in areas that had been both remote and protected from the cataclysms of World War II, both privileged and disadvantaged with regard to the naivety of their early rediscovery of these avant-garde projects. Thus we find early resuscitations named Concrete poetry in the context of Latin American countries and in Switzerland in the forties, often working in tandem with the academicization of abstraction (for example, Eugen Gomringer and Max Bill). Here the celebration of a newfound ludic irrelevance and of typographical gamesmanship displaced both the political, the graphic, and the semiological radicality of the originary figures.

condensation
Sigmund Freud developed this term in his interpretation of dreams, but it also signified a basic process of the unconscious in general, whereby a single idea—image and / or word—comes to represent multiple meanings through association.

This idea attracts different lines of associated meanings, "condenses" them, and so takes on a special intensity (as well as a particular obscurity) through them. In this light one can understand its function in dreams, the "manifest content" of which (the narrative that we seem to see) is more concentrated and confused than its "latent meaning" (the sense that we might decode); yet condensation is also in play in the formation of symptoms, which can also combine different desires into one trait or action. To the limited extent that images are analogous to dreams or symptoms, "condensation" has some use-value in art criticism as well. Its complement in psychoanalysis, as a fundamental process of the unconscious, is DISPLACEMENT, and its parallel in linguistics, as a layering of associated meanings, is metaphor (*see* METONYMY).

décollage
Décollage was initially envisioned by the late Surrealist writer Léo Malet, who in 1936 predicted that in the future the process of collage would be transferred from the small scale and intimate collections of found and glued remnants of the everyday (e.g., Kurt Schwitters) via an aggressive expansion to the large-scale frameworks of advertisement billboards, then increasingly taking control of what were once public urban spaces. It is only in the immediate postwar period in Paris that Malet's prognosis would be fulfilled by a group of young artists who were equally disenchanted with Surrealism as with *art brut* or ART AUTRE. Jacques de la Villeglé and Raymond Hains initiated *décollage* in 1946 by collecting lacerated billboards and transferring the remnants into pictorial formats, identifying their work as deliberate acts of collaboration with anonymous vandals who oppose the power of product propaganda. This collaborative dimension, as much as the totally aleatory nature of the found lacerations, was an important aspect of the process. *Décollage* positioned itself in a complex dialogic relationship with the cult of Pollock's *painterly allover* by replacing it with an *allover structure of textuality*. It was also the first postwar activity to resituate artistic production at the intersection of urban architectural space, advertisement, and the conditions of textuality and reading under the newly emerging regimes of advanced forms of consumer culture.

deductive structure
The Cubist grid is, perhaps, the first instance of the kind of pictorial composition that would later in the twentieth century come to comprise the whole of Frank Stella's paintings. Derived from the shape of the canvas and repeating its vertical and horizontal edges in a series of parallel lines, the grid is an instance of drawing that does not seem to delimit a representational object, but, mirroring the surface on which it is drawn, "represents" nothing but that surface itself. Stella would make this "mirroring" much more emphatic by casting his paintings into eccentric shapes, such as Vs or Us. With his drawing paralleling these edges, to create a series of concentric stripes, there was not only no question that anything but the shape itself was being represented, but also no possibility of reading "depth" or illusionistic space into the surface, which was stretched as tight as a drum-head by the constant representation of itself. Writing about Stella's work, the critic Michael Fried called this procedure "deductive structure."

desublimation
The concept of desublimation figures in contradictory ways within criticism and psychoanalytically informed writing on art history. In its obvious response to Freud's model of SUBLIMATION as the presumed precondition for any type of cultural production, the countermodel describes first of all the social conditions that foil the subject's capacities to sublimate libidinal demands and to differentiate experience within increasingly complex forms of social relations, knowledge, and production. Adorno's critique of the "desublimation" of musical listening, arising with the technologies of musical reproduction such the radio and the gramophone, would be a case in point. Here desublimation is identified as a socially and historically determining factor of cultural decline caused by mass-cultural formations. But in its opposite definition, desublimation has taken on the meaning of a strategy to foreground the conflicting impulses within the aesthetic object itself. The social enforcement of sublimation is counteracted in antiaesthetic gestures, processes, or materials that discredit the sublimatory triumphalism made by the work of high art. Desublimation is played out in the dialectics of high art versus mass culture, performed throughout the twentieth century as a counteridentification with the iconographies and the technologies of mass culture in order to debase the false autonomy claims with which modernism had propped up its myths. At the same time, these antiaesthetic gestures underline that all acts of sublimation are always also acts of libidinal repression, and that the work of art is the sole site to make these contradictions manifest by its emphatic invocation of the somatic origins of artistic production.

détournement

The French word for deflection, diversion, rerouting, distortion, misuse, misappropriation, hijacking, or otherwise turning something aside from its normal course or purpose, *détournement* is a technique developed in the 1950s by the Situationists. As defined in the third issue of the *Internationale Situationniste* (1959), "*détournement* is … first of all a negation of the value of the previous organization of expression." In general, it is where an artistic or nonartistic production—whether it be a work of art, a film, a news photograph, a poster, an advertisement, a text, a speech, or some other form of visual or verbal expression—is reworked so that the new version has a meaning that is antagonistic or antithetical to the original. In an early theorization of the concept, *A User's Guide to Détournement* (1956), Guy Debord and Gil J. Wolman categorized *détournements* into two types: minor *détournements* and deceptive *détournements*. "Minor *détournement* is the *détournement* of an element which has no importance in itself and which thus draws all its meaning from the new context in which it has been placed. For example, a press clipping, a neutral phrase, a commonplace photograph. Deceptive *détournement* … is in contrast the *détournement* of an intrinsically significant element, which derives a different scope from the new context. A slogan of Saint-Just, for example, or a film sequence from Eisenstein." The Situationists acknowledged their development of the *détournement* technique had had a number of precursors and influences, among them the Surrealists' use of collage and practice of placing incongruous objects beside one another. "*Détournement*, the reuse of preexisting artistic elements in a new ensemble, has been a constantly present tendency of the contemporary avant-garde, both before and since the formation of the SI," they wrote in the 1959 issue of *Internationale Situationniste*. But they went on to demonstrate how their own use of the technique extended into daily life: "Examples of our use of detourned expression include Jorn's altered paintings; Debord and Jorn's book *Mémoires*, 'composed entirely of prefabricated elements,' in which the writing on each page runs in all directions and the reciprocal relations of the phrases are invariably uncompleted; Constant's projects for detourned sculptures; and Debord's detourned documentary film *On the Passage of a Few Persons Through a Rather Brief Unity of Time*. At the stage of what the 'User's Guide' calls 'ultra-*détournement*, that is, the tendencies for *détournement* to operate in everyday social life' (e.g., passwords or the wearing of disguises, belonging to the sphere of play), we might mention, at different levels, Gallizio's industrial painting; Wyckaert's 'orchestral' project for assembly-line painting with a division of labor based on color; and numerous *détournements* of buildings that were at the origin of unitary urbanism. But we should also mention in this context the SI's very forms of 'organization' and propaganda." The last examples point to the Situationists' belief in the revolutionary potential of *détournement*, which consists of turning expressions of the capitalist system against itself. According to the *User's Guide*, "*détournement* not only leads to the discovery of new aspects of talent; in addition, clashing head-on with all social and legal conventions, it cannot fail to be a powerful cultural weapon in the service of a real class struggle. The cheapness of its products is the heavy artillery that breaks through all the Chinese walls of understanding. It is a real means of proletarian artistic education, the first step toward a literary communism."

diachronic

Although this term, derived from the Greek language, existed before the Swiss linguist Ferdinand de Saussure, its modern acceptation was forged in his *Course of General Linguistics*, posthumously published in 1916, where it is used in direct opposition to SYNCHRONIC. Meaning "lasting through time," diachronic designates any process observed from the point of view of its historical development. The diachronic study of a language deals exclusively with its evolution (for example, from Old English to present-day English).

dialogism / dialogical

The writings of Mikhail Bakhtin entered the world of structuralism in the sixties, when a group of Eastern Europeans—Tzvetan Todorov and Julia Kristeva among them—emigrated to France, bringing with them knowledge of Russian linguistic work that had previously been unknown in the West. *Discourse in the Novel* (1934) and *Problems of Dostoevsky's Poetics* (1929) were important sources of Bakhtin's notion of dialogism, or the dialogical principle. Dostoevsky's novels, Bakhtin observed, are polyphonic, which means that "a plurality of independent and unmerged voices and consciousnesses" takes up existence there. "What unfolds in his work," Bakhtin writes, "is not a multitude of characters and fates in a single objective world, illuminated by a single authorial consciousness; rather a plurality of consciousnesses, with equal rights and each with its own world, combine but are not merged in the unity of the event." The conventional novel, to which this technique is opposed, attempts to synthesize these voices within the vision of a single consciousness—that of the author—creating, thus, a monological universe. The dialogical principle carries over to Bakhtin's understanding of the linguistic utterance, which structuralism pictured as a coded message sent between a sender and a receiver. Instead, Bakhtin's dialogism assumed that any such message would already take the receiver's position into account and thus be conditioned by that position: supplicating it, refuting it, placating it, seducing it.

displacement

The complement of CONDENSATION in psychoanalysis, "displacement" is the other essential process at work in dreams, or the DREAM-WORK, according to Freud. Rather than a layering of meanings in a vertical (or metaphorical) association as in condensation, displacement signifies a slippage of meanings in a horizontal (or METONYMIC) connection. In the case of displacement, then, one idea—a word and / or an image "cathected" or invested with special energy or significance—passes on some of this charge to an adjacent idea, which, as in condensation, gains in intensity as well as obscurity. As in condensation, too, displacement is often at work in the formation of symptoms and other unconscious productions, and it might also be applied, with caution, to a reading of art—in terms of the unconscious processes involved in both making and viewing a work.

dream-work

In psychoanalysis this term encompasses all the operations of the dream as it transforms its various materials (bodily stimuli while asleep, traces of the events of the day, old memories, and so on) into visual narratives. The two essential operations are CONDENSATION and DISPLACEMENT; yet two other mechanisms are important as well: "considerations of representability" and "secondary revision." The first mechanism selects the dream-thoughts that can be represented by images and reformats them (as it were) accordingly. The second mechanism then arranges these dream-images so that they might form a scenario fluid enough to stage a dream in the first instance. In some sense both operations—"representability" and "revision"—already suggest activities of picture-making, and so they might appear to be of rather direct use in matters of art. But this proximity is also a danger: a painting that takes the dream as its model—as Paul Gauguin, say, or the young Jackson Pollock sometimes did implicitly, or as some Surrealists did explicitly—risks a reductive circularity whereby the painting illustrates the dream, which in turn delivers the key to its meaning.

durée

The French philosopher Henri Bergson, whose work was highly valued by the Italian Futurists, opposed "objective time" and "subjective time," which he called *durée* (duration). While "objective time" is space in disguise, argued Bergson (thus the spatial means used to measure or represent it: the clock, the arrow), the subjective time of experience flows indivisibly, and its intuitive apprehension is one of the means by which human consciousness accedes to its central unity. Bergson's views, enormously successful in the teens and twenties (he was awarded the Nobel Prize for literature in 1927) were eclipsed by psychoanalysis, for which the human psyche is a field divided by conflicting forces, but they have been regaining some currency from the sixties on, in a large measure thanks to the work of the French philosopher Gilles Deleuze.

entropy

The law of entropy, which is the second law of thermodynamics, a branch of physics founded in the nineteenth century, predicts the inevitability of the deperdition of energy in any given system, thus the future and irreversible dissolution of any organization and return to a state of indifferentiation. The concept of entropy had an immediate and enormous effect on the popular imagination, especially because the example chosen by Sadi Carnot, one of its creators, was the fact that the solar system would inevitably cool down. It was soon imported into many fields of knowledge, not only in hard sciences but also in the humanities, drawing the interest of authors as different as Sigmund Freud in psychology, Claude Lévi-Strauss in anthropology, and Umberto Eco in aesthetics. While the way in which words become clichés and gradually lose their meaning—a topic of immense concern for modernist writers, starting with Stéphane Mallarmé—can be characterized as an entropic process, it is only with the adoption of the concept of entropy by the theoreticians of information Claude Shannon and Norbert Wiener in the late forties that it was directly applied to the field of communication. In their definition, the less informational content a message carries the more entropic it is: were all American presidents assassinated, for example, the announcement of their death would be highly entropic; conversely, since American presidents are very rarely assassinated, the murder of John F. Kennedy was of exceptional informational value for the media. Until Robert Smithson's choice of entropy for

his main motto in the sixties, however, it had always been understood as a kind of dark inevitable doom. Fascinated by the strength and inevitability of entropy in any process, Smithson viewed it, positively, as performing in itself a kind of critique of humankind and its pretenses that it is the only universal condition of all things and beings.

epistemology

Derived from the Greek words *episteme* (science, knowledge) and *logos* (study, discourse), this term first meant the theory of knowledge or of science. At the beginning of the twentieth century, however, a major crisis in the foundations of mathematics and physics led epistemological inquiries—that is, critical analyses of the general principles and methods of sciences—into the realm of pure logic, a current that still dominates in Anglo-Saxon epistemology. Another trend, particularly active in France in the immediate postwar period(with Gaston Bachelard, Alexandre Koyre, and Georges Canguilhem) and represented in the United States by Thomas Kuhn, focuses on the formation of scientific disciplines and the internal evolution of scientific theories. It from this branch of epistemology that derives Michel Foucault's use of the concept of episteme, in *The Order of Things*, as the specific way knowledge is articulated in various sciences, or rather discursive practices, during any specific period, determining what is thinkable at any given time. While the historical shift from one episteme to another is always marked by a rupture, each episteme is characterized by a specific grouping of several dominant discursive practices that all conform to the same cohesive model. In *The Order of Things*, Foucault identified and discussed three successive epistemes in Western thought, that of the Renaissance, obsessed by resemblance, that of the Classical Age, for whom representation was crucial, and that of modernity, which presided over the advent of human sciences.

estrangement

This term, often mistranslated from the German or Russian as "alienation," originated in Russian Formalist theories of literature and it became a central concept in the practice and theory of the theatre of Bertolt Brecht. The Russian Formalists conceived of *ostranenie* (the devices and processes of "making strange") as one of the quintessential tasks of aesthetic operations. The aim of this artificial estrangement was primarily to alert the spectator / reader to a different perception of the world, to rupture the rote repetitions of everyday speech, and to renew the senses by estranging them from their conventional representations. But estrangement also meant to alert the spectator / reader to the formal devices and material tools of language as integral elements in the processes of meaning production. Following their own principles and inherent logic, they might even supersede meaning's more traditional elements such as narratives, semantics, or referents in the world of objects. Brecht's *theory or effect of estrangement* transfers the concept from linguistic analysis to the social and political situation of the subject. Throughout his work, Brecht attempted to define viewer participation as active transformations of those cognitive and behavioral structures that have become *naturalized*, as Roland Barthes would later say, and that are invisible to the subject. Estrangement in Brecht therefore means in fact the exact opposite of *alienation*, since one of the tasks of *estrangement* is precisely to resituate the subject in a comprehension of the social and political determinism that suddenly appears as "made" rather than as "fate" and therefore encourages the spectators of Brecht's plays to take the matter of political change directly into their own hands.

facture / faktura

These two terms are intricately related, yet they demarcate a significant shift in the evaluation of artisanal competence and artistic skills in the execution of painting and sculpture. While *facture* played a great role in judgments concerning painterly techniques until the end of the nineteenth (already challenged by Seurat's mechanical facture in divisionism), if not until the beginning of the twentieth century, its status as criterion vanished with the rise of collage aesthetics in Cubism. But even during the time of its validity, *facture* underwent dramatic changes: from the conception of painting as an act of manual bravura, and a display of virtuosity and skills, to the modernist insistence (beginning with Cézanne and culminating in Cubism) on the almost molecular clarity in making every detail and passage of painterly execution transparent in terms of its procedure of production and placement. With the rise of collage aesthetics, a painting became an object, rather than a substratum of illusionistic and perspectival conventions, and to the degree that it aspired to become an object of contemporaneity, it subjected itself to an aesthetic that mimicked manufacturing and industrial montage, all the way denigrating the supposedly hallow grounds of artisanal painting. Thus *facture* now came to mean the degree with which the painterly or sculptural object foregrounded its status

and condition of having been *fabricated*, self-reflexively revealing the principles of its own making, and the processes of its production (rather than pretending to have emerged from transcendental inspiration or supernatural talents). The artists emphasizing *facture* in this way is engaged in demystifying the creative process and the artistic object itself, as much as *facture* makes the object itself transparently contingent, rather than autonomous, let alone transcendental.

fetish / fetishism

In the anthropological sense of the word, a fetish is any object endowed with a cultic value or autonomous power of its own, often construed as a magical or divine force, which, rationally speaking, it does not possess. A term with a complex etymology—it was originally used by Portuguese and Dutch traders to designate things that Africans tribes exempted from trade (irrationally, according to the Europeans)—the fetish came to stand for the lowest form of spirituality in various accounts of religion (e.g., in Hegel); that is, to represent the superstitious vulgarity of a mere thing taken to be a sacred entity. It is this notion of the fetish—of an object overvalued by its producers in a manner that subjugates them in turn to it—that Karl Marx and Sigmund Freud turned to critical advantage. In a famous passage in *Capital* (volume 1, 1867), Marx argued that the division of labor in capitalist production leads us to forget how commodities are made, with the result that we "fetishize" them—endow them with a magical power of their own. And, some decades later, Freud suggested that all erotic life involves some fetishism, some investment of inanimate objects with libidinal energy. In short, both Marx and Freud implied that we enlightened moderns are also, at times, superstitious fetishists. In all three definitions—the anthropological, the Marxist, and the Freudian—fetishism has become a central concept in cultural criticism. It is also a multivalent category of the object that modernists have evoked, again and again, in order to test the given parameters—cultural, economic, and sexual —of the work of art.

Gesamtkunstwerk

A German term, translated as "total work of art," the *Gesamtkunstwerk* was vaunted by the nineteenth-century composer Richard Wagner in order to designate the aesthetic ambition of his grand operas—to subsume all the arts within one musical theater, to make an aesthetic experience so awesome that it might be, if not redemptive, at least ritualistic in its power. Thereafter the notion took on a life of its own (in this sense it became an artistic FETISH), soon central to most projects that claimed a transcendental or totalistic dimension for art, with different arts nominated at different times as the master form that would gather all others under it. Thus, for example, in Art Nouveau, design functioned as this dominant term; in De Stijl, it was the painted panel; in the Bauhaus, it was building (the founding program of the Bauhaus carried on its cover a woodcut of a Gothic cathedral under which all arts and crafts were, allegorically speaking, sheltered). However, because it subsumed all the arts, the *Gesamtkunstwerk* became the enemy of another imperative within modernism, that of "medium-specificity," which defined each art precisely in its difference from all the others. Although the notion of the *Gesamtkunstwerk* now seems archaic, it has hardly disappeared: reborn in happenings and other performances after World War II, it lived on in some spectacles of Nouveau Réalisme and Pop art, and has found a resurgence in much Installation art today.

Gestalt psychology

Emerging in the thirties in the work of Wolfgang Köhler and Kurt Koffka, Gestalt psychology was born as a refutation of Behaviorism, then the reigning theory of human mental development. Behaviorists pictured human and animal behavior as a series of learned, automatic responses to repeated stimuli (such as the bell accompanying the food provided a dog, then triggering salivation in the dog [stimulus / response] even when no food accompanies it). This view of the human condition as entirely passive and, worse, as entirely open to vicious training, worried the Gestaltists, who theorized activity within the human subject—the activity necessary to understanding and responding creatively to its environment. Focusing on the perceptual apparatus with which every human subject is endowed, the Gestaltists refused to grant a merely empiricist view of perception, in which the human eye forms a picture of the world by passively internalizing the visual stimuli that fall onto its retinal field. Instead, the Gestaltists argued that even from infancy the human observer is mastering that field by making inferences in which elements of the retinal pattern are associated with one another to form a "figure," everything around that figure being constituted as a "ground" or background. This actively constituted figure was called a gestalt, or form, which means, in addition, a force of hanging together, for which the Gestaltists' term was "praegnanz." Given the period when Gestalt psychology developed, it is clear that the rise of fascism lent urgency to its teaching.

grapheme

In normal usage, a grapheme is the smallest unit of written language, an element of writing that cannot be decomposed into smaller, meaningful units. Even before it gets down to the job of depicting anything, every linear deposit associates itself to another world of drawing or meaning, whether that be the wooden line of the mechanical draftsman, or the flowing mark of the comic-book illustrator, or the simpering contours of the advertisement illustrator. This associative identification is the work of the grapheme, or the cursive mark within which all drawing is formed.

Hegelianism

This shorthand is intended to signal some of the ideas of Georg Wilhelm Friedrich Hegel (1770–1831), the greatest philosopher of the early nineteenth century. Still important to many artists and critics a century later, Hegel argued that history proceeds in dialectical stages, through contradiction, in a steady progress of *thesis*, *antithesis*, and *synthesis* toward the self-consciousness of *Geist* (Mind or Spirit). For Hegel all aspects of society and culture participate in this march of Spirit toward freedom, and are to be judged according to their contributions to its development. In his scheme, then, there is a natural hierarchy in the arts, from the most material to the most spiritual, from architecture through sculpture and painting (equally based and refined), to poetry and music, all of which culminate in the pure reflections of philosophy. This idealism, with its assurance of artistic refinement and cultural progress, influenced many modernists, especially abstract painters such as Kazimir Malevich and Piet Mondrian, who harbored transcendental aspirations.

hegemony/hegemonic

A term in that appears in the writings of both Lenin and Mao, hegemony is most associated with the thought of the Italian Marxist Antonio Gramsci. In his *Prison Notebooks*, written while jailed by the Fascists, Gramsci argued that modern power is not limited to direct political rule but also operates through an indirect system of social institutions and cultural discourses that promote the ideology of the ruling classes as natural, normal, commonsensical, everyday. Such discursive power might seem more benign than direct subjugation, but it is also more subtle, and opposition to it must be rethought accordingly: "revolution" consists, then, not only in the transfer of control over politics and economics, but also in the transformation of forms of consciousness and experience. In this redefinition of politics as a struggle for hegemony, art and culture gain in importance; they are no longer seen as "superstructural" effects of the economy alone. The revision implies—at times romantically—that political change can be effected through critical interventions into art and culture.

hermeneutics

Derived from the Greek word meaning "to interpret," hermeneutics referred at first to the exegesis of The Bible considered as a historically sedimented text that is not to be read literally. By extension, hermeneutics has come to designate any method of interpretation that seeks the meaning of a text beyond its letter. We owe to the German philosopher Wilhelm Dilthey, at the end of the nineteenth century, the first investigation of the relationship between history as a scholarly practice and hermeneutics. Arguing that there is a radical difference between the human sciences, whose facts can be apprehended only through interpretation, and the natural sciences, whose facts can be empirically verified, he directly contradicted the positivist view according to which the ideal model of knowledge is physics. Dilthey's investigation of history, his analysis of how facts are deemed historical and are causally linked, led him to the formulation of what he called the "hermeneutic circle": in order to interpret a document we need to have a prior understanding not only of its whole but also of the culture to which it belongs (or of the genre of which it is only an example, or of the intention of its author), yet our understanding of this larger context depends upon our knowledge of similar documents.

iconic

The American philosopher Charles Sanders Peirce, anxious to analyze the activity of signs, felt the need to separate the profusion of signs into a manageable number of related types. The three kinds he isolated for this purpose were: symbols, icons, and indexes. Arguing that each of these types bore a different relation to its referent (or the thing for which it stood), he taught that symbols have a purely conventional (or agreed upon) relation, for which an example would be the words of a language; indexes, on the other hand, have a causal relationship, since they are the precipitates or traces of an engendering cause, the way footprints in the sand or broken branches in the forest are traces of the being that passed by; thirdly, the icon's relation is neither causal nor conventional but resemblant; it looks like its

referent either by sharing its shape (the way figures on a map do) or registering its image (the way photographs do). The problem for this tidy semiology (or study of sign-types) is that signs can be mixed rather than pure; photographs are both icons and indexes; and pronouns are both symbols and indexes (the referent of the pronoun "I" being caused by the source of utterance—the speaker —within the flow of speech).

iconography

This approach to the study of images and objects focuses on questions of *meaning* (more than, say, matters of form, style, etc.), for which it often refers to source texts found outside the art work. The term is most associated with the work of the German-born art historian Erwin Panofsky (1892–1968), who proposed iconography as the basic operation of art history soon after his departure from Nazi Germany for the United States in the early thirties. (In those initial years of the academic discipline, iconography offered the advantage of a technique that could be taught and reproduced—professionalized.) Panofsky proposed three levels of meaning within art: "primary or natural subject matter," which can be treated by "a pre-iconographical description" of the work; "secondary or conventional subject matter," which can be related to known themes in the culture at large (this is the work of iconography proper); and "intrinsic meaning or content," which involves "the basic attitude of a nation, a period, a class, a religious or philosophical persuasion—qualified by one personality and condensed into one work" (Panofsky called this level, which recalls the notion of KUNSTWOLLEN, "iconology"). Iconographic analysis is suited to ancient, medieval, and Renaissance art and architecture, informed as they are by classical mythology and Christian doctrine, more than to modern practices, which often challenged the presumption of an illustrational relation between image and text in different ways (e.g., through abstraction, chance, found or readymade objects).

ideograph

Discarded by most contemporary linguists, who deem it improper, this term was coined in the nineteenth century to designate a symbol directly representing an idea rather than its name (the Chinese characters and Egyptian hieroglyphs were long thought to be pure ideographs, or ideograms, or even pictograms, but we know now that their complex formation is far from entailing the simple one-to-one connection between an idea and its figurative expression). The word ideograph was appropriated by Barnett Newman in 1947 as a means to elucidate the mode of signification that he and fellow artists such as Mark Rothko or Clyfford Still wanted to implement in their art. Opposed to both the model provided by Surrealism (and its symbology derived from Freud) and that offered by abstract art (which he discarded as formalist exercise), Newman looked instead toward the art of Northwest Coast Indians, which he characterized as "ideographic pictures." For the Kwakiutl artist, wrote Newman, "a shape was a living thing, a vehicle for an abstract thought-complex, a carrier of the awesome feelings he felt before the terror of the unknowable." Although ideograph continued to be used by some critics with regard to the pseudo-glyphic marks that filled the canvases of his friend Adolph Gottlieb until the mid-fifties, it disappeared from Newman's vocabulary almost as soon as he had celebrated it. Not only did he realize that a truly ideographic mode of communication would require the elaboration of a code shared by producers and receivers of messages, but by 1948 he no longer wished to represent "pure ideas" in his art, nor did he think it possible.

informe

Georges Bataille, the challenger to André Breton's hold over the Surrealist group of artists and writers, formed his own journal during the twenties and thirties, which he called *Documents*. This journal published a dictionary of definitions for terms such as "spit," "eye," and *informe* (or formless). *Informe*, he wrote, could not have a definition; it could only have a job, since its work is to destroy the universe of classifications by "declassing" language, or bringing it down in the world. In this way, he said, words would no longer resemble anything but would, formless, operate like a spider or spit. Alberto Giacometti, operating in the mode of formlessness, would blur the differences between male and female (on which the concept of gender depends) in a work like *Suspended Ball*.

intertext

In the definition for DIALOGISM, Bakhtin's concept of dialogue was shown to have modified the picture of the structuralist utterance to show how the sender's message is always already affected by the receiver's imagined response. A further modification of that diagram concerns the channel of emission and reception, which the structuralists labeled "contact," as though it were the telegraph wire

opened by the utterance. Bakhtin relabeled this channel "intertext" since it is not the neutral connection of "contact" but the universe of associational relationships figured forth by the sender him / herself.

isotropic

Used in physics, this term means "exhibiting the same physical properties in all directions." A body of pure water, for example, is isotropic. The notion has often been used by modernist architects, from the twenties on, to express their conception of space as nonhierarchical, and their desire to create buildings that would have no center nor privileged point (they often drew in isometric projection, a mode of representation in which each of the three directions of space are equally foreshortened). It has also been applied to Jackson Pollock's allover drip paintings.

kitsch

Kitsch is a form of dissembling the nature of the material of which an object is made, a form that is largely a result of industrial production. Thus when the silversmith no longer works his metal by hand into the extrusions and relief that his technique suggests, and the metal is merely stamped by a "die" cut to imprint it, those forms are no longer conceived as respecting the metal's natural resistance to stress, but are made to mimic other patterns, such as floral motifs or the grooves of Ionic columns. It is this aping that came to be called kitsch and that Clement Greenberg named as the natural enemy of the avant-garde, in his "Avant-Garde and Kitsch" (1939). A more violent definition was proposed by Milan Kundera in his novel *The Unbearable Lightness of Being*, when he spoke of kitsch's transformation of disgust into universal approval and thus its dissimulation of the presence, in human life, of shit. Kitsch is thus the witless embrace of cliché as a defense against the weight of human reality. Because of this defense, he writes, "human existence loses its dimensions and becomes unbearably light."

Kunstwollen

A concept developed by the Viennese art historian Alois Riegl, *Kunstwollen* is usually translated as "artistic volition" or "artistic will," and it proposes, in Hegelian fashion, that a distinctive will-to-form, at once spiritual and aesthetic in nature, permeates all aspects of a given culture and / or period—from "low" crafts like textiles (Riegl worked as a curator in the Austrian Museum of Applied Arts) to "high" arts like easel painting. Unlike Hegel, however, Riegl argued that none of these forms or epochs should be denigrated, and his own work concentrated on practices and periods that were long undervalued, such as Baroque group portraiture and "the late Roman art industry." Pitched against the theories of architect Gottfried Semper (1803–79), who privileged the positive roles of material, technique, and function, the idealism of *Kunstwollen*—the implication that one will-to-form animates all products of a period—was attractive to some artists in the early twentieth century, especially ones involved in the Viennese Secession, whose motto encapsulated the *Kunstwollen* idea: "To each Age its Art, to Art its Freedom."

logocentrism / logocentric

In his doctoral dissertation, published as *Speech and Phenomena* (1973), the French philosopher Jacques Derrida examined Edmund Husserl's theory of language, which privileges speech over all other secondary transmission of meaning, such as writing or even memory. Husserl insisted that meaning must be immediate to the speaker, resonating inside his brain even as he or she produces and utters it. All secondary forms drive a wedge into this immediacy, either forcing the meaning to come after its conception—a temporal distancing that Derrida called "deferral,"—or traducing the meaning by differing from it. Derrida's term for this double betrayal is *différance* (spelled with an "a" to make its written form necessary to its reception). Husserl's refusal of writing in the name of speech, or *logos* (here meaning the "living presence" of the word), Derrida termed logocentrism, the ideology of *logos* and the condemnation of the GRAPHEME.

matrix

The gestalt, or figure, depends on its distinctness from its ground. This distinction brings with it the assumption that every figure is separate both from its neighbor and the space in which it exists. In thinking about this order of the visual, the philosopher Jean-François Lyotard constructed a third possibility, which he called "matrix", to describe a spatiality that is not consistent with the coordinates of external space, and from which the intervals and differences that make the external world recognizable and observable as objects are excluded. As with Freud's conception of the unconscious, the matrix contains incompatible figures that all occupy the same place at the same time, at war both with each other and with conscious experience. The matrix could, thus, be an avatar of Georges Bataille's concept of the INFORME, or formless.

medium-specificity

With the migration of the Surrealists to the United States at the outbreak of World War II, their work, which the critic Clement Greenberg found frivolously literary, threatened, he said, "to [assimilate] the arts to entertainment pure and simple." To escape this dire fate, the arts had to emulate the Enlightenment philosophy of Immanuel Kant, "because he was the first to criticize the means itself of criticism." As this "self-criticism" became the task of painters and sculptors, each was set the duty of revealing what was "specific" to a given aesthetic medium: "What had to be exhibited," Greenberg wrote in "Modernist Painting," "was not only that which was unique and irreducible in art in general, but also that which was unique and irreducible in each particular art. According to Greenberg, the essence of modernism lies "in the use of characteristic methods of a discipline to criticize the discipline itself, not in order to subvert it but in order to entrench it more firmly in its area of competence.… Each art had to determine, through its own operations and works, the effects exclusive to itself. By doing so it would, to be sure, narrow its area of competence, but at the same time it would make its possession of that area all the more certain. It quickly emerged that the unique and proper area of competence of each art coincided with all that was unique in the nature of its medium. The task of self-criticism became to eliminate from the specific effects of each art any and every effect that might conceivably be borrowed from or by the medium of any other art. Thus would each art be rendered 'pure,' and in its purity find the guarantee of its standards of quality as well as of its independence.… Modernism used art to call attention to art. The limitations that constitute the medium of painting—the flat surface, the shape of the support, the properties of the pigment." For the Old Masters, these were limitations to be dissembled, but for modernism they became positive factors to be acknowledged, for they were specific to the medium of painting, and painting alone.

metonym / metonymy / metonymic

A figure of speech by which a concept is expressed through a term referring to another concept that is existentially related to it. The most common form of metonymy is synecdoche, where a part stands for the whole (as in "sail" standing for "ship"), or the whole for a part (as in "China is losing" standing for "the Chinese soccer team is losing"). It was the Russian linguist and poetician Roman Jakobson who established metonymy as one of the two main axes of language (the other being metaphor), which he aligned to Ferdinand de Saussure's opposition of SYNTAGM and PARADIGM, as well as to Freud's opposition of DISPLACEMENT and CONDENSATION. Although he later admitted that the line of demarcation between metonymy and metaphor is sometime loose, Jakobson had recourse to these two concepts throughout his oeuvre about a vast array of phenomena (identifying Surrealism with metaphor and Cubist or Dadaist collage with metonymy, for example). His most explicit elaboration of the opposition between these two axes figures in his study of aphasia (or the incapacity to communicate linguistically), in which he distinguished two kinds of troubles: a patient whose metonymic function is affected cannot combine linguistic terms and construct propositions, while a patient whose metaphoric function is affected cannot choose between words nor relate any homonyms or synonyms.

mimesis / mimetic

The Greek word for "imitation," mimesis comes from the assumption that the imitative double must reproduce a single or simple object that comes before it, which is then duplicated by imitation. In his important essay "The Double Session" (1981), Jacques Derrida questions this traditional concept of representation as imitation by introducing Stéphane Mallarmé's reverie called "Mimique," in which "the false appearance of the present" is used to refer to a mime's performance of ideas that refer to no possible object, such as "she died laughing": a commonplace expression that names something impossible. In this way the mime does not imitate but rather initiates something. As Mallarmé expresses, "The scene illustrates but the idea, not any actual action, in a hymen tainted with vice yet sacred, between desire and fulfillment, perpetration and remembrance: here anticipating, there recalling, in the future, in the past, under the false appearance of a present."

objet trouvé

Along with the readymade, the construction, and the assemblage, the *objet trouvé* or "found object" is a critical alternative to traditional sculpture based in the idealist modeling of the human figure. As practiced by such Surrealists as André Breton and Salvador Dalí, the found object is best defined in contradistinction to the device closest to it in character, the readymade. First proposed by Marcel Duchamp, the readymade is an everyday product of industrial manufacture—a bicycle wheel, a bottlerack, a urinal—that, repositioned as art, questions basic assumptions about art and artist; the readymade tends to be anonymous,

detached from subjectivity and sexuality, with little or no sign of human labor. Not so the found object, at least in the hands of the Surrealists, who were drawn to old and odd things, often found in marginal stalls or flea markets, that spoke to a repressed desire within the artist and / or a surpassed mode of production within the society at large. One such object that constellated both kinds of enigmatic impulse was "the slipper-spoon" that Breton found one day in a flea market on the Paris outskirts (he recounts the anecdote in *Mad Love* [1937]). A wooden utensil, of peasant craft, carved with a little boot as its base, the spoon was an outmoded thing that Breton took as a sign of past desire and future love.

Oedipus complex
A fundamental concept in Freudian psychoanalysis, the Oedipus complex is the web of longings, fears, and prohibitions that captivates the psychological life of the young child, male and female. Named after the Sophocles tragedy *Oedipus Rex*, the complex involves a sexual desire for the parent of the opposite sex and a death wish for the parent of the same sex. The complex is most intense from ages three to five, but returns, after the period of sexual latency, at puberty, when it is usually resolved by the choice of a sexual object beyond the family (though this choice can also carry forward the preferences developed within the complex—that is, a man who seeks his mother, a woman her father—in another guise). According to Freud, the son is forced out of the Oedipus complex through the threat of the father—often, literally or figuratively, the threat of castration. The daughter does not face this same threat, and so, for Freud, the Oedipus complex is not so definitively terminated for the girl. As one might expect, this notion interested the Surrealists, and it continues to provoke feminist artists and theorists.

ontology / ontological
Derived from the Greek words *ontos* ("being," as present participle of the verb "to be") and *logos* (study, discourse), ontology is a term invented in the seventeenth century to designate that part of philosophy pertaining to "being qua being," or to the "essence of being," which had constituted the most important part of metaphysics since Aristotle. By extension, the adjective "ontological" means "that which concerns the essence." Clement Greenberg's conception of the history of each art as a quest for its own essence is both a TELEOLOGICAL and an ontological argument.

paradigm / paradigmatic
Although Ferdinand de Saussure used only the adjective form "paradigmatic," the opposition between paradigm and SYNTAGM is central to his linguistics and by extension to SEMIOLOGY as well as to structuralism. Having established that in language "everything is based on relations," Saussure distinguished between two kinds or relations: syntagmatic relations concern the association of discrete linguistic units resulting in elements of discourse (a word like "reread" is a syntagm made of two semantic units, "re," meaning repetition, and "read"; a sentence like "God is good" is a syntagm made of three units); paradigmatic relations concern the associations that are made *in absentia* between each unit of the syntagm and other units belonging to the same system. The word "revolution," for example, "will unconsciously call to mind a host of other words": revolutionary and revolutionize, but also gyration, rotation, turnover, reorganization, as well as evolution, or even any other word ending with the suffix "tion," such as population or argumentation, or beginning with the prefix re, such as reread. The group of these possible associations, which are governed by specific rules (phonetic and / or semantic) but whose number is indeterminate and which can appear in any order (as opposed to the succession of units in a syntagm) is called a paradigm. In recent years, the term has acquired a new meaning in the field of history of sciences, where it was introduced by Thomas Kuhn in *The Structure of Scientific Revolutions*. Almost a synonym of Michel Foucault's concept of *episteme*, it designates the intellectual horizon of a science during a certain period, determining a threshold beyond which it cannot go unless it fundamentally shifts its tenets and methods (the Newtonian paradigm of physics, for example, was definitively superseded by the Einsteinian one).

performative / performativity
In his book *How to Do Things with Words*, the British philosopher John Langshaw Austin (1911–60) divides language into two modes: the constative and the performative, the first a description of things that the structural linguist Émile Benveniste called "narrative" (which uses, he reminds us, the third person and the historical past tense); the second, an enactment of things, as when a judge says "I sentence you to five years in jail," or a person says either "I do" (in a marriage ceremony) or "I promise," Benveniste calling this "discourse" (which uses the first and second person pronouns and the present tense).

phallogocentrism
This feminist coinage complicates the concept of LOGOCENTRISM, developed by the philosopher Jacques Derrida, with the concept of "the phallus," developed by the psychoanalyst Jacques Lacan. If "logocentrism" signifies the persistent privilege given in Western culture to speech, to the "self-presence" of the spoken word (as in the Word, or *logos*, of God), the prefix "phal" suggests that this privilege is supported by the symbolic power accorded, within this same tradition, to the phallus as the prime signifier of all difference—prime because it is taken to signify the fundamental difference of them all, the difference between the sexes. For feminist artists and theorists this privilege is an ideology, however ingrained it might be in subjective and cultural formation, and as such is subject to radical deconstruction.

phenomenology
In the sixties, translation made Maurice Merleau-Ponty's *Phenomenology of Perception* (1945) available to English-speaking artists, and produced a collective meditation on the way the spatial coordinates of vision determine the meaning of objects. Because the individual's body is lived in its orientation to space—its head above, its feet below, its front fundamentally different from a reverse side it cannot even see—that body effectuates a "preobjective" meaning that determines the gestalts the individual must form. Preobjective meaning is, of course, another way of naming abstraction; thus phenomenology was seen as a support for the idea of abstract art.

phoneme
A phoneme is the smallest distinctive unit of articulated speech, an atom of language. Phonemes are vocal sounds that cannot be decomposed into smaller units, but not every such vocal sound, even in articulated speech, is a phoneme. The aspirated sound that necessarily follows the "p" or the "t" in English, for example, is not a phoneme because it has no distinctive (differential) function. The same sound at the beginning of the word "hair" is a phoneme in that it differentiates this word from "heir," from which it is absent.

polysemy / polysemous / polysemic
The polysemy of a word (and by extension of any other kind of signs, including visual ones) is its quality of having several distinct significations. Polysemy is often substituted for *ambiguity,* whose connotation of vagueness it does not share. Many more words are polysemous or polysemic than one is usually aware of (as the consultation of any good dictionary reveals), a fact on which most puns are based.

positivism
It was the French philosopher Auguste Comte (1798–1857) who first used this term, or that of "positive philosophy," to characterize his doctrine as radically opposed to metaphysics. Instead of attempting to discover the essence of things, thought Comte, philosophy should repel all a priori principles and seek to provide a systematic synthesis of all observable (positive) facts. Based on sense-experience, Comte's empirical theory of knowledge stressed that there was no difference in principle between the methods of the social sciences and the physical sciences, a idea that was directly contradicted by Wilhelm Dilthey's discussion of the HERMENEUTIC circle. Although the philosophers and mathematicians of the Vienna Circle grouped around Rudolf Carnap (1891–1970) and Otto Neurath (1882–1945) in the wake of Ludwig Wittgenstein gave a sounder philosophical base to Comte's argument in their logical positivism, the general tenets of positivism have been decried by most thinkers—and certainly all art historians—valued by each of the writers of the present book.

postcolonial discourse
This interdisciplinary form of critique aims to deconstruct the colonial legacy embedded within Western representations, verbal, visual, and other. Eclectic in its theoretical sources, it draws on Marxist and Freudian methods, especially as inflected by Michel Foucault, Jacques Derrida, and Jacques Lacan; it also elaborates on modes of thought more anthropological in character, such as "subaltern studies" in India and "cultural studies" in Britain. Even as postcolonial discourse works over the cultural-political residues of colonialism, it also seeks to come to conceptual terms with a present in which the old markers of the colonial world—of centers and peripheries, metropoles and hinterlands, within a globe divided up into First, Second, and Third Worlds— are no longer so relevant. Postcolonial discourse was all but inaugurated by Edward Said with his *Orientalism* (1978), a critique of "the imaginary geography" of the Near East, and it was thereafter developed by Gayatri Spivak, Homi Bhabha, and many others.

postmedium condition

In the sixties and seventies, five separate yet connected phenomena seemed to consign the MEDIUM-SPECIFICITY that had been so central to modernism in history. The first was postminimalism, which saw the concerted dematerialization of the art object into penciled lines on walls, photographic records of walks in the English landscape, and flows of asphalt poured down hillsides. The second was Conceptual art, related to the first in its dependence on photography and its disdain for the material object, since, as one of its founders Joseph Kosuth maintained, its only interest was a naked, and verbal, definition of the word "art." The third phenomenon was the rise of Marcel Duchamp, who seemed to eclipse Pablo Picasso as the most influential artist of the century. The fourth was postmodernism, a movement in painting, sculpture, and architecture that sought to void everything that modernist art had fought for. If the modernist architecture of the Bauhaus and Mies van der Rohe had followed the dictum "form follows function," it was to produce spatial volume that would articulate the principles of its construction in a move toward abstraction. Spurning such abstraction, however, postmodern architects such as Michael Graves and Charles W. Moore made architecture into a species of decoration, imitating the fluted colonnades of classical banks or the lattices of eighteenth-century garden pavilions or "follies." In the domains of painting and sculpture, Italian artists collected under the rubric "trans-avant-garde" abandoned constructed sculpture to return to casting in bronze, and jettisoned the monochrome and other forms of abstraction by importing the classical nudes of fascist realism. The fifth element in the mix was "deconstruction," the intellectual vogue of the late sixties and seventies, centered on the work of French philosopher Jacques Derrida. MEDIUM-SPECIFICITY, as Clement Greenberg had defined it, demanded that the self-reflexive—or "self-critical"—modernist artist determine "the unique and proper area of competence of each art [which] coincided with all that was unique in the nature of its medium." The task of this "self-criticism" was to eliminate from the specific effects of each art any and every effect that might conceivably be borrowed from or by the medium of any other art. Thus "would each art be rendered 'pure,' and in its *purity* find the guarantee of its standards of quality as well as of its independence" (italics added). However, the notions of "proper" and "purity" were linked to the meaning of *propre*, French for both "pure" and "selfhood," concepts that were considered illusory by deconstructionists. Selfhood is consolidated around the consciousness of the subject reflecting on its presence to itself in a grasp of the uniqueness of its specific being, which Derrida derided as the "metaphysics of presence." These concerted attacks on everything that had guaranteed the "specificity" of the medium brought about what some art critics began to refer to as "the postmedium condition," in which contemporary painters and sculptors felt a strong inhibition against reverting to practices that had been voided in the avalanche of postmodernist criticism.

referent

Within structural linguistics it was important to differentiate the idea to which a sign refers from the object it might name. This is because, as its founder, Ferdinand de Saussure, taught, "meaning is oppositive, relative, and negative." This means that meaning forms around oppositions, which the structuralists call "binaries" or "PARADIGMS," with the meaning of something depending on its contrast to what it is not; "high," for example, differentiating itself out from "low," or "black" from "white." The referent is this "relative and negative" result of opposition—not an object, but a concept.

relational aesthetics

Relational aesthetics is a critical term popularized by the French curator and critic Nicolas Bourriaud through several exhibitions and essays, many of which were collected in his influential book *Relational Aesthetics*, published in French in 1998 and translated into English in 2002. The term identifies a kind of art that establishes spaces, situations, or "platforms" designed to host a variety of social activities—often very ordinary ones, such as eating or watching movies, and sometimes more celebratory occasions, such as a parade or music performance. Some of the core artists associated with relational aesthetics, including Pierre Huyghe, Philippe Parreno, Liam Gillick, Dominique Gonzalez-Foerster, and Rirkrit Tiravanija, have described their objective as establishing "open scenarios," which may or may not be entered into by others, thus causing social relations to appear as aesthetic acts—as relational aesthetics. Sometimes these activities occur live as part of the life of the exhibition; at other times they are presented through some form of documentation such as film or video.

semiology / semiotics

In his *Course in General Linguistics*, posthumously published in 1916, Ferdinand de Saussure envisioned a "science that studies the life of signs within society," which he called semiology (from the Greek *semeion*, sign). It would "show what constitutes signs, what laws govern them," and these laws would be applicable to linguistics, which it would include as the science of only one particular system of signs, language. At around the same time, and independently, the American philosopher Charles Sanders Peirce developed his own science of signs, which he called semiotics. "Semiology" and "semiotics" are often used interchangeably, though there are major differences between Saussure's enterprise and that of Peirce. Paradoxically, although Saussure stressed that linguistics was only a part of the future semiology, albeit a privileged one, this discipline modeled itself on linguistics when it developed in the postwar period, to the point that the structuralist author Roland Barthes was led in his *Elements of Semiology* (1964) to reverse Saussure's proposal and state that semiology was in fact depending upon linguistics. This assertion fueled, in turn, Jacques Derrida's criticism of semiology as a LOGOCENTRIC discipline. By contrast, Peirce's semiotics, which consists largely of a TAXONOMY of signs from the point of view of their mode of reference, remained much less dependent upon the linguistic model. Peirce distinguished three categories of signs: the *symbol*, in which the relation between the sign and its referent is arbitrary; the *index*, in which this relation is determined by contiguity or co-presence (a footprint in the sand is an *indexical sign* of a foot, smoke an *indexical sign* of fire, etc.); the *icon*, in which this relation is characterized by resemblance (a painted portrait). These categories are somewhat porous (a photograph is both an index and an icon, for example), and although most linguistic signs are *symbols*, certain categories of words are *indexical signs* (the signification of these words, called *deictics,* change according to their context: "I," "you," "now," "here," etc.), while others, such as onomatopoeias (the moo of a cow, the cock-a-doodle-do of a rooster) are *iconic signs*.

signified / signifier

In his desire to stress the immateriality of the referent, Saussure divided the sign into two parts, one the conceptual domain of the signified, or meaning, the other the material domain of the signifier, or signifying deposit, whether written or auditory.

simulacrum / a

A term in ancient philosophy, a simulacrum is a representation that is not necessarily tied to an object in the world. As a copy without an "original"—in the double sense of both a physical referent and a first version—the simulacrum is often used, in cultural criticism, to describe the status of the image in a society of SPECTACLE, of mass-mediated consumerism. So too, in poststructuralist theory, the simulacrum is called upon to question the Platonic order of representation that adjudicates between "good" and "bad" copies according to their relative truth, or apparent verisimilitude, to models in (or, in Plato, *beyond*) the world. One finds this challenge intermittently posed in twentieth-century art, for example, in the fantastic paintings of René Magritte and in the serial silkscreens of Andy Warhol—images that, even as they appear to be representations, dissolve the truth-claims of most representations. Indeed, the simulacrum is a crucial concept in the understanding of both Surrealist and Pop art, as attested by important texts on these subjects by Gilles Deleuze, Michel Foucault, Roland Barthes, and Jean Baudrillard.

spectacle

Developed in critical debates within the radical European movement the Situationist International (1957–72), "the spectacle" is used to signal a new stage of advanced capitalism, especially evident in the reconstruction period after World II, in which consumption, leisure, and the image (or SIMULACRUM) became more important than ever before in the economies of social and political life. For the lead figure of Situationism, Guy Debord, "the spectacle" is the terrain of new forms of power but, as such, of new strategies of subversion as well, which the Situationists worked both to theorize and to practice. Taken with Marxist notions of "FETISHISM" and "reification," Debord argued in *The Society of the Spectacle* (1967) that the commodity and the image had become structurally one ("the spectacle is capital," he wrote in a famous line, "accumulated to the point where it becomes image"), and that, as a result, a qualitative leap in control had occurred, one that, through consumption, renders its subjects politically passive and socially isolated. The Situationist hope remains that, if power continues to live by the spectacle, it might still be challenged there as well.

sublimation

Within psychoanalysis sublimation remains an elusive concept, never precisely defined by Freud or any of his followers. It concerns the diversion of instincts from sexual to nonsexual aims; these drives are "sublimated"—at once refined and rechanneled—in the pursuit of goals that are more valued, or at least less disruptive, than sexual activity in the society at large: goals of intellect and art (the ones underscored by Freud) but also of law, sport, entertainment, and so on. The energy for this work remains sexual, but the aims are social; indeed, for Freud there is no civilization without sublimation (not to mention repression). However, no firm line exists between the erotic and the aesthetic; and some artists in the twentieth century—Duchamp most famously—liked to point to overlaps between the two. Other artists (e.g., other Dadaists) sought, more aggressively, to reverse the process of sublimation altogether, to break open aesthetic forms to libidinal energies—a strategy sometimes discussed as "DESUBLIMATION."

Symbolic, the

This term has a specific meaning in the psychoanalytic thought of Jacques Lacan that must be distinguished from its general use. In his controversial thought "the Symbolic" represents all phenomena of the psyche that are structured like a language, not, say, formed as images (he terms this adjacent realm of experience "the Imaginary"); such phenomena include, in part, dreams and symptoms (see CONDENSATION and DISPLACEMENT). In effect, Lacan reread the Freudian conception of the unconscious through the structural linguistics of Ferdinand de Saussure and Roman Jakobson (neither of whom Freud could have known). At the same time Lacan conveyed, through the term "the Symbolic," that these linguistic operations of the unconscious are also at work in the social order at large (here he was influenced by his contemporary, the anthropologist Claude Lévi-Strauss): the human subject is inserted into society as into language, and vice versa. In this sense "the Symbolic" also stands for an entire system of identifications and prohibitions—of laws—that each of us must internalize to become functional social beings at all. According to Lacan, our difficulties with this order are often expressed through neuroses; any outright denial of this order is tantamount to psychosis. Suggestive as this model is to some artists and many theorists, it can also project a profoundly conservative attitude to the social order, which is made to appear absolute.

synchronic

Trained as a comparativist historian of language, the founder of structural linguistics Ferdinand de Saussure realized that in order to study the essential structure of language (at least that common to all Indo-European languages), he had to ignore historical developments and examine the cross-section of a language at any given time, past or present, much as a biologist looks at some tissue under a microscope in order to study its cellular structure. This hypothetical cross-section is called synchronic because all its elements are frozen in time. The opposite of synchronic, in Saussure's terminology, is DIACHRONIC.

syncretism

Derived from a Greek word meaning "union of all Cretans," this term was first coined to characterize the work of Proclus (CE 410–485), the last major philosopher of ancient Greece, who attempted a synthesis of all past philosophies and scientific doctrines. Although it did not have any negative connotations at first, and it can still be used in a positive sense, this word is now most commonly used to describe any incoherent combination of contradictory doctrines or systems.

synecdoche

Speech is understood either as literal or figurative, the figures of speech swerving away from the literal names into imagistic relations for things. In The New Science (1725), the Italian philosopher Giambattista Vico wondered how knowledge might be acquired if it were not revealed to man by God. Imagining a caveman, he assumed that his only means to understanding was a comparison of the unknown with the known, which is the savage's own body. Hearing thunder, the savage likens it to what he knows and decides it is a loud voice, this act of likening constituting the poetic form of metaphor. Next the savage wonders about its cause and imagines a very large body producing the voice, this body being, he thinks, that of a god, the notion of cause then constituting the poetic form of METONYMY. Finally the savage wonders why the god should emit the noise and decides this is because the god is angry, the cause or conceptual foundation, constituting for Vico the poetic form of synecdoche. Unsurprisingly, Vico called this progression from the unknown to the known "poetic knowledge." It is poetic knowledge that in turn structures Michel Foucault's influential study of periods of Western historical development, The Order of Things (1970), which he identified as separate epistemes. The Renaissance, he taught, imagines knowledge as based on resemblance, or metaphor. The seventeenth and eighteenth centuries, which he called the Classical period, imagines it as identity and difference, or metonymy; while the nineteenth century, during which the modern disciplines are born, imagines it as analogy and succession, or synecdoche.

syntagm / syntagmatic

First defined by Ferdinand de Saussure as constituting one of the most important elements of language, a syntagm is any succession in the spoken chain of a minimum of two semantic units that cannot be replaced or whose order cannot be changed without changing the meaning or the intelligibility of the utterance. Syntagms can be words ("reread" is made of two units, "re" and "read"), phrases ("human life") or whole sentences ("God is good"). Syntagmatic relations, which he opposed to PARADIGMATIC ones, were particularly important for Saussure, whose primary interest was language as a social fact, in that in them the distinction between the collective and the individual use of language is particularly difficult to distinguish. The case is rather simple when it concerns colloquial syntagms (they belong to common use and thus cannot be changed), but the formation of new words (neologisms) is also governed by rules transmitted by tradition, and thus by common use. After Saussure, Roman Jakobson related METONYMY and metaphor, which he saw as the two main axes of language, respectively to Saussure's conception of syntagmatic and paradigmatic relations.

tachisme

A European toned-down version of Abstract Expressionism, tachisme (from the French tache, meaning "stain," "splash," or "mark") was also referred to as "lyrical abstraction." The main difference between tachiste works and their American counterparts is their modest scale and reliance upon the figurative tradition of landscape. Despite the interest expressed by several tachiste artists for the automatic method favored by Pollock, their art remained highly composed and as such dependent upon a Cubist conception of the picture as a harmonious totality. SEE ART INFORMEL

taxonomy

From the Greek word taxis, meaning "arrangement," taxonomy is the practice or principle of classification or grouping. When the eighteenth-century Swedish botanist Linnaeus drew up a graph as a way of sorting out the orders of living beings, he set the large categories (such as "animal") down one side of the table and called them genus, and the smaller ones (such as "dog," "cat," etc.) across the horizontal axis, calling them species. Such an inclusive graph is a taxonomy.

telos / teleology / teleological

Telos means "goal" or "end" in Greek, and initially teleology designated the study of finality. The first major teleological argument, concluding from the regularities in the operations of nature that all things had a purpose in the universe, was elaborated in the Middle Ages as a proof of God's existence. It was then staunchly refuted during the Enlightenment, first by David Hume in his Dialogues Concerning Natural Religion of 1779, then by Immanuel Kant in his Critique of Pure Reason of 1781. Today the word teleology is used to characterize any theory presupposing or predicting that a process has an end (in both senses of ending and of purpose), or retroactively interpreting a process as geared toward its end. Darwin's theory of evolution, though attacked by the Church upon its inception, is today commonly recognized as teleological, as is Marx's conception of history.

trope

A trope is a figure of speech—a word, phrase, or expression that is used in a figurative way—usually for rhetorical effect. Giambattista Vico's "poetic knowledge" (see SYNECDOCHE) depends on language's figurative potential, its swerve away from the literal into a set of comparisons and contrasts. This swerve is an example of a "trope," the most common of which is metaphor.

zaum

An abbreviation of the Russian word zaumnoe (transrational), the term was coined in 1913 by the futurists Aleksei Kruchenikh and Velemir Khlebnikov to refer to the new poetic language they were inventing, replete with new, nonsensical words and nonrepresentational sounds or, in its written form, groups of letters. Arguing that the word-as-such directly affects our senses and has a meaning independently of its ascribed signification, they sought to bypass the rational use of language and underscored the phonetic materiality of linguistic utterances.

further reading

GENERAL: SURVEY AND SOURCE BOOKS

William C. Agee, *Modern Art in America 1908–1968* (London and New York: Phaidon, 2016)

Michael Archer, *Art Since 1960* (London and New York: Thames & Hudson, 1997; third edition, 2014)

Iwona Blazwick and Magnus Af Petersens (eds), *Adventures of the Black Square: Abstract Art and Society 1915–2015* (New York and London: Prestel and Whitechapel Gallery, 2015)

Herschel Chipp, *Theories of Modern Art: A Source Book by Artists and Critics* (Berkeley: University of California Press, 1968)

Francis Frascina and Jonathan Harris (eds), *Art in Modern Culture: An Anthology of Critical Texts* (London: Phaidon, 1992)

Francis Frascina and Jonathan Harris (eds), *Modern Art and Modernism: A Critical Anthology* (New York: Harper and Row, 1982)

Jason Gaiger and Paul Wood (eds), *Art of the Twentieth Century: A Reader* (New Haven and London: Yale University Press, 2003)

George Heard Hamilton, *Painting and Sculpture in Europe, 1880–1940* (New Haven and London: Yale University Press, 1993)

Charles Harrison, Francis Frascina, and Gill Perry, *Primitivism, Cubism, Abstraction: The Early Twentieth Century* (New Haven and London: Yale University Press, 1993)

Charles Harrison and Paul Wood (eds), *Art in Theory, 1900–2000: An Anthology of Changing Ideas* (Cambridge: Blackwell, 2003)

Robert Hughes, *The Shock of the New* (London: Thames & Hudson, 1991)

David Joselit, *American Art Since 1945* (London: Thames & Hudson, 2003)

Rosalind Krauss, *Passages in Modern Sculpture* (New York: Viking Press, 1977; reprint Cambridge, Mass.: MIT Press, 1981)

Christopher Phillips, *Photography in the Modern Era: European Documents and Critical Writings, 1913–1940* (New York: Metropolitan Museum of Art/Aperture, 1989)

Alex Potts, *The Sculptural Imagination: Figurative, Modernist, Minimalist* (New Haven and London: Yale University Press, 2000)

Kristin Stiles and Peter Selz (eds), *Theories and Documents of Contemporary Art* (Berkeley: University of California Press, 1996)

Paul Wood et al., *Modernism in Dispute: Art Since the Forties* (New Haven and London: Yale University Press, 1993)

Paul Wood et al., *Realism, Rationalism, Surrealism: Art Between the Wars* (New Haven and London: Yale University Press, 1993)

GENERAL: AVANT-GARDE, MODERNISM, POSTMODERNISM

Marcia Brennan, *Modernism's Masculine Subjects: Matisse, the New York School, and Post-Painterly Abstraction* (Cambridge, Mass.: MIT Press, 2004)

Peter Bürger, *Theory of the Avant-Garde* (1974), trans. Michael Shaw (Minneapolis: University of Minnesota Press, 1984)

Douglas Crimp, "Pictures," *October*, no. 8, Spring 1979

Thierry de Duve, *Sewn in the Sweatshops of Marx: Beuys, Warhol, Klein, Duchamp*, trans. Rosalind Krauss (Chicago: University of Chicago Press, 2012)

Hal Foster (ed.), *Discussions in Contemporary Culture* (Seattle: Bay Press, 1987)

Hal Foster (ed.), *The Anti-Aesthetic: Essays on Postmodern Culture* (Seattle: Bay Press, 1983)

Serge Guilbaut (ed.), *Reconstructing Modernism* (Cambridge, Mass.: MIT Press, 1990)

Serge Guilbaut, Benjamin H. D. Buchloh, and David Solkin (eds), *Modernism and Modernity* (Halifax: The Press of the Nova Scotia College of Art and Design, 1983)

Andreas Huyssen, *After the Great Divide: Modernism, Mass Culture, Postmodernism* (Bloomington: Indiana University Press, 1986)

Rosalind Krauss, *"A Voyage on the North Sea": Art in the Age of the Post-Medium Condition* (London: Thames & Hudson, 1999)

Craig Owens, "The Allegorical Impulse: Towards a Theory of Postmodernism," *October*, nos 12 and 13, Spring and Summer 1980

Brian Wallis (ed.), *Art After Modernism: Rethinking Representation* (New York: New Museum of Contemporary Art, 1994)

GENERAL: COLLECTED ESSAYS

Yve-Alain Bois, *Painting as Model* (Cambridge, Mass.: MIT Press, 1991)

Yve-Alain Bois and Rosalind Krauss, *Formless: A User's Guide* (New York: Zone Books, 1997)

Benjamin H. D. Buchloh, *Neo-Avantgarde and Culture Industry: Essays on European and American Art from 1955 to 1975* (Cambridge, Mass.: MIT Press, 2000)

T. J. Clark, *Farewell to an Idea: Episodes from a History of Modernism* (New Haven and London: Yale University Press, 1999)

Thomas Crow, *Modern Art in the Common Culture* (New Haven and London: Yale University Press, 1996)

Thierry de Duve, *Kant after Duchamp* (Cambridge, Mass.: MIT Press, 1996)

Briony Fer, *On Abstract Art* (New Haven and London: Yale University Press, 1997)

Hal Foster, *Prosthetic Gods* (Cambridge, Mass.: MIT Press, 2004)

Hal Foster, *The Return of the Real: The Avant-Garde at the End of the Century* (Cambridge, Mass.: MIT Press, 1996)

Michael Fried, *Art and Objecthood* (Chicago: University of Chicago Press, 1998)

Clement Greenberg, *Art and Culture: Critical Essays* (Boston: Beacon Press, 1961)

Clement Greenberg, *The Collected Essays and Criticism*, vols 1 and 4, ed. John O'Brian (Chicago: University of Chicago Press, 1986 and 1993)

Clement Greenberg, *Homemade Esthetics: Observations on Art and Taste* (Oxford: Oxford University Press, 1999)

Rosalind Krauss, *Bachelors* (Cambridge, Mass.: MIT Press, 1999)

Rosalind Krauss, *The Optical Unconscious* (Cambridge, Mass.: MIT Press, 1993)

Rosalind Krauss, *The Originality of the Avant-Garde and Other Modernist Myths* (Cambridge, Mass.: MIT Press, 1985)

Rosalind E. Krauss, *Perpetual Inventory* (Cambridge, Mass.: MIT Press, 2010)

Meyer Schapiro, *Modern Art: 19th and 20th Century*, *Selected Papers, Vol. 2* (New York: George Braziller, 1978)

Leo Steinberg, "Rodin," *Other Criteria: Confrontations with Twentieth-Century Art* (London, Oxford, and New York: Oxford University Press, 1972)

Anne M. Wagner, *Three Artists (Three Women): Georgia O'Keeffe, Lee Krasner, Eva Hesse* (Berkeley and Los Angeles: University of California Press, 1997)

Peter Wollen, *Raiding the Ice Box: Reflections on Twentieth-Century Culture* (London: Verso, 1993)

GENERAL: THEORY AND METHODOLOGY

Frederick Antal, *Classicism and Romanticism* (London: Routledge & Kegan Paul, 1966)

Roland Barthes, *Critical Essays*, trans. Richard Howard (Evanston: Northwestern University Press, 1972)

Roland Barthes, *Image, Music, Text*, trans. Stephen Heath (New York: Hill and Wang, 1977)

Roland Barthes, *Mythologies* (1957), trans. Annette Lavers (New York: Noonday Press, 1972)

Leo Bersani, *The Freudian Body: Psychoanalysis and Art* (New York: Columbia University Press, 1986)

Walter Benjamin, *Selected Writings*, four volumes, ed. Michael Jennings (Cambridge, Mass.: Harvard University Press, 1999, 2004, and 2006)

Benjamin H. D. Buchloh, *Formalism and Historicity: Models and Methods in Twentieth-Century Art* (Cambridge, Mass.: MIT Press, 2015)

T. J. Clark, *Image of the People: Gustave Courbet and the 1848 Revolution* (London: Thames & Hudson, 1973)

T. J. Clark, *The Absolute Bourgeois: Artists and Politics in France 1848–1851* (London: Thames & Hudson, 1973)

T. J. Clark, *The Painting of Modern Life: Paris in the Art of Manet and his Followers* (London: Thames & Hudson, 1984)

T. J. Clark, *The Sight of Death: An Experiment in Art Writing* (New Haven and London: Yale University Press, 2006)

Thomas Crow, *Painters and Public Life in 18th-Century Paris* (New Haven and London: Yale University Press, 1985).

Thomas Crow, *The Intelligence of Art* (Chapel Hill, N.C.: University of North Carolina Press, 1999)

Whitney Davis, *A General Theory of Visual Culture* (Princeton: Princeton University Press, 2011)

Jacques Derrida, *Of Grammatology*, trans. Gayatri Spivak (Baltimore: The Johns Hopkins University Press, 1976)

Jacques Derrida, "Parergon," *The Truth in Painting*, trans. Geoff Bennington (Chicago and London: University of Chicago Press, 1987)

Jacques Derrida, "The Double Session," *Dissemination*, trans. Barbara Johnson (Chicago and London: University of Chicago Press, 1981)

Michel Foucault, *The Archaeology of Knowledge* (Paris: Gallimard, 1969; translation London: Tavistock Publications; and New York: Pantheon, 1972)

Michel Foucault, "What is an Author?", *Language, Counter-Memory, Practice*, trans. D. Bouchard and S. Simon (Ithaca, N.Y.: Cornell University Press, 1977)

Sigmund Freud, *Art and Literature*, trans. James Strachey (London: Penguin, 1985)

Nicos Hadjinicolaou, *Art History and Class Struggle* (London: Pluto Press, 1978)

Arnold Hauser, *The Social History of Art* (1951), four volumes (London: Routledge, 1999)

Fredric Jameson, *The Prison-House of Language: A Critical Account of Structuralism and Russian Formalism* (Princeton: Princeton University Press, 1972)

Fredric Jameson (ed.), *Aesthetics and Politics* (London: New Left Books, 1977)

Richard Kearney and David Rasmussen, *Continental Aesthetics—Romanticism to Postmodernism: An Anthology* (Malden, Mass. and Oxford: Blackwell, 2001)

Francis Klingender, *Art and the Industrial Revolution* (1947) (London: Paladin Press, 1975)

Sarah Kofman, *The Childhood of Art: An Interpretation of Freud's Aesthetics*, trans. Winifred Woodhull (New York: Columbia University Press, 1988)

Jean Laplanche and J.-B. Pontalis, *The Language of Psychoanalysis*, trans. Donald Nicholson-Smith (New York: W. W. Norton, 1973)

Thomas Levin, "Walter Benjamin and the Theory of Art History," *October*, no. 47, Winter 1988

Jacqueline Rose, *Sexuality in the Field of Vision* (London: Verso, 1986)

Ferdinand de Saussure, *Course in General Linguistics*, trans. Wade Baskin (New York: McGraw-Hill, 1966)

Meyer Schapiro, *Theory and Philosophy of Art: Style, Artist, and Society*, *Selected Papers*, *Vol. 4* (New York: George Braziller, 1994)

Richard Shone and John-Paul Stonard (eds), *The Books that Shaped Art History: From Gombrich and Greenberg to Alpers and Krauss* (London and New York: Thames & Hudson, 2013)

VIENNESE AVANT-GARDE

Walter Benjamin, "The Paris of the Second Empire in Baudelaire," in *Charles Baudelaire: A Lyric Poet in the Era of High Capitalism* (London: New Left Books, 1973)

Gemma Blackshaw, *Facing the Modern: The Portrait in Vienna 1900* (London: National Gallery, 2013)

Gemma Blackshaw and Leslie Topp (eds), *Madness and Modernity: Mental Illness and the Visual Arts in Vienna 1900* (London: Lund Humphries, 2009)

Allan Janik and Stephen Toulmin, *Wittgenstein's Vienna* (New York: Simon and Schuster, 1973)

Adolf Loos, "Ornament and Crime," in Ulrich Conrads (ed.), *Programs and Manifestoes on 20th-Century Architecture* (Cambridge, Mass.: MIT Press, 1975)

Carl E. Schorske, *Fin-de-Siècle Vienna: Politics and Culture* (New York: Vintage Books, 1980)

Kirk Varnedoe, *Vienna 1900: Art, Architecture, and Design* (New York: Museum of Modern Art, 1985)

MATISSE AND FAUVISM

Alfred H. Barr, Jr., *Matisse: His Art and His Public* (New York: Museum of Modern Art, 1951)

Roger Benjamin, *Matisse's "Notes of a Painter": Criticism, Theory, and Context, 1891–1908* (Ann Arbor: UMI Research Press, 1987)

Yve-Alain Bois, "Matisse and Arche-drawing," *Painting as Model* (Cambridge, Mass.: MIT Press, 1990)

Yve-Alain Bois, *Matisse and Picasso* (New York: Flammarion Press, 1998)

Yve-Alain Bois, "On Matisse: The Blinding," *October*, no. 68, Spring 1994

Marcia Brennan, *Modernism's Masculine Subjects: Matisse, the New York School, and Post-Painterly Abstraction* (Cambridge, Mass.: MIT Press, 2004)

John Elderfield, "Describing Matisse," *Henri Matisse: A Retrospective* (New York: Museum of Modern Art, 1992)

John Elderfield, *The "Wild Beasts": Fauvism and its Affinities* (New York: Museum of Modern Art, 1976)

Jack D. Flam, (ed.), *Matisse on Art* (Berkeley and Los Angeles: University of California Press, 1995)

Jack D. Flam, *Matisse: The Man and His Art, 1869–1918* (Ithaca, N.Y. and London: Cornell University Press, 1986)

Judi Freeman (ed.), *The Fauve Landscape* (New York: Abbeville Press, 1990)

Lawrence Gowing, *Matisse* (London: Thames & Hudson, 1976)

James D. Herbert, *Fauve Painting: The Making of Cultural Politics* (New Haven and London: Yale University Press, 1992)

John Klein, *Matisse Portraits* (New Haven and London: Yale University Press, 2001)

John O'Brian, *Ruthless Hedonism: The American Reception of Matisse* (Chicago and London: Chicago University Press, 1999)

Margaret Werth, *The Joy of Life: The Idyllic in French Art, Circa 1900* (Berkeley: University of California Press, 2002)

Alastair Wright, *Matisse and the Subject of Modernism* (Princeton: Princeton University Press, 2004)

Yve-Alain Bois (ed.), *Matisse in the Barnes Foundation* (London and New York: Thames & Hudson, 2016)

PRIMITIVISM

James Clifford, "Histories of the Tribal and the Modern," *The Predicament of Culture* (Cambridge, Mass.: Harvard University Press, 1988)

Hal Foster, "The 'Primitive' Unconscious of Modern Art," *October*, no. 34, Fall 1985

Jack D. Flam (ed.), *Primitivism and Twentieth-Century Art: A Documentary History* (Berkeley: University of California Press, 2003)

Robert Goldberg, *Primitivism in Modern Art* (1938) (New York: Vintage Books, 1967)

Colin Rhodes, *Primitivism and Modern Art* (London: Thames & Hudson, 1994)

William Rubin (ed.), *"Primitivism" in 20th Century Art: Affinity of the Tribal and the Modern* (New York: Museum of Modern Art, 1984)

EXPRESSIONISM

Aesthetics and Politics: Debates between Ernst Bloch, Georg Lukács, Bertolt Brecht, Walter Benjamin, Theodor Adorno (London: New Left Review Books, 1977)

Vivian Endicott Barnett, Michael Baumgartner, Annegret Hoberg, and Christine Hopfengart, *Klee and Kandinsky: Neighbors, Friends, Rivals* (London and New York: Prestel, 2015)

Stephanie Barron, *German Expressionism: Art and Society* (New York: Rizzoli, 1997)

Timothy O. Benson (ed.), *Expressionism in Germany and France: From Van Gogh to Kandinsky* (Los Angeles and New York: Los Angeles County Museum of Art and Prestel, 2014)

Lisa Florman, *Concerning the Spiritual—and the Concrete—in Kandinsky's Art* (Palo Alto: Stanford University Press, 2014)

Donald Gordon, *Expressionism: Art and Idea* (New Haven and London: Yale, 1987)

Donald Gordon, "On the Origin of the Word 'Expressionism'," *Journal of the Warburg and Courtauld Institutes*, vol. 29, 1966

Charles Haxthausen, "'A New Beauty': Ernst Ludwig Kirchner's Images of Berlin," in Charles Haxthausen and Heidrun Suhr (eds), *Berlin: Culture and Metropolis* (Minneapolis: University of Minnesota Press, 1990)

Yule Heibel, "They Danced on Volcanoes: Kandinsky's Breakthrough to Abstraction, the German Avant-Garde and the Eve of the First World War," *Art History*, 12, September 1989

Siegfried Kracauer, *From Caligari to Hitler: A Psychological History of German Film* (Princeton: Princeton University Press, 1947)

Wassily Kandinsky, *Concerning the Spiritual in Art* (1912) (New York: Dover Publications, 1977)

Wassily Kandinsky and Franz Marc (eds), *The Blaue Reiter Almanac* (London: Thames & Hudson, 1974)

Angela Lampe and Brady Roberts (eds), *Kandinsky: A Retrospective* (Paris: Centre Georges Pompidou and Milwaukee Art Museum, 2014)

Carolyn Lanchner (ed.), *Paul Klee* (New York: Museum of Modern Art, 1987)

Jill Lloyd, *German Expressionism: Primitivism and Modernity* (New Haven and London: Yale University Press, 1991)

Bibiana K. Obler, *Intimate Collaborations: Kandinsky and Münter, Arp and Taeuber* (New Haven: Yale University Press, 2014)

Rose-Carol Washton Long, *German Expressionism: Documents from the End of the Wilhelmine Empire to the Rise of National Socialism* (New York: Macmillan International, 1993)

Joan Weinstein, *The End of Expressionism: Art and the November Revolution in Germany, 1918–1919* (Chicago: University of Chicago Press, 1990)

O. K. Werckmeister, *The Making of Paul Klee's Career 1914–1920* (Chicago and London: Chicago University Press, 1988)

CUBISM AND PICASSO

Mark Antliff and Patricia Leighten, *Cubism and Culture* (London: Thames & Hudson, 2001)

Alfred H. Barr, Jr., *Cubism and Abstract Art* (New York: Museum of Modern Art, 1936)

Yve-Alain Bois, "Kahnweiler's Lesson", *Painting as Model* (Cambridge, Mass.: MIT Press, 1990)

Yve-Alain Bois, "The Semiology of Cubism," in Lynn Zelevansky (ed.), *Picasso and Braque: A Symposium* (New York: Museum of Modern Art, 1992)

T. J. Clark, *Picasso and Truth: From Cubism to Guernica* (Princeton: Princeton University Press, 2013)

David Cottington, *Cubism in the Shadow of War: The Avant-Garde and Politics in Paris 1905–1914* (New Haven and London: Yale University Press, 1998)

Lisa Florman, *Myth and Metamorphosis: Picasso's Classical Prints of the 1930s* (Cambridge, Mass.: MIT Press, 2000)

Edward Fry, *Cubism* (London: Thames & Hudson, 1966)

John Golding, *Cubism: A History and an Analysis, 1907–1914* (New York: G. Wittenborn, 1959)

Christopher Green, *Juan Gris* (New Haven and London: Yale University Press, 1992)

Christopher Green (ed.), *Picasso's Les Demoiselles d'Avignon* (Cambridge: Cambridge University Press, 2001)

Clement Greenberg, "The Pasted Paper Revolution" (1958), *The Collected Essays and Criticism*, vols 1 and 4, ed. John O'Brian (Chicago: University of Chicago Press, 1986 and 1993)

Daniel-Henry Kahnweiler, *The Rise of Cubism*, trans. Henry Aronson (New York: Wittenborn, Schultz, 1949)

Rosalind Krauss, "In the Name of Picasso," *The Originality of the Avant-Garde and Other Modernist Myths* (Cambridge, Mass.: MIT Press, 1985)

Rosalind Krauss, "Re-Presenting Picasso," *Art in America*, vol. 67, no. 10, December 1980

Rosalind Krauss, "The Motivation of the Sign," in Lynn Zelevansky (ed.), *Picasso and Braque: A Symposium* (New York: Museum of Modern Art, 1992)

Rosalind Krauss, *The Picasso Papers* (New York: Farrar, Straus & Giroux, 1998)

Fernand Léger, *Functions of Painting*, ed. Edward Fry (London: Thames & Hudson, 1973)

Patricia Leighten, *Re-Ordering the Universe: Picasso and Anarchism, 1897–1914* (Princeton: Princeton University Press, 1989)

Marilyn McCully (ed.), *A Picasso Anthology: Documents, Criticism, Reminiscences* (Princeton: Princeton University Press, 1982)

Christine Poggi, *In Defiance of Painting: Cubism, Futurism, and the Invention of Collage* (New Haven and London: Yale University Press, 1992)

Robert Rosenblum, *Cubism and Twentieth-Century Art* (New York: Harry N. Abrams, 1960, revised 1977)

William Rubin, "Cezannism and the Beginnings of Cubism," *Cezanne: The Late Work* (New York: Museum of Modern Art, 1977)

William Rubin, "From Narrative to Iconic: The Buried Allegory in *Bread and Fruitdish on a Table* and the Role of *Les Demoiselles d'Avignon*," *Art Bulletin*, vol. 65, December 1983

William Rubin, "Pablo and Georges and Leo and Bill," *Art in America*, vol. 67, March–April 1979

William Rubin, *Picasso and Braque: Pioneering Cubism* (New York: Museum of Modern Art, 1989)

William Rubin, "The Genesis of *Les Demoiselles d'Avignon*," *Studies in Modern Art* (special *Les Demoiselles d'Avignon* issue), Museum of Modern Art, New York, no. 3, 1994 (chronology by Judith Cousins and Hélène Seckel, critical anthology of early commentaries by Hélène Seckel)

Leo Steinberg, "Resisting Cezanne: Picasso's Three Women," *Art in America*, vol. 66, no. 6, November–December 1978

Leo Steinberg, "The Algerian Women and Picasso at Large," *Other Criteria: Confrontations with Twentieth-Century Art* (London, Oxford, and New York: Oxford University Press, 1972)

Leo Steinberg, "The Philosophical Brothel" (1972), *October*, no. 44, Spring 1988

Leo Steinberg, "The Polemical Part," *Art in America*, vol. 67, March–April 1979

Ann Temkin and Anne Umland (eds), *Picasso Sculpture* (New York: Museum of Modern Art, 2015)

Jeffrey Weiss (ed.), *Picasso: The Cubist Portraits of Fernande Olivier* (Washington, D.C.: National Gallery of Art; and Princeton: Princeton University Press, 2003)

Lynn Zelevansky (ed.), *Picasso and Braque: A Symposium* (New York: Museum of Modern Art, 1992)

FUTURISM AND VORTICISM

Mark Antliff and Scott Klein (eds), *Vorticism: New Perspectives* (Oxford: Oxford University Press, 2013)

Germano Celant, *Futurism and the International Avant-Garde* (Philadelphia: Philadelphia Museum of Art, 1980)

Hal Foster, *Prosthetic Gods* (Cambridge, Mass.: MIT Press, 2004)

Anne Coffin Hanson, *The Futurist Imagination* (New Haven and London: Yale University Press, 1983)

Pontus Hulten (ed.), *Futurism and Futurisms* (New York: Abbeville Press; and London: Thames & Hudson, 1986)

Wyndham Lewis (ed.), *Blast* (London: Thames & Hudson, 2009)

Marianne W. Martin, *Futurist Art and Theory 1909–1915* (Oxford: Clarendon Press, 1968)

Marjorie Perloff, *The Futurist Moment: Avant-Garde, Avant Guerre, and the Language of Rupture* (Chicago: University of Chicago Press, 1986)

Apollonio Umbro (ed.), *Futurist Manifestoes* (London: Thames & Hudson, 1973)

DADA

Dawn Ades (ed.), *Dada and Surrealism Reviewed* (London: Arts Council of Great Britain, 1978)

Jenny Anger, *Paul Klee and the Decorative in Modern Art* (Cambridge and New York: Cambridge University Press, 2004)

George Baker, *The Artwork Caught by the Tail: Francis Picabia and Dada in Paris* (Cambridge, Mass.: MIT Press, 2007)

Hugo Ball, *Flight Out of Time: A Dada Diary* (New York: Viking Press, 1974)

Timothy Benton (ed.), *Hans Richter: Encounters* (Los Angeles: LACMA, 2013)

Annie Bourneuf, *Paul Klee: The Visible and the Legible* (Chicago: University of Chicago Press, 2015)

William Camfield, *Francis Picabia: His Art, Life, and Times* (Princeton: Princeton University Press, 1979)

Leah Dickerman (ed.), *Dada* (Washington: National Gallery of Art, 2005)

Brigid Doherty, *Montage: The Body and the Work of Art in Dada, Brecht, and Benjamin* (Berkeley: University of California Press, 2004)

John Elderfield, *Kurt Schwitters* (London: Thames & Hudson, 1985)

Hal Foster, *Prosthetic Gods* (Cambridge, Mass.: MIT Press, 2004)

Maud Lavin, *Cut with the Kitchen Knife: The Weimar Photomontages of Hannah Höch* (New Haven and London: Yale University Press, 1993)

Andreas Marti (ed.), *Paul Klee: Hand Puppets* (Bern: Zentrum Paul Klee, 2006)

Robert Motherwell, *The Dada Painters and Poets: An Anthology* (New York: Wittenborn, Schultz, 1951)

Francis Naumann, *New York Dada, 1915–1923* (New York: Abrams, 1994)

Anson Rabinbach, *In the Shadow of Catastrophe: German Intellectuals Between Apocalypse and Enlightenment* (Berkeley: University of California Press, 1997)

Ruth Hemus, *Dada's Women* (New Haven and London: Yale University Press, 2009)

Hans Richter, *Dada: Art and Anti-Art* (New York: McGraw-Hill, 1965)

William Rubin, *Dada, Surrealism, and Their Heritage* (New York: Museum of Modern Art, 1968)

Isabel Schulz (ed.), *Kurt Schwitters: Color and Collage* (New Haven and London: Yale University Press, 2010)

Richard Sheppard, *Modernism—Dada—Postmodernism* (Chicago: Northwestern University Press, 1999)

Anne Umland and Adrian Sudhalter (eds), *Dada in the Collection of the Museum of Modern Art* (New York: Museum of Modern Art, 2008)

Michael White, *Generation Dada: The Berlin Avant-Garde and the First World War* (New Haven: Yale University Press, 2013)

DUCHAMP

Dawn Ades, Neil Cox, and David Hopkins, *Marcel Duchamp* (London: Thames & Hudson, 1999)

Martha Buskirk and Mignon Nixon (eds), *The Duchamp Effect* (Cambridge, Mass.: MIT Press, 1998)

Pierre Cabanne, *Dialogues with Duchamp* (New York: Da Capo Press, 1979)

T. J. Demos, *The Exiles of Marcel Duchamp* (Cambridge, Mass.: MIT Press, 2007)

Thierry de Duve, *Kant After Duchamp* (Cambridge, Mass.: MIT Press, 1996)

Thierry de Duve, *Pictorial Nominalism: On Marcel Duchamp's Passage from Painting to the Readymade* Minneapolis: University of Minnesota Press, 1991)

Thierry de Duve (ed.), *The Definitively Unfinished Marcel Duchamp* (Halifax: The Press of the Nova Scotia College of Art and Design, 1991)

Linda Dalrymple Henderson, *Duchamp in Context: Science and Technology in the Large Glass and Related Works* (Princeton: Princeton University Press, 1998)

David Joselit, *Infinite Regress: Marcel Duchamp, 1910–1914* (Cambridge, Mass.: MIT Press, 1998)

Rudolf Kuenzli and Francis M. Naumann (eds), *Marcel Duchamp: Artist of the Century* (Cambridge, Mass.: MIT Press, 1989)

Robert Lebel, *Marcel Duchamp*, trans. George Heard Hamilton (New York: Grove Press, 1959)

Francis M. Naumann and Hector Obalk (eds), *Affect t l Marcel.: The Selected Correspondence of Marcel Duchamp* (London: Thames & Hudson, 2000)

Molly Nesbit, *Their Common Sense* (London: Black Dog Publishing, 2001)

Arturo Schwarz, *Complete Works of Marcel Duchamp* (New York: Delano Greenridge Editions, 2000)

MONDRIAN AND DE STIJL

Carel Blotkamp, *Mondrian: The Art of Destruction* (New York: Harry N. Abrams, 1994)

Carel Blotkamp et al., *De Stijl: The Formative Years* (Cambridge, Mass.: MIT Press, 1986)

Yve-Alain Bois, "Mondrian and the Theory of Architecture," *Assemblage*, 4, October 1987)

Yve-Alain Bois, "The De Stijl Idea" and "Piet Mondrian: *New York City*," *Painting as Model* (Cambridge, Mass.: MIT Press, 1990)

Yve-Alain Bois, Joop Joosten, and Angelica Rudenstine, *Piet Mondrian* (Washington, D.C.: National Gallery of Art, 1994)

Harry Cooper, *Mondrian: The Transatlantic Paintings* (Cambridge, Mass.: Harvard University Art Museums, 2001)

Gladys Fabre and Doris Wintgens Hötte (eds), *Van Doesburg and the International Avant-Garde* (London: Tate Publishing, 2009)

Hans L. C. Jaffé (ed.), *De Stijl* (London: Thames & Hudson, 1970)

Joop Joosten, "Mondrian: Between Cubism and Abstraction," *Piet Mondrian Centennial Exhibition* (New York: Guggenheim, 1971)

Joop Joosten and Robert P. Welsh, *Piet Mondrian*, catalogue raisonné, two volumes (New York: Harry N. Abrams, 1998)

Francesco Manacorda and Michael White (eds), *Mondrian and His Studios: Colour in Space* (London: Tate Publishing, 2015)

Annette Michelson, "De Stijl, It's Other Face: Abstraction and Cacophony, Or What Was the Matter with Hegel?," *October*, no. 22, Fall 1982

Piet Mondrian, *The New Art—The New Life: The Collected Works of Piet Mondrian*, ed. and trans. Harry Holtzman and Martin S. James (Boston: G. K. Hall and Co., 1986)

Nancy Troy, *The De Stijl Environment* (Cambridge, Mass.: MIT Press, 1983)

Nancy Troy, *The Afterlife of Piet Mondrian* (Chicago: University of Chicago Press, 2014)

Michael White, *De Stijl and Dutch Modernism* (Manchester and New York: Manchester University Press, 2003)

RUSSIAN AVANT-GARDE, SUPREMATISM, AND CONSTRUCTIVISM

Troels Andersen, *Malevich* (Amsterdam: Stedelijk Museum, 1970)

Richard Andrews and Milena Kalinovska (eds), *Art into Life: Russian Constructivism 1914–32* (Seattle: Henry Art Gallery; and New York: Rizzoli, 1990)

Stephen Bann (ed.), *The Tradition of Constructivism* (London: Thames & Hudson, 1974)

Yve-Alain Bois, "El Lissitzky: Radical Reversibility," *Art in America*, vol. 76, no. 4, April 1988

Yve-Alain Bois, Aleksandra Shatskikh, and Magdalena Dabrowski, *Malevich and the American Legacy* (London and New York: Prestel, 2011)

Achim Borchardt-Hume (ed.), *Kazimir Malevich* (London: Tate Publishing, 2013)

John Bowlt (ed.), *Russian Art of the Avant-Garde: Theory and Criticism* (London: Thames & Hudson, 1988)

Benjamin H. D. Buchloh, "Cold War Constructivism" in Serge Guibaut (ed.), *Reconstructing Modernism* (Cambridge, Mass.: MIT Press, 1990)

Benjamin H. D. Buchloh, "From Faktura to Factography," *October*, no. 30, Fall 1984

Rainer Crone and David Moos, *Kazemir Malevich: The Climax of Disclosure* (Chicago: University of Chicago Press, 2015)

Magdalena Dabrowski, Leah Dickerman, and Peter Galassi, *Aleksandr Rodchenko* (New York: Museum of Modern Art, 1998)

Charlotte Douglas, "Birth of a 'Royal Infant': Malevich and 'Victory Over the Sun'," *Art in America*, vol. 62, no. 2, March/April 1974

Matthew Drutt (ed.), *Kasimir Malevich: Suprematism* (New York: Guggenheim Museum, 2003)

Hal Foster, "Some Uses and Abuses of Russian Constructivism," *Art into Life: Russian Constructivism, 1914–1932* (Seattle: Henry Art Gallery; and New York: Rizzoli, 1990)

Hubertus Gassner, "Analytical Sequences," in David Elliot (ed.), *Rodchenko and the Arts of Revolutionary Russia* (New York: Pantheon, 1979)

Hubertus Gassner, "John Heartfield in the USSR," *John Heartfield* (New York: Museum of Modern Art, 1992)

Hubertus Gassner, "The Constructivists: Modernism on the Way to Modernization," *The Great Utopia* (New York: Guggenheim Museum, 1992)

Maria Gough, "In the Laboratory of Constructivism: Karl Ioganson's Cold Structures," *October*, no. 84, Spring 1998

Maria Gough, "Tarabukin, Spengler, and the Art of Production," *October*, no. 93, Summer 2000

Camilla Gray, *The Great Experiment: Russian Art 1863–1922* (1962), republished as *The Russian Experiment in Art 1863–1922* (London: Thames & Hudson, 1986)

Selim O. Khan-Magomedov, *Rodchenko: The Complete Work* (Cambridge, Mass.: MIT Press, 1987)

Christina Kiaer, "Rodchenko in Paris," *October*, no. 75, Winter 1996

Christina Kiaer, *Imagine No Possessions: The Socialist Objects of Russian Constructivism* (Cambridge, Mass.: MIT Press, 2005)

Alexei Kruchenykh, "Victory over the Sun," *Drama Review*, no. 15, Fall 1971

El Lissitzky, *El Lissitzky: Life, Letters, Texts*, ed. Sophie Lissitzky-Kuppers (London: Thames & Hudson, 1968)

Sophie Lissitzky-Küppers, *El Lissitzky: Life-Letters-Texts* (London: Thames & Hudson, 1968)

Christina Lodder, *Russian Constructivism* (New Haven and London: Yale University Press, 1983)

Nancy Perloff and Brian Reed (eds), *Situating El Lissitzky: Vitebsk, Berlin, Moscow* (Los Angeles: Getty Research Institute, 2003)

Margit Rowell, "Vladimir Tatlin: Form/Faktura," *October*, no. 7, Winter 1978

Margit Rowell and Deborah Wye (eds), *The Russian Avant-Garde Book 1910–1934* (New York: Museum of Modern Art, 2002)

Herbert Spencer, *Pioneers of Modern Typography*, revised edition (Cambridge, Mass: MIT Press, 2004)

Margarita Tupitsyn, "From the Politics of Montage to the Montage of Politics: Soviet Practice, 1919 through 1937," in Matthew Teitelbaum (ed.), *Montage and Modern Life, 1919–1942* (Cambridge, Mass.: MIT Press, 1992)

Margarita Tupitsyn et al., *El Lissitzky—Beyond the Abstract Cabinet: Photography, Design, Collaboration* (New Haven and London: Yale University Press, 1999)

Larisa Zhadova, *Malevich: Suprematism and Revolution in Russian Art 1910–1930* (New York: Thames & Hudson, 1982)

Larisa Zhadova (ed.), *Tatlin* (New York: Rizzoli, 1988)

PURISM, NEUE SACHLICHKEIT, AND THE RETURN TO ORDER

Stephanie Barron and Sabine Eckmann (eds), *New Objectivity: Modern German Art in the Weimar Republic 1919–1933* (New York: Prestel, DelMonico Books, and LACMA, 2015)

Gottfried Boehm, Ulrich Mosch, and Katharina Schmidt (eds), *Canto d'Amore: Classicism in Modern Art and Music, 1914–1945* (Basel: Kunstmuseum, 1996)

Benjamin H. D. Buchloh, "Figures of Authority, Ciphers of Regression: Notes on the Return of Representation in European Painting," *October*, no. 16, Spring 1981

Carol S. Eliel, *L'Esprit Nouveau: Purism in Paris 1918–1925* (Los Angeles and New York: Los Angeles County Museum of Art and Abrams, 2001)

Romy Golan, *Modernity and Nostalgia: Art and Politics in France Between the Wars* (New Haven and London: Yale University Press, 1995)

Christopher Green, *Cubism and its Enemies: Modern Movements and Reaction in French Art, 1916–1928* (New Haven and London: Yale University Press, 1987)

Jeffrey Herf, *Reactionary Modernism: Technology, Culture, and Politics in Weimar and the Third Reich* (Cambridge, Mass.: MIT Press, 1990)

Anton Kaes, Martin Jay, and Edward Dimendberg (eds), *Weimar Republic Sourcebook* (Berkeley: University of California Press, 1994)

Nina Rosenblatt, "Empathy and Anaesthesia: On the Origins of a French Machine Aesthetic," *Grey Room*, no. 2, Winter 2001

Kenneth Silver, *Esprit de Corps* (Princeton: Princeton University Press, 1989)

BAUHAUS AND PREWAR GERMAN MODERNISM

Herbert Bayer, Walter Gropius, and Ise Gropius, *Bauhaus 1919–1928* (New York: Museum of Modern Art, 1938)

Christopher Burke, *Active Literature: Jan Tschichold and New Typography* (London: Hyphen Press, 2007)

Arthur A. Cohen, *Herbert Bayer: The Complete Work* (Cambridge, Mass: MIT Press, 1984)

Éva Forgács, *The Bauhaus Idea and Bauhaus Politics* (Budapest: Central European University Press, 1995)

Margaret Kentgens-Craig, *The Bauhuas and America: First Contacts 1919–1936* (Cambridge, Mass.: MIT Press, 1996)

Mary Emma Harris, *The Arts at Black Mountain College* (Cambridge, Mass.: MIT Press, 1987)

Margret Kentgens-Craig, *The Bauhaus and America: First Contacts 1919–1936*, trans. Lynette Widder (Cambridge, Mass.: MIT Press, 1999)

Richard Kostelanetz (ed.), *Moholy-Nagy* (London: Allen Lane, 1971)

Ruari McLean, *Jan Tschichold: Typographer* (Boston: David R. Godine, 1975)

László Moholy-Nagy, *An Anthology*, ed. Richard Kostelanetz (New York: Da Capo Press, 1970)

László Moholy-Nagy, *Painting, Photography, Film* (1927), trans. Janet Seligman (Cambridge, Mass.: MIT Press, 1969)

László Moholy-Nagy, *The New Vision* (New York: Wittenborn, Schultz, 1947)

Herbert Spencer, *Pioneers of Modern Typography*, revised edition (Cambridge, Mass: MIT Press, 2004)

Frank Whitford, *Bauhaus* (New York: Thames & Hudson, 1984)

Frank Whitford (ed.), *The Bauhaus: Masters and Students by Themselves* (Woodstock, N.Y.: The Overlook Press, 1992)

Hans Wingler, *The Bauhaus: Weimar, Dessau, Berlin, Chicago* (Cambridge, Mass.: MIT Press, 1969)

EARLY AMERICAN MODERNISM

Allan Antliff, *Anarchist Modernism: Art, Politics, and the First American Avant-Garde* (Chicago: University of Chicago Press, 2007)

Stephanie Barron and Lisa Mark (eds), *Calder and Abstraction: From Avant-Garde to Iconic* (New York: Del Monico Books, 2013)

Achim Borchardt-Hume (ed.), *Alexander Calder: Performing Sculpture* (New Haven: Yale University Press, 2016)

Marcia Brennan, *Painting Gender, Constructing Theory: The Alfred Stieglitz Circle and American Formalist Aesthetics* (Cambridge, Mass.: MIT Press, 2001)

Erin B. Coe, Bruce Robertson, and Gwendolyn Owens, *Modern Nature: Georgia O'Keeffe and Lake George* (London and New York: Thames & Hudson, 2013)

Helen Molesworth, *Leap Before You Look: Black Mountain College 1933–1957* (New Haven: Yale University Press, 2015)

Mark Rawlinson, *Charles Sheeler: Modernism, Precisionism and the Borders of Abstraction* (London: I. B. Tauris, 2007)

Terry Smith, *Making the Modern: Industry, Art, and Design in America* (Chicago: University of Chicago Press, 1993)

SURREALISM

Dawn Ades (ed.), *Dada and Surrealism Reviewed* (London: Arts Council of Great Britain, 1978)

Dawn Ades and Simon Baker, *Undercover Surrealism: Georges Bataille and Documents* (Cambridge, Mass.: MIT Press, 2006)

Dawn Ades, Michael Richardson, and Krzysztof Fijalkowski (eds), *The Surrealism Reader: An Anthology of Ideas* (Chicago: University of Chicago Press, 2016)

Matthew Affron, and Sylvie Ramond (eds), *Joseph Cornell and Surrealism* (University Park, Penn.: Penn State University Press, 2015)

Anna Balakian, *Surrealism: The Road to the Absolute* (Cambridge: Cambridge University Press, 1986)

Yve-Alain Bois and Rosalind Krauss, *Formless: A User's Guide* (New York: Zone Books, 1997)

André Breton, "Introduction to the Discourse on the Paucity of Reality," *October*, no. 69, Summer 1994

André Breton, *Mad Love*, trans. Mary Ann Caws (Lincoln: University of Nebraska Press, 1980)

André Breton, *Manifestoes of Surrealism*, trans. Richard Seaver and Helen R. Lane (Ann Arbor: University of Michigan Press, 1972)

André Breton, *Nadja*, trans. Richard Howard (New York: Grove Weidenfeld, 1960)

André Breton, *What is Surrealism?*, trans. David Gascoyne (New York: Haskell House Publishers,1974)

William Camfield, *Max Ernst: Dada and the Dawn of Surrealism* (Munich: Prestel, 1993)

Mary Ann Caws (ed.), *Surrealist Painters and Poets: An Anthology* (Cambridge, Mass.: MIT Press, 2001)

Jacqueline Chenieux-Gendron, *Surrealism* (New York: Columbia University Press, 1990)

Herschel B. Chipp, *Picasso's Guernica: History, Transformations, Meaning* (Berkeley and Los Angeles: University of California Press, 1988)

Hal Foster, *Compulsive Beauty* (Cambridge, Mass.: MIT Press, 1993)

Michel Foucault, *This is Not a Pipe* (Berkeley: University of California Press, 1982)

Francis Frascina, "Picasso, Surrealism and Politics in 1937," in Silvano Levy (ed.), *Surrealism: Surrealist Visuality* (New York: New York University Press, 1997)

Carlo Ginzburg, "The Sword and the Lightbulb: A Reading of *Guernica*," in Michael S. Roth and Charles G. Salas (eds), *Disturbing Remains: Memory, History, and Crisis in the Twentieth Century* (Los Angeles: Getty Research Institute, 2001)

Jutta Held, "How do the political effects of pictures come about? The case of Picasso's *Guernica*," *Oxford Art Journal*, vol. 11, no. 1, 1988, pp. 38–9

Gijs van Hensbergen, *Guernica: The Biography of a Twentieth-Century Icon* (London and New York: Bloomsbury, 2004)

Denis Hollier, *Against Architecture: The Writings of Georges Bataille*, trans. Betsy Wing (Cambridge, Mass.: MIT Press, 1989)

Denis Hollier, *Absent Without Leave: French Literature Under the Threat of War*, trans. Catherine Porter (Cambridge, Mass.: Harvard University Press, 1997)

Rosalind Krauss, *The Optical Unconscious* (Cambridge, Mass.: MIT Press, 1993)

Rosalind Krauss and Jane Livingston, *L'Amour fou: Surrealism and Photography* (New York: Abbeville Press, 1986)

Alyce Mahon, *Surrealism and the Politics of Eros 1938–1968* (London: Thames & Hudson, 2005)

Jennifer Mundy (ed.), *Surrealism: Desire Unbound* (London: Tate Publishing, 2001)

Maurice Nadeau, *History of Surrealism* (New York: Macmillan, 1965)

Sidra Stich, "Picasso's Art and Politics in 1936," *Arts Magazine*, vol. 58, October 1983, pp. 113–18

Dickran Tashjian, *A Boatload of Madmen: Surrealism and the American Avant-Garde 1920–1950* (London: Thames & Hudson, 2002)

Lynne Warren, *Alexander Calder and Contemporary Art: Form, Balance, Joy* (London: Thames & Hudson, 2010)

MEXICAN MURALISTS

Alejandro Anreus, *Orozco in Gringoland: The Years in New York* (Albuquerque: University of New Mexico Press, 2001)

Jacqueline Barnitz, *Twentieth-Century Art of Latin America* (Austin, Texas: University of Texas Press, 2001)

Linda Downs, *Diego Rivera: A Retrospective* (New York and London: Founders Society, Detroit Institute of Arts in association with W. W. Norton & Company, 1986)

Desmond Rochfort, *Mexican Muralists* (London: Laurence King Publishing, 1993)

Antonio Rodriguez, *A History of Mexican Mural Painting* (London: Thames & Hudson, 1969)

SOCIALIST REALISM

Matthew Cullerne Bown, *Socialist Realist Painting* (London and New Haven: Yale University Press, 1998)

Leah Dickerman, "Camera Obscura: Socialist Realism in the Shadow of Photography," *October*, no. 93, Summer 2000

David Elliott (ed.), *Engineers of the Human Soul: Soviet Socialist Realist Painting 1930s–1960s* (Oxford: Museum of Modern Art, 1992)

Hans Guenther (ed.), *The Culture of the Stalin Period* (New York and London: St. Martin's Press, 1990)

Thomas Lahusen and Evgeny Dobrenko (eds), *Socialist Realism without Shores* (Durham, N.C. and London: Duke University Press, 1997)

Brandon Taylor, "Photo Power: Painting and Iconicity in the First Five Year Plan," in Dawn Ades and Tim Benton (eds), *Art and Power: Europe Under the Dictators 1939–1945* (London: Thames & Hudson, 1995)

Andrei Zhdanov, "Speech to the Congress of Soviet Writers" (1934), translated and reprinted in Charles Harrison and Paul Wood (eds), *Art in Theory 1900–1990* (Oxford and Cambridge, Mass.: Blackwell, 1992)

HARLEM RENAISSANCE

Mary Ann Calo, *Distinction and Denial: Race, Nation, and the Critical Construction of the African-American Artist, 1920–40* (Ann Arbor: University of Michigan Press, 2007)

M. S. Campbell et al., *Harlem Renaissance: Art of Black America* (New York: Studio Museum in Harlem and Harry N. Abrams, 1987)

David C. Driskell, *Two Centuries of Black American Art* (New York: Alfred A. Knopf and Los Angeles County Museum of Art, 1976)

Patricia Hills, *Painting Harlem Modern: The Art of Jacob Lawrence* (Berkeley: University of California Press, 2010)

Alain Locke (ed.), *The New Negro: An Interpretation* (first published 1925; New York: Atheneum, 1968)

Guy C. McElroy, Richard J. Powell, and Sharon F. Patton, *African-American Artists 1880–1987: Selections from the Evans-Tibbs Collection* (Washington, D.C.: Smithsonian Institution Traveling Exhibition Service, 1989)

James A. Porter, *Modern Negro Art* (first published 1943; Washington, D.C.: Howard University Press, 1992)

Joanna Skipworth (ed.), *Rhapsodies in Black: Art of the Harlem Renaissance* (London: Hayward Gallery, 1997)

ABSTRACT EXPRESSIONISM

David Anfam, *Abstract Expressionism*, second edition (London and New York: Thames & Hudson, 2015)

David Anfam, *Jackson Pollock's Mural: Energy Made Visible* (London and New York: Thames & Hudson, 2015)

David Anfam (ed.), *Mark Rothko: The Works on Canvas*, catalogue raisonné (New Haven and London: Yale University Press, 1998)

Marcia Brennan, *Modernism's Masculine Subjects: Matisse, the New York School, and Post-Painterly Abstraction* (Cambridge, Mass.: MIT Press, 2004)

T. J. Clark, "The Unhappy Consciousness" and "In Defense of Abstract Expressionism," *Farewell to an Idea* (New Haven and London: Yale University Press, 1999)

Harry Cooper, *Mark Rothko: An Essential Reader* (Houston: Museum of Fine Arts, 2015)

John Elderfield (ed.), *De Kooning: A Retrospective* (New York: Museum of Modern Art, 2011)

Francis Frascina (ed.), *Pollock and After: The Critical Debate* (New York: Harper & Row, 1985)

Serge Guilbaut, *How New York Stole the Idea of Modern Art: Abstract Expressionism, Freedom, and the Cold War* (Chicago: University of Chicago Press, 1983)

Melissa Ho, *Reconsidering Barnett Newman* (New Haven and London: Yale University Press, 2005)

Rosalind Krauss, *Willem de Kooning Nonstop: Cherchez La Femme* (Chicago: University of Chicago Press, 2015)

Ellen G. Landau, *Reading Abstract Expressionism: Context and Critique* (New Haven and London: Yale University Press, 2005)

Michael Leja, *Reframing Abstract Expressionism: Subjectivity and Painting in the 1940s* (New Haven and London: Yale University Press, 1993)

Barnett Newman, *Selected Writings and Interviews*, ed. John O'Neill (Berkeley: University of California Press, 1992)

Francis O'Connor and Eugene Thaw (eds), *Jackson Pollock: A Catalogue Raisonné of Paintings, Drawings, and Other Works* (New Haven and London: Yale University Press, 1977)

Ad Reinhardt, *Art as Art: Selcted Writings of Ad Reinhardt*, ed. Barbara Rose (Berkeley: University of California Press, 1991)

Harold Rosenberg, *The Tradition of the New* (New York: Horizon Press, 1959)

Irving Sandler, *Abstract Expressionism: The Triumph of American Painting* (London: Pall Mall, 1970)

David Shapiro and Cecile Shapiro, *Abstract Expressionism: A Critical Record* (Cambridge: Cambridge University Press, 1990)

Kirk Varnedoe with Pepe Karmel, *Jackson Pollock* (New York: Museum of Modern Art, 1998)

DUBUFFET, FAUTRIER, KLEIN, AND NOUVEAU RÉALISME

Jean-Paul Ameline, *Les Nouveaux Réalistes* (Paris: Centre Georges Pompidou, 1992)

Nuit Banai, *Yves Klein* (Chicago: University of Chicago Press, 2015)

Benjamin H. D. Buchloh, "From Detail to Fragment: Décollage/Affichiste," *Décollage: Les Affichistes* (New York and Paris: Virginia Zabriske Gallery, 1990)

Curtis L. Carter and Karen L. Butler (eds), *Jean Fautrier* (New Haven and London: Yale University Press, 2002)

Bernadette Contensou (ed.), *1960: Les Nouveaux Réalistes* (Paris: Musée d'Art Moderne de la Ville de Paris, 1986)

Hubert Damisch, "The Real Robinson," *October*, no. 85, Summer 1998

Jean Dubuffet, *Prospectus et tous écrits suivants*, four volumes, ed. Hubert Damisch (Paris: Gallimard, 1967–91) and "Notes for the well read" (1945), trans. in M. Glimcher, *Jean Dubuffet: Towards an Alternative Reality* (New York: Pace Publications and Abbeville Press, 1987)

Catherine Francblin, *Les Nouveaux Réalistes* (Paris: Editions du Regard, 1997)

Thomas F. McDonough, *"The Beautiful Language of My Century": Reinventing the Language of Contestation in Postwar France, 1945–1968* (Cambridge, Mass.: MIT Press, 2007)

Rachel Perry, "Jean Fautrier's *Jolies Juives*," *October*, no. 108, Spring 2004

Francis Ponge, *L'Atelier contemporain* (Paris: Gallimard, 1977)

Jean-Paul Sartre, "Fingers and Non-Fingers," translated in Werner Haftmann (ed.), *Wols* (New York: Harry N. Abrams, 1965)

RAUSCHENBERG, JOHNS, AND OTHERS

Yve-Alain Bois, *Ellsworth Kelly: Catalogue Raisonné of Paintings, Reliefs, and Sculpture Vol. 1, 1940–1953* (London and New York: Thames & Hudson, 2015)

Yve-Alain Bois, *Ellsworth Kelly: The Early Drawings, 1948–1955* (Cambridge, Mass.: Harvard University Press, 1999)

Russell Ferguson (ed.), *Hand-Painted Pop: American Art in Transition, 1955–62* (Los Angeles: Museum of Contemporary Art, 1993)

Walter Hopps, Susan Davidson et al., *Robert Rauschenberg: A Retrospective* (New York: Guggenheim Museum, 1997)

Walter Hopps, *Robert Rauschenberg: The Early 1950s* (Houston: Menil Collection, 1991)

Hiroko Ikegami, *The Great Migrator: Robert Rauschenberg and the Global Rise of American Art* (Cambridge, Mass.: MIT Press, 2010)

Jasper Johns, *Writings, Sketchbook Notes, Interviews* (New York: Museum of Modern Art/ Harry N. Abrams, 1996)

Branden W. Joseph (ed.), *Robert Rauschenberg*, October Files 4 (Cambridge, Mass.: MIT Press, 2002)

Branden W. Joseph, *Random Order: Robert Rauschenberg and the Neo-Avant-Garde* (Cambridge, Mass.: MIT Press, 2003)

Fred Orton, *Figuring Jasper Johns* (Cambridge: Harvard University Press, 1994)

James Rondeau, *Jasper Johns: Gray* (Chicago: Art Institute of Chicago, 2007)

Leo Steinberg, *Other Criteria: Confrontations with Twentieth-Century Art* (London, Oxford, and New York: Oxford University Press, 1972)

Kirk Varnedoe, *Jasper Johns: A Retrospective* (New York: Museum of Modern Art, 1996)

Jeffrey Weiss, *Jasper Johns: An Allegory of Painting, 1955–1965* (New Haven and London: Yale University Press, 2007)

FONTANA, MANZONI, AND ARTE POVERA

Yve-Alain Bois, "Fontana's Base Materialism," *Art in America*, vol. 77, no. 4, April 1989

Germano Celant, *Arte Povera* (Milan: Gabriele Mazzotta; New York: Praeger; London: Studio Vista, 1969)

Germano Celant, *The Knot: Arte Povera* (New York: P.S.1; Turin: Umberto Allemandi, 1985)

Germano Celant (ed.), *Piero Manzoni* (London: Serpentine Gallery, 1998)

Carolyn Christov-Bakargiev (ed.), *Arte Povera* (London: Phaidon, 1999)

Richard Flood and Frances Morris (eds), *Zero to Infinity: Arte Povera 1962–1972* (Minneapolis: Walker Art Gallery; London: Tate Gallery, 2002)

Jaleh Mansoor, "Piero Manzoni: 'We Want to Organicize Disintegration'," *October*, no. 95, Winter 2001

Jon Thompson (ed.), *Gravity and Grace: Arte Povera/Post Minimalism* (London: Hayward Gallery, 1993)

Anthony White, *Lucio Fontana: Between Utopia and Kitsch*, October Books (Cambridge, Mass.: MIT Press, 2012)

Sarah Whitfield, *Lucio Fontana* (London: Hayward Gallery, 1999)

COBRA AND SITUATIONISM

Iwona Blazwick (ed.), *An Endless Adventure—An Endless Passion—An Endless Banquet: A Situationist Scrapbook* (London: Verso, 1989)

Guy Debord, *The Society of the Spectacle* (1967), trans. Donald Nicholson-Smith (Cambridge, Mass.: MIT Press, 2002)

Ken Knabb (ed.), *Situationist International Anthology* (Berkeley: Bureau of Public Secrets, 1981)

Karen Kurczynski, *The Art and Politics of Asger Jorn: The Avant-Garde Won't Give Up* (London: Ashgate, 2014)

Thomas F. McDonough (ed.), *Guy Debord and the Situationist International* (Cambridge, Mass.: MIT Press, 2002)

Willemijn Stokvis, *Cobra: The Last Avant-Garde Movement of the Twentieth Century* (Aldershot: Lund Humphries, 2004)

Elisabeth Sussman (ed.), *On the Passage of a Few People Through a Rather Brief Moment in Time: The Situationist International 1957–1972* (Cambridge, Mass.: MIT Press, 1989)

GUTAI, NEOCONCRETISM, AND NONWESTERN MODERNISM

Barbara von Bertozzi and Klaus Wolbert (eds), *Gutai: Japanese Avant-Garde 1954–1965* (Darmstadt: Mathildenhöhe, 1991)

Guy Brett et al., *Hélio Oiticica* (Minneapolis: Walker Art Center, 1994)

Guy Brett et al., *Lygia Clark* (Barcelona: Fundació Antoni Tàpies, 1997)

Guy Brett et al., *Lygia Pape: Magnetized Space* (London: Serpentine Gallery, 2011)

Cornelia Butler and Luis Pérez-Oramas, *Lygia Clark: The Abandonment of Art 1948–1988* (New York: Museum of Modern Art, 2014)

Luciano Figueiredo et al., *Hélio Oiticica: The Body of Color* (Houston: Museum of Fine Arts, 2007)

Gutai magazine, facsimile edition (with complete English translation) (Ashiya: Ashiya City Museum of Art and History, 2010)

Sergio Martins, *Constructing an Avant-Garde: Art in Brazil 1949–1979* (Cambridge, Mass.: MIT Press, 2013)

Tetsuya Oshima, "'Dear Mr. Jackson Pollock': A Letter from Gutai," in Ming Tiampo (ed.), *"Under Each Other's Spell": Gutai and New York* (East Hampton: Pollock-Krasner House, 2009)

Ming Tiampo, *Gutai: Decentering Modernism* (Chicago: Chicago University Press, 2011)

Ming Tiampo and Alexandra Munroe, *Gutai: Splendid Playground* (New York: Guggenheim Museum, 2013)

Paulo Venancio Filho, *Reinventing the Modern: Brazil* (Paris: Gagosian Gallery, 2011)

POP

Darsie Alexander and Bartholomew Ryan (eds), *International Pop* (Minneapolis: Walker Art Center, 2015)

Lawrence Alloway, *American Pop Art* (New York: Collier Books, 1974)

Graham Bader, *Roy Lichtenstein*, October Files 7 (Cambridge, Mass.: MIT Press, 2009)

Graham Bader, *Hall of Mirrors: Roy Lichtenstein and the Face of Painting in the 1960s* (Cambridge, Mass.: MIT Press, 2010)

Yve-Alain Bois, *Edward Ruscha: Romance with Liquids* (New York: Gagosian Gallery, 1993)

Benjamin H. D. Buchloh, *Andy Warhol: Shadows and Other Signs of Life* (Cologne: Walther König, 2008)

Thomas Crow, *The Long March of Pop: Art, Music, and Design, 1930–1995* (New Haven: Yale University Press, 2014)

Thomas Crow, *The Rise of the Sixties: American and European Art in the Era of Dissent* (New York: Abrams, 1996)

Hal Foster, *The First Pop Age: Painting and Subjectivity in the Art of Hamilton, Lichtenstein, Warhol, Richter, and Ruscha* (Princeton: Princeton University Press, 2014)

Hal Foster (ed.), *Richard Hamilton*, October Files 10 (Cambridge, Mass.: MIT Press, 2010)

Hal Foster and Mark Francis, *Pop Art* (London: Phaidon, 2005)

Lucy Lippard, *Pop Art* (London: Thames & Hudson, 1966)

Marco Livingstone, *Pop Art: A Continuing History* (London: Thames & Hudson, 2000)

Michael Lobel, *Image Duplicator: Roy Lichtenstein and the Emergence of Pop Art* (New Haven: Yale University Press, 2002)

Michael Lobel, *James Rosenquist: Pop Art, Politics, and History in the 1960s* (Berkeley: University of California Press, 2009)

Steven Henry Madoff, *Pop Art: A Critical History* (Berkeley: University of California Press, 1997)

Kynaston McShine (ed.), *Andy Warhol: A Retrospective* (New York: Museum of Modern Art, 1989)

Annette Michelson (ed.), *Andy Warhol*, October Files 2 (Cambridge, Mass.: MIT Press, 2001)

Jessica Morgan and Flavia Frigeri (eds), *The World Goes Pop* (New Haven and London: Yale University Press, 2015)

David Robbins (ed.), *The Independent Group: Postwar Britain and the Aesthetics of Plenty* (Cambridge, Mass.: MIT Press, 1990)

James Rondeau and Sheena Wagstaff, *Roy Lichtenstein: A Retrospective* (Chicago: Art Institute of Chicago, 2012)

Nadja Rottner (ed.), *Claes Oldenburg*, October Files 13 (Cambridge, Mass.: MIT Press, 2012)

Ed Ruscha, *Leave Any Information at the Signal: Writings, Interviews, Bits, Pages* (Cambridge, Mass.: MIT Press, 2002)

John Russell and Suzi Gablik, *Pop Art Redefined* (New York: Praeger, 1969)

Alexandra Schwartz, *Ed Ruscha's Los Angeles* (Cambridge, Mass.: MIT Press, 2010)

Paul Taylor, *Post-Pop Art* (Cambridge, Mass.: MIT Press, 1989)

Cecile Whiting, *A Taste for Pop: Pop Art, Gender, and Consumer Culture* (Cambridge: Cambridge University Press, 1997)

CAGE, KAPROW, AND FLUXUS

Elizabeth Armstrong, *In the Spirit of Fluxus* (Minneapolis: Walker Art Center, 1993)

Benjamin H. D. Buchloh, and Judith Rodenbeck (eds), *Experiments in the Everyday: Allan Kaprow and Robert Watts—Events, Objects, Documents* (New York: Wallach Gallery, Columbia University, 1999)

John Cage, *Silence* (Hanover, N.H.: Weslyan University Press, 1939)

Rudolf Frieling and Boris Groys, *The Art of Participation: 1950 to Now* (London: Thames & Hudson, 2008)

Jon Hendricks (ed.), *Fluxus Codex* (Detroit: Gilbert and Lila Silverman Fluxus Collection, 1988)

Branden W. Joseph, *Beyond the Dream Syndicate: Tony Conrad and the Arts After Cage* (New York: Zone Books, 2008)

Allan Kaprow, *Assemblage, Environments & Happenings* (New York: Abrams, 1966)

Allan Kaprow, *Essays on the Blurring of Art and Life* (Berkeley: University of California Press, 1993)

Liz Kotz, "Post-Cagean Aesthetics and the 'Event' Score," *October*, no. 95, Winter 2001

Julia Robinson (ed.), *John Cage*, October Files 12 (Cambridge, Mass.: MIT Press, 2011)

POSTWAR GERMAN ART

Dan Adler, *Hanne Darboven: Cultural History 1880–1983* (Cambridge, Mass.: MIT Press, 2009)

Danielle Arasse, *Anselm Kiefer* (New York and London: Thames & Hudson, 2015)

Georg Baselitz and Eugen Schönebeck, *Pandämonium Manifestoes*, excerpts in English translation in Andreas Papadakis (ed.), *German Art Now*, vol. 5, no. 9–10, 1989

Joseph Beuys, *Where Would I Have Got If I Had Been Intelligent!* (New York: Dia Center for the Arts, 1994)

Benjamin H. D. Buchloh, *Gerhard Richter, 18 Oktober 1977* (London: Institute of Contemporary Arts, 1989)

Benjamin H. D. Buchloh, "Gerhard Richter's Atlas: The Anomic Archive," *October*, no. 88, Spring 1999

Benjamin H. D. Buchloh, "Joseph Beuys at the Guggenheim," *October*, no. 12, Spring 1980

Benjamin H. D. Buchloh (ed.), *Gerhard Richter*, October Files 8 (Cambridge, Mass.: MIT Press, 2009)

Lynne Cooke, Karen Kelly, and Barbara Schröde (eds), *Blinky Palermo: Retrospective 1964–77* (New Haven and London: Yale University Press, 2010)

Stefan Germer, "Die Wiederkehr des Verdrängten. Zum Umgang mit deutscher Geschichte bei Baselitz, Kiefer, Immendorf und Richter," in Julia Bernard (ed.), *Germeriana: Unveröffentlichte oder übersetzte Schriften von Stefan Germer* (Cologne: Oktagon Verlag, 1999)

Siegfried Gohr, "In the Absence of Heroes: The Early Work of Georg Baselitz," *Artforum*, vol. 20, no. 10, Summer 1982

Tom Holert, "Bei Sich, über allem: Der symptomatische Baselitz," *Texte zur Kunst*, vol. 3, no. 9, March 1993

Andreas Huyssen, "Anselm Kiefer: The Terror of History, the Temptation of Myth," *October*, no. 48, Spring 1989

Kevin Power, "Existential Ornament," in Maria Corral (ed.), *Georg Baselitz* (Madrid: Fundacion Caja de Pensiones, 1990)

Gerhard Richter, *The Daily Practice of Painting: Writings 1960–1993* (London: Thames & Hudson, 1995)

Gerhard Richter, *Text: Writings, Interviews and Letters 1961–2007*, ed. Dietmar Elger and Hans Ulrich Obrist (London: Thames & Hudson, 2009)

Margit Rowell, *Sigmar Polke: Works on Paper, 1963–1974* (New York: Museum of Modern Art, 1999)

Caroline Tisdall, *Joseph Beuys: Coyote* (London: Thames & Hudson, 2008)

MINIMALISM, POSTMINIMALISM, AND POSTWAR SCULPTURE

Carl Andre, *Cuts: Texts 1959–2004*, ed. James Meyer (Cambridge, Mass.: MIT Press, 2005)

Carl Andre and Hollis Frampton, *12 Dialogues, 1962–1963*. Halifax: The Press of the Nova Scotia College of Art and Design, 1981)

Jo Applin, *Eccentric Objects: Rethinking Sculpture in 1960s America* (New Haven: Yale University Press, 2012)

Gregory Battcock, *Minimal Art: A Critical Anthology* (New York: E. P. Dutton, 1968)

Tiffany Bell and Frances Morris (eds), *Agnes Martin* (London: Tate, 2015)

Maurice Berger, *Labyrinths: Robert Morris, Minimalism and the 1960s* (New York: Harper & Row, 1989)

Julia Bryan-Wilson (ed.), *Robert Morris*, October Files 15 (Cambridge, Mass.: MIT Press, 2013)

Lynne Cooke and Karen Kelly (eds), *Agnes Martin* (New Haven and London: Yale University Press, 2011)

Hal Foster (ed.), *Richard Serra*, October Files 1 (Cambridge, Mass.: MIT Press, 2000)

Carmen Gimenez, Hal Foster, et al., *Richard Serra: The Matter of Time* (Göttingen: Steidl, 2005)

Ann Goldstein (ed.), *A Minimal Future? Art as Object 1958–1968* (Los Angeles: Museum of Contemporary Art, 2004)

Suzanne P. Hudson, *Robert Ryman: Used Paint* (Cambridge, Mass.: MIT Press, 2009)

Donald Judd, *Donald Judd, Complete Writings, 1959–1975* (Halifax: The Press of the Nova Scotia College of Art and Design, 1975)

Rosalind Krauss, *Passages in Modern Sculpture* (New York: Viking Press, 1977

Rosalind Krauss, *The Sculpture of David Smith: A Catalogue Raisonné* (New York: Garland Publishing, 1977)

Lucy Lippard, *Eva Hesse* (New York: Da Capo Press, 1992)

James Meyer, *Minimalism: Art and Polemics in the Sixties* (New Haven and London: Yale University Press, 2001)

Robert Morris, *Continuous Project Altered Daily: The Writings of Robert Morris* (Cambridge, Mass.: MIT Press, 1993)

Mignon Nixon (ed.), *Eva Hesse*, October Files 3 (Cambridge, Mass.: MIT Press, 2002)

Mignon Nixon, *Fantastic Reality: Louise Bourgeois and a Story of Modern Art* (Cambridge, Mass.: MIT Press, 2005)

Nancy Princenthal, *Agnes Martin: Her Life and Art* (London and New York: Thames & Hudson, 2015)

Julia Robinson, (ed.), *New Realisms, 1957–1962: Object Strategies Between Readymade and Spectacle* (Madrid: Museo Nacional Centro De Arte Reina Sofia; And Cambridge, Mass.: MIT Press, 2010)

Corinna Thierolf and Johannes Vogt, *Dan Flavin: Icons* (London: Thames & Hudson, 2009)

Clara Weyergraf-Serra and Martha Buskirk (eds), *The Destruction of Tilted Arc: Documents* (Cambridge, Mass.: MIT Press, 1991)

EARTHWORKS, PROCESS ART, AND ENTROPY

Suzaan Boettger, *Earthworks: Art and the Landscape of the Sixties* (Berkeley: University of California Press, 2003)

Thomas Crow et al., *Gordon Matta-Clark* (London: Phaidon, 2003)

Robert Hobbs, *Robert Smithson: Sculpture* (Ithaca, N.Y.: Cornell University Press, 1981)

Bruce Jenkins, *Gordon Matta-Clark: Conical Intersect* (Cambridge, Mass.: MIT Press, 2011)

Philipp Kaiser and Miwon Kwon, *Ends of the Earth: Land Art to 1974* (Los Angeles and New York: Museum of Contemporary Art, Los Angeles in association with Prestel, 2012)

Pamela Lee, *Chronophobia* (Cambridge, Mass.: MIT Press, 2004)

Pamela Lee, *Object to be Destroyed: The Work of Gordon Matta-Clark* (Cambridge, Mass.: MIT Press, 2000)

James Nisbet, *Ecologies, Environments, and Energy Systems in Art of the 1960s and 1970s* (Cambridge, Mass.: MIT Press, 2014)

Ann Reynolds, *Robert Smithson: Learning from New Jersey and Elsewhere* (Cambridge, Mass.: MIT Press, 2003)

Jennifer L. Roberts, *Mirror-Travels: Robert Smithson and History* (New Haven: Yale University Press, 2004)

Robert Smithson, *The Collected Writings*, ed. Jack Flam (Berkeley: University of California Press, 1996)

Eugenie Tsai (ed.), *Robert Smithson* (Berkeley: University of California Press, 2004)

CONCEPTUAL ART

Alexander Alberro and Sabeth Buchmann (eds), *Art After Conceptual Art* (Cambridge, Mass.: MIT Press, 2007)

Alexander Alberro and Blake Stimson (eds), *Conceptual Art and the Politics of Publicity* (Cambridge, Mass.: MIT Press, 2003)

Mel Bochner, *Solar System & Rest Rooms: Writings and Interviews, 1965–2007*, foreword by Yve-Alain Bois (Cambridge, Mass.: MIT Press, 2008)

Benjamin H. D. Buchloh, "Conceptual Art 1962–69: From an Aesthetics of Administration to the Critique of Institutions," *October*, no. 55, Winter 1990

Ann Goldstein (ed.), *Reconsidering the Object of Art: 1965–1975* (Los Angeles, Museum of Contemporary Art, 1995)

Boris Groys, *History Becomes Form: Moscow Conceptualism* (Cambridge, Mass.: MIT Press, 2010)

Boris Groys (ed.), *Total Enlightenment: Conceptual Art in Moscow 1960–1990* (Frankfurt: Schirn Kunsthalle and Ostfildern: Hatje Cantz, 2008)

Joseph Kosuth, *Art After Philosophy and After: Collected Writing 1966–1990* (Cambridge, Mass.: MIT Press, 1991)

Liz Kotz, *Words to Be Looked At: Language in 1960s Art* (Cambridge, Mass.: MIT Press, 2007)

Lucy Lippard, *Six Years: The Dematerialization of the Art Object 1966–1972* (Berkeley: University of California Press, 1973)

Ursula Meyer, *Conceptual Art* (New York: Dutton, 1972)

Kynaston McShine, *Information* (New York: MoMA, 1970)

Anne Rorimer, *New Art in the 60s and 70s: Redefining Reality* (New York: Thames & Hudson, 2001)

Blake Stimson and Alexander Alberro (eds), *Conceptual Art : An Anthology of Critical Writings and Documents* (Cambridge, Mass.: MIT Press, 2000)

Margarita Tupitsyn, "About Early Moscow Conceptualism," in Luis Camnitzer, Jane Farver, and Rachel Weiss (eds), *Global Conceptualism: Points of Origin 1950s–1980s* (New York: Queens Museum of Art, 1999)

INSTALLATION, INSTITUTIONAL CRITIQUE, AND SITE-SPECIFICITY

Alexander Alberro (ed.), *Museum Highlights: The Writings of Andrea Fraser* (Cambridge, Mass.: MIT Press, 2005)

Alexander Alberro and Blake Stimson (eds), *Institutional Critique: An Anthology of Artists' Writings* (Cambridge, Mass.: MIT Press, 2009)

Michael Asher, *Writings 1973–1983 on Works 1969–1979* (Halifax: The Press of the Nova Scotia College of Art and Design, 1983)

Claire Bishop, *Installation Art: A Critical History* (New York: Routledge, 2005)

Marcel Broodthaers, *Broodthaers: Writings, Interviews, Photographs* (Cambridge, Mass.: MIT Press, 1987)

Julia Bryan-Wilson, *Art Workers: Radical Practice in the Vietnam War Era* (Berkeley: University of California Press, 2009)

Daniel Buren, *Daniel Buren: Les Couleurs, Sculptures, Les Formes, Peintures* (Paris: Centre Georges Pompidou, 1981)

Victor Burgin, "Situational Aesthetics," *Studio International*, vol. 178, no. 915, October 1969

Rachel Churner (ed.), *Hans Haacke*, October Files 18 (Cambridge, Mass.: MIT Press, 2015)

Rosalyn Deutsche, *Evictions: Art and Spatial Politics* (Cambridge, Mass.: MIT Press, 1996)

Dan Graham, *Two-Way Mirror Power: Selected Writings by Dan Graham on His Art* (Cambridge, Mass.: MIT Press, 1999)

Dan Graham, *Video, Architecture, Television: Writings on Video and Video Works, 1970–1978* (Halifax: The Press of the Nova Scotia College of Art and Design, 1979)

Hans Haacke, *Unfinished Business* (Cambridge, Mass.: 1986)

Rachel Haidu, *The Absence of Work: Marcel Broodthaers, 1964–1976* (Cambridge, Mass.: MIT Press, 2011)

Jennifer King (ed.), *Michael Asher*, October Files 19 (Cambridge, Mass.: MIT Press, 2016)

Alex Kitnick (ed.), *Dan Graham*, October Files 11 (Cambridge, Mass.: MIT Press, 2011)

Rosalind Krauss, "The Cultural Logic of the Late Capitalist Museum," *October*, no. 54, Fall 1990

Miwon Kwon, *One Place After Another: Site-Specific Art and Locational Identity* (Cambridge, Mass.: MIT Press, 2002)

Jennifer Licht, *Spaces* (New York: Museum of Modern Art, 1969)

Brian O'Doherty, *Inside the White Cube: The Ideology of the Gallery Space* (Berkeley and Los Angeles: University of California Press, 1999)

Spyros Papapetros and Julian Rose (eds), *Retracing the Expanded Field: Encounters between Art and Architecture* (Cambridge, Mass.: MIT Press, 2014)

Kirsi Peltomäki, *Situation Aesthetics: The Work of Michael Asher* (Cambridge, Mass.: MIT Press, 2010)

Birgit Pelzer, Mark Francis, and Beatriz Colomina, *Dan Graham* (London: Phaidon, 2001)

Erica Suderburg (ed.), *Space, Site, Intervention: Situating Installation Art* (Minneapolis: University of Minnesota Press, 2000)

Marsha Tucker, *Anti-Illusion: Procedures/Materials* (New York: Whitney Museum of American Art, 1969)

Fred Wilson, *Mining the Museum* (Baltimore: Museum of Contemporary Art, 1994)

PERFORMANCE AND BODY ART

Sally Banes, *Democracy's Body: Judson Dance Theater, 1962–1964* (Durham, N.C.: Duke University Press, 1993)

Stephen Barber, *Performance Projections: Film and the Body in Action* (London: Reaktion Books, 2015)

Sabine Breitwieser (ed.), *Simone Forti: Thinking with the Body* (Chicago: Hirmer, 2015)

Julia Bryan-Wilson, *Art Workers: Radical Practice in the Vietnam War Era* (Berkeley: University of California Press, 2009)

Rudolf Frieling and Boris Groys, *The Art of Participation: 1950 to Now* (London: Thames & Hudson, 2008)

RoseLee Goldberg, *Performance Art: From Futurism to the Present* (London and New York: Thames & Hudson, 2001)

RoseLee Goldberg, *Performance: Live Art Since the 60s* (London: Thames & Hudson, 2004)

Adrian Heathfield and Tehching Hsieh, *Out of Now: The Lifeworks of Tehching Hsieh* (Cambridge, Mass.: MIT Press, 2009)

Fred Hoffman et al., *Chris Burden* (London: Thames & Hudson, 2007)

Amelia Jones, *Body Art: Performing the Subject* (Minneapolis: University of Minnesota Press, 1998

Amelia Jones and Andrew Stephenson (eds), *Performing the Body/Performing the Text* (London and New York: Routledge, 1999)

Carrie Lambert-Beatty, *Being Watched: Yvonne Rainer and the 1960s* (Cambridge, Mass.: MIT Press, 2008)

Sally O'Reilly, *The Body in Contemporary Art* (London: Thames & Hudson, 2009)

Paul Schimmel and Russell Ferguson (eds), *Out of Actions: Between Performance and the Object: 1949–1979* (Los Angeles: Museum of Contemporary Art, New York, 1998)

Kristine Stiles, "Uncorrupted Joy: International Art Actions," in Paul Schimmel and Russell Ferguson (eds), *Out of Actions: Between Performance and the Object 1949–1979* (London: Thames & Hudson, 1998)

Frazer Ward, "Some Relations Between Conceptual and Performance Art." *Art Journal*, vol. 56, no. 4, Winter 1997

Anne Wagner, "Performance, Video, and the Rhetoric of Presence," *October*, no. 91, Winter 2000

FEMINISM, POSTCOLONIAL ART, IDENTITY ART, AND POLITICIZED ART

Carol Armstrong and Catherine de Zegher (eds), *Women Artists at the Millennium* (Cambridge, Mass.: MIT Press, 2006)

Homi Bhabha, *The Location of Culture* (London: Routledge, 1994)

Gregg Bordowitz, *General Idea: Imagevirus (The AIDS Project)* (Cambridge, Mass.: MIT Press, 2010)

John P. Bowles, *Adrian Piper: Race, Gender, and Embodiment* (Durham, N.C.: Duke University Press, 2011)

Julia Bryan-Wilson, *Art Workers: Radical Practice in the Vietnam War Era* (Berkeley: University of California Press, 2009)

Cornelia H. Butler and Lisa Gabrielle Mark (eds), *WACK!: Art and the Feminist Revolution* (Cambridge, Mass.: MIT Press, 2007)

Judith Butler, *Gender Trouble: Feminism and the Subversion of Identity* (New York: Routledge, 1989)

Gavin Butt, *Between You and Me: Queer Disclosures in the New York Art World, 1948–1963* (Durham, N.C.: Duke University Press, 2005)

Judy Chicago, *Beyond the Flower: The Autobiography of a Feminist Artist* (New York: Viking, 1996)

Judy Chicago, *The Dinner Party: Restoring Women to History* (New York: Monacelli Press, 2014)

Douglas Crimp (ed.), *AIDS: Cultural Analysis/Cultural Activism* (Cambridge, Mass.: MIT Press, 1988)

Douglas Crimp and Adam Rolston (eds), *AIDS DEMOgraphics* (Seattle: Bay Press, 1990)

Olivier Debroise (ed.), *The Age of Discrepancies: Art and Visual Culture in Mexico 1968–1997* (Mexico City: Universidad Nacional Autónoma de México; Madrid: Turner, 2006)

Darby English, *How to See a Work of Art in Total Darkness* (Cambridge, Mass.: MIT Press, 2007)

Ales Erjavec (ed.), *Postmodernism and the Postsocialist Condition: Politicized Art under Late Socialism* (Berkeley: University of California Press, 2003)

Sujatha Fernandes, *Cuba Represented: Cuban Arts, State Power, and the Making of New Revolutionary Cultures* (Durham, N.C.: Duke University Press, 2006)

Joanna Frueh, Cassandra L. Langer, and Arlene Raven (eds), *New Feminist Art Criticism: Art, Identity, Action* (New York: HarperCollins, 1994)

Coco Fusco, *The Bodies That Were Not Ours* (New York: Routledge, 2001)

Thelma Golden, *Black Male: Representations of Masculinity in Contemporary Art* (New York: Whitney Museum of American Art, 1994)

Jennifer A. González, *Subject to Display: Reframing Race in Contemporary Installation Art* (Cambridge, Mass.: MIT Press, 2008)

Stuart Hall and Mark Sealy, *Different: Contemporary Photography and Black Identity* (London: Phaidon, 2001)

Harmony Hammond, *Lesbian Art in America: A Contemporary History* (New York: Rizzoli International Publications, 2000)

Amelia Jones and Erin Silver, *Otherwise: Imagining Queer Feminist Art Histories* (Manchester: Manchester University Press, 2016)

Jonathan David Katz and Rock Hushka, *Art AIDS America* (Seattle: University of Washington Press, 2015)

Mary Kelly, *Imaging Desire* (Cambridge, Mass.: MIT Press, 1997)

Zoya Kocur (ed.), *Global Visual Cultures: An Anthology* (Chichester: Wiley-Blackwell, 2011)

Lucy R. Lippard, *Get the Message? A Decade of Social Change* (New York: Dutton, 1984)

Lucy R. Lippard, *The Pink Glass Swan: Selected Essays in Feminist Art* (New York: New Press, 1995)

Jean-Hubert Martin et al., *Les Magiciens de la terre* (Paris: Centre Georges Pompidou, 1989)

Kobena Mercer, *Welcome to the Jungle: New Positions in Cultural Studies* (New York: Routledge, 1994)

Gerardo Mosquera and Jean Fisher, *Over Here: International Perspectives on Art and Culture* (Cambridge, Mass.: MIT Press, 2005)

Lisa Ryan Musgrave (ed.), *Feminist Aesthetics and Philosophy of Art: The Power of Critical Visions and Creative Engagement* (New York: Springer, 2014)

Linda Nochlin, *Women, Art and Power: And Other Essays* (New York: Harper & Row, 1988; and London: Thames & Hudson, 1989)

Linda Nochlin, *Women Artists: The Linda Nochlin Reader*, ed. Maura Reilly (London and New York: Thames & Hudson, 2015)

Roszika Parker and Griselda Pollock, *Framing Feminism: Art and the Women's Movement 1970–85* (London: Pandora, 1987)

Griselda Pollock, *Vision and Difference: Femininity, Feminism, and Histories of Art* (New York: Routledge, 1988)

Helaine Posner (ed.), *Corporal Politics* (Cambridge, Mass.: MIT List Visual Arts Center, 1992)

Maura Reilly and Linda Nochlin (eds), *Global Feminisms: New Directions in Contemporary Art* (New York: Brooklyn Museum and Merrell Publishers, 2007)

Blake Stimson and Gregory Sholette (eds), *The Art of Social Imagination after 1945* (Minneapolis: University of Minnesota Press, 2007)

Catherine de Zegher (ed.), *Inside the Visible: An Elliptical Traverse of 20th-Century Art* (Cambridge, Mass.: MIT Press, 1994)

PHOTOGRAPHY, FILM, VIDEO, AND THE PROJECTED IMAGE

Dawn Ades, *Photomontage* (London: Thames & Hudson, 1976)

Carol Armstrong, *Scenes in a Library: Reading the Photograph in the Book* (Cambridge, Mass.: MIT Press, 1998)

George Baker (ed.), *James Coleman*, October Files 5 (Cambridge, Mass.: MIT Press, 2003)

Béla Balázs, *Theory of the Film: Character and Growth of a New Art* (London: D. Dobson, 1952)

Peter Barberie, *Paul Strand: Master of Modern Photography* (New Haven: Philadelphia Museum of Art, Fundacion Mapfre, and Yale University Press, 2014)

Roland Barthes, *Camera Lucida: Reflections on Photography*, trans. Richard Howard (New York: Hill and Wang, 1981)

Roland Barthes, "The Photographic Message" and "The Rhetoric of the Image," *Image/Music/Text* (New York: Hill and Wang, 1977)

Geoffrey Batchen, *Photography Degree Zero* (Cambridge, Mass.: MIT Press, 2009)

André Bazin, *What is Cinema?*, vol. 1, trans. Hugh Gray (Berkeley: University of California Press, 1967)

John Berger, *Another Way of Telling* (New York: Pantheon, 1982)

Jennifer Blessing, *Catherine Opie: American Photographer* (New York: Solomon R. Guggenheim Museum, 2008)

Jay Bochner, *An American Lens: Scenes from Alfred Stieglitz's New York Secession* (Cambridge, Mass.: MIT Press, 2005)

Stan Brakhage, *The Essential Brakhage* (Kingston, N.Y.: McPherson & Company, 2001)

Benjamin H. D. Buchloh, "Allegorical Procedures: Appropriation and Montage in Contemporary Art," *Artforum*, vol. 21, no. 1, September 1982

Johanna Burton (ed.), *Cindy Sherman*, October Files 6 (Cambridge, Mass.: MIT Press, 2006)

Noel Burch, *Theory of Film Practice*, trans. Helen R. Lane (New York: Praeger, 1973)

Stanley Cavell, *The World Viewed: Reflections on the Ontology of Film* (Cambridge: Harvard University Press, 1971)

Diarmuid Costello and Margaret Iversen (eds), *Photography After Conceptual Art* (*Art History* Special Issues) (Chichester: Wiley-Blackwell, 2010)

Charlotte Cotton, *The Photograph as Contemporary Art* (London: Thames & Hudson, 2009)

Malcolm Daniel, *Stieglitz, Steichen, Strand* (New Haven and London: Yale University Press, 2010)

Corinne Diserens (ed.), *Chasing Shadows: Santu Mofokeng—Thirty Years of Photographic Essays* (Munich: Prestel, 2011)

Mary Ann Doane, "Information, Crisis, Catastrophe" in Patricia Mellencamp (ed.), *Logics of Television: Essays in Cultural Criticism* (Bloomington: Indiana University Press, 1990)

Sergei Eisenstein, *Film Form: Essays in Film Theory* (San Diego: Harvest Books, 1969)

Okwui Enwezor and Rory Bester (eds), *Rise and Fall of Apartheid: Photography and the Bureaucracy of Everyday Life* (New York: International Center of Photography; Munich: DelMonico Books / Prestel, 2013)

Tamar Garb, *Figures & Fictions: Contemporary South African Photography* (London: V & A Publishing; Göttingen: Steidl, 2011)

Robert Hirsch, *Seizing the Light: A History of Photography* (Boston: McGraw-Hill, 2000)

Chrissie Iles, *Into the Light: The Projected Image in American Art, 1964–1977* (New York: Whitney Museum of American Art, 2001)

Gabrielle Jennings and Kate Mondloch (eds), *Abstract Video: The Moving Image in Contemporary Art* (Oakland: University of Califoria Press, 2015)

Omar Kholeif (ed.), *Moving Image*, Documents of Contemporary Art (London and Cambridge, Mass.: Whitechapel Gallery and MIT Press, 2015)

David Joselit, *Feedback: Television Against Democracy* (Cambridge, Mass.: MIT Press, 2007)

Friedrich Kittler, *Gramophone, Film, Typewriter* (Stanford: Stanford University Press, 1999)

Elizabeth Ann McCauley, *Industrial Madness: Commercial Photography in Paris 1848–1871* (New Haven and London: Yale University Press, 1994)

Darren Newbury, *Defiant Images: Photography and Apartheid South Africa* (Pretoria: Unisa Press, 2009)

Beaumont Newhall, *The History of Photography: From 1839 to the Present* (Boston: Little, Brown and Company, 1999)

Erwin Panofsky, "Style and Medium in the Motion Pictures" (1974), in Gerald Mast and Marshall Cohen (eds), *Film Theory and Criticism: Introductory Readings* (London: Oxford University Press, 1974)

John Peffer, *Art and the End of Apartheid* (Minneapolis: University of Minnesota Press, 2009)

John Peffer and Elisabeth L. Cameron (eds), *Portraiture and Photography in Africa. African Expressive Cultures* (Bloomington: Indiana University Press, 2013)

Kira Perov (ed.), *Bill Viola* (London: Thames & Hudson, 2015)

Christopher Phillips, *Photography in the Modern Era: European Documents and Critical Writings, 1913–1940* (New York: Metropolitan Museum of Art, 1989)

Eva Respini, *Cindy Sherman* (New York: Museum of Modern Art, 2012)

Naomi Rosenblum, *A World History of Photography* (New York: Abbeville Press, 1984)

"Round Table: Independence in the Cinema," *October*, no. 91, Winter 2000

"Round Table: The Projected Image in Contemporary Art," *October*, no. 104, Spring 2003

Michael Rush, *Video Art* (London: Thames & Hudson, 2007)

Allan Sekula, "On the Invention of Photographic Meaning," *Artforum*, vol. 13, no. 5, January 1975

Allan Sekula, "The Traffic in Photographs." *Art Journal*, vol. 41, no. 1, Spring 1981

P. Adams Sitney, *Modernist Montage: The Obscurity of Vision in Cinema and Literature* (New York: Columbia University Press, 1990)

P. Adams Sitney, *The Avant-Garde Film: A Reader of Theory and Criticism* (New York: New York University Press, 1978)

P. Adams Sitney, *Visionary Film: The American Avant-Garde, 1943–2000* (Oxford: Oxford University Press, 2002)

Abigail Solomon-Godeau, *Photography at the Dock: Essays on Photographic History, Institutions, and Practices* (Minneapolis: University of Minnesota Press, 1991)

Susan Sontag, *On Photography* (New York: Farrar, Straus, Giroux, 1977)

Yvonne Spielmann, *Video: The Reflexive Medium* (Cambridge, Mass.: MIT Press, 2008)

Edward Steichen (ed.), *The Family of Man*, 60th anniversary edition (New York: Museum of Modern Art, 2015)

John Tagg, *The Burden of Representation: Essays on Photographies and Histories* (Amherst, Mass.: University of Massachusetts Press, 1988)

Matthew Teitelbaum (ed.), *Montage and Modern Life: 1919–1942* (Cambridge, Mass.: MIT Press, 1992)

Chris Townsend (ed.), *The Art of Bill Viola* (London: Thames & Hudson, 2004)

Alan Trachtenberg (ed.), *Classic Essays on Photography* (New Haven: Leete's Island Books, 1980)

Malcolm Turvey, "Jean Epstein's Cinema of Immanence: The Rehabilitation of the Corporeal Eye," *October*, no. 83 (Winter 1998)

Malcolm Turvey, *The Filming of Modern Life: European Avant-Garde Film of the 1920s* (Cambridge, Mass.: MIT Press, 2011)

Andrew V. Uroskie, *Between the Black Box and the White Cube: Expanded Cinema and Postwar Art* (Chicago: University of Chicago Press, 2014)

Dziga Vertov, *Kino-Eye: The Writings of Dziga Vertov* (Berkeley: University of California Press, 1984)

Jonathan Walley, "The Material of Film and the Idea of Cinema: Contrasting Practices in Sixties and Seventies Avant-Garde Film," *October*, no. 103, Winter 2003

CONTEMPORARY ART AND ARTIST MONOGRAPHS

Ernst van Alphen, *Staging the Archive: Art and Photography in the Age of New Media* (London: Reaktion Books, 2015)

The Atlas Group, *The Truth Will Be Known When the Last Witness is Dead: Documents from the Fakhouri File in The Atlas Group Archive* (Cologne: Walther König, 2004)

George Baker, "An Interview with Pierre Huyghe," *October*, no. 110, Fall 2004, pp. 80–106

George Baker (ed.), *James Coleman* (Cambridge, Mass.: MIT Press, 2003)

Bernadette Corporation, *Reena Spaulings* (New York: Semiotext(e), 2004)

Claire Bishop, *Artificial Hells: Participatory Art and the Politics of Spectatorship* (London: Verso, 2012)

Joline Blais and Jon Ippolito, *At the Edge of Art* (London: Thames & Hudson, 2006)

Iwona Blazwick, Kasper König, and Yve-Alain Bois, *Isa Genzken: Open Sesame!* (Cologne: Walther König, 2009)

Yve-Alain Bois (ed.), *Gabriel Orozco*, October Files 9 (Cambridge, Mass.: MIT Press, 2009)

Yve-Alain Bois and Benjamin H. D. Buchloh, *Gabriel Orozco* (London: Thames & Hudson, 2007)

Sabine Breitwieser, Laura Hoptman, Michael Darling, Jeffrey Grove, and Lisa Lee, *Isa Genzken: Retrospective* (New York: Museum of Modern Art, 2013)

Tania Bruguera et al., *Tania Bruguera* (Venice: La Biennale di Venezia, 2005)

Nicolas Bourriaud, *Relational Aesthetics*, trans. Simon Pleasance and Fronza Woods with the participation of Mathieu Copeland (Dijon: Les Presses du Réel, 2002)

Benjamin H. D. Buchloh, *Raymond Pettibon: Here's Your Irony Back* (Göttingen: Steidl, 2011)

Benjamin H. D. Buchloh and David Bussel, *Isa Genzken: Ground Zero* (Göttingen: Steidl, 2008)

Johanna Burton, "Rites of Silence: On the Art of Wade Guyton," *Artforum*, vol. XLVI, no. 10, Summer 2008, pp. 364–73, p. 464

Sophie Calle, *Take Care of Yourself* (Paris: Dis Voir/Actes Sud, 2007)

Melissa Chiu and Benjamin Genocchio, *Contemporary Asian Art* (London: Thames & Hudson, 2009)

Charlotte Cotton, *The Photograph as Contemporary Art* (London: Thames & Hudson, 2009)

Jean-Pierre Criqui (ed.), *Christian Marclay: Replay* (Zurich: JRPIRingier, 2007)

Florence Derieux, *Tom Burr: Extrospective: Works 1994–2006* (Zurich: JRP Editions, 2006)

Anna Dezeuze, *Thomas Hirschhorn: Deleuze Monument* (London: Afterall Books, 2014)

Yilmaz Dziewior et al, *Zhang Huan* (London: Phaidon, 2009)

Tom Eccles, David Joselit, and Iwona Blazwick, *Rachel Harrison: Museum Without Walls* (New York: Bard College Publications, 2010)

Antje Ehmann and Kodwo Eshun (eds), *Harun Farocki: Against What? Against Whom?* (London: König Books, 2009)

Richard Flood, Laura Hoptman, Massimiliano Gioni, and Trevor Smith, *Unmonumental: The Object in the 21st Century* (London: Phaidon, 2007)

Ruba Katrib and Thomas F. McDonough, *Claire Fontaine: Economies* (North Miami: Museum of Contemporary Art, 2010)

Gao Minglu, *Total Modernity and the Avant-Garde in Twentieth-Century Chinese Art* (Cambridge, Mass.: MIT Press, 2011)

Alison M. Gingeras, Benjamin H. D. Buchloh, and Carlos Basualdo, *Thomas Hirschhorn* (London: Phaidon, 2004)

RoseLee Goldberg, *Performance: Live Art Since the 60s* (London: Thames & Hudson, 2004)

Ann Goldstein, *Martin Kippenberger: The Problem Perspective* (Los Angeles: Museum of Contemporary Art; Cambridge, Mass.: MIT Press, 2008)

Rachel Greene, *Internet Art* (London: Thames & Hudson, 2004)

Kelly Grovier, *Art Since 1989* (London: Thames & Hudson, 2015)

Eleanor Heartney, "Life Like," *Art in America*, vol. 96, no. 5, May 2008, pp. 164–5, p. 208

David Joselit, *After Art* (Princeton: Princeton University Press, 2012)

Rosalind Krauss, "The Rock: William Kentridge's Drawings for Projection," *October*, vol. 92, Spring 2000, pp. 3–35

Carrie Lambert-Beatty, "Political People: Notes on Arte de Conducta," in *Tania Bruguera: On the Political Imaginary* (Milan: Edizioni Charta; Purchase, N.Y.: Neuberger Museum of Art, 2009)

Carrie Lambert-Beatty, "Make-Believe: Parafiction and Plausibility," *October*, no. 129, Summer 2009, pp. 51–84

Lars Bang Larsen (ed.), *Networks*, Documents of Contemporary Art (London and Cambridge, Mass.: Whitechapel Gallery and MIT Press, 2014)

Lisa Lee (ed.), *Isa Genzken*, October Files 17 (Cambridge, Mass.: MIT Press, 2015)

Charles Merewether, *Ai Weiwei: Under Construction* (Sydney: University of New South Wales Press, 2008)

Richard Meyer, *What Was Contemporary Art?* (Cambridge, Mass.: MIT Press, 2014)

Helen Molesworth (ed.), *Louise Lawler*, October Files 18 (Cambridge, Mass.: MIT Press, 2013)

Jochen Noth et al., *China Avant-Garde: Counter-Currents in Art and Culture* (Oxford: Oxford University Press, 1994)

Sally O'Reilly, *The Body in Contemporary Art* (London: Thames & Hudson, 2009)

Christiane Paul, *Digital Art* (London: Thames & Hudson, 2008)

Michael Rush, *New Media in Art* (London: Thames & Hudson, 2005)

Michael Rush, *Video Art* (London: Thames & Hudson, 2007)

Edward A. Shanken (ed.), *Systems*, Documents of Contemporary Art (London and Cambridge, Mass.: Whitechapel Gallery and MIT Press, 2015)

Terry Smith, *What is Contemporary Art?* (Chicago: The University of Chicago Press, 2009)

Robert Storr, *Jenny Holzer: Redaction Paintings* (New York: Cheim & Reid, 2006)

Texte zur Kunst, "The [Not] Painting Issue," March 2010

Samantha Topol (ed.), *Dear Nemesis, Nicole Eisenman* (St. Louis: Contemporary Art Museum; Verlag der Buchhandlung Walther König, 2014)

Chris Townsend (ed.), *The Art of Rachel Whiteread* (London: Thames & Hudson, 2004)

Chris Townsend (ed.), *The Art of Bill Viola* (London: Thames & Hudson, 2004)

Anton Vidokle, *Produce, Distribute, Discuss, Repeat* (New York: Lukas & Sternberg, 2009)

Anton Vidokle, Response to "A Questionnaire on 'The Contemporary,'" *October*, no. 130, Fall 2009, pp. 41–3

Wu Hung, *Transience: Chinese Experimental Art at the End of the Twentieth Century*, revised edition (Chicago: David and Alfred Smart Museum of Art; University of Chicago Press, 2005)

Wu Hung (ed.), *Contemporary Chinese Art: Primary Documents*, with the assistance of Peggy Wang (New York: Museum of Modern Art; Durham, N.C.: Duke University Press, 2010)

RELATED ISSUES

Walter L. Adamson, *Embattled Avant-Gardes: Modernism's Resistance to Commodity Culture in Europe* (Berkeley and Los Angeles: University of California Press, 2006)

Giorgio Agamben, *The Open: Man and Animal* (Palo Alto: Stanford University Press, 2003)

Gwen Allen, *Artists' Magazines: An Alternative Space for Art* (Cambridge, Mass.: MIT Press, 2011)

Philip Armstrong, Laura Lisbon and Stephen Melville (eds), *As Painting: Division and Displacement* (Cambridge, Mass.: MIT Press, 2001)

Artforum, vol. XLVI, no. 8, April 2008 (special issue on "Art and its Markets")

Hans Belting, Andrea Buddensieg, and Peter Weibel (eds), *The Global Contemporary and the Rise of New Art Worlds* (Cambridge, Mass.: MIT Press, 2013)

Luc Boltanski and Eve Chiapello, *The New Spirit of Capitalism*, trans. Gregory Elliot (London: Verso, 2005)

Giovanna Borradori, *Philosophy in a Time of Terror: Dialogues with Jürgen Habermas and Jacques Derrida* (Chicago: University of Chicago Press, 2003)

Nestor Garcia Canclini, *Consumers and Citizens: Globalization and Multicultural Conflicts* (Minneapolis: University of Minnesota Press, 2001)

T. J. Demos, *The Migrant Image: The Art and Politics of Documentary during Global Crisis* (Durham, N.C.: Duke University Press, 2013)

Romy Golan, *Muralnomads: The Paradox of Wall Painting Europe 1927–1957* (New Haven and London: Yale University Press, 2009)

Isabelle Graw, *High Price: Art Between the Market and Celebrity Culture* (Berlin and New York: Sternberg Press, 2009)

Boris Groys, *Art Power* (Cambridge, Mass.: MIT Press, 2008)

Boris Groys, *History Becomes Form: Moscow Conceptualism* (Cambridge, Mass.: MIT Press, 2010)

Michael Hardt and Antonio Negri, *Empire* (Cambridge, Mass.: Harvard University Press, 2000)

Juliet Koss, *Modernism After Wagner* (Minneapolis: University of Minnesota Press, 2010)

Richard Curt Kraus, *The Party and the Arty in China: The New Politics of Culture* (Lanham: Rowman & Littlefield Publishers, 2004)

Claude Lichtenstein and Thomas Schregenberger (eds), *As Found: The Discovery of the Ordinary* (Zurich: Lars Müller Publishers, 2001)

Alexander Nagel, *Medieval Modern: Art Out of Time* (London: Thames & Hudson, 2013)

Gabriel Pérez-Barreiro (ed.), *The Geometry of Hope: Latin American Abstract Art from the Patricia Phelps Cisneros Collection* (Austin: Blanton Museum of Art and Fundación Cisneros, 2006)

Martin Puchner, *Poetry of the Revolution: Marx, Manifestos, and the Avant-Gardes (Translation/Transnation)* (Princeton: Princeton University Press, 2005)

Eric S. Santner, *On Creaturely Life: Rilke, Benjamin, Sebald* (Chicago: University of Chicago Press, 2006)

Arnd Schneider and Christopher Wright (eds), *Between Art and Anthropology: Contemporary Ethnographic Practice* (Oxford: Berg, 2010)

Edward A. Shanken (ed.), *Art and Electronic Media* (London: Phaidon, 2009)

Julian Stallabrass, *Art Incorporated* (London: Verso, 2004)

Barbara Vanderlinden and Elena Filipovic, *The Manifesta Decade: Debates on Contemporary Art Exhibitions and Biennials in Post-Wall Europe* (Cambridge, Mass.: MIT Press, 2006)

Olav Velthius, *Talking Prices: Symbolic Meanings for Prices on the Market for Contemporary Art* (Princeton: Princeton University Press, 2005)

Anne M. Wagner, *Mother Stone: The Vitality of Modern British Sculpture* (New Haven and London: Yale University Press, 2005)

selected useful websites

Listed below is a small selection of the many websites devoted to modern and contemporary art. Many contain links to other related websites for those wishing to continue their study and research.

GENERAL INFORMATION, RESEARCH PORTALS, AND LINKS

http://www.aaa.si.edu The Archives of American Art, the world's largest and most widely used resource on the visual arts in America

http://www.abcgallery.com "Olga's Gallery"—brief histories of movements, artists' biographies, images of art works, with extensive links to other websites

http://americanhistory.si.edu/archives/ac-i.htm Largest source in the United States of primary documentation on the visual arts

http://artcyclopedia.com Links to websites by artist and movement

http://arthist.net Information, links, and news for art historians

http://the-artists.org Links to art works, essays, artists' biographies, portraits, and websites, and museums

http://www.artnet.com An online resource about artists and the art market

http://www.theartstory.org Extensive information about the key styles, movements, artists, critics, curators, galleries, schools, and ideas in modern art

http://www.askart.com AskART is an online database containing close to 300,000 artists, with information ranging from biographies to auction records

http://www.bc.edu/bc_org/avp/cas/fnart/links/art_19th20th.html Links to websites on nineteenth- and twentieth-century art, by movement, period, and artist

http://www.biennialfoundation.org Information and links about contemporary art biennials and triennials worldwide

https://www.ebscohost.com/academic/art-source Art Source, an online resource for art and architecture research

http://getty.edu/research/tools/portal/index.html The Getty Research Portal is a free online search platform providing worldwide access to an extensive collection of digitized art history texts from a range of institutions

http://www.jstor.org JSTOR, a digital library of academic journals, books, and primary sources

http://www.moma.org/learn/moma_learning Museum of Modern Art Learning, an online information resource about themes and movements in modern art

http://www.nyarc.org The New York Art Resources Consortium (NYARC) consists of the research libraries of three leading art museums in New York City: Brooklyn Museum, Frick Collection, and Museum of Modern Art

http://witcombe.sbc.edu/ARTH20thcentury.html Links to art works, essays, artists' biographies and websites, and museums

IMAGE BANKS

http://www.artstor.org Non-profit initiative, founded by the Andrew W. Mellon Foundation—archive of hundreds of thousands of digital images and related data

https://www.google.com/culturalinstitute/project/art-project The Google Cultural Institute's Art Project, providing links to and images from a variety of worldwide collections

http://www.photo.rmn.fr Visual archive of the French national holdings of modern and contemporary art

http://www.videomuseum.fr Visual archive of modern and contemporary art held in public collections in France

MUSEUMS AND INSTITUTIONS OF ART

http://www.artic.edu Art Institute of Chicago

http://www.berlinbiennale.de Berlin Biennial for Contemporary Art

http://www.bienalhabana.cult.cu Havana Biennial

http://www.biennaleofsydney.com.au Sydney Biennial of Contemporary Art

http://www.brandeis.edu/rose Rose Art Museum, Brandeis University

http://www.cmoa.org/ Carnegie Museum of Art, Pittsburgh

http://www.cnac-gp.fr Centre Georges Pompidou, Paris

http://commonpracticeny.org Network of small-scale arts organizations in New York City, including Anthology Film Archives, Artists Space, The Kitchen Center, Printed Matter, and others

http://www.diaart.org Dia Art Foundation, New York

http://www.documenta.de Documenta

http://www.guggenheim.org Solomon R. Guggenheim Museum, New York

https://hammer.ucla.edu Hammer Museum, Los Angeles

http://hirshhorn.si.edu/collection/home/#collection=home Hirshhorn Museum and Sculpture Garden, Washington, D.C.

http://www.icaboston.org Institute of Contemporary Art, Boston

http://www.icp.org International Center of Photography, New York

http://www.istanbulmodern.org Istanbul Museum of Modern Art, Istanbul

http://www.labiennale.org Venice Biennale

http://www.lacma.org Los Angeles County Museum of Art

http://www.maaala.org Museum of African American Art, Los Angeles

http://mam.org.br Museu de Arte Moderna, São Paulo

http://www.manifesta.org Manifesta, the European Biennial of Contemporary Art

http://www.metmuseum.org Metropolitan Museum of Art, New York

http://www.mcachicago.org Museum of Contemporary Art, Chicago

http://moma.org Museum of Modern Art, New York

http://www.newmuseum.org New Museum of Contemporary Art, New York

http://www.nga.gov/content/ngaweb.html National Gallery of Art, Washington, D.C.

http://njpac-en.ggcf.kr Nam June Paik Center, Yongin, South Korea

http://on1.zkm.de/zkm/e ZKM, Center for Art and Media Karlsruhe

http://performa-arts.org Performa, biennial of visual art performance, New York

http://www.philamuseum.org Philadelphia Museum of Art

http://www.secession.at Vienna Secession, forum for experimental art

http://www.sfmoma.org San Francisco Museum of Modern Art

http://www.stedelijk.nl Stedelijk Museum, Amsterdam

http://www.studiomuseum.org Studio Museum, Harlem, New York

http://www.tate.org.uk Tate, London

http://ucca.org.cn/en Ullens Center for Contemporary Art, Beijing

http://www.whitney.org Whitney Museum of American Art, New York
(also see "General information, research portals, and links")

ARTISTS' AND MOVEMENTS' WEBSITES

http://www.albersfoundation.org Josef and Anni Albers Foundation, Bethany, Connecticut

http://www.artsmia.org/modernism "Milestones in Modernism 1880–1940"

http://www.bauhaus.de/en Bauhaus Archive and Collection, Berlin

http://www.cia.edu/library/artists-books The Cleveland Institute of Art's important international collection of artists' books, containing more than 1700 books and multiples from the 1960s to the present

http://www.dekooning.org Willem de Kooning Foundation, New York

http://www.fundaciomiro-bcn.org Joan Miró Foundation, Barcelona

http://www.iniva.org/harlem Institute of International Visual Arts—Harlem Renaissance archive

http://sdrc.lib.uiowa.edu/dada/index.html International Dada Archive

http://www.luxonline.org.uk Online resource and archive devoted to British-based film and video artists

http://www.moma.org/brucke Museum of Modern Art, New York—Die Brücke archive

http://www.mondriantrust.com Mondrian Trust

http://www.musee-picasso.fr Musée National Picasso, Paris

http://www.museupicasso.bcn.es/en Picasso Museum, Barcelona

https://www.okeeffemuseum.org Georgia O'Keeffe Museum

http://www.paikstudios.com The Nam June Paik Estate

https://picasso.shsu.edu Online Picasso Project—extensive archive of works

http://www.pkf.org The Pollock-Krasner Foundation, New York

http://www.rauschenbergfoundation.org Robert Rauschenberg Foundation, New York

http://rhizome.org An online resource on new media art, the intersection of new technologies and contemporary art

http://sdrc.lib.uiowa.edu/dada/index.html The International Dada Archive, part of the Dada Archive and Research Center

http://www.surrealismcentre.ac.uk The Centre for the Study of Surrealism and its Legacies

http://www.theviennasecession.com An online museum devoted to the Vienna Secession

http://www.usc.edu/dept/architecture/slide/babcock Cubism archive

www.warhol.org The Andy Warhol Museum, Pittsburgh
(also see "General information, research portals, and links")

ONLINE DICTIONARIES AND GLOSSARIES

http://www.artlex.com Basic dictionary of terms

http://www.cia.edu/files/resources/14ciaglossaryofartterms.pdf Cleveland Institute of Art glossary of art terms

http://www.dictionaryofarthistorians.org Online biographical dictionary of historic scholars, museum professionals, and academic historians of art

http://www.moma.org/learn/moma_learning/glossary Museum of Modern Art glossary of art terms

http://www.tate.org.uk/learn/online-resources/glossary Tate glossary of art terms

http://www.oxfordartonline.com/public Home of Grove Art Online, the online version of *The Dictionary of Art*, the authoritative dictionary of art and artists; over 45,000 articles on the fine arts, decorative arts, and architecture; written by over 6,000 international scholars; over 130,000 art images, with links to museums and galleries around the world; access to full text of *The Encyclopedia of Aesthetics*, *The Oxford Companion to Western Art*, and *The Concise Oxford Dictionary of Art Terms* (subscription)

ONLINE JOURNALS, BLOGS, AND ART PUBLISHERS

http://artcritical.com Online magazine of art and ideas

http://www.artfagcity.com Online art news, reviews, and culture commentary blog; links to modern and contemporary art galleries

http://www.artforum.com *Artforum* magazine—international news digest, features, and selected articles from past issues; links to modern and contemporary art galleries

http://www.artinamericamagazine.com Online version of *Art in America Art* magazine—archive of past issues

http://www.artinfo.com Online news magazine about international art and culture

http://artlog.com Online magazine and art guide

http://www.artmonthly.co.uk Online version of *Art Monthly* magazine—archive of past issues

http://www.artnews.com Online version of *ArtNews* magazine—archive of past issues

http://www.artsjournal.com Online aggregator of international news reports and features on art, culture, and ideas

https://www.artsy.net Artsy, an online resource for art collecting and education

http://www.caareviews.org College Art Association—extensive archive of reviews of books and catalogues

http://canopycanopycanopy.com Online magazine, workspace, and platform for editorial and curatorial activities

http://www.contemporaryartdaily.com *Contemporary Art Daily*, a daily journal of international exhibitions

http://www.e-flux.com International network that reaches more than 50,000 visual art professionals on a daily basis through its website, e-mail list and special projects. Its news digest – e-flux announcements – distributes information on some of the world's most important contemporary art exhibitions, publications and symposia.

http://www.flashartonline.com Online version of *Flash Art* magazine—archive of past issues

http://www.frieze.com/magazine Online version of *Frieze* magazine—archive of past issues

http://www.mitpressjournals.org/loi/octo *October* journal —selected articles from past issues

http://newsgrist.typepad.com NEWSgrist "where spin is art"—blog that gathers short profiles, exhibition reviews, op-ed pieces, and commentary

http://www.textezurkunst.de *Texte zur kunst* journal—archive of past issues; links to modern and contemporary art galleries

http://www.thamesandhudson.com and http://www.thamesandhudsonusa.com Extensive range of books on modern and contemporary art; links to related websites

http://www.theartnewspaper.com Online version of the monthly newspaper; links to modern and contemporary art galleries

http://www.twocoatsofpaint.com Online articles, reviews and writing on painting

http://www.uchicago.edu/research/jnl-crit-inq *Critical Inquiry* journal—selected articles from past issues; links to websites of critical interest

http://universes-in-universe.org/eng Online magazine about the global art world

picture credits

Measurements are given in centimeters, followed by inches, height before width before depth, unless otherwise stated.

p.5 (top) Ernst Ludwig Kirchner, *The Street, Dresden*, 1908. Oil on canvas, 150.5 × 200 (59¼ × 78⅞). Museum of Modern Art, New York. © Dr. Wolfgang & Ingeborg Henze-Ketterer, Wichtrach/ Bern; **(second top)** František Kupka, *Amorpha, Fugue in Two Colors*, 1912. Oil on canvas, 211.8 × 220 (83⅜ × 86⅝). Národní Galerie, Prague. © ADAGP, Paris and DACS, London 2004; **(center)** Franz Marc, *The Fate of the Animals*, 1913. Oil on canvas, 194.3 × 261.6 (76½ × 103). Kunstmuseum, Basle; **(second bottom)** Kazimir Malevich, *Warrior of the First Division*, 1914. Oil and collage on canvas, 53.6 × 44.8 (21⅛ × 17⅝). Museum of Modern Art, New York; **(bottom)** Marcel Duchamp, *Fountain*, 1917 (1964 replica). Readymade: porcelain, 36 × 48 × 61 (14⅛ × 18⅞ × 24). Photo Tate, London 2004. © Succession Marcel Duchamp/ADAGP, Paris and DACS, London 2004; **p.6 (top)** Fernand Léger, *The City*, 1919. Oil on canvas, 231.1 × 298.4 (91 × 117½). ADAGP, Paris and DACS, London 2016; **(second top)** Gustav Klutsis, *Let us Fulfill the Plan of our Great Projects*, 1930. Photomontage. Russian State Library, Moscow; **(center)** Barbara Hepworth, *Large and Small Form*, 1934. Alabaster, 23 × 37 × 18 (9 × 14 × 7). The Pier Gallery Collection, Stromness. © Bowness, Hepworth Estate; **(second bottom)** Karl Blossfeldt, *Impatiens Glandulifera; Balsamine, Springkraut*, 1927. Silver salts print. Courtesy Galerie Wilde, Cologne; **(bottom)** Wolfgang Paalen, *Ciel de Pieuvre*, 1938. Fumage and oil on canvas, 97 × 130 (38¼ × 51⅛). Private Collection, Courtesy Paalen Archiv, Berlin; **p.9 (top)** Morris Louis, *Beta Kappa*, 1961. Acrylic resin on canvas, 262.3 × 429.4 (103¼ × 173). National Gallery of Art, Washington, D.C. © 1961 Morris Louis; **(second top)** Ellsworth Kelly, *Colors for a Large Wall*, 1951. Oil on canvas, mounted on 64 joined panels 243.8 × 243.8 (96 × 96). Museum of Modern Art, New York. © Ellsworth Kelly; **(center)** Mario Merz, *Objet Cache Toi*, 1968–77. Metal tubes, glass, clamps, wire mesh, neon, 185 × 365 (72⅞ × 143¾). Courtesy Archivo Merz, Turin; **(second bottom)** Chris Burden, *Trans-fixed*, 1974. Performance, Venice, California. Courtesy the artist; **(bottom)** Bernd and Hilla Becher, *8 Views of a House*, 1962–71. Black-and-white photographs. Courtesy Sonnabend Gallery, New York; **p.10 (top)** Gerhard Richter, *October 18, 1977: Confrontation 1 (Gegenüberstellung 1)*, 1988. Oil on canvas, 111.8 × 102.2 (44 × 40¼). Museum of Modern Art, New York. Photo Axel Schneider, Frankfurt/Main. © Gerhard Richter; **(second top)** Barbara Bloom, *The Reign of Narcissism*, 1989. Mixed media, dimensions variable. © Barbara Bloom, 1989. Courtesy Gorney, Bravin + Lee, New York; **(center)** Rachel Whiteread, *(Untitled) House*, 1993. Destroyed. Commissioned by Artangel. Sponsored by Beck's. Photo Sue

Ormera. Courtesy Rachel Whiteread and Gagosian Gallery, London; **(second bottom)** Kiki Smith, *Blood Pool*, 1992. Painted bronze 35.6 × 99.1 × 55.9 (14 × 39 × 22). Cast two of an edition of two. Collection of the artist. Photo Ellen Page Wilson, courtesy Pace Wildenstein, New York. © Kiki Smith; **(bottom)** Kara Walker, *Camptown Ladies*, 1998 (detail). Cut paper and adhesive on wall, dimensions variable. Courtesy the artist and Brent Sikkema, NYC; **p.11 (top)** Douglas Gordon, *24 Hour Psycho*, 1993. Video projection installation. Courtesy Lisson Gallery, London; **(second top)** Rirkrit Tiravanija, *Secession*, 2002. Installation and performance at the Vienna Secession. Courtesy Gavin Brown Enterprise © Rirkrit Tiravanija; **(center)** John Miller, *Glad Hand*, 1998. Mixed media, 160 × 81.3 × 38.1 (63 × 32 × 15). Courtesy the Artist and Metro Pictures; **(second bottom)** Thomas Hirschhorn, "Utopia, Utopia = One World, One War, One Army, One Dress," Institute of Contemporary Art, Boston, 2005. Installation view. Courtesy Gladstone Gallery, New York; **(bottom)** Sharon Hayes, *In the Near Future*, 2009 (detail). 35mm multiple-slide-projection installation, 13 projections, edition of 3 + 1 AP. Courtesy Sharon Hayes; **Introduction 1: 1** • Museum Folkwang, Essen; **2** • Museum of Modern Art, New York. © DACS 2004; **3** • Collection William Rubin, Bronxville, New York. © ADAGP, Paris and DACS, London 2004; **4** • Galerie Krikhaar, Amsterdam. © Karel Appel Foundation/DACS, London 2004; **5** • Courtesy Ydessa Hendeles Art Foundation, Toronto; **6** • © DACS, London/VAGA, New York 2004; **7** • © Lee Miller Archives, Chiddingly, England, 2004. All rights reserved; **Introduction 2: 1** • Photo Akademie der Künste der DDR, Berlin. © The Heartfield Community of Heirs/VG Bild-Kunst, Bonn and DACS, London 2004; **2** • From Szymon Bojko, *New Graphic Designs in Revolutionary Russia*, Lund Humphries, London, 1972. Lissitzky: © DACS 2004; **4** • Martha Rosler, © Martha Rosler, 1969–72. Courtesy the artist and Gorney Bravin & Lee, New York; **5** • Photo Dave Morgan, London. Courtesy Lisson Gallery, London; **6** • Courtesy the artist. © DACS 2004; **7** • Photo Reiner Ruthenbeck. Courtesy Konrad Fischer Galerie. © Gerhard Richter; **Introduction 3: 1** • Kunstmuseum, Basel. Gift of Raoul La Roche, 1952. © ADAGP, Paris and DACS, London 2004; **2** • Musée Picasso, Paris. © Succession Picasso/DACS 2004; **3** • Pablo Picasso, Museum of Modern Art, New York. Gift of the artist. © Succession Picasso/DACS 2004; **4** • Haags Gemeentemuseum. © 2004 Mondrian/Holtzman Trust. c/o hcr@ hcrinternational.com; **Introduction 4: 1** • Städtische Kunsthalle, Düsseldorf. Photo © Gilissen. © DACS 2004; **2** • © ADAGP, Paris and DACS, London 2004; **3** • Museum of Contemporary Art, Chicago, gift of Susan and Lewis Manilow. © Estate of Robert Smithson/ VAGA, New York/DACS, London 2004; **4** • © the artist; **5** • © 1981 by The University of Chicago; © 1981 by Continuum.; **6** • Courtesy the artist

and Metro Pictures; **Introduction 5: 3** • *Gutai* journal, no. 11, November 1960, p. 13; **4** • Courtesy Kwon Ohyup; **5** • Third Havana Biennial 1989; **6** • Photo Archivo Aldo Menéndez; **7** • Courtesy Queens Museum, New York; **8** • Photo courtesy Secession/Oliver Ottenschläger **9** • Revolver Verlag/Secession, 2012; **1900: 1** • Photo Dr F. Stoedther; **4** • Leopold Museum, Vienna; **5** • Photo Jörg P. Anders. Nationalgalerie Staatliche Museen Preussischer Kulturbesitz, Berlin. © DACS 2004; **1900b: 1** • Baltimore Museum of Art, The Cone Collection – formed by Dr. Claribel Cone and Miss Etta Cone of Baltimore, Maryland. 50.422. © Succession H. Matisse/DACS 2004; **2** • Iris & B. Gerald Cantor Collection, Beverly Hills, California; **3** • Musuem of Modern Art, New York. Lillie P. Bliss Bequest. Photo Soichi Sunami. © Succession H. Matisse/ DACS 2004; **4** • Museum of Modern Art, New York. Gift of Stephen C. Clark. © ADAGP, Paris and DACS, London 2004; **5** • Museum of Modern Art, New York. Gift of Mrs. Simon Guggenheim Fund. © Succession H. Matisse/ DACS 2004; **6** • Museum of Modern Art, New York. Gift of Mrs. Simon Guggenheim Fund. © Succession H. Matisse/DACS 2004; **7** • Museum of Modern Art, New York. Gift of Mrs. Simon Guggenheim Fund. © Succession H. Matisse/ DACS 2004; **8** • Museum of Modern Art, New York. Gift of Mrs. Simon Guggenheim Fund. © Succession H. Matisse/DACS 2004; **9** • Museum of Modern Art, New York. Gift of Mrs. Simon Guggenheim Fund. © Succession H. Matisse/ DACS 2004; **10** • Baltimore Museum of Art, The Cone Collection. © Succession H. Matisse/ DACS 2004; **1903: 1** • Private Collection. © ADAGP, Paris and DACS, London 2004; **2** • Private Collection; **3** • Albright Knox Art Gallery, Buffalo, New York, A. Conger Goodyear Collection, 1965; **4** • Kunstsammlung Nordrhein-Westfalen, Dusseldorf. © Dr. Wolfgang & Ingeborg Henze-Ketterer, Wichtrach/Bern; **5** • The Baltimore Museum of Art, The Cone Collection, formed by Dr Claribel Cone and Miss Etta Cone. © Succession H. Matisse/DACS 2004; **1906: 1** • Musée d'Orsay, Paris. © Succession H. Matisse/DACS 2004; **box** Roger Fry, *Self-Portrait*, 1918. Oil on canvas, 79.8 × 59.3 (31⅜ x 23⅜). By permission of the Provost and Fellows of King's College, Cambridge. Photo Fine Art Photography; **2** • San Francisco Museum of Modern Art. Bequest of Elise S. Haas. © 2004 Succession H. Matisse/DACS 2004; **3** • Musée Matisse, Nice. © Succession H. Matisse/DACS 2007; **4** • National Gallery of Art, Washington D.C. © Succession H. Matisse/ DACS 2004; **5** • The Barnes Foundation, Merion, Pennsylvania / The Bridgeman Art Library, London. © Succession H. Matisse/DACS 2004; **1907: 1** • Museum of Modern Art, New York, Lillie P. Bliss Bequest. © Succession Picasso/ DACS 2004; **2** • Metropolitan Museum of Art. Bequest of Gertrude Stein, 1946. © Succession Picasso/DACS 2004; **3** • Offentliche Kunstsammlung, Kunstmuseum, Basel. ©

Succession Picasso/DACS 2004; **4** •
Photographed for Gelett Burgess, 1908; **5** •
Musée Picasso, Paris. © Succession Picasso/
DACS 2004; **6** • Sergei Pankejeff, sketch from
The Wolf-Man & Sigmund Freud, ed. Murial
Gardiner, Hogarth Press, 1972, p.174; **7** • The
State Hermitage Museum, St. Petersburg. ©
Succession Picasso/DACS 2004; **1908: 1** •
Städtische Galeries im Lenbachhaus, Munich.
© ADAGP, Paris and DACS, London 2004; **2** •
Städtische Galeries im Lenbachhaus, Munich.
GMS 153. © ADAGP, Paris and DACS, London
2004; **3** • Museum of Modern Art, New York. ©
Dr. Wolfgang & Ingeborg Henze-Ketterer,
Wichtrach/Bern; **4** • Kunstmuseum, Basel; **5** •
© Wyndham Lewis and the Estate of the late Mrs
G. A. Wyndham Lewis by kind permission of the
Wyndham Lewis Memorial Trust (a registered
charity); **1909: 2** • Civica Galleria d'Arte
Moderna, Milan. © DACS 2004; **3** • Albright-
Knox Art Gallery, Buffalo, New York, Bequest
of A. Conger Goodyear and Gift of George F.
Goodyear, 1964. © DACS 2004; **4** • Museum
of Modern Art, New York. Acquired through the
Lillie P. Bliss Bequest; **box** Edward Muybridge,
Movement Phases of a Galloping Horse, 1884–5.
Collotype print; Étienne-Jules Marey,
Investigation into Walking, c. 1884. Geometric
chronograph (from original photograph). Collège
de France Archives, Paris; **5** • Peggy
Guggenheim Collection, Venice; **6** • Mattioli
Collection, Milan. © DACS 2004; **7** • Galleria
Nazionale d'Arte Moderna, Rome. Isabella
Pakszwer de Chirico Donation. © DACS 2004;
8 • Pinacoteca di Brera, Milan. Photo © Scala,
Florence/Courtesy of the Ministero Beni e Att.
Culturali 1990. © DACS 2004; **1910: 1** •
The State Hermitage Museum, St. Petersburg.
© Succession H. Matisse/DACS 2004; **2** •
The State Hermitage Museum, St. Petersburg.
© Succession H. Matisse/DACS 2004; **3** •
The State Hermitage Museum, St. Petersburg. ©
Succession H. Matisse/DACS 2004; **4** • St. Louis
Art Museum, Gift of Mr & Mrs Joseph Pulitzer. ©
Succession H. Matisse/DACS 2004; **5** • The
State Hermitage Museum, St. Petersburg. ©
Succession H. Matisse/DACS 2004; **6** • Musée
de Grenoble. Gift of the artist, in the name of his
family. © Succession H. Matisse/DACS 2004;
Pablo Picasso, *Apollinaire blessé (Apollinaire
Wounded)*, 1916. Pencil on paper, 48.8 x 30.5
(19¼ x 12). © Succession Picasso/DACS 2004;
1911: 1 • Art Institute of Chicago. Gift of Mrs.
Gilbert W. Chapman in memory of Charles B.
Goodspeed. © Succession Picasso/DACS 2004;
2 • Kunstmuseum, Basel. Donation Raoul La
Roche. © ADAGP, Paris and DACS, London
2004; **3** • Museum of Modern Art, New York.
Nelson A. Rockefeller Bequest. © Succession
Picasso/DACS 2004; **4** • Museum of Modern Art,
New York. Nelson A. Rockefeller Bequest. ©
Succession Picasso/DACS 2004; **5** • Musée
Picasso, Paris. Photo © RMN – R. G. Ojeda. ©
Succession Picasso/DACS 2004; **1912: 1** •
Private Collection. © ADAGP, Paris and DACS,
London 2004; **2** • Musée National d'Art
Moderne, Centre Georges Pompidou, Paris. Gift
of Henri Laugier. © Succession Picasso/DACS
2004; **3** • Musée National d'Art Moderne, Centre

Georges Pompidou, Paris. Gift of Henri Laugier.
© Succession Picasso/DACS 2004; **4** • Mildred
Lane Kemper Art Museum, Washington
University in St. Louis. University Purchase,
Kende Sale Fund, 1946. © Succession Picasso/
DACS 2004; **5** • Musée National d'Art Moderne,
Centre Georges Pompidou, Paris. Gift of Henri
Laugier. © Succession Picasso/DACS 2004;
6 • Marion Koogler McNay Art Museum, San
Antonio. © Succession Picasso/DACS 2004;
7 • Photo Pablo Picasso. © Succession Picasso/
DACS 2004; **8** • Guillaume Apollinaire, 'La
Cravate et la Montre', 1914. From *Calligrammes:
Poèmes de la paix et de la guerre, 1913–16, Part
I: Ondes*. Paris: Éditions Gallimard, 1925; **1913:
1** • Private Collection. © DACS 2004; **2** •
Národní Galerie, Prague. © ADAGP, Paris and
DACS, London 2004; **3** • Philadelphia Museum
of Art, The Louise and Walter Arensberg
Collection. © ADAGP, Paris and DACS, London
2004; **4** • Solomon R. Guggenheim Museum,
New York. © 2004 Mondrian/Holtzman Trust. c/o
hcr@hcrinternational.com; **5** • L & M Services
B.V. Amsterdam 20040801; **6** • L & M Services
B.V. Amsterdam 20040801; **7** • L & M Services
B.V. Amsterdam 20040801; **8** • Museum of
Theatrical and Musical Arts, St Petersburg; **1914:
1** • Philadelphia Museum of Art, The Louise and
Walter Arensberg Collection. © Succession
Marcel Duchamp/ADAGP, Paris and DACS,
London 2004; **2** • Whereabouts unknown. ©
DACS 2004; **3** • Photo State Film, Photographic
and Sound Archive, St Petersburg. © DACS
2004; **4** • Hessisches Landesmuseum,
Darmstadt. © Succession Marcel Duchamp/
ADAGP, Paris and DACS, London 2004; **5** •
Photo Tate, London 2004. © Succession Marcel
Duchamp/ADAGP, Paris and DACS, London
2004; **1915: 1** • Museum of Modern Art, New
York; **3** • State Russian Museum, St Petersburg;
4 • Stedelijk Museum, Amsterdam; **5** • Museum
of Modern Art, New York; **1916a: 1** • Musée
National d'Art Moderne, Centre Georges
Pompidou, Paris. © ADAGP, Paris and DACS,
London 2004; **3** • Private Collection. © DACS
2004; **4** • bpk/Nationalgalerie, Staatliche
Museen zu Berlin/Jörg P. Anders. © DACS,
2016; **5** • Stiftung Arp e.V., Berlin/Rolandswerth.
© DACS, 2016; **1916b: 1** • Metropolitan
Museum of Art, New York. © ADAGP, Paris and
DACS, London 2004; **2** • Museum of Modern
Art, New York. © ARS, NY and DACS, London
2004; **3** • Museum of Modern Art, New York.
Reprinted with permission of Joanna T. Steichen;
4 • Museum of Modern Art, New York. © ARS,
NY and DACS, London 2004; **5** • © 1971
Aperture Foundation Inc., Paul Strand Archive;
6 • Philadelphia Museum of Art, The Alfred
Stieglitz Collection. © ARS, NY and DACS,
London 2004; **1917a: 1** • Rijksmuseum Kröller-
Müller, Otterlo, The Netherlands. © 2011
Mondrian/Holtzman Trust c/o HCR International
Virginia; **2** • Rijksmuseum Kröller-Müller, Otterlo,
The Netherlands. © 2011 Mondrian/Holtzman
Trust c/o HCR International Virginia; **3** •
Gemeentemuseum Den Haag. © 2011
Mondrian/Holtzman Trust c/o HCR International
Virginia; **4** • Stedelijk Museum, Amsterdam. ©
2011 Mondrian/Holtzman Trust c/o HCR

International Virginia; **5** • Stedelijk Museum,
Amsterdam. © 2011 Mondrian/Holtzman Trust
c/o HCR International Virginia; **1917b: 1** •
Rijksdienst voor Beeldende Kunst, L'Aia/
Gemeentemuseum, L'Aia. © DACS 2011; **2** •
Gemeentemuseum Den Haag; **3** • Nederlands
Architectuurinstituut, Rotterdam-Amsterdam;
4 • British Architectural Library, RIBA. © DACS,
London 2004; **6** • Stedelijk Museum,
Amsterdam. © DACS 2011; **1918: 1** •
Philadelphia Museum of Art, Walter and Louise
Arensberg Collection. © Succession Marcel
Duchamp/ADAGP, Paris and DACS, London
2004; **2** • Museum of Modern Art, New York.
Katherine S. Dreier Bequest. © Succession
Marcel Duchamp/ADAGP, Paris and DACS,
London 2004; **3** • Museum of Modern Art, New
York. © DACS 2004; **4** • Yale University Art
Gallery, New Haven, Connecticut. Gift of
Katherine S. Dreier. © Succession Marcel
Duchamp/ADAGP, Paris and DACS, London
2004; **5** • Private Collection, Paris. © Succession
Marcel Duchamp/ADAGP, Paris and DACS,
London 2004. © Man Ray Trust/ADAGP, Paris
and DACS, London 2004; **box** Man Ray, *Rrose
Sélavy*, c. 1920–1. Silver-gelatin print, 21 x 17.3
(8¼ x 6¾). Philadelphia Museum of Art. The
Samuel S. White 3rd and Vera White Collection.
© Man Ray Trust /ADAGP, Paris and DACS,
London 2004. © Succession Marcel Duchamp/
ADAGP, Paris and DACS, London 2004; **1919:
1** • Musée Picasso, Paris. © Succession
Picasso/DACS 2004; **box** Pablo Picasso,
Portrait of Sergei Diaghilev and Alfred Seligsberg,
1919. Charcoal and black pencil, 65 x 55 (25⅝ x
21⅝). Musée Picasso, Paris. © Succession
Picasso/DACS 2004; **2** • Private Collection. ©
Succession Picasso/DACS 2004; **3** • © ADAGP,
Paris and DACS, London 2004; **4** • Musée
Picasso, Paris. © Succession Picasso/DACS
2004; **5** • Yale University Art Gallery, New Haven,
Connecticut. Gift of Collection Société Anonyme;
1920: 2 • Staatliche Museen, Berlin. © DACS
2004; **3** • Musée National d'Art Moderne, Centre
Georges Pompidou, Paris. © ADAGP, Paris and
DACS, London 2004; **4** • Photo Akademie der
Künste der DDR, Berlin. Grosz © DACS, 2004.
Heartfield © The Heartfield Community of Heirs/
VG Bild-Kunst, Bonn and DACS, London 2004;
5 • Musée National d'Art Moderne, Centre
Georges Pompidou, Paris. © ADAGP, Paris and
DACS, London 2004; **6** • Akademie der Kunst,
Berlin. © The Heartfield Community of Heirs/VG
Bild-Kunst, Bonn and DACS, London 2004; **7** •
Russian State Library, Moscow; **1921a: 1** • ©
Succession Picasso/DACS, London 2016; **2** • ©
Succession Picasso/DACS, London 2016; **3** • ©
Succession Picasso/DACS, London 2016; **4** •
Photo Courtesy Sotheby's, Inc. © 2016. ©
ADAGP, Paris and DACS, London 2016; **6** • ©
ADAGP, Paris and DACS, London 2016; **1921b:
1** • National Museum, Stockholm. © DACS
2004; **4** • Museum of Modern Art, New York. ©
DACS 2004; **5** • A. Rodchenko and V. Stepanova
Archive, Moscow. © DACS 2004; **1922: 1** • ©
DACS 2004; **2** • Paul Klee-Stiftung,
Kunstmuseum, Berne (inv. G62). © DACS 2004;
3 • Private Collection. © ADAGP, Paris and
DACS, London 2004; **4** • Sammlung Prinzhorn

ADAGP, Paris and DACS, London 2004; 4 • Philadelphia Museum of Art. Gift of the Cassandra Foundation. © Succession Marcel Duchamp/ADAGP, Paris and DACS, London 2004; **1966b: 1** • Museum of Modern Art, New York. Photo © Estate of Peter Moore/VAGA, New York/DACS, London 2004. © Louise Bourgeois/VAGA, New York/DACS, London 2004; **2** • Courtesy Cheim & Read, New York. Photo Rafael Lobato. © Louise Bourgeois/VAGA, New York/DACS, London 2004; **3** • Courtesy the artist; **4** • National Gallery of Australia, Canberra, 1974. © The Estate of Eva Hesse. Hauser & Wirth Zürich and London; **5** • Daros Collection, Switzerland. © The Estate of Eva Hesse. Hauser & Wirth; **1967a: 1** • Estate of Robert Smithson/VAGA, New York/DACS, London 2004; **2** • Collection of Geertjan Visser. Courtesy Sperone Westwater, New York. © ARS, NY and DACS, London 2004; **3** • Courtesy Gagosian Gallery, London. © Ed Ruscha; **4** • Private Collection. © ARS, NY and DACS, London 2004; **5** • Courtesy the Estate of Gordon Matta-Clark and David Zwirner, New York. © ARS, NY and DACS, London 2004; **1967b: 1** • Courtesy Archivo Merz, Turin; **2** • Photo Claudio Abate. Courtesy the artist; **3** • © the artist; **4** • Installation of 12 Piedi at Centre Georges Pompidou, Paris, 1972. Photo © Giorgio Colombo, Milan; **5** • Courtesy the artist; **6** • Galleria Civica d'Arte Moderna e Contemporanea di Torino – Fondazione De' Fornaris. Courtesy Fondazione Torino Musei – Archivio Fotografico, Turin; **7** • Photo the artist; **8** • Collection Annemarie Sauzeau Boetti, Paris. © DACS 2004; **1967c: 1** • No 58005/1–4, Collection Manfred Wandel, Stiftung für Konkrete Kunst, Reutlingen, Germany; Courtesy François Morellet. © ADAGP, Paris and DACS, London 2004; **2** • Photo Moderna Museet, Stockholm. © ADAGP, Paris and DACS, London 2004; **3** • Private Collection. Photo André Morain. © ADAGP, Paris and DACS, London 2004; **4** • © Photo CNAC/MNAM Dist. RMN; **5** • D.B. © ADAGP, Paris and DACS, London 2004; **1968a: 1** • Courtesy Sonnabend Gallery, New York; **2** • Courtesy Sonnabend Gallery, New York; **3** • Courtesy the artist and Marian Goodman Gallery, New York; **4** • Museum of Modern Art, New York. The Fellows of Photography Fund. © DACS 2004; **5** • © DACS 2004; **6** • Courtesy Monika Sprueth Gallery/Philomene Magers. © DACS, London 2004; **1968b: 1** • Courtesy Gagosian Gallery, London. © Ed Ruscha; **2** • Museum Ludwig, Cologne. Courtesy Rheinisches Bildarchiv Cologne. © Sol LeWitt. © ARS, NY and DACS, London 2004; **3** • Museum of Modern Art, New York. © ARS, NY and DACS, London 2004; **4** • Musée Nationale d'Art Moderne, Centre Georges Pompidou, Paris. © ARS, NY and DACS, London 2004; **5** • © ARS, NY and DACS, London 2004; **6** • Courtesy Lisson Gallery, London; **7** • Collection Van Abbe Museum, Eindhoven, The Netherlands. © ARS, NY and DACS, London 2004; **8** • Courtesy of John Baldessari; **1969: 1** • Formerly Saatchi Collection, London. © ARS, NY and DACS, London 2004; **2** • Courtesy the artist. Photo ©

Estate of Peter Moore/VAGA, New York/DACS, London 2004; **3** • Museum of Modern Art, New York. Courtesy the artist. Photo © Estate of Peter Moore/VAGA, New York/DACS, London 2004; **4** • Art Institue of Chicago, through prior gifts of Arthur Keating and Mr. and Mrs. Edward Morris. © The Estate of Eva Hesse. Hauser & Wirth Zürich and London; **1970: 1** • Photo © Estate of Peter Moore/VAGA, New York/DACS, London 2004; **2** • Drawing by Lawrence Kenny. Courtesy the artist; **2** • Photo Frank Thomas. Courtesy the artist; **2** • Photo Frank Thomas. Courtesy the artist; **3** • Solomon R. Guggenheim Museum, New York (Panza Collection). Courtesy the artist. Photo © Estate of Peter Moore/VAGA, New York/DACS, London 2004; **4** • © Estate of Robert Smithson/VAGA, New York/DACS, London 2004; **1971: 1** • Musée National d'Art Moderne, Centre Georges Pompidou, Paris. Courtesy the artist. © DACS 2004; **2** • D.B. © ADAGP, Paris and DACS, London 2004; **3** • Collection Daled, Brussels. Courtesy of the artist. © DACS 2004; **1972a: 1** • Collection Benjamin Katz. © DACS 2004; **1** • Collection Benjamin Katz. © DACS 2004; **2** • Collection Anne-Marie and Stéphane Rona. © DACS 2004; **3** • Galerie Michael Werner, Cologne. © DACS 2004; **4** • Ruth Kaiser, Courtesy Johannes Cadders. © DACS 2004; **5** • Municipal Van Abbe Museum, Eindhoven. © DACS 2004; **6** • © DACS 2004; **7** • © DACS 2004; **1972b: 1** • Museum Ludwig, Köln. Courtesy Rheinisches Bildarchiv, Köln (Cologne) ; **2** • Courtesy the artist. © DACS 2004; **3** • Art Institute of Chicago, Barbara Neff Smith Memorial Fund, Barbara Neff Smith & Solomon H. Smith Purchase Fund, 1977.600a-h. Courtesy Sperone Westwater, New York; **4** • Courtesy the artist. © DACS 2004; **5** • Collection Kunstmuseum, Bonn. © DACS 2004; **6** • Collection Speck, Cologne. Copyright the artist; **1972c: 1** • Archigram Archives 2016. © Archigram 1964; **2** • Venturi, Scott Brown and Associates, Inc.; **3** • Dorling Kindersley Ltd/Alamy Stock Photo; **4** • Courtesy Superstudio; **5** • Photo Diane Andrews Hall. © Ant Farm (Lord, Michels, Shreier), 1975. All rights reserved; **6** • Photo Arnaud Chicurel/Getty Images; **7** • Nikreates/Alamy Stock Photo; **1973: 1** • Photo © Estate of Peter Moore/VAGA, New York/DACS, London 2004. © Nam June Paik; **2** • Courtesy Electronic Arts Intermix (EAI), New York; **3** • Courtesy Electronic Arts Intermix (EAI), New York; **4** • © ARS, NY and DACS, London 2004; **5** • Courtesy Electronic Arts Intermix (EAI), New York; **1974: 1** • Photo Erró. Collection the artist. © ARS, NY and DACS, London 2004; **2** • Photo by Minoru Niizuma. © Yoko Ono; **3** • Photo Bill Beckley. Courtesy the artist; **3** • Photo Bill Beckley. Courtesy the artist; **4** • Photo Kathy Dillon. Courtesy the artist; **5** • Courtesy the artist; **6** • San Francisco Museum of Modern Art. © ARS, NY and DACS, London 2004; **1975a: 1** • © Judy Chicago 1972. © ARS, NY and DACS, London 2004; **2** • Philip Morris Companies, Inc. Faith Ringgold © 1980. ; **3** • The Brooklyn Museum of Art, Gift of The Elizabeth A. Sackler Foundation. Photo © Donald Woodman. © Judy

Chicago 1979. © ARS, NY and DACS, London 2004; **4** • Photo David Reynolds. Courtesy the artist; **5** • Courtesy of the Estate of Ana Mendieta and Galerie Lelong, New York; **6** • Arts Council of Great Britain. Courtesy the artist; **1975b: 3** • Photo Vlad Burykin. Courtesy of Museum of Avant-Garde Mastery and Knigi WAM, Moscow; **4** • Photo Hermann Feldhaus. Courtesy of Ronald Feldman Fine Arts, New York. © 2016 Komar and Melamid; **5** • Courtesy Andrei Monastyrski; **6** • Courtesy Garage Museum of Contemporary Art, Moscow. © Inspection Medical Hermeneutics; **1976: 1** • Photo E. Lee White, NYC, 1978. Courtesy the artist and The Kitchen, New York; **2** • Photo © Christopher Reenie/Robert Harding; **3** • Permanent collection the Chinati Foundation, Marfa, Texas. Photo Florian Holzherr. Art © Judd Foundation. Licensed by VAGA, New York/DACS, London 2004; **1977a: 1** • Courtesy the artist; **2** • Courtesy the artist and Metro Pictures; **3** • Courtesy the artist and Metro Pictures; **4** • Courtesy the artist and Metro Pictures; **5** • Courtesy Ydessa Hendeles Art Foundation, Toronto; **1977b: 1** • © Harmony Hammond/DACS, London/VAGA, NY 2016; **2** • Photo Chie Nishio; **3** • Courtesy Alexander and Bonin, New York. © The Estate of George Paul Thek; **4** • Courtesy Gladstone Gallery, New York and Brussels. © Jack Smith Archive; **5** • Photo Ellen Page Wilson. Courtesy the artist and Koenig & Clinton, New York; **6** • Photo Ellen Page Wilson. Courtesy the artist and Koenig & Clinton, New York; **7** • Courtesy Regen Projects, Los Angeles. © Catherine Opie; **8** • Courtesy of the artist; **1980: 1** • Courtesy the artist and Gorney Bravin and Lee, New York. © Sarah Charlesworth, 1978; **2** • Courtesy Barbara Gladstone Gallery, New York; **2** • Courtesy Barbara Gladstone Gallery, New York; **2** • Courtesy Barbara Gladstone Gallery, New York; **2** • Courtesy Barbara Gladstone Gallery, New York; **3** • Courtesy the artist; **4** • Courtesy Sean Kelly Gallery, New York; **1984a: 1** • Courtesy the artist; **2** • © ARS, NY and DACS, London 2004; **2** • © ARS, NY and DACS, London 2004; **3** • Collection the artist. Fred Lonidier, Visual Arts Department, University of California, San Diego; **3** • Collection the artist. Fred Lonidier, Visual Arts Department, University of California, San Diego; **4** • Courtesy the artist and Gorney Bravin & Lee, New York. © Martha Rosler, 1967–72; **5** • Courtesy the artist and Christopher Grimes Gallery, Santa Monica, CA; **6** • © Martha Rosler, 1974–5. Courtesy the artist and Gorney Bravin & Lee, New York; **6** • © Martha Rosler, 1974–5. Courtesy the artist and Gorney Bravin & Lee, New York; **1984b: 1** • Collection Mrs. Barbara Schwartz. Photo courtesy Gagosian Gallery, New York; **2** • Photo Jenny Holzer. © ARS, NY and DACS, London 2004; **3** • Courtesy Canal St. Communications; **1986: 1** • © Jeff Koons; **2** • Courtesy the artist and Jay Jopling/White Cube (London). © the artist; **3** • Courtesy the artist; **4** • Courtesy the artist; **5** • © Barbara Bloom, 1989. Courtesy Gorney, Bravin + Lee, New York; **1987: 1** • Courtesy of Group Material; **2** • Collection of Ulrich and Harriet Meyer. Photo James Dee. © DACS, London/VAGA, New York 2004; **3** • © Krzysztof Wodiczko. Courtesy Galerie Lelong, New York; **4** • The New York Public Library;

box Richard Serra, *Tilted Arc*, 1981 (destroyed). Cor-ten steel, 365.8 x 3657. 6 x 6.4 (144 x 1440 x 2½). Federal Plaza, New York. Photo Ann Chauvet, Paris; **5 •** The Werner and Elaine Dannheisser Foundation, New York. © The Felix Gonzalez-Torres Foundation. Courtesy of Andrea Rosen Gallery, New York; **6 •** The Werner and Elaine Dannheisser Foundation, New York. On long term loan to the Museum of Modern Art, New York. © The Felix Gonzalez-Torres Foundation. Courtesy of Andrea Rosen Gallery, New York; **7 •** Philadelphia Museum of Art. Courtesy the artist; **1988: 1 •** Museum of Modern Art, New York. Photo Axel Schneider, Frankfurt/Main. © Gerhard Richter; **2 •** Museum of Modern Art, New York. Photo Friedrich Rosenstiel, Cologne. © Gerhard Richter; **3 •** Städtische Galerie im Lenbachhaus, Munich. © Gerhard Richter; **4 •** Courtesy the artist; **1989: 1 •** Courtesy the artist; **2 •** Photo Dawoud Bey. Courtesy Jack Tilton/Anna Kustera Gallery, New York; **3 •** Courtesy Jack Tilton Gallery, New York; **4 •** Courtesy Marian Goodman Gallery, New York; **5 •** Courtesy Gavin Brown's Enterprise, New York; **1992: 1 •** Courtesy of Documenta Archiv. © DACS 2004; **2 •** Courtesy the artist and Metro Pictures Gallery, New York; **3 •** Courtesy Galleria Emi Fontana, Milan. Photo Roberto Marossi, Milan; **4 •** Courtesy the artist. Photo Nina Möntmann; **4 •** Photo courtesy De Vleeshal, Middelberg, American Fine Arts, Co., New York and Tanya Bonakdar Gallery, New York; **1993a: 1 •** Collection Alexina Duchamp, France. © Succession Marcel Duchamp/ADAGP, Paris and DACS, London 2004; **2 •** Courtesy the artist. © ARS, NY and DACS, London 2004; **3 •** Courtesy James Coleman and Marian Goodman Gallery, New York. © James Coleman; **4 •** Courtesy the artist and Metro Pictures Gallery, New York; **5 •** Courtesy the artist and Metro Pictures Gallery, New York; **1993b: 1 •** Private Collection. Courtesy of the Paula Cooper Gallery, New York; **2 •** Arts Council of England, London. Photo Edward Woodman. Courtesy the artist and Jay Jopling/White Cube (London). © the artist; **3 •** Courtesy the artist; **4 •** Commissioned by Artangel. Sponsored by Beck's. Courtesy Rachel Whiteread and Gagosian Gallery, London. Photo Sue Ormera; **1993c: 1 •** Courtesy the Paula Cooper Gallery, New York; **2 •** Courtesy the artist and P.P.O.W. Gallery, N.Y.; **3 •** Courtesy Sean Kelly Gallery, New York; **4 •** Photograph. © Rotimi Fani-Kayode/Autograph ABP; **5 •** Courtesy Stephen Friedman Gallery, London; **6 •** Courtesy the artist and Brent Sikkema, NYC; **7 •** Courtesy the artist and Hauser & Wirth. Photo courtesy Gagosian Gallery, New York; **8 •** © 2004 Glenn Ligon; **1994a: 1 •** Courtesy Sonnabend Gallery, New York; **2 •** Collection of the artist. Photo Ellen Page Wilson, courtesy Pace Wildenstein, New York. © Kiki Smith; **3 •** Courtesy the artist and Matthew Marks Gallery. Photo K. Ignatiadis for Jeu de Paume; **4 •** Courtesy the artist; **5 •** Private Collection/Courtesy Jablonka Galerie, Cologne. Photo Nic Tenwiggenhorn, Düsseldorf; **1994b: 1 •** Solomon R. Guggenheim Museum, New York. © Sol LeWitt. © ARS, NY and DACS, London 2004; **2 •** Courtesy Regen Projects, Los Angeles; **3 •** Courtesy the artist; **4 •** Courtesy the artist; **1997: 1 •** Courtesy Lunetta Batz, Maker, Johannesburg.

© Santu Mofokeng; **2 •** © Peter Magubane; **3 •** © David Goldblatt; **4 •** Courtesy Lunetta Batz, Maker, Johannesburg. © Santu Mofokeng; **5 •** Courtesy the artist and Jack Shainman Gallery, New York. © Zwelethu Mthethwa; **6 •** Courtesy Goodman Gallery, Cape Town. © Nontsikelelo Veleko; **7 •** Courtesy Stevenson, Cape Town and Johannesburg. © Zanele Muholi; **1998: 1 •** Photo Florian Holzherr. © James Turrell; **2 •** Courtesy the artist. Photo © 1997 Fotoworks Benny Chan; **3 •** Courtesy Lisson Gallery, London; **4 •** Courtesy David Zwirner, New York; **1999: 1 •** Courtesy the artist and Marian Goodman Gallery, New York; **2 •** Courtesy the artist and Jay Jopling/White Cube (London). © the artist; **3 •** Collection the artist. Courtesy Monika Sprueth Gallery/Philomene Magers. © DACS, London 2004; **2003: 1 •** Courtesy the artist and Corvi-Mora, London; **2 •** Courtesy the artist and Stephen Friedman Gallery, London; **3 •** Courtesy Marian Goodman Gallery, New York; **4 •** Courtesy the artist, Frith Street Gallery, London and Marian Goodman Galleries, New York and Paris; **2007a: 1 •** Courtesy Paula Cooper Gallery, New York. © Christian Marclay; **2 •** Courtesy Paula Cooper Gallery, New York. © Christian Marclay; **3 •** Photo courtesy the Artist and Marian Goodman Gallery, New York. © James Coleman; **4 •** Courtesy Paula Cooper Gallery, New York. © ADAGP, Paris and DACS, London 2011; **5 •** Photo courtesy the Artist and Marian Goodman Gallery, New York. © William Kentridge; **6 •** Photo courtesy the Artist and Marian Goodman Gallery, New York. © William Kentridge; **2007b: 1 •** © ADAGP, Paris and DACS, London 2011; **2 •** Courtesy the Artist and Galerie Daniel Buchholz, Cologne/Berlin; **3 •** Courtesy Stuart Shave/Modern Art, London. © Tom Burr; **4 •** Image courtesy the Artist and Kimmerich Gallery, New York; **5 •** Courtesy the Artist and Greene Naftali Gallery, New York; **6 •** Courtesy the Artist and Metro Pictures; **2007c: 1 •** © Hirst Holdings Limited and Damien Hirst. All rights reserved, DACS 2011; **2 •** Photo Laurent Lecat. © Jeff Koons; **3 •** Photo © Andy Rain/epa/Corbis. © Hirst Holdings Limited and Damien Hirst. All rights reserved, DACS 2011; **2009a: 1 •** Courtesy Galerie Lelong, New York. © The Estate of Ana Mendieta Collection; **2 •** Courtesy Studio Tania Bruguera; **3 •** Courtesy Gavin Brown Enterprise © Rirkrit Tiravanija; **4 •** Courtesy Gavin Brown Enterprise © Rirkrit Tiravanija; **5 •** Courtesy Marian Goodman Gallery, Paris / New York. © ADAGP, Paris and DACS, London 2011; **6 •** Courtesy Anton Vidokle; **2009b: 1 •** Installation view "Martin Kippenberger", Van Abbe Museum, Eindhoven, 2003. © Estate Martin Kippenberger, Galerie Gisela Capitain, Cologne; **2 •** Courtesy the Artist, Reena Spaulins, New York and Galerie Daniel Buchholz, Cologne/Berlin; **3 •** National Gallery of Art, Washington, D.C., January 20, 2004. Image courtesy Friedrich Petzel Gallery, New York. Photo Lammy Photo; **4 •** Courtesy the Artist and Galerie Daniel Buchholz, Cologne/Berlin; **5 •** Courtesy the Artist and Galerie Daniel Buchholz, Cologne/Berlin; **6 •** Image courtesy Friedrich Petzel Gallery, New York. Photo Thomas Mueller; **7 •** Photo Jeffrey Sturges; **2009c: 1 •** Courtesy Gladstone Gallery, New York; **2 •** Courtesy Gladstone Gallery, New York; **3 •** Courtesy

Andrea Geyer; **4 •** © Harun Farocki 2009; **5 •** Courtesy Cheim & Read Gallery, New York / © ARS, NY and DACS, London 2011; **2010a: 1 •** Courtesy the Artist; Leister Foundation, Switzerland; Erlenmeyer Stiftung, Switzerland and Galerie Urs Meile, Beijing-Lucerne; **2 •** Courtesy the Artist; Leister Foundation, Switzerland; Erlenmeyer Stiftung, Switzerland and Galerie Urs Meile, Beijing-Lucerne; **3 •** Photo Tate, London, 2011. © Ai Weiwei; **4 •** Courtesy the Artist; Leister Foundation, Switzerland; Erlenmeyer Stiftung, Switzerland and Galerie Urs Meile, Beijing-Lucerne. Photograph by Frank Schinski; **5 •** © Wang Guangyi; **6 •** © Zhang Huan; **7 •** Courtesy Pace Gallery, New York. © Zhang Huan; **2010b: 1 •** Courtesy Bernadette Corporation; **2 •** Courtesy John Kelsey; **3 •** Images from the Jumex traveling show curated by Adriano Pedrosa "Intruders (Foreigners Everywhere, 2004–10)", 2010, Courtesy the Artist and Gaga Arte Contemporanea, Mexico D.F. and Metro Pictures, New York; **4 •** © 2010 Cao Fei, courtesy Lombard Fried Projects, New York; **5 •** Courtesy Anthony Reynolds Gallery, London. © the Artist; **6 •** Courtesy www.theyesmen.org; **2015: 1 •** Photo Ed Lederman; **2 •** Courtesy Herzog & de Meuron; **3 •** Photo Roland Halbe; **4 •** age fotostock/Alamy Stock Photo; **5 •** Diller Scofidio + Renfro; **6 •** Courtesy Jeremy Deller; **7 •** Courtesy Sharon Hayes

index

Orozco, Gabriel 58, 720–2, *723*, 779, 781, 790–7

Orozco, José Clemente 303–7, *304*

Ortiz, Raphael Montanez 649

Oshima, Tetsuya 435

OST (Society of Easel Painters) 310, 313

ostranenie 37, 143–5, 860

Oud, J. J. P. 166, 169

Oursler, Tony 766

Ozenfant, Amédée 183, 222–3, 259, 287, 400, 406, 449

Paalen, Wolfgang 348–52, *348*

Pace Gallery, New York 829, *829*

Paik, Nam June 527, 528, 644, *645*, 648, 766

Palais Stoclet, Brussels 65, *65*

Palermo, Blinky 551, 553, 630–5, *634*

Pane, Gina 652

Pankejeff, Sergei 94, *94*

Pankok, Bernhard 274

Panofsky, Erwin 379, 841, 861

Paolozzi, Eduardo 419–21, *421*, 447–52, *447*, *450*, 483

Pape, Lygia 495, 497, 500, *501*

Paper Tiger Television 645

paradigm, structural 38, 125, 128–9, 462–5, 862–5

"Parallel of Life and Art" 420–1, 449, *449*

Parc, Julio le 443, 446

Pardo, Jorge 705–6

Paris Match 189, 274

Parker, Cornelia 737

Parker, Raymond 430

Parmentier, Daniel 596, *596*

Parreno, Philippe 779–80, 805–7, 864

Partisan Review 348–50, 377

part-object 486, 576–80, *576–7*, 613, 733, 748, 843

Pascali, Pino 585, 587–8, *587*

Pasolini, Pier Paolo 587

Passloff, Pat 401

pastiche 76–7, 146, 178–83, *179*, 222, 332, 472, 674, 699–702, *699*, 738, 774

Patterson, Benjamin 528–9

Paulhan, Jean 395–7, 857

Paxton, Steve 839

"Peau de l'Ours," The 140, 380

Pechstein, Max 76, 204

Pedersen, Carl-Henning 416

Pedrosa, Mario 494–6

Peirce, Charles Sanders 34, 861, 864

Penck, A. R. 551

Penn, Irving 489–91

Penone, Giuseppe 588–9, *589*

Penrose, Roland 342, 447

Pepperstein, Pavel 666

Peredvizhniki 308–9

Performance art 19, *32*, *147*, 148–9, 153, 437–8, *437–40*, 440, 466, 498, *499–501*, 520–4, 526–39, *522–4*, *526–8*, 535, *537–9*, 556–7, *556–7*, 558, 610, 637, 640, 644, *645*, 646, 648, 649–53, *649–52*, 654–5, *655*, 663, 665, *665*, 668, 672, 700, *701*, 709, 711, 717, 720–3, *722*, 728, 729, 732, 737–8, 741, 748–51, 764, 768, 785, 798, 799, 804–9, *804–6*, 810–13, 827–9, 832, *835*, 836–40, *840*, *841*, 846–9, 860

performatives, linguistic 43, 526, 559, 604, 675, 863

Peri, László 264, *264*

Permanyer, Lluis 338

Perret, Gustave 220

Perriand, Charlotte 636

Pest 710

Peterhans, Walter 283

Pettibon, Raymond 752–5, *754*

Pevsner, Antoine 335, 357, 540

Pevsner, Nikolaus 419

Pfeiffer, Paul 766–7

phallogocentrism 732, 863

phenomenology 19, 134, 282, 402, 415, 417, 427, 498–500, 462–3, 484, 512–13, 570–1, 587, 612–13, 617–18, 622, 633–5, 648, 650, 653, 658, 738–9, 764–6, 790, 794, 844, 863

Philadelphia Museum of Art 466, 541, 572–5

phoneme 139, 167, 189, 245, 863

photoconceptualism 290, 602, 603–9, 621–3, 692–7, 717, 742

photograms 211, 268, 275–6, 399, 420, *421*, 645

photography 14, *20–21*, *23*, *26*, 28–9, *28–9*, *49*, 102, 106, *106*, 154–9, *156–9*, 172–7, 181, 214–19, *217–19*, 227, 230–1, 233, 238, 243, 257, 258, 259, 268–9, 274–9, *275–9*, 282–6, *283–6*, *290–1*, *309*, 310, 312, 318, 319–23, *319–21*, 324–8, *325–8*, 383, 399, 400, 420, 432, 442, 488–93, *489–93*, 542, 562, 566, 573, *583*, 585, 597–609, *598–603*, 650, 672–5, *672–5*, *684–5*, 688–97, *689–92*, *694–7*, *712*, 715, *716*, 717, *736*, 742, 743, *743*, 744, 756–63, *757–63*, 773–7, *774–6*, 782, *783*, 792, 811, 846, 850, 864

photomontage 17, 25, *25–6*, 29, *29*, 150, 186–91, *187–91*, 211, 228, 270, 275, *291*, 310, 338–40, *340*, 343–4, *344*, 375, 383, 399, 507, 597, 693–5, *695*, 773, 785

Photo-Secession, New York 154–9

Piano, Renzo 641, *641*, 836, *836*

Picabia, Francis 139, 147, 149, 150, 154, *154*, 175, 180–1, *182*, 183, 186, 207, 234, 243, 244–5, 256, 259, 261, 357, 439, 848

Picasso, Pablo 18, 37, 39–40, *39–40*, 70–1, 75, 76–81, 90–6, *91–3*, 95, 99–100, 114–16, 118–23, *119–20*, *122–3*, 124–9, *125–9*, 130, 133, 137–8, 140, 154, 160, 162, 172, 178–83, *179–82*, 186–8, 192–7, *193–4*, 214, 218, 222–3, 226, 255, 294–5, 297, 300–2, *302*, 314, 315, 322, 333, *333*, 335, 338–45, *339*, *341–2*, 351–2, 353, 357, 363, 369–72, *371*, 373, 379, 382, 388, *389*, 393, 405, 416, 426, 442, 449, 474, 489, 505, 519, 540, 553, 572, 668, 720, 785, 803, 858, 864

Pictorialism 155–7, 277–9, 283, 773

"Pictures" 49, 672–5

Piene, Otto 445

Pieret, Géry 118

Pierson, Jack 710

Pimenov, Yury 310

Pinault, François 799

Pincus-Witten, Robert 680

Piper, Adrian 663, 720, 741–3, *741*, 830

Piper, John 335

Piper, Keith 719, 744

Pistoletto, Michelangelo 588, *588*

pittura metafisica 108–9, *109*, 138, 183, 226–8, 373, 585, 589

Plekhanov, Georgy 308

Pleynet, Marcelin 549

Poliakoff, Serge 594

Polke, Sigmar 515, 517, 551, 553, 633–5, *635*

Pollard, Ingrid 744

Pollock, Jackson 19, 35, 49, 53, 298, 306, 343, 345, 350–2, *350*, 357, 366, 371–2, 376–9, 384, 404–7, 411–15, *411–15*, 419–20, 424–5, 427, 433, 435–40, *435*, 452, 469, 472, 480, 483, 486, 489, 509, *509*, 513, 515, 518, 520–2, 524, 527–8, 530–1, 534, 546–7, 549, 558, 578, 582, 595, 605, 611, 650, 673, 688, 752, 754, 837, 846, 858–9, 862, 865

Pomona College 306, 616–18

Pondick, Rona 747–8, *747*

Ponge, Francis 396–7, 485

Pop art 19, 30, 53, 259, 261, 307, 354, 377–8, 383, 402, 408, 410, 421, 447–52, *447–51*, 457, 469, 471, 473, 479, 483, 486, 507, 515–20, *515–16*, *518–19*, 526, 531, 537, 545–50, *545–50*, 553, 557–8, 562–7, *563–5*, *567*, 572, 578, 581, 585, 587, 603, 605, 608, 631, 636–8, 640–1, 643, 652, 665, 680, 688–9, 693–5, 697, 702, 709, 710, 711, 714, 717, 753, 773, 790, 792–3, 798, 810–11, 844–9, 860, 864

Popova, Liubov 133, 202–3, 237

Porstmann, Walter 272–3

Porter, Elliott 50

Porter, James A. 358–63

Posada, José Guadalupe 303

positivism 31, 138, 142, 144, 181, 218, 380, 413, 464, 471, 493, 511, 536–8, 543, 561, 589, 597, 609, 631, 634, 671, 861, 863

Possibilities 404, 406, 408, 605

postcolonialism 20, 719–23, 726, 729, 731, 764, 853, 857, 863

Postimpressionism 25, 51–2, 67, 76–81, *79*, 82–9, 113, 116, 130, 143, 160, 257, 303, 308–9, 610

postmedium condition 610, 649, 785–6, 788, 832, 837, 847–8, 864

Postminimalism 21, 576–80, *576–80*, 588–9, 599, 610–13, *611–13*, *616*, *618*, 621–4, 634, 649, 653, 678, 692, 710–11, 737–40, *737–40*, 785, 790, 793, 837, 840, 843, 853

postmodernism 41, 49–50, 519, 636–43, *637–42*, 648, 672–5, 688–91, 698–701, 719, 727, 729, 732, 737, 742, 767, 777, 779, 798, 844, 847, 851–4, 864

"post-painterly abstraction" *510–11*, 513, *513–14*

poststructuralism 14, 34, 41–50, 562, 575, 623, 630, 698–701, 712, 847, 851–4, 864

Pound, Ezra 100, 253, 315

Poussin, Nicolas 82, 85, 88, 96, 178, 180, 192, 222, 365, 371, 774, 811–12, 817

"praegnanz" 392, 415, 860

Prague Linguistic Circle 34

Pratella, Ballila 102

Precisionism, American 256–61, *259*, 327, 360

Price, Cedric 637, 641

"primal scene, the" 23, 94, 208

"Primary Structures" 568–70, 610, 839

primitivism 17, 18, 36, 76–81, 90–6, 99, 108, 204, 224, 252–3, 259, 287–90, 292, 329, 358, 378, 416, 459, 474, 554, 590, 719, 721, 729, 744

Prina, Stephen 812–17, *812*

Prince, Richard 688–90, *690*

Prinzhorn, Hans 18, 204–8, 395, 554

Pritzel, Lotte 232, 234

Process art 19, 54, 414, 464, *464–5*, 469, 471, 610–13, *612*, 646, 649, 726, 728–9, *734*, 738, 773

Productivism, Soviet 26, 27, 28, 29, 198–203, 191, 245, 263–5, 310, 380, 527–8, 531, 570

projected image *709*, 764–8, *764–5*, *767–8*, *780*

Proletkult 199, 308

Proust, Marcel 623, 768, 841

Prouvé, Jean 224, 254, 807

P.S.1, New York 668–9

psychic automatism 18, 214–19; *see also* automatism

psychoanalysis 17–23, 24, 38, 64–8, 94, 182–3, 204–8, 214–16, 219, 288, 293–6, 299, 378, 405, 413, 525, 531, 535–6, 538, 566, 576–80, 612, 653, 656–8, 692, 727, 750–1, 844, 850–1, 853, 858–9, 863, 865; *see also* psychoanalytic interpretation

psychoanalytic interpretation 14, 17–23, 94, 182–3, 219, 295, 376, 413, 566, 576–80, 843, 852

psychobiography *see* biographism

psychogeography 456, *456*

Pudovkin, Vsevolod 636

punctum 566

Puni, Ivan 143

Punin, Nikolai 199–200

puppets *see* dolls, use of

Purism 183, 222–3, *222*, 257, 259, 334–5

"Puteaux Group" 139

Quaytman, R. H. *816*, 817

Queens Museum of Art 57, *57*

queer aesthetics and art 676–85, *677*, *679*, *681*, *682–5*, 707–13, 726, 741, 747–9, 764, 857

queer theory, "queerness" 676, 679, 680, 682

Queneau, Raymond 485

Quine, Willard 785

Quinn, John 155, 255

Raad, Walid *834*, 835

Rahv, Philip 349

Rainer, Arnulf 538

Rainer, Yvonne 524, 612, 649, 839